Studies in Religious Iconography by Emile Mâle

EDITED BY HARRY BOBER, TRANSLATED BY MARTHIEL MATHEWS

This Volume Has Been Edited, with a Foreword, by
Harry Bober; Consulting Editor, Louis Grodecki

EMILE MÂLE

Religious Art in France

THE TWELFTH CENTURY

A Study of the

Origins of Medieval Iconography

BOLLINGEN SERIES XC · 1

PRINCETON UNIVERSITY PRESS

Copyright © 1978 by Princeton University Press
Published by Princeton University Press, Princeton, New Jersey
In the United Kingdom: Princeton University Press,
Guildford, Surrey

Translated from Emile Mâle, *L'Art religieux du XIIe
siècle en France. Etude sur l'origine de
l'iconographie du Moyen Age*. Paris, Armand Colin.
First edition, 1922; reprinted 1924, 1928, 1940, 1947,
1953 (revised and corrected), 1966.
This volume has been translated from the 1953 edition.

Library of Congress Cataloging in Publication Data will
be found on the last printed page of this book.

This is the first of several English translations of works by
Emile Mâle constituting number XC in Bollingen Series
sponsored by Bollingen Foundation.

Printed in the United States of America
by the Meriden Gravure Company, Meriden, Connecticut
Composed by Princeton University Press, Princeton, New Jersey

EDITOR'S FOREWORD

Rare few are those older books on art that effectively outlive, much less transcend, the obsolescence that usually sets in with changes of taste and developments in new knowledge from one generation to the next. Pre-eminent among such books is the timeless work of the French scholar Emile Mâle (1862–1954) on the medieval art of France. Originally conceived as a single book on the thirteenth century, published some eighty years ago, it turned out, in the end, to be a comprehensive three-volume work embracing Romanesque and Gothic art to the close of the Middle Ages. In that final form the original volume on the thirteenth century remained central, the main panel, in effect, of a triptych flanked by the twelfth-century volume on one side, and the volume on the end of the Middle Ages on the other. A later and final volume carried the study of religious iconography into the period following the Council of Trent but the geographic area covered in that book is no longer restricted to France.

While each of the first three volumes stands, and has served as, an independent work, together they constitute an integrated and monumental entity, an unrivaled masterwork of French literature on the art of medieval France. For every generation of French medievalists, be it in the arts, letters, or history, and for all these years of the twentieth century, Mâle's work has held its place as a standard and esteemed classic. Even in the English-speaking world, where only the volume on the thirteenth century has been generally available, and the rest only in excerpts[1]—at that, in translations that are far from adequate—his name has become a byword for medievalists and his work an acknowledged foundation stone in the edifice of medieval studies.

The volume that we are publishing herewith, dealing with the twelfth century, first appeared in 1922 and has been issued in six French editions.[2] Even a Japanese translation has been announced, but there has never been a complete translation into English. It is therefore time indeed that this, the first English edition, should be made available, and that the translation be such as to preserve accuracy in all technical and critical content, while at the same time sensitive in style to the literary qualities of the original. It is especially appropriate that the present volume should also serve to inaugurate the complete three-volume work, in which the next two volumes, also newly translated and edited on the model of the first, will be issued in this series, to be followed finally by the fourth and related volume.

There is a curious circumstance with respect to the place of the present volume in the triptych that is most revealing for our understanding of

1 Emile Mâle, *Religious Art from the Twelfth to the Eighteenth Century*, New York, 1949, includes selections from all three volumes as well as from his later work, *L'Art religieux après le Concile de Trente*, Paris, 1932.
2 See "Bibliographie des travaux d'Emile Mâle, 2 juin 1862—6 octobre 1954," *Cahiers de civilisation médievale* (Université de Poitiers), 2 (1959), pp. 69–84.

Mâle's place in the historiography of medieval art. Although the first in the chronological sequence of history, this volume was in fact the very last that he wrote. Instead, the thirteenth-century volume, which was also his doctoral dissertation published in 1898, was the first. Its title, *L'Art religieux du XIIIe siècle en France*, anticipated what was to become the theme for the four centuries covered in the final work; its subtitle, *Etude sur l'iconographie du moyen âge et sur ses sources d'inspiration*, an indication of his method and approach. In both respects—the choice of the thirteenth century, and in iconographic method—Mâle was the product of his nineteenth-century birth and early life. In the brilliance of his exposition, he achieved the *summa* of medieval scholarship of that century.

The nineteenth was the first century of sustained scholarship in the restoration of medieval art to good standing after four centuries of deprecation since the Renaissance. For the nineteenth century, Gothic art, particularly of the thirteenth century, represented the quintessence of medieval art. Thirteenth-century art, for the nineteenth-century critic and scholar, was medieval art attained, medieval art at its height, and medieval art in its most complete expression, unmatched before and unequaled thereafter. Emile Mâle was speaking for his century when he said that the thirteenth was the century when "medieval art expressed all things," that in this art was to be found "the finished system."[3]

In effect, Emile Mâle was defining medieval art as thirteenth-century Gothic, and his first book was the comprehensive statement not only of his position but of the nineteenth century in which he was then writing. As for the rest of the Middle Ages, the earlier periods then seemed to present complexities and such imperfect vacillations and gropings that no single previous century or centuries could be taken as truly medieval art arrived; all was Christian art, it is true, but otherwise without any compellingly distinct medieval character when compared with the thirteenth. The centuries beyond the thirteenth, on the other hand, appeared to be equally disqualified in the light of the thirteenth-century standard. At best, fourteenth- and fifteenth-century art appeared to manifest only derivative ramifications of the thirteenth; at worst, "a period of dissolution."[4] His book on the thirteenth century was to be a complete statement on the iconographic essence of the whole of medieval art. Not even one, much less two, of the eventual complementary volumes was envisaged by him in 1898.

Nevertheless, it was almost inevitable that he should have been drawn into the pursuit of later medieval art, if only for the fact that so many of the thirteenth-century monuments were still being completed, with new sculptural and painted decoration, well into the fourteenth and fifteenth centuries. Thus, the iconography of religious art in France at the end of the Middle Ages became the subject for a second book, published ten

3 *L'Art religieux du XIIIe siècle en France*, Paris, 1898, pp. iv, v.
4 *Ibid.*, p. vi.

years after the first.[5] Not only did the new book complement the old, it seemed also to complete it. Together they constituted a comprehensive work on the iconography of Gothic art. But there was still no first volume in the sense of the chronological series as it now exists. Indeed, Mâle seemed to have moved even further away from those beginnings.

It was not until 1922, almost a quarter of a century after his first book, and thirty years since he "first embarked upon these studies," that Mâle published the volume on the twelfth century,[6] offered here as the first in our new English edition. He tells us, in the very first words of the book, that "It is with the present volume that I should have begun this history of religious art of the Middle Ages." The reverse sequence in his studies that began and continued with Gothic and then returned to Romanesque came about neither by chance nor design. It was a factor of the circumstances in the history of the nineteenth- and twentieth-century recovery of medieval art.

The nineteenth-century restoration of the Middle Ages to the canons of good taste and high art was far from categoric. It was not simply partial to Gothic, it was reserved for Gothic alone, to the exclusion of all the preceding Christian centuries. The term "Gothic," used until the late eighteenth century in the generic sense for all the "debased" are between antiquity and the Renaissance, was now detached from the rest, elevated and restricted to the "ogival style" best exemplified in the thirteenth century. But the old critical opprobrium of the "dark ages" still applied to all the rest of the Middle Ages. Now it was the pre-Gothic Middle Ages that was, *en bloc*, the "barbarous epoch." The fact that there was favorable allowance for such manifestations as Carolingian art did not effect, in essence, the broad outlines of that simple history. Between venerated antiquity and the Renaissance stood the decline of art during the long Dark Ages and the recovery of Christian art in thirteenth-century Gothic.

Everywhere in France, even as Gothic buildings were being studied and restored, Romanesque and pre-Romanesque monuments stood abandoned —ignored or despised. Worse, still, they were being destroyed not alone by the effects of time, but by deliberate intention.[7] The most famous and the greatest single tragedy of all was the case of the abbey church of Cluny. It was sold by the State to contractors as mere building materials in 1790 and, by 1823, all of the vast church with its enormous complex of monastic buildings, except for a single transept tower, had been demolished down to the ground.

At the beginning of the nineteenth century, while Gothic was already beginning to take its eventual place, the history of the rest of medieval art was but indifferently understood, much less differentiated as to chronology, periods, and styles. There was not even agreement on the designations then applied to the entire pre-Gothic span, or on the use of such

5 *L'Art religieux de la fin du moyen âge en France*, Paris, 1908.

6 *L'Art religieux du XIIe siècle en France. Etude sur les origines de l'iconographie du moyen âge*, Paris, 1922.

7 See Paul Léon, *La Vie des monuments français. Destruction. Restauration.* Paris, 1951.

terms as "Lombard," "Saxon," and "Byzantine." In 1818, the eminent expatriate French archeologist Gerville, concerned to find proper headings for the development of architecture in Normandy, which he had come to understand so well, wrote: "I know practically none of the terms for medieval architecture, and especially in French, although I know some in English but I find it impossible to translate them. I have been unable to find in Paris any work that explains them."[8]

It was Gerville, together with the Norman antiquarian August Le Prévost, who, already in the second decade of the century, prepared the groundwork for the methodical characterization of pre-Gothic architecture. Romanesque—the term and the stylistic concept—was thus first brought into being and defined by Gerville, in 1818, as "opus romanum dénaturé ou successivement degradé par nos rudes ancêtres." The term was meant to include "architecture after Roman domination and prior to the twelfth century."[9] But neither the negative characterization, nor the unqualified sweep of its application—hardly surprising for the time—detract from the essential contribution, the discernment and naming of Romanesque. If we must credit Gerville for the coinage of the term, we must acknowledge that it was Arcisse de Caumont, another Norman antiquarian, who in 1824 established "Romanesque" as international currency for the rest of the history of art. De Caumont's "Essai sur l'architecture religieuse du moyen âge," published in the *Mémoires de la Société des Antiquaires de Normandie*, in 1824, marked the first great step in the continuous development of what was to become our modern histories of medieval art.[10] One year before de Caumont's publication, Sulpice Boisserée had proposed a comparably methodical history, in the context of his book on the cathedral of Cologne.[11] Although Boisserée's work was published in Paris as well as Stuttgart in that same year, it was neither known to de Caumont when he wrote his "Essai," nor was it to have much future impact. The new medieval archeology was launched by Gerville, Le Prévost, Boisserée and de Caumont, but it was Arcisse de Caumont alone who distilled and shaped their contributions into the academic structure through which it became formally integrated in cultural and intellectual history. This would have been achieved with his public lectures alone, held in Caen from 1830 to 1841. But it became a fixed part of French scholarship for the rest of the century with the publication of his lectures in twelve volumes, his *Cours d'antiquités monumentales professé à Caen; Histoire de l'art dans l'ouest de la France, depuis les temps les plus reculés jusqu'au XVIII siècle*, Paris, 1830–1841.

To gauge the radical novelty of the new history, with its sequence of Romanesque and Gothic art, we need only cite the huge "picture book" of 1823 by Seroux d'Agincourt of which the title alone betrays the persistent ancient prejudice. He called it the *Histoire de l'art par les monuments,*

8 In an unpublished letter, cited in Jean Mallion, *Victor Hugo et l'art architectural* (Université de Grenoble, Publications de la faculté des lettres et sciences humaines, no. 28), Paris, 1962, p. 29.

9 For the origins of the term "Romanesque," see Jules Quicherat, "De l'Architecture romane," *Revue archéologique*, 8 (1951), pp. 145-158 (reprinted in *Jules Quicherat, sa vie et ses travaux*, Robert de Lasteyrie, ed., Paris, 1883, pp. 86ff.); Louis Courajod, *Leçons professées à l'école du Louvre (1887–1896)*, Henri Lemonnier and André Michel, eds., Paris, 1899, I, pp. 409ff.; and cf. Mallion, *op. cit.*, p. 31.

10 Arcisse de Caumont, "Essai sur l'architecture religieuse du moyen âge, particulièrement en Normandie," *Mémoires de la Société des Antiquaires de Normandie*, 1824. Cf. F. Deshoulières, "Historique de la Société Française d'Archéologie 1834-1934)," sec. I, on Arcisse de Caumont, *Centenaire du Service des Monuments Historiques et de la Société Française d'Archéologie, Congrès archéologique de France* (session XCVII, held in Paris in 1934), 2 vols., Paris, 1935, II, pp. 9-28.

11 Cf. Mallion, *loc. cit.*

depuis sa décadence au IVe siècle jusqu'à son renouvellement au XVIe.[12] France scarcely enters into this history; Gothic architecture is presented under the chronological heading of "the ninth to the mid-fifteenth century," while Romanesque is never mentioned, by term or concept.

With the July Monarchy of 1830 the restoration of medieval art was raised from the status of regional antiquarianism to nationalist concern with centralized State organization, promulgation, and support. The signal event in that change was the creation of a national *Service des Monuments Historiques de France*, at the behest of the Minister of the Interior, François Guizot.[13] Behind this achievement lay years of zealous public agitation, led by Victor Hugo and Charles de Montalembert—the latter an influential political figure as well as an active "pamphleteer" for the cause—against vandalism of the historic monuments. Under the administration of Prosper Mérimée, of "Carmen" fame, who served as Inspector-General of Historic Monuments for eighteen years (1834–1852), the tide of destruction was arrested and, with the undertaking of restorations which he entrusted to Viollet-le-Duc, turned.[14]

Hitherto centered mainly in Normandy, and around architecture, under the national ministry and under Mérimée, every region of France was now encompassed, and all of the arts. Mérimée studied, described and analyzed Romanesque as well as the favored Gothic, cogently and methodically. Sculpture as well as painting took its proper place in the context of architecture. Interspersed in his four volumes of reports on the regional tours, published between 1835 and 1840, we find the most comprehensive account known to that time of most of the now familiar monuments of Romanesque sculpture and of still others, lost since, funds and rescue coming too late. For all his sensitivity to positive qualities of Romanesque sculpture and painting, remarkable enough for the period, Mérimée was still not free of the overwhelming prejudices of his time. When he comments on some of the attractive qualities of the sculptured tympanum of Ste.-Foy at Conques, for instance, it is with surprise considering its otherwise "barbarous" carving that is to be expected from such a "crude epoch."[15]

Unlike architecture, which entailed no comparison with living forms or standards of verisimilitude that is the denominator of all those diverse styles oriented toward nature, Romanesque figurative arts continued to frustrate efforts by even its most friendly critics—to say nothing of its inherently antagonistic classicistic critics—to accept fully its peculiar forms. Only after the painters of the abstract movements in the late nineteenth and early twentieth centuries—the post-impressionists, fauvists, cubists and expressionists—finally shattered the tyrannical esthetic of naturalism, did critics and historians begin to discover their freedom to admire the autonomous formal virtues of Romanesque sculpture. Stendhal, to cite one

12 (J.-B.-L.-G.) Seroux d'Agincourt, *Histoire de l'art par les monuments depuis sa décadence au IVe siècle jusqu'à son renouvellement au XVIe*, 6 vols., Paris, 1823 (English edition in 3 vols., London, 1847).

13 Léon, *op. cit.*, pp. 125ff., and *passim*. See also Paul Verdier, "Le Service des Monuments Historiques, son histoire, organization, administration, législation (1830–1934)," *Centenaire du Service*, I, pp. 53–286.

14 See Prosper Mérimée, *Inspecteur Général des Monuments Historiques, Notes de voyages* (Edition du Centenaire), Pierre-Marie Auzas, ed., Paris, 1971.

15 *Ibid.*, p. 539.

antagonist around the middle of the century, stood aghast before the church of St.-Lazare at Autun. "Great God, what ugliness!" he exclaimed, adding, "To study our ecclesiastical architecture you would have to be made of bronze!"[16] Even the sympathetic Walter Pater, on a pilgrimage of devotion to Vézelay at the end of the century, and not insensitive to the variety and energy of the nave capitals, found but "wild promise in their coarse execution" and, alas, "little or no sense of beauty."[17]

Even with the advances in knowledge and understanding on the part of historians in the last decades of the century, the study of Romanesque art could be said only to have begun to pass finally its first, primitive stage. In his lectures at the Ecole du Louvre, between 1887 and 1896, Louis Courajod still took as his foundation the work of Gerville and de Caumont, which had "become universal law in France."[18] Nevertheless, Courajod opened the way for the new directions his students were to develop. For one thing, he contested de Caumont's history which would have the "first half of the Middle Ages," up to the eleventh century, as essentially a period of continued decadence of classical and Roman art. To this end he painstakingly explored the contributions of "Gallic or Celtic," Gallo-Roman, Latin (Christian), Byzantine, Barbaric, and Arabic art to this first period, and eventually to the creation of the Romanesque. For another, he saw in "the Barbaric temperament" an "aesthetic and moral principle perceptibly different" and, indeed, opposed to the "corrupted and exhausted classical and Roman."[19] The importance of Courajod's "barbaric temperament" cannot be overestimated. For, as the new movements in painting had done—and possibly as a concomitant of those movements—so the recognition of barbaric abstraction and colorism as positive esthetic qualities opened the way to an understanding by the historian of the puzzling "distortions" and totally unclassical form of so much of Romanesque sculpture. (The critics did not have the same problem with Provençal and other Romanesque monuments in which the influence of Roman antiquity was marked.) Then, too, Courajod's position led another generation of students to the next step beyond de Caumont, namely, to the study and definition of the stages of medieval development between late antiquity and the Romanesque.

There can be no more indicative "fossil index" of the close of one stage in a historical or historiographical development, and the opening of another, than the encounter of a new species. When that new species is not merely different from but is the total opposite of the preceding kind, then the indication that a new stage is being signaled could not be more compelling. Thus the beginning of the twentieth century is seen as marking the end of a first period in the study and recovery of Romanesque art when we encounter the statement that the hitherto exalted Gothic thirteenth century was but a "sterile epoch" in comparison to the originality

16 Henri Stendhal (Beyle), *Mémoires d'un touriste*, Paris, 1938, I, p. 66.

17 Walter Pater, "Vézelay," reprinted in *Some Great Churches in France, Three Essays by William Morris and Walter Pater*, Portland, Maine (Thos. B. Mosher), 1912, p. 99 (from *The Nineteenth Century*, June, 1894).

18 Courajod, *op. cit.*, I, p. 410.

19 *Ibid.*, p. 423.

and vitality of the Romanesque twelfth.[20] "The culminating point, indeed, is certainly the twelfth century," wrote Emile Molinier in 1901, in a chapter entitled "Le grand Siècle du moyen âge." The title, he admits, is borrowed from his master, Jules Quicherat, Director of the Ecole des Chartes and famous for precision and clarity of method in his writings and lectures on the archeology of the Middle Ages. But the extreme of passion in Molinier's argument is his own, for he overlooks the fact that Quicherat had called the very next chapter in his book "La Période brillante du moyen âge, de 1190 à 1340," and that in the text, the thirteenth century was still "le plus brillant du moyen âge."[21] In the larger perspective of time it is not the polemic of Romanesque versus Gothic that concerns us, nor need it, but the attainment of balance between them.

But there was more, and the first decades of the twentieth century did indeed bring into being the first complete and systematic scholarly histories of medieval art of the modern era. Suffice it to mention a few of the general histories, specialized studies, manuals of method, and comprehensive archeological handbooks, such as those by Brutails, Enlart, Cabrol, de Lasteyrie,[22] and the very basic, collaborative history which is André Michel's *Historie de l'art* of 1905.[23] In the first two volumes of Michel's work, all the periods and styles, essentially as we now know them, from the Early Christian through Romanesque, are systematically set forth by the leading scholars of the day. The second volume, in fact, is devoted entirely to a judicious account of Romanesque art. Two additional volumes, published in 1906, are devoted to the "formation, expansion and evolution of Gothic art."

Emile Mâle's first volume, in 1898, and his last, in 1922, in the trilogy on the iconography of medieval art in France, appeared on the stage of historiography with that fateful symmetry of convergence with which so many decisive events seem to fall at very special times. Reckoned by the years of his life, Mâle was thoroughly a figure of the nineteenth century and yet, as much if not more, fully a figure of the twentieth. For one century, his work was the capstone; for the other it was a ground-breaking pioneer in his chosen field of study. If something less than half of his years were spent in the former, they were also, on balance, the telling years of his intellectual formation and early maturity. For the rest, his life and work extended across all of the first half of the twentieth century and, if only barely, even into the second. With the first book he wrought the culminating masterpiece of the first, the Gothic century, of medieval studies, distilling its essential contributions and articulating them in that century's finest expression as no other single book had, and as none has since. With his book on the twelfth century he crystallized the second period of medieval historiography at the point where the great surge of modern scholarship was consolidating the gains of its first phase with

20 Emile Molinier, *Histoire générale des arts appliqués à l'industrie, du Ve à la fin du XVIIIe siècle*, Paris, 1901, IV, pp. 139–141.

21 J. Quicherat, *Histoire du costume en France, depuis les temps les plus reculés jusqu'à la fin du XVIIIe siècle*, Paris, 1875, chap. VIII, pp. 177ff., following chap. VII ("Le grand Siècle du moyen âge, de 1090 à 1190").

22 J.-A. Brutails, *L'Archéologie du moyen âge et ses methodes, études, critiques*, Paris, 1900; Camille Enlart, *Manuel d'archéologie française depuis les temps merovingiens jusqu'à la Renaissance*, 3 vols. in 6, Paris, 1902; Fernand Cabrol, *Dictionnaire d'archéologie chrétienne et de liturgie*, 11 vols., Paris, 1903ff.; Robert de Lasteyrie, *L'Architecture religieuse en France à l'époque romane*, 2 vols., Paris, 1912.

23 André Michel, *Histoire de l'art depuis les premiers temps chrétiens jusqu'à nos jours*, 8 vols. in 17, Paris, 1905–1929.

the close of the first quarter of the twentieth, the Romanesque century of medievalism. From that book at its center, the development of iconographic studies of the twelfth century was to radiate for the next half century, to our own day.

That he chose the thirteenth century for his subject in 1898 was in the very nature of the state of intellectual history and the history of art at that time. Mâle, it is sometimes forgotten, came to this work from an academic profession in literature.[24] Beginning in 1886, at the age of twenty-four, he taught literature at the lycée for the next twelve years. When his book appeared in 1898, Mâle gives his title as *Professeur de Rhétorique au Lycée Lakanal.* It is only surmise, but likely, that while he considered himself an historian of medieval art, he may well have been chary of declaring himself formally in that arena. Hence the hint of ambivalence when he writes in the preface to his book the impersonal, "It is hoped that it may prove of service to historians of art," in a sentence which then proceeds to instruct those historians on method.[25] Over the previous years he had already published, among other articles, essays on the iconography of the liberal arts in medieval sculpture (1891), Romanesque capitals in the museum of Toulouse (1892), the origins of French sculpture in the Middle Ages (1895), and even a study of the teaching of the history of art in the university (1894).[26] By 1908, however, the proper title for his actual scholarly professing was formally bestowed with the accolade of election to a new chair in medieval archeology at the Sorbonne.

For the wedding of literature and the visual arts there was ample precedent in France. But its salience in the nineteenth century, and its particular brilliance in the literature on medieval art, bore a special relationship to the anticlassicism of the Romantic movement. The spark that fired writers and scholars alike, with the interaction that gave to the former the visual arts as a subject, and the latter, an ideal of literary quality in their histories, was Victor Hugo's *Notre-Dame de Paris* of 1831. The Cathedral of Notre-Dame of Paris was the central figure of Hugo's novel; it became a living thing, vibrant at the heart of the city, its people, their actions and emotions, and the spirit of the whole Gothic epoch. Not only in the spiritual but also the intellectual sense, the cathedral was the actual as well as symbolic embodiment of the Middle Ages. In this vein, Victor Hugo discovered and formulated the first theorem of nineteenth-century medieval iconography when he observed, in his book, "In the Middle Ages men had no great thought that they did not write down in stone." Victor Hugo's theorem was a living truth for medievalists; through iconographic method they undertook its proof.

From the point of view of method, the two principal classes of medieval art scholarship in the nineteenth century were the archeologists or, as they

24 See the important paper read by André Grabar on the occasion of his becoming a number of the Institut de France, as a successor to Emile Mâle: "Notice sur la vie et les travaux de M. Emile Mâle," *Institut de France, Académie des Inscriptions et Belles-Lettres, séance du 16 novembre 1962,* pp. 1–18.

25 *L'Art religieux du XIIIe siècle,* preface, p. iii ("Un pareil travail pourra avoir son utilité pour les historiens de l'art").

26 Emile Mâle, "L'Enseignement de l'histoire de l'art dans l'université," *Revue universitaire,* 1, Jan. 15, 1894, pp. 10–20; and cf. note 2 above.

also called themselves, the antiquarians, and the historians. The former brought together descriptive and technical data on monuments then being examined for the first time, making them available for analytical studies. The latter interpreted their significance for the structuring or restructuring of the histories. Practice of one method did not preclude the other; and the antiquarians essayed their histories while historians also explored the monuments.[27] It was, of course, inevitable that neither could avoid dealing with the subject matter in sculptures and paintings that came within their scope. However, the treatment of such subject matter was neither conceived nor intended to provide anything more than a descriptive identification of subjects, persons, objects or motifs. To that end, familiarity with literature, history, and religion afforded much of the necessary information. Often the monuments themselves provided the simple answers sought, sometimes in the form of an inscription, naming the hero, saint, or event. But beyond what could be readily identified were the great numbers of figures and scenes for which there were no overt clues, and whose meaning, once familiar, has been lost from memory after the long centuries of neglect.

Not even the most erudite of Benedictines of the famous congregation of St.-Maur, authors of exemplary works on Christian scholarship during the seventeenth and eighteenth centuries, could effectively penetrate the blackness in which Renaissance "Dark Ages" historiography had shrouded taste for, and understanding of the medieval monuments. Mâle properly chided them for their "ignorance";[28] others have commented on their fanciful "discoveries" of Egyptian, druidical and other occult mysterious readings in medieval works of art.[29] And it is certainly true, for instance, that both Mabillon and Montfaucon were convinced that the twelfth century abbey church of St.-Germain-des-Prés, in which they lived and wrote, was of seventh-century date, and that the jamb statuary of the main portal included contemporary Merovingian representations of King Clovis and Queen Clothilde.[30]

The creation of systematic Christian medieval iconography is rightly credited to Didron, devoted friend and follower of Victor Hugo. That is should have come into being at just this time, was a factor of a concatenation of events in the decade between 1831 and 1841. The former date marks the publication of Victor Hugo's *Notre-Dame de Paris*, the latter, the completion of Didron's *Iconographie chrétienne*, although it appeared two years later.[31] It was during this decade that Minister Guizot established the Commission on Historic Monuments of France, the first initiative in the officially sponsored study and preservation of the monuments; and it was the period of the intense activity of Ludovic Vitet and Prosper Mérimée as, respectively, first and second in the office of Inspector-General of Historic Monuments. It was the decade of Commissions. At Gui-

27 Beneath the surface, however, distinctions were sometimes jealously preserved, as is evident in the ungenerous necrology of Prosper Mérimée by Arcisse de Caumont: "M. Mérimée was less an antiquarian than artist and writer; however, he knew the history of the art of the Middle Ages well. . ." (*Prosper Mérimée, Edition du Centenaire*, p. 12, n. 1).

28 *L'Art religieux du XIIIe siècle*, preface, p. 11 (". . . [qui], quand ils parlent de nos vieilles églises, font preuve d'une ignorance choquante chez de si grands érudits").

29 See Jacques Vanuxem, "The Theories of Mabillon and Montfaucon on French Sculpture of the Twelfth Century," *Journal of the Warburg and Courtauld Institutes*, 20 (1957), pp. 45–58.

30 *Ibid.*, pp. 47ff.

31 (Adolphe Napoléon) Didron, *Iconographie chrétienne, histoire de Dieu*, Paris, 1843 (English translation by E. J. Millington, *Christian Iconography, The History of Christian Art in the Middle Ages*, completed with additions and appendices by Margaret Stokes, 2 vols., London, 1851; reprinted, New York, 1965). In his introduction, p. v, Millington writes: "We have not at this moment any work in our language to which the student could apply for a knowledge of the leading principles of sacred Archaeology. . . . What has been principally required is a grammar of the science, containing its fundamental principles clearly set forth, systematically arranged, and illustrated by choice examples and copious authorities. Each subject should be traced through the various changes which have taken place since Christian artists first commenced their labours of love, and should be compared with the holy texts from which they were originally derived. All this M. Didron has done, and the evidence of his success is before us." One might amend this generous estimate by noting that while Didron had in fact begun, he had certainly not yet done, all this.

zot's behest, commission after commission was established until there was a considerable network of bureaucratic structures for the recovery, publication, and preservation of the monuments of France. The Middle Ages loomed largest in this concern, and necessarily so, for it had been generated in the rightful agitation of the medievalists. Among the ever recurrent names in the interlocking membership rosters of the commissions and committees were those of Victor Hugo, Didron, and Prosper Mérimée.[32]

Within a decade after his plea, in the famous "Essai" of 1824, urging the imperative need to rescue "from nothingness and oblivion all that has not yet entirely perished,"[33] de Caumont was able to witness the formidable initiative towards the realization of his hope. And, beyond the rescue of monuments, he could also see that the time was already coming when no more would he need lament that "we are more versed in the arts of Greece than in those of Christian architecture."[34] Guizot's genius for the institutional organization to recover the now precious past, reached an extraordinary climax with his creation, in 1835, of a "Committee for Unpublished Monuments of Literature, Philosophy, Sciences and Arts, Considered in their Relationship to the General History of France." The addition of a "Historical Committee on Moral and Political Sciences" completed the working program. The multiform and many-titled organization was then reduced to a single commission, subsuming all the rest, with the simplified title of "Committee on Arts and Monuments." The title, and the fact that both Victor Hugo and Didron continued to be members, the latter as secretary, are of indicative significance.[35] Clearly, the monuments of medieval art, as focus for all the arts and sciences, dominated the new national interest. France had placed its official seal upon the diverse initiatives of those zealous first medievalists. Their "holy enterprise, a sort of crusade," as de Caumont called it,[36] had conquered.

When Guizot wrote, in a report of 1835, that "the history of art is not written in books, it is written in the monuments,"[37] he understood by "monuments," from the evidence of his committees, the legacy of all of French cultural history and, above all, of the Middle Ages. That the totality of this history was to be read in the monuments, and that the tools and materials of all the intellectual disciplines were to be brought to bear meant that neither archeology, history, nor any single discipline could pursue or accomplish such a mission alone. A methodology was required in which all the rest could be integrated around the monuments. That method, implied in Guizot's organizational prescription but not specified, could only be iconography. From the primitive practice of medieval iconography up to that time, its potential for the new purpose, could not have been suspected.

Didron's special competence lay in the sphere of medieval art. His un-

32 Cf. Mallion, *op. cit.*, pp. 445–465.
33 Cited in Léon, *op. cit.*, p. 95.
34 *Ibid.*
35 See above, note 32.
36 Léon, *op. cit.*, p. 95.
37 *Rapport au Roi sur l'état des travaux relatifs à la recherche et à la publication de documents inédits concernant l'histoire de France*, Dec. 2, 1835, cited in Léon, *op. cit.*, p. 120.

dertaking of its pursuit, within the broad framework of the Committee on Arts and Monuments, would have not been expected to promise anything more or less remarkable than the work of his fellow scholars in other disciplines. Conscientious to a fault, however, and, as Secretary of the Committee,[38] more profoundly impressed than the others with its grand ideal, he was no longer content to continue along the old lines of antiquarian studies with which he had begun in Normandy. What he undertook instead, was the humble mission of putting his archaeology to the service of his adored Victor Hugo. Simple as it seemed, he thus happened upon a method which served, for the rest of the nineteenth century, as the single most influential force for system and order in the excogitation and exposition of what was believed to be the greatest visual achievement of the Middle Ages, the cathedral.

The success of Didron's iconography and its novelty was due as much to its simplicity as to its substantially scholarly approach. What Didron undertook to do was to prove Victor Hugo's cathedral theorem, to demonstrate its truth from the evidence of medieval art. His own statement of purpose is set forth in the form of a dedicatory letter to Victor Hugo, which serves as an introduction to his *Manuel d'iconographie chrétienne* published in 1845.[39] It is nothing less than the manifesto of nineteenth-century medievalism. It reads:

My illustrious friend,

In some few weeks you have created, in *Notre-Dame de Paris*, the cathedral of the Middle Ages; I, for my part, would wish to devote my life to carving and painting it. Engage me then, sublime architect, as one of your most devoted if not most skillful workers.

Take—for the walls and the capitals, the tympana and the archivolts, the stained glass and the rose windows of your colossal monument— those personages of the Old and the New Testament, of history, of legend and symbolism: God with his angels, his patriarchs, his prophets, his apostles and his numberless legions of saints; with the Virtues and Vices, paradise and hell.

The book itself was not so much Didron's own but the presentation of a Byzantine "Guide to Painting," a manual giving technical instructions for the painter and detailed descriptions of a remarkably comprehensive range of Christian subjects.

The work of discovery, in the monuments and their iconography, of the historical truth of Victor Hugo's metaphor of the cathedral, had already been begun by Didron in 1843 with the publication of his *Iconographie chrétienne*. On the principle that the Church intended its figural and illustrative art for the instruction of the unlettered people—who could thus "read" in the monuments—he went on to consider the principal

38 For Didron's participation on the *Comité des Arts et Monuments*, and for his unpublished minutes of the meetings as they concern Victor Hugo, see Mallion, *op. cit.*, pp. 449ff., and Appendix IV, pp. 652–684.

39 Didron, *Manuel d'iconographie chrétienne, grecque et latine, traduit du manuscrit Byzantin, le Guide de la Peinture*, par Paul Durand, Paris, 1845. An English translation by Margaret Stokes is included in Millington's edition of Didron's *Christian Iconography* (see above, note 31), II, Appendix II, pp. 263–399.

of the Romanesque period that was prerequisite to such an undertaking. "The magnificent art of the twelfth century," he writes in the present volume, "is still too little known."[46] Moreover, he rightly says, "Had I wanted to go back farther in time, venturing into the obscurity of origins, I would surely have lost my way."[47]

It is also essential, for any appreciation of the circumstances, to underscore the terms in which he saw his iconographic mission. It was one which, while oriented in history and returning to history its yield, excluded any pretense of offering itself as strict history or art or the formal development of styles and schools. Writing in 1908, by way of stressing his "consecration to iconography," he warns his readers that they must not look to his book for "the history of our schools of art, of their struggles, of their conquests, or their metamorphosis."[48]

With all the considerable contributions to knowledge that had been produced, the histories of medieval art during most of the second half of the nineteenth century were nevertheless progressing on a plateau, so far as the broader historical and stylistic concepts are concerned. Gothic art, of course, is the admitted exception. It was, rather, for all of that history before the Gothic that basically the same structure and formulae, first outlined by de Caumont, were still employed in active service. Architecture was still the principal—practically the exclusive—technical area of study.[49] Scholarly method was still cast and then recast, in what were essentially the early antiquarian molds. Preoccupation with demonstrations of the newly named Romanesque as a distinct style from the eleventh to the thirteenth century, as seen in architecture, left little room, if any, for discovery of the major distinctions within that span. So far as pre-Gothic art is concerned, historiography was still in its primitive state, the study of Romanesque art in its infancy, the earlier periods, embryonic.

With the dawn of the twentieth century, signs of major changes in the direction of the study of medieval art were soon visible.[50] By the end of the first generation, the novel character of those changes had become so unmistakably evident that, by retrospective contrast, the nineteenth-century picture of medieval art began to look antiquated. Of the more significant elements and accomplishments wrought by the new generation of medieval scholarship, particularly as it relates to Emile Mâle and the contribution of the present book, the most important was the positive recognition of the twelfth century. This was now acknowledged a major period of medieval art, on a par with the thirteenth to which it was closely related as antecedent in all essentials, but with its own distinctive character.

Integral with this development was the discovery of Romanesque figurative arts in new terms of taste and appreciation. An epitome of this change may be illustrated in the contrast of two early twentieth-century

46 See his preface to this volume, p. xxxi below.

47 *Ibid.*, p. xxix.

48 *L'Art religieux de la fin du moyen âge en France*, preface, p. i.

49 "There does not yet exist any history of Romanesque sculpture," Enlart noted in 1905 at the beginning of the bibliography to his section on "La Sculpture romane" of Michel's *Histoire de l'art*, I, pt. 2, p. 708.

50 Cf. Marcel Aubert, "Les Etudes d'archéologie du moyen âge en France de 1834 à 1934," *Centenaire du Service des Monuments Historiques*, II, pp. 211–257, *passim*.

views by eminent scholars. Camille Enlart, Director of the Musée de Sculpture Comparée, the museum of casts for the history of French sculpture, may be taken as representative of the lingering nineteenth-century esthetic. Writing in 1911, in a guide to the superb casts of all the major French Romanesque and Gothic monuments, he places in opposition the "perfection" of Gothic sculpture, "inspired directly from nature" with the child-like Romanesque.[51] No longer horrified by it, he is obviously describing its failure when he characterizes Romanesque sculpture as: "practically never does it imitate nature, faithfully or directly; the artists of those days were like children who prefer to copy drawings, rather than draw from the objects themselves."[52] At practically the same time, Victor Terret, in a monumental undertaking of the study of Burgundian Romanesque sculpture, published in 1914, introduces his subject with an extended refutation of the old allegations of ignorance and incompetence of Romanesque sculpture in general.[53] Terret's critique was the first comprehensive review and analysis of nineteenth-century pejorative views of Romanesque sculpture and the principal landmark in the historical reversal of that position. He goes on to propose a positive interpretation of the strange and abstract forms of that sculpture, in terms of their meaning. Those forms, in Romanesque sculpture, that had been misunderstood in the past, he argues, represent calculated intention for the expression of doctrinal conceptions and ideas, rather than imitation of the mere terms of material existence.[54]

There is another, more interesting aspect to this juxtaposition of Enlart and Terret as representative of significant currents in the new Romanesque scholarship. For both, the issue of taste in relation to Romanesque art was integral with a new method, one with direct relevance for Mâle's twelfth-century book in which it plays a fundamental role. With the ubiquitous and active pursuit of iconographic studies, illuminated manuscripts had come to comprise a vast and evergrowing body of pictorial material to complement sculpture, since manuscripts provided the richest body of medieval illustrated subjects. Both Enlart and Terret recognized, as had others, that the very subjects of monumental sculpture and decoration were to be found in great numbers and diverse interpretations, in the illustrated manuscripts. Both espoused the theory that in the miniatures were to be discovered pictorial models for the sculptures. In the theory that twelfth-century sculpture largely derived from such models was the essence of their method.[55] The important difference between them was in the direction of its application, Enlart for the formal character, and Terret for the iconographic interpretation of Romanesque sculpture. Thus, for all the naive and "engaging sincerity" which he conceded them, Enlart saw this sculpture as still imitating the pen and brushwork hatchings of the miniatures—not yet true sculptural forms.[56] Terret, on the

51 Camille Enlart, *Le Musée de la Sculpture Comparée du Trocadero*, Paris, 1911, pp. 48–49. Created at the instigation of the medievalists, and finally inaugurated May 20, 1882, the considerable collection of casts of medieval monuments was formed quite early. This was an important resource for Emile Mâle. For the history of the Museum, from the earlier nineteenth century on, see Paul Deschamps, "Le Musée de la Sculpture Comparée" in *Centenaire du Service*, I, pp. 381–410.

52 Enlart, *op. cit.*, p. 24.

53 Victor Terret, *La Sculpture bourguignonne au XIIe et XIIIe siècles, ses origines et ses sources d'inspiration: Cluny*, Paris, 1914, pp. 2–4.

54 *Ibid.*, pp. 5–9.

55 Enlart, *op. cit.*, diffuses this emphasis on manuscripts by including other smaller, portable works of art such as ivories, textiles and metalwork.

56 *Ibid.*, p. 30.

other hand, constructed a detailed and painstaking argument for the encyclopedic character of Romanesque sculpture as a whole, based on the evidence of the illustrated manuscripts. Specifically, his argument was that whereas the encyclopedic *Speculum* of Vincent de Beauvais had not yet been written in the twelfth century, its entire scope and content did exist, although spread among the numerous illustrated texts that were available in the monastic libraries.[57] Although the iconography of Romanesque sculpture could not, as in the case of Gothic, be found in one book, it nevertheless conformed to the same encyclopedic range and organization, by following the pictorial models in the diverse manuscripts. Marvelous to relate, Victor Hugo's encyclopedic cathedral theorem, whose actuality in Gothic art had been proposed, now seemed to have its Romanesque counterpart.

The seductive simplicity of the encyclopedia theory for twelfth-century art would seem, on the face of it, to offer a neat principle which one might suppose that Mâle would accept for development to its full and magnificent potential in his book on that century. His grasp of advances in medieval scholarship for that period would admit of no such simplistic cliché of transposition from his nineteenth-century perceptions for the Gothic. When he was writing this book on the twelfth century, he could accept no single formula to account for the whole range of twelfth-century iconography.

Mâle's theme, for this book, stands in sharp contrast with his earlier work. Twelfth-century iconography, he finds, abounds in complexities, even contradictions. But he achieves unity in the accounting of this complexity by a subtle interweaving of iconography and history. The warp of the historical structure of this work is almost imperceptible beneath the wealth of iconographical materials that make up the dense pile of the tightly woven weft. That there is an underlying historical order is unmistakable. His book takes as its point of departure the birth of monumental sculpture in France, just before 1100. Implicit across the whole work is the recognition of Romanesque art and the twelfth century as a distinct historical period, the century and the art which twentieth-century scholarship had divined as the great first stage, without which the Gothic thirteenth century would be inconceivable. His book closes with the declaration that "practically all the ideas expressed in the magnificent facades of the thirteenth century, appeared in the twelfth"; that "the twelfth century, too, merits the name 'great.'" The whole work, in this historical sense, pivots around the middle chapter of the book and the mid-point of the century, namely with the turn of developments in new directions under Abbot Suger.

Mâle's iconography for this volume is of a richness and diversity which one could scarcely imagine, from a tabulation, could be contained in a single coherent presentation. However, he effects its unity in historical

57 Terret, *op. cit.*, chap. ii: "Les Sources d'inspiration de la sculpture bourguignonne," pp. 12–109.

terms. It is chronological history when, in the earlier chapters, he proposes that the diversity of iconographic types in the formative stages stems from developments in Hellenistic, Syrian and Byzantine iconography during the preceding centuries. It becomes cultural history when he devotes the largest part of his book to the enrichment of twelfth-century iconography through the influence of liturgy, liturgical drama, the cult of local and national saints, the pilgrimages, and monastic life. Of the encyclopedic tradition, which he also considers, he credits the twelfth century with undertaking only some of the themes out of the principal compilations, both from the past and the twelfth century itself. With the iconography of its sculptured portal programs, the twelfth century accomplished its own great creations while preparing the basis for all that was to come with the thirteenth.

In the middle of the nineteenth century, when iconographic studies were only just beginning, one devotee of the new "science" lamented that iconography which treated only of "minor details," omitting "the colours, and all that gives warmth and animation to the subject."[58] To the Romanesque, that the nineteenth century almost did not care to know, Emile Mâle's book brought both "understanding and love of this magnificent art."

NOTES ON THIS EDITION

That Bollingen Foundation undertook to bring out an English edition of Emile Mâle's books on religious art of the Middle Ages is to the lasting credit of John D. Barrett, President, and the late Vaun Gillmor, Vice-President of Bollingen Foundation and, respectively Editor and Assistant Editor of Bollingen Series. Without their devoted personal interest in the project, through every stage of its preparation, and without the complete support of Bollingen Foundation, it would never have been realized. At their request, much of the preliminary investigation necessary for the development of the project was carried out by the late Wallace Brockway, who then continued to act as an editorial advisor for it on behalf of the Foundation. With the approval and blessing of Emile Mâle's widow, and their daughter Gilberte, art historian on the staff of the Louvre Museum, there remained only the choice of a medievalist scholar to carry out the project. The present editor was readily persuaded to undertake the challenge of providing, for the English speaking world, an edition which would be both sound and attractive for the edification of general readers while, at the same time, of scholarly service to students of the Middle Ages.

Since the proposed series of translations was not intended to be merely a reissue of any of the previous editions of Mâle's works, it is necessary to indicate here the general principles and policies which the editor has

58 E. J. Millington, in the preface to his edition of Didron's *Christian Iconography*, p. v.

followed, based on guidelines worked out in closest collaboration between him and the persons named above. It was agreed that the English texts should present, as nearly as any translations could, the content of Mâle's work just as he had written it, without revisions, additions, or intrusions. The present volume on the twelfth century is based on the sixth French edition of 1953, the last which Mâle had himself revised.

Following the first appearance of his book in 1922, Mâle continued to add notes to the successive reprintings (which appeared in 1924, 1928, 1940, 1947, 1953, and posthumously in 1966). In the 1953 edition these fill several pages of an appended section of "Additions and Corrections." In the present edition, all of this material has been incorporated in the footnotes at the appropriate places. We have also made minor changes and added simple factual data whenever only a change in location of a work of art, or the designation of manuscript signatures, were involved. Citations of recent publications directly relevant to Mâle's discussion constitute the only substantive additions to his footnotes. They are, as often as not, works which in fact developed out of his book. Such additions are set off in square brackets to distinguish these from Mâle's own footnotes. Following the guiding principle of presenting the original work as faithfully as possible and without interpretation, we have avoided any discussion of what the works cited in these additional footnotes may or may not contribute to the argument. It is left to the readers to pursue such questions as they choose, through the references given. For the preparation of the supplementary footnotes to this volume on the twelfth century, the editor solicited the help of Professor Louis Grodecki, presently at the University of Paris, who carried out his share of this work while he was still at the University of Strasbourg. The generous support of the University of Strasbourg as well as the collaboration of Madame Simone Schulz and Madame Thérèse Metzger, assistants to Professor Grodecki, is gratefully acknowledged. These notes are essentially their contribution. The editor has made such revisions and additions, particularly of references to publications in English, as seemed appropriate and desirable. Also added to this edition is a completely new and much expanded index, which should make the wealth of information contained in the volume more readily accessible to the student.

For the illustrations for this book, we have found it desirable not to reproduce exactly the French edition. Let it be added at once that all the subjects illustrated in the original book are illustrated here, but they are now reproduced from the best photographs available. All too often, in the French edition, works of art figuring significantly in Mâle's discussion are illustrated by old nineteenth-century line cuts or lithographs of dubious documentary value. Among such illustrations are a number from Lassus' monograph on Chartres (1867), miniatures from a manuscript now in the Pierpont Morgan Library reproduced from line drawings

published in 1879, and even an illustration after a lithograph in Mérimée's book on St.-Savin (1845). In addition, many of the illustrations are based on photographs made from casts of the monuments, and still others on reproductions in journals of the last three decades of the nineteenth century. The problem is not so much the age of such illustrations but the fact that frequently they are, for instance, injudiciously silhouetted and cropped, and so falsify the impression of the works shown. Not only the faulty illustrations but every one in the book has therefore been redone so that the pictorial documentation of Mâle's work could be presented in a consistent style. Moreover, we have sometimes added illustrations of particular works of art not reproduced in the original volume but nevertheless treated at some length or in an important context. Some of the monuments have been rephotographed especially for this volume. Indeed, among the very finest of our illustrations, and by far the largest proportion, reproduce the beautiful photographs by James Austin of Cambridge, England, who so patiently carried out the commissions assigned to him by the editor. As far as the illustrations in this edition are concerned, we think we can claim to have fulfilled our promise to Mme. Mâle and her daughter, namely, that we would create for Emile Mâle the book he would have wanted from the beginning, had resources of that time permitted.

For the translation, we were fortunate to obtain the services of Marthiel Mathews, who has produced a sensitive and fluent text, faithful to the original, and responsive to the author's personal style.

We hope that this English edition will be found to be worthy of Emile Mâle and that, for a long time to come, it will serve well those who follow in his footsteps.

ACKNOWLEDGMENTS

The editor wishes to thank the following persons, institutions, and agencies for information and help in obtaining photographs, as well as for the provision of photographs for this book: Archives Photographiques, Paris; James Austin, Cambridge, England; François Avril, Département des Manuscrits, Bibliothèque Nationale, Paris; Bibliothèque Nationale, Paris; M.-T. Baveas, librarian, Ecole française, Athens; Jo Bayle, Clermont-Ferrand; Bayerische Nationalmuseum, Munich; Biblioteca Medicea-Laurenziana, Florence; Bibliothèque Royale, Brussels; Bildarchiv Foto Marburg; M. Blanch, Archivo Maas, Barcelona; British Museum, London; Mauriche Chuzeville, Vanvas (Seine); Alfred Deflandre, Musée des Augustins, Toulouse; Henri Desaye, Conservateur, Musée Municipal, Die; Pierre Devinoy, Paris; François Enaud, Service des Monuments Historiques, Paris; Foto Fiorentini, Venice; Professor Ilene Haering Forsyth, University of Michigan; Denise Fourment, Paris; Marie-Madeleine Gau-

thier, Centre National de la Recherche Scientifique; Laurence Reverdin-Goodman, Paris; Professor Philip Gould, Sarah Lawrence College, Bronxville, New York; Professor André Grabar, Collège de France; Jacques Guignard, Conservateur-en-Chef, Bibliothèque de l'Arsenal, Paris; Dr. Victor Guirgis, director of the Coptic Museum, Cairo; Foto Guitian, Santiago de Compostela; Ronald Hall, Librarian, The John Rylands Library, Manchester, England; Hirmer Photoarchiv, Marburg; Photo Hurault-Viollet, Paris; Luc Joubert, Paris; Adalbert Graf von Keyserlingk, Stuttgart-Heumaden; Henry Kraus, Paris; Laboratorio Fotografico Rampazzi, Turin; Professor Peter Lasko, Director, Courtauld Institute Galleries; Jeannine Le Brun, Constance, Switzerland; Antoine Mappus, Le Puy; Yves Metman, Archives Nationale, Service des Sceaux, Paris; S. Montagne, Conservateur, Bibliothèque Municipal et Universitaire, Clermont-Ferrand; R. Mathias, Poitiers; Ernest Nash, Fototeca, American Academy, Rome; Dr. Hayrullah Örs, Director, Topkapi Saray Museum, Istanbul; Professor Edith Porada, Columbia University; the Pierpont Morgan Library, New York; Dr. Floridus Röhrig, Chorherrenstift, Klosterneuburg, Austria; the Royal Hellenistic Research Foundation, Athens; Service de Documentation Photographiques, Union des Musées Nationaux, Versailles; Professor Whitney S. Stoddard, Williams College, Williamstown, Massachusetts; Studio Allix, Sens; Jean Taralon, Inspecteur Général des Monuments Historiques, Paris; the Biblioteca Apostolica Vaticana; the Museo Sacro, and the Pontifici Musei Lateranensi of the Vatican; Dr. Vittorio Viale, Museo Camillo Leone, Vercelli; Dr. David McKenzie Wilson, Department of British and Medieval Antiquities, British Museum; R. Van der Walle, Archives Iconographiques d'Art National, Brussels; Yan, Toulouse.

In the course of work on this volume, the editor benefited from the assistance of his students, especially: Sanford Eisen, Nancy Coleman Wolsk, Elizabeth Smith Schwartzbaum, and Temily Weiner-Mark. Others who assisted in various ways were: Susan Amato, Madeleine Fidell Beaufort, Stephen Lamia, Janet Silver, and Mary O'Connor Viola.

In addition, his warmest thanks are due to friends and colleagues whose help and advice contributed in so many ways to this work. Among them: Barbara Sessions; Jean Adhémar, Conservateur adjoint, Cabinet des Estampes, Bibliothèque Nationale, Paris; Evelyn K. Samuel, Librarian, Institute of Fine Arts, New York University; Françoise Perrot, Paris; Professor Lionel Casson, Department of Classics, New York University, who provided the translations from Latin; Anne Hecht of New York, who prepared the index; and Dr. Elizabeth Parker, Fordham University, who helped in the very last stages of the completion of this volume.

Harry Bober
AVALON FOUNDATION PROFESSOR IN THE HUMANITIES
INSTITUTE OF FINE ARTS, NEW YORK UNIVERSITY
March, 1976

CONTENTS

In the usual order of things, I should have begun my history of medieval art with this volume. But when I started on these studies thirty years ago, with all the enthusiasm of youth, it fortunately did not occur to me to write it. I was drawn instinctively to the thirteenth century, where all is order and light. Had I wanted to go back farther in time, venturing into the obscurity of origins, I would surely have lost my way. At that time Christian art was believed to have originated in Rome; the role of the Near East had barely been glimpsed. But little by little, a fuller knowledge of Byzantine art, study of the oldest illustrated manuscripts, the analysis of early ivories, the exploration of Christian Egypt, and the discovery of the frescoes of Cappadocia made it clear that Christian art owed little to Roman genius, itself infused with Eastern influences, but rather that it was the joint creation of the Greek genius and the Syrian imagination. The excavations undertaken by France in the Levant will soon confirm, I am convinced, these conclusions, which to me now seem certain.

Christian iconography, born in the Near East, came to us ready-made. It was not our artists who conceived the Gospel scenes by meditating on the sacred text; the scenes were handed down to them from a distant world. The art historian who confines himself to twelfth-century France is doomed to understand nothing about the works he hopes to explain. He must constantly go back to the beginnings, searching out in Egypt, Syria, and Cappadocia the models of which our churches often provide only copies. This was scarcely dreamed of thirty years ago.

This early Christian iconography was for a long time perpetuated in illuminated manuscripts, but the day came when sculpture assimilated it and gave it new life. This book starts precisely with the beginnings of our sculpture.

In all probability, monumental sculpture was born in the eleventh century in southwestern France. The Cluniac abbeys of this region were most likely its cradle: La Daurade at Toulouse, and Moissac, where I believe the first examples of this great art are to be found, were both priories belonging to Cluny.

In any case, sculpture was propagated mainly by the Cluniac priories. Where else, in fact, do we find the art of Moissac? At Beaulieu, Carennac, and Souillac, all three priories of Cluny. What is the most magnificent sculptured façade in the Midi? That of St.-Gilles; and St.-Gilles had been a dependency of Cluny from the time of Abbot Hugh. Where was the oldest artistic center of Haut-Languedoc? At St.-Pons-de-Thomières, one

of the first monasteries of the south to be affiliated with Cluny. The traveler searching throughout France for twelfth-century art comes repeatedly upon Cluny. In Auvergne, the most beautiful historiated capitals are those of Mozat; Mozat was attached to Cluny in 1095. In the west, the façade of St.-Eutrope at Saintes, now destroyed, seems to have been one of the prototypes of the art of Saintonge; it was a Cluniac church. In Burgundy and nearby provinces, some of the most remarkable monuments of sculpture are, or were, in Cluniac priories: Vézelay, Charlieu, Nantua, Vizille, Souvigny, St.-Sauveur of Nevers, St.-Benoît-sur-Loire. Cluny, the mother church, if we are to judge by its few surviving capitals, was the most beautifully decorated of almost all twelfth-century churches. It seems clear that the monks of Cluny were the true propagators of sculpture, and the impression is that the bishops merely followed their example. If the cathedrals of Autun, Arles, Cahors, and Angoulême were as magnificently decorated as monastic churches, it was because they were built in regions where the Cluniac priories had already introduced sculpture.

In northern France, monumental sculpture first appeared at the abbey of St.-Denis in the time of Suger; it spread from there. It is true that St.-Denis was not a dependency of Cluny, but we shall see that Abbot Suger brought to St.-Denis the southern sculptors who had just decorated the Cluniac priories of Moissac, Beaulieu, Souillac, and Carennac. The traces of Cluny are everywhere.

Thus sculpture, whose rebirth we witness in the eleventh century, was soon adopted by the Cluniac abbots, St. Hugh and Peter the Venerable, as the most powerful auxiliary to thought. Through them it was propagated in Aquitaine, Burgundy, Provence, and even Spain. We owe these great men our profound gratitude. They believed in the virtue of art. At the time when St. Bernard was stripping his churches of all their ornaments, Peter the Venerable was having capitals and tympanums carved. He was not convinced by the eloquence of the ardent apostle of austerity that beauty was dangerous; on the contrary, as St. Odo said, he saw in beauty a presage of heaven. Love of art was one of Cluny's claims to greatness, and it had many. The magnificent and melancholy name of Cluny will be repeated throughout this book. It is a name that now evokes only ruins but seems still to retain the sense of majesty of the great ruins of Rome.

The Cluniacs were right. To be poor like St. Bernard required great inner richness; the humble Christian needed help. Who can say how many souls were moved, consoled, and sustained throughout the centuries by the reliefs and capitals that expressed so great a faith and so much hope? I myself have felt this keenly while deciphering, in the light of cloisters or the dusk of Romanesque churches, the old stories written in stone.

Twelfth-century art, then, is above all monastic art. This is not to say that the artists of the time were all monks, but that it was almost always

monks who dictated the artists' subjects. In their libraries, rich in illuminated manuscripts, the monks preserved all the treasures of ancient Christian art; they were the guardians of tradition. Consequently, when they wanted to decorate their churches, they went for models to the miniatures in their books. The miniature has therefore played a major role: it explains both the contorted aspect of our nascent sculpture and the profoundly traditional character of our iconography. We shall see all that our artists took from the past through the intermediary of the miniature. But we shall also see what they themselves created, for they did not long remain simple copyists. Church doctrine, liturgy, drama, the cult of the saints, pilgrimages, the struggle against heresies, monastic learning and the monastic ideal, all left their imprint on twelfth-century iconography. The foundation remained Eastern, but it was modified by gradual alteration and enriched by new creations. From its very beginnings, medieval art shows that it was fashioned by thought. The exercise of thought on art is the subject of this, as of my preceding volumes. Here we shall see the erudite iconography of the following age taking shape, and the great ensembles of the thirteenth century in preparation.

My hope is that this volume will contribute to the love and understanding of the magnificent art of the twelfth century, which is still too little known; that it will give, too, a sense of how fertile France then was, and of the admiration due her. The creation of monumental sculpture was a marvelous achievement. In the twelfth, as in the thirteenth century, France was the great initiator.

Emile Mâle
[Paris, 1922]

RELIGIOUS ART IN FRANCE:
THE TWELFTH CENTURY

I

The Birth of Monumental Sculpture:
Influence of Manuscripts

I

Monumental sculpture, neglected for centuries, reappeared in southern France in the eleventh century.[1] Its revival is one of the strangest phenomena in history. Mankind rediscovered a lost secret and again set to work.

How could the practice of this magnificent art have disappeared for more than five hundred years? The real reason, long misunderstood, is today becoming clear. It is not true that Christianity had been systematically opposed to plastic art and, as we have so often heard, that the Church condemned sculpture. The truth lies elsewhere.[2] As early as the fifth century after Christ, the Greek genius, the genius par excellence for the plastic arts, which had endowed the statue with divine beauty, succumbed to the spirit of the old Roman *Oriens,* the Near East. A new art had been born in Syria, in Mesopotamia, which conquered the Christian world. This art was purely decorative. The sculptor's role was reduced to carving on stone the delicate lacework and interlaces of braided strands whose arabesques give momentary pleasure to the eye. Sculpture, the most virile of the arts, became mere embroidery, and was relegated to a secondary role. The churches and palaces of the Near East were decorated with mosaics, paintings, and tapestries. The sculptured plaques covering the walls were no more than extensions of the silken hangings. A tendency toward abstraction, a force seeking to dominate nature, had always been instinct in the genius of the Near East; artists did not copy, they stylized; they preferred the vagaries of the imagination to reality. The statue, as the formulation of an idea, could have no place in this dreamlike art; the East remained oblivious to sculpture in the round, so that it soon disappeared everywhere, since all of Christian Europe followed the Near Eastern lead. Byzantine and Arab art are infused with the Eastern spirit; Merovingian and Carolingian art are hardly more than modes of Eastern art. It is not hard to see why artists formed in this school completely forgot how to sculpt in the round.

Sculpture disappears at the end of classical antiquity. The triumph of Eastern art. Under the influence of the miniature, sculpture reappears in southern France in the late eleventh century.

But how was the art rediscovered? This is a problem that a number of attempts have not yet satisfactorily resolved. It has been pointed out that by the tenth century the cult of relics had taken a distinctive form in southern France: instead of being enclosed in a reliquary, the relics were placed inside a wooden statue sheathed in gold, which represented the saint himself, seated in majesty. Such were the statues of St. Marius at Vabre, St. Gerald at Aurillac, and St. Martial at Limoges; and such is the famous statue of St. Foy at Conques.[3] The appearance of these statues at the end of the Carolingian period is most certainly an interesting fact; it proves that the ancient populations of the Midi had an instinct for form that was lacking in the people of northern France, and is a sign that the Midi would one day become the cradle of sculpture. This is no doubt important, but I am less than convinced that these hieratic effigies, these "idols" as they were called by an eleventh-century cleric, had any great influence on the rebirth of great monumental art. For this art form reappeared not as freestanding but as relief sculpture. And many years would pass before an image detached from a wall, a true statue in the round, would appear in France. Such being the case, the secret of the rebirth of sculpture is clearly not to be found in the reliquary statues of the French central plateau.

The secret lies elsewhere. What I would like to demonstrate here is that at Moissac, as well as in Auvergne, Burgundy, and Provence, relief sculptures were at first little more than miniatures transposed to stone. This fact is important enough in the history of art, but it is of capital importance for the history of the origins of monumental iconography undertaken here.

II

The miniatures of the Spanish Apocalypse of Beatus. Relations between France and Spain. The tympanum of Moissac imitates a miniature of the Beatus Apocalypse. The capitals of the Moissac cloister derive from the miniatures of the Beatus Apocalypse. The Beatus Apocalypse is imitated at St.-Benoît-sur-Loire, at La Lande-de-Cubzac, and at St.-Hilaire of Poitiers.

Sculpture reappeared in southern France in the eleventh century. The earliest capitals of La Daurade, at Toulouse, were carved between 1065 and 1080. It was in 1065 that La Daurade was affiliated with Cluny, and we know that by 1080 St. Hugh, the great Cluniac abbot, had already had the conventual buildings reconstructed and the cloister restored.[4] Shortly after 1080, the Toulouse sculptors were called to Moissac where they reproduced in the cloister several of the Daurade capitals. Other sculptors also worked at Moissac and, as we shall see, drew on other sources of inspiration. An inscription in the cloister tells us that the work was finished in 1100. The great portal of Moissac was begun immediately afterwards and, according to the chronicler Aymeric de Peyrac, was finished by abbot Ansquitil, who died in 1115.

The influence of miniatures was already apparent in the earliest capitals of La Daurade. I have shown elsewhere that the capital representing David

and his musicians was inspired by a page from a manuscript of Charles the Bald.[5] But the main portal of Moissac provides the clearest evidence of the influence of the miniature on the great sculpture that was just emerging.

There we recognize an imitation of the most famous of all the manuscripts illuminated in the Midi: the Apocalypse of St.-Sever, now in the Bibliothèque Nationale.[6] It does not contain the Book of Revelation itself, but a commentary on it composed in Spain by Beatus, abbot of Liebana. In 784, hidden in a mountain valley of the Asturias where the Arab invasion had come to a stop, he wrote his commentary on the Book of St. John and seemed to foretell the approaching end of the world. His book was adopted by the Church in Spain and recopied century after century. The admirable miniatures contributed as much as the text to the book's success; from the tenth to the early thirteenth century, they were continually reproduced. But it must not be thought that these miniatures were slavishly copied one from another; far from it. Beatus had borrowed a great deal from ancient Eastern commentators of the Apocalypse, and it could be that his miniaturists imitated the illustrations of a Syrian or Egyptian manuscript.

The Beatus Commentary did not remain within the monasteries of northern Spain; it was known on the other side of the Pyrenees. The Apocalypse of the abbey of St.-Sever had been illuminated in Gascony, after a Spanish model, under Abbot Gregory, that is, between 1028 and 1072. It is one of the most magnificent manuscripts of the series, and the miniaturist, however much a copyist, shows evidence of a rare talent. His beautiful angels in clinging tunics come close to resembling the designs on Greek vases.

It is not surprising that relations were so close between northern Spain and southwestern France, for Spain had already been opened to France for a full century by the Santiago pilgrimages. In 951, Godescalc, bishop of Le Puy, had stopped on his way to Compostela at the monastery of Albelda, so that he might have a manuscript copied.[7] In the following century, the great abbots of Cluny entered Spain and established their monasteries on the pilgrimage roads at San Juan de la Peña, Sahagun, and Santa Colomba of Burgos. Knights followed to enlist in the armies fighting the Moors. Books, works of art, and ideas traveled back and forth across the mountains. Spain received much from France. The French brought her architecture and sculpture, but she gave something in return. Architects from south of the Loire borrowed several charming motifs from Arab Spain: the trefoil arch, the multifoil arch, carved brackets—all veritable trophies lifted from the mosque.[8] Christian Spain gave to the monasteries of southwestern France its manuscripts of the Apocalypse, with their strange themes and splendid colors. The imaginations of the Midi

artists were rekindled. It is a curious fact that the manuscripts from St.-Martial at Limoges are painted in the vivid reds, saffron yellows, and intense blues of the Spanish miniaturists. Limoges, a stop on the pilgrim route to Santiago, was in constant communication with Spain. Limoges enamels were decorated with Arab lettering, and the figures were placed against a background of dark blue, resembling the almost African sky of Castille.[9]

The close relations between France and Spain explain why the Beatus manuscripts were prevalent in the Midi, and why their influence extended as far north as the Loire.

That the abbey of Moissac possessed a Beatus Apocalypse cannot be doubted, for it was from this book that the sculptors took several of their themes. The Moissac manuscript may have closely resembled the St.-Sever manuscript, but, as we shall see, it also differed from it on some points.

The magnificent tympanum at Moissac represents Christ in Majesty surrounded by the four beasts, and accompanied by the four-and-twenty elders of the Apocalypse, seated on their thrones and carrying chalices and viols. This is the Son of Man as he appeared to St. John (fig. 1).

This imposing image first appeared in Roman basilicas and then in Carolingian manuscripts, but neither the Roman mosaics nor the Carolingian miniatures resemble the tympanum at Moissac. In both the Roman and the Carolingian works, the elders of the Apocalypse stand and present their crowns to the lamb,[10] or to a simple bust of Christ.[11] It is clear that there is not a true family relationship between these works and the Moissac tympanum.

Since it seems to have no ancestors, where then does the Moissac tympanum come from? Was it created by twelfth-century sculptors? Study of the Beatus Apocalypse suggests otherwise.

One of the most beautiful pages of the manuscript represents Christ in Majesty, surrounded by the four beasts. Around Christ, the four-and-twenty elders form a great circle: seated on thrones and with crowns on their heads, they hold a chalice in one hand and a viol in the other; they turn their gaze toward the resplendent vision and endure its brilliance; around them angels fly in the heavens (fig. 2).

This was the Moissac sculptor's model. From a manuscript closely resembling it he borrowed the new type of the elders of the Apocalypse. In fact, it is only in the Beatus manuscripts that we find them with their crowns, chalices, viols like Spanish guitars, and their thrones of carved wood. The splendid figures of the elders passed almost unchanged from miniatures into monumental art. Since the sculptor could not arrange them in a circle, he ranged them in tiers, rising as high as possible on each side of Christ.

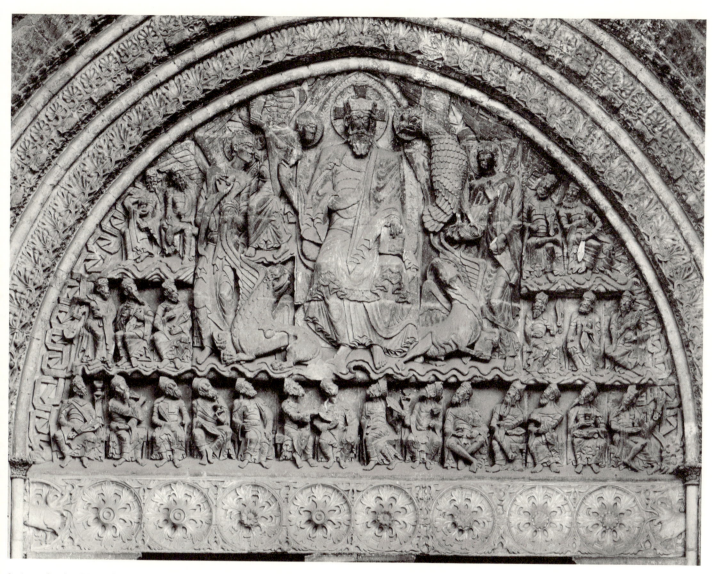

1. Apocalyptic vision of Christ. Moissac (Tarn-et-Garonne), Abbey Church of St.-Pierre.
South portal, tympanum.

The Moissac Christ does not, it is true, resemble the Christ of the manuscript exactly. He does not hold the long scepter, as in the St.-Sever Apocalypse. But it is quite likely that the miniature serving as the sculptor's model was slightly different, and this is why I think so: at the cathedral of Auxerre, two drawings from the early twelfth century have been preserved,[12] one of which represents Christ in Majesty surrounded by the four-and-twenty elders (fig. 3). These drawings came from the Midi, as we shall soon see even more clearly. The Christ in Majesty surrounded by the seated four-and-twenty elders carrying chalices and viols could have been copied only from a Beatus manuscript. One small detail removes all doubt. The eagle at Christ's left carries in its claws not a book as do the other evangelical beasts, but a scroll. Now this detail is also found in the St.-Sever Apocalypse and in the Moissac tympanum, and nowhere else. This alone is enough to connect the Auxerre leaf with the Beatus group. There must, then, have been manuscripts of the Apocalypse showing Christ as we see him at Moissac, for the resemblance is almost complete between the Moissac tympanum and the Auxerre page.

The Moissac tympanum therefore derives from a manuscript related to the St.-Sever Apocalypse. Even the type of the miniaturist's angels is the same; they have the same low foreheads with heavy caplike hair. The folds of their mantles and tunics—broad folds resembling a series of strips placed side by side—are quite in the tradition of the miniaturists of the Midi. One of these beautiful manuscripts from the south of France, dating from the eleventh century, shows Christ on the cross, the Virgin, and St. John, draped in the same fashion as the later figures at Moissac (fig. 4):[13] there are the same wide bands of cloth and the same full pleats. It is as though the miniaturists had suddenly become impromptu sculptors.

Near the porch at Moissac is the entrance to the famous cloister, with its great trees, its flowers, and its luminous shadows, one of the most beautiful in France today. The arcades were rebuilt in the thirteenth century, but the historiated capitals date from the late eleventh century; they are slightly earlier than the large relief of the portal, and we shall see that they were derived from the same models.

We must again refer to the St.-Sever Apocalypse if we are to understand their arrangement. The strange manuscript begins with the story of the Fall and Redemption, sketched in bold strokes. The miniatures represent in sequence Adam and Eve, the Flood, the Sacrifice of Abraham, and with the passage of time, the Annunciation to the Shepherds and the Adoration of the Magi. Only at this point does the Vision of St. John unfold. The manuscript does not end with the Beatus commentary on the Book of Revelation, but with a treatise by St. Jerome on the interpretation of the Book of Daniel. There are, in fact, singular analogies between

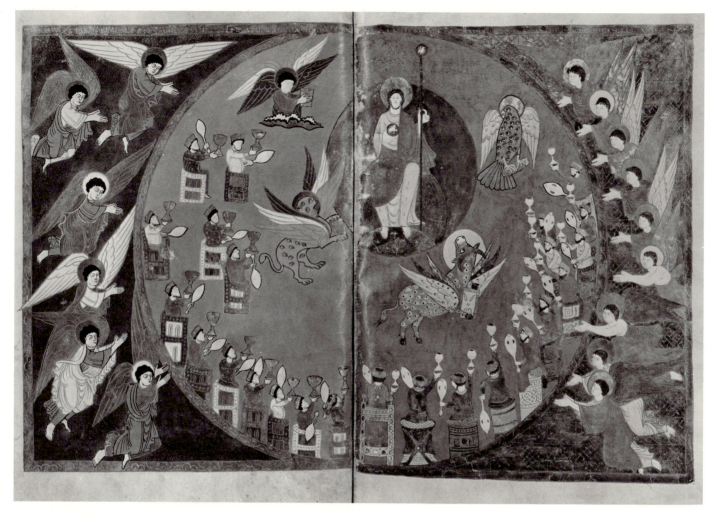

2. Christ between the four beasts and the twenty-four elders. Beatus Apocalypse of
St.-Sever. Paris, Bibl. Nat., ms. lat. 8878, fols. 121v–122r.

3. Christ between the four beasts and
the twenty-four elders. Vellum leaf.
Auxerre (Yonne), Treasury of the
Cathedral of St.-Etienne.

the visions of St. John and of Daniel, which explain their juxtaposition.
Both the Old and the New Testaments prophesy, with the same air of
mystery, the reign of the Beast at the end of time; the same sense of terror
emanates from both books. St. Jerome's commentary is illustrated with
as much care as that of Beatus; beautiful miniatures represent Daniel in
the lions' den with the prophet Habakkuk, the three Hebrews in the
fiery furnace, King Nebuchadnezzar, and lastly, the symbolic beasts. This
is the ending of not only the St.-Sever manuscript, but also of the finest
examples of the Beatus Apocalypse.

We can now more easily recognize what the sculptors of Moissac bor-
rowed from this book. There is no logical order in the sequence of the
cloister capitals; a miracle of Christ is followed by a miracle of St. Bene-
dict and by a scene from the Old Testament. But if we take the trouble
to classify these capitals according to subject, we shall see that one series
is devoted to the Apocalypse and another to the Book of Daniel. The
choice is easily explained: the sculptors, who were soon to take the ar-

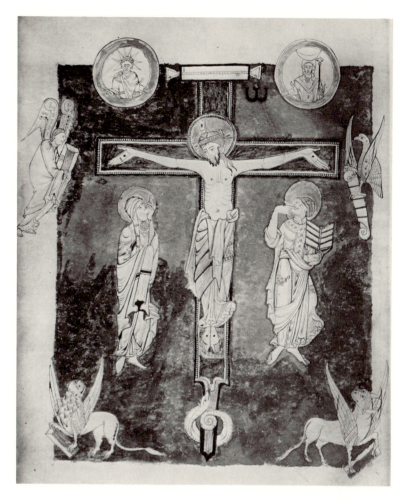

4. Crucifixion. Psalter-Hymnal from
St.-Germain-des-Prés. Paris, Bibl. Nat.,
ms. lat. 11550, fol. 6r.

rangement of their tympanum from a Beatus manuscript, went to it as
early as 1095 for the subjects of their capitals. Not that the copies were
literal ones; it is simply that there are analogies between the capitals and
the miniatures, and some of them are very significant. The sculptor, work-
ing within the restricted space of a triangle, was constantly obliged to
abridge and condense. Furthermore, the Beatus manuscripts contain end-
less variations, and we are far from possessing all of them.

The capitals based on the Apocalypse represent horsemen mounted on
lions, the battle between St. Michael and the dragon, the beast bound by
the angel, Babylon the Great, the Heavenly Jerusalem, and the four evan-
gelical beasts.

The capitals based on the Book of Daniel represent the three young
Hebrews in the fiery furnace, Daniel in the lions' den visited by the prophet
Habakkuk, and King Nebuchadnezzar changed into a beast. All of these
subjects are found in at least the most richly illustrated of the Beatus
manuscripts.

Let us study some of these capitals.

The capital representing two horsemen mounted on lions and preceded by an angel on foot carrying a sickle was composed by the artist from two miniatures of the Beatus book.[14] He brought together two visions from completely different parts of the Apocalypse having no relation to one another. Thus, he took great liberties with his model and was in no sense a simple copyist; but that he consulted his model is indubitable. In fact, the capital showing the angel binding the dragon contains a completely typical detail: the angel does not have his feet on the ground, but neither is he flying; he seems to fall from the sky, head foremost. Now this is the extraordinary attitude of the angel conquering the beast in almost all of the Beatus manuscripts.[15] The parallel can hardly be laid to chance. In addition, the type of dragon was not invented by the artist but is an evident borrowing from a manuscript: the beast, chained by the neck, is winged and its long tail is knotted in the middle, as in one of our miniatures.[16] The capital representing the symbols of the evangelists is especially revealing: they are fabulous beings with animal heads and human bodies (fig. 5). This is precisely the aspect of the lion, the ox, and the eagle in several of the Beatus manuscripts (fig. 6).[17] They could be ancient Egyptian divinities. Such a strange motif, completely isolated in French art of the twelfth century, clearly proves that the artist had looked through a Beatus manuscript for inspiration.

Two other capitals that might be taken as creations of the artist's imagination were also borrowed from our manuscript. They both represent a town with battlements and towers; two inscriptions supply their names. One is Babylon the Great, *Babylonia magna*, the other is *Jerusalem*. These two mystical cities, one of which symbolizes the reign of evil over the earth and the other the celestial city, are both found in the Apocalypse of Beatus. At Moissac, only the great serpent coiled in a circle around Babylon is missing.

The episodes taken from the Book of Daniel are no less significant. It could be claimed that a subject as frequently represented as the story of Daniel in the lions' den can prove nothing, but the same cannot be said of the capital devoted to the Three Young Hebrews in the Fiery Furnace. This is, of course, a frequent subject in early Christian art: there are many examples of it in the frescoes of the catacombs, in gold glass, and in the reliefs on sarcophagi. This is because the names of the young Hebrews occurred in the prayer recited for the dead, and the art of the early Christian era was almost exclusively funerary in character. But in the Middle Ages, the image of the Young Hebrews in the Fiery Furnace became rare and we find very few examples of it in twelfth-century monumental art. It seems clear that the Moissac artist had before him a model that revived a forgotten subject. The model was to be found only

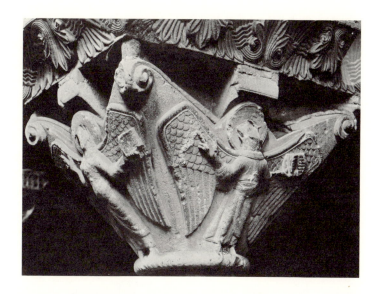

5. Animal-headed evangelist. Moissac (Tarn-et-Garonne), Abbey Church of St.-Pierre. Cloister capital.

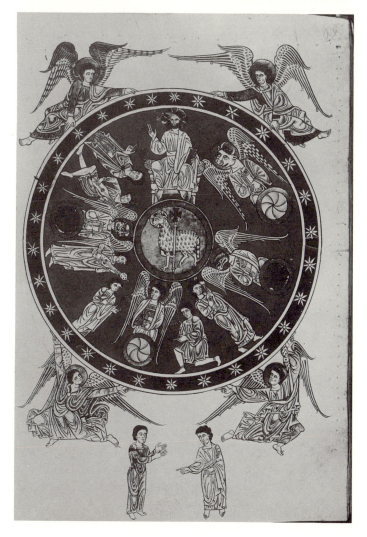

6. Animal-headed evangelists. Beatus Apocalypse. Manchester, The John Rylands Library, ms. 8, fol. 89r.

in the Apocalypse of Beatus, which ends, as I have said, with an illustration of the Book of Daniel. Another capital at Moissac adds certainty to this hypothesis. It represents a subject that could have come only from the Book of Daniel: Nebuchadnezzar changed into a beast. It will be recalled that Daniel, before explaining to Belshazzar the meaning of the three words written by the hand on the wall, reminded him that God had punished Nebuchadnezzar's pride by reducing him to brute level.[18] This episode was not illustrated in the St.-Sever manuscript, but we find it in the beautiful Beatus Apocalypse belonging to the library of Astorga.[19] The Moissac sculptor had a very richly illustrated manuscript before him, and one that provided him not only with the Three Young Hebrews in the Furnace, but also with Nebuchadnezzar Changed into a Beast.

If this was the case, we may go even further. The Beatus manuscript opens, as already noted, with several scenes from the Old and New Testaments: the story of Adam and Eve, the Sacrifice of Abraham, the Annunciation to the Shepherds, and the Adoration of the Magi. Now these four scenes are precisely the ones to be found on four capitals of the Moissac cloister. It may seem unusual for the artist to have represented the Annunciation to the Shepherds and the Adoration of the Magi and not the Nativity itself. This oddity can now be explained: the artist had a guide from which he took his subjects. However, he treated these subjects with great freedom and probably often strayed from his model.

The miniatures of the Beatus Apocalypse exerted their influence throughout the old province of Aquitaine. They were imitated even beyond the Loire. The monastery of St.-Benoît-sur-Loire is located on the north bank of the river and through its history was attached to royal or northern France. The ancient manuscript from the south had nevertheless made its way there, as study of some of the capitals in the church will show.

At the entrance to the beautiful church of St.-Benoît-sur-Loire there is an unfinished bell tower, the ground floor of which forms a porch of considerable grandeur. Among the foliated capitals we find several which are historiated. Two are devoted to the Apocalypse. One represents the Son of Man appearing to St. John among the seven stars and the seven candlesticks, and the other, the four horsemen each unloosing a scourge upon the earth. These are naïvely crude works, but we recognize in them, nevertheless, an imitation of the Beatus Apocalypse. The Christ placing his hand upon the head of the prostrate St. John, and the seven stars resembling fully opened flowers are exactly in the tradition of our manuscripts. But one group carved on the flank of the capital removes all doubt: the angel and St. John hold a book between them. This is an image found in all our Apocalypses and it is even repeated several times.[20] This cannot have occurred fortuitously. The capital of the four horsemen, crude as it

is, contains several reminders of the original miniature. The four horsemen are brought together on the same capital just as they were united on the same page of the manuscript; the Lamb of God accompanies them. For lack of space as well as lack of talent, the sculptor placed one close up against another and gave them no expression. However, the horseman with the strange headdress who holds a bow and wears a short coat that flares out behind betrays the imitation of an original resembling the Apocalypse of St.-Sever.[21]

Two other capitals, found not in the porch but in the transept of the church, complete the series and furnish additional proof. They are taken from the Book of Daniel; one represents the visit of the prophet Habakkuk to Daniel in the lions' den, and the other, Nebuchadnezzar changed into a beast. The latter subject is sufficient to indicate the model the sculptor followed.[22]

Thus, there was a Beatus manuscript at St.-Benoît-sur-Loire as well as at Moissac. Consequently, we are not surprised to learn that in the time of Abbot Gauzelin, between 1004 and 1030, scenes from the Apocalypse were painted on the west wall of the church;[23] these were no doubt also imitated from the miniatures of the manuscript.

Moissac and St.-Benoît-sur-Loire offer the most striking examples of the imitation of the Apocalypse manuscript, but they are by no means the only ones; I can cite at least two others.

The tympanum of the church of La Lande-de-Cubzac (Gironde) represents the Son of Man appearing to St. John. He is standing, a sword issues from his mouth, and in his right hand he holds a circle enclosing seven stars; the seven candlesticks are beside him, and seven arches symbolize the seven churches (fig. 7). This is not at all the way Christ appears in the manuscript of St.-Sever: instead of standing, he is seated on a throne; there is no sword in his mouth; he does not hold the stars in his hand. If we knew only the beautiful manuscript in the Bibliothèque Nationale, we might believe the tympanum of La Lande-de-Cubzac to be completely independent of the Apocalypse manuscripts. But, as we have said, these manuscripts often contain variants. If we open another manuscript in the Bibliothèque Nationale, more recent than the St.-Sever manuscript by at least a century,[24] we shall find the Christ of this tympanum (fig. 8). There are differences to be sure: the stars are enclosed not in a complete circle but in a half-circle, the seven arches are below instead of at the side, St. John bows more deeply. It is nonetheless evident that the tympanum of La Lande-de-Cubzac is the copy of a miniature belonging to this family.

The sculptor of La Lande-de-Cubzac had undoubtedly come from some great abbey in the Midi where he had been able to study a manuscript of the Apocalypse. The book, constantly recopied, passed from abbey to

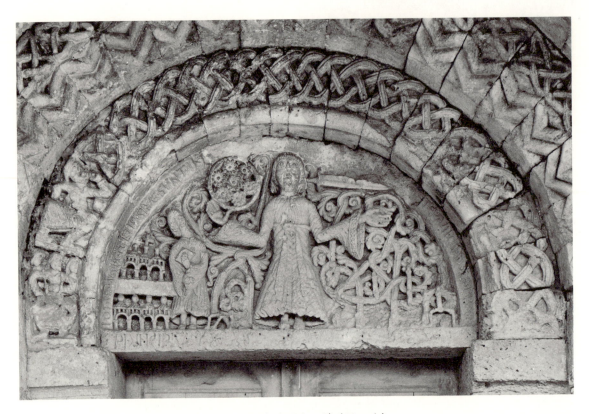

7. Vision of St. John. La Lande-de-Fronsac ("La Lande-de-Cubzac") (Gironde),
St.-Pierre. South portal, tympanum.

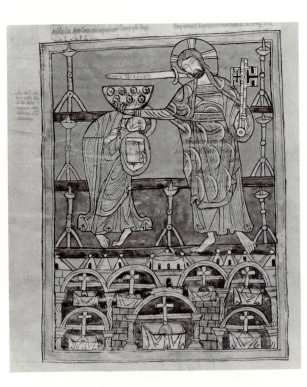

8. Vision of St. John. Beatus Apocalypse.
Paris, Bibl. Nat., ms. nouv.
acq. lat. 1366, fol. 12v.

abbey on its way north. We can affirm that the ancient abbey of St.-Hilaire at Poitiers possessed a Beatus Apocalypse almost like that of St.-Sever. The St.-Sever manuscript is decorated with small genre subjects that have no relation to the text, as if the artist wished to allow the reader a momentary rest from so many scenes of terror. Thus, at the bottom of a page we see two bald men face to face attacking each other (fig. 9). Since they have no hair to seize, they pull each other's beards while a woman watches them. Below is written this ironic Latin verse, from who knows where: *Frontibus attritis barbas conscindere fas est.*

This is a curious interlude to place between the image of the beast vomiting toads and the image of the angel pouring out the vial of divine wrath upon the Euphrates. There was an artist at St.-Hilaire of Poitiers who preferred the farcical to the tragic miniatures; he copied the fight between the two bald men onto one of the capitals with a faithfulness which, while not absolute, permits easy recognition of the original (fig. 10).[25]

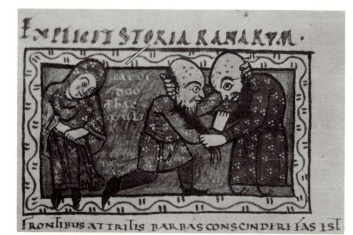

9. Two old men fighting.
Beatus Apocalypse of St.-Sever. Paris, Bibl. Nat., ms. lat. 8878, fol. 184r.

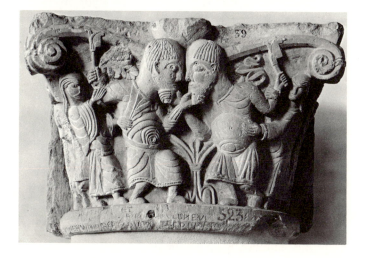

10. Two old men fighting.
Capital from St.-Hilaire. Poitiers (Vienne), Musée des Beaux-Arts.

These examples prove that the sculptors often sought their models, or at least their inspiration, in the manuscripts of the Beatus Apocalypse. Why should this be surprising? The book, with its violent color, its strange drawings, and its atmosphere of dream, exercises a real power over the imagination; once seen, it can never be forgotten. From it, the artists took the Christ surrounded by the four beasts; from it, they took the four-and-twenty elders of the Apocalypse wearing crowns on their heads and holding a chalice in one hand and a viol in the other—completely new types of which there are no examples in earlier art. Thus, these strange manuscripts of the Apocalypse left a profound imprint on twelfth-century art. They directed the imagination of the artists toward grandeur and mystery; nothing could be more harmonious with the shadow-filled Romanesque churches than these solemn tympanums. No doubt more than one sculptor had never seen the Apocalypse of Beatus, but it was enough that the spirit of the book had passed into such a work as the Moissac tympanum. Moissac was, for our artists, the real point of departure.[26]

This strange, visionary art lasted until the end of the twelfth century, but not beyond. In the thirteenth century, the representation of the Son of Man seated among the four beasts and the four-and-twenty elders disappeared. It was replaced by the more human image of Christ showing his wounds to the men he was to judge. Heaven was no longer symbolized by the severe and almost formidable figures of the four-and-twenty elders, but by gentle martyrs, confessors, and virgins forming great concentric circles around Christ. The old Apocalypse was decidedly forgotten, but it had reigned for a century.

III

Other influences of the miniature in the art of Moissac. The trumeau of Souillac and the Bible of St.-Martial at Limoges. The Dives of Moissac and the manuscripts.

The illustrated manuscripts of the Apocalypse were not the only models used by twelfth-century sculptors; they had many others. We can sometimes discover, if not the originals themselves (which have long since disappeared), at least manuscripts closely related to the originals.

Let us return again to Moissac. In the cloister a few massive pillars stand at intervals among slender colonnettes; they are carved in very low relief, almost like engraved drawings, with figures of the apostles. The sculpture is so timid that we seem to be present at the beginnings of an art; and indeed these reliefs, which are certainly prior to 1100, are some of the first attempts of the school of the Midi. The silhouettes carved almost without relief and the tunics with pleats indicated only by concentric lines remind us not, as has been said, of Byzantine ivories, which are modeled in quite another manner, but of miniatures.

In the Bibliothèque Nationale there is an eleventh-century Gospel-

book from St.-Martial of Limoges; it is illuminated with only four minia-
tures.[27] The image of each evangelist is placed at the beginning of his
Gospel. Contrary to the old Carolingian tradition, the evangelists are not
seated; they stand beneath a portico, blessing with the right hand and
holding a book in the left (fig. 11). There are striking resemblances be-
tween these figures and the reliefs of Moissac: the same arched architec-
tural frame, the same gestures, the same system of pleats revealing the legs
beneath the tunic. The St. Andrew of Moissac holds a long scepter in his
hand, as does one of the evangelists in the manuscript. It seems evident
that the sculptor had before him a manuscript of the same family, in which
the apostles were represented in the same manner as the evangelists of
Limoges. A singular detail, the imbrications beneath the feet of the figures,
is found in another manuscript from southwestern France which is con-
temporary with the Gospel-book.[28] In it we see St. Augustine seated; his
legs, crossed in an odd way, form a kind of x; his feet rest on imbrications
(fig. 12). At once we are reminded not only of the art of Moissac, but of

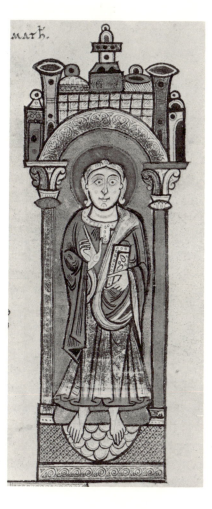

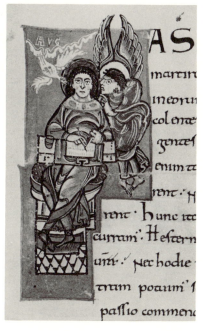

11. St. Matthew. New Testament from
Agen-Moissac. *Paris, Bibl. Nat.,*
ms. lat. 254, fol. 10r (detail).

12. St. Augustine. St. Augustine,
Enarrationes in Psalmos. Paris,
Bibl. Nat., ms. lat. 1987, fol. 43r.

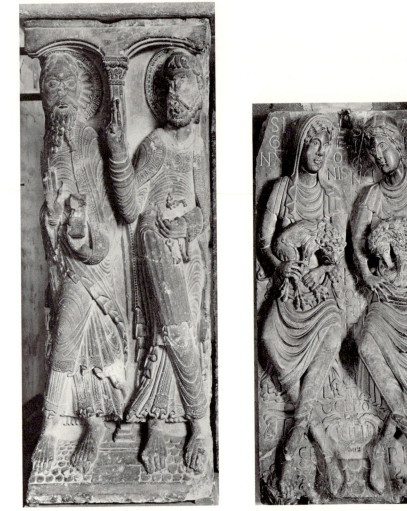

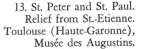

13. St. Peter and St. Paul.
Relief from St.-Etienne.
Toulouse (Haute-Garonne),
Musée des Augustins.

14. Women holding a lion and a ram.
Relief from St.-Sernin.
Toulouse (Haute-Garonne),
Musée des Augustins.

the art of Toulouse. The legs of the famous apostles of Gilabertus (fig. 13) and of the two seated women holding the lion and the ram (fig. 14)[29] are crossed in the same manner, and beneath their feet are the same imbrications. It would seem that the origins of the sculpture of both Toulouse and Moissac are to be found in manuscripts of the Midi. But so many of these manuscripts are lost that the truth can only be glimpsed.

One example, however, provides us with almost certain evidence. The trumeau of the portal at Souillac (Lot) is one of the most extraordinary monuments of twelfth-century sculpture in the Midi; it shows birds and animals superposed and devouring one another (fig. 15). What has not been written about the Souillac trumeau? It has been attributed in turn to the Celtic and to the barbarian spirit surviving in the provinces of the central plateau. A cosmogony, almost, has been read into it. But we have only to open the great tenth-century Bible from St.-Martial of Limoges, now in the Bibliothèque Nationale, to see at the beginning of the New Testament some of the most magnificent canon tables in existence.[30] There are round arches supported by pilasters with strange capitals: here

we see a lion's head presented frontally with bristling mane; there, the entire figure of a bull. The pilasters themselves rest not on the ground but on animals. They recall the art of ancient Persia and Mesopotamia; and this first impression turns out to be quite correct, for the canon tables of the Limoges Bible are nothing more than imitations of the Gospel canons of Syrian manuscripts, which revived the most ancient traditions of Asia:[31] the birds sporting above the arches—a pre-eminently Syrian motif—are sufficient proof. Now in the Limoges manuscript, two of the pilasters of the canon tables are covered from top to bottom with superposed animals devouring each other (fig. 16): there are dogs or cheetahs seizing on hares, and aquatic birds with fish in their beaks—so many Eastern motifs that the artist has brought together in one bizarre whole.[32]

What must we conclude from this? Does it not seem clear that the

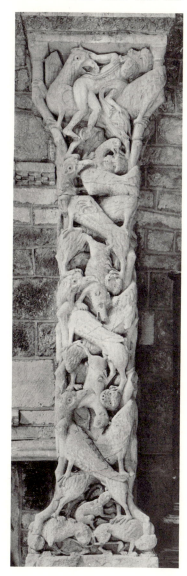

15. Trumeau. Souillac (Lot), Abbey Church of Ste.-Marie.

16. Detail of canon table. Bible from St.-Martial of Limoges. Paris, Bibl. Nat., ms. lat. 5 (vol. ii), fol. 134r.

sculptor of the Souillac trumeau knew, if not the Limoges manuscript itself, at least a manuscript of like inspiration? Copy though he did, he can be credited with entangling his animals more skillfully, with interlacing them with more art.

Certain practices of this Midi sculpture can be explained only as in imitation of manuscripts. A capital at Moissac contains an unusual detail in the scene of the Sacrifice of Abraham: Isaac stands on a hillock that appears to be composed of small, curled-back waves. This strange way of drawing mountains had been adopted by the miniaturists of the Midi; it was used in the Apocalypse of St.-Sever as well as in a beautiful lectionary of the Limoges school.[33] Sculptors sometimes imitated this device of the miniaturists. In Spain, a relief in the cloister of Silos, closely related to the art of the Midi, represents the Descent from the Cross; there the rock of Golgotha is formed by layers of small waves. Imitation is as obvious here as at Moissac.

Are these the only features that art in the Midi borrowed from miniatures? There are indications of many others, but the all too rare surviving manuscripts provide only approximate evidence. I have not found the exact original of the scene of Dives and Lazarus carved on the porch of Moissac (fig. 17); I am nonetheless convinced that the artist was inspired by an illuminated manuscript. A miniature taken from a twelfth-century manuscript[34] shows Abraham wearing a skullcap and holding the soul of Lazarus in his bosom; below, Dives is in the flames, tormented by devils

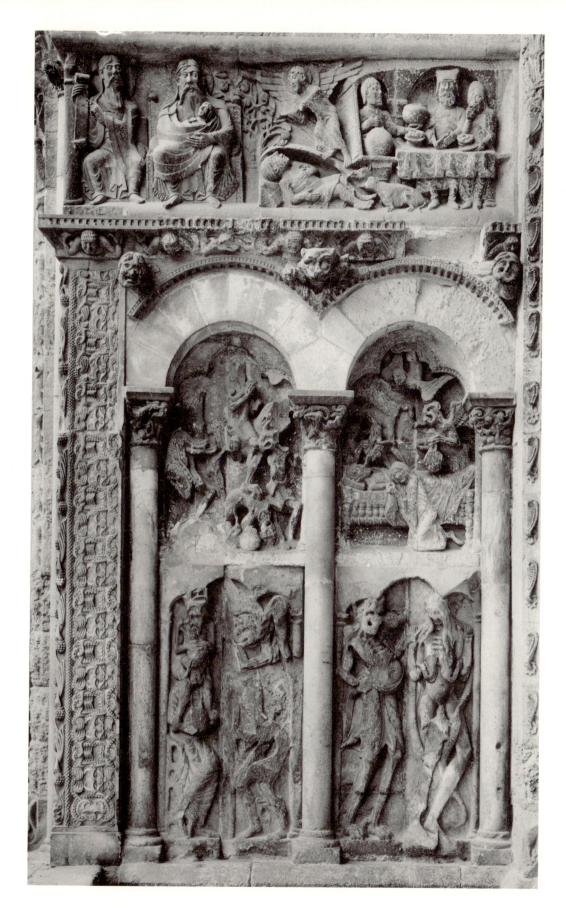

17. Parable of Dives.
Moissac (Tarn-et-Garonne),
Abbey Church of St.-Pierre.
Porch, west wall.

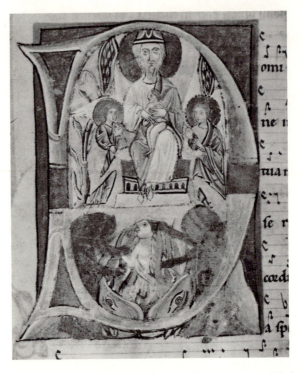

18. Parable of Dives. Missal from
Prémontré. Paris, Bibl. Nat.,
ms. lat. 833, fol. 135v.

(fig. 18). The arrangement and even some of the details are the same as
in the scene carved at Moissac. The confrontation of Lazarus seated on
Abraham's knees and Dives tortured in Hell goes far back in time; it
had appeared in the ninth-century Greek manuscript of St. Gregory of
Nazianzus[35] which was probably based on a sixth-century original. It was
a traditional form with the Greeks.[36] None of these manuscripts, it is true,
contains the feast of Dives, his death, and the death of Lazarus—all of
which are shown at Moissac. But these scenes are found in other manu-
scripts: in a twelfth-century manuscript now in Austria,[37] and in the
famous Alsatian manuscript of Abbess Herrade, the *Hortus deliciarum.*[38]
In the Austrian manuscript, which doubtless was unknown to our artists
of the Midi, we see, as at Moissac, a servant presenting a cup to Dives
seated with his wife at table. We sense a tradition and surmise that the
Moissac sculptor had a model.

But the examples already given will perhaps seem sufficiently conclusive.
There can now be no doubt that the sculptors of southwestern France
were inspired by manuscripts, and that they learned from miniatures.

IV

The miniature and the capitals of Au-
vergne. Capitals of Clermont and Royat.
The tympanum of Notre-Dame-du-Port.

It must now be shown that the same was true of other schools. Here also,
we can give only a few examples, for where today are we to find the
originals the sculptors used? However, a certain number of manuscripts
preserved by chance provide us with some significant comparisons.

As I have studied the capitals of Auvergne, which are archaic in appearance though dating only from the twelfth century, I seem always to have glimpsed earlier models behind them. For example, it is a surprise to find that occasionally the figures wear helmets of a style dating from the Carolingian period.

A capital of Notre-Dame-du-Port, at Clermont-Ferrand, represents the battle of the Virtues and the Vices. Here we easily recognize the setting of the *Psychomachia,* the famous poem by Prudentius (fig. 19).[39] The subject was often treated by twelfth- and thirteenth-century artists, but the capitals at Clermont present some details not found elsewhere. The Virtues have armor over their long robes, they wear helmets, and carry lances, swords, and shields. This completely military aspect of the Virtues proves that the artist had been inspired by an illuminated manuscript of Prudentius' *Psychomachia*. These manuscripts are numerous;[40] almost all represent the Virtues as women wearing armor. In the earliest examples, the Virtues resemble Roman soldiers,[41] but the style of armor soon changed and they take on the appearance of medieval knights. An eleventh-century manuscript in the Bibliothèque Royale of Brussels[42] shows them wearing the same accouterments as the Virtues of Clermont: chain mail over long robes, helmet, shield, and lance decorated with a gonfalon (fig. 20). At Clermont, the Vice opposed to the Virtue is represented as

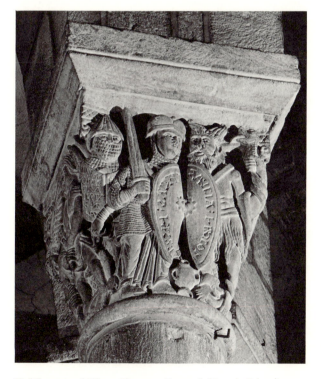

19. Virtues and Vices. Clermont-Ferrand (Puy-de-Dôme), Notre-Dame-du-Port. Ambulatory capital.

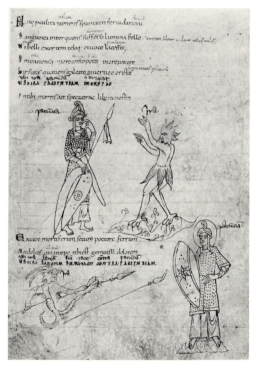

20. Patience and Wrath. Prudentius, *Psychomachia*. Brussels, Bibl. Royale, ms. 9968–72, fol. 82v.

a barbarian, and is completely nude except for a belt around his waist from which the skins of wild beasts hang; his hair stands up in separate tufts on his head. A kind of faun personifying all the base instincts of human nature, he is found in almost all of the manuscripts of Prudentius,[43] and goes back to antiquity. Exactly the same figure represents Vice on the capital at Clermont, but as far as I know, there is no other like him in medieval art. Such a figure, and the image of the armed Virtues as well, can be explained only as copies from an illuminated manuscript of the *Psychomachia*. The artist took many liberties with his model; he arranged the figures as he pleased, but he did not invent their types.

A capital in the church at Royat turns out to be an imitation of another miniature; its subject cannot otherwise be understood. A figure with a long beard holds a scale; beside him, a beardless figure holds a kind of knife in his right hand, and with his left clutches the folds of his tunic (fig. 21).[44] What does this puzzling scene mean? The Book of Ezekiel explains it. The prophet is ordered by God to shave off his beard and hair and weigh them in the balance; he must divide them into several parts, burning one, throwing another to the wind, and keeping the third part in the folds of his tunic.[45] This is the subject of the Royat capital. Ezekiel is represented twice: we see him holding the scale, and then the razor with which he has just shaved off his hair and beard. These he seems to clutch in his tunic.

Now this strange composition was not, as one might think, imagined by the sculptor; it is a copy. In fact, in Haimon's Commentary on Ezekiel, a tenth-century work, we find a drawing exactly like our capital.[46]

It represents, first, the prophet holding the scales, then the same personage carrying the razor he used to cut off his beard and hair. A page very similar but even closer to the Royat capital is to be found in the famous Noailles Bible, an eleventh-century manuscript (fig. 22).[47] This representation of Ezekiel passed from manuscript to manuscript. The sculptor of Royat thus had before him an illustrated Bible which he imitated.

The sculptors who found the model for the Royat capital in their illustrated Bible also found there the model for the tympanum of Notre-Dame-du-Port. This tympanum represents the Vision of Isaiah (fig. 23). God appears to the prophet in the temple; he is seated on his throne and seraphim stand at his sides. The text says: "In the year that King Uzziah died I saw also the Lord sitting upon a throne, high and lifted up, and his train filled the temple. Above it stood the seraphim; each one had six wings; with twain he covered his face, and with twain he covered his feet, and with twain he did fly. And one cried unto another, and said, Holy, holy, holy, is the Lord of hosts: the whole earth is full of his

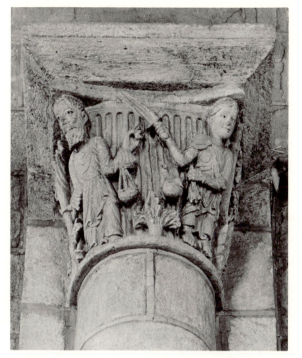

21. Ezekiel. Royat (Puy-de-Dôme), Priory of
St.-Léger. Capital of north wall.

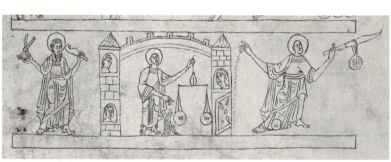

22. Ezekiel. The Noailles or Roda Bible. Paris, Bibl. Nat.,
ms. lat. 6 (vol. III), fol 45r (detail).

glory. And the posts of the door moved at the voice of him that cried, and the house was filled with smoke."[48] This majestic vision, which so successfully fills the tympanum, seems made for monumental sculpture; nevertheless, it had been the subject of drawings long before it was executed in sculpture. The Noailles Bible, which has given us the story of Ezekiel, also illustrates the Vision of Isaiah.[49] There is the same arrangement, the same symmetry: the seraphim open and cross their six wings in the same manner. We sense that the form of the scene is fixed, and in fact, so it had been for centuries. The famous manuscript of Cosmas Indicopleustes in the Vatican Library represents it in the same manner as the Noailles Bible (fig. 24). The manuscript of Cosmas dates from the seventh century, but it appears to reproduce a sixth-century original. The first illuminated manuscript of Cosmas came from Alexandria in the Greek East. It was thus at Alexandria, and as early as the sixth century, that the Vision of Isaiah was conceived with the noble symmetry we find seven centuries later on the Clermont portal. It was through manuscripts that the early type was faithfully transmitted, and it was from a manuscript that the twelfth-century sculptor borrowed it.

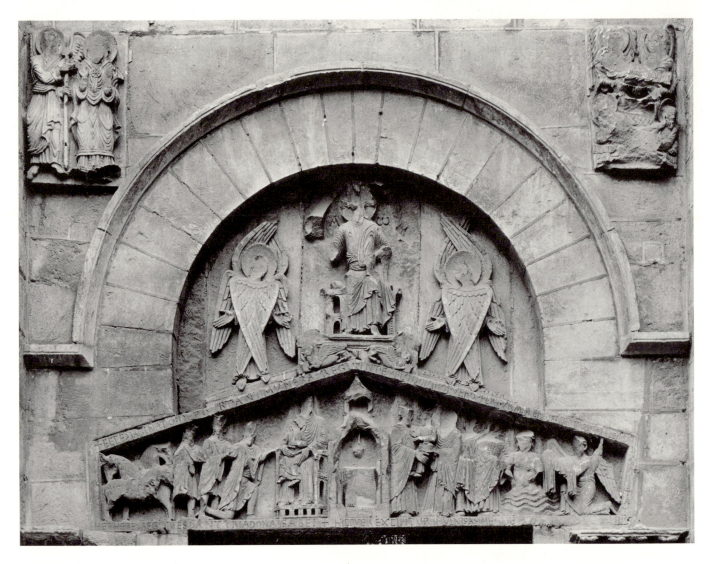

23. Vision of Isaiah; Adoration of
the Magi; Presentation in the Temple;
Baptism of Christ. Clermont-Ferrand
(Puy-de-Dôme), Notre-Dame-du-Port.
South portal.

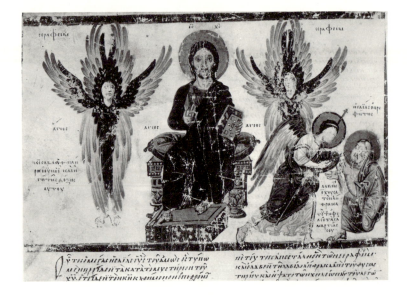

24. Vision of Isaiah. Christian
Topography of Cosmas Indicopleustes.
Vatican, Biblioteca Apostolica, cod.
gr. 699, fol. 72v.

The sculpture of the Rhone Valley belongs to a fairly late period—the end of the twelfth century. It is an art already with a past and traditions, and less need, it would seem, to seek models in illuminated manuscripts. Nevertheless, it provides a number of examples of miniature copying; some are obvious, others can be inferred.

At the cathedral of Valence there is an ancient tympanum, now relegated to a place beneath a porch, which in the upper section represents Christ seated in majesty among the angels, and in the lower, the Miracle of the Loaves (fig. 25).[50] The latter subject is conceived with singular grandeur. Christ stands facing us in the center of the composition, and rests his hands on the baskets presented by the two disciples at his right and left. This solemn symmetry has an antique beauty that takes us back to the origins of Christian art; and in fact, one of the earliest Christian paintings, the half-effaced fresco in the catacombs of Alexandria, shows the Miracle of the Loaves in the same manner as at Valence.[51] The Alexandria fresco is the work of a Greek, and its noble symmetry retains something of the Greek genius. This composition was considered so beautiful that it was constantly imitated in the Near East. We find it in the richly illustrated Homilies of St. Gregory of Nazianzus, now in the Bibliothèque Nationale (fig. 26).[52] This manuscript dates only from the ninth century, but the illuminator worked from much earlier originals. The Greek formula for the Miracle of the Loaves passed from East to West. About

The miniature and the art of the Rhone Valley. The tympanum of Valence. Relief sculptures of Arles and Nîmes. The Passion of St.-Gilles and the Auxerre manuscript from the Midi.

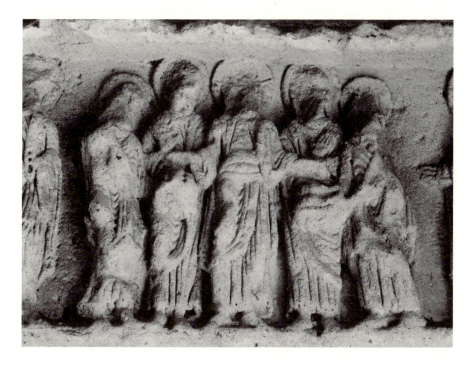

25. Miracle of the Loaves. Valence (Drôme), Cathedral. South transept, detail of the old portal.

26. Temptation of Christ. Miracle of the Loaves. Homilies of St. Gregory of Nazianzus. Paris, Bibl. Nat., ms. gr. 510, fol. 165r (detail).

the year 1000, it reappeared in the Codex Egberti of Trier, and in a group of German manuscripts from the Ottonian period illuminated at Reichenau. Thus, the composition of the Alexandrian painting was handed down from manuscript to manuscript until the eleventh century. It was probably through a manuscript that the Valence sculptor knew it, and it is clear that the beautiful motif is of Greek origin.[53]

The façade of St.-Trophime at Arles is a composite work in which northern influences are visible. The Christ in Majesty is clearly an imitation of the Christ in Majesty of the west portal of Chartres; furthermore, the apostles at Arles often make the same gestures as the patriarchs and kings of Chartres. But along with these borrowings from northern art, there is one feature that could have come only from Byzantine painting. Paradise is personified by three figures receiving souls in their bosoms: they are Abraham, Isaac, and Jacob (fig. 27). In French art, Abraham alone had the privilege of symbolizing heaven; we never find the three patriarchs together.[54] On the other hand, all three often figured in Byzantine scenes of the Last Judgment, and the frescoes of Mount Athos contain more than one example.[55] Although these works are of a fairly late period, it is certain that the three patriarchs must have appeared much earlier in Byzantine art, for Italy offers an example in a wholly Byzantine mosaic of the thirteenth century: in the Last Judgment scene of the Baptistery of Florence, on which the Greek mosaicist Apollonius collaborated, the three patriarchs receiving the souls in their bosoms are placed beside the elect. There is no doubt that in the late twelfth century a Byzantine manuscript had made known the motif of the three patriarchs to the sculptors of Arles. The clear proof is that a tree separates the three patriarchs one from the other, exactly as in the Mount Athos frescoes and the Byzantine mosaic at Florence. The trees are an ancient image of Paradise, which the people of the East conceived of as a garden.

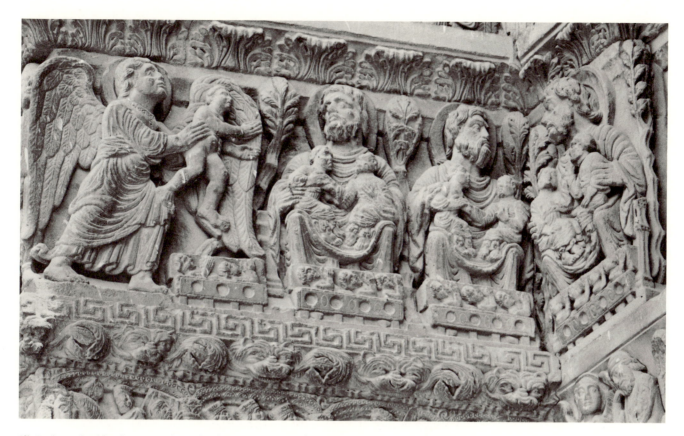

27. Souls received by the patriarchs. Arles (Bouches-du-Rhône), St.-Trophime.
West façade, detail of frieze.

The façade of the cathedral of Nîmes, whose stonework seems Roman, is decorated with a pediment very like those of antiquity; beneath the pediment there is a frieze of figures similar to a temple frieze. It tells of the origins of the world and the history of the sons of Adam. One of the reliefs shows the offering made to the Lord by Cain and Abel; they present, one a sheaf of wheat, and the other a lamb to the enormous hand of God (fig. 28). The work is so primitive that at first we take it for the creation of a Romanesque artist, but on examining it closely we discover details that seem to have come from a much older world than twelfth-century France. For example, Cain and Abel, as a sign of respect, present their offerings on a cloth, as the servants of Eastern kings would have done. The hand issuing from the clouds, a kind of hieroglyph for divine intervention, also derives from ancient Eastern iconography.

And in fact, if we look into Byzantine Octateuchs of the eleventh and twelfth centuries,[56] we find Cain and Abel represented exactly as they are at Nîmes: the same tunics and mantles, the same cloth beneath the offering, the same hand issuing from heaven (fig. 29). The miniatures

32

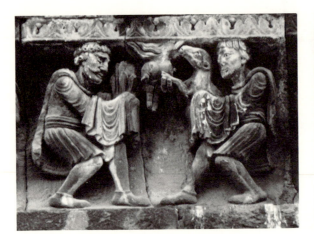

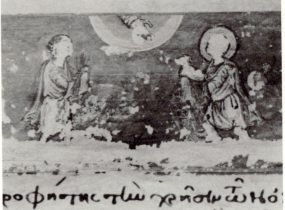

28. Cain and Abel presenting their offerings.
Nîmes (Gard), Cathedral of Notre-Dame and St.-Castor.
West façade, detail of frieze.

29. Cain and Abel presenting their offerings.
Octateuch. Istanbul, Seraglio,
ms. 8, fol. 5or (detail).

of Byzantine Octateuchs date only from the eleventh and twelfth centuries, but they often reproduce fifth- and sixth-century originals, which is certainly true in this case. Thus, the hieratic and mystical elements of the relief at Nîmes—the symmetry of the figures, the cloth on which their offerings rest, the hand of God descending from heaven—all these are the very mark of the grave spirit of the East.[57]

Let us now glance at the magnificent façade of St.-Gilles. There also, as at Nîmes, is an unbroken frieze of figures above the columns of the portico that reminds us of the decorations of the temples of antiquity, but the frieze of St.-Gilles is as elegant and delicate as that of Nîmes is heavy and coarse. The frieze of St.-Gilles represents a subject that now seems commonplace, but that on the contrary was quite new in medieval art: the Passion of Christ. Shown successively are the Arrest in the Garden of Olives, the Judgment of Pilate, the Flagellation (fig. 30), and the Carrying of the Cross. Sculptors had only recently begun to represent all these subjects. They had been used a few years earlier, it would seem, on the capitals of the cloisters of La Daurade at Toulouse,[58] on the frieze of the church at Beaucaire,[59] and on the capitals of St.-Nectaire. All these works, as we see, belong to the Midi of France. We find nothing like them in the north. Burgundy, for example, although rich in historiated capitals, has no series devoted to the Passion of Christ. We are therefore led to believe that there were in the Midi some manuscripts, illuminated at the beginning of the twelfth century, in which the Passion was a central theme and to which artists went for inspiration. Now it happens that fragments of one of these manuscripts still exist: these are the two illustrated pages of the canon of the Mass which are preserved in the treasury of Auxerre Cathedral. We said earlier that the Christ in Majesty surrounded by the

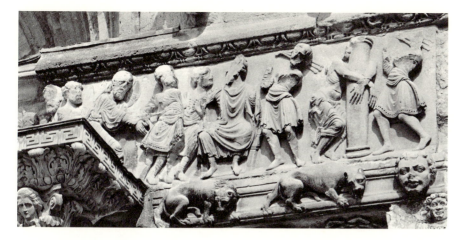

30. Christ led before Pilate; Flagellation.
St.-Gilles-du-Gard (Gard), Abbey Church. West façade,
detail of frieze.

four-and-twenty elders was the work of a miniaturist from the Midi.[60] With a vigorous line, the same hand drew the Christ on the Cross surrounded by scenes from the Passion.[61] When we compare these sharp little drawings with the reliefs of St.-Gilles, we are struck by their similarities (fig. 31). The scenes of the Flagellation, in particular, are almost identical: Christ, bare to the waist, is placed not behind the column as in later art but beside it, and embraces it with both arms; the column is not slender, as it was soon to become, but thick as a church pillar; the executioners are dressed in short tunics gathered at the waist, and the hem of one of the tunics is finished with a decorated band. All these details are the same in the relief and in the drawing.[62] It is also notable that the Judgment of Pilate, in spite of differences in detail, is conceived in the same manner in both cases. The scene is filled with movement. Christ is not immobile before his judge, but is brutally led before the tribunal by two soldiers; one walks before the accused man with head high, dragging him without a backward glance, and the other pushes him from behind. Such similarities can scarcely be laid to chance; it is evident that the sculptors of St.-Gilles had consulted a manuscript belonging to the same family as the Auxerre fragment.

There remains another and, it is true, somewhat later example of the manuscripts illustrated in the Midi which give a prominent place to the Passion of Christ. I refer to the Life of Jesus Christ, illuminated at Limoges, which was published some time ago by the Comte de Bastard.[63] The work was done around 1200, and consequently is later in date than the reliefs of St.-Gilles and all the Passions carved in the Midi. In the Limoges manuscript we see the new iconography emerging, but there is also more than a trace of the old. For example, the Carrying of the Cross,

31. Crucifixion surrounded by scenes
from the Passion. Vellum leaf.
Auxerre (Yonne), Treasury of the
Cathedral of St.-Etienne.

which is not represented in the Auxerre fragment, appears in the Limoges manuscript; now the cross, its arms flared, has precisely the form to be seen—not at St.-Gilles, where the cross is no longer distinct—but in the relief at Beaucaire.

In the early twelfth century, then, there were in the Midi illuminated manuscripts of the Life of Christ in which, for the first time, the Passion was given an important place. Today we know only fragments or later works, but enough has been preserved to affirm that the sculptors of the Midi sought their models in manuscripts.

VI

The relation between Burgundian painting and sculpture. The portal of Charlieu and the fresco of Lavaudieu. The portal of Anzy-le-Duc. The portal of Vézelay and the miniature.

Burgundian sculpture, too, gives us reason to infer more than one transcription of the miniature.

The main portal of the priory of Charlieu (Loire) is one of the most beautiful monuments of Cluniac art. The delicacy of the ornament and

the exquisite quality of the mutilated figures recall archaic Greek sculpture. In the tympanum, an aureole surrounds Christ seated among the four beasts. The lintel is no less majestic: the Virgin, seated like a queen, occupies the center, and two angels stand at her right and left; the apostles accompany her and are also seated (fig. 32).

This imposing composition, which seems to open the heavens to us, has so monumental a character and seems so perfectly suited to the place it occupies that we cannot for a moment imagine it to have come from elsewhere.

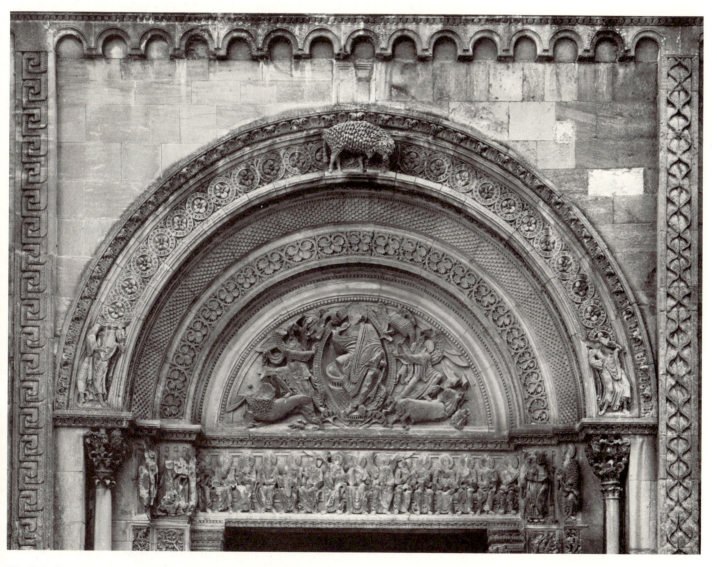

32. Christ between the four beasts; Virgin and apostles. Charlieu (Loire),
Priory of St.-Fortunat. North façade of narthex, main portal.

But let us examine a fresco in the abbey of Lavaudieu, near Brioude (Haute-Loire).[64] It is a great surprise to find there all the figures of the Charlieu portal arranged in the same way. Above, Christ appears in glory surrounded by the four beasts; below him, the Virgin is seated on a throne between two angels, and the apostles are placed at her right and left (fig. 33). Here we have the same idealized scene conceived in an almost identical way: it is scarcely noticeable that at Lavaudieu the apostles are standing instead of sitting, as at Charlieu.

This is a strange coincidence and all the more surprising because we can imagine no connection between Lavaudieu and Charlieu. Charlieu was a priory for men and a dependency of Cluny, Lavaudieu an abbey for women founded by St. Robert and consequently a dependency of La Chaise-Dieu. Both works belong to the twelfth century, but it is impossible to tell which is the earlier. What is clear, in any case, is that such a subject did not belong exclusively to sculpture; it was painted as well as carved.

But I think we can go further and say that the subject appeared first in painting. This great composition which we take to be a creation of the twelfth century was then already nearly seven hundred years old, for it has been discovered in a fresco on the wall of a chapel at Bawit in Upper Egypt.[65] At Bawit, Christ soars in majesty among the four beasts and is accompanied by two angels; below, the apostles are ranged at each side of the Virgin seated on her throne (fig. 34). The broad outlines are the same, and there is the same idealized and timeless reunion of Christ, the Virgin, and the apostles. True, the two angels at each side of the Virgin are missing, but they are to be found—and at Bawit itself—in another chapel.[66] This poetic group of the Virgin between two angels had been created by Christian artists as early as the sixth century.[67]

In the Bawit frescoes, the Virgin is represented with the Child: this is the Theotokos whom the Egyptian painters were honoring—the Mother of God whose grandeur had been proclaimed by the Council of Ephesus. But in the East, the Virgin was also represented enthroned alone between two angels. In the illustrated Homilies of James the Monk, a Byzantine work of the twelfth century,[68] the Virgin with her guard of angels is seated with her open hands raised against her breast, as at Lavaudieu.[69] She is honored for herself, as the holiest of creatures.

There were undoubtedly several intermediaries between the Bawit paintings, the Charlieu portal, and the Lavaudieu fresco. Over the centuries, the original conception could have been slightly modified, but what is certain is that the Charlieu portal and the Lavaudieu fresco derive from one prototype. It was no doubt an illuminated manuscript that perpetuated in the West an Eastern tradition at least seven hundred years old.

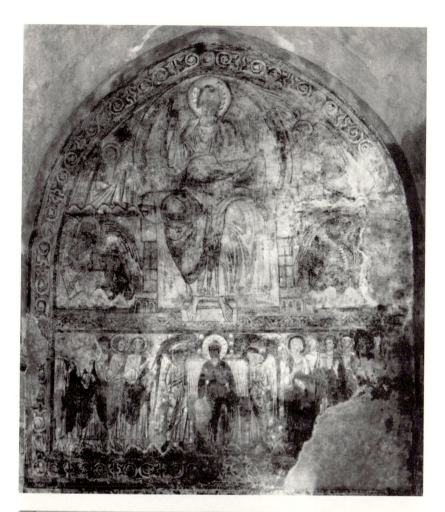

33. Christ between the four beasts;
Virgin and apostles. Lavaudieu
(Haute-Loire), Old Priory of St.-André.
Fresco of the chapter room.

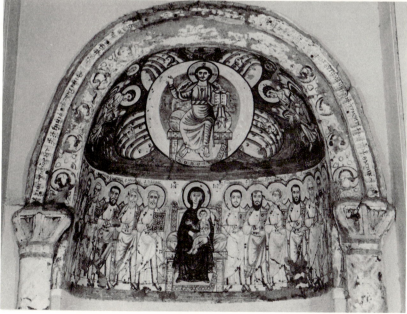

34. Christ between the four beasts;
Virgin and apostles. Fresco from Bawit
Chapel VI (Cloister of St. Apollo).
Old Cairo, Coptic Museum.

The Charlieu portal is not the only example in Burgundy of this beautiful composition. The resemblance of the tympanum of Anzy-le-Duc, now in the museum of Paray-le-Monial, to the Bawit fresco is even more striking. Beneath the Christ in Majesty, it is again the Virgin holding the Child on her knees that is represented, and as in the Bawit fresco, she is about to give him suck. The analogy would be complete if the apostles standing at her right also appeared at her left, but they are replaced by four female saints (fig. 35).[70]

It is certain, then, that the Lavaudieu painter, as well as the sculptors of Charlieu and Anzy-le-Duc, had models; the oldest traditions of the East had reached them. Perhaps these traditions were perpetuated in France by frescoes and illuminated manuscripts, or perhaps they had only recently arrived. Twelfth-century France had just discovered the Near East; the Order of Cluny, in particular, had several priories in the Holy Land. And there was probably more than one work of antiquity and more than one precious manuscript still preserved in Syria. This contact with the ancient genius of Asia could not possibly have been completely unproductive.

But again we can only conjecture, for the library of Cluny, where so many questions could have been answered, has been almost completely destroyed. The Huguenots began their pillage in 1562, and in 1793 the rabble of Cluny made a bonfire of all the manuscripts they could find; only a few, now preserved in the Bibliothèque Nationale, escaped this double disaster.

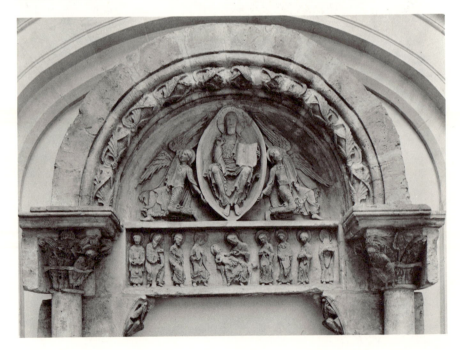

35. Christ in Majesty; Virgin and saints. Tympanum from the Priory of Anzy-le-Duc. Paray-le-Monial (Saône-et-Loire), Musée Eucharistique du Hiéron.

One of these manuscripts, decorated with miniatures, is invaluable to our study.[71] It represents the Pentecost (on fol. 79v) in a way that is rather unusual in the art of the Middle Ages: a half-length figure of Christ is shown in an aureole, arms widespread; long rays reach from him to the apostles seated below him (fig. 232). It is impossible not to think at once of the famous tympanum at Vézelay. If the Christ of the manuscript were full-length instead of half-length, the miniature and the relief would be almost identical. We are left with a feeling that the tympanum of Vézelay was inspired by a miniature closely resembling the one that happens to be preserved for us. The long rays carved in stone, so little adapted to the medium of sculpture, are enough to betray the copying of an illuminated manuscript.[72] We shall soon see, in a discussion of the portal of Vézelay, that the mysterious surrounding figures were also borrowed from a manuscript.[73]

VII

To buttress the argument, let us go beyond the borders of France and consider the portal of a famous Catalan monastery, the abbey of Ripoll. This portal has no tympanum, but the wall through which it opens offers a large surface which the artist has covered with reliefs. The ensemble forms a kind of triumphal arch. There are episodes from the stories of Moses, David, and Solomon. All of these sculpted scenes faithfully reproduce drawings from a Catalan Bible, the Bible of Farfa.[74]

There was in fact a monastic school in Catalonia in the late tenth century that devoted itself to illustrating the Bible. It stands in sharp contrast with the Asturian school at the other end of the Pyrenees which illuminated the Apocalypse of Beatus in such vivid colors. The Catalan monks were draftsmen, not painters. Just how original were their drawings? It is difficult to say. However, here and there we discover certain archaisms that remind us of ancient Eastern models, and it may be that the artists themselves invented very little.

Two of these Catalan Bibles are now famous: one, from Rosas, is in the Bibliothèque Nationale;[75] the other, for a long time in the Italian monastery of Farfa, is now in the Vatican Library.[76] The originals of the Ripoll reliefs are to be found in the Farfa Bible. There can be little doubt that the abbey of Ripoll possessed a Bible resembling the Farfa Bible when the sculptors set to work about 1160.[77] To be convinced, we have only to compare the reliefs with the drawings in the manuscript. Take the scenes from Exodus, for example: Moses, standing on a hillock, speaks to the murmuring crowd; the pillar of fire appears; the quails and manna fall from heaven; the Hebrews prevail over the Amalekites, while on the

An example borrowed from Spain. The reliefs of Ripoll reproduce the miniatures of the Farfa Bible.

mountain Hur and Aaron hold up Moses' arms. Not only is the disposition of the scenes the same in the drawings and the reliefs, but even the slightest details are identical. The pillar of fire is a tall torch from which the head of an angel seems to issue; rays of light accompany the fall of quails, and heads of open-mouthed monsters appear in the sky. The stories of David and Solomon are just as faithfully reproduced. It will suffice to mention Solomon's Dream, where the figure of Christ seated within an aureole supported by two angels is placed above the sleeping king (figs. 36 and 37). There is no better example of the influence of manuscripts on sculpture than these Ripoll reliefs, for at Ripoll the artist was not merely inspired by the originals he had before him, he copied them literally. Even though they were a century and a half old, these drawings did not seem too ancient to him. And this explains those often disconcerting archaisms in the art and iconography of the twelfth century.

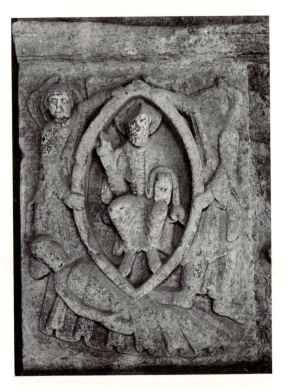

36. Dream of Solomon. Ripoll (Gerona),
Sta. María. West façade, relief of north side.

37. Dream of Solomon. Farfa Bible.
Vatican, Biblioteca Apostolica, cod. lat. 5729,
fol. 95r (detail).

All the examples just cited show how much the sculpture of the twelfth century owes to the miniature. But the influence of the miniature was even greater than we have said, for many of the decorative themes beloved by Romanesque sculptors and thought to have been invented by them were borrowed from miniatures.

We have already shown that a manuscript provided the model for the strange trumeau at Souillac, but there are other instances just as striking.

On church porches in northern Italy—at Modena and Verona, for example—we sometimes find columns resting on lions. The Lombard artists made this motif known over almost all of Italy and even carried it to Dalmatia. We sometimes find it in Provence, as on the porch of the cathedral of Embrun. There is something quite strange and mysterious in this barbaric union of the column and the beast—something that takes us far beyond the classical world of Greece and Rome to the ancient civilizations of the East. And in fact, it was only in Assyria that columns resting on the backs of lions or bulls were to be seen.[78] We sense that these forms conceal religious symbols that we may perhaps never discover. But how is it possible that medieval artists knew the monuments of Assyria? The answer is simple. Between occidental artists and Assyrian art there were numerous intermediaries: illuminated manuscripts. As early as the sixth century, the Syrians decorated manuscripts of the Gospels with graceful porticoes beneath which they placed the canon tables giving the concordance of the four Gospels. These porticoes were full of fantasy, but they also show more than one element taken from real life. The monks of Mesopotamia who created them were surrounded by the imposing ruins of Assyrian palaces, and it was there that they found the idea of the column with an animal base. The earliest manuscripts of this type have unfortunately disappeared, and those which have been preserved, such as the Greek manuscript of the Gospels now in Venice (fig. 38),[79] do not go back beyond the eleventh century. But it is clear that a great many earlier manuscripts once existed, for our Carolingian manuscripts, which were so often inspired by Syrian manuscripts, already show columns resting on animals.[80]

Thus, an intermediary between the Assyrian palaces and the Lombard porticoes is reestablished and the chain of time is joined again; what seemed impossible is explained. However, the Lombard sculptors probably did not use Syrian manuscripts as models but followed much more recent or even contemporary copies, for up until the twelfth century, drawings of columns resting on animals were placed at the beginning of the Gospels.[81]

Decorative themes borrowed from the miniature. Columns resting on lions. Diagonal frets in ornament and the Greek fret. Knotted columns. Form of the tympanum.

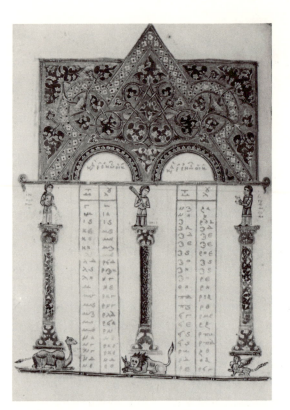

38. Columns of canon table carried by animals. Gospel-book. Venice, Biblioteca Marciana, ms. gr. 540(=557), fol. 5v.

These canon tables from eastern manuscripts exerted, I am convinced, a profound influence on the decoration of Romanesque portals. They were natural models for our twelfth-century artists. There they found the beautiful round arches ingeniously decorated and resting on colonnettes, like the archivolts of their portals. They often imitated them. The very idea of decorating the archivolts must have been suggested to them by the beautiful Carolingian manuscripts. In the archivolts, many Norman portals have a simplified Greek border called the "Greek fret"; it is almost always accompanied by a series of diagonal frets forming a continuous chevron or zigzag pattern. From the Early Christian era on these two motifs had been used to decorate the arches of the canon tables of Syrian manuscripts. The diagonal fret appeared as early as 586 in the famous Syrian Gospel-book now in the Laurentian Library of Florence, illuminated by the monk Rabula at the monastery of Zagba in Mesopotamia. The Greek fret appears in a Syrian manuscript belonging to the Bibliothèque Nationale, a manuscript related to the Rabula Gospels.[82] In the sixth century, both motifs were employed to frame the completely Eastern mosaic in S. Apollinare in Classe at Ravenna, which represents Abel and Melchisedek: this is the very decoration used on Norman portals.[83] The sculptors have thus, with primitive force, expressed in stone an ancient motif that had come down to them in manuscripts.[84]

But it is not only in the colonnettes decorating Romanesque portals that we meet the faithful imitation of the colonnettes drawn by the miniaturists. We find in Lombardy, on the south portal of the cathedral of Modena, clustered columns that seem to be fastened together with a knot: a powerful hand seems to have knotted the stone as one knots a rope. The Lombards took the knotted columns to Tuscany, where we find them again on the façade of the church of S. Michele at Lucca; they also took them to Germany, where they were once to be seen in the narthex of the church at Würzburg. Where did this singular fantasy come from? Did the artists of Lombardy invent it? It would seem not, for we discover that the knotted columns were already to be found in Eastern manuscripts. A Byzantine manuscript in the Vatican Library[85] shows a portico formed of clustered columns fastened together with a knot. The Lombards borrowed the knotted columns from Eastern miniatures, just as they borrowed the columns resting on lions.

The twisted columns of St.-Lazare at Avallon are a no less striking example of the influence of miniatures on the decoration of portals (fig. 39). On Gospel canon pages, Carolingian miniaturists sometimes brought

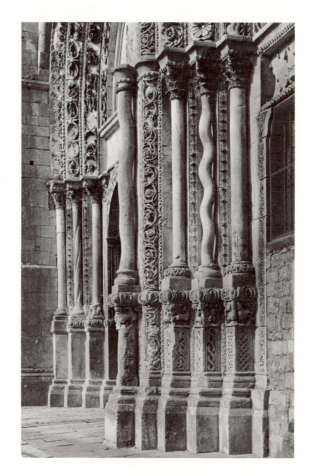

39. Jamb columns. Avallon (Yonne), Ancient Collegiate Church of St.-Lazare. West façade, portal jambs.

together straight and twisted columns.[86] A manuscript similar to the Gospel-book of Soissons, where the two kinds of columns are used alternately, had no doubt charmed the architect of Avallon. The Carolingian artist himself had imitated an Eastern model derived from the architecture of antiquity. It was through these intermediaries that the master of works at Avallon had come to know the twisted columns of antiquity. So it was that the decorative miniatures of the East, which had often imitated existing architecture, in turn inspired architects.

The somewhat unusual disposition of certain tympanums can also be explained as an imitation of Gospel canon tables. At Oloron, Morlaas, and San Vicente of Avila, we note that the great tympanum of the portal is divided into two smaller tympanums by two half-circles. These inner divisions lend richness to the tympanum, but they take away its majestic unity. Such a conception seems unarchitectural, and indeed it seems likely that the master of works was imitating what he had seen in certain manuscripts. From earliest times, the Syrian miniaturists had had the notion of enclosing two smaller arches in the large arch of their Gospel canon pages. The Gospel-book at Echmiadzin in Armedia offers an example of this combination;[87] Byzantine manuscripts perpetuated it.[88]

We should perhaps go still further. The very idea of carving sacred personages on a tympanum may have come to our artists from certain manuscripts illuminated with splendid porticoes whose round arches were filled with scenes and figures. In the half-circle surmounting a portico, Carolingian manuscripts sometimes show a standing Christ or a Fountain of Life:[89] we could be looking at the first sketch of a Romanesque portal. No doubt the Carolingian miniaturists were inspired by Eastern models, for it is more than probable that tympanums decorated with scenes and figures were to be seen in Syrian manuscripts. And perhaps it was from these manuscripts that the Christians of Egypt took the idea of carving scenes on the tympanums of their portals. The tympanum of an Egyptian church, now in the Berlin museum, dates from the sixth or seventh century; there we see Christ between an abbot and a saint whom he crowns.[90] The idea was hardly born before it disappeared without leaving a trace. Five centuries were to pass before it was given shape again by the artists of southern France.

IX

Imitation of the miniature explains some characteristics of twelfth-century sculpture.

It is evident what a profound influence miniatures exercised on the monumental art of the early twelfth century. This is scarcely surprising, for as far back as the Carolingian period, carved ivories were under the constant influence of the miniature. Several ivories of the ninth century were for

long a complete puzzle to scholars; they suddenly became understandable after it was discovered that they reproduced the illustrations of a famous manuscript of the school of Reims, the Utrecht Psalter.

Let us examine, for example, the ivory in the Bibliothèque Nationale which is the cover of one of the beautiful books once belonging to Charles the Bald (fig. 40). There, beneath the image of God in Majesty, we see an angel seated on a bed and holding on his knees a tiny soul whom he defends against two attacking lions; below, soldiers armed with lances and arrows also seem to threaten the soul, who is shown as a child; lower still, men dig a ditch into which other men fall headfirst. Father Cahier saw in this mysterious scene an episode from the history of Julian the Apostate. But Paul Durand soon demonstrated that the sculptor had simply copied from the Utrecht Psalter, or a manuscript of the same family, the illustration of Psalm 57. The text has been rendered literally: "I slept troubled," says the Psalmist, "but God hath delivered my soul from the young of the lions and the sons of men, whose teeth are weapons and arrows. . . . They dug a pit before my face, and they are fallen into it."

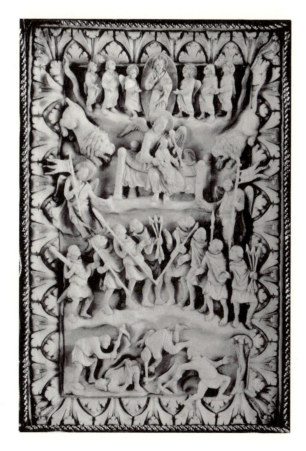

40. Soul of David protected by God (psalm 57). Ivory cover (front), Psalter of Charles the Bald. Paris, Bibl. Nat., ms. lat. 1152.

This discovery led to several others. Ivories in the Bibliothèque Nationale, the Zurich museum, and private collections, which until then had been inexplicable, were seen as carved transpositions of the subtle pages of the Utrecht Psalter.[91]

Better still, a more detailed study of Carolingian ivories revealed features that linked them closely with the great miniaturist schools of the ninth century. Along with the ivories that imitated the manuscripts of the Reims school, others were found to have been inspired by the school of Metz or by the Ada Gospels.[92]

This is not to say that Carolingian ivory carvers copied only miniatures; sometimes they copied Early Christian ivories that can easily be recognized behind the imitation. Nevertheless, miniatures remained their principal source of inspiration.[93]

This applies also to monumental sculpture in the twelfth century. Several details of our early sculpture—fabric clinging to the body, concentric pleats drawn on the chest and around the knees, and flaring drapery—can be explained only as imitations of the style of the miniature. The long ends of floating drapery that are nonetheless ordered in symmetrical folds are a legacy of Eastern miniaturists; sculptors imitated with the chisel the fine strokes of the quill. The imitation of miniatures is responsible for something tormented and calligraphic in twelfth-century sculpture. Sculpture in the Middle Ages was born complicated, and it took almost a century for it to become simple again.

The miniature, however, was not the only model. Sculptors borrowed the monsters for their capitals from the designs in Persian, Arabic, and Byzantine cloth, and it is possible that the textiles woven in Christian workshops helped to transmit to them the composition of the Gospel scenes. The ivories and the gold and silver altarpieces had their role in this spread of iconography. The terracotta plaques decorated with religious subjects and ornamentation, which from Merovingian times had served as friezes in the churches of Gaul, perpetuated the ancient traditions.[94] We might ask, too, whether the frescoes in Carolingian churches had not also sometimes served as models. The hypothesis seems likely but it cannot be verified, for the ancient paintings have disappeared.

If our subject were the study of form in art and not of the thought expressed, it would have to be pointed out that our first sculptors must have gone to the workshops where ivories were carved and metal altarpieces chased in order to learn the technique of relief, which is nonexistent in the miniature. It would also have to be observed that in certain somewhat backward schools of sculpture, such as those of Provence and the Rhone Valley, which were born among the remains of antiquity, Gallo-Roman models were used. This is why we more rarely find in the reliefs

of these regions the sinuous and fluid lines of the sculpture of Languedoc and Burgundy, where the influence of the miniature is so clearly apparent.

But our subject is iconography, and it is above all in the miniature that the origins of twelfth-century iconography are revealed. Miniatures played a leading role in transmitting religious themes to the artists of the time; miniatures also suggested to them elegance of line and delicacy of carving. It was not, however, in manuscripts that the sculptors discovered that monumental beauty and feeling for the sublime which burst from the portals of Moissac and Vézelay. Such moving grandeur of feeling could be the product only of their own genius.

II

The Complexity of Twelfth-Century
Iconography: Its Hellenistic, Syrian,
and Byzantine Origins

I

Twelfth-century iconography explained by
the miniatures of manuscripts.

The critical role of miniatures had first to be brought to light before the
study of twelfth-century iconography could be undertaken. The true
character of that iconography is now understandable. Sculptors found in
manuscripts both the secret of line and the repository of tradition; that
is, the sacred types and the composition of the religious scenes. Later we
shall discuss what the Romanesque artists invented—and their share of
invention is large enough that we need not conceal their borrowings—
but we must first know what they took from the past. For the most part,
the composition of the great Gospel scenes, as they represented them,
was not their own. They simply reproduced the scenes as they saw them
in manuscripts. If all the illuminated manuscripts of such abbeys as Mois-
sac, St.-Gilles, Cluny, and Vézelay had been faithfully preserved, we
should no doubt find in them the prototypes of many twelfth-century
reliefs.

These manuscripts were undoubtedly from different periods and places:
some could have come from the Near East and have belonged to the
Early Christian era; others were Carolingian, and still others, more re-
cent, would nonetheless have perpetuated ancient models. It was from
these manuscripts of all periods that twelfth-century artists, whether
painters or sculptors, took their material. The result is something quite
extraordinary; twelfth-century iconography is filled with oddities, in-
consistencies, and contradictions. Works that are almost contemporary
seem to be separated by several centuries. For instance, in the ambulatory
of the choir of St.-Sernin at Toulouse, there is a Christ seated in majesty
(fig. 41); he is beardless, like the Christ of the catacombs, of the sarcoph-
agi, and of the first Christian ivories. And here on the south tympanum

of the same church of St.-Sernin is a Christ with a curling beard (fig. 42). These two figures of Christ, so different from each other, are separated by only a few years.[1]

There was nothing unified about the iconography of the time, and at every turn we are surprised to find the same scene represented in two completely different ways. A capital in the cloister of St.-Trophime at Arles shows the Virgin peacefully seated and spinning the purple wool when the angel of the Annunciation appears before her; but in the tympanum of La Charité-sur-Loire, the Virgin has risen to stand motionless and listening before the angel. Should credit for these variations be attributed to the Romanesque artist who carved them? Not when we find that in certain manuscripts the Virgin of the Annunciation is seated, and in others standing. There were in fact two traditions for representing this scene, and they can be traced back century by century to the first period of Christian art. Romanesque artists followed sometimes one tradition and sometimes the other, according to the manuscript that inspired them. As a result, we can sense behind most Romanesque relief sculptures a world of Early Christian thought and many centuries of art. This long past confers on them a particular majesty. Hence, our first task must be to search out the archetypes and to show what twelfth-century sculptors owe to them.

II

The task is certainly not an easy one. It would have been impossible in the last century, but the problem of the origins of Christian art has become infinitely clearer in the last forty years. A great many hypotheses still surround the few certainties; nevertheless, the main lines of the subject —one of the most absorbing in history—are beginning to take shape.

We shall review briefly what is known and also what we think can be surmised.

A fundamental and now undeniable fact is that in the fourth, fifth, and sixth centuries there were two kinds of Christian art: the Christian art of the great Greek cities of the East, Alexandria, Antioch, Ephesus, and the Christian art of Jerusalem and the Syrian regions. Each of these had its own character, its consecrated types, its traditions. They first developed independently of each other, then drew closer, and out of their mutual borrowings, created composite types. However, for a long time each retained something of its own distinct character, since the two strains can still be recognized in the art of the twelfth century.

The Christian art of the Greek cities of the East, insofar as we can recognize it today, bears the stamp of the Hellenic genius. Like the Greek

Dual iconography of the Early Christian era. Hellenistic iconography. The art of the catacombs. The Greek spirit in Christian Hellenistic art. The type of Christ.

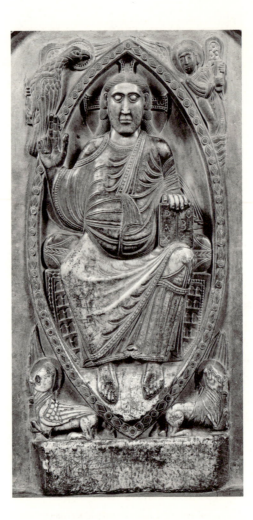

41. Christ in Majesty. Toulouse
(Haute-Garonne), St.-Sernin.
Relief in ambulatory.

art of the period of Alexander's successors, and by a now accepted misuse of language, it is called Hellenistic, a convenient term which has the merit of pointing to all that persists of the Greek spirit in early Christian art.

It is no surprise to find that Christian art was born in the great cities laid out in formal symmetry by Alexander and his successors when we know what role the Greek Near East played in the history of Christianity. It was in the East that Christian theology was elaborated, that the first heresies appeared, that the great councils assembled, and that monastic life was born. The role of Rome seems pale beside that of Alexandria or of Antioch. Even before Constantinople was founded, the center of the world had shifted; the East had once more become the productive part of the antique world. In the cities of Asia Minor and Egypt, where so many races were mingled, the Greek spirit remained alive. This prodigious genius, which seemed to have created all and exhausted all, was still inventive. It appears increasingly evident that the first Christian art was its work.

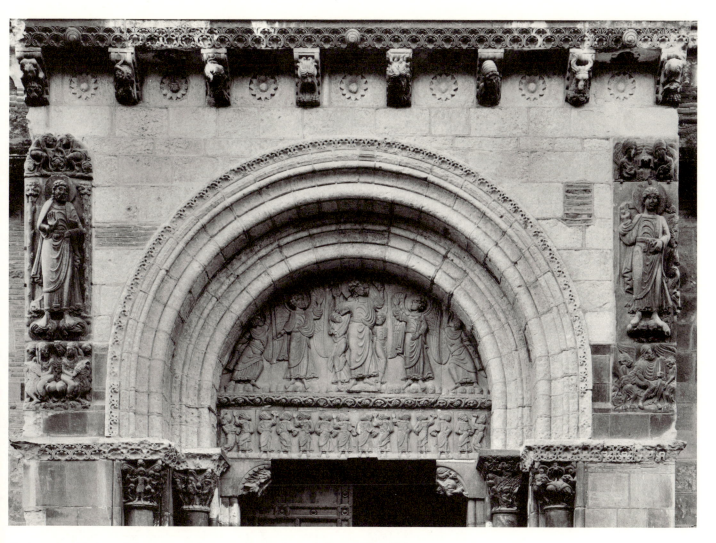

42. Ascension. Toulouse (Haute-Garonne), St.-Sernin. South portal (Porte Miègeville),
tympanum and lintel.

It is now thought that the art of the catacombs was created by Eastern Greeks. This is a funerary art; the paintings to be made out in the lamplight are all supplications for the souls of the dead. Like the art of ancient Egypt, the art of the new world began in the darkness of tombs and was born of the hope of immortality. Death was the first inspirer of the great religious peoples. A prayer recited in the early Christian communities for the souls of the dead gives unity to scenes as seemingly disparate as those decorating the underground chambers: the Raising of Lazarus, the Healing of the Paralytic, the Young Hebrews in the Furnace, Daniel in the Lions' Den, Susanna and the Elders, Jonah Swallowed by the Whale. Here are the principal lines of this prayer for the dead: "Father, deliver his soul as thou hast delivered Jonah from the sea monster, the young Hebrews from the furnace, Daniel from the lions' den, Susanna from the hands of the elders. . . ." Then the prayer addresses the Son: "I pray Thee, also, Son of God, who hast wrought such miracles, who hast opened the eyes of the blind and the ears of the deaf, healed the paralytic, brought Lazarus back from the dead. . . ." The most interesting thing about this prayer is its date. We know that it was composed in the East, and at the end of the second century by St. Cyprian of Antioch.[2] It is completely Eastern, so Eastern that the first part addressed to God the Father is the very same prayer recited by the Jews in their synagogues on fast days. This being the case, there is reason to believe that the scenes painted on the walls of the Roman catacombs had been represented first in the East. The catacombs of Antioch have unfortunately disappeared without leaving a trace; those of Alexandria have scarcely been glimpsed; but the paintings discovered in Egypt in the necropolis of El Bagawat, in the great Kharga oasis deep in the Libyan desert, seem to prove that the subjects long thought to be of Roman origin are really indigenous to the East.[3]

Were the art of the catacombs the subject of our study, it would not be difficult to point out the purely Greek character of a great many of its details. Jonah's whale resembles the monster of Andromeda; Noah's ark is like the singular square chest on the coins of Apamea;[4] Christ is not dressed in the Roman toga but in the Greek himation. We recognize the Greek imagination in the figure of this Christ represented as an Orpheus charming the wild beasts with the harmonies of his lyre. And we recognize it above all in the figure of the Good Shepherd who, like the Hermes Criophorus,[5] carries the lamb on his shoulders. This delightful image might illustrate an idyll of Theocritus, but in the catacombs it is bathed in another atmosphere. The graceful Greek spirit is united with the mystical poetry of the Shepherd of Hermas and the Vision of St. Perpetua.[6] There is nothing more beguiling than this union of the beauty

of Greek antiquity and the Christian genius. The faded outlines in the catacombs, which today seem to float like a dream about to vanish, have an inexpressible charm for us, for nothing conveys better a sense of the innocence, purity, and sweetness of early Christianity than these few touches of color half effaced by time.

As long as the era of persecution lasted, Christian art retained its funerary character; it became a narrative art only after the Peace of the Church. In the fourth, fifth, and sixth centuries, the narrative works devoted to the Old and New Testaments multiplied. It was then that the great Greek cities of the East were particularly creative. We do not know the paintings that must have decorated the churches of Alexandria, Antioch, and Ephesus, but the Christian sarcophagi of Rome and Arles preserve many features of Hellenistic iconography (fig. 43). Contrary to what was long thought, the art of sarcophagi is no more Roman than the art of the catacombs. Today we recognize in it, and rightly, the art of the Greek East. The reliefs of the sarcophagi, in fact, are often conceived like the beautiful ivories carved in the fifth and sixth centuries, almost all of which, as we now know, came from Alexandria and Antioch. It is impossible to imagine anything more closely related to the art of sarcophagi than the ivory coffer of the Brescia museum, in all likelihood carved at Antioch. Other works, such as the Trivulzio ivory, the Munich ivory, the pyxes of Bologna and Berlin, etc., carved either at Antioch or Alexandria, complete our knowledge of Hellenistic iconography.[7]

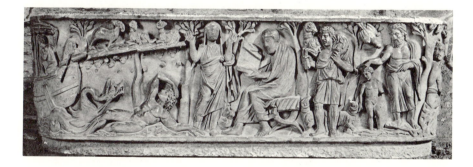

43. Old and New Testament scenes. Jonah sarcophagus. Rome, Sta. Maria Antiqua.

Some manuscripts with miniatures, illuminated in the sixth century or in the following centuries but copied from earlier originals, add much to what the sarcophagi and ivories teach us. The Vienna Genesis, the Joshua Roll of the Vatican, and the famous Psalter in the Bibliothèque Nationale show us the Greek conception of Old Testament illustration.[8]

This art of the Eastern Greeks was still completely imbued with the Hellenistic spirit of antiquity. What the Greeks saw in the Gospel was its luminous rather than its sorrowful side. When they represented the

Passion on sarcophagi, they showed neither the humiliation nor the suffering. The crown of thorns held above Christ's head by a soldier resembles a triumphal crown; before his judges and his torturers, Christ retains the resolute attitude of a hero of antiquity or a Stoic sage.

The Greek artists remained pagan in imagination even though they had become Christian, and continued to people the world with nymphs and gods. Beside Christ baptized by St. John, they show the god of the Jordan crowned with water leaves.[9] After the Hebrews have crossed the Red Sea, βυθός, the genius of the deep, rises up from the depths, seizes Pharaoh by the hair, and drags him down into the abyss.[10] They give David as a companion the muse Melodia, who seems to dictate his Psalms to him; a mountain god, reclining lazily, listens to the poet's lyre while Echo shows her young face beside the fountain (fig. 44).[11] They represent Isaiah standing between a goddess in a dark veil, who is Night, and a child carrying a torch, who is Dawn.[12] This beautiful image signifies that the prophet's inspiration came at the mysterious moment when the light first begins to dispel the darkness. The figure of Night, with a blue veil

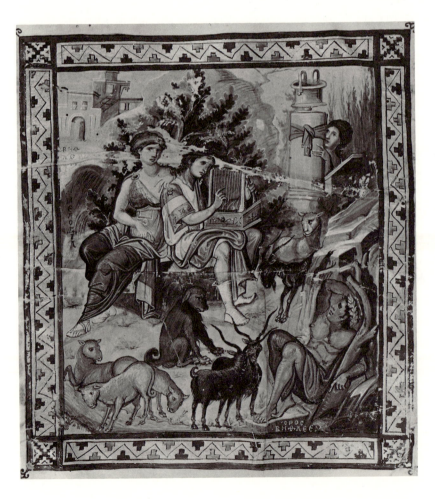

44. David as harpist. The Paris Psalter.
Paris, Bibl. Nat.,
ms. gr. 139, fol. IV.

sown with stars floating above her haloed head, is as magnificent as a verse of Homer. It is wonderful to find the Greeks always true to themselves. The Homeric turn of imagination that had persisted after several centuries of Christianity gives infinite charm to the art they created but, to tell the truth, it diminishes it. The Arcadia they show us peopled with nymphs cannot be the imposing world of the Bible—those vast solitudes brushed by the shadow of God. Christian Hellenistic art did not possess the secret of grandeur. Leafing through the Vienna Genesis, a work created by the Alexandrian genius, we find there a last reminder of the pleasing grace of the paintings at Herculaneum, but not the sublimity of the Bible. The Greeks had greater feeling for the New Testament; they rendered its sweetness well, but its majesty seems to have eluded them altogether.

Nothing is better proof of this than their conception of the type of Christ. The Christ of the Greeks is not a man thirty years old, but a beardless youth, almost an adolescent. The Greeks of Asia Minor and Antioch give him long hair, the Greeks of Alexandria short hair, but both endow him with the charm of youth. It is a touching conception, and shows how the Greeks imagined Christ after they had read the Gospels. For them, he was a young master whose charm was irresistible, a poet who was all beauty, eloquence, and gentleness. But the majesty of God is lacking in this beautiful figure. To convey that it was not a man, the Greeks were obliged to place around his head the circular nimbus which they had sometimes given to their divinities—the nimbus they also gave to Buddha when they carved the first statues of him in India.[13]

III

While the Greeks in the cities of the Near East were creating a Christian art in their own image, another art was coming into being at Jerusalem.

The discovery of the Holy Sepulcher and the True Cross in 326 must be considered as one of the great events in the history of Christianity; it was seen as a genuine miracle. Constantine immediately had magnificent monuments built on the site of rediscovered Calvary.

First, there was the Rotunda of the Anastasis or Resurrection, which enclosed the Holy Sepulcher. It had the circular form of antique tombs, but its splendor was a reminder that it was not so much a funerary as a triumphal monument, τὰ τρόπαια, commemorating the victory of Christ over death. Facing the Rotunda, on the very spot where St. Helena was said to have discovered the cross, a great basilica, the Martyrium, was built. Between the two edifices, on the exact place where the cross had been planted—the sacred spot regarded as the center of the world—a great cross was erected, encased in gold and decorated with precious stones.

Syrian iconography. The Jerusalem mosaics and the ampullae of Monza. Syrian influences in manuscripts and frescoes. Characteristics of Syrian iconography. Ethnic traits. Pilgrimage souvenirs. Theological grandeur. Composite works.

This most ignominious instrument of torture, the slaves' gallows which Christians had not yet dared to represent, appeared transfigured, radiant with glory. The cross thenceforth became a part of artistic tradition.

Porticoes formed an enclosure around these imposing monuments. They had scarcely been finished when countless pilgrims from the remotest parts of the Roman world flocked to Jerusalem.[14] It was not enough for them to venerate the Holy Sepulcher; they visited all of the places consecrated by the Gospels, and everywhere they found magnificent basilicas. There was one on the Mount of Olives, where tradition located the Ascension. There was another on Mount Zion; this was the Cenacle, the place of the Last Supper and of the Descent of the Holy Ghost, which had been transformed into a church. There was a basilica at Bethlehem, another at Nazareth, and another on the banks of the Jordan to commemorate the baptism of Christ.

All of these buildings were decorated with mosaics. Some of the mosaics undoubtedly dated from the time of Constantine, but others could have been the work of succeeding centuries. By the end of the sixth century, in any case, the series had been completed, for we find them reproduced on the ampullae of Monza.[15] These famous silver ampullae decorated with Gospel scenes were presented in about 600 to Theodelinda, queen of the Lombards; they contained some oil from the lamps that burned in the sanctuaries of the Holy Land. Scholars now agree that the Gospel scenes engraved on these ampullae reproduce the mosaics of the Palestinian basilicas.[16] Consequently, the Monza ampullae, which were long considered to be mere objects of curiosity, have in recent years become monuments of the utmost interest;[17] it is through them, in fact, that we know the great Christian art of Jerusalem and the Holy Land, which differs in so many ways from the art of the Hellenistic cities. True, the originals were not always scrupulously copied by the silversmiths. Sometimes two ampullae representing the same mosaic present variants, which means that the artist had taken liberties with his model. However, the main lines of the subject are fixed; certain secondary details may elude us, but we know the essential.

We can be completely certain that the Adoration of the Magi decorated the façade of the church at Bethlehem. Other evidence indicates that the Annunciation and the Visitation were to be seen in Nazareth. The scene of the Nativity probably decorated the grotto which served as the crypt of the church of Bethlehem; it was there, according to tradition, that Christ was born. The Baptism of Christ probably decorated the church on the banks of the Jordan; the Visit of the Holy Women to the Tomb, the Rotunda of the Anastasis; the Ascension, the church of the Mount of Olives; the Descent of the Holy Ghost, the Cenacle of Mount Zion which had been transformed into a church.

Thus, the ampullae of Monza reflect Syrian art at its origins; other monuments record its diffusion.

In the sixth century, the monasteries of Mesopotamia, which had sprung up along the borders of the Christian world, practiced an art that was closely akin to that of Palestine. This is proved by the miniatures of the Gospel-book in Florence, illuminated in 586 at Zagba on the Euphrates by the monk Rabula.[18] The manuscript at Echmiadzin in Armenia[19] and those of Rossano[20] and Sinope[21] testify to the same Palestinian influences. Throughout the East, the monks seem to have adopted the stern art of Jerusalem, already marked by the stamp of theology. The monasteries discovered several years ago in Egypt—Bawit and Saqqara—have frescoes from the sixth century that are completely Syrian in inspiration. Thus, in monastic Egypt the art of Jerusalem supplants the Hellenistic art of Alexandria. Even more recently, some astonishing series of frescoes, painted over a period of years from the ninth to the thirteenth century, were discovered in Cappadocia.[22] They decorated the chapels hewn in the mountainsides by colonies of Basilian monks. They are to be found in the vicinity of Caesarea in Cappadocia, a volcanic, desert landscape where fire still spurted from the earth in Strabo's time—a land whose wild solitude was as appealing to the monks as the deserts of Egypt. The study of these Cappadocian frescoes reveals an iconography that time has enriched but which remains Syrian in origin.[23]

What are the characteristics that distinguish this Syrian art from Hellenistic art?

Created in the very land where the Gospel stories had taken place, the art of Jerusalem had the ring of actuality. Christ appeared under an entirely new aspect: he was not a Greek adolescent; he was a Syrian in all the vigor of manhood, with black beard and long hair. For the first time, Christ appeared as a type of his own race; until then, he had been endowed only with grace; henceforth he was to have a masculine strength and majesty.

Hellenistic art had given the Virgin the tunic, the style of hair, and sometimes even the earrings of the great ladies of Alexandria and Antioch;[24] the art of Jerusalem clothed her in the long veil worn by Syrian women, the maphorion, which hid her hair and lent a modest grace to her silhouette.[25] The Virgin of the mosaics resembled the girls who climbed the steep streets of Zion. The artists of the time quite naturally gave to Christian art the Oriental color that present-day artists try to recover at the cost of so much artifice.

This sense of actuality, this local accent are always present in Syrian art. We must not forget that the art of Palestine was a commemorative art, its purpose to eternalize for numberless generations of pilgrims the events of the Gospel at the very places where they had occurred. It was an art

created for pilgrims; it assimilated the recollections and even the legends that held such charm for them. This is why the artists placed the scene of the Nativity in the famous grotto of Bethlehem, where tradition claimed Christ had been born. In the scene of the Annunciation to the Shepherds, they showed the tower that was pointed out to pious travelers at the spot where the angel had appeared.[26] Near Christ baptized by St. John, they represented a cross in the middle of the Jordan; it was the very cross that had been planted in the river to indicate to pilgrims the actual place of the baptism.[27] In the scene of the Holy Women at the Tomb, the sepulcher was given the strange form of a kind of little temple supported by columns; this was the tugurium which marked the site of the tomb in Constantine's Rotunda.

But even more striking in the art of Palestine is a sense of majesty never attained by Hellenistic art. The mosaicists of the Holy Land represented the scenes from the life of Christ with a solemnity hitherto unknown. For them, the Gospels were not just a moving story; they had already become a series of dogmas defined by the councils of the Church. In the mediocre copies on the ampullae of Monza, we glimpse the imposing symmetry of the originals: there is already something hieratic in this art. In the scene of the Ascension, Christ rises to heaven in an aureole carried by angels. We begin to sense in these representations of the Gospel the workings of mystical thought: an angel standing on the banks of the Jordan witnesses the baptism of Christ and unites heaven and earth. But the figure of greatest mystery and grandeur is the Virgin: she is seated full-face on a throne and holds the Child exactly at the center of her breast; the magi are at her right and the shepherds at her left. Never had a queen more majesty. Here we witness the creation of the magnificent type of sovereign Virgin who would soon reappear in the mosaics of S. Apollinare Nuovo at Ravenna, in the frescoes of S. Maria Antiqua at Rome,[28] and later, on the portals of our twelfth-century churches. It seems to me unlikely that the original of the Monza ampulla—that is, the mosaic on the façade of the Bethlehem church where the Virgin was represented in this way—could have been conceived before the Council of Ephesus. It was the Council of Ephesus, in fact, that in 431 proclaimed the divine motherhood of Mary. Nestorius had insisted that she was the mother of Christ only, that is, of the man; the Council ruled that she was at the same time the mother of the man and the mother of God, the Theotokos. Eastern thinking was henceforth to cling to these words of superhuman grandeur: "Mother of God." So this young Nazarene girl had carried in her womb one whom the world could not contain; how then was her majesty to be expressed? The Jerusalem artists imagined her as the queen of created beings, and set her on a throne.

Such are the main characteristics of Palestinian art, which contrasts so sharply with Hellenistic art.

In the sixth century, however, the two arts began to merge. There are works such as the famous ivory throne of Maximian at Ravenna, carved in all likelihood at Alexandria, where the traditions of Christian Greece meet those of Syria.[29] The mixture of Hellenistic and Palestinian iconography also characterizes the carved doors of S. Sabina at Rome and the mosaics of the Life of Christ at S. Apollinare Nuovo at Ravenna: both the beardless Christ of the Greeks and the full-bearded Christ of the East are to be found there. Only rarely did the late works created by the Greek cities remain perfectly pure. As time goes on, the increasing influence of the art of Jerusalem makes itself felt. However, the Hellenistic tradition persisted for a long time, since it can still be identified, as we shall see, in works created at the height of the Middle Ages.

IV

Having outlined the main characteristics of the two schools of art that divided the East, we must now come down to details. We shall study briefly some of the great Gospel scenes, pointing out the Hellenistic and the Syrian formulas, and then we shall show what our twelfth-century artists owed to each.

The Greeks' conception of the Annunciation is one of noble simplicity. The Virgin is seated when the angel appears before her; when she hears his words she remains motionless, incapable of rising, as if her great mission were weighing her down.

A fresco in the catacombs of Priscilla gives us the Hellenistic formula at its origin. A little later, the Virgin is represented as holding or dropping the spindle on which she winds the purple thread, for the apocryphal Gospels make her out to have been working on the veil of the temple when the angel appeared to her. A sarcophagus at Ravenna of an almost classical style, a textile from the Lateran (fig. 45),[30] and ivories from Alexandria represent her in this way.[31]

The Syrian formula is quite different. It appears on one of the ampullae of Monza, which probably reproduces the mosaic of the Nazareth church (fig. 63). When God's envoy appears, the Virgin, who had been seated, rises, and by rising seems to assent to the divine message. In the Greek formula, she appeared passive; here, she expresses her willingness to participate in the salvation of mankind; the idea is more profound.

We can trace the spread of this Annunciation scene in the East as far back as the sixth century. Syrian manuscripts (fig. 46) and the frescoes of Cappadocia show the Virgin standing in the presence of the angel.[32]

The Hellenistic and Syrian formulas for the Annunciation scene. Both found in French art. The dual formulas for the Visitation. For the Nativity. For the Adoration of the Magi. The Journey of the Magi and its Eastern origins. The dual formulas for the Baptism of Christ. For the Entry into Jerusalem. For the Washing of Feet. The Apostles Removing Their Shoes. The dual formulas for the Crucifixion. Combination of the two formulas. Christ Dead on the Cross. The Holy Women at the Tomb. The form of the tomb in Hellenistic and Syrian art. The dual formulas for the Ascension.

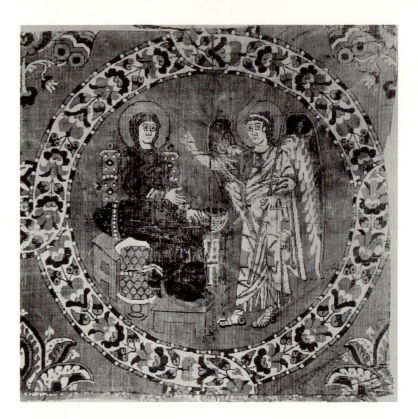

45. Annunciation. Byzantine woven silk
(detail). Vatican, Museo Sacro.

46. Annunciation. Gospel-book.
Paris, Bibl. Nat., ms. syr. 33,
fols. 4r and 3v.

In the monumental art of twelfth-century France, the Hellenistic and the Syrian formulas coexist, for manuscripts had perpetuated both.[33] We now understand why our twelfth-century artists sometimes represented the Virgin of the Annunciation standing and sometimes seated. She is seated in the scene on the capital of St.-Martin d'Ainay at Lyon (fig. 47),[34] on the capital at Lubersac (Corrèze), on the capital of the façade of St.-Trophime at Arles as well as on a capital of the cloister. But she is standing in the twelfth-century stained-glass window at Chartres Cathedral (fig. 48), on a capital at Gargilesse (Indre), on the portal of La Charité-sur-Loire (fig. 112), and in the beautiful group now in the museum at Toulouse.[35]

The artists were simply inspired by whatever models chance provided. Their imitation is very exact, for on the Arles capital the Virgin holds in her hand the skein of wool and the spindle shown in the ancient monuments of Hellenistic art. If one wished to go into detail, it would be easy to demonstrate that in our twelfth-century art the attitude of the angel, who raises his right hand like an orator of antiquity and carries in his left the herald's staff, and the Virgin's gesture of opening her hand against her breast, are faithfully imitated from the earliest models of antiquity.

The Visitation was represented in Hellenistic art as early as the fifth century, as is proven by the Ravenna sarcophagus, whose Annunciation

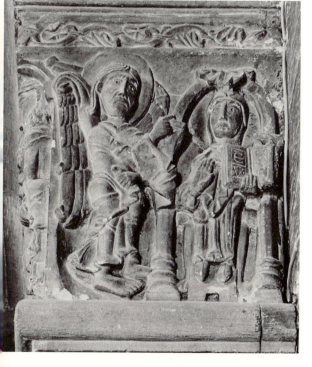

47. Annunciation. Lyons (Rhône), Abbey Church of St.-Martin d'Ainay. Choir capital.

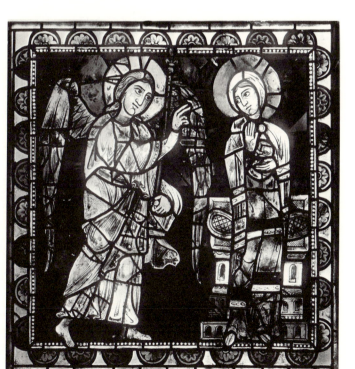

48. Annunciation. Chartres (Eure-et-Loir), Cathedral of Notre-Dame. West façade, panel of the central window.

scene we have already seen. The two women advance to meet each other, both as grave as tomb figures; they retain that nobility of attitude and that reserve of feeling which always characterize Greek art.

Syrian art, on the other hand, is here passionate and dramatic, and display of emotion is in contrast to the restraint of Greek art. A Monza ampulla, which probably reproduces a mosaic at Nazareth, shows the two women throwing themselves into each other's arms and embracing tenderly (fig. 63). The frescoes of Cappadocia prove that this was indeed the Syrian formula.[36]

Christian art was early divided between these two formulas, in the sixth century. In the basilica of Parenzo in Istria, where in spite of profound Syrian influences the mosaics preserve the Hellenistic form of the Visitation: the two women stand facing each other and make a simple gesture of the hand.[37]

On the other hand, in the manuscript of St. Gregory of Nazianzus in the Bibliothèque Nationale,[38] where Hellenistic influences are often striking, the Visitation is completely Syrian: St. Elizabeth clasps the Virgin in her arms and brings the other's face close to her own.

Twelfth-century French artists were also divided between the two traditions imparted to them by the miniaturists. The Hellenistic formula was adopted by the sculptor of the porch at Moissac (fig. 57), by the sculptor of one of the Vézelay portals (fig. 54), and by the stained-glass artist of Chartres (fig. 49): in these examples, the two women stand facing each other, grave and restrained.

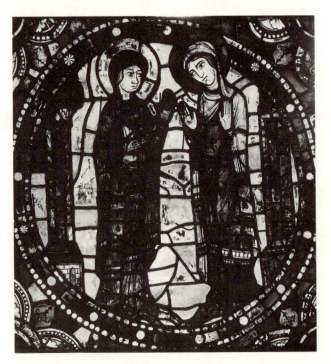

49. Visitation. Chartres (Eure-et-Loir), Cathedral of Notre-Dame. West façade, panel of the central window.

In contrast, we recognize the Syrian formula in the embracing women on the capital of the triforium of St.-Benoît-sur-Loire, on the portal of St.-Gabriel near Tarascon, on the capital of the cloister at Arles, the capital at Die (Drôme) (fig. 50), and the reliefs of La Trinité at Fécamp.[39]

Like the Annunciation and the Visitation, the Nativity appeared from the beginning in both its Hellenistic and its Syrian forms.

A fourth-century sarcophagus, now in the Lateran museum, shows the Hellenistic formula in all its charm (fig. 51). It could be an illustration of an Alexandrian idyll. The Child, in a rush cradle, lies beneath a light roof supported by rustic poles and covered with tiles like those of the temples; the ox and the ass warm the newborn child with their breath; a shepherd out of Theocritus approaches, a crook in his hand; the magi come forward from the other side; the Virgin, seated slightly apart on a rock, resembles a veiled Demeter. The work certainly dates from the first half of the fourth century, for the Adoration of the Magi is here still a part of the Nativity scene—a detail that takes us back to the time when the two feasts were celebrated on the same day. It was only after 354 that they were separated. The Nativity, whch had been celebrated on 6 January along with the Adoration of the Magi, was then assigned to 25 December.[40]

From this time on, the sarcophagi and ivories of Antioch and Alexandria reproduce the Greek formula of the Nativity.[41] There are several variants, but all the works have a common characteristic: the Virgin is always seated. The Greeks sought in this way to express the miraculous side of

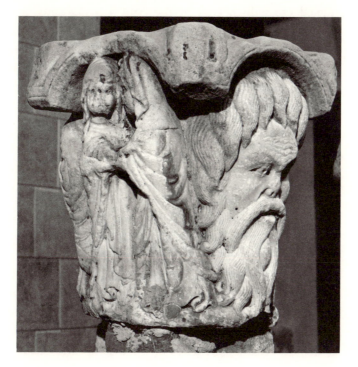

50. Visitation. Capital from the Cathedral. Die (Drôme), Musée Municipal.

the nativity: when we see the Virgin peacefully seated after giving birth, we understand that she has not brought forth a child in sorrow, as other women do. Curiously enough, this beautiful composition with its great charm and great nobility did not last long, even in the East.[42] It did not survive into the Middle Ages.

The future, in fact, belonged to the Syrian formula of the Nativity. One of the Monza ampullae seems to offer it in its earliest form (fig. 63).[43] On it we see the Child lying in the crib between the two animals; the star shines above him; at the left, St. Joseph is seated in thought with his head resting on his hand; at the right, the Virgin lies on a pallet, her head turned away, seemingly overcome by fatigue. What did the Palestinian artist mean to convey by depicting the Virgin reclining? A Greek commentator of the late twelfth century, Mesarites, explains it thus: "The Virgin presents the face of a woman who has just suffered, even though she has been spared the pain, so that the Incarnation might not be doubted."[44] Syrian art is therefore less lofty here than the Greek, but it is more careful to convince. Also, in this figure of a woman apparently overcome with fatigue there was something sorrowful and tender that touched the heart. It never occurred to the East that this suffering Virgin did not exactly conform to dogma.

The Monza ampulla probably reproduces the mosaic in the grotto of Bethlehem. The mosaic could have dated from the time of Constantine. Soon we find the scene, still quite simple (fig. 52),[45] enriched by new episodes that could have been conceived only in Palestine. On the enameled cross discovered in the Sancta Sanctorum of the Lateran (fig. 53),[46] which is probably from the sixth century, there are two new figures near the reclining Virgin and the seated St. Joseph: two women are busy washing the Child in a basin. These are the two midwives mentioned by the apocryphal Gospels, even though these stories nowhere say that the midwives washed the Child after his birth. But here, oral tradition filled out the silence of the books. The pilgrims to the Holy Land were told many things that had not been written down. At Bethlehem, they were told of the Child's bath and were even shown the stone near the grotto of the Nativity over which the bath water had been poured.[47] The explanation is that in Palestine the episode of the Child's bath had in time been added to the story of the Nativity in order to satisfy pilgrim piety. The addition soon became an inseparable part of the Nativity scene.

At a time not precisely known but which must have been very early, artists placed the scene of the Nativity inside a cave, the famous grotto of Bethlehem (cf. fig. 52).[48] Palestine thus contributed even the picturesque frame for the scene. In the eleventh-century Byzantine miniatures, a slice seems to have been cut in the mountain to show what is going on within its depths. All the characters of the drama—the Child lying between the

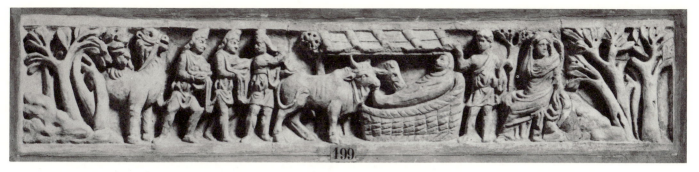

199

51. Nativity and Adoration of the Magi. Sarcophagus lid. Vatican, Pontifici Musei Lateranensi.

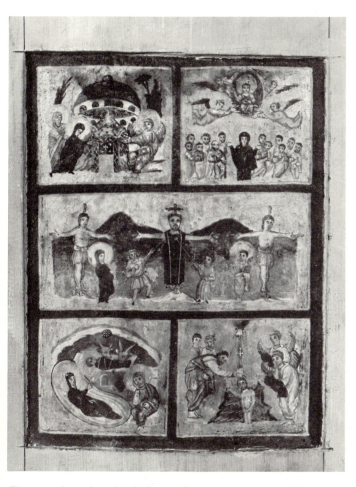

52. Scenes from the Life of Christ. Reliquary cover.
Vatican, Museo Sacro.

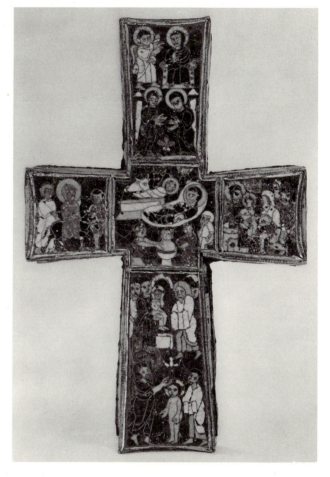

53. Scenes from the Infancy of Christ. Cloisonné cross.
Vatican, Museo Sacro.

animals, the Virgin reclining on a bed, St. Joseph seated, the midwives bathing the Child—are grouped together in the cavern that opens to our view. The rays of the star descend into the shadows and illuminate them. Outside, the angels stand on the mountain top, and we see the shepherds approaching from one side, and the magi appearing at the other.[49]

In this way the Eastern formula was enlarged and amplified until it reached its full flowering.

The composition conceived by the artists of Palestine was probably known early in the West, but the oldest existing example in France is from the Carolingian period. A magnificent initial letter in the Drogo Sacramentary encloses the figures of the Syrian Nativity: the Child lying in the crib, the Virgin reclining on her bed, St. Joseph seated, and the midwives bathing the Child.[50]

From this time on, the Syrian formula became customary in France. Artists sometimes reduced it to its simplest form. The twelfth-century frescoes discovered some years ago at Brinay (Cher) show only the Child in his crib, the Virgin reclining, and St. Joseph seated.[51] At times, sculptors were equally restrained, as shown by the capital of the chapter hall of St.-Caprais at Agen, and the exterior capital of the church of Ste.-Croix at Gannat (Allier).[52] But sometimes, too, the Child's bath was added to complete the scene. It is to be seen on a capital of the cloister of St.-Trophime at Arles, where a single midwife bathes the Child, and again on one of the twelfth-century capitals of the cathedral of Lyon; but there, the two women placed at each side of the basin reproduce even more faithfully the Eastern originals.[53]

In France, I know of only one attempt by our artists to imitate the fully developed Eastern formula.[54] On the south portal of the narthex of Vézelay, the sculptor wanted to represent the grotto seen in Byzantine miniatures (fig. 54). Into a narrow half-circle, he crowded the Child, the reclining Virgin, a midwife, and St. Joseph resting his head on his hand. Above the grotto there are angels, and at the left, the approaching shepherds. The model is easily recognized, but the copy is so condensed that it becomes almost unintelligible.

Without citing further examples, it can be affirmed that all French twelfth-century Nativity scenes derive through intermediaries from Syrian prototypes. In these Nativities, the reclining Virgin—that essential feature which is by itself a mark of origin—is never missing.

Only slight nuances distinguish the Hellenistic formula for the Adoration of the Magi from the Syrian one, and each had certainly borrowed from the other.

The pure Hellenistic formula is reproduced by a fresco from the catacombs of S. Callisto[55] and by the sarcophagi: the Virgin, seated in profile with a naturalness untouched by solemnity, holds the Child on her knees;

she seems to receive the visitors kindly, and the Child holds out his hands toward them. The three beardless magi approach, one behind the other, bearing their gifts. They are all alike; they wear mantles that flutter in the wind, tight trousers, and the Phrygian cap of the priests of Mithra, for the three mysterious travelers were supposed to have come from Persia. Nothing could be simpler or closer to folk art than this composition (fig. 55).

The Monza ampullae illustrate the Palestinian formula. However, these ampullae pose a problem, for they are not all exactly alike. Two of them contain rather notable variants. It may be supposed that they reproduce two different mosaics, both of which decorated sanctuaries in the Holy Land. But they both have a common feature, and it is in this above all that the Syrian formula differs from the Hellenistic: the Virgin is not seated in profile, but *full-face*. This, as already noted, is the image of the Virgin as Queen, the Theotokos, in all her majesty. The grandiose solemnity of the figure of the Virgin characterizes the Syrian Adoration of the Magi; the Mother and Child, wrapped in thought, look straight ahead and seem unaware of what is happening around them. As for the magi, they are almost identical with those conceived by the Greeks; they wear the same costume.[56] One of the Monza ampullae shows them one behind the other, as on the sarcophagi; the shepherds are arranged as their counterparts. On another ampulla, they are more artfully grouped and one of them kneels (fig. 56).

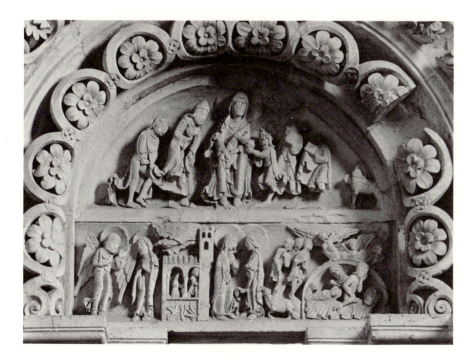

54. Annunciation; Visitation; Nativity; Adoration of the Magi. Vézelay (Yonne), Abbey Church of Ste.-Marie-Madeleine. Narthex, south portal, tympanum.

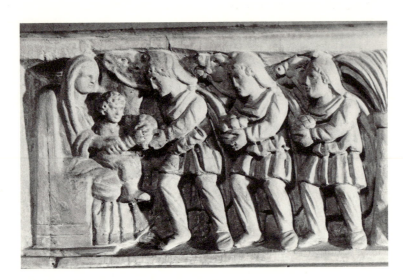

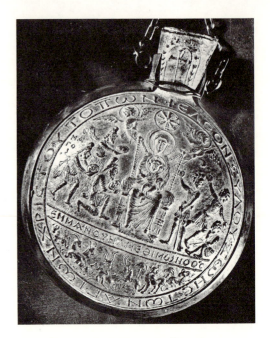

55. Adoration of the Magi. Sarcophagus lid (detail). Vatican, Pontifici Musei Lateranensi.

56. Adoration of the Magi. Ampulla. Monza, Treasury of the Collegiate of St. John.

A miniature of the Gospel-book of Echmiadzin[57] and two sixth-century ivories[58] introduce us to a composition very closely related to the last mentioned Monza ampulla but even more monumental. The magi, accompanied by an angel, are grouped at the Virgin's sides. Here, no doubt, we have a copy of another mosaic from Palestine, perhaps the very one which decorated the façade of the church at Bethlehem.[59] In these examples we note one completely Eastern detail, and one which, moreover, passed into Hellenistic art: the magi respectfully veil their hands when they present the gifts,[60] and we seem suddenly transported to the hieratic world of the East.

The two formulas, the Hellenistic and the Eastern, of the Adoration of the Magi meet in French twelfth-century art. The Hellenistic formula, with the Virgin in profile, comes to us through Carolingian art. The Drogo Sacramentary and an admirable ivory in the Bibliothèque Nationale show it in its pure form: the Virgin and Child, seated in profile, gaze at the visitors and make a welcoming gesture; the magi have kept their Mithraic dress, but, as in some of their models, their hands are veiled.

From Carolingian art the Hellenistic formula passed into the art of the eleventh century. In the Apocalypse of St.-Sever, the magi, standing one behind the other before the Virgin seated in profile, still wear tight trousers and are shown with veiled hands, as in ancient models.[61] This is why we find a faithful reproduction of the old arrangement on the

twelfth-century porch at Moissac. Only the costume of the magi is different: here they wear the long robe of the twelfth century and a king's crown (fig. 57).[62] The same formula appears on the portal of La Charité-sur-Loire: the Virgin and Child in profile welcome the three travelers with their eyes and their hands. We even see St. Joseph standing behind the Virgin's throne, as on certain sarcophagi in the Lateran and at Arles; but at La Charité, as at Moissac, the costume of the magi has been brought up-to-date (fig. 89).

The Syrian formula must have come to the West through the intermediary of Eastern manuscripts. A Syriac manuscript in the British Museum shows the magi advancing, one behind the other, toward the Virgin who is seated full-face, and who does not even glance at them;[63] this is the same arrangement as on one of the Monza ampullae. In France, an eleventh-century lectionary of St.-Bertin represents the Adoration of the Magi in the same way.[64] The Syrian formula also appears several times in French monumental art. On the north portal of the cathedral of Bourges, a work of the second part of the twelfth century, the Virgin and Child, seated full-face, stare straight ahead while the magi approach bearing their gifts (fig. 58).[65] If the Annunciation to the Shepherds were shown at the right, we would have an exact copy of one of the Palestinian mosaics in all its majesty. We may well believe that the French artist had no idea that his models had come from so remote a past. The portal of St.-Ours at Loches, where undoubtedly the hand of the artists of Bourges is to be recognized, reproduces the same arrangement.[66] In another region of France and from another school, a capital of the chapter house of St.-Caprais at Agen is conceived in the same way. The Virgin is full-face, and the first of the magi-kings, instead of standing, kneels as on one of the Monza ampullae.[67]

But along with the scene of the Adoration of the Magi in twelfth-century art, we frequently encounter episodes from their story that seem at first sight to be picturesque inventions of our own artists. Here they are on their journey; a fresco at Vic (Indre) shows them on horseback on the way to Bethlehem (fig. 59). These magi on horseback reappear on a capital of the cloister of St.-Etienne at Toulouse, now in the museum.[68] In a fresco at Brinay (Cher), the three horsemen point out the star to each other as they ride along.[69]

But there are other picturesque scenes. On the façade of St.-Trophime at Arles, the magi are brought before Herod; he is seated majestically like a feudal baron, with his great sword on his knees and his men-at-arms standing behind him. On the St. Anne Portal of Notre-Dame of Paris, he is accompanied not by a soldier but by two doctors of the Law; at his orders, they search the Scriptures for prophecies of the Messiah.[70]

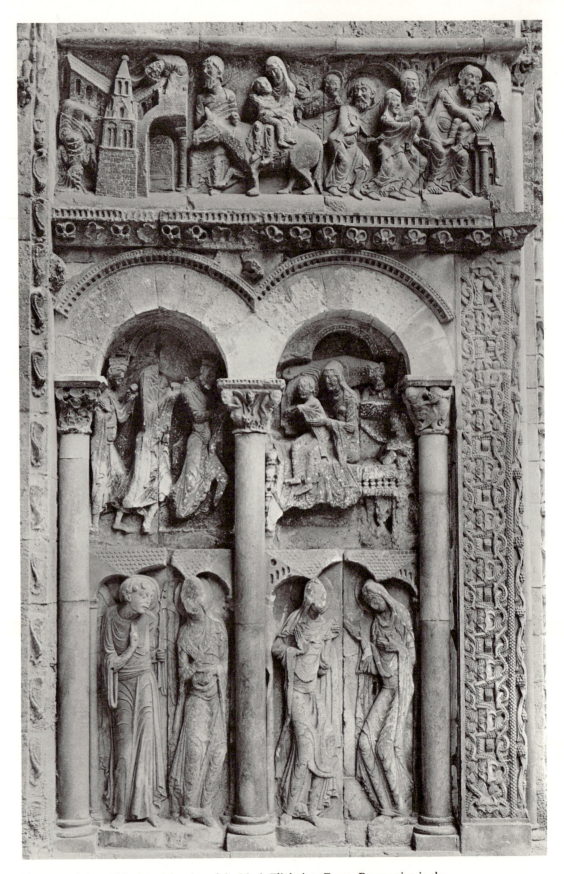

57. Annunciation; Visitation; Adoration of the Magi; Flight into Egypt; Presentation in the Temple. Moissac (Tarn-et-Garonne), Abbey Church of St.-Pierre. Porch, east wall.

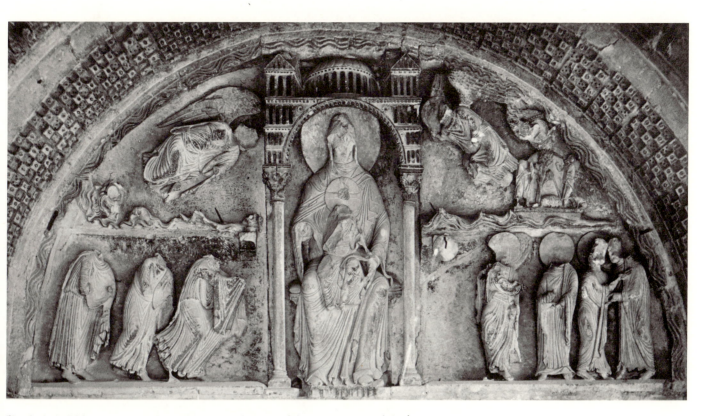

58. Virgin in Majesty; Annunciation; Visitation; Adoration of the Magi. Bourges (Cher), Cathedral of St.-Etienne. North portal, tympanum.

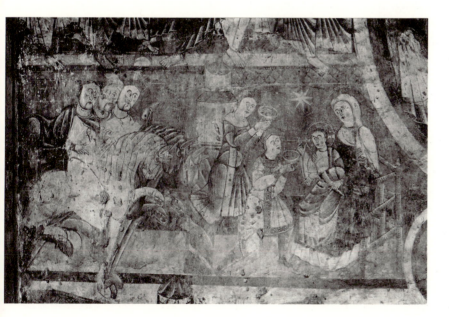

59. Adoration of the Magi.
Nohant-Vic (Indre), St.-Martin.
Fresco in the nave.

Furthermore, when the magi have presented their gifts to the Child, and their mission is fulfilled, they rest before resuming their long journey. A capital of the cathedral of Autun shows all three of them lying in one bed, asleep with their crowns on their heads like figures in a fairy tale; an angel leans over them to tell them not to pass by Herod on their return home (fig. 60).[71] We see this naïve group on the archivolts of the portal of Le Mans Cathedral, and again on the tympanum at Loches.[72]

At the orders of the angel, the magi set off again. At Brinay, they had come on horseback and they return on horseback.

Were all these very inventive scenes actually conceived by our artists? It might seem so were we not familiar with Eastern manuscripts.

The story of the magi was told very early and in full detail in the art of Palestine.[73] The original work has been lost, but scattered fragments are to be found in various manuscripts. In an eighth-century Syriac manuscript, which is a mediocre copy of a much earlier original, the mounted magi point out the star to each other.[74] In the beautiful tenth-century St. Gregory of Nazianzus, now in the Bibliothèque Nationale, the magi, sleeping side by side, are awakened by the angel (fig. 61).[75] In a Greek manuscript of the same century, the magi appear before Herod: an armed guard stands behind the throne and, farther back, the doctors of the Law unroll the book of prophecy.[76] In an eleventh-century Greek manuscript at Florence, the magi arrive on horseback, adore the Child, and then return on horseback.[77]

So we find in Eastern manuscripts the various episodes from the story of the magi that we were tempted to think were invented by our artists. Even though certain of these manuscripts date only from the eleventh century, it can be said with assurance that the originals that inspired them date from a far earlier period, for they had already been reproduced in Carolingian manuscripts and ivories. In the Drogo Sacramentary, the magi travel on horseback and appear before Herod (fig. 62);[78] in an ivory at Frankfort and another at Lyons, the magi, all asleep in the same bed, are awakened by the angel, and then depart on horseback as they had come.[79]

Thus, our Romanesque art only perpetuates the distant traditions transmitted to it through Carolingian art. It is clear that the story of the magi, as told by our twelfth-century painters and sculptors, took form in the East. In these episodes, the contribution of our artists is very small and limited almost entirely to bringing the costumes up-to-date.

And now we come to the Baptism of Christ. In the Hellenistic art of the catacombs and of the sarcophagi it is represented in a curious way. We recognize St. John the Baptist but do not recognize Christ, for St. John baptizes not a man but a child. This baptism is thus above all symbolic: it is that of a Christian imitating Christ, his master.[80] Consequently,

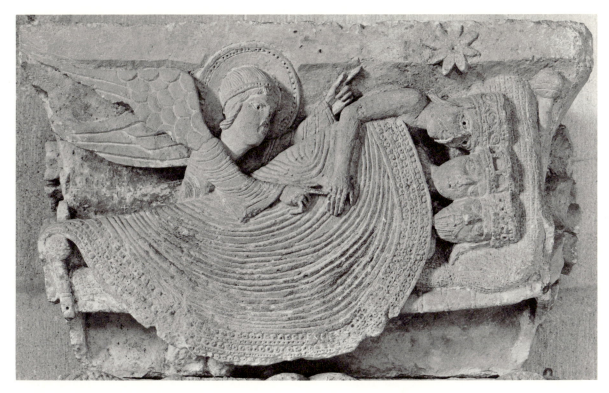

60. Sleeping magi and the angel. Capital from St.-Lazare. Autun (Saône-et-Loire), Musée Rolin.

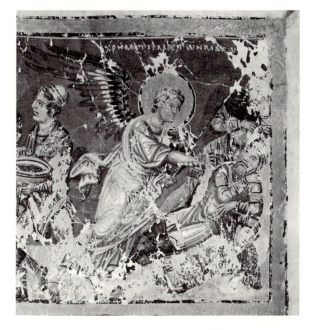

61. Adoration of the Magi; Sleeping magi and the angel. Homilies of St. Gregory of Nazianzus. Paris, Bibl. Nat., ms. gr. 510, fol. 137r.

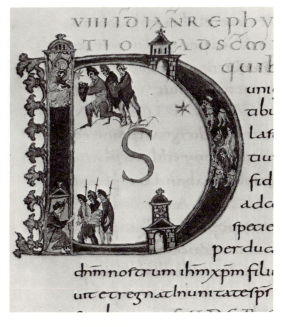

62. Adoration of the Magi. Drogo Sacramentary. Paris, Bibl. Nat., ms. lat. 9428, fol. 34v.

what we see is not an historical scene but the representation of a sacrament. The tradition was so strong that when artists represented the actual baptism of Christ, they sometimes persisted in showing him as a child.[81]

The true Hellenistic formula appears in the fifth century in a mosaic in the Baptistery of the Orthodox at Ravenna. Here we see a last and pale image of the charming world created by the Greek genius. The beardless Christ,[82] nude, his arms at his sides, is plunged into the water, and he has—as has been observed—the attitude of an archaic Apollo statue. St. John the Baptist, given a cross by a restoration of the mosaic, originally carried the crook of the Greek shepherds.[83] The river god rises from the depth of the water, a crown of water leaves on his head and in his hand the reed scepter. Christ would seem to be baptized in the river Alphaeus or Cephissus instead of in the Biblical Jordan.

The Syrian formula appears on one of the Monza ampullae (fig. 63). Basically it does not differ greatly from the Hellenistic formula but has two characteristic features: the god of the Jordan has disappeared, and we see a new figure standing on the river bank, an angel descended from heaven to witness the baptism of the Saviour. This astonishing innovation was to be perpetuated by more than ten centuries of art. One scholar has advanced the theory that the presence of the angel (and later of several angels) in the scene of the Baptism was due to the influence of *The Celestial Hierarchy*, the famous book attributed to Dionysius the Areopagite.[84] It is there that for the first time the world of angels is described with a kind of mathematical exactitude, and it is there that the role played by

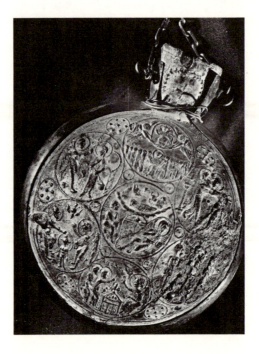

63. Baptism and other Gospel scenes. Ampulla. Monza, Treasury of the Collegiate of St. John.

the angels as intermediaries between man and God was defined. A deacon was present at the baptism of the catechumens; only an angel was worthy of witnessing the baptism of Christ.[85] This hypothesis seems likely, and if it is true, we must conclude that the mosaic reproduced by the Monza ampulla is not earlier than the second half of the sixth century, for the book of Dionysius the Pseudo-Areopagite dates from the first half.

As we move farther from Jerusalem into the monastic world of Asia Minor, the Syrian formula takes on a profoundly Eastern character. The frescoes discovered in Cappadocia demonstrate what it had become by the tenth century. Several of the frescoes represent the Baptism of Christ. Two new features are to be noted. First, we see—and for the first time—Christ veiling his nakedness with his hands as he is immersed in the water. The Greeks, accustomed to heroic nudes, had not hesitated to represent Christ completely nude behind the transparent veil of the water. But to the Eastern monk, who was so acutely conscious of original sin and transgression, nakedness was the image of the Fall and even Christ must cover himself.[86] That is not all. The river in which Christ is immersed is represented in a most unusual way: it forms a kind of dome, with Christ in the center, as if it were a bell-shaped garment he is wearing. The lines rise instead of receding (fig. 64). Here we recognize a childlike conception of nature that is purely Eastern; the Egyptians and the Assyrians never conceived landscape in any other way. The Greeks, however, knew the laws of perspective, and in the Baptism of Christ they indicated the level of the river by a horizontal line. The Syrian Baptism, in which the river

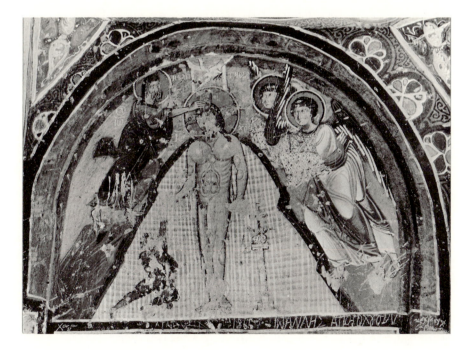

64. Baptism of Christ. Göreme, Chapel 19 (Elmali Kilise). Fresco of narthex.

rises almost to Christ's head, could have been conceived only at the borders of Mesopotamia, in those regions where the oldest traditions of Eastern art were still alive.

If we pass without transition from the frescoes of Cappadocia to French sculpture of the twelfth century, we are astonished to find them almost identical. On an archivolt of the portal at Le Mans there is a representation of the Baptism: Christ is immersed in the river as in a sheath reaching to his hips, and he covers his nakedness with his hand. St. John is at his left; an angel with veiled hands is at his right.[87] Here, we find again all the features of the tenth-century Syrian formula. The portal of Notre-Dame-du-Port at Clermont-Ferrand, badly damaged as it is, provides a glimpse of the same details (fig. 23); here, as in certain Cappadocian frescoes, Christ covers his nakedness with both hands. The angel, however, is kneeling instead of standing upright, but the sloping sides of the pediment framing the scene dictated this attitude.

The twelfth-century window of Chartres Cathedral and the fresco of Brinay present the Baptism in the same way. In neither example, it is true, does Christ cover his nakedness, but it must not be forgotten that the Eastern formula did not always include this gesture.[88]

These examples clearly prove that our artists were inspired probably not by Syrian originals, but by Latin manuscripts deriving from them. We presume that the monasteries of Asia Minor and Syria had close relations with the monasteries of Gaul, even from the earliest times. It is probable that the East transmitted its iconography to us as early as Merovingian times, but we have no proof of this today.

In this scene of the Baptism, the Hellenistic formula disappeared almost completely. Our artists never represented the Jordan in perspective as the Greeks had done, and they never omitted the angel, who was unknown to the Greeks. Curiously enough, however, the personified Jordan does sometimes appear in French art. The Carolingian ivory cover of the Drogo Sacramentary shows, beside the figure of Christ, the river god leaning against his urn.[89] We find him in a twelfth-century manuscript from Limoges (fig. 115).[90] And again, in a thirteenth-century window of the cathedral of Troyes, he is seated on the river bank.[91]

The Passion, which we will now study briefly, begins with the Entry into Jerusalem. The sarcophagi present the Hellenistic formula in all its simplicity: Jesus rides astride his mount; a youth throws his cloak beneath his feet; another is shown cutting branches in a tree, and sometimes an apostle walks behind Christ. The subject is reduced to its essential elements. But sometimes the scene contains additional figures while remaining the same in its general outline. On a sarcophagus in the Lateran, two children, instead of one, throw their cloaks on the road; spectators appear at the gates of the town; a following of apostles is shown.[92]

It is rather curious that it is youths, and sometimes even children, who spread their cloaks before Christ. The Gospels are not so specific. It has been thought, and it is probable, that this detail was adopted from the Apocryphal Gospel of Nicodemus,[93] for it is there that it is said that "the children of the Hebrews held branches in their hands and spread out their garments."[94] The expression οἱ παῖδες τῶν Ἑβραίων was taken literally. In the fourth century when the sarcophagus of Junius Bassus was carved, on which an adolescent appears in the scene of the Entry into Jerusalem, the Gospel of Nicodemus perhaps did not yet exist in its present form, but the traditions on which it is based were certainly not unknown.

The Eastern formula is shown in the sixth-century Rossano Gospels which give, if not the pure Jerusalem tradition, at least the tradition of Asia Minor.[95] In the miniature of the Rossano manuscript, there is an unusual and striking detail: instead of being astride his mount, Jesus is *seated sidesaddle*. Anyone who has been in the East knows that the Arab is apt to ride his donkey sidesaddle: it is the immemorial attitude of the people of the Syrian regions or of the Nile Valley. Thus, Jesus appears here as a man of his own race; the realistic art with its ethnic imprint, dear to the Orientals, is here set up against the noble and generalizing art of the Greeks.

This is the decisive detail, and one which enables us to classify a work at first glance. As for the rest, with a few exceptions we find the Hellenistic formula. There are a few variations of the details, but they are superfluous to our study, since none of them appears in French art.

Let us glance for a moment at French twelfth-century art. One of the lintels of the St.-Gilles portal is decorated with a beautiful Entry into Jerusalem, which unfortunately has been mutilated by vandals (fig. 65).

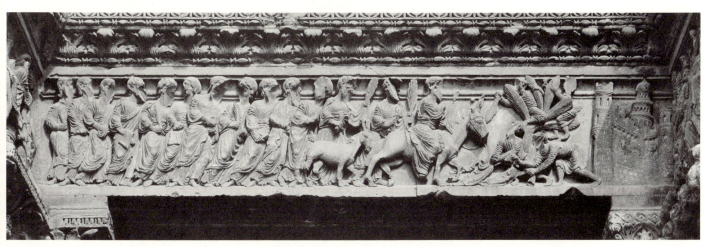

65. Entry into Jerusalem. St.-Gilles-du-Gard (Gard), Abbey Church. West façade, north portal, lintel.

It is clear that Christ's attitude—astride his mount, not sidesaddle—links this relief directly with the Hellenistic prototype. As on certain sarcophagi, two youths spread their tunics, while others cut branches from a tree, and the apostles follow behind.[96]

This old Greek formula reached us through manuscripts, and the transmission took place in Carolingian times. A capital letter in the Drogo Sacramentary encloses an Entry into Jerusalem where we find all the elements noted on the sarcophagi: Christ astride his mount, youths spreading their tunics, apostles following Christ.[97]

This composition is the one usually adopted by twelfth-century sculptors and painters. We find it on a capital of the cloister of St.-Trophime at Arles,[98] on a capital of the west façade of Chartres, and in the fresco at Vic (Indre).[99]

But the Eastern formula was also known to our artists. A capital from St.-Benoît-sur-Loire is devoted to the Entry into Jerusalem: it is of the liveliest interest because Christ is shown *sitting sidesaddle* on his mount. Consequently, the artist was following an Eastern manuscript, and one small detail almost identifies the family of manuscripts he was imitating; for Christ, instead of advancing from left to right, advances from right to left. Now there are several Greek Psalters of the eleventh century which are pervaded with Syrian influences and in which Christ, seated in the Near Eastern fashion on his mount, advances toward the left. In these manuscripts the composition is reduced to a very few figures who are disposed almost exactly as those at St.-Benoît-sur-Loire.[100] The relationship seems evident. The St.-Benoît manuscript was probably Greek, but our French manuscripts also reproduced the ancient Eastern models. A Gospel-book of Perpignan, illustrated in the twelfth century by an unskillful artist, includes an Entry into Jerusalem which is a kind of last reflection of the Rossano Gospels, and in which, naturally, Christ is seated sidesaddle on the ass.[101] Likewise, in a miniature from the Gospel-book of Limoges, he rides sidesaddle (fig. 66).[102]

As we see, for the scene of the Entry into Jerusalem, the two formulas existed side by side in twelfth-century France.

Leaving aside the scene of the Last Supper, which our artists greatly transformed and which will be discussed in a later chapter, let us examine an episode that often accompanied the Last Supper: the Washing of Feet.

The sarcophagi give the Hellenistic form of the Washing of Feet. Christ, standing, holds the apron tied in front of him in both hands. He is a young beardless man of sweetness and humility; the simple gesture of his bowed head expresses selflessness and renunciation of all pride. At his master's command, St. Peter, seated on a dais, holds out a foot, but his outspread hands express his embarrassment; a small basin is in front of the dais. It would be difficult to give this scene a nobler and more moving

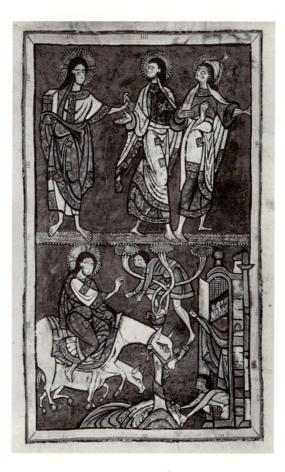

66. Entry into Jerusalem. Sacramentary from St.-Etienne of Limoges. Paris, Bibl. Nat., ms. lat. 9438, fol. 44v.

character. The Greek artist, while making us feel Christ's moral grandeur, refrains from humiliating him by representing him in the attitude of a slave (fig. 67).[103]

The Eastern spirit was quite otherwise. It was probably at Jerusalem, in the hall of the Cenacle transformed into a church, that the Washing of Feet had first been represented in its Eastern form. Only one miniature from the Rossano manuscript has survived to perpetuate this formula as it was about the time of its origin. Here, we begin to see the scene as it actually happened. St. Peter is seated, his arms rest on his knees, his legs are bare, his two feet are in the basin of water; Jesus bends low with outstretched hands ready to take the feet and wash them; the standing apostles contemplate the master and the disciple. The artist no longer fears to humiliate Christ.[104] But the East goes even further. In the frescoes of Cappadocia and in a tenth-century manuscript discovered at Patmos, Christ, bowing low, has already taken St. Peter's foot and washes it in the basin; St. Peter no longer resists but brings his hand to his head as if to say, in the words of the Gospel of St. John: "Lord, not my feet only, but also my hands and my head" (fig. 68).[105] Thus the Eastern spirit, avid for realistic detail, represents what the Greeks were content to suggest.

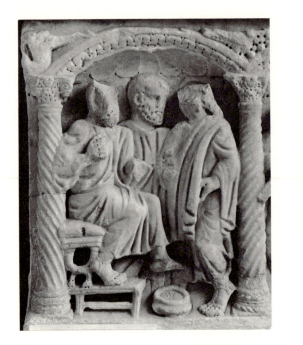

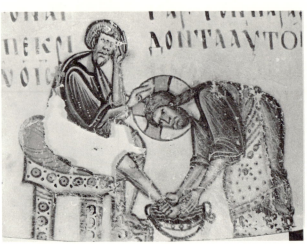

67. The Washing of Feet.
Sarcophagus end. Nîmes (Gard), Chapel
of St.-Baudile.

68. The Washing of Feet. Lectionary.
Patmos, Monastery of St. John the
Theologian, cod. 70, fol. 177v.

The West had to choose between the two traditions. Very early, it re-
nounced the beautiful Hellenistic formula and we barely find a last trace
of it in the manuscripts illuminated for the German emperors in the tenth
and eleventh centuries at the abbey of Reichenau. These are copies of very
early originals, but ones in which Syrian and Hellenistic art already min-
gled. In the scene of the Washing of Feet, a beardless Christ stands, as on
the sarcophagi: his arm is raised as he speaks to St. Peter, who already
has one foot in the water, but Christ neither bows before him nor ap-
proaches him.[106]

We find nothing like this in France; only the Eastern formula is to be
seen. The window at Chartres reproduces with surprising exactitude the
general arrangement and details of the Cappadocian fresco:[107] the same
attitude of Christ, who bends forward as he takes St. Peter's foot in both
hands, the same gesture of Peter in putting his hand to his head, the
same disposition of the apostles into two groups at each side of the com-
position (fig. 69). Clearly, the French artist had before him a miniature
that perpetuated the traditions of Asia Minor. This kind of miniature
must not have been rare in France in the twelfth century, for in Provence
as in Burgundy and Auvergne, sculptors faithfully reproduced these al-
ready consecrated gestures. At St.-Gilles, Christ bends over to take St.
Peter's foot in both hands, while St. Peter raises his hand to his head. Ex-
actly the same gestures reappear on the portal of Vandeins (Ain) and
on the portal of Bellenaves (Allier), both works of the Burgundian school.
These same gestures are again found at Clermont-Ferrand on a former
lintel, now inlaid in the wall of a house.[108]

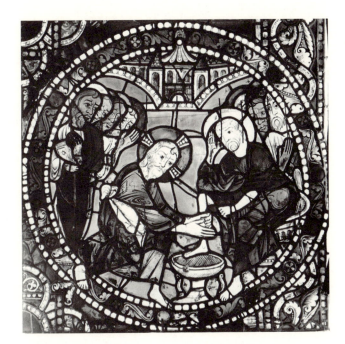

69. The Washing of Feet. Chartres
(Eure-et-Loir), Cathedral of Notre-Dame.
West façade, stained glass panel,
south window.

Occasionally, here and there, we come upon a slightly different tradition which goes back to the Rossano Gospels. One of the crude exterior reliefs of the church of Selles-sur-Cher (Loir-et-Cher) shows a St. Peter who does not raise his hand to his head. This St. Peter, who makes no gesture, whose hands rest on his knees, is also found in the reliefs of the church of Beaucaire.[109]

But sometimes our twelfth-century works include a feature not yet mentioned: beside Christ and St. Peter, seated apostles take off their shoes and wait their turn. This detail is to be seen on a beautiful capital from the cloister of La Daurade, now in the museum of Toulouse, and also on the lintel at Clermont-Ferrand just referred to. It would be a mistake to attribute this invention to our artists: they had before them not a miniature reproducing the old types of Asia Minor, but a Byzantine miniature. In the eleventh century, in fact, the Byzantines enriched the old models even while remaining faithful to them. Beside St. Peter and Christ, they seated the apostles on a long bench; some were shown in the act of taking off their shoes, others were already barefooted, and all were calmly waiting their turn.[110] In this way, they injected life into this immobile group of the apostolic college. It was this new model that our artists imitated. We see how exact their imitations were, since they enable us to recognize even the family to which the originals belonged.

The crucifixion is the center of the Gospels, and yet it is one of the last scenes to appear in art. For a long time, Christians did not dare to represent their God submitting to the tortures reserved for slaves. The pagans

would have held such an image in scorn. In the time of St. Augustine, it was still being said: "What kind of heart do these Christians have, to worship a crucified God!" However, since the fourth century the cross had stood on Golgotha, but it was a golden cross decorated with precious stones—a triumphal cross. Christ was not nailed to it. After the fourth century, the Cross of Jerusalem often appears in art, but nowhere is an image of the Crucifixion to be seen.

However, the world was becoming Christian, and Christian thought dwelt constantly on the stupendous idea of a God dying for mankind. The Fathers of the Greek Church, holding to the metaphysics of redemption, taught that God, by dying as men die, had deified humanity. The Syrians, moved by the reality of the sacrifice, themselves participated in the Passion and themselves suffered Christ's sufferings. It was only natural that art in its turn should participate in this long meditation.

The earliest monument representing the Crucifixion is probably an ivory, now in the British Museum (fig. 70). It can be attributed to the end of the fifth century and gives us the Hellenistic formula.[111] The beardless crucified Christ with long hair faithfully preserves the type of Christ created by the Greek cities of Asia Minor. One characteristic touch reveals the Hellenic spirit: the Christ on the cross is nude, like ancient heroes, with only a narrow band veiling his nakedness.

In the sixth century, the same formula appeared at Rome on the door of S. Sabina, but with one variation: the Christ is still almost nude, but

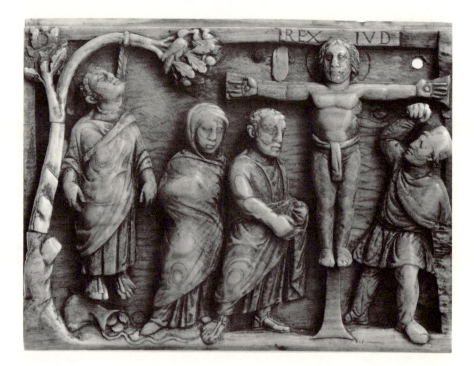

70. Crucifixion; Suicide of Judas.
Ivory plaque. London, British Museum.

he has a full beard. Thus, the Hellenistic type has here been modified by Syrian influences. This is no surprise at all to anyone who has studied this unusual door of S. Sabina, where the art and iconography are almost completely Hellenistic, but where, nevertheless, several details could have come only from Palestine. The work was produced, therefore, at a time when the two great currents of Christian art had begun to mingle.

Let us examine the Syrian as opposed to the Hellenistic formula. It must have originated at Jerusalem, if we are to judge by the composition decorating a Monza ampulla.[112] It was adopted by Syria. The Syriac manuscript of Florence, illuminated in 586 by the monk Rabula, reproduces the scene from the Monza ampulla and adds to it new details (fig. 71).[113] In conformity with the Syrian tradition, Christ has a full beard, but what characterizes him here is the long tunic, the colobium, which reaches to his feet. Unlike the Greeks, the Syrians did not want to show Christ nude on the cross; nudity, familiar to the Greeks, shocked them. In their eyes, this was the supreme humiliation that they wished to spare their God. The long tunic gives Christ a sacerdotal majesty, and dying, he appears as the priest of the New Law. It is conceivable that the Syrians thought of this, for their Crucifixion is both realistic and symbolic. For the first time, in fact, we see the scene of Calvary reproduced in all its actuality: the thieves are crucified at each side of Christ, the soldiers cast lots for his garments, the sponge bearer offers him the vinegar, the lance bearer pierces his side, the Virgin, St. John, and the holy women lament.

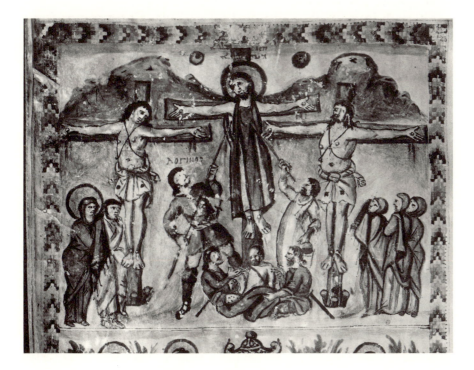

71. Crucifixion. Rabula Gospels. Florence, Biblioteca Medicea-Laurenziana, Syriac ms. Pluteus 1, 56, fol. 13a (detail).

But we observe that already the lance bearer is placed at Christ's right and the sponge bearer at his left. Contrary to all likelihood, it is in Christ's right side that the lance opens the Saviour's wound, because this wound is of course symbolic.[114] And lastly, the cross stands between the red sun and the violet moon, which perhaps already express the two natures of Christ.[115]

Such are the three earliest images of the Crucifixion that have been preserved. For centuries, we shall come again upon all three.

At first the Syrian formula seemed likely to prevail. Works of art from Syria and Palestine spread it throughout the Christian world. It appears on amulets discovered in Egypt,[116] on the cover of a reliquary found in the Sancta Sanctorum of the Lateran (fig. 52),[117] and on a silver plate taken as far into Russia as Perm.[118]

Soon, crowds of Syrian monks, driven out by the Arab invasion, established themselves at Rome, bringing their iconography with them. The church of S. Maria Antiqua discovered in the Forum in 1900, whose frescoes date from the seventh to the ninth century, has preserved a Christ on the Cross dressed in a long robe, like the Christ of the Rabula manuscript (fig. 72).[119] As in the manuscript, the lance bearer and the sponge bearer are placed at the right and the left of Christ, but in the fresco the composition is even more perfect still, since the Virgin is also at the right and St. John at the left of the cross. Here we have that perfect symmetry which was perpetuated until almost the end of the Middle Ages. It is clear that we owe it to the Syrians.[120]

Although in the West, as we shall see, the nude Christ was preferred to the robed Christ, we can nevertheless follow there the traces of the Syrian formula from the ninth until the end of the twelfth century. On a Carolingian ivory in the Cluny museum, the crucified Christ is clothed in the long robe.[121] In the Gospel-books illuminated at the end of the tenth and the beginning of the eleventh century for the German emperors Otto II and Henry II,[122] the scene of the Crucifixion reproduces in almost all of its details the miniature of the Syriac Gospel-book of Rabula. In France, in the twelfth century, Limoges artists spread throughout Europe enameled crosses to which a Christ clothed in the colobium was attached.[123] The sculptors themselves sometimes remained faithful to the old Syrian motif, as we see from the Christs carved in wood that are still to be found in the churches of the Pyrénées-Orientales.[124] But we shall soon take up the question of whether the persistence of this clothed Christ, so different from the Christ adopted by the Middle Ages, was not owing to some profounder cause than the simple imitation of a miniature.[125]

We see that the Syrian type, even though it was not often reproduced in Western art, was not unknown. The same can be said of the pure Hellenistic type. Hellenistic art, we recall, represented Christ as beardless

and wearing only a loincloth. This Christ was known to Carolingian art: ninth- and tenth-century miniatures and ivories sometimes show a young, beardless man nailed to the cross. It is true that instead of a narrow loincloth, drapery is hung around his hips (fig. 73). Only in this does he differ from the ancient model.[126] Miniaturists reproduced this Christ until the twelfth century,[127] but I have never encountered it in our monumental art.[128]

It was the nude figure of Christ dying on the cross that triumphed in the Middle Ages, but it was a Hellenistic Christ retouched by the Syrians —a fully bearded Christ such as we see on the door of S. Sabina. Only the nudity of the crucified figure was borrowed from the Greeks; all other details came from the Syrians. It is quite certain, moreover, that this type of mixed Crucifixion, which was to prevail in the future, was transmitted to us by the East itself, for the churches of Cappadocia present this type in its fully developed form.[129] It had already reached the Carolingian

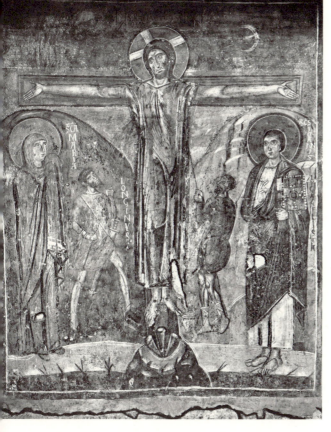

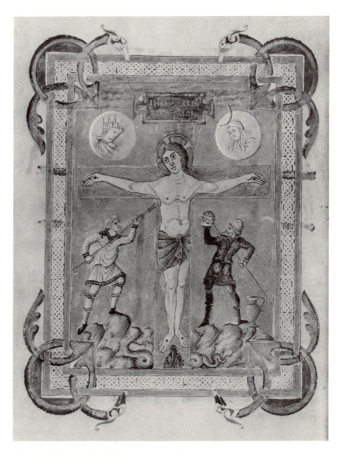

72. Crucifixion. Rome, Sta. Maria Antiqua. Fresco of left chapel.

73. Crucifixion. Gospels of Francis II. Paris, Bibl. Nat., ms. lat. 257, fol. 12v.

artists, for on ninth- and tenth-century ivories the nude Christ usually has a beard, and as in Eastern works, the Virgin and the lance bearer stand at Christ's right while St. John and the sponge bearer are at his left.[130]

Such are the remote origins of the Romanesque Crucifixion, of which unquestionably the most magnificent example is that of the window at Poitiers (fig. 74). This great Christ nailed to a red cross that suggests the color of blood has a grim beauty. The Virgin and the lance bearer, St. John and the sponge bearer all stand in the places assigned to them by the ancient Eastern tradition.[131] But it can certainly be said that there is no work in all the art of the East that approaches the tragic grandeur or the visionary aspect of this one.

In monumental sculpture, the scene on the tympanum at Champagne

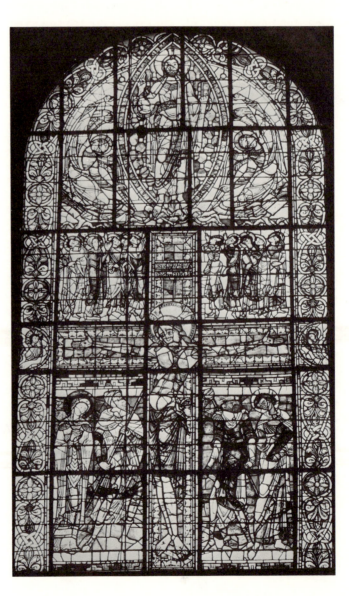

74. Crucifixion; Ascension. Poitiers (Vienne), Cathedral of St.-Pierre. Apse window.

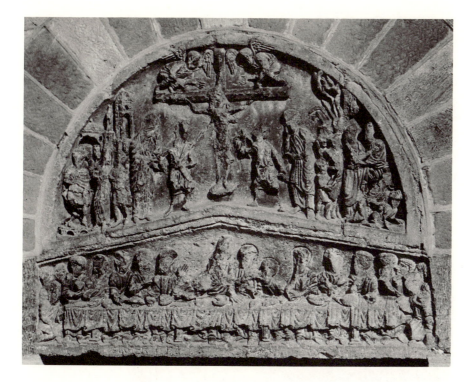

75. Crucifixion. Champagne (Ardèche),
Priory. West façade, central portal,
tympanum.

(Ardèche) is arranged in the same way (fig. 75). The very same figures
are in the very same places. Imitation of the East is even more easily recog-
nized here; in fact, the Virgin places her left hand against her cheek, and
St. John his right hand—the gesture for grief in antiquity. In the tenth-
century frescoes of Cappadocia, we see this same gesture made symmetri-
cally by the two witnesses of the Passion.[132]

The models that the Romanesque artists had before them provided them
with all the nuances of Eastern iconography—nuances to be found in their
work. In the crude and almost formless Crucifixion on the exterior of the
church of St.-Paul at Dax (Landes),[133] St. John alone raises his hand to
his cheek, while the Virgin clasps her hands against her breast. The origi-
nal of this scene was thus from the same family as the mosaic of St. Luke
of Stiris in Phocis, in which St. John alone expresses his grief while the
Virgin, with hands crossed over her breast, seems to participate in the
sacrifice.[134]

Were it not known that Romanesque artists drew on models from all
periods, it would be quite surprising to find on the portal of the abbey
of St.-Pons (Hérault)[135] a Crucifixion that still recalls somewhat the one
in the Syriac manuscript of Rabula. The Christ, it is true, no longer wears
the long robe, but he is crucified between the two thieves, and as in the
Rabula manuscript, the Virgin and St. John both stand at the right of the
cross. There were assuredly many intermediaries, but the work preserves
nonetheless a distant kinship with the old sixth-century manuscript.

On the other hand, the Crucifixion of the Chartres window seems to have been modeled on a much more recent Eastern work (fig. 76). Christ, until then represented as alive on the cross, is here perhaps for the first time in France shown as dead; his eyes are closed, and the last convulsions of death have slightly arched the line of his body by a forward thrust of the right hip. This could be thought an innovation of our mid-twelfth century artists were it not for proof that more than a century earlier the Greeks had represented Christ at the moment of his death on the cross, the body slightly arched, the eyes closed.[136]

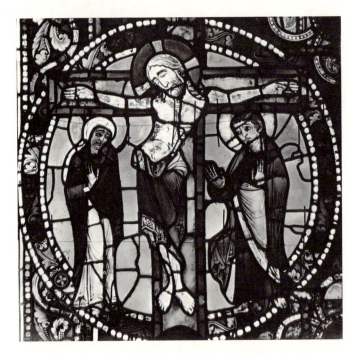

76. Crucifixion. Chartres (Eure-et-Loir), Cathedral of Notre-Dame. West façade, stained glass panel, south window.

Let it be noted further that in all our twelfth-century Crucifixions, Christ is nailed to the cross with four nails, in conformity with the earliest Eastern tradition. This was to be the practice until the beginning of the thirteenth century, the period when France broke with the old tradition and reduced the number of nails to three by representing the feet nailed one over the other.[137]

These few examples will suffice to show what our twelfth-century Crucifixion scene owed to the East.

For centuries, the Resurrection had not been represented realistically. Instead of showing Christ issuing from the tomb, the artists merely represented the holy women meeting the angel at the entrance to the tomb.

The Greeks and the Syrians imagined the scene in two different ways.

A feeling for the picturesque, so common to the Alexandrians, dominated the Hellenistic formula. The tomb is not at all the Holy Sepulcher

erected by Constantine, but is conceived as one of the funerary constructions that gave so solemn a beauty to the approaches of the towns of antiquity. An ivy-clad rotunda rests on a delicately carved rectangular base.[138] Sometimes the rotunda is carved with open work, and the entire monument reminds us of the elegant antique tomb at St.-Remy in Provence. The guardians of the sepulcher lean against the base of the tomb or recline on the platform separating the two storeys. The angel, a youth without wings, seems to be speaking to the holy women as they approach. The holy women do not carry phials of ointments, and—an important detail—in the Munich ivory they are three in number (fig. 77). Birds perch in a tree and herald the dawn with their song. The scene has that sweetness and charm of youth that the Greeks were able to give to their creations until the very end.

Quite different is the Syrian formula, which undoubtedly originated in Jerusalem. It has been preserved on the ampullae of Monza, and all of these, in spite of a few slight variations, agree on certain essential points (fig. 78).[139] The tomb is not an edifice created by the artist's fancy; it is

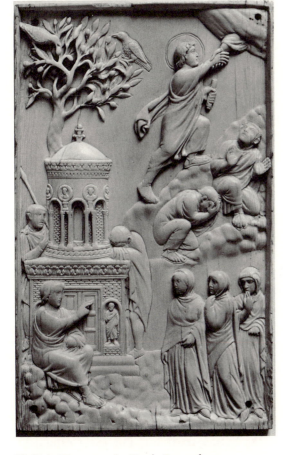

77. Holy Women at the Tomb. Ivory plaque.
Munich, Bayerische Nationalmuseum.

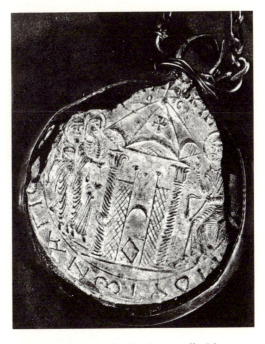

78. Holy Women at the Tomb. Ampulla. Monza,
Treasury of the Collegiate of St. John.

an actual monument. It is not the Rotunda of the Resurrection built by Constantine, but only the tugurium which, within the Rotunda, surrounded the sepulcher.[140] This tugurium was a kind of vast canopy, a ciborium supported by columns and enclosed by a grill; lamps hung in this holy of holies, where pilgrims could enter and contemplate the tomb. The angel carrying a long scepter in his hand sits at the right of the tugurium. The holy women come forward on the left, but there are only two of them, which proves that the artist was following the Gospel according to St. Matthew, which names only two holy women.[141] The Greek artist of the Munich ivory followed St. Mark, who names three myrrhophores (spice bearers).[142] The first of the two holy women carries a censer resembling a lamp hung from chains, like censers that have been found in Mesopotamia.[143] This detail is strange. It suggests that the artist had wished to represent a liturgical ceremony rather than an historical scene. In fact, it was the practice in Jerusalem, on Easter Day, to act out in some fashion the visit of the holy women to the tomb, and to cense the tugurium.[144] The guardians of the sepulcher played no role in this liturgical ceremony, and that explains why they do not appear on the Monza ampullae, although they figure in the scene conceived by the Greek artists. Such are the profound differences separating the Syrian from the Hellenistic formula.

Carolingian art accepted these two formulas and reproduced both. In a ninth- or tenth-century ivory, now in London,[145] the main outlines of the Hellenistic type are imitated. We can presuppose behind this mediocre copy a remote model almost like the beautiful Munich ivory. As in the Munich ivory, the rotunda has two stages, and the soldiers emerge between the first and second storeys; the angel is seated in the same place and attitude, and the holy women who advance toward him are three in number.[146]

In another ivory of the same period, on the other hand, we recognize the scarcely modified Syrian formula.[147] The composition has been reversed so that the holy women advance from right to left, instead of from left to right. But here there are only two of them, as on the Monza ampulla, and—a characteristic detail—they carry the censer. As on the Monza ampulla, the angel is seated at the other side of the monument, but it must be said that this monument only faintly resembles the tugurium of Constantine. For the tenth-century artists, the form of the ancient tugurium, which had been destroyed in the seventh century by the Persians, was not understood. The guards, who were not present in the Syrian formula, are naturally omitted.

But it is rare in Carolingian art for the two formulas to appear in such pure form. Sometimes the Hellenistic formula adopted by the artist includes a detail borrowed from the Syrian tradition. The great capital D

79. Holy Women at the Tomb.
Drogo Sacramentary. Paris, Bibl. Nat.,
ms. lat. 9428, fol. 58r.

of the Drogo Sacramentary encloses a charming miniature representing the Holy Women at the Tomb (fig. 79). We easily recognize a Hellenistic prototype of the family to which the Munich ivory belongs: the form of the monument, the group of three women, and the presence of the guards are all marks of its origin. But, singularly enough, the first of the three holy women carries the censer that we saw to be one of the characteristics of the Syrian type. Thus, the two formulas were sometimes mixed. Nothing could be less surprising, since the Carolingian artists imitated ancient models whose spirit they did not completely understand. Similar combinations are to be found in manuscripts of the eleventh and twelfth centuries.

It was in this way that the old formulas, reproduced century after century, finally reached our artists. Our twelfth century, as we shall see in another chapter,[148] represented the Visit of the Holy Women to the Tomb in an entirely new way; an original composition was created, one which cannot be confused with the ancient formula since the funerary monument is replaced by a sarcophagus. However, even in the twelfth century, certain artists clung to the ancient tradition. A capital in the church at Mozat (Puy-de-Dôme) representing the Holy Women at the Tomb shows the final development of the Hellenistic formula (fig. 116).[149] It can still be easily recognized. Even after eight centuries, the angel, seated in profile, preserves the gesture seen in the Trivulzio and the Munich ivories; nearby stands a kind of small church whose two storeys recall the ancient tomb; the holy women are three in number, and behind the monument we see the guardians of the Holy Sepulcher. Such an image is all the more interesting because of its rarity. I know of only two replicas, almost identical: one at St.-Nectaire, the other at Brioude, both the work of artists trained in the same school.[150] A tradition begun at Alexandria

or Antioch is seen to end in Auvergne: an illuminated manuscript preserved in an Auvergnat abbey unquestionably illustrates this fidelity to the past. But elsewhere, the artists had already broken away from the ancient types and had conceived those new formulas for the Resurrection that we shall study later on.

Like the other great scenes from the life of Christ, the Ascension appeared from the outset in both its Hellenistic and its Palestinian form.

It is curious to see the Greeks representing the Ascension as an apotheosis, like an entry of one of their ancient heroes into heaven. Christ seems to climb the slopes of Olympus; he is about to reach the summit when the hand of God issues from the clouds and takes his hand. Meanwhile, on the mountainside, his disciples make gestures of awe, or, as the Gospel of Nicodemus says, they fall face down on the ground.[151] This is the form in which the Ascension appears in the Munich ivory just referred to (fig. 77); the identical scene appears on some of our sarcophagi of Gaul.[152] The Ascension scene on the door of S. Sabina at Rome is conceived in the same manner; but there Syrian influences modify the purity of the Hellenistic formula, for the hero is not alone on his Olympus—angels surround him and help him climb the slope to heaven.

Quite the opposite of this almost pagan scene conceived by the Greeks is the solemn formula created at Jerusalem. The ampullae of Monza represent it,[153] and, as we have said, probably reproduce the mosaics of the church erected on the Mount of Olives (fig. 80). Christ appears in heaven

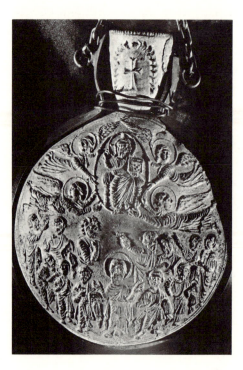

80. Ascension. Ampulla. Monza, Treasury of the Collegiate of St. John.

seated on a throne and surrounded by an aureole supported by four angels. He seems already to have accomplished the end of his journey and is seated in glory as the Master, the Judge of Mankind; he holds the book in his left hand and raises his right. On earth, the apostles are grouped symmetrically, and at the center of the composition, the Virgin, with nimbus, stretches out both arms in the attitude of an orant. The place of honor given to the Virgin is significant: it proves that the mosaic was not earlier than 431 and the Council of Ephesus, which marks the real starting point of the cult of the Virgin in the East as in the West. We sense that theology had already begun its work. Neither the Acts of the Apostles, nor the canonical Gospels, nor the apocryphal Gospels say that the Virgin was present at the ascension. Consequently, her image here has the value of a symbol: she personifies the Church that Christ, by ascending to heaven, left on earth.

We can scarcely imagine a more imposing composition, and one worthier of monumental art; consequently, it spread over all of Christendom. A sixth-century fresco discovered at Bawit, in Egypt, is almost identical with the original.[154] The reliquary of the Sancta Sanctorum testifies to its presence at Rome (fig. 52).[155] The silver plate found at Perm proves that it reached Russia.[156]

However, as early as the sixth century the Syrian monks, while respecting the general arrangement of the subject, altered several details: Christ appeared no longer seated but standing in his aureole, which henceforth was to be supported by only two angels. On earth, the Virgin remained at the center of the apostolic college, but two angels with scepters in their hands were placed at her right and left; they turn toward the apostles and, in accordance with the text of the Acts, announce that the Christ about to disappear from their sight will one day reappear in the same attitude.[157] This is the Ascension of the Rabula manuscript.[158] On the borders of Syria, the solemn Jerusalem composition became animated, less hieratic. Henceforth, the Palestinian type had a Syrian variant.

It is extremely interesting to observe the way in which the Carolingian artists imitated (while combining) the Eastern formulas. The curious thing is that they almost always preferred the half-pagan Hellenistic formula; from it they took the essentials of their composition. In the Drogo Sacramentary (fig. 81),[159] in the Bible of S. Paolo fuori le Mura,[160] and in the Essen ivory, Christ climbs the mountain with hand outstretched toward his Father; on his shoulder he carries a small cross with long shaft, an attribute of Coptic origin, which indicates an Egyptian model.[161] But if the upper part of the composition is Hellenistic, the lower part is Syrian: the Virgin appears among the apostles; two angels with long scepters in their hands tower above the witnesses to the miracle and seem to pronounce the consecrated words.

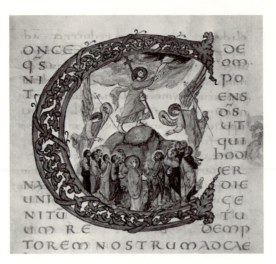

81. Ascension. Drogo Sacramentary. Paris, Bibl. Nat., ms. lat. 9428, fol. 71v (detail).

This type of Ascension, half Hellenistic and half Syrian, was transmitted to succeeding centuries but in a weakened form. At the end of the eleventh century, miniatures still represented a Christ in profile, rising to heaven as he holds out his hand toward God; but he does not climb the mountain, and the hand of the Father no longer grasps his (fig. 82).[162] It was a miniature of this kind that inspired the Ascension on the south portal of St.-Sernin at Toulouse (fig. 42). The Christ ascending to heaven is shown in profile, with arms raised and hand outstretched toward an invisible hand. But, by a strange touch of realism, and the first example of it since the door of S. Sabina, two angels support Christ's arms and seem to help him rise upward. It is in this singular work that the ancient Hellenistic formula reached its final stage. The Toulouse tympanum retains a certain nobility; it is as if the small angels supporting Christ were the servants of God. But in the crude imitation of this relief on the portal of San Isidoro at León, all feeling for grandeur has disappeared: Christ seems to lean heavily on the arms of the two angels supporting him.[163] Here we are a long way from the deified heroes climbing the slopes of Olympus.

The Syrian type of the Ascension also was transmitted to the twelfth century: our artists were familiar with both forms, that of the Monza ampulla and that of the Syriac manuscript of Florence.

The characteristic of the Monza formula, which is the formula created at Jerusalem, is, we recall, the attitude of Christ represented as seated in his aureole. In the Western manuscripts I have been able to study, I have never seen the Christ of the Ascension seated. On the other hand, in Byzantine manuscripts he always appears in this way. Consequently, it is probably imitation of a Byzantine model that accounts for the Ascension scene of the portal of Anzy-le-Duc (Saône-et-Loire) (fig. 83).[164] On the tympanum, Christ is seated in an aureole and is lifted up by two angels; on the lintel, the Virgin, in an attitude of prayer, stands in the midst of

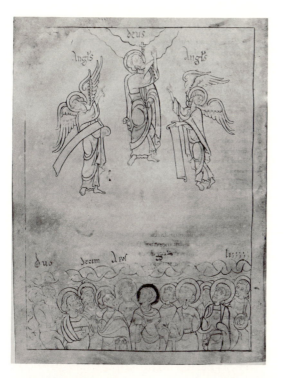

82. Ascension. St. Ambrose, various texts.
Paris, Bibl. Nat., ms. lat. 13336,
vol. 91v.

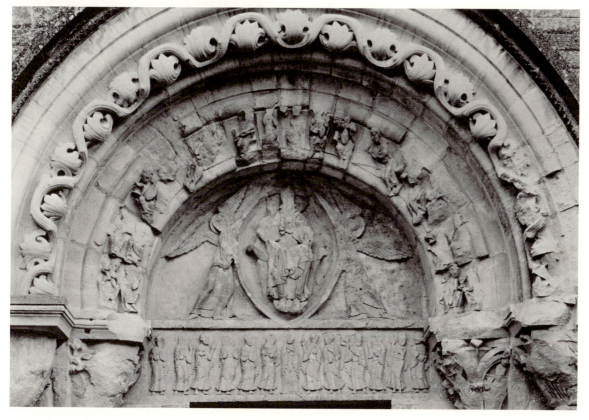

83. Ascension. Anzy-le-Duc (Saône-et-Loire), Priory. West portal.

the apostles and forms the exact center of the composition. There is nothing surprising about this imitation of Byzantine art in a region dominated by Cluny.[165] For Cluniac art—and we shall furnish other proof—was openly receptive to Eastern influences.

If the Jerusalem formula is to be found only rarely in France, the Syrian formula of the Rabula manuscript, on the other hand, was adopted by our twelfth-century artists. Here Christ is represented standing in an aureole supported by two angels, and on earth two other angels at the right and left of the Virgin speak to the apostles. This type of the Ascension is the one usually found in our eleventh- and twelfth-century manuscripts. The Sacramentary of St.-Bertin, an eleventh-century manuscript, preserves the Syrian formula in an almost pure form: Christ stands in his aureole, and on earth the two angels speak to the apostles. However, the Virgin is no longer the center of the group, but is partly lost in the crowd.[166] This is very nearly the only difference between the two compositions.

There is little doubt that the sculptor of Montceaux-l'Etoile (Saône-et-Loire) imitated a miniature of this genre (fig. 84): his Christ stands with a cross in his hand; the two angels (without wings) are in the midst of the apostles; the Virgin, as in the St.-Bertin manuscript, seems to merge with the apostolic group. Credit is due the Burgundian artist for the vitality animating this relief, but it is clear that the composition is not his own.

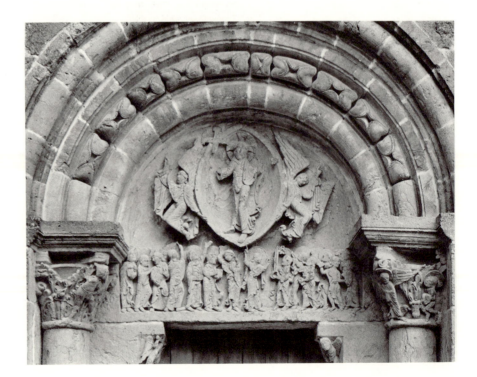

84. Ascension. Montceaux-l'Etoile (Saône-et-Loire), St.-Pierre-et-St.-Paul. West façade, tympanum.

Sometimes our manuscripts simplify the Syrian Ascension by omitting the two angels from the group of apostles; it is the two angels on each side of the aureole who lean down toward the apostles from the sky and seem to be speaking to them. Such is the Ascension of a beautiful early twelfth-century manuscript from Limoges (fig. 85).[167] This type must have been spread throughout southwestern France by manuscripts of the same family, for it was reproduced on the tympanum of the cathedral of Cahors (fig. 86). The gesture of Christ is similar, although more restrained; the same end of the mantle falls in similarly noble folds over the arm holding the book. The subtle curve of the angels bending down to the apostles is identical.[168]

The tympanum at Mauriac (Cantal) has neither the beauty of style nor the Greek purity of the Cahors tympanum, but is nevertheless derived from it. The iconography of the two works is almost the same, and the bending angels are closely related to those of the Cahors tympanum and the Limoges manuscript (fig. 279).

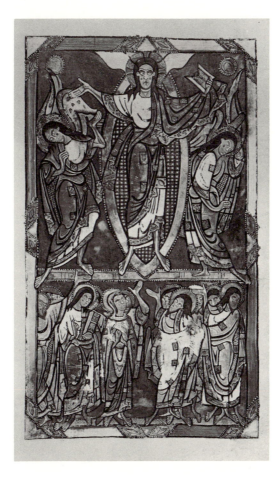

85. Ascension. Sacramentary from St.-Etienne of Limoges. Paris, Bibl. Nat., ms. lat. 9438, fol. 84v.

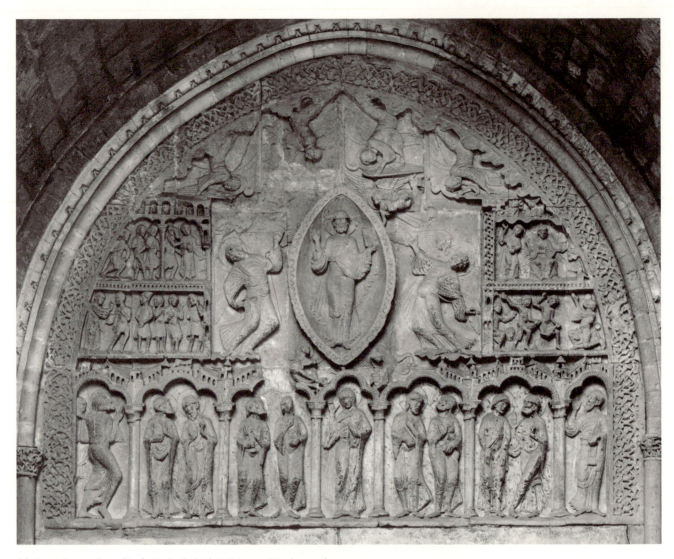

86. Ascension. Cahors (Lot), Cathedral of St.-Etienne. North portal, tympanum.

This composition, so monumental in conception, seemed made for the artists in stained glass. We find it in the upper part of the great window at Poitiers devoted to the Crucifixion (fig. 74). The two angels form magnificent arabesques at each side of the Christ standing in his aureole; and the Virgin, mingling with the apostles, gestures with her hand.

V

Byzantine iconography and its influences. The Transfiguration. The Arrest of Christ in the Garden of Olives. The Descent from the Cross. The Descent into Limbo.

All the scenes from the Gospels that we have studied thus far have a double origin: Hellenistic and Syrian. They were passed along, as we have seen, in one form or the other. But there are certain scenes which were created later and which never had a Greek form; the Greek form of others disappeared so early that they entered into artistic tradition only in their

Syrian form. And it was most frequently via the intermediary of Byzantine art that they became known in France.

Up to now, Byzantine art has scarcely been mentioned; there has been no reason to do so. In fact, we observed that our twelfth-century French works were inspired by much earlier models than Byzantine originals. All can be explained by Hellenistic or Syrian prototypes which we traced to Egypt, Syria, and Cappadocia. In the Merovingian and Carolingian epochs, illuminated manuscripts had been brought from the East, and they transmitted the first Christian art to Gaul, which drew on these ancient sources until the twelfth century.

The name of Byzantine art, once evoked at every turn, must thus be used only sparingly. Now that the Eastern sources of Christian art are better known, Byzantine art appears a bit like a newcomer who garners a rich inheritance.

It is nonetheless true that from the ninth until the eleventh century, Byzantine art—the art of Constantinople—had reclothed the old models in a most noble beauty. The foundation of Byzantine art is almost always Eastern, that is, Palestinian, Syrian, or Cappadocian, but its form is Greek. It ennobled the realism of Eastern art, and sometimes it seems even to recapture the spirit of Greece. Its form is almost classical: in the mosaics at Daphni on the road to Eleusis, we see again the gestures of heroes, philosophers, and orators. The somewhat severe art of the Eastern monks was purified, undergoing an initiation before being given the rights of the city.

Byzantine art had its greatest and widest influence during the eleventh and twelfth centuries; it reached Russia, Italy, and Sicily. It was then that the mosaics at Kiev, Venice, Torcello, Palermo, and Monreale were created.[169] Little by little, the German miniature became completely Byzantine.[170] It is not surprising that in France, at this time, certain scenes from the Gospels were known in their Byzantine form and that these new models were imitated.

Let us study the scene of the Transfiguration as an example. In the East, its origins went far back in time: it appears in a fourth-century mosaic of Sinai, and later in the paintings of Cappadocia. But it was in the eleventh century, and thanks to the harmonizing genius of the Byzantine artists, that it attained its perfect form. Christ rises above the mountain, floating in an aureole of light. Moses and Elias stand, their feet on the ground at his right and left, bowing their heads before his splendor. They are no longer enclosed in the same aureole as Christ, as had long been the practice in the East. Light emanates from Christ alone; he appears as dazzling as the sun, and rays of light shooting forth from his aureole strike the two saints of the Old Law and the three apostles, witnesses of the mystery. The three apostles prostrate themselves on the slopes of the mountain, each in an attitude expressive of his character.[171] St. Peter, passionate and energetic,

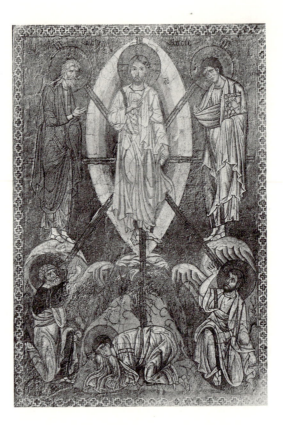

87. Transfiguration. Byzantine
miniature mosaic. Paris, Louvre.

kneels on one knee and with raised hand seems to address Christ in the
words of the Gospel: "Let us make here three tabernacles." On the other
side, St. James, too, tries to rise but cannot endure the brilliant light; he
covers his eyes with his hand or turns his head. St. John, prostrated be-
tween the two disciples, is motionless; he does not want to see, "caring
only to love Jesus and to be loved by Him."[172] Such is the Byzantine Trans-
figuration in the steatite plaque in the cathedral of Toledo,[173] and in the
mosaic picture in the Louvre (fig. 87).[174] Attentive study of this latter
work convinces us that it would be impossible to bestow greater majesty
upon this mysterious scene, to unite more imposing immobility with great-
er hidden vitality. It is not surprising that this magnificent model fas-
cinated our artists; twice they reproduced it almost literally: in a window
at Chartres (fig. 88) and in a fresco of the cathedral of Le Puy.

It is enough to bring together the reproduction of the Chartres window
with that of the mosaic picture of the Louvre to be convinced:[175] both
show Moses and Elias in the same attitude, the same rays of light emanate
from the aureole, and the apostles make the same gestures. We scarcely
notice that the French artist, who was not accustomed, like the Greeks, to
representing Moses as a young man, has given him a beard. Also, St. James
does not raise his hand to protect his eyes but turns away, as in the steatite
plaque at Toledo—slight differences that come from a different model.

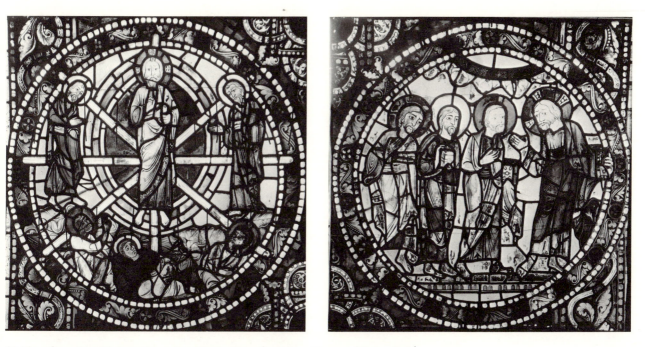

88. Transfiguration; Christ and apostles after the Transfiguration. Chartres (Eure-et-Loir), Cathedral of Notre-Dame. West façade, panel of south window.

This model was most certainly a Byzantine manuscript with miniatures, as the next panel of the Chartres window proves. There we see Christ, after the transfiguration, speaking to the three apostles. The same scene accompanies the Transfiguration in the Byzantine Gospels of the eleventh century.[176] The Christ of the Chartres window, with his right hand raised, the book in his left hand, and a fold of his garment flaring in the wind, is exactly like the Christ of the Byzantine Gospel in Paris. True, the group of apostles, turned differently, seems to move away from Christ, but the Gospel-book of Florence shows them in the same way.

The fresco of Le Puy is just as faithful an imitation.[177] The model that inspired it was almost identical to the one the Chartres stained-glass artist had in front of him. St. Peter, St. James, and St. John make the familiar gestures. But St. Peter and St. James, at the extreme sides of the composition, are shown only in half-length, which proves that the original belonged to the same family as the steatite plaque of Toledo, where the same feature is to be seen.

This is a striking proof of the influence of Byzantine models on French art of the twelfth century. We may wonder whether the sculptor of the tympanum at La Charité-sur-Loire may not have been inspired by the same model, modifying it according to his own needs (fig. 89).[178]

A study of Christ's Arrest in the Garden of Olives will provide us with

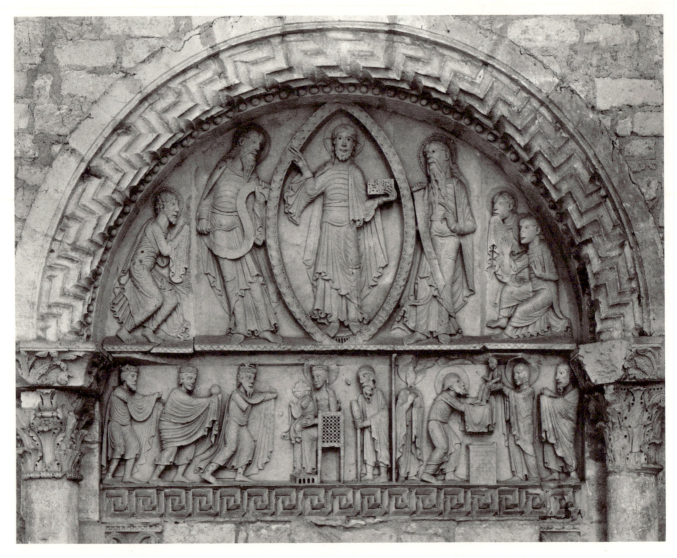

89. Transfiguration; Adoration of the Magi; Presentation in the Temple. La Charité-sur-Loire
(Nièvre), Abbey Church of Ste.-Croix-Notre-Dame. South transept, inner wall,
tympanum (removed from west façade).

another example of Byzantine influence, for it was in the Byzantine form
that our artists knew this scene.

It was developed in the East,[179] but the ancient Eastern forms anterior
to Byzantine art have left scarcely a trace in our art. We do come upon
one in the crude reliefs decorating the exterior of the church at Selles-sur-
Cher (Loir-et-Cher),[180] where Christ's Arrest appears in an unusual form.
Judas and Jesus are isolated at the extreme left of the frieze; farther on,
there are soldiers with clubs, but both St. Peter and Malchus are absent.
Later, Jesus and Judas would be shown surrounded by the crowd, but here
they stand apart. Now this scene appears in exactly this same way in the
ninth-century Drogo Sacramentary, and again in a Coptic manuscript,
which proves that the composition came originally from the East.[181]

But there is no point in insisting on such exceptions. It was Byzantine art that gave the scene its lasting character. Three successive moments in the action were united in one composition. At the same time, we see the kiss of Judas, the arrest of Christ, and the struggle between St. Peter and Malchus: the entire drama is thus contained in this synoptic picture. The subject could not have been better conceived. To give an example, this is how the Byzantine Gospel-book of the Vatican represented the Arrest of Christ (fig. 90):[182] Judas, approaching from the left, places his hand on the Saviour's shoulder and brings his cheek close to the Saviour's; one of the soldiers seizes Christ, whom the traitor has just identified. The entire cohort surrounds the group of Jesus and Judas; rows of heads build up into a half-circle, contrary to all laws of perspective but, despite this, harmonious in effect; pikes and torches rise above the heads and give the impression of a compact crowd. We are given the sense of an abandoned Christ, alone in the presence of many enemies. The apostles, indeed, have fled; however, St. Peter is there, somewhat to one side, and with his sword cuts off the ear of Malchus who is seated on the ground and appears to be the size of a child.

Exactly the same scene is to be seen on one of the capitals of La Daurade in the museum of Toulouse (fig. 91). As in the Byzantine original, Judas comes from the left, Jesus is seized at the very instant the kiss identifies him; the soldiers' heads, the pikes and torches projecting above them, form a half-circle; St. Peter strikes Malchus who has fallen to the ground

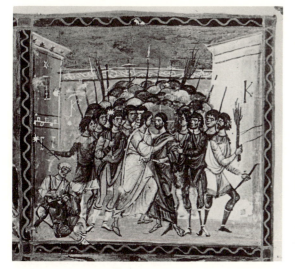

90. Arrest of Christ. Gospel-book.
Vatican, Biblioteca Apostolica, cod. gr. 1156,
fol. 194v (detail).

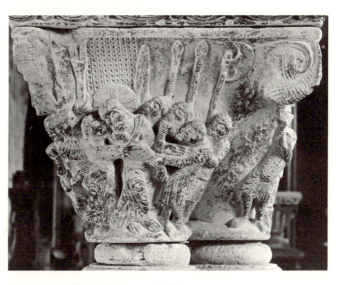

91. Arrest of Christ. Cloister capital from
La Daurade. Toulouse (Haute-Garonne), Musée
des Augustins.

and is much smaller than the other figures. The copy would be literal if the soldier did not seize Jesus by the wrist with a brutally realistic gesture of which there is no example in Byzantine art. The scene in the Toulouse museum is reproduced with even more spirit on a capital of the west façade of Chartres. The figures are placed in the same way in the drawing at the cathedral of Auxerre, which I have frequently referred to (fig. 31),[183] and in the Life of Christ from St.-Martial at Limoges.

But other examples will show just how faithful our artists were in imitating. Although in appearance this scene of the Kiss of Judas is always the same, several variants are to be observed when Byzantine miniatures are considered. A Gospel-book from Gelat, in Georgia, shows St. Peter near Judas and at Christ's left cutting off the ear of Malchus, who remains *standing* and seems not to notice.[184] At the cost of this unlikelihood, the composition retains a sober grouping and an uninterrupted line. On the exterior of the church of St.-Paul at Dax, there is an almost formless relief in which, however, we can recognize the Arrest of Christ. When these childish figures are examined, Judas is seen to be at Christ's left, and at the extreme edge of the composition St. Peter cuts off Malchus' ear. *Malchus is standing.* It is clear that the poor artist did not invent the composition of this crude work and that he copied a model very like the miniature of Gelat.

But there is another variant in Byzantine art. Certain artists, instead of placing Malchus to one side, imagined on the contrary that he was the one who had laid hands on Jesus: while at the spectator's left Judas embraces Christ, Malchus seizes him from the right. Thus, it is now at the right that St. Peter cuts off the ear of the *standing* Malchus. Consequently, the episode of Malchus is no longer an isolated scene but is directly related to the drama. This is the form in which the Kiss of Judas appears on the completely Byzantine crucifix of San Gimignano (fig. 92).[185] This type was known to twelfth-century French artists, for it is found in a section of the window at Chartres: both the composition and the gestures are almost the same (fig. 93). I had first thought this to be an original creation, but the San Gimignano painting compels us to accept the obvious and recognize the imitation.

In Byzantine art, there are still other variations. In all the examples that we have studied, Judas approaches Christ from the left, but there are many Greek miniatures in which he approaches from the right.[186] This is why Judas is shown approaching Christ from the right in the relief of St.-Gilles (fig. 94). At the extreme opposite side, St. Peter cuts off Malchus' ear; Malchus is represented as a child. The composition would be completely Byzantine if the heads were arranged in a half-circle around Christ, but the Provençal artist, with a truly classical sense of monumental decoration, placed all the heads at the same level and carved a relief as composed as

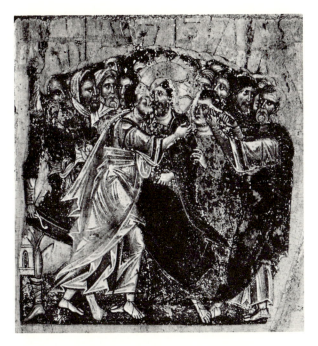

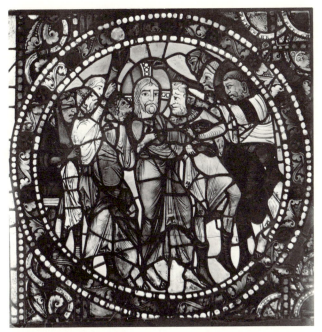

92. Arrest of Christ. Detail of painted crucifix.
San Gimignano, Museo Civico.

93. Arrest of Christ. Chartres (Eure-et-Loir),
Cathedral of Notre-Dame. West façade, stained glass
panel, south window.

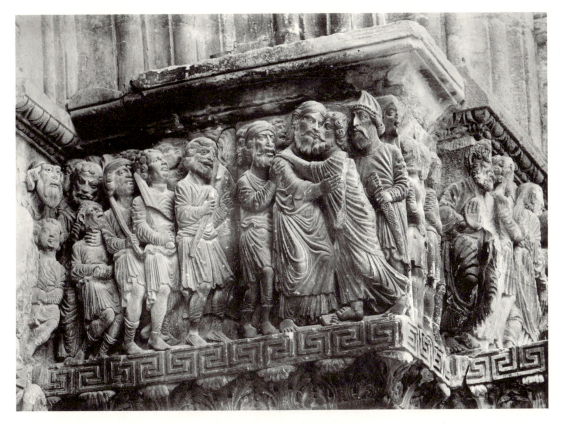

94. Arrest of Christ. St.-Gilles-du-Gard (Gard), Abbey Church. West façade,
frieze (detail).

the frieze of a temple. The Kiss of Judas at Beaucaire, a heavy and faulty work, is conceived in the same way as that at St.-Gilles.[187]

Thus, no matter what form the scene takes, its origin can always be found in Byzantine art.[188]

A study of the Descent from the Cross will just as clearly reveal these Byzantine influences.

It was in the tenth century that the Byzantine type of the Descent from the Cross appeared in all its beauty. A Greek manuscript in Florence preserves the earliest example (fig. 95).[189] Joseph of Arimathaea supports Christ's body while Nicodemus pulls the nail from the left hand; the right arm has already been freed; it would hang inert if the Virgin did not take it in her veiled hands with a tender but respectful gesture and bring it to her lips; St. John, standing immobile, expresses his grief in the manner of antiquity by placing his hand against his face.

Such an image presupposes a long meditation on the scene of Calvary.

In the East, at first, following the text of the Gospel, only Joseph of Arimathaea and Nicodemus, alone, had been represented freeing Christ from the cross.[190] There was a kind of desolate sadness, something heart-rending about the abandoned cross with the two men working in solitude. Was it possible that the Virgin and St. John had already departed from the

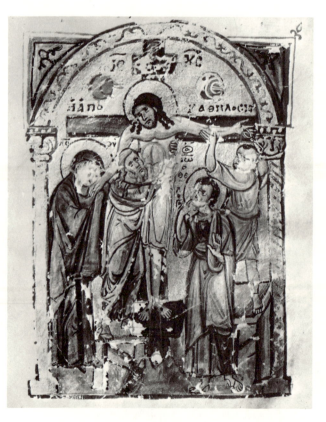

95. Descent from the Cross.
Gospel-book. Florence, Biblioteca
Medicea-Laurenziana, Greek ms. conv.
soppr. 160, fol. 213v.

foot of the cross? The Gospels do not say, but the Apocryphal Gospel of Nicodemus says that Mary witnessed the burial of her Son,[191] and thus it could be supposed that she and St. John had remained on Calvary. Even in a tenth-century manuscript, St. John and the Virgin witness the descent from the cross, but they play no part in it; they remain immobile, lost in contemplation.[192] The stroke of genius was to place Christ's freed arm in the hands of the Virgin. In this, writers preceded painters; the Greek mystics had already imagined what the artists represented. A tenth-century sermon writer, George of Nicomedia, has left us impassioned homilies on the Virgin that could have been written by a fourteenth-century Franciscan. The attitude he attributes to her at the moment of the descent from the cross is this: "She took the nails as they were pulled out, she kissed the freed members, embracing them tightly. She wanted to take him to her breast, to be alone in bringing him down from the cross. . . ."[193] This explosion of feeling explains the appearance in the same century of the Byzantine Descent from the Cross we have described above.

The scene was transmitted to France and imitated there. Most of our twelfth-century representations of the Descent from the Cross reproduce very exactly the Byzantine originals. The fresco at Vic (Indre),[194] the beautiful mutilated fresco of Le Liget (Indre-et-Loire) (fig. 96), the capital from La Daurade in the Toulouse museum, the capital at Lubersac

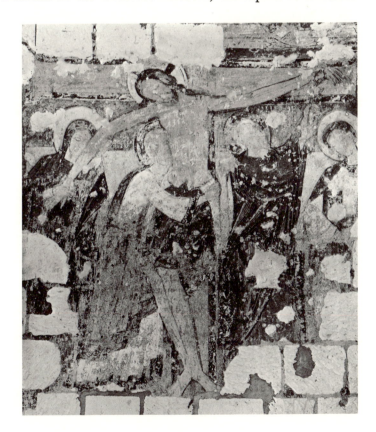

96. Descent from the Cross.
Le Liget (Indre-et-Loire), Chapel of
St.-Jean. Fresco.

(Corrèze) all copy most of the details of the ancient models.[195] Our artists, it is true, did not always imitate the delicacy of the Eastern artists who veiled the Virgin's hands: in France, the arm of Christ rests in the bare hand of his mother. However, some works are more faithful to the spirit of the originals: in the Descent from the Cross carved on the façade of the church of St.-Hilaire at Foussais (Vendée),[196] the Virgin's hand that takes Christ's arm is veiled; in Spain, in a relief of the cloister of Santo Domingo de Silos, a work derived from the school of southwestern France, the Virgin takes Christ's arm in her veiled hands.

In this moving Descent from the Cross, the Eastern artists had introduced very early a detail that makes the scene even more moving. Nicodemus, after freeing the hands, bends over before the cross to pull out the nails from the feet.[197] As a result, the almost detached body leans farther forward on the shoulder of Joseph of Arimathaea, and both arms are now held by the Virgin. This clearly conveyed that the Saviour was no more than a corpse; it gave a better sense of death's work. This new Descent from the Cross appeared at Tokali, in Cappadocia, in a tenth-century fresco (fig. 97).

Byzantine miniatures made it known in the West. It was faithfully imitated in one of the panels of the great window of Chartres devoted to the Passion (fig. 98), where, as in certain Byzantine works, Nicodemus kneels with one knee on the ground to pull the nail from the feet; Christ leans on the shoulder of Joseph of Arimathaea, and the Virgin has a thin veil over her hands as she supports the two arms of her Son.

But the Orientals, whose imaginations seem here inexhaustible, soon added a new feature to this touching Descent from the Cross. Until then, St. John had taken no part in the drama; he contemplated and wept in silence. But now that both of Christ's arms were freed, the Byzantine artists placed one in John's hands and the other in the hands of the Virgin. Like the Virgin, he holds it to his lips. Thus, as the composition gained in pathos, it gained also in balance and noble symmetry.[198]

This variant was not unknown in western art. In the Life of Christ illuminated at St.-Martial of Limoges in the late twelfth century, St. John holds the left arm of Christ while the Virgin supports the right arm.[199] As we see, there is not one detail in our western Descents from the Cross that is not already to be found in Byzantine models.

Another scene, the Descent into Limbo, or the Anastasis as it was called by the Greeks, appeared in twelfth-century France in a Byzantine form.

It is possible that the scene of the Anastasis was conceived very early in the East and that it had been represented in the Martyrium of Constantine at Jerusalem.[200] What is certain is that the Descent into Limbo had already been represented in art in the sixth century, as is proved by the carved columns of the ciborium of S. Marco in Venice, a priceless monument of

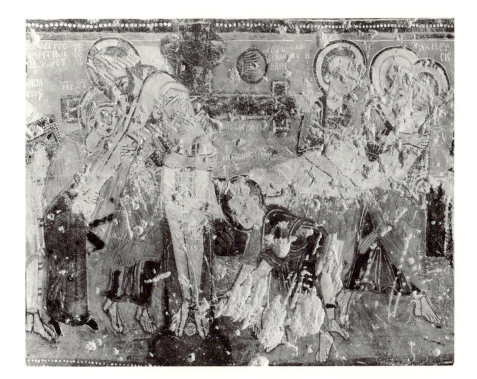

97. Descent from the Cross. Göreme,
Chapel 7 (Tokali Kilise). Fresco of
central apse.

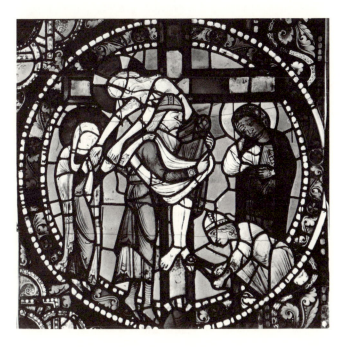

98. Descent from the Cross. Chartres
(Eure-et-Loir), Cathedral of
Notre-Dame. West façade, stained
glass panel, south window.

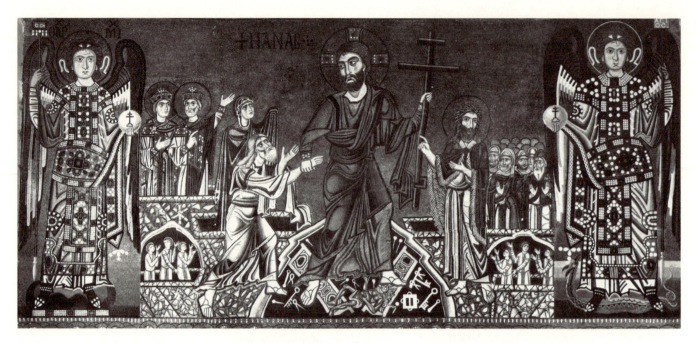

99. Descent into Limbo. Torcello, Cathedral. Detail of mosaic of west wall.

early Eastern Christian art.[201] There we see emerge the subject that the
Byzantines represented with such grandeur in the eleventh-century mosaics
of St. Luke of Stiris, of Daphni, of S. Marco in Venice,[202] and of Torcello
(fig. 99). Never has a scene had such fierce majesty. Christ, carrying the
cross of his martyrdom like a banner, has just passed through death and
seems to have increased in stature on emerging from the tomb; he seizes
Adam by the hand and leads him, along with Eve, toward the light. He
wrenches the symbolic pair from eternal darkness, as on that day he re-
leased all of humanity from the law of death. Satan and the Gates of Hell,
of which the Apocryphal Gospel of Nicodemus speaks, are beneath his
feet.[203] The work has that perfection of scale, the kind of implacable
majesty that overpowers us in Byzantine art.

How could our artists break away from such a model? A twelfth-
century window in the cathedral of Le Mans is an imitation of it in which
we find all the principal features of the original (fig. 100): as at Venice
and Torcello, Christ, whose thrust is to the right, turns toward the left for
an instant to seize Adam's hand and draw him along; Adam and Eve
are both clothed in the same way as their Byzantine models; Satan is
beneath Christ's feet.[204] But the French artist has added several details
to the original. He represents souls springing toward Christ out of a kind
of fiery furnace as devils try to hold them back. Such details were to
multiply until, as we shall see, they soon almost obscure the model.

Our demonstration is now complete. All of the scenes we have just

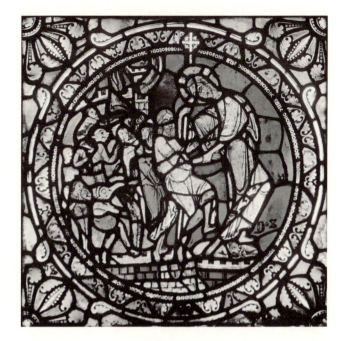

100. Descent into Limbo. Le Mans (Sarthe), Cathedral of St.-Julien. Stained glass panel of nave window.

reviewed prove that France, like all Christian countries, received its iconography from the East. As true artists, our painters and sculptors instinctively felt the beauty of this inheritance handed down to them from so distant a past. They did not know that so many peoples and so many centuries had collaborated to produce it; they were not aware that the Greeks had contributed their beautiful rhythm and the Syrians their passion, but in this art of antiquity they respected a mystery almost as venerable as the mystery of the dogma. For a long time they preserved these imposing forms, and it can be said that the Middle Ages never entirely renounced them. But our twelfth-century artists were too gifted to be nothing but copyists. We shall see them transform, little by little and with the collaboration of the Church itself, the inheritance they had received.

III

Eastern Iconography Modified
by Our Artists

The Nativity scene simplified by our artists. A new detail introduced into the Baptism of Christ. A new way of representing the Last Supper. Jesus giving Judas the morsel of bread. The Descent into Limbo and the Mouth of Leviathan. The rustic charm of the Annunciation to the Shepherds. The Annunciation simplified, the Visitation made more expressive, the Transfiguration modified.

There was a degree of youthful verve in our artists that must sometimes have caused them to chafe under the weight of tradition. In the admirable capitals from the cloisters of La Daurade and St.-Etienne, now in the museum of Toulouse, we sense a surge of life behind the consecrated forms. The sculptor expresses what he feels by gestures so well observed and even eloquent that they disrupt the old compositions: Herod familiarly takes Salome's chin in his hand after she has danced before him (fig. 101); Adam and Eve, liberated from Limbo by Christ, are drawn with irresistible force to heaven by two angels; on the morning of the Resurrection, St. John runs with St. Peter to the tomb and enters with such dash that he is obliged to catch hold of a column (fig. 102). It is obvious that such artists could not remain simple copyists, and there was no danger that they would stagnate in a routine like that of the Russian monks who century after century painted the same Byzantine icon.

The clergy themselves must not always have been completely satisfied with the ancient models they furnished to artists. In these scenes, conceived so far in the past, some details could have seemed irrelevant, and others were probably incomprehensible. The clerics must have suggested omissions and corrections. In this way, several of the great compositions created in the East were modified in the twelfth century by Western genius.

A few examples will illustrate this process of adaptation.

In Eastern art, as we have seen, the Nativity scene was excessively complicated. There was the open grotto in which the Child appeared twice, once in the crib and again being bathed by the midwives; there were the shepherds arriving from one side of the mountain while the magi appeared from the other—this kind of compartmentalized picture was oddly distracting. Eastern art, usually so great, is here petty, without unity, and almost childish. This is why this composition with its various parts was

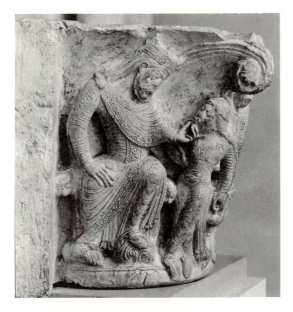 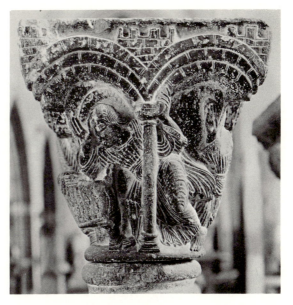

101. Herod and Salome. Cloister capital from
St.-Etienne. Toulouse (Haute-Garonne),
Musée des Augustins.

102. St. John entering the tomb of Christ.
Cloister capital from La Daurade. Toulouse
(Haute-Garonne), Musée des Augustins.

never imitated in France, if we except the Vézelay relief already mentioned. I have also said that a few miniatures and reliefs[1] showed only the midwives washing the Child beside the reclining Virgin. But even this episode was soon to seem irrelevant, and in the mid-twelfth century there appeared a composition of admirable simplicity and grandeur. True, its elements are still borrowed from the East, but a totally new feeling pervades the scene. The Chartres window devoted to the Infancy of Christ offers the earliest example (fig. 103). Nothing remains but the Virgin, St. Joseph, and the Child. At first glance, nothing seems changed: the Virgin reclines, St. Joseph sits and rests his chin on his hand, the Child lies between the two animals. But a closer examination reveals several innovations. The Virgin no longer lies on a pallet, as in the old Eastern models. Our artists were no doubt pained to see the Virgin lying on a kind of sack thrown on the ground; such poverty—perhaps not so considered in the East—seemed unworthy of the Mother of God. With that tender respect for Our Lady that will be seen to increase in art, they laid her gently on a bed. As before, the Child lies in a crib, but we observe that the crib is an altar. It is an arcaded altar like many such preserved from the Romanesque period; above the Child hangs a lamp, and the sanctuary curtains are pulled partly back. Here for the first time we see, as in the works of the Church doctors, the crib merged with the altar,

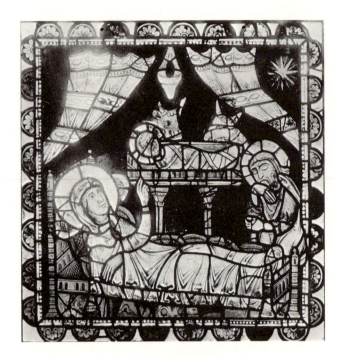

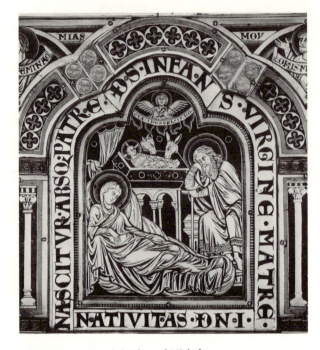

103. Nativity. Chartres (Eure-et-Loir), Cathedral of Notre-Dame. West façade, stained glass panel of central window.

104. *Nativitas Domini*. Altar of Nicholas of Verdun (detail). Klosterneuburg, Abbey Church, Stiftsmuseum.

and the Child represented at the very moment of his birth as a victim—profound symbolism that will be transmitted from the twelfth to the thirteenth century.[2] How far above the picturesque composition conceived in the East is this sober Nativity, with its solemn meaning! The western genius has scarcely wakened and already it outdoes its masters. An enameled plaque dating from 1181 represents a Nativity absolutely identical in feeling: it is one of the panels of the altarpiece of Klosterneuburg in Austria, the work of a French goldsmith, Nicholas of Verdun (fig. 104). The figures are disposed in the same way, and an open curtain allows the Child to be seen lying on the altar. These similarities give rise to a tempting hypothesis. The Chartres window, installed in the church about 1150, is the work of the stained-glass artists of St.-Denis;[3] the iconography they brought to Chartres is the one Suger had elaborated with his artists.[4] Also, Nicholas of Verdun seems to have been the heir of the goldsmith Godefroid de Claire of Huy who, as we now know, had worked at St.-Denis under the direction of Suger.[5] It seems natural to conclude that this Nativity, so imbued with Church doctrine, was created in Suger's presence and with his help. This hypothesis may seem surprising, but a later chapter will make clearer what a powerful center of art St.-Denis was in the time of Abbot Suger.

The Baptism scene was not so profoundly changed by our artists as the scene of the Nativity. They scrupulously respected the Eastern arrangement, but they did modify one detail. In Eastern art, the angels who witness the baptism of Christ have veiled hands; sometimes it is the tunic itself that covers the hands outstretched in a beautiful gesture of adoration that seems to come from the oldest religions of Asia; sometimes, a thin cloth covers their hands.[6] It has been thought that this pure cloth was intended to dry Christ's body when he emerged from the Jordan. But this is by no means certain, for it so happens that the angels beside God's throne also have their hands veiled in the same manner.[7] In Eastern art, this is one of the forms of veneration. In the previous century, the artist-monks of Greece still knew very well that at the moment of the baptism the angels were not preparing to dry Christ's body but covered their hands out of respect. The *Guide de la peinture* of Mt. Athos, written down only in the eighteenth century but composed of very ancient formulas, says expressly in describing the Baptism: "The angels respectfully cover their hands with their garments."[8]

It is possible that the artists and even the clergy of France, who were not familiar with Eastern ceremony, did not understand the significance of the veils over the angels' hands; they might have imagined them to be Christ's garments. What is certain is that in the panel of the Chartres window devoted to the Baptism, dating from about 1150, an angel was shown for the first time holding a long tunic which is the tunic of Christ (fig. 105). It would seem natural for the Son of God to be served by angels.

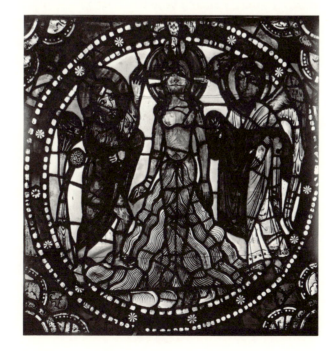

105. Baptism of Christ. Chartres (Eure-et-Loir), Cathedral of Notre-Dame. West façade, stained glass panel of central window.

This innovation became popular; we find it in manuscripts from the second half of the twelfth century, for example in the Life of Christ illuminated toward 1200 at St.-Martial of Limoges.[9]

In its proper place, I shall point out another change introduced into the iconography of the Baptism through the influence of the liturgy, but on the whole, these changes are small. The Last Supper, on the other hand, seems at first glance to be a creation of our twelfth-century artists. How much did they invent? How much did they copy? This is the problem we must try to solve.

The Last Supper as imagined by the Greeks still carried the mark of pagan civilization. The semicircular table has the form of a sigma; Christ and the apostles recline on couches in the manner of antiquity; Jesus is at one end, Judas at the other, the apostles are between them. One would say that a triclinium from Pompeii served as a frame for the mystical meal. Such is the Last Supper in a sixth-century mosaic at S. Apollinare Nuovo in Ravenna. Christ seems to speak and pronounce the terrible words of the Gospel of St. Matthew: "One of you shall betray me." Judas looks at him, the apostles look at Judas, but no one makes a gesture. The immobility, the stupefaction of the table companions, are not without beauty; here we find again something of the classical Greek spirit which always sought to conceal too violent emotions. But one detail indicates that we have entered a new world: the only food to be seen on the table is a plate of fish. During the first Christian centuries, Christ was $\iota\chi\theta\acute{\upsilon}\varsigma$ (ichthus), the mystical fish. As we know, the initial letters of the five words Ἰησοῦς Χριστὸς θεοῦ υἱὸς σωτήρ[10] form the mystical word $\iota\chi\theta\acute{\upsilon}\varsigma$. Thus, there is no doubt that in the Ravenna Last Supper the fish which replaces the paschal lamb on the table has symbolic meaning: when Jesus offers the fish to his disciples, he is offering them his own flesh.

Without any transition, let us set against this sixth-century Last Supper the twelfth-century Last Supper as it is represented in a window at Chartres (fig. 106). Everything is new. The table is no longer semicircular but is a sort of long and narrow trestle; the table companions no longer recline, they are seated; Jesus is no longer at one end of the table but in the middle; the apostles are placed at his right and left, and are consequently lined up on the same side of the table; St. John, formerly indistinguishable, can now be identified by his attitude, for he leans over with his head near the breast of the master; Judas, finally, can be seen at first glance, for he is isolated and sits at the other side of the table facing Christ. Here is a composition with absolutely nothing in common with the preceding one; a single detail relates it to the past: the presence of the fish on the table.

Nevertheless, we are not confronting here a totally new creation, but

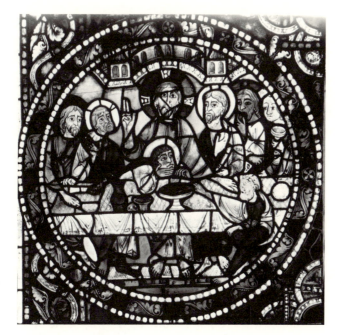

106. Last Supper. Chartres
(Eure-et-Loir), Cathedral of Notre-Dame.
West façade, stained glass panel of
south window.

an adaptation. Each of the details we have just noted can be found in earlier art, but nowhere do we find them all together.

In fact, the Last Supper, accepted by the Syrians in its Greek form, had little by little taken on new aspects in Eastern art.[11] Even though they retained the semicircular table, the Eastern artists had very early represented Christ seated at the center, not reclining at one end. This is proved by a miniature of the famous Cambridge manuscript, a very ancient Western copy of an Eastern manuscript.[12]

Although the semicircular table was the form usually represented in Eastern art, the long rectangular table with all the apostles seated at one side was not unknown. In one of the eleventh-century mosaics of S. Marco at Venice, a work in pure Eastern style, the table in the Last Supper has the latter form;[13] but the artist, faithful to the old traditions, placed Christ not at the middle of the table but seated at one end; St. John rests his head against Christ's breast.

Eastern artists usually placed Judas at the end of the row of apostles, but they, too, sometimes isolated him, calling attention to him by seating him alone and facing the semicircular table. This is proved by a very early Gospel-book illuminated in the East.[14]

Thus, the unusual features which caught our attention in the Chartres window had already been represented in Eastern art, but they appeared separately and never all together in one work. By bringing them together in one well-composed scene, the West created a new composition.

But in the Chartres window there is one profoundly original detail that is a kind of mark of the Western artists: they established between Christ and Judas a relationship that did not exist in their models. In Eastern art, the scene was based solely on the text of St. Matthew, and at first the artists had translated only the first part of Christ's words: "One of you shall betray me," as in the mosaic at Ravenna. Later they translated the second part: "He that dippeth his hand with me in the dish." In Byzantine art, Judas had often been shown stretching his hand toward the dish, but the scene went no further.

In the West, this was deemed insufficient, and St. Matthew's text was filled out by the text from St. John.[15] Here is the passage that inspired our artists: "When Jesus had thus said, he was troubled in spirit, and testified, and said: Verily, verily, verily, I say unto you, that one of you shall betray me. Then the disciples looked one on another, doubting of whom he spake. Now there was leaning on Jesus' bosom one of his disciples, whom Jesus loved. Simon Peter therefore beckoned to him, that he should ask who it should be of whom he spake. He then lying on Jesus' breast saith unto him, Lord, who is it? Jesus answered, He it is to whom I shall give a sop, when I have dipped it. And when he had dipped the sop, he gave it to Judas Iscariot, the son of Simon."[16]

This episode was never represented in Eastern art. Was it thought to be too intimate? Or that it would disturb the harmony of line? We do not know. The Western artists, on the other hand, translated the passage from St. John literally. In the Chartres window, Judas sits in front of the table and extends his hand toward the dish as in the text of St. Matthew, but at the same time and as in the text of St. John, he receives the morsel of dipped bread tended by Christ. The artist interpreted the original so exactly that he represented St. John placing his hand before his face so that the other apostles would not hear him when he asked the name of the betrayer. Thus, the composition became more complicated, but it acquired a dogmatic meaning that it did not have in the East. For the Christian, Judas' communion here is the terrifying image of sacrilegious communion.

In twelfth-century French art, the Last Supper appeared very frequently in this form. Miniatures, mural paintings, and reliefs reproducing the arrangement in the Chartres window are not rare. It will suffice to cite a capital of the Daurade cloister, now in the museum of Toulouse;[17] a fresco at Vic (Indre); a miniature of a twelfth-century missal, now in the Bibliothèque Nationale.[18]

But it happened that certain sculptors were disturbed by the figure of Judas isolated in front of the table. They no doubt found, and rightly so, that it upset the balance of the composition by cutting the beautiful horizontal line of the table. Consequently, they seated Judas among the apos-

tles, at the left or the right of Christ. But they nonetheless continued to represent the communion of Judas: Christ extends to him the morsel of bread over the head of St. John, who leans on the bosom of his master. Such is the formula that was adopted by the Provençal school. The Last Supper is represented thus on the central portal of St.-Gilles, where the relief, even in its mutilated state, preserves a classical nobility.[19] We find it again, but less delicately refined, in the frieze at Beaucaire (fig. 107), on a pillar of the cloister of St.-Trophime at Arles, on the lintel of the portal at Champagne (Ardèche), and in the church of Vizille (Isère).

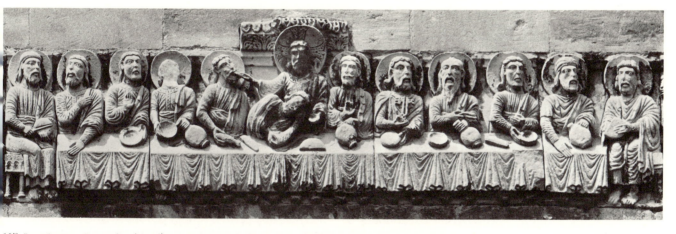

107. Last Supper. Beaucaire (Gard), Notre-Dame-des-Pommiers. Detail of frieze of south wall.

The Provençal formula of the Last Supper reached as far north as the Department of the Ain, where we recognize it on the portal of the church of Vandeins.[20] But it is also to be found much farther away. The Last Supper of the cathedral of Modena is conceived in exactly the same way as those of Beaucaire and St.-Gilles, and this is an important fact, for it clearly proves that the Provençal sculptors carried their art and iconography into northern Italy.

This is the kind of freedom our artists exercised in the face of Eastern tradition. The two ways of representing the Last Supper (and with many little variations in detail) belonged to them alone; here they did not modify only, they created.[21]

Other episodes from the life of Christ testify to an equal originality. The Descent into Limbo is, as we saw earlier, a scene conceived in the East. The theme was adopted by Western art but was soon transformed. As an example, let us study a late twelfth-century French miniature that came from St.-Martial of Limoges: Christ, crowned as a conquering hero, carries a long-staffed cross with which he pierces Satan stretched out at his feet (fig. 108). So far, nothing differs greatly from what we have already seen, but now French art departs from Byzantine art. Near

Christ, a monster's enormous mouth opens to create a passage for the saints of the Old Law; these saints, instead of being clothed as in Byzantine art, are naked, as they will be in eternal life. Christ takes Adam's hand—an Adam who seems to be clothed in new innocence: redeemed by the blood of Christ, he becomes again what he was before the Fall. This is certainly an entirely new conception, less nobly Greek perhaps but richer in doctrine. For the mouth of the monster—the terrible jaws of the grave—which opens at Christ's voice to render up its prey, is, as I have explained elsewhere, the mouth of Leviathan spoken of in the Book of Job.[22] And here we recognize the commentaries of the Church Doctors and the teaching of the Schools.[23]

For the Descent into Limbo, it is theological teaching that transforms the Eastern model; for the Annunciation to the Shepherds, it is the sense of life.

It is true that this latter scene as our artists conceived it is in large part only an imitation of ancient originals, since in Greek manuscripts of Gospel-books and Psalters from the eleventh and twelfth centuries we find almost all the features that strike us in their work.

We are surprised, for example, to note that in some twelfth-century works the angel speaks to two shepherds and in others to three,[24] and we are tempted to attribute these variants to the initiative of the artist. But we cannot do so, for Byzantine models sometimes show two and sometimes three shepherds.[25] There were two traditions in the East; the number of shepherds, unlike the number of magi, was never precisely established. Our artists conformed to one or the other of these traditions, depending on the model before them.

When there are two shepherds, the Greeks generally represent them as a young man and an old man. The old man, with his goatskin mantle covering his bare legs, has something of the classical about him which reminds us of the swineherd Eumaeus. We sometimes find these details in our art. On the St. Anne Portal of Notre-Dame of Paris, we recognize the traditional young and old shepherds and we observe that the old man wears the goatskin, but he has been transformed by the artist and no longer evokes the idea of Greek antiquity.

On the old portal of Chartres, there are three shepherds, one of whom plays a kind of Syrinx as he goes along. In a miniature of the Life of Christ, from St.-Martial of Limoges, one of the three shepherds plays a flute (fig. 109). Do we finally have here an invention of a French artist? Not at all. There is no longer any doubt that the idea of depicting a musical shepherd came from the East,[26] for as early as the tenth century, the flute player was represented in the underground churches of Cappadocia, and he could no doubt be seen in much earlier works. At an early period in the East, allusion was made in sermons and in the liturgy to the music of

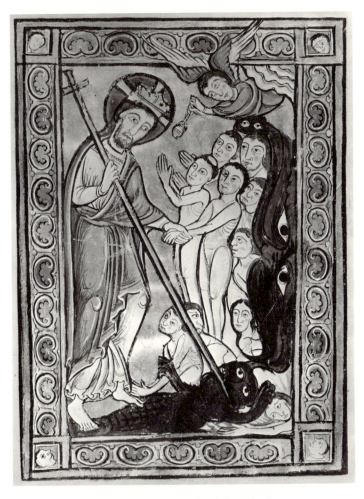

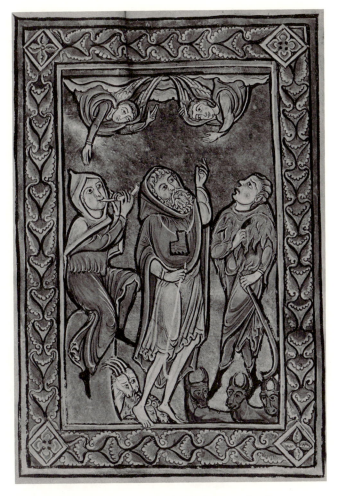

108. Descent into Limbo. Miniature cycle of the Life of
Christ from St.-Martial of Limoges. New York,
The Pierpont Morgan Library, ms. 44, fol. 11v.

109. Annunciation to the Shepherds. Miniature cycle of
the Life of Christ from St.-Martial of Limoges.
New York, The Pierpont Morgan Library, ms. 44, fol. 2v.

the shepherds; on that holy night, the music of their humble pipes ac-
companied the celestial song of the angels.[27] As we see, the shepherds'
Christmas carols are of no recent date. The musical shepherd, copied from
manuscript to manuscript, eventually appeared in the Greek Gospel-books
of the eleventh century, as for example in the Gospel-book in the Lau-
rentian Library.[28] It was from some of these Greek manuscripts that our
artists borrowed the figure. Sometimes there are striking similarities
between the miniatures of these manuscripts and our sculpture. In the
Greek Gospels in the Bibliothèque Nationale, the angel no longer speaks
from the top of a mountain or from the heavens; he stands on the plain,
facing the two shepherds; the old shepherd leans on his stick and leads
the way; the young man follows behind, carrying his little flute.[29] This

is exactly the Annunciation to the Shepherds on the portal of La Charité-sur-Loire: the beautiful angel, his wings still quivering, has just touched his feet to the ground; he turns toward the shepherd and speaks to the old man who listens thoughtfully;[30] behind him, the young shepherd comes forward carrying his flute (fig. 110).[31] It is quite evident that the

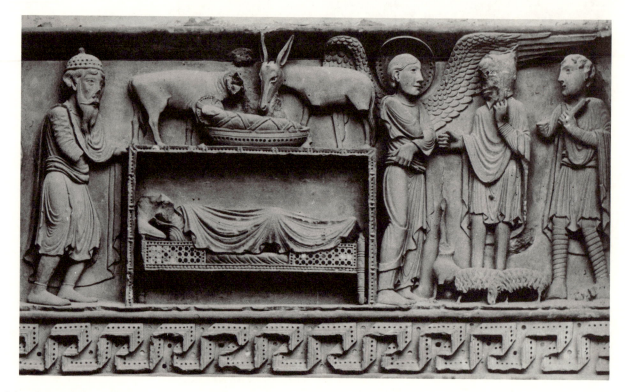

110. Nativity; Annunciation to the Shepherds. La Charité-sur-Loire (Nièvre), Abbey Church of Ste.-Croix-Notre-Dame. West façade, north portal, lintel.

artist was imitating, but he imitated with a breadth and fullness that raises his work far above those Byzantine miniatures in which the lean figures often seem to have antennae rather than arms and legs. The work already has a gentle rustic air: the old man with his hooded cape and high gaiters, the young man with his legs wrapped in narrow bands of cloth—these are the peasants of the old France on their way to midnight Mass. They lack only the flaming torch of twisted straw with which they lighted their way. Thus, our image makers were provided by the East with the basic outline of the scene; they sometimes followed it faithfully but at other times transformed it so completely that it is no longer recognizable. Given a subject whose heroes are peasants, certain artists could not keep from expressing what they had seen and loved since their childhood. As an example, take the Annunciation to the Shepherds from Notre-Dame-de-la-Coudre at Parthenay, a church now completely destroyed. This work, for a long time abandoned in a courtyard and then bought by an antique dealer, is now in the Louvre.[32]

Doubt has recently been raised about the authenticity of the heads of the three figures, but even while admitting a foundation for these doubts, the rest of the relief, which is reproduced in an old drawing, cannot be questioned. Now, we have here a composition which is largely new. The angel, almost destroyed, no longer has his feet on the ground but soars in the sky. The two shepherds are traditional, but the shepherdess shearing a sheep which lies on her lap has no model. Listening to the words of the angel, whom she does not see, she closes her shears to pay closer attention —a naïvely realistic touch. All of the details are taken from local life: one of the peasants, a shepherd from the marshy prairies of western France, is mounted on short stilts. Here we are far from Byzantine art.

Such artists could very well have turned to miniatures for inspiration, but they were far from being simple copyists. When it is a question of the life of Christ itself, they undoubtedly stick closer to their models and respect all the more the compositions consecrated by centuries. Even so, there are few Gospel scenes with which they do not take some liberties. In the preceding chapter, we reviewed the works in which they faithfully imitated their masters; we could cite many others in which they made changes.

Sometimes they simplified the originals. In Eastern art, the Annunciation was always filled with detail: there is an architectural setting behind the Virgin; she holds a ball of thread in her hand, and the angel carries the tall herald's staff of antiquity. In twelfth-century French art, these details gradually disappear. In the window at Chartres, the angel still carries the scepter, and behind the standing Virgin is the chair from which she has just risen; but on the west portal of Chartres (fig. 111), both the angel's scepter and the chair behind the Virgin are gone; only the book she has let fall from her hand catches our eye momentarily.[33] Soon, no detail will distract attention from the mystery just fulfilled. Gradually the grave Annunciation scenes of our thirteenth-century portals were being developed—scenes in which nothing recalls the transitory, and which leave us with a sense of timelessness.

Or again, our artists wavered between two formulas and created a third. In the Visitation as it was conceived in the Hellenistic cities, the two women stand facing each other, as we have seen; at Jerusalem and in Syria, on the other hand, they embrace, clasping each other in their arms. The first attitude seemed somewhat cold to certain of our artists, and the second lacking in restraint. Consequently, they placed the two women face to face, but clasping each other's hand (fig. 112); or, as at Notre-Dame of Paris, they extend their arms toward one another. These are only slight variations, but it was almost an act of creation to imagine any change at all when faced with originals in which everything was so strictly established.

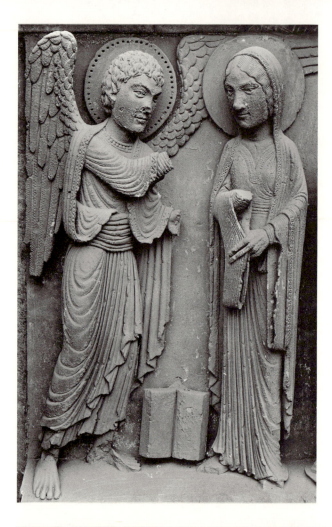

111. Annunciation. Chartres
(Eure-et-Loir), Cathedral of
Notre-Dame. West façade, south
portal, detail of lintel.

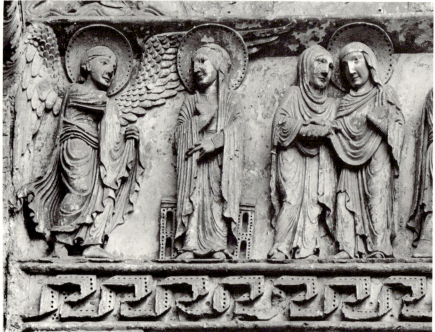

112. Annunciation; Visitation.
La Charité-sur-Loire (Nièvre),
Abbey Church of Ste.-Croix-Notre-Dame.
West façade, north portal, lintel.

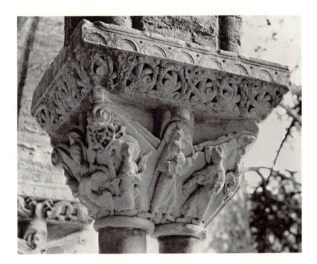

113. Transfiguration. Moissac
(Tarn-et-Garonne), Abbey Church of
St.-Pierre. Cloister capital.

Sometimes the French artists take liberties with their models that East-ern artists would have shrunk from. In the scene of the Transfiguration, the Byzantines would never have placed the two prophets at Christ's left and the three apostles at his right. Our artists did just this, and with one stroke destroyed the skillful architecture of the composition. A capital of the Moissac cloister has this bold arrangement (fig. 113).[34] And yet the artist undoubtedly had before him a Byzantine miniature, for on the other face of the capital he carved the three apostles descending the mountain under the guidance of Christ, who turns to speak to them—an episode that occurs in almost all illustrated Greek Gospel-books.[35] The Moissac sculptor had thus been quite free in his adaptation of the original. The Transfiguration was conceived with the same freedom on a capital from the cloister of La Daurade, now in the museum of Toulouse, and on a capital of the church of St.-Nectaire. At St.-Nectaire, the scene would not be recognizable were it not for an inscription.[36]

Is it necessary to recall the liberty taken by artists in bringing the cos-tumes of nonsacred figures up-to-date? A scene in the same series of capi-tals at St.-Nectaire shows the soldiers who seize Christ wearing the coat of mail and helmet of the twelfth century. The same military costume is represented in the Life of Christ illuminated at St.-Martial of Limoges.

The examples we have just given demonstrate that twelfth-century French art was not a slavish imitation of Eastern art, and that the West frequently added its own genius to the genius of Greece and the East. As a consequence, even the most modest works devoted to the Gospels are of the greatest interest. As we contemplate them, we seem to hear the mur-mur of centuries, the voice of all Christendom.

But what has been said thus far may seem insufficient. The following chapters will reveal how France enriched Eastern iconography[37] through the liturgy, through liturgical drama, and through the genius of her Church Doctors.

IV

Enrichment of the Iconography: The Liturgy and Liturgical Drama

I

The difficulty of this study. Art and the liturgy. The candles of Candlemas in the Presentation in the Temple. The Baptism of Christ and the liturgy of the baptism.

First of all, we shall see how the liturgy and liturgical drama enriched traditional iconography.

Such a subject must be treated with caution, for if we are not careful, we may attribute a detail to liturgical influence when it can be explained much more simply as an imitation of an Eastern original. For example, we could think that the procession of Palm Sunday had led our sculptors to place palm fronds in the hands of the apostles walking behind Christ in the scene of the Entry into Jerusalem.[1] In fact, on the morning of the feast of Palm Sunday, the canons, carrying palm leaves, did follow behind the cross, just as the apostles had followed Christ. The hypothesis is tempting, but we hesitate to adopt it when we learn that as early as the sixth century, in Eastern art, Christ and the apostles were already shown carrying palm leaves as they enter Jerusalem. This detail is found on an ivory, now in the Bibliothèque Nationale, that is probably of Alexandrian origin but in which Syrian influences are mixed with Hellenistic traditions.[2] At present, this is an isolated example, but it testifies to an ancient tradition which reappeared in a famous tenth-century Anglo-Saxon manuscript, the Benedictional of St. Aethelwold,[3] and in the eleventh-century Gospels of St. Bernward at Hildesheim Cathedral.[4] Thus, the presence of palm branches in the hands of the apostles can quite naturally be explained as an imitation of Eastern models.[5]

We must be no less careful when we attribute an innovation in iconography to the influence of liturgical drama. For example, in the window at Chartres and on the St. Anne Portal of Notre-Dame in Paris, we see Herod, troubled by the words of the magi, consulting the scribes and asking them to look in the Bible for prophecies of the Messiah. This tempts us to believe that the artists had been inspired by liturgical drama, for this episode was almost always included in the little plays devoted

to the magi that were performed in churches. But when we remember that this scene figures in Byzantine Gospels illuminated in the eleventh century, we see that it is useless to search for influences in plays.

These examples will give a sense of the problems involved in a study of this kind. We risk being mistaken, but it is nonetheless true that in many cases we can arrive at certainty or something approaching it.

Let us examine the scene of the Presentation in the Temple. The scene always conformed to the Eastern models, and these are of two kinds: in one, the Virgin holds the Child and presents him to the aged Simeon, who stretches out his veiled hands;[6] in the other, Simeon has already taken the Child and holds him in his arms.[7] In both types, St. Joseph, carrying doves, almost always stands behind the Virgin, while the prophetess Anna stands behind Simeon; an altar sometimes occupies the center of the composition.[8]

In the Middle Ages, sometimes one and sometimes the other model was reproduced. But toward the middle of the twelfth century, in the window at Chartres devoted to the Infancy of Christ, a detail was introduced for which we find no model in Eastern art: two attendants carrying lighted candles follow the Virgin as she presents the Child to the aged Simeon (fig. 114). Where did this new attribute come from? Here, there is no possible doubt. The artist was commemorating the procession of

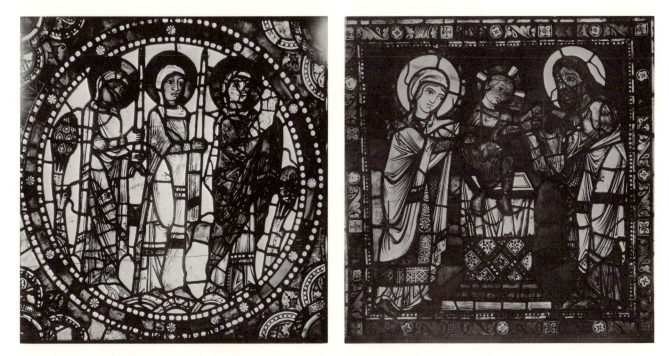

114. Presentation in the Temple. Chartres (Eure-et-Loir), Cathedral of Notre-Dame. West façade, stained glass panels of central window.

Candlemas, celebrated the second of February, the day of the feast of the Presentation in the Temple. Honorius of Autun, whose works are only a few years earlier than this window, mentions this procession in which each of the faithful had to carry a lighted candle. The ceremony, he tells us, was of great symbolic significance, for the candles represent Christ himself; their wax is his humanity, their light his divinity.[9] This is the ceremony commemorated by the Chartres artist, and he has the Candlemas procession originating during the very lifetime of the Virgin. The great art of the thirteenth century did not scorn this twelfth-century innovation, for on the small south portal of the cathedral of Rouen, where the tympanum is devoted to the Presentation in the Temple, we see the attendant carrying a candle.

 This is a clear case of liturgical influence. This influence is no less visible in certain representations of the Baptism of Christ. When we study the groups of charming twelfth-century figurines on the left portal of the cathedral of Sens,[10] where the story of St. John the Baptist is told on the archivolt,[11] we find among them a Baptism of an unusual sort. The catechumen is not plunged into the water, as was usual: St. John baptizes him simply by pouring water over his head. This is a curious innovation, and nothing like it is to be found in the preceding centuries. Nowhere do we see St. John baptizing *by affusion*, as it is called by the liturgists.[12] On the other hand, there are several examples of this oddity in the twelfth century. In a sacramentary from Limoges, which seems to date from the first half of the twelfth century,[13] St. John is shown pouring water from a small phial over Christ's head (fig. 115). In 1181, Nicholas of Verdun represented the Baptism of Christ in the same manner in one of the Klosterneuburg enamels. In both examples, Christ is immersed in the water, so that the baptism was both by immersion and by affusion.

 During the Early Christian era, as we know, the catechumen was immersed completely in the baptismal basin; at that time, only adults were baptized. Later, the custom was established of baptizing infants a few days after their birth, and fonts replaced the baptismal basins. In certain regions of Christian Europe in the twelfth century, infants were still completely immersed in the baptismal font; such was the case in southern Germany, as a miniature from the Salzburg school proves.[14] At what period did baptism by affusion begin to replace baptism by immersion? No liturgist has been able to say precisely.[15] From a passage by St. Bonaventura, we learn that in the thirteenth century baptism by affusion was already practiced in several Christian countries, notably in France.[16] For how long had this been true? He does not say, but I think we can say with assurance that this was already an old practice in France and went back at least to the twelfth century, as the works of art we have just cited prove. For it is evident that if artists represented St. John baptizing Christ

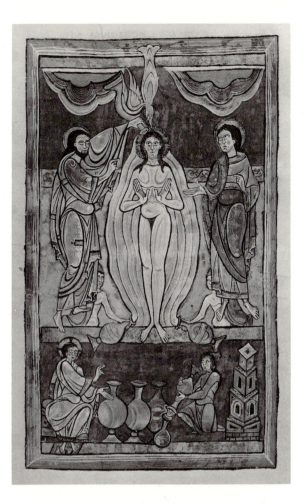

115. Baptism of Christ; Miracle at
Cana. Sacramentary from St.-Etienne
of Limoges. Paris, Bibl. Nat.,
ms. lat. 9438, fol. 24r.

by pouring a phial of water over his head, they did so because this form
of baptism was familiar to them. Art does not precede liturgy; it can only
follow.

These iconographic innovations drawn from the liturgy are not in
themselves considerable, but they prove that the art of the time was not
a kind of dead language; it drew life from the life of the Church.

We shall have an even stronger sense of this when we study the liturgical
dramas that were performed in the sanctuary on great feast days. Art,
we shall see, was inspired by completely new motifs and was enriched
by them.

II

Liturgical drama was originally only one of the forms of the liturgy. The
Christian cult is essentially dramatic. In symbolic form, the Mass repro-
duces the sacrifice on Calvary. After the elevation of the Host in the an-
cient rite of the church of Lyons, the priest stood for a moment with arms
extended, thus appearing as the very image of Christ on the cross. The
oldest parts of the Mass are a majestic dialogue between the celebrant and

Liturgical drama. The Play of Easter
morning and the new iconography of the
Resurrection. Appearance of the sarcopha-
gus. The holy women buying spices.
Mary Magdalene fainting on the tomb.
The Play of the Pilgrims to Emmaus.
The costumes of Christ and the pilgrims.

the congregation. On Palm Sunday, the Passion was read by several narrators; the shrill voices of the Jews replied to the grave voice of Christ. During Holy Week, at the Tenebrae service, the candles of the hearse were extinguished one after the other, and in this way the abandonment of Christ was both seen and felt. When only one lighted candle was left, it was concealed beneath the altar, just as Christ had been laid in the tomb, and a great tumult filled the darkened church; the world, abandoned by God, seemed to return to chaos. But suddenly the lighted candle reappeared, and God reentered creation after conquering death.

It is only natural that, very early, the powerful dramatic spirit inherent in the ceremonies of the Church should have given rise to representational drama.

The oldest of the liturgical dramas, the Resurrection Play, appeared at the end of the tenth century. It is described in full detail in the *Regularis Concordia*, which St. Dunstan wrote in 967 for the English monasteries.[17]

The ceremony began on Good Friday. On that day, after the Veneration of the Cross, the cross was wrapped in a linen cloth representing Christ's winding sheet and was carried in ceremony to the tomb: this cross was the Saviour himself. "An imitation of Christ's tomb" (*quaedam assimilatio sepulcri*) had been prepared on the altar; there the cross was placed and there it remained until Easter morning. Before the first bells were rung, it was secretly removed and only the linen was left in the sepulcher. Then the Mass began, and soon the Gospel of Easter Day was acted out before the eyes of the faithful: a monk dressed in a white alb came to sit beside the tomb, as the angel had done; three other monks, dressed in long mantles that made them look like women, advanced slowly and hesitatingly, thuribles in hand. "Whom seekest thou?" the angel asked them in a sweet low voice. "Jesus of Nazareth," the holy women replied. "He whom you seek is no longer here," the angel said. "He has arisen. Come and behold the place where they laid him." Then the angel showed that only the linen remained in the place where the cross had been. The holy women took the linen and held it up before the eyes of the congregation as they joyfully sang: "The Lord is arisen." At this signal, the congregation intoned a triumphal chant, and the bells rang in full peal.

St. Dunstan must not be thought to have invented this drama; he says in his preface that, quite to the contrary, he had gathered his honey, like the bee, from all kinds of flowers and had borrowed much from the churches of the Continent for use in his rude English church. The famous abbey of Fleury in Gaul had especially served as a model. Thus it is likely that from Carolingian times onward, the ceremony of Easter morning was celebrated in French monasteries. It gradually spread, and in the course of the Middle Ages was adopted by great numbers of churches in the Christian world.[18]

In these early times, and in this way, faith itself turned creator. As the candles paled in the dawn light of Easter morning, the mere reading of the Gospel did not satisfy the hearts of the faithful; they, like the holy women, yearned to see the angel seated beside the tomb and to hear from his mouth the *Resurrexit* on which Christianity is founded. Christian drama was born of the uniting of youthful imagination with this ardent desire to believe.

Did the drama of Easter morning have any influence on iconography? Are traces of it to be found in the study of twelfth-century works of art? That is the question posed for us.

Until the twelfth century, our artists had followed a very ancient formula in their representations of the Resurrection: the tomb is a two-storied monument reminiscent of the funerary monuments of antiquity; an angel seated before the door speaks to the holy women. Such is the Resurrection on the capitals of Mozat (fig. 116), Brioude, and St.-Nectaire. Behind these works is an original created by Eastern Greeks of the Early Christian era.

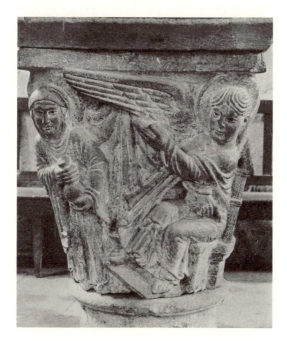

116. Holy Women at the Tomb. Mozat (Puy-de-Dôme), Abbey Church of St.-Pierre. Capital from the old ambulatory.

But in the course of the twelfth century, a completely new formula for the Resurrection appeared: the angel is seated no longer at the door of a funerary monument but beside a sarcophagus; the open or partly open sarcophagus almost always reveals a winding sheet. So they imagined at that time, and without concern for the Gospel texts, that Christ had been buried in a rectangular stone sepulcher like those to be seen in the cemeteries and churches.

This is a strange innovation. How is it to be explained? This time, it is difficult to refer to the imitation of an Eastern original, although Millet tried to prove in his vast work on the iconography of the Gospels that again our artists had been inspired by Eastern models—but by models they misunderstood.[19]

When the pilgrims to Jerusalem entered Christ's tomb, which was enclosed in a monument called the tugurium, they venerated several sacred stones. The first was the long, narrow slab that the disciples had used as a door at the opening to the sepulcher hewn in the rock; the next was the "stone rolled back from the sepulcher" which they had put against the slab to hold it in place; and lastly, there was a kind of stone bench, placed inside the funerary cave, on which the body of Christ had rested in death, and on which only Christ's shroud remained on the morning of the resurrection. Eastern miniaturists represented these stones. The angel sits before the sepulcher on a stone cube—the "rolled back stone," and sometimes leaning against it is the long slab that had sealed the door of the cave.[20] In other works we glimpse the funerary bench through the open door of the sepulcher. One can suppose that there came a time when the Western artists who imitated these Eastern miniatures no longer understood their meaning. The funerary bench suggested the idea of a sarcophagus, and it was assumed that the long slab was its lid.

Such is the explanation proposed by Millet. It is certainly ingenious, but can be found complicated. It is strange that Western artists would associate the slab found outside the monument with the bench inside. It is even stranger that the mistake of one or two copyists would in the long run become everybody's mistake; for in the twelfth century, it was not only in France but in England, Italy, and Germany, that Christ's tomb was represented as a sarcophagus.

I would propose another explanation instead. St. Dunstan's *Regularis Concordia* states that the cross was placed on the altar in "imitation of Christ's tomb." How must we imagine this simulacrum? The numerous rituals that have been preserved are no more explicit than the *Regularis Concordia*, although one does say that the tomb of Christ placed on the altar was a silver coffer.[21] This text is crucial, for the silver coffer in which the cross was placed was certainly a reliquary in the form of a sarcophagus, as were all the reliquaries of the time.

But the cross, wrapped in its shroud, was not always entombed on the altar. Often it was taken to another part of the church where a monument had been prepared for it: insofar as we can tell from a few words sprinkled here and there in the texts, this was a kind of ciborium supported by columns and enclosed with curtains. Sometimes this improvised monument was large enough for the angel and the holy women to enter it. It was there that the cross was taken.[22] There is good reason to think that it

was enclosed, as on the altar, in a coffer or a reliquary. The earliest texts are silent on this point, but at the very end of the Middle Ages, in the account books of English churches, it is said very explicitly that the sepulcher placed under the canopy was a coffer:[23] in this we see the perpetuation of an ancient tradition. This is why, when the ancient texts say that the angel opens the sepulcher,[24] or that two angels stand at the sepulcher, one at the head and the other at the foot,[25] we must imagine this sepulcher in the form of a sarcophagus.

If we accept this explanation, it is no longer hard to understand why the sarcophagus was substituted in Western art for the two-storied monument represented by the Eastern Greeks, or for the cave hewn in the rock represented by the artists of Constantinople. It explains why our artist had imagined, against all likelihood, that the body of Christ was placed in a rectangular tomb: this was the tomb of the cross which represented Christ.

Moreover, liturgical drama will make certain twelfth-century works suddenly intelligible when no Eastern miniature can explain them.

In the ambulatory of the church of St.-Paul at Dax, there is a relief representing the Holy Women at the Tomb (fig. 117). Nothing in it recalls Eastern types: the tomb is a kind of coffer surmounted by a triangular lid; two angels raise this lid to demonstrate that the tomb is empty; above it, two hands swing censers; another hand holds a cross.

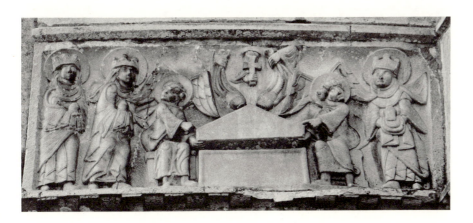

117. Holy Women at the Tomb.
Dax (Landes), St.-Paul.
Exterior relief of apse.

The cross is the most revealing detail: inevitably we think of the cross that had been taken from the tomb before the arrival of the holy women, and we think also of the two angels who sometimes figured in the liturgical drama in conformity with the texts of St. Luke and St. John, and were seated at the head and the foot of the sepulcher.[26] And again, do the two censers not recall that from the time of St. Dunstan the tomb of the cross was censed?

The influence of liturgical drama is no less visible on one of the pillars

of the cloister of St.-Trophime at Arles. There again we see the two angels at the two sides of the tomb; the cross, which has just been lifted from the sarcophagus, rises above, and we see the shroud that had enveloped it; an angel in the upper part of the composition swings a censer. The holy women appear in the adjacent panel, and the spice merchants near them prove, as we shall demonstrate later on, that the whole work was inspired by liturgical drama.

In these examples the sarcophagus has no architectural frame, but quite often it appears beneath a sort of canopy: we think at once of the ciborium erected in churches for the ceremony of Easter morning. This canopy above the sarcophagus is to be found in many reliefs in the churches of western France: Chalais, Chadenac,[27] the bell tower of the Abbaye-aux-Dames at Saintes, and the façade of the church at Cognac. Is it only an illusion to see again here the traces of liturgical drama? I find it hard to believe. In the magnificent window at Poitiers, the scene of the Holy Women at the Tomb is placed beneath the great Christ on the Cross;[28] there, also, the sarcophagus rests beneath a kind of canopy, and the angel, seated outside the monument, holds in his hand a small cross reminiscent of the cross at Dax (fig. 118). The impression is that this is the angel who has just taken the cross from the tomb, where the shroud remains. As always, we are led back to liturgical drama.

118. Holy Women at the Tomb.
Poitiers (Vienne), Cathedral of
St.-Pierre. Apse, detail
of "Crucifixion" window.

Liturgical drama, and not Eastern originals, explain certain striking gestures of the holy women and of the angel in our twelfth-century monuments.

As early as the tenth century, as we have seen, the holy women took the shroud and showed it to the faithful—a tradition that was handed down from century to century, as the rubrics prove. This accounts for the attitude of the first of the holy women. She leans over the open tomb and grasps the sudarium. This gesture, unknown in the East, is shown on a capital from the cloister of La Daurade, now in the museum of Toulouse. We find it again on a Limoges reliquary, now at Nantouillet, which seems

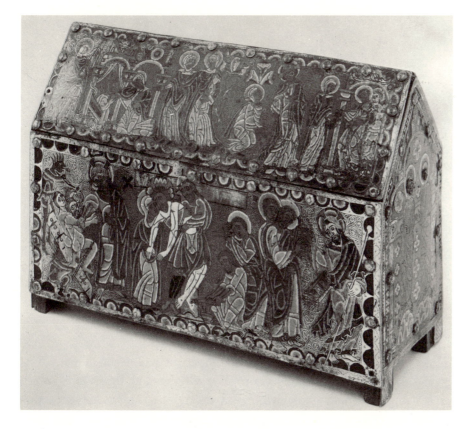

119. Holy Women at the Tomb and other scenes of the Passion. Enameled reliquary. Nantouillet (Seine-et-Marne), Church.

to date from the late twelfth century (fig. 119).[29] This was a bold innovation, for nowhere in the Gospels does it say that the holy women saw the sudarium, much less that they touched it; only liturgical drama can explain it.

In our monuments, the angel does not just point to the sarcophagus; sometimes he raises the lid to prove that it is empty (fig. 120).[30] We think immediately of the rubrics directing the angel "to uncover the tomb." Nothing could be more beautiful, more magnificently symbolic than the angel's gesture. This terrifying lid of the sepulcher, which had never been opened for anyone, is raised by the angel; he shows that the tomb has lost its terror, that henceforth death is nothing. Eastern art had not imagined this.

Lastly, the holy women, who preserve a noble gravity in Eastern art, are sometimes shown in our art with their hands convulsively clenched, as for example on the capital at Lesterps (Charente). In liturgical drama from the twelfth century onward, the holy women express their grief, as we shall see in what follows.

So there are quite a number of details in the scene of the Holy Women at the Tomb that came from liturgical drama. Should we go even further and follow German scholarship in proposing that the idea of representing Christ himself standing in the tomb came from the drama?[31] We must

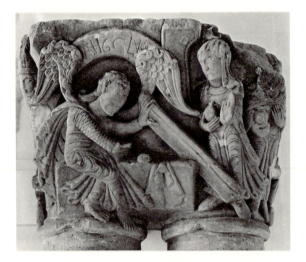

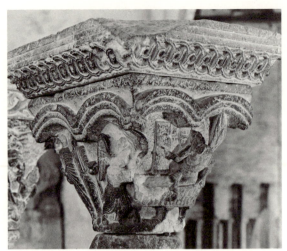

120. Angel lifting the cover of the tomb. Cloister capital from St.-Pons-de-Thomières (Hérault). Paris, Louvre.

121. Resurrection. Cloister capital from La Daurade. Toulouse (Haute-Garonne), Musée des Augustins.

admit that for centuries, curiously enough, artists had never shown Christ at the moment of his resurrection. The Greeks and the Near Eastern artists represented the holy women at the tomb; the Byzantines represented the descent into Limbo; neither represented Christ issuing from the tomb. But in the twelfth century, on a capital from the cloister of La Daurade now in the museum of Toulouse, we see Christ stepping out of the sarcophagus, the lid of which he has pushed aside; two angels aid him, one supporting his arm (fig. 121).[32] The resurrection, the mystery that ancient artists, imitating the restraint of the Gospels themselves, had never dared to represent, is here shown in all its reality—an extraordinary audacity and truly hard to explain. It would be tempting indeed to suppose that as early as the twelfth century a participant concealed in the tomb, like the actor in the fifteenth-century Mystery of the Resurrection, suddenly pushed aside the lid and rose up as the conqueror of death. Such a hypothesis would also explain why Christ emerges from an open rather than a closed tomb as indicated by the Gospels. The trouble with such a hypothesis is that it is entirely without foundation; no text supports it.

Everything seems to prove that, on the contrary, in the twelfth century —the great theological century when art and drama were closely bound up with liturgy—the Easter morning ceremony had only the characters we have indicated. Would anyone have dared at the time to represent Christ issuing from the tomb in a church, before the eyes of the congregation? Would that not have seemed a profanation of the mystery? Certainly not one of the extant liturgical dramas contains anything of the sort. We must therefore admit that we know nothing of the causes for so surprising

an innovation. It is moreover an imposing one and does honor to Western artists. The scene as conceived at Toulouse is still somewhat lacking in nobility; it was only in the thirteenth century that it attained true grandeur. In the window at Bourges,[33] the Christ standing on the tomb between two angels, the fierce Christ rising up in the shadows, has a terrible majesty; we sense that he has shed his humanity and has become fully a God.

The resurrection as told in the Gospels contained other elements of drama; the twelfth century developed them. A short dramatic interlude was soon added to the completely liturgical ceremony of Easter morning. St. Mark tells us that the holy women bought ointments before going to the tomb;[34] that is why a dialogue of the three Marys with the spice merchants was inserted in the Paschal liturgy in the twelfth century. In a manuscript from Tours, this episode has been developed so that it already resembles a little mystery play.[35]

Here is the dialogue, but robbed in translation of its charm, its song, its cadence, and its Latin rhyme:

MARIA JACOBUS: We have lost our solace, Jesus Christ, son of Mary; He was our aid and our refuge. Alas, how great is our sorrow!

MARIA SALOME: My sisters, in spite of our grief, let us go to buy ointments that we may anoint the body; no longer will it be a prey to worms.

MERCHANT: If you wish to buy ointments, come, here they are. They have a marvelous potency whereby, if you anoint a body with them, it can decay no further, nor can worms eat it.

THE THREE MARYS: O grief! (*Speaking to merchant*) Tell us, young merchant, how much do you ask for these ointments?

MERCHANT: Women, listen to me, notice that the ointments I offer you are of the best quality; they are worth one gold talent; that is the fairest price.

THE MARYS: Who will tell the grief of our hearts?

SECOND MERCHANT: Women, what do you desire?

THE MARYS: Merchant, we want spices, have you what we need?

SECOND MERCHANT: You have only to tell me.

THE MARYS: We need balm, frankincense, myrrh, aloes.

SECOND MERCHANT: Here is everything laid out before you. How much do you need?

THE MARYS: We need about a hundred pounds. How much will that be, merchant?

SECOND MERCHANT: A thousand sous.

THE MARYS: It's a bargain. (*Then the Marys give him the money and take the ointments and spices; then they go to the sepulcher.*)

This dialogue is certainly still not very adroit, but in it we glimpse

already a shrewd observation of human nature. The three Marys may very well be inconsolable, but all the same they see that the young merchant asks too much for his wares; they do not bargain, but they go to the next merchant. Thus, even in the deepest grief, man's instinct to protect his own interests does not desert him. Here we see the liturgy opening out, no longer into drama but almost into comedy.

The novelty of this dialogue must have charmed the people of the time, for it was imitated. The scene between the holy women and the spice merchants appeared in Germany in the following century;[36] and again, with all the embellishments imaginable, in our great fifteenth-century mystery plays.

We can affirm that in the twelfth century the dialogue of the holy women and the spice merchants was recited on Easter morning in the churches of southern France, for Provençal artists were inspired by it many times. On the lintel of a portal at St.-Gilles, we see the three holy women pausing before the counter of a merchant who weighs the spices in a scale (fig. 122).[37] We recognize exactly the same scene in the frieze decorating the church of Beaucaire (fig. 123). And we find it again in the cloister of St.-Trophime at Arles, where a large relief represents the three holy women in the upper part, and in the lower part, the two merchants seated before a counter.[38] The analogy between these works of art and the liturgical drama is complete, for at Arles, as at Beaucaire and St.-Gilles, there are two merchants, not one, and at Beaucaire, moreover, one of the merchants is an old man and one is young.

But there is something even more curious. In the museum of Modena there is a Romanesque capital which, on one face, has the same three

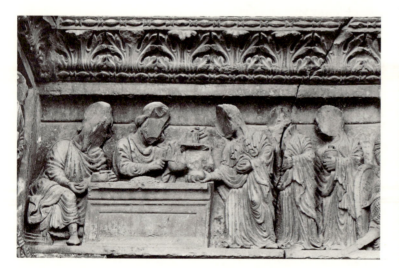

122. Holy women buying spices. St.-Gilles-du-Gard (Gard), Abbey Church. West façade, south portal, lintel.

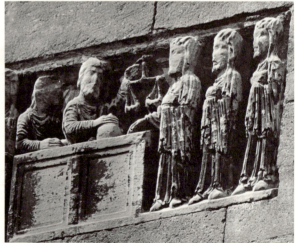

123. Holy women buying spices. Beaucaire (Gard), Notre-Dame-des-Pommiers. South façade, detail of frieze.

Marys buying the spices; there also we see two merchants and it cannot be by chance that one is old and the other young (fig. 124). The second face of the capital contains an extraordinary scene, and the only example I know. One of the holy women, overcome with weeping, has fainted on the tomb and her two companions try to raise her (fig. 125). Now, in the liturgical Play of Tours, several pages after the scene of the holy women and the spice merchants, we read:

"Mary Magdalene, who must be standing at the left side of the church, should rise and go to the sepulcher; she should clap her hands together and say, weeping: 'Woe unto me! O grief, O sorrow! Jesus Christ, Glory of the World, it is thou who redeemed me, it is because of thee that I shall be blessed with life eternal; and now the Jews have nailed thee to the cross and thou hast died for us. . . .' "

Mary Magdalene's lamentation continues until she is overcome and faints, for this is what we read farther on:

"Then Mary Jacobus should come and take her right arm, and Mary Salome should take her left arm and raise her up, saying: 'Dear sister, there is too much grief in your soul. . . .' "

Thus, the Modena capital represents another scene from the Play of Tours. Should we assume that it had been performed at Modena? Such a supposition is beside the point, for there is no doubt that the Modena capital is the work of a Provençal artist. The likeness is complete between the face of the capital representing the Holy Women Buying Spices and the relief at Beaucaire devoted to the same subject. Since this example is unique in Italian art while there are three examples of it in Provençal art, and furthermore, since there is nothing in twelfth-century Italian liturgy

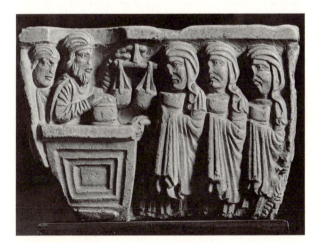

124. Holy women buying spices. Capital. Modena, Museo Civico.

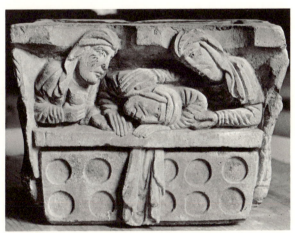

125. Mary Magdalene swooning on the tomb. Capital. Modena, Museo Civico.

comparable to the Play of Tours, we may conclude that the subject is of French origin and that Provençal artists introduced it into Italy. A study of the Modena reliefs can only confirm this conclusion, because at Modena, the Last Supper, for example, is identical with that at Beaucaire.

It is worth noting that in the scene at Modena, Mary Magdalene falls fainting on the sarcophagus of Christ—part of the shroud hangs out of the sarcophagus.[39] Thus, in a scene copied from liturgical drama, the artist represented Christ's tomb as a rectangular stone box. This provides proof that in certain churches the sepulcher prepared for the ceremony of Easter morning had the form of a sarcophagus. Thus, monuments confirm what we had surmised from texts.[40]

For a long time, the Resurrection Play was no more than a setting for the Gospels on Easter morning. The angel announced the resurrection, but the resurrected Christ was not seen. In the course of time, imaginations grew bolder and from the twelfth century onward, Christ himself appeared to the holy women and to the disciples. When we think about it, such daring is truly unbelievable. It amazes us today that a priest or a monk could, even for an instant, have put himself forward as the Son of God without seeming sacrilegious. Artistic feeling had indeed to be powerful and imagination authoritative among our Western peoples; we can see how the people who dared transform the Gospel into drama could, at the same time, create sculpture. The same order of genius gave birth both to the theater and to the plastic arts.

In the twelfth century during Holy Week, usually at vespers on Tuesday, the meeting of Christ with the pilgrims on the road to Emmaus was performed in certain churches.[41] Two travelers came forward, with caps on their heads and staffs in their hands;[42] as they walked, they sang softly: "Jesus our redeemer, our love, our desire." It was then that Christ appeared as a pilgrim. He, too, carried a staff and had a scrip slung from his shoulder. The travelers did not recognize him and began to talk of what had come to pass in Jerusalem, how Christ had been condemned to death and crucified. The stranger showed no surprise, but said to them: "The prophets announced that Christ would have to suffer to enter into glory." As they talked, they came to a table already set, and sat down. When Christ had broken the bread, he pronounced these words: "I leave you this bread, and peace be unto you." Then he vanished from their sight. It was only then that the travelers realized who the stranger was; they looked for him, but in vain. Then, full of sadness, they went on their way, saying: "Was not our heart burning within us whilst he spoke?"

As we see, the liturgical drama here begins to take on the aspect of a true mystery play.

When did the Play of the Pilgrims to Emmaus begin to be performed in the West? I think we can say that it was presented in many churches

as early as the first half of the twelfth century, for at that period it began to exercise an influence upon art. A relief in the cloister of Santo Domingo de Silos, in Spain, apparently closely related to the French art of Aquitaine, represents the episode of the pilgrims to Emmaus in a new way: Christ wears a ribbed cap and a scrip decorated with a cockleshell is slung over his shoulder;[43] he resembles the pilgrims who passed along the route to Santiago de Compostela. Here we recognize the costume worn in the liturgical drama.[44] This work dates from about 1130, the approximate date also of a famous English Psalter illuminated in the abbey of St. Albans,[45] in which a miniature devoted to the Pilgrims to Emmaus represents Christ with a cap, a scrip, and a double staff.

In the St. Albans manuscript, as in the Silos relief, the two disciples have not yet any characteristic attribute, but already on one of the small portals of Vézelay, the disciples carry the scrip.[46] The scrip of the disciples is not mentioned in the rubric of the Play of St.-Benoît-sur-Loire, but the drama that was performed in the cathedral of Rouen mentions it expressly.[47] That is why it is to be seen at Chartres in one of the panels of the window devoted to the Passion and the Resurrection (fig. 126), and also on a capital of the Daurade cloister, now in the museum of Toulouse.[48]

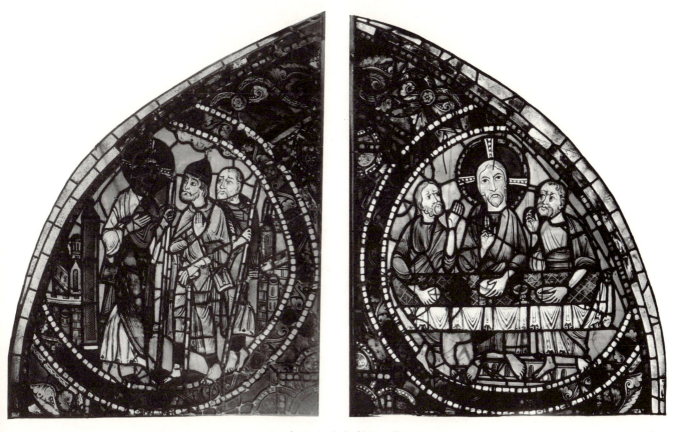

126. Pilgrims on the road to Emmaus. Chartres (Eure-et-Loir), Cathedral of Notre-Dame.
West façade, stained glass panels of south window.

If we would cast doubt on the influence of liturgical drama in this instance, we would have to establish that the attributes of Christ and the two disciples had already appeared in Eastern art, but Byzantine manuscripts offer nothing similar.[49]

We can now understand the meaning of the group of statues decorating one of the pillars of the cloister of St.-Trophime at Arles (fig. 127). This group had for a long time seemed incomprehensible, but we shall see that this is hardly the case. The figure in the center with bare head and feet carries a staff and a scrip; at his sides, two men wearing pointed caps also carry staffs and scrips slung over their shoulders. Instructed by the rubrics in liturgical dramas, we recognize at once the figures of Christ and the pilgrims to Emmaus. Here, as at Chartres, Christ is now bareheaded but the disciples still wear caps. It is strange that on the next pillar of the cloister, another group represents Christ showing his wounds to St. Thomas. This is, in fact, because Christ's appearance to St. Thomas directly

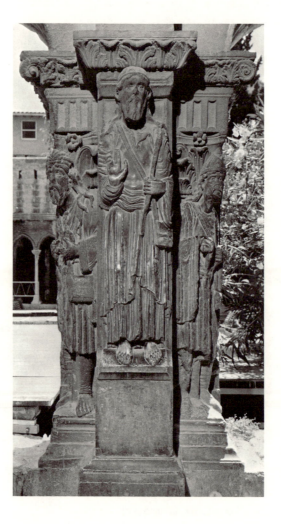

127. Christ and the pilgrims at Emmaus.
Arles (Bouches-du-Rhône),
St.-Trophime. Cloister pier.

follows his appearance to the pilgrims to Emmaus in the Play of St.-Benoît-sur-Loire. Consequently, it is as if the pillars of the St.-Trophime cloister, which in succession represent the Buying of Spices, the Visit of the Holy Women to the Tomb, the Pilgrims to Emmaus, and lastly, Doubting Thomas, were illustrations of the play presented in the church at Easter time.

III

Liturgical drama grew out of the Easter liturgy—the greatest feast of the Christian calendar, but very early the Christmas feast, so appealing to the imagination, produced its own plays. The Annunciation to the Shepherds, the Adoration of the Magi, the Flight into Egypt provided rich material. The Easter dramas had grandeur, but the Christmas plays had the charm of childhood.

The Play of the Magi originated in France, as, apparently, did the entire cycle of liturgical plays.[50] Ours was a double genius, the genius for drama and for art. For medieval Europe, France was what the Greece of antiquity had been for the Mediterranean world: the initiator.

The earliest known form of the Play of the Magi is found in an eleventh-century manuscript from St.-Martial of Limoges.[51] In the course of the twelfth century, the action was enlarged, a tradition governing the gestures of the characters was established, and the ceremony was enacted in the following way.

A few days after Christmas, during the Mass of Epiphany, three crowned figures dressed in silk robes came forward in the church. These were the three magi. They advanced solemnly, carrying golden boxes and singing as they walked, preceded by a star suspended from a thread. One pointed out the star to his companions, and said: "This is the sign that heralds a king." Then the magi approached the altar where an image of the Virgin holding the Child seems to have been placed, and they presented their offerings of gold, frankincense, and myrrh.

This is the simplest form of the drama.[52] Later, a new gesture was added. In the Play of Laon, the first of the magi-kings genuflects before offering his gift: *Accedunt Magi, et, genu flexo, primus dicit.*[53]

It was in the second half of the twelfth century that this little drama suddenly transformed the scene of the Adoration of the Magi as artists had represented it for centuries. Until that time, as we have seen, the magi had been placed one behind the other with their offerings in their hands, and they advanced toward the Child seated on his mother's knees. This was the type most often represented. The three figures, almost identical, made the same gesture and had the same attitude. Suddenly, life

The Christmas liturgical drama. New iconography of the Adoration of the Magi. The procession of prophets. Found in France on the façade of Notre-Dame-la-Grande at Poitiers. In Italy, at Cremona, Ferrara, and Verona. Moses represented with horns on his head. Aaron in the costume of a bishop.

was infused into the old formula. On the portal of St.-Trophime at Arles, the first of the magi-kings kneels before the Virgin; the second turns to the third, who is behind him, and points to the star; the third expresses his wonder by raising his hand.

On the portal of St.-Gilles, where the Adoration of the Magi fills a tympanum, we find the same gestures and attitudes, but the figures are grouped artfully instead of being placed one behind the other (fig. 128). A capital of the cloister of St.-Trophime, at Arles, is decorated with an identical Adoration of the Magi. This innovation, which was spread abroad by our ivories and miniatures, was adopted by all of Europe.

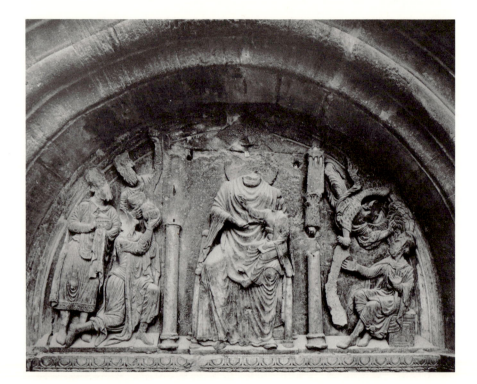

128. Adoration of the Magi.
St.-Gilles-du-Gard (Gard), Abbey Church.
West façade, north portal, tympanum.

Here, the influence of liturgical drama is unmistakable.[54] As a matter of fact, the gesture of the magus showing the star to his companion came from the drama, for the texts are categorical. The Limoges text says: *Unus corum elevat manum ostendentem stellam*;[55] the Besançon text says, *Rex ostendens stellam aliis*;[56] the Orléans text says, *Quam [stellam] ipsi sibi mutuo ostendentes procedant.*[57] Thus, the artists were merely reproducing a consecrated scene. The drama also explains the attitude of the first magus who kneels before the Child: the Laon text cited above leaves no doubt of it.[58]

This is a first influence of the Christmas cycle of plays on the iconography of the twelfth century. Here is another.

In certain churches, it was the custom at matins on Christmas[59] to read a sermon attributed to St. Augustine.[60] This was a vivid, dramatic work intended to convince the Jews by the testimony of the Bible itself. "Jews," cried the lector, "here I call upon you, who until this very day have denied the Son of God. . . . You want evidence of the Christ; is it not written in your own Law that if two men give the same testimony, they tell the truth? So be it! Let the men of your Law come forward, and there will be more than two to convince you. Isaiah, give us your evidence of the Christ."

Isaiah: *Ecce virgo concipiet et pariet filium et vocabitur nomen ejus Emmanuel.*

"Let another witness come forward. Jeremiah, in your turn give us testimony of the Christ."

Jeremiah: *Hic est Deus et non aestimabitur alius absque illo. Post haec in terris visus est, et cum hominibus conversatus est.*

"We already have two witnesses, but let us call on others to break down our hard-headed enemies." And successively the author calls on Daniel, Moses, David, Habakkuk, Simeon, Elizabeth, and John the Baptist. Daniel says: *Cum venerit sanctus sanctorum, cessabit unctio.* Moses: *Prophetam suscitabit Dominus de fratibus vestris.* David: *Adorabunt eum omnes reges terrae; omnes reges servient illi.* Habakkuk: *Domine audivi auditum tuum et timui; consideravi opera tua et expavi. In medio duorum animalium cognosceris.* Simeon: *Nunc dimittis, Domine, servum tuum in pace, quia viderunt oculi mei salutare tuum.* Elizabeth: *Unde mihi hoc ut veniat mater Domini mei ad me. . . .* John the Baptist: *Quem me suspicamini esse non sum ego, sed ecce venit post me cujus pedum non sum dignus solvere corrigium calceamenti.*

The lector speaks again: "O Jews, are not these great witnesses of your own Law, your own race, sufficient? Do you say that there must be witnesses of the Christ from men of other nations? Very well! When Virgil, the most eloquent of poets, said: *Iam nova progenies coelo demittitur alto,* was he not speaking of Christ?" And from among the Gentiles, the preacher cites two other testimonies, that of Nebuchadnezzar who, when he had thrown the three young Hebrews in the furnace, saw a fourth and said: *Nonne tres viros misimus in fornace? Ego video quatuor viros et aspectus quarti similis est filio Dei*; and that of the sibyl who pronounced the famous acrostic verses on the Last Judgment:

> *Judicii signum: tellus sudore madescet,*
> *E coelo rex adveniet per secla futurus.*

The lector concludes: "O Jews, I think that now you are overwhelmed by these many testimonies, and that henceforth you will have nothing to bring forward, nothing to reply."[61]

Out of this dramatic sermon the Middle Ages brought forth a true drama. First the sermon was read by several voices, as the Passion was read on Palm Sunday; then it was performed, as the Visit of the Holy Women to the Tomb and the Adoration of the Magi were performed. As early as the second part of the eleventh century, at St.-Martial of Limoges the precentor called on the prophets to appear to the Gentiles and the Jews; they came forward, one after the other, and chanted their replies.[62] They were the same characters as in the sermon;[63] their prophecies, changed only slightly by the exigencies of rhythm and the Latin rhymes, are easily recognizable. Isaiah, however, instead of speaking of the Virgin who will give birth, prophesies that a flower will emerge from the roots of Jesse.

The Play of the Prophets was quickly adopted by many churches in France. It was performed at the cathedral of Laon exactly as at St.-Martial of Limoges; the same characters chanted the same verses, but at Laon the procession was enlarged. When the prophets and the sibyl had filed before the nomenclator, Balaam, mounted on an ass, appeared to prophesy that a star would issue from Jacob.[64] Thus, it was thanks to the Play of the Prophets that the donkey made its entrance into the church.

At Rouen, the procession became much larger because the new prophets were added to the old.[65] Curiously enough, the Play of the Prophets was inserted in our oldest mystery play, the famous twelfth-century *Mystère d'Adam*, written in French.[66] Indeed, after the Fall, mankind would have remained without hope had not inspired men come, one after the other, to prophesy that God would send them a Saviour. Here again, new prophets—Abraham, Aaron, and Solomon—were added to the others.

This is all that has been preserved, but surely the old sermon had many more descendants. We may well believe that the Play of the Prophets was performed in numberless other churches of France whose ancient rituals have not been preserved.

But my subject is neither the history of the liturgy nor the history of literature, and I have discussed the Play of the Prophets only because it inspired artists.

When we study the façade of Notre-Dame-la-Grande of Poitiers, a façade carved like an ivory box, we see, above the arch on the left, four figures carrying banderoles and books on which inscriptions are carved (fig. 129). The first says: *Prophetam dabit vobis de fratibus vestris*; no name accompanies the words, but if we reread the sermon of the Pseudo-Augustine we quickly recognize the lines (scarcely changed) that the author puts in the mouth of Moses. The second character says: *Post haec in terris visus est et cum hominibus conversatus est*; and these are the very words given to Jeremiah in the sermon.[67] On the phylactery of the fourth figure is written: *Cum venerit sanctus sanctorum*, the prophesy attributed to Daniel in the sermon, and which must be completed with the words

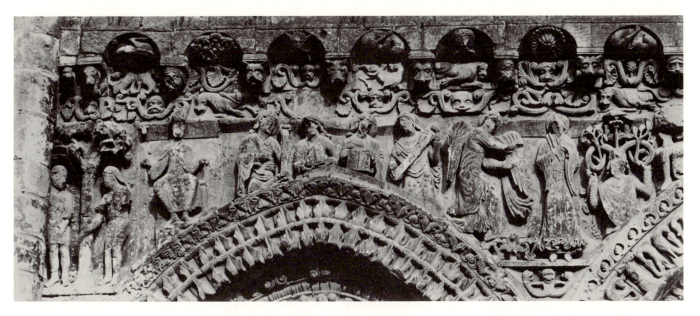

129. Play of the Prophets. Poitiers (Vienne), Notre-Dame-la-Grande. West façade, spandrel reliefs.

cessabit unctio. The third figure, about whom nothing has been said so far, has these words written on his book: *Egredietur virga de radice Jesse et flos de radice ejus ascendet*. There is nothing like this in the sermon, but if we go back to the *Mystère d'Adam*, we see that these are the very words spoken by Isaiah. And this is still not all: near the four prophets, a king is seated on a throne; he does not speak, but his name is inscribed beside him: *Nabuchodonosor rex*. Here, then, are the five characters of the famous sermon.[68] Had the artist been inspired by the sermon, or by the play derived from the sermon? That is difficult to say. However, there is some reason to favor the play, for there only do we find the prophesy that the Poitiers artist attributes to Isaiah. A relief devoted to the sin of Adam and Eve and placed alongside the five prophets inevitably calls to mind the structure of the *Mystère d'Adam*, but here the epilogue is added, since the Annunciation is paired with the Fall. The *Ave* of the angel is, according to the Schoolmen, the name of Eva written backwards. We can easily believe that a sacred drama very similar to the Anglo-Norman *Mystère d'Adam* was performed at Poitiers in the twelfth century, and that a reminiscence of it remains inscribed on the façade of Notre-Dame-la-Grande.

It is in Italy that we again find the prophets of the famous sermon. At the cathedral of Cremona, there are superposed reliefs at both sides of the portal; at the cathedrals of Ferrara and Verona, there are statues engaged in the columns of the portal. In all of these works, the imitation of French sculpture is apparent; in them we recognize the influence of Moissac, Toulouse, and the old portal of Chartres. Even the idea had come from France. At Cremona and Ferrara, the artist copied the text of the

sermon so exactly that he transcribed both the question asked by the lector and the response of the prophet (fig. 130). On David's banderole is written: *Dic, sancte Daniel, de Christo quid nostri—Cum venerit sanctus sanctorum cessabit unctio.*[69] At Cremona and Ferrara, there are only four prophets: Isaiah, Jeremiah, Ezekiel, and Daniel. But on the Verona portal we see Malachi, David, Jeremiah, Isaiah, Haggai, Zechariah, Micah, Ezekiel, Daniel, and Habakkuk. The number of the prophets and the inscriptions they carry on their phylacteries prove that the artist had been inspired not by the sermon but by a liturgical play very similar to that of Rouen.[70]

Thus, at Cremona, Ferrara and Verona, as at Poitiers, the prophets carved on the façade of the portal speak to the passerby, to the Jew and to the skeptic, constantly repeating their plea; constantly they urge men to read their mysterious words and to meditate on them. We see that the liturgical ceremony, in the form of a sermon in dialogue or as a play, had produced a theme of great majesty.

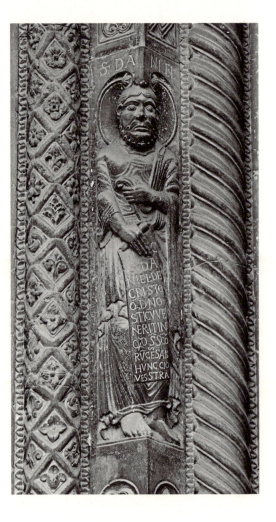

130. Daniel. Ferrara, Cathedral of San Giorgio. West façade, central portal, jamb.

But what is more, a certain small detail, which at this time became a part of iconography, can be explained only by the staging of the play. It is a surprise to see that Moses, until this time not singled out from the other prophets, has two knoblike horns on his forehead. So did the Moses formerly on the portal of St.-Bénigne at Dijon; the statue no longer exists, but Dom Plancher included a drawing of it in his *Histoire de Bourgogne* (fig. 174).[71] The portal of St.-Bénigne was carved in the second half of the twelfth century, but its exact date is not known. An English miniature, also from the second half of the twelfth century, represents Moses with two gold-colored horns (fig. 131).[72] It is clear that the artist had wanted to depict in this way the rays of light that emanated from Moses' face when he talked with God. His face shone so brightly, says the Bible, that he had to cover it with a veil; he took away the veil only when in the presence of the Eternal.[73] But it was not the artist who thought of materializing light by giving the rays shining from the forehead of the prophet the aspect of two horns; it was the staging director of the famous sermon.

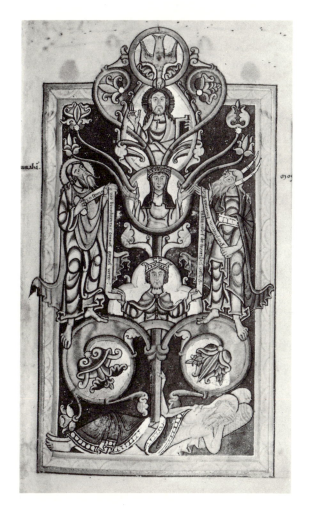

131. Tree of Jesse with Abraham and Moses. Psalter from Shaftesbury. London, Brit. Mus., ms. Lansdowne 383, fol. 15r.

Indeed, in the Play of Rouen, Moses, who led the procession, was distinguished by the horns on his forehead, *cornuta facie*.[74]

Such is the source of this strange attribute that appeared in the second half of the twelfth century; that is, at the time when the Play of the Prophets was having its greatest vogue. And the clearest proof that the Moses with golden horns of the English miniature had been inspired by liturgical drama is the text inscribed on his phylactery: *Prophetam Dominus suscitabit vobis de fratibus vestris*. This is exactly the verse from the sermon of the Pseudo-Augustine, which appears in more or less the same form in the *Mystère d'Adam*. But it must be added that in the miniature, as in the *Mystère d'Adam*, Moses is accompanied by Abraham. We read in the play, as on the phylactery carried by Abraham in the miniature: *In semine tuo benedicentur omnes gentes terrae*.[75] Such coincidences cannot be attributed to chance; therefore, it seems to me certain that Moses first appeared with golden horns on his head in the Play of the Prophets.[76]

Thus, Moses was presented as strange and formidable, like an Assyrian god. Eventually, it was found that this naïve idea could be turned into a most imposing one. It lay dormant for a long time; neither the twelfth nor the thirteenth centuries were able to uncover its hidden poetry. It was only at the end of the fourteenth century that Claus Sluter, by a stroke of genius, sensed all the overwhelming majesty contained in this union of human and animal nature. His Moses has the mane of a lion and the budding horns of a bull; he carries within him all the energy of untamed nature disciplined by thought. As a legislator, he emanates that force without which justice would be only a word; as the historian of the origins of the world, he seems to belong to a race older than the Flood. Even Michelangelo, who also represented Moses with the horns of a bull, did not surpass the old sculptor of Dijon; he gave no more superhuman grandeur to the one with whom the Lord spoke "face to face, as a man speaketh unto his friend."[77]

The rubrics of the liturgical Play of the Prophets give another very curious indication. In both the *Mystère d'Adam* and the Play of Rouen, the high priest Aaron was dressed in episcopal garments; he wore a miter on his head and in all respects resembled a bishop.[78] It is clear that the Middle Ages had only a confused notion of the past and had little feeling for the differences between centuries, but they were served by their own ignorance. By representing Aaron as a bishop, they expressed with naïve grandeur the continuity of the priesthood under the two Laws and the perpetuity of the Church. This costume of Aaron's, which we see appear in liturgical plays, passed into art under the influence of the drama.[79] In a late twelfth-century manuscript, Aaron sacrificing the lamb wears the episcopal miter; beside him, Moses, with horns on his forehead, receives the Tables of the Law from God (fig. 132).[80] Moses and Aaron are

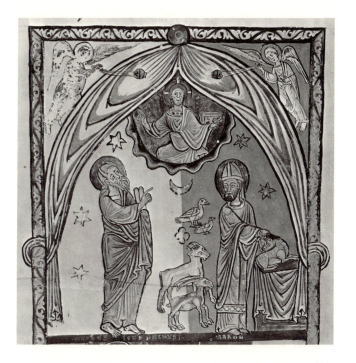

132. Moses receiving the Tables of
The Law and Aaron sacrificing the lamb.
Commentary on Leviticus. Paris,
Bibl. Nat., ms. lat. 11564,
fol. 2v (detail).

here represented as they appeared in liturgical drama. On the now de-
stroyed portal of St.-Bénigne of Dijon, alongside St. Peter who was paired
with St. Paul, Moses appeared opposite a bishop. This bishop was Aaron:
with Moses he represented the Old Law just as St. Peter and St. Paul
represented the New Law. This is the meaning of that statue of a bishop
which at one time stood on many twelfth-century portals. At Nesle-la-
Reposte (Marne), Aaron was at one side of the portal, St. Peter at the
other.[81]

Thus it was that the Play of the Prophets enriched or transformed tradi-
tional iconography; but its influence was even more profound for, as we
shall see, it inspired in Suger and his artists the magnificent theme of
the Tree of Jesse.

IV

Drama grew out of the Easter and Christmas liturgies, but dramatic sub-
jects were soon found in other ceremonies of the Christian year. From
the beginning of the twelfth century, the parable of the Wise and Foolish
Virgins had been performed at St.-Martial of Limoges. This poetic and
mystical story, both winning and terrifying, was well designed to affect
those souls whose only preoccupation was the Gospels. It belongs to the
sequence of terrifying stories in the Gospel of St. Matthew which, under
the veil of symbolism, prophesy the end of the world and the Last Judg-
ment. In the Limoges play, the French spoken south of the Loire was for
the first time mixed with Latin—a proof of the people's interest in these
austere representations.

The Play of the Wise and Foolish Virgins.
The Wise and Foolish Virgins in art.

The play must indeed have been moving. We must imagine it being performed in the darkness of the Romanesque church lit only by the five lamps of the wise virgins. In vain the foolish virgins implored their companions to give them a drop of oil; in vain they asked the oil merchant. It was too late. As they advanced, they repeated the lamentation: *Dolentas! chaitivas! trop i avem dormit.*[82]

They had slept too long. But they still had hope; they beseeched the bridegroom to open the door to them. The bridegroom then appeared and pronounced the terrible words: "I know you not! Since you have no lamps, begone! Wretched ones! You will be taken off to hell." Whereupon, devils seized them and led them into the darkness. No doubt the spectators shivered when they glimpsed the demons in the shadows. They appeared there for the first time, and we may well believe that they did not look like the jester-devils of the fifteenth century.

It was in the twelfth century that the Play of the Virgins was performed at St.-Martial in Limoges. Is it only by chance that the enamelists of Limoges, at the very end of the twelfth century, represented the Wise Virgins, and probably also the Foolish Virgins, in a series of enameled plaques, only two of which have been preserved?[83] It is difficult to think so.

The play must have been performed throughout southwestern France, for in the twelfth century, the artists of this region frequently represented the Wise and Foolish Virgins. They are carved on two capitals in the museum of Toulouse, one of which came from the cloister of St.-Etienne (fig. 133). These are probably the earliest works devoted to this subject. One, found there for the first time but which was to be endlessly repeated later, links the work of art with the play. The foolish virgins carry in their hands a lamp tapered at the bottom and opened out at the top like a chalice, and they carry it *upside down*. The Gospel says nothing about

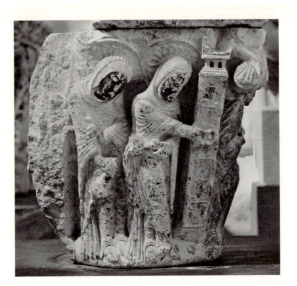

133. Foolish virgins. Cloister capital from St.-Etienne. Toulouse (Haute-Garonne), Musée des Augustins.

this, but the play is singularly precise on this point. "We, the Virgins who come toward you, negligently spill our oil."

> *Nos, Virgines, quae ad vos venimus*
> *Negligenter oleum fundimus.*

Thus is explained the gesture of the foolish virgins, for which there is no precedent in Eastern art. For there, the virgins hold long torches in their hands.[84] In France, the lamps they carried were the actual lamps of the church—those hung above the altars.

It was in the provinces bordering Limousin, in Poitou and Saintonge, that the Wise and Foolish Virgins was most often represented by artists;[85] the Play of St.-Martial of Limoges was no doubt performed throughout that region.

The theme of the Wise and Foolish Virgins soon found its way into the art of northern France. We shall see in the following chapter that it was taken to St.-Denis by sculptors from the south, but we must observe here that at St.-Denis the first of the foolish virgins is represented in the tympanum at the side of the damned; she is on the threshold of the infernal regions and, as in the play, will soon feel Satan's claw on her shoulder.

Such were the principal influences of liturgical drama on iconography; their importance was great. Freed of Eastern models, artists for the first time found themselves face to face with nature. They had to establish the moving gesture of the angel raising the lid from the tomb; they had to represent Mary Magdalene leaning over the sepulcher to take away the shroud or fainting on the sarcophagus. Along with the scenes of pathos, they had to represent popular scenes: the merchant at his counter weighing the spices in his scales, the holy women paying him for their purchase. They breathed life into the monotonous procession of magi-kings. They expressed the emotion of the magi at the sight of the star standing still above the head of the Child: two of the kings point toward it, while the first of them kneels. Each scene had to be created.

So it was that drama introduced an element of freedom into art, and enriched it at the same time. New motifs appeared on the portals of churches: prophets carrying phylacteries carved with the words of the Play of the Wise and Foolish Virgins, and somewhat later, as we shall see, the Tree of Jesse.

Costumes and singular attributes gave to consecrated personages an aspect they had never had. Moses had the horns of a bull growing from his forehead, Aaron wore a bishop's miter, the disciples at Emmaus carried the staff and scrip and wore the cap of pilgrims to Compostela, the wise and foolish virgins carried the lamps of the sanctuary. French art began to acquire a distinct character, to differentiate itself from Eastern art.

V

Enrichment of the Iconography
Suger and His Influence

Various factors contributed to the transformation and enrichment of twelfth-century iconography. Liturgical drama is one; the genius of Suger is another.

We are apt to think that the great art of the Middle Ages was a collective work, and it must be admitted that there is much truth in this concept, since the art of the time expressed the thought of the Church. But this very body of thought was incarnated in several outstanding men. Individuals, not the masses, are creators. Let us leave to romantics the mystical idea of a people building the cathedrals by instinct alone—an instinct more infallible than science and reason. The supposed magic wand called instinct never built anything. If we knew history better, we would find a great mind at the source of every innovation. When iconography is transformed and art adopts new themes, it is because a thinker has collaborated with the artists. Suger was one of those great men who directed art into new paths; thanks to him, St.-Denis from 1145 onward was the center from which a renewed art spread over France and Europe.[1]

It is only recently that we have begun to have an idea of all that French art owed to St.-Denis. First, it was discovered that Suger's famous ambulatory, with its radiating chapels and their particularly characteristic median-ribbed vaulting, had set a fashion. More or less faithful imitations can be recognized at St.-Germain-des-Prés, Senlis, Noyon, St.-Leu-d'Esserent, St.-Pourçain, Ebreuil, Vézelay, and St.-Etienne at Caen. Then it was perceived that the great monumental sculpture of northern France had been created at St.-Denis: on the portals of Chartres, Etampes, Provins, Le Mans, and Angers (to cite only the best known), the statues and reliefs were arranged according to the model provided by Suger's sculptors. Lastly, it was seen that the windows of St.-Denis had been imitated in France and in England, and that the splendid twelfth-century school of stained glass deserved to be called "the school of St.-Denis."

These are many claims to distinction for the church of St.-Denis. But

there were still others. I am convinced that medieval iconography owes as much to St.-Denis as architecture, sculpture, and stained glass. In the domain of symbolism, Abbot Suger was a creator; he provided artists with new types and new combinations that were adopted in the following century. Many chapters of thirteenth-century iconography were formulated at St.-Denis.

I

It is well known that Suger was careful to write down himself the story of the reconstruction of his church.[2] We are captivated by the tone of his book, even though it is written in difficult language, poorly composed, and without proportion. Love of the beautiful and faith in the virtue of art shines forth from every page. To Suger, art seemed a necessary mediator between the human spirit and pure idea. He wrote this noble verse: *Mens hebes ad verum per materialia surgit* (The dull mind rises to truth through that which is material).[3] Such a book, animated by lofty thought and rich in precise details, is unique; thanks to it, some of the profound mystery surrounding the creations of twelfth-century art is dissipated.

It is noteworthy that in his work Suger speaks less of the church itself than of the works of art that decorated it. He writes at greatest length of the windows, the altar frontals, and the great golden cross of the choir. He himself worded the inscriptions, and we sense that he carefully supervised execution. Now it so happens that all these works have the same character, and insofar as we can judge today, all were profoundly symbolic.

The golden cross deserves our attention above all, for it appears to have been one of the most precious monuments not only of the art but of the thought of the Middle Ages. It was intended to mark the holy place where St. Denis and his two companions had originally been buried. It could be seen from all parts of the church, for it was almost seven meters high. A large golden Christ, whose wounds were rubies, was fixed to the dazzling jewel-incrusted cross. A tall square pillar supported the cross, and this pillar itself was a marvel. On each face it was decorated with seventeen enamels in which the events in the life of Christ paralleled the scenes from the Old Testament which prefigured them; at the pedestal, the four evangelists wrote the story of the Passion, and at the top, four mysterious figures contemplated the death of the Saviour.[4] Five, and sometimes seven, goldsmiths had worked for two years on this masterpiece.

The vandals who melted down Suger's cross deprived us of a monument of primary importance. How many things would become clear if we still had the symbolic enamels of this pillar!

However, Suger's cross is not completely lost. A copy exists, but it is

St.-Denis and medieval art. The role of Suger. The great golden cross of St.-Denis, the work of Godefroid de Claire.

so reduced that it scarcely gives us an idea of the original. The museum of St.-Omer has a twelfth-century pedestal of a cross that came from the abbey of St.-Bertin. It is not more than thirty centimeters high; it is a square pillar faced with enamels; its base is decorated with four seated figurines who are the four evangelists (fig. 134). This charming monument, tiny as it is, seemed to Labarte to be a clear imitation of Suger's great cross. I believe that I can add evidence to Labarte's somewhat vague argument that will change probability into certainty.

In its upper part, the St.-Bertin pedestal is decorated with four singular figures. Two of them have their names inscribed beside them. One is Earth, a woman who holds a spade in her hand; the other is Sea, an old man carrying a fish. The two missing names are easy to guess; it is clear

134. Four evangelists; four elements. Pedestal of cross from the Abbey Church of St.-Bertin. St.-Omer (Pas-de-Calais), Musée des Beaux-Arts.

that the figure with a salamander in his arms is Fire, and that the other pointing to the sky is Air. These four figures are the four elements; they symbolize the principle of things. The Elements of the universe contemplate with stupefaction the death of the Orderer of the universe.

Now these four figures also decorated the capital that crowned the pillar of Suger's cross.[5] J. Doublet, the early historian of St.-Denis, copied the verses that were carved on the capital and which explain the meaning of the figures:[6]

> Terra tremit, pelagus stupet, alta vacillat abyssus,
> Jure dolent domini territa morte sui.

(The earth trembles, the sea takes fright, the profound abyss of air shakes; it is just that the elements, terror-stricken by the death of their creator, should lament.)[7]

There is no possible doubt. Although the inscription speaks only of earth, sea, and air, we may well believe that the four elements decorated the capital of the St.-Denis pillar. Thus, the goldsmith who chased the St.-Bertin pedestal of a cross faithfully copied the cross of St.-Denis. This beautiful and poetic idea, the great lamentation of the universe over the death of the Creator, was the product of Suger's imagination. The distich is clearly his; and moreover, above the capital Suger himself was to be seen, prostrated at the foot of the cross. This was his signature and a proof, as it were, that he had composed it all.

As an imitation of one of the most imposing works of the twelfth century, the St.-Bertin pedestal becomes a monument of the first order. One may suppose that the goldsmith who chased it was, in all likelihood, one of the seven artists who had worked at St.-Denis under Suger's direction. Who was this goldsmith? Until a few years ago he was not known, but we now know that the St.-Bertin pedestal came from the workshop of Godefroid de Claire of Huy.[8]

Godefroid de Claire is one of the great artists of the twelfth century. He was born at Huy, between Namur and Liège, in a valley of the Meuse that for centuries had reverberated with the sounds of the hammers of the brass workers and stonecutters. Godefroid de Claire was a French-speaking Walloon; he belonged to that active, ingenious race that produced so many artists and gave more than one to France.

His work, which must have been immense, has not entirely disappeared. It has been reconstructed by two scholars, Von Falke and Frauberger. Beginning with two reliquaries of Huy attributed to Godefroid de Claire by authentic documents, they have associated with them several other monuments, now dispersed in museums and church treasuries, that are certainly by the same hand. The likeness of the enamels embellishing all of these works indicates a common origin. In this way, the work of a great

artist has been restored to us. When we have read the pages written by the two scholars about the work of Godefroid de Claire, we willingly grant that the St.-Bertin pedestal came from his workshop. Its resemblance to the monuments of the same group is so close that no doubt is possible.

Let us accept their conclusions, for we cannot go into the details of their deductions here, and let us see what consequences we can draw from them. Von Falke and Frauberger said, "Perhaps it is not too daring to propose that Godefroid de Claire and his workshop were called to St.-Denis by Suger."[9] They say no more, and it is astonishing that they stopped there. We must show that it is possible to go farther and arrive at real certainty.

What we first recall is that Suger, speaking of the goldsmiths who worked at St.-Denis, referred to them as *aurifabros Lotharingos,* and hence that he had brought them from Lorraine. Now in the time of Suger, Namur, Huy, and Liège were part of what was then called the duchy of Lower-Lorraine, one of the divisions of ancient Lotharingia. This is the first striking evidence.

But it is in the work itself that we must find proof.

As we have said, the St.-Bertin pedestal is decorated with symbolic scenes in enamel. For example, there is Moses and the Brazen Serpent, Isaac Carrying Wood to the Sacrifice, and the *Tau* Sign Marked on the Foreheads of the Just. Each of these Biblical episodes is a figure of Christ's sacrifice.

If Suger's cross still existed, we would no doubt find on it all these scenes treated in the same way; but it has disappeared and nothing of Suger's work now remains at St.-Denis except several panels in the windows. By happy chance, two of the panels represent two of the very same scenes which decorate the pedestal of the St.-Bertin cross: Moses and the Brazen Serpent, and the Just Marked with the Letter *Tau.* A comparison is most interesting. To be sure, there are differences between the glass and the enamels, but there are also singular similarities. For example, in both (figs. 135 and 136), the prophet draws the *tau* sign on the *bald* forehead of an old man. And in both works, Moses has the same attitude: he raises his right hand toward the brazen serpent, and in his left hand he carries the Tables of the Law (figs. 137 and 138). Can we not infer a common original?[10]

This is not all. Other works of Godefroid de Claire show clear reminiscences of the art of St.-Denis. An enamel reliquary of the True Cross, originally from Stavelot and now at Hanau, has all the characteristics of his workshop and can be attributed to him with certainty. Now, an enamel medallion of the reliquary representing the battle of Constantine and Maxentius is very similar to one, and even two panels of the window of

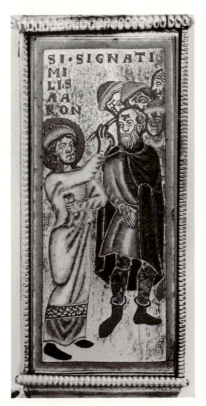

135. Prophet tracing the *tau* sign. St.-Denis (Seine),
Abbey Church. Chapel of St. Cucuphas,
tained glass.

136. Prophet tracing the *tau* sign.
Detail of pedestal of cross from the
Abbey Church of St.-Bertin. St.-Omer
(Pas-de-Calais), Musée des Beaux-Arts.

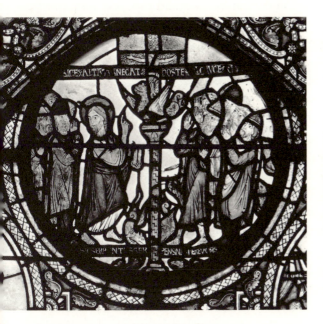

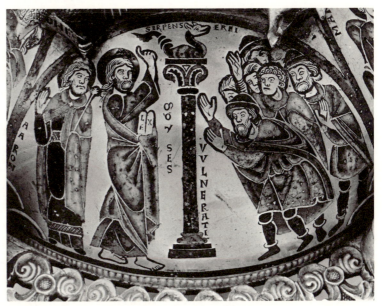

137. Moses and the Brazen Serpent. St.-Denis (Seine),
Abbey Church. Chapel of St. Cucuphas,
detail of "Moses" window.

138. Moses and the Brazen Serpent. Detail of pedestal of cross
from the Abbey Church of St.-Bertin. St.-Omer (Pas-de-Calais),
Musée des Beaux-Arts.

the First Crusade, which was once at St.-Denis.[11] The original has disappeared, but a poor drawing of it by Montfaucon gives us an idea of it.[12] The grouping of the horsemen, the movement of the oriflamme among the lances, the flight of the vanquished, the dead under the horses' hooves —all are conceived in the same manner.[13]

Such similarities cannot be laid to chance. As we pursue this study we will find other proofs, but even now it seems to me quite evident that Godefroid de Claire belonged to the great school of St.-Denis, which, about 1140, was the foremost in Europe. The dates are in no way at variance with this supposition, for if we are to believe Jean d'Outremeuse, Godefroid de Claire was an old man in 1173, and in 1174 entered the monastery of Neufmoustier to finish his days.[14] Consequently, in 1140[15] he would have been at the height of his powers.

II

Symbolic correspondence of the Old and New Testaments reappears at St.-Denis under Suger's influence.

Thus, Godefroid de Claire placed his talent at Suger's service; but if he contributed much, he also received much in return. Study of the monuments grouped under his name reveals the astonishing role that symbolism plays in his work: the ante-types prefiguring the death and the resurrection of Christ appear again and again.

Now, one of the strangest phenomena of medieval art is the sudden appearance, toward 1140, of symbolism. To be sure, earlier centuries were not unaware of the harmonies between the Old and the New Testaments, since the Church Fathers had discussed them fully. It had always been taught that Isaac carrying the wood of the sacrifice was the prefiguration of Christ carrying the cross. The book most frequently cited in the Schools since the time of Charlemagne, the *Glossa ordinaria* of Walafrid Strabo, pointed out Christ's presence on every page of the Old Testament and found his entire history there. But the strange thing is that so well established a doctrine seems to have been almost unknown to the artists, for they took nothing from it. Carolingian ivories and manuscripts never place scenes from the Old Testament in correspondence with scenes from the New.[16] There was the same lack of symbolism in tenth- and eleventh-century works. For this long period of three centuries, I can cite only one miniature from the sacramentary of Drogo, the brother of Louis the Pious and Bishop of Metz. In the capital letter T of the canon of the Mass, we see Abel offering the lamb, Abraham carrying the ram substituted for Isaac,[17] and in the center, Melchisedek placing the bread and wine on the altar (fig. 139). It is clear that each of these offerings is symbolic and recalls a greater offering. But the artist was barely aware of this, being content to illustrate the canon of the Mass which reads: "On this offering, Lord, deign to cast a favorable eye, as it pleased thee to accept the gift of

139. *Te Igitur*. Drogo Sacramentary. Paris, Bibl. Nat., ms. lat. 9428, fol. 15v.

the just Abel, thy servant, the sacrifice of Abraham, thy patriarch, and the holy sacrifice, the pure host of thy high priest Melchisedek." This is not yet true symbolism as it was later understood.

The dearth of symbolism during these centuries seems even more unusual because Early Christian art had made use of the correspondence of the two Testaments. In the sixth century, Rusticus Helpidius composed explanatory inscriptions for a cycle of typological frescoes. These frescoes have disappeared and we do not even know which Italian church they decorated, but the verses still exist.[18] In them, the correspondences are as precise as we could want. Isaac walking to the sacrifice corresponds to Jesus carrying his cross; Moses receiving the Old Law on Sinai corresponds to Jesus on the mountain promulgating a New Law; the Tower of Babel and the confusion of languages corresponds to Pentecost, when the apostles received the gift of tongues.

In the following century, artists continued to place the Old Testament in correspondence with the New. In 684, Benedict Biscop, abbot of Wearmouth in England, brought symbolic pictures back from Rome to decorate his monastery. The Venerable Bede said, "They express methodically the concordance of the two Testaments. For example, there is Isaac carrying the wood of the sacrifice opposite the Lord carrying his cross; also, the serpent raised up in the desert by Moses corresponds to the Son of Man raised on the cross."[19]

This is the last mention of a symbolic work; henceforth, there was silence, and it lasted for three and a half centuries. Meanwhile, ivories and illuminated manuscripts were produced in abundance, and descriptions of works of art are not rare either. But nowhere does symbolism appear.

Symbolism was suddenly revived at St.-Denis in the time of Suger. The harmony of the two Testaments was the principal theme of the interior decoration of the church. It shone forth from the windows, the altar frontals, and the pillar supporting the cross. This great cross must have been a true monument to theological learning, for on each face of the pillar eight scenes from the Old Testament were matched by eight scenes from the Gospels, so that thirty-two representations corresponded to thirty-two events.[20] Here is the symbolic richness of a *Biblia pauperum*, of which this is the earliest example. Where did this learning come from if not from Suger, who according to his biographer spent a part of each night reading the books of the Church Fathers and who could not have been unacquainted with a symbolic work like the recently written *Speculum ecclesiae* of Honorius of Autun. Suger, a great man of action, was also a man who meditated and dreamed. The harmony of the holy books, the poetry of the miraculous concord brought about by God in the Scriptures charmed his imagination; he returned to this again and again. The windows still existing at St.-Denis, the windows that he himself composed, are symbolic in the most subtle way. One medallion sums up all his thought: Christ with one hand crowns the New Law, and with the other he lifts the veil concealing the face of the Old Law; below, these words are written: *Quod Moyses velat Christi doctrina revelat* (What Moses veiled, the doctrines of Christ unveiled).[21]

That such a man restored symbolism to an honored place in art, and that from St.-Denis symbolism spread, as we shall see, over all of Europe is surely no cause for surprise.

III

The symbolic windows of the thirteenth century originate at St.-Denis.

Godefroid de Claire was no doubt one of the first to take up the St.-Denis symbolism.[22] Three enameled crosses and two portable altars from his workshop are decorated with symbolic scenes that had not been used in art for centuries. Several scenes seem to be entirely new. For example, we see Jacob blessing his two sons by crossing his arms over their heads;[23] the Hebrews sacrificing the lamb and with its blood tracing the *tau* sign on their doors;[24] the widow of Sarepta carrying two sticks of wood in the shape of a cross;[25] the two spies bringing from the Promised Land the bunch of grapes suspended from a pole (fig. 140);[26] Jonah vomited forth by the whale;[27] and Samson carrying off the gates of Gaza.[28] All of these episodes from the Old Testament are prefigurations of the Carrying of

the Cross, the Crucifixion, and the Resurrection;[29] they were appropriate either on a cross or on an altar.

Where did such new scenes come from? Godefroid de Claire did not invent them; he brought them back from St.-Denis. We know this to be true in the case of the Grapes of the Promised Land, represented with other allegorical subjects on the gold casing of the main altar of the church: one of Suger's verses leaves no doubt on this point.[30]

As for the other scenes, I think it safe to claim that they were all to be seen at St.-Denis, and for the following reason.

In the twelfth century, St.-Denis was the great workshop for stained glass.[31] The models created at St.-Denis were so much admired that they were still imitated in the early thirteenth century. At Chartres, the Charle-magne window is in part an imitation of a window at St.-Denis, seventy

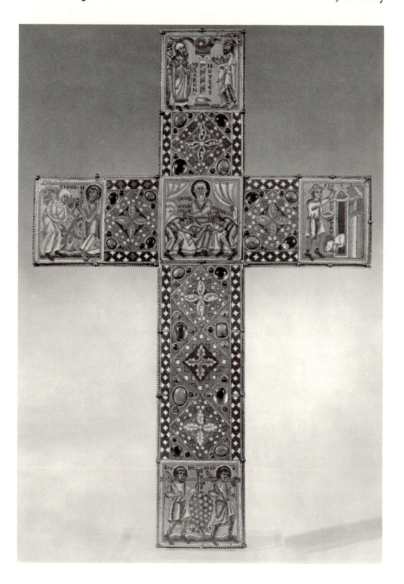

140. Old Testament scenes. Enameled cross. London, British Museum.

years earlier, of which Montfaucon reproduced several panels.[32] Perhaps the most interesting of the Chartres windows is a symbolic window which associates the Passion, the Death, and the Resurrection of Christ with scenes from the Old Testament. The window was unfortunately mutilated, but the original was reproduced several years later, with very few changes, at Bourges and at Le Mans. Now, in the Chartres window, there are, or were, all the Biblical types adopted by Godefroid de Claire: Jacob's blessing, the widow of Sarepta, the door marked with the *tau*, the grapes from the Promised Land, Samson, and Jonah. Did the stained-glass artist of Chartres, like Godefroid de Claire, take his inspiration from the creations of Suger at St.-Denis? I am convinced that he did, although direct proof is lacking. But there are indirect proofs. The extraordinary similarities between the works of Godefroid and the windows of Chartres and Bourges prove the existence of a common original which could only have been at St.-Denis. To point out some of these similarities: on the portable altar of Stavelot, now in Brussels, Abraham as he leads Isaac to the sacrifice carries a cutlass in his right hand, and in his left, a vessel from which flames shoot out (fig. 141). So does the Abraham of the windows of Chartres and of Bourges. This same Stavelot altar shows Jonah halfway out of the mouth of the sea monster; from heaven the hand of God causes a rain of fire to fall on the face of the prophet. The Jonah of Chartres has been shattered, but the Jonah of Bourges bears the most striking resemblance to the Jonah of Stavelot: the quite original detail of the rain of fire issuing from the hand of God appears there also (fig. 142). The enamel cross of the British Museum has, at its center, the Blessing of Jacob; the patriarch crosses his arms in blessing over his two grandsons, Ephraim and Manasseh, who bow before him (fig. 140). The scene is identical with the scene in the windows of Chartres and Bourges (fig. 143); one small detail betrays their common origin: on the cross in the British Museum, as in the Bourges window, Jacob is seated between two looped-back curtains.

After these examples, it will seem evident that one model, now lost, inspired both the work of Godefroid de Claire and that of the French stained-glass artists. All of the facts assembled here prove that the model could only have come from St.-Denis. Thus, all of the figurative scenes that we encounter for the first time in the work of Godefroid de Claire were created at St.-Denis and were furnished to the artists by Abbot Suger.[33]

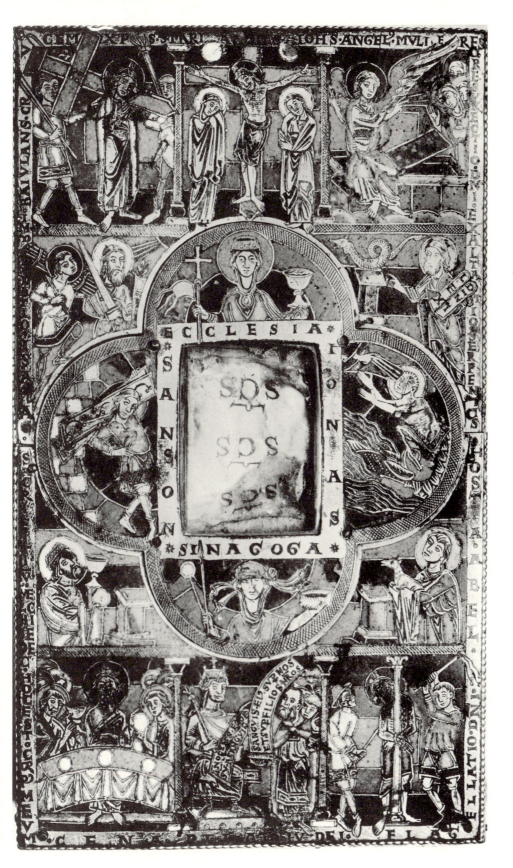

141. Typological subjects. Top of
portable altar of Stavelot. Brussels,
Musées Royaux d'Art et d'Histoire.

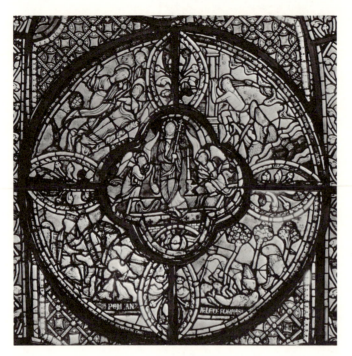

142. Typological subjects. Bourges (Cher),
Cathedral of St.-Etienne. Stained glass,
ambulatory.

143. Jacob's Blessing. Bourges (Cher),
Cathedral of St.-Etienne. Stained glass,
ambulatory (much restored).

IV

Spread of the St.-Denis symbolism through-
out France and Europe.

All the symbolic works of St.-Denis—the windows, the altar frontals, the
enameled cross—must be prior to 1144, the date of the formal consecra-
tion of the choir. Before that date, symbolism is extremely rare in Eu-
rope;[34] after that date, it is to be found everywhere.

In England, the earliest example of a great typological ensemble was
to be seen at Peterborough. The entire choir of the church was decorated
with frescoes, now destroyed, but the inscriptions, transcribed in the past,
are known to us. Each scene from Christ's life was accompanied by the
episode from the Old Testament that prefigured it. In the richness of its
symbolism, the work must almost have equaled the famous pedestal of
Suger's cross.

To be seen there were, indeed, the same figurative scenes that we thought
appeared first at St.-Denis: the Widow of Sarepta, Jacob's Blessing, the
Tau Written on the Foreheads of the Hebrews and on the Doors of Their
Houses.[35] Now, the Peterborough frescoes, as a document proves, were
not painted before 1170.[36]

The new symbolism was known in Germany a little earlier than in
England. It was toward 1160 that the goldsmith Fridericus of Cologne

must have finished the strangest of the German portable altars.[37] Small scenes accompanied by explanatory inscriptions contain the prefigurations of the Redemption that are now familiar to us: the Grapes from the Promised Land, the Cross of the Widow of Sarepta, the *Tau* Written on the Doors of Houses and on the Foreheads of the Hebrews. This is the symbolism of St.-Denis that has spread to Germany. Who transmitted such new motifs to the German goldsmith? Von Falke and Frauberger, struck by certain similarities of technique, were convinced that Fridericus, at some point in his career, had been in touch with the workshop of Godefroid de Claire. This meeting might have taken place toward 1160 when Godefroid de Claire was working at Cologne on the reliquary of St. Heribert of Deutz, and this seems most likely. If we accept this hypothesis, it is no longer a surprise to find the St.-Denis symbolism in the work of a German goldsmith.

It was another goldsmith, but this time the Frenchman Nicholas of Verdun, who twenty years later gave to Austria the beautiful symbolic ensemble at Klosterneuburg. There is nothing more magnificent in Europe. In the wonderful enamels, which once decorated an ambo and now form a magnificent reredos, scenes from the New Testament are placed in correspondence with scenes from the Old Testament.[38] This is what Suger's cross, when it was encased in enamels, must have looked like. One would say that the artist was inspired by the cross, for the Grapes of the Promised Land and the *Tau* Sign Inscribed on the House Fronts (fig. 144) take us back again to St.-Denis. The work is dated

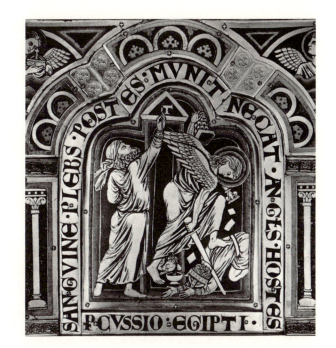

144. *Percussio Egipti.* Prophet tracing the *tau* sign. Altar of Nicholas of Verdun (detail). Klosterneuburg, Abbey Church, Stiftsmuseum.

1181. Had Nicholas of Verdun been taught by Godefroid de Claire? Was he one of the last Lorraine disciples who had worked for Suger? We do not know, but everything invites us to suppose so.

Thus, in the second half of the twelfth century, Germany took over the symbolism that had been created in the Ile-de-France. After about 1160, symbolic enamels, frescoes, and miniatures appeared in Germany.[39] In these works we sometimes find traces of known originals. A fresco from the abbey of Gröningen, in Saxony, shows a Moses striking the rock almost identical to the Moses of the St.-Bertin pedestal.

It was not long before the new symbolism had spread from St.-Denis over a part of Christian Europe. The strange thing is that it is in France that it left the fewest traces in the twelfth century. However, there is a close relationship between thirteenth-century symbolic windows and Suger's creations; we must therefore suppose that the intermediary works have disappeared. If the late twelfth-century windows of Notre-Dame of Paris still existed, they would no doubt fill this gap.

Apart from St.-Denis, only a very few twelfth-century symbolic works on which Suger's thought has left its mark have survived in France. They are all very interesting, because they clearly proclaim their origins.

Suger composed a window for St.-Denis in which Christ stands between the Church and the Synagogue; with his right hand he crowns the Church, while with his left he raises the veil covering the face of the Synagogue (fig. 145). A Latin verse, also Suger's composition, explains

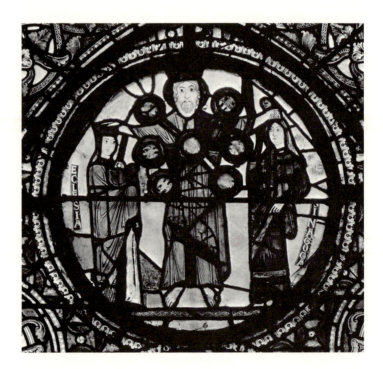

145. Christ between the Church and Synagogue. St.-Denis (Seine), Abbey Church. Chapel of St. Peregrinus, detail of "Anagogical" window.

the meaning of this allegory: *Quod Moyses velat Christi doctrina revelat* (What Moses veiled, the doctrines of Christ unveiled).[40] This imposing composition made clear the Church's doctrine concerning the harmony of the two Testaments. It was a visualization of St. Augustine's famous statement in *The City of God*: "The Old Testament is not other than the New covered by a veil, and the New is not other than the Old unveiled."[41]

So original a work could not pass unnoticed in the twelfth century. In fact, two imitations of it still exist. On the portal of the church of Berteaucourt (Somme) (fig. 146), at the center of the upper band of archivolts there is a Christ crowning the Church with one hand and lifting the veil of the Synagogue with the other.[42] A wholly similar composition decorates the baptismal font of Sélincourt, now in the museum of Amiens.[43] These are without any doubt works from the shop of St.-Denis. Thus, all the artists who had worked under Suger's direction contributed to the spread of his thought.

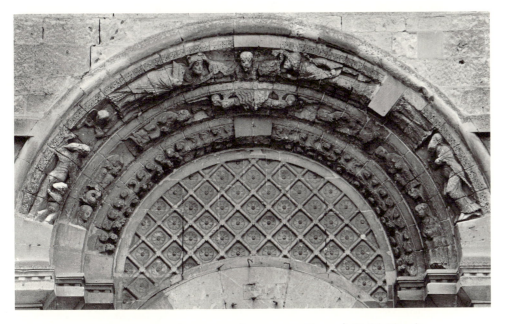

146. Christ between the Church and Synagogue. Berteaucourt (Somme), Parish Church. West façade, archivolts of portal.

One of the capitals in the nave of Vézelay represents a scene that is very simple in appearance: a figure pours grain into a mill, and another figure, while the grinding wheel turns, bends over to collect the flour (fig. 147). We might take this to be a simple picture of everyday life, but will think differently if we recall a passage from Suger's book. Indeed, he tells us that in order to elevate the soul from appearances to the things of the spirit, he had had placed in the medallion of a window a representation

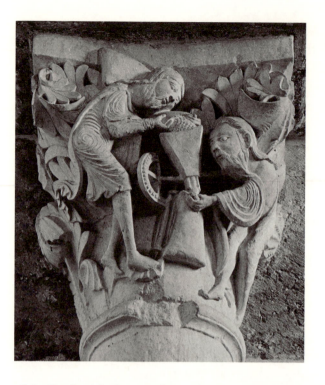

147. The Mystic Mill. Vézelay
(Yonne), Abbey Church of Ste.-Marie-
Madeleine. Nave capital.

of St. Paul with the prophets: the prophets carried grain to the mill, and St. Paul, turning the millstone, transformed the wheat into flour. Latin verses explained the meaning of the scene:[44]

> *Tollis agendo molam de furfure, Paule, farinam,*
> *Mosaicae legis intima nota facis;*
> *Fit de tot granis verus sine furfure panis*
> *Perpetuusque cibus noster et angelicus.*

Which is to say that the Old Testament, interpreted by the symbolic method of St. Paul, is completely resolved into the New; the wheat of Moses and the prophets became the pure flour with which the Church nourishes mankind.

The medallion of the St.-Denis window has unfortunately disappeared; but the Vézelay capital gives us some idea of it, for the artist meant to represent the same symbolic scene. The long flowing beard he gave to the apostle is completely appropriate to St. Paul. Thus, what seemed to be only a simple scene from country life becomes a profound symbol.[45]

Suger's thought, veiled at Vézelay, is on the contrary clearly written out at St.-Trophime at Arles.

Among the large figures of apostles decorating the façade of St.-Trophime, we observe St. Paul in the first row. With his finger he points to a banderole, on which is written: *Lex Moisi celat quae sermo Pauli revelat. Nunc data grana Sinai per eum sunt facta farina.* That is: "What the law of Moses concealed, the word of Paul revealed. The wheat given

by him at Sinai became flour." This is not only Suger's metaphor, but these are the very terms he used, for the words of the inscription *Lex Moisi celat quae sermo Pauli revelat* correspond exactly to the famous verse of Suger, which is written in a medallion next to that of the mill: *Quod Moyses velat Christi doctrina revelat.*[46] This is only an allusion to Suger's window, but it is clear that the artist who carved the inscription knew St.-Denis.

A few years ago it was thought that the façade of St.-Trophime at Arles had inspired the sculptors of St.-Denis and Chartres. We now know that the Arles portal is later than those of St.-Denis and Chartres. The inscription on the phylactery of St. Paul is one more argument to add to many others. It proves that the inspiration came from the north; at the same time, it shows us that Suger's thought was still alive and productive at the end of the twelfth century.

V

We see that medieval iconography owed the revival of ancient symbolism to Suger. But it owed something else as well. Suger seems to have created the imposing composition that is called the Tree of Jesse,[47] or at least, under his direction, the artists of St.-Denis gave it its perfected form and the one that was to prevail in the following centuries.

Suger himself took the pains to tell us that there was a window devoted to the Tree of Jesse at St.-Denis. This window still exists. It has, it is true, been greatly restored, but some parts of it are original and the restoration of the whole can be considered exact (fig. 148).[48] In fact, it was very easy to restore the St.-Denis window, for a copy made toward 1145 and still perfectly preserved exists: the window of the Tree of Jesse at the cathedral of Chartres. Except for a few slight details, the two works are identical.[49] It is at Chartres, today, much more than at St.-Denis, that Suger's work must be studied (fig. 149).

The composition has such grandeur that in copying it succeeding centuries could only weaken it. A great tree grows out of Jesse; seated one above the other, and forming the trunk of the symbolic tree, are the kings. They carry no scepters, they hold no banderoles, they do not play the harp as they do in later versions. They do nothing; they are content to be, for their true role was to perpetuate a predestined race. It is because they had lived that a Virgin sits enthroned above them, and above her, a God over whom the seven doves of the Holy Spirit hover. At each side of the tree, the prophets are superposed, as if the generations of the spirit were facing the generations of the flesh. The hand of God, or the dove issuing from the cloud above their heads, designates them as visionaries and confers a mission upon them. From age to age, they foretell the coming of

The Tree of Jesse was very probably created at St.-Denis. Its relation to liturgical drama. The Tree of Jesse spreads throughout Europe.

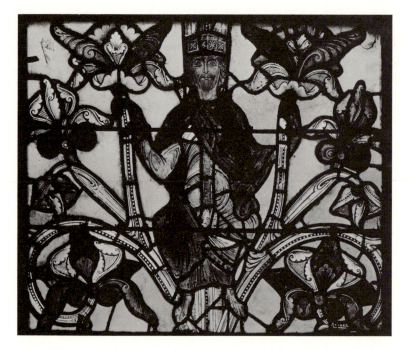

148. A King. St.-Denis (Seine), Abbey Church. Chapel of the Virgin, detail of "Tree of Jesse" window.

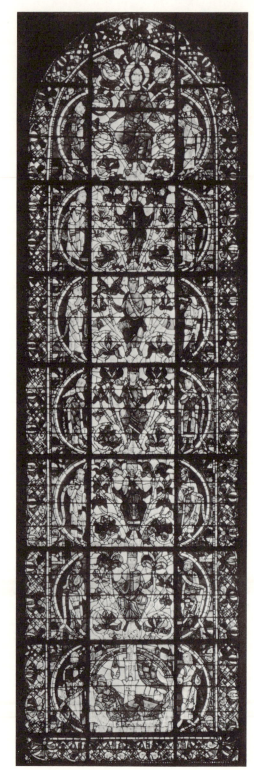

149. Tree of Jesse. Chartres (Eure-et-Loir), Cathedral of Notre-Dame. West façade, north window.

the scion of Jesse and repeat the same words of hope. Such is this astonishing creation. One detail confers on it the beauty implicit in the mystery: Jesse reclines on a bed and sleeps; it is night and a lamp hangs above his head; thus, it is in dream that he sees the future. What Biblical grandeur there is in this sleep, this dream, this prophetic night! And what a magnificent way to represent the verses of Isaiah: "And there shall come forth a rod out of the root of Jesse, and a flower shall rise up out of his root. And the spirit of the Lord shall rest upon him."

Was the idea for this great composition Suger's? Was he the first to have it represented by an artist? There is every reason to think so. Two things can be said about it: first, there is no existing Tree of Jesse earlier than the St.-Denis window, that is, before 1144; second, after approximately 1150, almost every Tree of Jesse was conceived in the same way as that of St.-Denis, except for minor details, and seems to derive from it.[50]

However, there is a text which would lead us to think that there had been an attempt to represent the verses from Isaiah as early as the late eleventh century. A fourteenth-century English monk, William Thorne, wrote a compilation under the title *Chronica* in which he summarized the history of England beginning with the sixth century. He said that in the year 1091, Hugo de Flory, on becoming abbot of Westminster, undertook the decoration of his abbey. "For the choir, he bought on the continent a large bronze candelabrum that is called a Jesse."[51] Since William Thorne cited no authorities, what credence does he deserve? Moreover, what does his sentence mean? Was it in his own time that the candelabrum of Westminster was called a Jesse, or had it been called that in the eleventh century? Should we believe that this candelabrum was something other than a bronze tree, called metaphorically a Jesse, with a trunk composed of the kings of Judah and issuing from Jesse's side? There are no answers to these questions.

The only conclusion we can draw from William Thorne's vague text is that in the eleventh century the attention of artists had been directed to Jesse. It appears likely that the first attempts to give artistic form to Isaiah's prophecy could not have been made before the end of the eleventh century,[52] for the Tree of Jesse seems to me to have originated in a liturgical play which appeared at that time, the famous Play of the Prophets.

I explained in the preceding chapter that on Christmas day in many churches there was a procession of certain of the prophets. One after another, they came to foretell the coming of the Saviour by reciting verses from their own books. This play appeared for the first time in a manuscript from St.-Martial of Limoges, and seems to date from the late eleventh century.[53] Here the form of the play is extremely simple, but it was later amplified and the number of characters increased.

In all the versions of the play, Isaiah was included among the prophets who came to bear witness. The verse he pronounced was always the same; he foretold that a scion would come forth out of Jesse. Now, it is quite remarkable that in the Chartres window the prophets superposed at each side of the Tree of Jesse are exactly those of the liturgical play.[54] Certain details are significant: at Chartres, beside Habbakuk, Zephaniah, Zechariah, Joel, etc., we see Moses and Balaam, who are not ordinarily placed with the prophets but who appear in the window because they appeared in the liturgical play.[55] Their presence alone would indicate their derivation, but there is even more decisive proof. At Chartres, Moses is the only figure who has a verse transcribed on the banderole he holds in his hand. This verse, only partially transcribed, reads as follows: *Suscita [bit] Deus vobis. . . .* Now these are the very same words that Moses recites in the Play of the Prophets.[56]

Do we need other proof? In the British Museum there is a Psalter illuminated in England between 1161 and 1173.[57] A miniature represents the Tree of Jesse according to the St.-Denis formula; but it is a much simplified Tree of Jesse for there are only three superposed figures, represented half-length, and two prophets (fig. 131). These two prophets carry banderoles on which the verses they pronounce are written. One prophet is Abraham, who says: *In semine tuo benedicentur omnes gentes terrae*; the other is Moses, who says: *Prophetam dominus suscitabit vobis de fratribus vestris.* Let us refer to the Play of the Prophets, which is so strangely woven into the *Mystère d'Adam.* The first prophet who appears to foretell the Messiah is Abraham; he recites these words: *. . . in semine [tuo] benedicentur omnes gentes*; Moses next comes forward and says: *Prophetam suscitabit deus de fratribus vestris.*

The analogy between the play and the miniature is complete.[58]

But I can cite other examples even more convincing, if that were possible. One of the beauties of the Play of the Prophets is the appearance, after the Old Testament figures, of two representatives of the pagan world: Virgil and the sibyl. To the Middle Ages, Virgil, with his gentleness, his melancholy, and his priestly seriousness, belonged to the family of prophets: his fourth Eclogue seemed a rediscovered fragment from Isaiah.

Now Virgil figures at least once in a Tree of Jesse. An early thirteenth-century Psalter, now in the library of Wolfenbüttel, is decorated with a very interesting Tree of Jesse.[59] Among the prophets accompanying the ancestors of Christ, we see Balaam mounted on an ass at Isaiah's side and holding a whip in his hand; farther on, we see Virgil. Most of the inscriptions carried by the prophets on banderoles are undecipherable, but we can read Virgil's inscription: *Jam nova progenies. . . .* This is the famous verse from the Fourth Eclogue. It is only in the Play of the Proph-

ets, and nowhere else, that we find this bizarre association of Isaiah, Balaam, and Virgil.[60]

The sibyl is found along with the prophets in a miniature of the Tree of Jesse dating from about 1200 from the Psalter of Queen Ingeborg, now at Chantilly (fig. 150). The prophetess, crowned like a queen,[61] holds a banderole on which is written: *Omnia cessabunt, tellus confracta peribit.* This is one of the acrostic verses concerning the end of the world which she recites in the play. Here again, the bringing together of Daniel, Malachi, Aaron, and the sibyl can be explained only by the Play of the Prophets.[62]

These examples will suffice, I believe, to demonstrate that there is a close connection between the Play of the Prophets and the Tree of Jesse; both works came out of the same atmosphere. The Play of the Prophets must have predated the Tree of Jesse by several years; consequently, since the earliest Prophets play, that of Limoges, seems to date from the late eleventh century, the conception of the Tree of Jesse must not go back beyond that date.

I think that the first versions of the scene represented Jesse with a branch in his hand, or with several young shoots placed above his head as on the façade of Notre-Dame-la-Grande at Poitiers. The true formula, the imposing composition I have just described, was conceived at St.-Denis under Suger's direction and was judged to be perfect. For more than a century, the Tree of Jesse of St.-Denis was imitated everywhere.

First of all, we find it in a window of Chartres. As we have seen, this is a faithful copy made after 1145. There is nothing surprising about the imitation, for the two windows were the work of the same stained-glass artists. But the imitations done fifty or sixty years later were just as exact. The Tree of Jesse in the Psalter of Blanche of Castile, now in the Bibliothèque de l'Arsenal,[63] is of the St.-Denis type and is a pure example of it; there is one rare innovation: King David plays his harp and seems to celebrate his future descendent (fig. 151). A century later, the original work was still as faithfully reproduced: we find it in a window of the Sainte-Chapelle and, a little later, in windows at Le Mans, Beauvais, and Angers.[64] Everywhere, the trunk of the kings of Judah culminates in Christ who sits enthroned at the top. The Virgin is in her place at the feet of her Son. Later, as the cult of the Virgin grows, she will become the topmost flower of the tree; true, she will hold the Child in her arms, but it is she, we feel, who is being glorified.[65] The Tree of Jesse thus becomes the genealogical tree of the Virgin. In this, we are far from the original conception and from Suger's thought.

The creation of the St.-Denis stained-glass artists seemed so felicitous that it was imitated not only in France but abroad.

In England, the Tree of Jesse at York is a copy of the St.-Denis Tree of

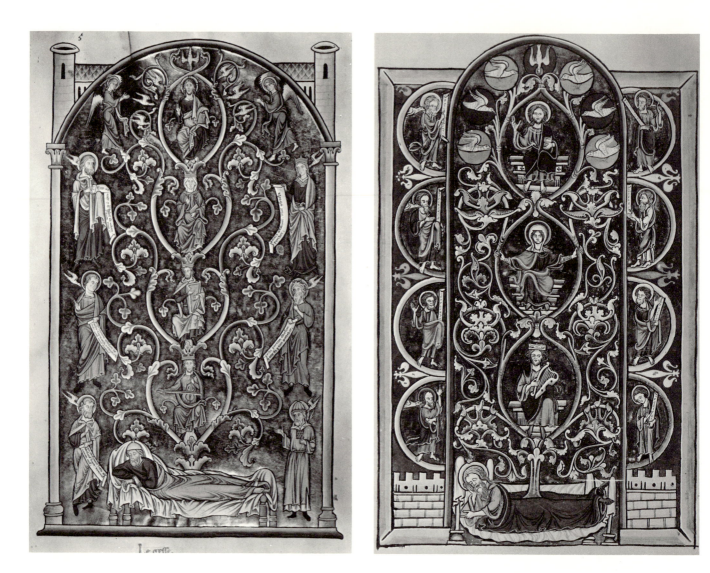

150. Tree of Jesse. Ingeborg Psalter.
Chantilly (Oise), Musée Condé,
ms. 1695, fol. 15v.

151. Tree of Jesse. Psalter of Blanche
of Castile and St. Louis. Paris,
Bibl. de l'Arsenal, ms. 1186, fol. 15v.

Jesse, and as close as that of Chartres: the York window dates from the
second half of the twelfth century.[66] English manuscripts of the same pe-
riod contain Trees of Jesse that are freer in treatment but in which the
imitation is apparent. In the English Bible, now in the Bibliothèque
Sainte-Geneviève, the kings, the Virgin, and Christ are placed one above
the other as at St.-Denis;[67] as at St.-Denis, they hold in both hands the
foliage scrolls that simulate branches. Such similarities can scarcely be
the work of chance. The miniaturist imitated a consecrated type.

In Germany, the most famous Tree of Jesse is, without question, the
one decorating the ceiling of the church of St. Michael at Hildesheim.
This is a fresco painted about 1200. The extent of space to be covered
obliged the artist to fill out his composition with new figures. The border,
for example, is composed of medallions in which the forty-two ancestors

of Christ enumerated by St. Luke appear. But the central part is completely traditional: Jesse reclines on his bed, the kings of Judah sit among the branches, the Virgin is below Christ's feet,[68] the prophets form a line parallel to the line of kings—all of which conforms to the original at St.-Denis. Even the fairly numerous differences of detail do not prevent us from recognizing the relation between the Tree of Jesse of Hildesheim and our French Trees of Jesse.

Through the Crusades, the Tree of Jesse became known in the East. In 1169, during the reign of Amaury, king of Jerusalem, the mosaicist Ephrem represented the Tree of Jesse in the church at Bethlehem. What better choice of place could there have been? There, the genealogical tree of Christ rose above his cradle. This ancient mosaic has disappeared, and we know it only through the description of a sixteenth-century pilgrim, Father Quaresimus.[69] Although this description leaves much to be desired, it proves nonetheless that the Bethlehem Tree of Jesse was of French inspiration. We see that the prophets correspond to the ancestors of Christ, and the prophets' phylacteries were inscribed with the same words they spoke in our liturgical plays. As in the *Mystère d'Adam*, Balaam said: *Orietur stella*; Nahum said, as in the Rouen play: *Ecce super montes pedes evangelizantis*; and lastly, the decisive proof is that the Erythraean sibyl appeared in the company of the prophets and, as in the Limoges play, said: *E coelo rex adveniet*.[70] Thus, although the Bethlehem mosaic was the work of an Eastern artist, it had been conceived by a Frenchman who was perfectly familiar with our traditions.[71]

Such was the vast spread of the Tree of Jesse motif, which had appeared for the first time and in its perfect form at St.-Denis. Why should we not think that we owe this beautiful composition to the organizing genius of Suger?

VI

Already the number of fertile innovations is considerable, but St.-Denis can claim still others. It is on the central portal of its façade that the scene of the Last Judgment appeared in sculpture for the first time—at least in the north of France (fig. 152). And this Last Judgment presents an iconographic innovation that was to be adopted by the following centuries.

Since the restorations undertaken by Debret in 1839, the façade of St.-Denis has had the worst possible reputation. No archeologist deigns to give it a glance. And this is not surprising. The ugliness of the heads, restored with the most pretentious clumsiness, and the effrontery of a gross pastiche posing as an original, are discouraging. At St.-Denis, sculpture seems to have reverted to its childhood. These portals are dangerous, for

The Last Judgment at St.-Denis, an imitation of the Beaulieu Last Judgment. The Wise and Foolish Virgins.

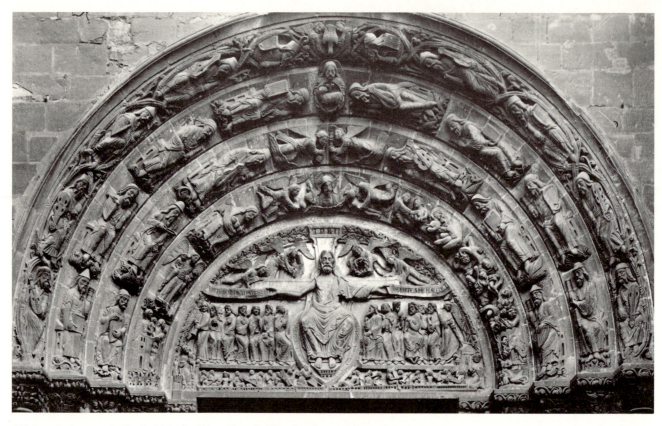

152. Last Judgment. St.-Denis (Seine), Abbey Church. West façade, central portal, tympanum (restored).

in an especially sensitive person they could inspire a lasting distaste for medieval art.

However, if we can rise above an all too legitimate repugnance, we will observe that the central portal has retained its original composition. The heads and the hands are restored, the draperies have no doubt been re-touched, but the principal lines of the scene remain intact. It is a Last Judgment, and insipid as it is today, it remains of considerable interest.

A valuable manuscript in the Bibliothèque Nationale by the Baron de Guilhermy[72] furnishes proof that the composition of the St.-Denis Last Judgment scene is ancient. In his account, Guilhermy, who closely fol-lowed the work, makes scrupulously exact note of the restoration; he mentions all the figures on the portals and points out the parts that were restored. Now, it is clear from a reading of this manuscript that the Revolu-tion had been content to break off only the heads and sometimes the hands; it sufficed to decapitate the saints just as suspects were decapitated. Only the archivolts on the right, in which the sufferings of hell were repre-sented, were almost completely destroyed; they are in large part modern.[73]

As for the rest of the portal, the restorations are confined to heads, hands,

attributes, and inscriptions.[74] True, these modern parts are so inept that they completely change the character of the work, but if we are looking for the subject only, it is easily found.

We must first reply to one objection: does the Last Judgment at St.-Denis date in fact from the time of Suger?

It is repeatedly said that Suger says not one word in his book about the sculpture decorating the portals, but this is not true. Suger made the clearest allusion to the Last Judgment of the tympanum in the two verses carved on the lintel:

> *Suscipe vota tui, judex districte, Sugeri,*
> *Inter oves proprias fac me clementer haberi.*

"Receive, stern judge, the prayers of thy Suger; Grant that I be mercifully numbered among thy own sheep."[75]

The designation "Judge" for God, and the evangelical metaphor of the sheep (separated from the goats), immediately evoke the idea of the Last Judgment. These two verses seem to me to prove that a Last Judgment was carved on the tympanum, and that this tympanum was contemporary with Suger.

It is curious that until now no scholar has given any attention to the tympanum of St.-Denis. A study of it is revealing.

Vöge, in comparing the large statues of St.-Denis (now destroyed but reproduced by Montfaucon) with certain figures on the portal of Moissac, had been struck by the resemblances, and he came to the conclusion that the sculptors brought by Suger had come from the Midi.[76] His argument was tempting but not altogether convincing. Study of the Last Judgment will transform his hypothesis into certainty.

The Last Judgment at St.-Denis appears at first glance to be an imitation of the Last Judgment on the church of Beaulieu (Corrèze) (fig. 153). The figures of Christ alone are enough to prove the kinship of the two works. At Beaulieu as at St.-Denis, he presents himself to mankind with widespread arms; on the last day he assumes again the attitude he had on the cross. There are no other examples of this ample gesture; a few years later, the Christ will merely open his two hands to reveal his wounds.[77] Let us get down to minute detail. At St.-Denis, as at Beaulieu, the left arm of Christ is draped and the right arm is bare. The cross which appears in the sky is alike on both tympanums: the crosspieces flare at the ends and form a circle where they meet. Such similarities are proofs. Lastly, the two tympanums are composed of the same elements: apostles seated beside Christ, angels blowing trumpets, the dead resurrected. But the composition at St.-Denis has gained in clarity. Rigorous order has replaced confusion: the dead fill one register, Christ and the

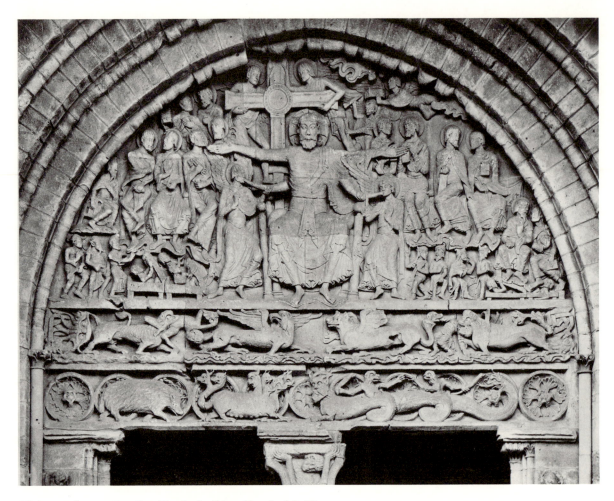

153. Last Judgment. Beaulieu (Corrèze), Abbey Church of St.-Pierre.
South portal, tympanum.

apostles fill another. The artist has discovered the virtue of symmetry;
he has arranged his work in relation to a center which is Christ and his
cross. Thus, the still somewhat muddled thought at Beaulieu is clarified
at St.-Denis.[78]

The close resemblances linking Beaulieu with Moissac are known.
One proof among many others that the Beaulieu sculptor knew the Mois-
sac portal is that he copied its beautiful decorative rosettes. The art of
Beaulieu is still the art of Moissac.

So we can now state positively that Suger brought his sculptors to St.-
Denis from the Midi. He summoned those teams of artists who had
wandered over Languedoc and Aquitaine, who went from Toulouse to
Moissac, from Moissac to Beaulieu, and from Beaulieu to Souillac. As a
consequence, the resemblances that Vöge observed between the statues of

St.-Denis and certain figures at Moissac and Toulouse can be explained in a most natural way.

Furthermore, the dates of the carved portals of the Midi have long been discussed and they are still discussed, but they have not been established. Henceforth it can be stated that the portal of Beaulieu is earlier than 1140, because by that date it had already been imitated at St.-Denis.[79]

I confess that I felt great satisfaction when, on reading Guilhermy's manuscript, I became certain that the St.-Denis Last Judgment is ancient. For the Last Judgment of St.-Denis is an indispensable link; without it, nothing is clear. I could not explain to myself why the Last Judgment, which had appeared at Beaulieu in southern France in the early twelfth century, reappeared only at the end of the same century in northern France on the portal of Corbeil.[80] I sensed that an intermediary work was missing: it has now been found. We now know by what path the theme of the Last Judgment, created by artists of the Midi, came into the monumental art of northern France: north and south met at St.-Denis.

The portal of St.-Denis, however, is not a simple imitation of the Beaulieu portal, for there are many felicitous innovations to be found in it. To satisfy such a man as Suger, the artists found new resources within themselves; association with him enlarged their imaginations. They created a type of portal of which there are no examples in the Midi. Large statues were aligned like columns at each side and formed a majestic avenue. These were the personages of the Old Law, who seemed to be directing thought to the Christ of the tympanum.[81] Deepset archivolts above the Last Judgment scene formed four great concentric circles. These were bare at Beaulieu, but in the Midi, at Cahors and Angoulême, they began to be filled with figures. At St.-Denis, the artists carved a whole world there: the elders of the Apocalypse, angels carrying the elect, demons dragging away the damned, beatitudes and punishments, heaven and hell.

Thus, it was at St.-Denis, between 1133 and 1140, that that marvel, the Gothic portal, was created. Thirteenth-century France endowed it with such beauty that it was imitated over a part of Europe.

But this is not a history of form; our object is iconography. And are there iconographic innovations to be found on the portal of St.-Denis? There is at least one that deserves mention, for it was very productive.

On each side of the portal we observe four female figures placed one above the other. They carry lamps, some held right side up and others upside down.[82] These figures are the wise and foolish virgins. The two series seem to be incomplete, but if we look up we see that in the tympanum a wise virgin stands at the gate of paradise and a foolish virgin on the threshold of hell. So there are indeed, as the Gospels would have it, five wise and five foolish virgins.

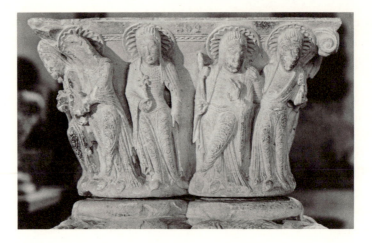

154. Wise virgins. Cloister capital
from St.-Etienne. Toulouse
(Haute-Garonne), Musée des Augustins.

Representation of the Gospel parable was not new in the art of the Middle Ages. The Wise and Foolish Virgins had already appeared on two capitals that are now in the museum of Toulouse (fig. 154).[83] The St.-Denis sculptor, evidently a man from the Midi, seems to have been inspired by them. In spite of crude restorations[84] and probably retouching, we again find at St.-Denis the clinging robes, the long sleeves, and even the crossed legs of the Toulouse virgins.[85] The theme of the Wise and Foolish Virgins, long out of use, reappeared in sculpture of the Midi in the early twelfth century. As I have said, the revival of this old motif in the Midi can be explained by the fact that it was there that the liturgical play of the Wise and Foolish Virgins was being performed at this same time. The Limoges manuscript containing this famous drama is only a few years earlier than the Midi sculpture.

Thus, the theme of the Wise and Foolish Virgins was not new, but the interesting thing is the place given to it at St.-Denis. There, the Gospel parable was associated with the Last Judgment. And in fact, the medieval Church Doctors considered the Gospel story to be a prefiguration of the Last Judgment. To them, the foolish virgins symbolized the damned, and the wise virgins the elect. Their sleep expresses the long waiting of the generations asleep in death, and the cry awakening them is none other than the trumpet of the archangel.

This interpretation is not indicated in the liturgical play of Limoges; nor is it on the two capitals at Toulouse; there the parable is represented for itself. At St.-Denis, it suddenly takes on a profound meaning: united with the Last Judgment which they prefigure, the ten virgins become the image of the two halves of mankind to be separated by God on the final day. It is possible that works of art now lost had suggested this parallel to Suger. Verses by Alcuin about a fresco in the church of Gorze (Moselle) prove that already in the Carolingian period the Wise and Foolish Virgins had been associated with the Last Judgment.[86] But to Suger

goes the credit for bringing this motif into great monumental sculpture.

The idea caught on. At Notre-Dame of Paris, as at St.-Denis, the ten virgins appear on the jambs of the Last Judgment portal;[87] and they occupy the same place at Amiens. Elsewhere, they are carved on the archivolts, but everywhere they are closely associated with the Last Judgment. Here again is a tradition that goes back to St.-Denis.

VII

Suger seems to me to have invented still other themes. In medieval art we frequently come upon an imposing figure representing God the Father with arms outspread to hold against his breast his Son on the cross. Such an image means that the Father participated in the Passion of the Son, and that this Passion had been inscribed in his breast throughout eternity.

Who imagined this kind of sacred hieroglyph? The earliest example I know is at St.-Denis (fig. 155). Several of the fragile panels that made up the great symbolic windows of St.-Denis have, by some miracle, been preserved since 1145. Some of these pieces of red, blue, green, and violet glass —more precious to us than rubies, sapphires, emeralds, or amethysts— represent Christ crucified on a cross that is decorated with arabesques; behind him stands the great figure of the Father, who supports him by his two arms.

This is the original that the Middle Ages were to imitate throughout four centuries. The subtle symbolism of the St.-Denis window, in which the cross rises above the chariot of Aminadab as the New Testament rises above the Old,[88] proves that the work was conceived by Suger himself. He explained it in two Latin verses that can still be read on the window, and which he included in his book. Thus, Suger is the real creator of the image of God sustaining the Son. No examples that I know are earlier than his; moreover, the earliest—those from the twelfth century—are still related to the art of St.-Denis.

A miniature in the library of Troyes,[89] painted a few years later than the St.-Denis window, would seem to derive from it, since the conception is the same. True, the chariot of Aminadab has disappeared, but nevertheless, still to be seen, as at St.-Denis, are the four evangelical beasts associated with the Christ on the cross sustained by the Father. The affiliation seems clear. A new detail has been added to the scene, and it completes Suger's thought: the dove of the Holy Spirit flies between the Father and the Son, so that the entire Trinity seems to participate in the sacrifice. This was the form in which the image created at St.-Denis was to be perpetuated throughout the following centuries. In a Gospel-book of Perpignan, from St.-Michel-de-Cuxa, the formula had not yet been found; the dove is placed at one side (fig. 156).[90]

God the Father Supporting his Son on the Cross appears at St.-Denis. The Coronation of the Virgin probably created by Suger.

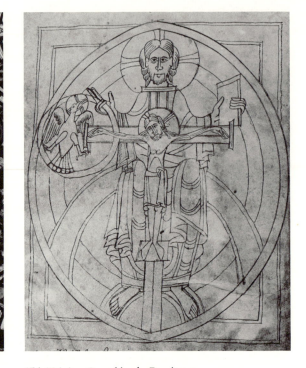

155. Chariot of Aminadab and God the Father supporting his Son on the cross. St.-Denis (Seine), Abbey Church. Chapel of St. Peregrinus, detail of "Anagogical" window.

156. Trinity. Gospel-book. Perpignan (Pyrénées-Orientales), Bibl. Mun., ms. 1, fol. 2v.

But even further credit is probably due Suger.

I have often wondered if he were not responsible for the beautiful scene of the Coronation of the Virgin, so greatly beloved in the Middle Ages. The monk Guillaume, Suger's biographer, tells us that the abbot had given magnificent windows to the cathedral of Paris.[91] Now, according to Levieil, several fragments of these windows were still in existence in the mid-eighteenth century in the upper gallery of the choir of Notre-Dame.[92] To be seen there, he said, was "a kind of Triumph of the Virgin." What did Levieil mean? When we think about it, it is hard to imagine anything else than a triumphal scene taking place in heaven: Christ seated on his throne, the Virgin taking her place at his right, and angels swinging censers before her. This is the first form in which the Coronation of the Virgin appeared in medieval art. If this interpretation is correct, we would have here the original which was to be imitated forty or fifty years later by the sculptor of the portals of Senlis (fig. 157). The Senlis Coronation of the Virgin is the earliest known in France. The Virgin, already crowned, is seated on a throne at the right of her Son. I have often thought that this beautiful scene had not been created at Senlis, but at some more illustrious place. Levieil's words invite us to give credit for it to the great

abbot of St.-Denis. The imitations of Suger's church to be observed in the architecture and the sculpture at Senlis can only strengthen this hypothesis.[93]

It is odd that the scene of the Coronation of the Virgin appeared in Rome in the apse of S. Maria in Trastevere at very nearly the same time that Suger must have composed the window for Notre-Dame of Paris.[94] The coincidence seems even stranger when we learn that the Roman mosaic was undertaken at the order of Suger's friend and host, Pope Innocent II. It was begun in 1140. Now, in 1131, Innocent II had gone to France and had spent two weeks at Paris and St.-Denis.[95] Did Suger's window already exist? Was the Pope struck by the novelty of the idea? We may well think so, for the theme of the Coronation of the Virgin, which was so productive in France from the end of the twelfth century

157. Coronation of the Virgin. Senlis (Oise), Cathedral of Notre-Dame. West façade, central portal, tympanum.

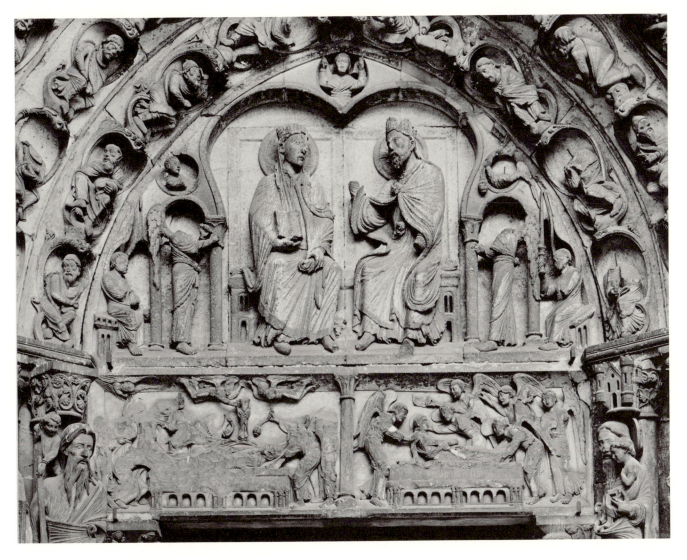

onward, remained sterile in Italy for a long time. In thirteenth-century France, the Coronation of the Virgin could be seen in almost all cathedrals; in Italy, it was not until 1296 that it reappeared in the beautiful mosaic at S. Maria Maggiore.[96] We sense that the subject was indigenous to France, that it had been imported into Italy. A few words jotted down in passing by Levieil permit us to believe that Suger was its creator.[97]

It is not in the least surprising to find in Suger one of the creators of the new iconography, for Suger was one of the great minds of the Middle Ages. His vast culture embraced all of Christian antiquity: the Church Fathers and their symbolic exegesis were familiar to him. His fabulous memory enabled him to keep his learning ever present, but he was not overwhelmed by it. He had a genius for order, and it was this genius that made him a statesman. His biography says, "He could have been governor of the world." This man of reason was also a man of passion. When he consecrated the Host, his face was bathed in tears; he radiated joy at Christmas and Easter. His profound sensibility explains his love for art. He loved it as true artists love it—artists who worship beauty and scorn luxury. He gave everything to his work, keeping nothing for himself. When Peter the Venerable, the great abbot of Cluny, went to St.-Denis, he admired the church and its marvels as a connoisseur, but when he saw the small cell where Suger slept on a straw pallet, he cried: "This man condemns us all; unlike us, he does not build for himself, but only for God."

Is it not natural that such a man should have regenerated Christian art?

VI

Enrichment of the Iconography: The Saints

One of the causes contributing to the liberation of iconography from Eastern domination was the representation of saints and their legends. With a few exceptions, the saints represented by twelfth-century artists were Western, and above all French, for whom there were no precedents in Eastern art. Therefore, when saints were their subject, artists could no longer imitate; they were obliged to create.

In France, images of saints begin to appear in monumental art in the twelfth century. They are still rare, and it is only reservedly that they are introduced inside the church; they are all the more curious for that, and it is fascinating to apprehend at its very beginnings this glorification in art of the saints.

In the twelfth century, the saints were rarely placed on portals, which were reserved for Christ and the apostles, but they were honored elsewhere. They were represented on the capitals of church and cloister; they were painted on the walls of the sanctuary. Goldsmiths and enamelers told their stories on reliquaries or carved their busts for altars. A few windows had already been devoted to them. But of so many works, only fragments remain: cloisters and their historiated capitals have been destroyed, frescoes effaced, windows broken, shrines melted down. Our losses have been vast, for the art of the twelfth century has been destroyed to a greater extent by time and revolutions than thirteenth-century art. It is among these ruins that we must look for remnants of the past.

However, as we travel through France scrutinizing the stones, we may still find here and there, and with singular pleasure, some chapters from our ancient religious history. In several provinces, the memory of the saints who had shed luster on the region is preserved in art: early apostles of the faith, martyrs, bishops, hermits of the mountains or forests. For our twelfth-century artists were not so much interested in representing the saints known to the entire Christian world; they preferred provincial and local saints. Hence the interests of these images, which have for us all the charm of a native flora.

Their history, moreover, is often nothing more than legend. At various periods, and above all in the eleventh century, there had been an intense poetic creativity which transformed the lives of many of our saints into stories as interesting as fiction. Many illustrious personages of the Gospel were said to have gone to France, and many new adventures were woven into their lives. Miracles multiplied. A kind of Christian epic was born comparable to the *Chansons de geste*, which were developing at the time. The genius of the age, an age both heroic and avid for marvels, was expressed both in Latin legends and in French poems. The saint and the hero, the two ideal models for mankind, were celebrated with equal fervor. So, if these stories teach us nothing about the saints they meant to glorify, they tell us a great deal about the Middle Ages themselves. In them we see the profound idealism of the age, its asceticism, its indifference to reality, its unshakable conviction that faith is the strongest force in this world. These legends, sometimes as poetic as the fabrications of the epics, had very different consequences: they created pilgrimages, they caused churches to be built and filled with works of art, they set millions of people in movement; to many souls they represented consolation and hope and provided in this world a glimpse of the Kingdom of God.

I

Saints of Languedoc: St. Sernin. St. Foy. St. Caprasius. St. Vincent. St. Maurinus. Saints of the Pyrenees: St. Volusian. St. Aventinus. St. Bertrand de Comminges. Spanish Saints in the Midi of France: Sts. Fructuosus, Augurius and Eulogius. St. Justus and St. Pastor. St. Eulalia.

In searching out these saints, let us begin our journey in Languedoc, the home of our earliest sculptors.

Toulouse had preserved a profound memory of its first apostle—that Saturninus who had refused to sacrifice before the gods of Rome; an angry bull dragged him bleeding down the steps of the Capitol. St. Saturninus, or St. Sernin as he was called by the people, had been buried outside the walls, and a new town had grown up around his tomb. The colossal church of St.-Sernin at Toulouse, the largest of the Romanesque churches, is a monument to this hero. But it is a surprise, on visiting the church today, to find no early works of art that recall his memory. This was not true in the past. The pilgrim who arrived at the west portal was greeted by a twelfth-century relief representing the martyr standing with the bull beneath his feet. But other reliefs proved that legend had already distorted the facts. To the *Acts* of St. Sernin, so sober and with so much the character of antiquity, new episodes had been added.[1] It was said that he had baptized Austris, the daughter of Antoninus, the governor of Toulouse, who in the new legend became a king. Austris had leprosy: St. Sernin healed her by plunging her into the baptismal basin. Thus, on the portal of the church there was to be seen a group representing the young princess being baptized by St. Sernin. Another relief showed the persecutor of the apostle, King Antoninus, seated on a throne. These works, which

we can imagine to have been fine and sensitive, like all the twelfth-century sculpture of Toulouse, have disappeared without leaving a trace, and we know them only through an ancient description.[2]

At the other end of the town, the cathedral of St.-Etienne also perpetuated the memory of the first bishop of Toulouse. Against the pillars of the canons' cloister, one of the earliest sanctuaries of French art, unfortunately destroyed in 1813, there were twelfth-century statues of St. Peter, St. Sernin, St. Exuperius, and a deacon.[3] St. Sernin stood beside St. Peter, because according to a tradition then current the apostle of Toulouse had received his mission from the first of the popes. The inscription read: *Ecce Saturninus quem miserat ordo latinus.* "This is Saturninus sent by the Latin Church." Thus, Toulouse put itself forward as the spiritual daughter of Rome. St. Sernin was the hero of the faith; St. Exuperius, one of his first successors, was the hero of charity. In a time of famine, he had sold all the ornaments of the church, even the chalice and the paten, to feed the poor. The Toulouse artist represented him with a chalice in his hand—this was the glass chalice that had replaced the chalice of silver; near him, a deacon carried a paten of wickerwork, touching testimony of saintly poverty in early Christian antiquity.

In this way, the newborn art sought to eternalize the memory of the two greatest saints of Toulouse; we can find no trace of them today.

What we cannot find at Toulouse we find elsewhere, for the glory of St. Sernin had spread. In a deep valley between Carcassonne and the former bishopric of Alet stands the ancient abbey of St.-Hilaire. It has preserved a valuable document from the past: a twelfth-century sarcophagus carved on all sides which tells of the martyrdom of St. Sernin. He is shown being seized by the pagans at the moment he announces the Gospels; then he is lashed to the bull, which is goaded by a torturer. Animals with almost human faces surround the saint and seem to incarnate the savagery of the ancient world; two women tenderly contemplate the martyr (fig. 158).[4] These are the two holy virgins, *les saintes puelles*, who are to bury the martyr, and who themselves were honored at Mas-Saintes-Puelles on the road between Carcassonne and Toulouse.

Far from St.-Hilaire, on the other side of Toulouse, a capital in the cloister of Moissac also celebrates the glory of St. Sernin.[5] The judge seated on his bench has just condemned the apostle, who is already lashed to the horns of the bull. The Capitol appears as a tall tower of many stories, reminiscent of the fortress dominating Toulouse in the Middle Ages—the Narbonnais castle attributed to the Romans. On another face of the capital, the hand of God issues from heaven to receive the soul of the martyr.

As we see, some of the works devoted to St. Sernin in the art of the Midi still exist.

If we travel down the Garonne toward Bordeaux, we come to a province

158. Martyrdom of St. Sernin. Detail
of a sarcophagus. St.-Hilaire
(Aude), Abbey Church.

where other saints were honored. This is the Agenais, which was the domain of St. Foy, St. Caprasius, and St. Vincent, all martyrs of the great persecution of Diocletian.

The youthful St. Foy refused to sacrifice to the idols when she was brought before the Roman governor. For this she was stretched on a red-hot grill and then decapitated.[6] The pastor of the flock, St. Caprasius, who had hidden himself in a mountain cave, was filled with remorse by the courage of this twelve-year-old child. He was present, at a distance, at the struggle of the saint, and saw, says the legend, angels holding a crown above her head; whereupon he went resolutely to the governor, proclaimed himself a Christian, and laid his head on the block. St. Vincent, who according to a later legend was the successor to St. Caprasius, wished to put an end to the cult of Belenus, and he stopped the flaming wheel, symbol of the sun, which each year was made to descend the slope of the hill. He was brought before the Roman magistrate, beaten with rods, and decapitated.

We would expect to find at Agen, the very site of St. Foy's martyrdom, some splendid piece of Romanesque sculpture devoted to the young saint, but in the eleventh century her relics, which had long been coveted as a priceless treasure, were stolen by a monk from Conques and taken into the mountains of Rouergue. Thereafter, it is Conques that becomes the center of the cult of St. Foy, and we shall seek her out there later. At Agen, there remains only one capital devoted to St. Caprasius in the church dedicated to him (fig. 159). The saint is decapitated before the Roman governor, Dacianus; an inscription designates each figure: *Dacianus, miles, sanctus Caprasius*; and a Latin verse indicates the role of each: *Praecipit, occidit, moritur, coelestia scandit* (Dacianus is there to rule, the soldier to kill, St. Caprasius to die).[7]

159. St. Caprasius beheaded before
Dacianus. Agen (Lot-et-Garonne),
Cathedral of St.-Caprais.
Transept capital.

Nor was St. Vincent forgotten in art. His relics were preserved for a
long time in the Gallo-Roman town of Pompejac, later called Le Mas
d'Agenais,[8] and a magnificent fifth-century sarcophagus, still to be seen
there, is supposed to have been his tomb. In the church of Le Mas, there
is a capital representing a kneeling martyr decapitated by an executioner.
There is no inscription, but being where it is, it can scarcely represent
anything other than the death of St. Vincent. It is true that his relics
were then no longer at Le Mas; they had been transferred to Conques
during the time of the Norman invasions, but the memory of St. Vincent
remained alive at Le Mas d'Agenais, and his cult continued to be ob-
served there.

At the time of the Visigothic kings, Euric and Alaric, Gascony pro-
duced a new generation of martyrs. The Visigoths were Arians; they
persecuted the Catholics, who were obliged under threat of death to be-
come converts to the Arian creed. Ancient liturgical books and popular
legends perpetuated the memory of some of these martyrs. The most
famous was St. Maurinus, a young apostle who, far from concealing his
faith, proclaimed it in the public square of Lectoure. He was decapitated
by order of King Alaric, and according to tradition he was seen carrying
his own head to the Militane fountain. Artists would perhaps never have
illustrated his story if an abbey had not been founded in his name at the
border of Agenais and Quercy. The church of St.-Maurin (Lot-et-Ga-
ronne) is now a ruin, but two of its columns are still crowned with beau-
tiful Romanesque capitals carved in the style of Toulouse and Moissac.
On one, a martyr carries his head in his hands; a Christian woman, bow-
ing before him, prepares to receive the head on a cloth. Since the church

is dedicated to St. Maurinus, there is no question about the meaning of the scene.[9]

This is about all in the way of saints' images that the vast region of the Midi has to offer us. In times past, it must have been incomparably richer; the great school of Toulouse had without any doubt lavished its masterpieces upon the region, but time has not respected them. In the twelfth century, no region was more productive than the beautiful plain which spreads out like a Lombardy of France under the sun at the foot of the Pyrenees, but no region has been more often devastated: the Albigensian Crusade, the Hundred Years' War, and the Wars of Religion accumulated so many ruins that one marvels that any vestiges of what had been the genius of the Midi remain.

To find the saints, we must go on to the Pyrenees. These poetic mountains had their Golden Legend; they had their martyrs, their ancient bishops, and their hermits. No doubt many of them were celebrated in art, but very few of these works still exist today.

At the entrance to the valleys of the Pyrenees, at Foix, there was a once famous abbey named for St. Volusian, a martyr of the Arian persecution. The church was rebuilt and the Romanesque cloister completely destroyed, but happy chance has preserved one of the historiated capitals. This capital is most interesting, for it relates an episode from precisely the story of St. Volusian. Volusian, bishop of Tours, was a subject of Alaric, king of the Visigoths, whose realm extended to the Loire. At Alaric's orders, he was wrested from his see of Tours and taken to Toulouse, because he was suspected of favoring the designs of Clovis, who was preparing an expedition against the Arians of the south. At Toulouse, he was treated as a felon; his hands were bound together, and he was led toward Spain. But when they came to the foot of the mountains, the soldiers ordered him to kneel in a field and they cut off his head. The capital represents Volusian with bound hands and a rope around his neck, pulled along by his executioners.[10] His death is not shown, nor are the ash trees that miraculously sprang up on the place of his martyrdom, but we see the vengeance sent by heaven. The other face of the capital represents the victorious army of Clovis besieging Toulouse; in another scene, the town is taken as the victors destroy the walls. This invaluable monument has been preserved in the museum of Foix, and it deserves to be, for Foix itself is a creation of the relics of St. Volusian: the town grew up around the monastery that preserved the tomb of the martyr.

Penetrating into the mountains, we see rising above the valley of Luchon a Romanesque church dedicated to St. Aventinus. The capitals of the portal tell his story. St. Aventinus was an eighth-century hermit who lived in solitude, with only the bears of the forest as companions. Sometimes he left his hut to preach the Gospel to the mountain people who were still

attached to their ancient gods. Everywhere, he was surrounded with respect. But the Arabs, who were then overrunning the Midi, heard of this propagator of the Christian faith. They set out to find him, and when they discovered his retreat, they seized him and cut off his head. The capitals tell of the birth, life, and death of the holy hermit; like many other saints, he is shown holding his head in his hands. In the apse, a relief represents the bull who rediscovered the long-forgotten tomb of St. Aventinus (fig. 160). The power of Christian art! For more than eight hundred years, a church clinging to a rock has perpetuated the memory of a poor unknown hermit.

160. Tomb of St. Aventinus found by a bull. St.-Aventin (Haute-Garonne), Church of St.-Aventin. West façade, south buttress relief.

On the summit of an acropolis in a region near Luchon stands the cathedral of St.-Bertrand-de-Comminges. It dates from the fourteenth century, but the portal and the rugged bell tower dominating it are from the twelfth. A beautiful tympanum from the school of Toulouse represents the Adoration of the Magi; on one side of this tympanum, behind the Virgin, a bishop faces the spectator; he raises his right hand in benediction and holds the crozier in his left hand (fig. 161). Who is this mysterious figure introduced by the artist into a sacred scene? Archeologists have cited as a guess St. Sernin, but in this place another name comes to mind. It was at the end of the eleventh century that the grandson of the Count of Toulouse, Bishop St. Bertrand, rebuilt from its ruins the abandoned town of antiquity, Lugdunum Convenarum; he brought back its inhabitants, rebuilt the church, and caused the surrounding desert to flower. He was the second founder of the town that bears his name. We cannot doubt that this great bishop, to whom the gift of performing

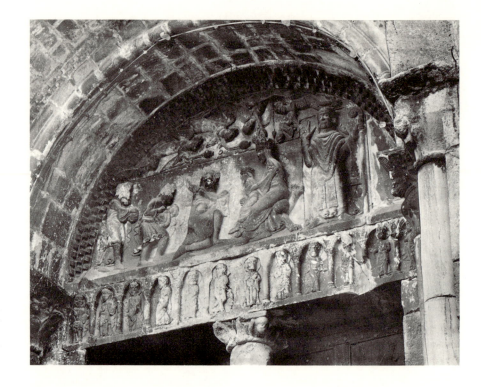

161. Adoration of the Magi and
St. Bertrand. St.-Bertrand-de-
Comminges (Haute-Garonne), Cathedral.
West portal, tympanum.

miracles was also attributed, would have been represented on the portal of his cathedral. St. Bertrand died in 1123.[11] His image must have been carved a few years after his death, at a time when his memory was still alive, and it was surely done before 1179, the date of his canonization, for he has no nimbus. This image of a great man, not yet sainted, is most interesting; feeling for him must have been very deep for anyone to have dared represent a contemporary, someone known to everyone, and to have placed him alongside the Virgin and the magi-kings.

At that time, the high Pyrenees were not a barrier between France and Spain; French saints were venerated in northern Spain and Spanish saints in the Midi of France. It is curious to find traces here and there of the cult the Midi churches had dedicated to the saints from beyond the mountains.

A capital in the cloister of Moissac represents the martyrdom of three saints of Tarragona: Fructuosus, Augurius, and Eulogius.[12] These illustrious Christians of the third century, celebrated by St. Augustine and Prudentius, are represented in the costume of the twelfth century; the bishop Fructuosus carries a crozier and wears a miter, the deacons Augurius and Eulogius wear the dalmatic and the maniple. The proconsul Emilianus, governor of Tarragona, is seated on a throne and, like a feudal baron, has beside him a rote player. This is the moment when the famous words were exchanged between Emilianus and Fructuosus: "I am the bishop of Christ," said Fructuosus. "Say that you *were* the bishop of

Christ," replied Emilianus, and sent him to martyrdom with his two companions. Another face of the capital shows the three saints praying in the middle of their pyre and, farther on, angels carrying their souls to heaven in an aureole.

The presence in the abbey of Moissac of some noteworthy relic of the martyrs of Tarragona no doubt explains why the monks wished to have the stories of the saints always in view. Relics found several years ago in the altar of the church of Valcabrère (Haute-Garonne) identified three of the statues decorating the porch:[13] they represent the deacon St. Stephen and two Spanish saints, St. Justus and St. Pastor (fig. 162).[14] These were two schoolboys of Complutum, which was later called Alcalá de Henares; at the time of Diocletian's persecutions, they were brought before the

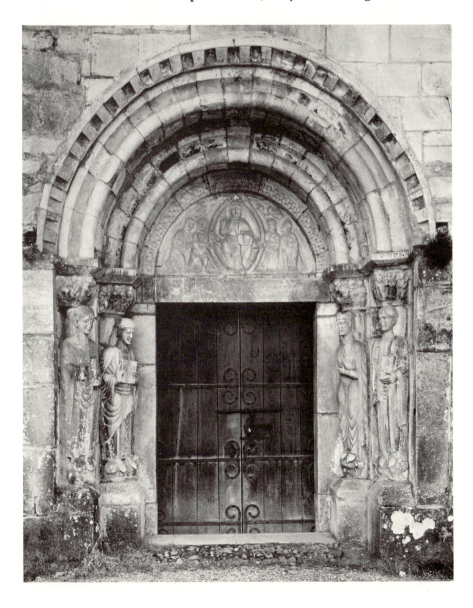

162. Christ in Majesty; St. Stephen, St. Justus, St. Pastor. Valcabrère (Haute-Garonne), St.-Just. North portal.

prefect Dacianus, who had them beaten with rods and put to death. Prudentius celebrated their courage. The artist knew their history well, for he did his utmost to give them a youthful appearance; above their heads, the story of their martyrdom is carved on capitals. One of the saints is lashed to a tree for his flagellation; the other is decapitated.[15]

It is not surprising to find a Spanish saint in the marble cloister of Elne (Pyrénées-Orientales), not far from the great Roman road that led to Spain. One of the capitals represents the martyrdom of St. Eulalia, patron saint of the cathedral of Elne.[16] The young saint of Merida was already famous in France, since the earliest of our poems in the Romance tongue is devoted to her.

This is nearly all that remains in the southwest of twelfth-century works devoted to the saints of southern France and of Spain.

II

Saints of Aquitaine: St. Martial of Limoges. St. Valeria. St. Amadour. St. Veronica. Saints of the Central Plateau: St. Foy of Conques. St. Chaffre. St. Baudimus, St. Stephen of Muret. St. Calminius.

When we come to Aquitaine, we enter the realm of St. Martial. St. Martial was venerated very early as the apostle to Limousin, but until the eleventh century little was known of his history. It was then that his marvelous legend was written.[17] It was attributed to St. Aurelian, the first of his successors—the Aurelian whose chapel still stands along the rue des Bouchers at Limoges. This account was further embellished, and an entire cycle of poetic legends grew up around St. Martial. He was no longer a simple missionary; he became a contemporary and disciple of Christ; as a child he had heard Christ's words, and it was of him that Christ had said: "Whosoever is not like unto this child, shall not enter into the kingdom of heaven." He had been present at the Miracle of the Loaves, and at the Washing of Feet; later, he accompanied St. Peter to Rome. St. Peter had given him his staff and sent him to evangelize Gaul; with this famous staff, which was long preserved in the church of St.-Seurin at Bordeaux,[18] St. Martial resurrected the dead. As he progressed through Aquitaine, he conquered: everywhere he passed, a church sprang up. He was the founder not only of the church of Limoges, but of the churches of Bourges, Poitiers, Saintes, Bordeaux, Cahors, Tulle, Rodez, Aurillac, Mende, and Le Puy. The first bishops of these towns, once thought to be apostles, were only his disciples. Poetic personages accompanied St. Martial. It was said that he had come into Gaul with St. Veronica who had wiped the face of the Saviour on the road to Calvary, and with St. Amadour who was later confounded with the Zacchaeus of the Gospels to whom Christ had spoken.[19] Veronica and Amadour, who both had seen and heard the Word, could no longer endure to live in the company of men; they sought solitude, St. Amadour in a deep valley where the sanctuary of Rocamadour

was later built, and St. Veronica in the desert of Soulac, beside the ocean.

Legend also associated a young virgin, St. Valeria, with St. Martial. She belonged to one of the most illustrious families of the land of the Lemovices, and was betrothed to the Roman proconsul. But she had heard St. Martial preach and was baptized. She aspired to perfection. She refused to marry the proconsul, who, in his anger, had her put to death. A centurion cut off her head; the saint took it in her hands and presented it to St. Martial, who was celebrating Mass in the church of Limoges.

Visitors to the Papal Palace at Avignon know the delightful frescoes by Matteo da Viterbo, in which we see all these stories about St. Martial unfold beneath an azure sky. We must not expect works of such charm from the twelfth century. Moreover, St. Martial, who held such a large place in the imaginations of twelfth-century men, left only a few traces in the art of that time. Many works, certainly, have disappeared.

The great abbey church of Limoges, where his tomb stood, that famous church of St.-Martial which had attracted so many pilgrims, was destroyed with all its works of art during the Revolution—an irreparable loss for the iconography of St. Martial. Had his legend been told there in fresco? Believably, for according to Adhémar de Chabannes, there were mural paintings relating the story of his life in the church that preceded this one.[20] At the end of the tenth century, a monk who was the goldsmith of the abbey had made a golden statue of St. Martial for the altar. It represented him as seated and giving the benediction with his right hand while carrying the book in his left.[21]

In many churches that gloried in being founded by St. Martial, there were probably works of art recalling his apostleship. At Toulouse, legend went so far as to associate St. Martial with St. Sernin in the preaching of the Gospel. That is why St. Martial was represented on the portal of St.-Sernin; near his image, paired with that of St. Sernin, is the inscription: *Hic socius socio subvenit auxilio*.[22] Thus, according to the clerks of Toulouse who were the guardians of the tomb of St. Sernin, their patron saint had been seconded in his work by the great St. Martial, disciple of Christ.

At the other end of Aquitaine, on the borders of Berry, in the Romanesque church of Méobecq (Indre) there is still to be seen a mural painting from the twelfth century representing St. Martial. The monks of Méobecq, indeed, related that St. Martial had come that far in his evangelical mission.[23]

Probably more than one twelfth-century work exists in which St. Martial goes unrecognized. On the façade of Notre-Dame-la-Grande at Poitiers, beneath arcades, two bishops appear alongside the twelve apostles. It is likely that one of them is St. Martial, the legendary founder of the church of Poitiers and almost equal in dignity to the apostles.[24]

Several works from the late twelfth century offer the earliest representations of the legend of St. Martial: these are the enameled reliquaries from the workshops of Limoges.

On one of these (fig. 163),[25] St. Martial resembles an apostle, and like the apostles, has bare feet—an exceptional privilege and a sign of his exalted mission. He carries the famous staff in his hand; he has only to extend it toward the man possessed, with hair standing straight up, for the demon to rush out of his mouth.[26] This miracle so impressed St. Valeria that it disposed her to receive baptism. On the other side of the shrine, she is shown kneeling before St. Martial who blesses her; but the proconsul has already ordered her to be put to death (fig. 164).

Another reliquary of the same period represents the centurion leading St. Valeria to martyrdom.[27] The young saint wears the clinging robe with long sleeves of the earliest statues of Chartres. The executioner cuts off her head, but she takes it in her hand and goes to present it to St. Martial, who is celebrating Mass; an angel flies above her, and by a charming artifice, the head of the angel takes the place of the saint's head. Here, St. Valeria is the heroine being celebrated by the artist, and no doubt it was one of her relics that the reliquary casket contained.

St. Valeria was, in fact, almost as popular as St. Martial himself. When the counts of Poitiers came to Limoges to be crowned dukes of Aquitaine, the bishop presented them with crown and sword, and then the dean of the chapter placed on their finger the ring of St. Valeria. This was the betrothal of the duke and the Church of Aquitaine, of which Valeria was

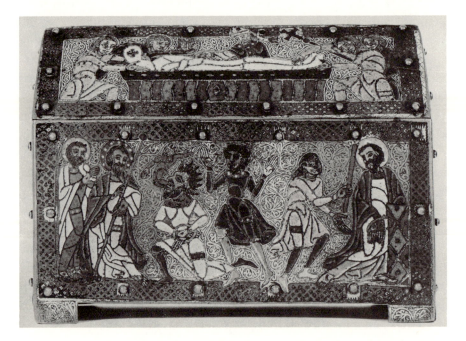

163. Scenes from the Life of St. Martial. Enameled reliquary. Paris, Louvre (formerly Martin Le Roy Coll.).

the purest symbol. That is why the works of art that represent her—and they are only too rare today—are a moving and poetic image of the past. Not far from Bellac, in the ancient church of St.-Pierre of La Trémouille, there are some vestiges of a twelfth-century fresco. Two saints are still visible, and their names can be read: St. Valeria and St. Radegund.[28] The Golden Legend of Poitou was here united with that of Limousin.

The monastery of Chambon-sur-Voueize (Creuse), at the far end of La Marche, was one of the centers of the cult of St. Valeria. It possessed some of her relics, but the charming silver bust that contains them today goes back only to the fifteenth century. It represents the young martyr with a crown and a rich necklace. None of the works devoted to St. Valeria in the twelfth century has been preserved in the old church of Chambon; but what can no longer be seen there may be seen a little farther on in the abbey church of Ebreuil-en-Bourbonnais (Allier).[29] In the tribune, a twelfth-century mural painting represents the martyrdom of St. Valeria along with the martyrdom of St. Pancratius, of whom a relic was no doubt preserved in the church. This was the boundary of the saint's glory.

St. Martial's other companions, St. Amadour and St. Veronica, both of whom were already famous in the twelfth century, inspired works of art that have been almost completely destroyed throughout the years. Rocamadour, only too often sacked, has no images of the founder of the sanctuary, St. Amateur, whom the people called St. Amadour. But we may still see the wooden Virgin, once covered with silver plate, which was said to have been made by his hand.[30]

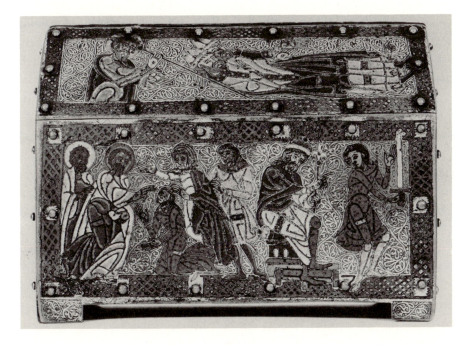

164. Scenes from the Life of St. Martial. Enameled reliquary. Paris, Louvre (formerly Martin Le Roy Coll.).

At Soulac, a monastery grew up near the tomb of St. Veronica. The church containing the relics of the saint was called Notre-Dame-de-la-fin-des-Terres, and in fact this was one of the ends of the earth, the shore of the unknown. A vast desert of sand and the distant murmur of the great and then limitless ocean lent religious beauty to the place. Little by little the dunes, pushed by the wind, invaded the monastery and in the end completely covered it. In 1860, excavations brought the Romanesque church again to light, emerging from its shroud of sand like a temple of Upper Egypt. Two capitals were then observed to decorate the entrance to the chapel once dedicated to St. Veronica: one represents a tomb; the other, pilgrims standing at each side of an altar on which rests a reliquary shrine. In all likelihood, these are the tomb and the reliquary of St. Veronica, which attracted so many pilgrims to Soulac.

So it was that the legend of St. Martial and his companions spread from Bourbonnais to the ocean, and from Berry to Toulouse.

The center of ancient Aquitaine with its deep valleys and swift-flowing rivers has the beauty of primitive nature, but it is a country of granite where stone resists the chisel. Consequently, the saints were not honored by sculptors but by goldsmiths. At the end of the tenth century, several churches in Aquitaine possessed images of their patron saints in gold, silver, or brass—images which were also reliquaries.

Let us listen to Bernard, the schoolman of Angers, who traveled over the central plateau in the early eleventh century. "Until now," he says, "I had thought that the saints should be honored only in drawings and paintings; it seemed absurd and impious to erect statues to them. But this is not the sentiment of the inhabitants of Auvergne, Rouergue, the region of Toulouse, and the neighboring country. There it is an ancient practice for each church to possess a statue of its patron saint. According to the means of the church, this statue is of gold, silver, or a less precious metal; it contains the head or some noteworthy relic of the saint."[31] Thus, a man from the north discovered, on going to the Midi, another France. Bernard has made known to us some of these statues. Several were brought to the Synod of Rodez and placed under tents in a field outside the gates of the city; they were more imposing than the assembly of bishops. These were all golden statues of the saint in majesty: the "golden Majesty" of St. Marius, patron of the abbey de Vabres in Rouergue; the "golden Majesty" of St. Amand, the second bishop of Rodez; the "golden Majesty" of St. Foy of Conques; and lastly, beside the golden reliquary of St. Sernin, there was the "golden Majesty" of the Virgin.[32] On Bernard's way south, he had already seen the "Majesty" of St. Gerald, the young knight become monk who had lent his name to the great abbey of Aurillac. But he apparently did not see the "Majesty" of St. Martial in the abbey at Limoges.

Some of these strange statues still exist. The "Majesty" of St. Foy is still

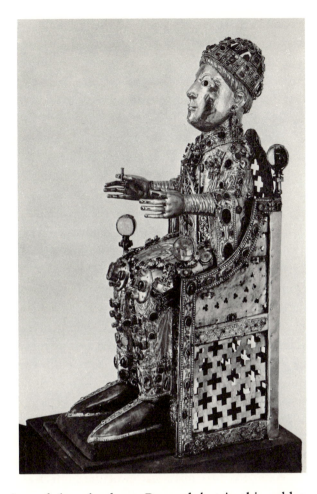

165. St. Foy. Reliquary statue. Conques (Aveyron), Treasury of the Abbey Church of Ste.-Foy.

at Conques, as in the time of the schoolman Bernard, but in this golden idol we scarcely recognize the story we have told above of the young martyr of Agen (fig. 165). The saint is seated on a throne and glitters with gold and precious stones; she wears a solid crown of a very ancient form; long earrings hang down on her shoulders; in each hand she delicately holds between thumb and forefinger two small tubes for flowers; beautiful cameos from antiquity are incrusted here and there on her robe.[33] The artist could not make her beautiful, but he made her so rich that she is awe-inspiring. And there was an aura of the miraculous about her that was even more dazzling than the gold. If a plague devastated the neighboring country, a dispute arose between two towns, or a baron claimed one of the abbey's domains, St. Foy's statue was brought out of the sanctuary at once. She was carried on a horse chosen for its easy gait. Around her, young clerics clashed cymbals and blew on ivory horns.[34] Her progress was as majestic as the Magna Mater's had been when these mountain people were pagan. Everywhere she passed, she brought concord and peace; her miracles were so abundant that the monks hardly had time to write them down. Above all, it pleased the saint to liberate prisoners; on the portal

of Conques, we see her prostrated before the hand of God; she is no doubt praying for captives, since behind her, chains are hung as votive offerings. The statue of St. Foy was carried far beyond the limits of Rouergue, to Auvergne and the Albigensian country.[35] Every night a tent was pitched over her, and over the tent, an arbor of greenery. How fortunate it is that the "Majesty" of St. Foy has been preserved intact. And how this piece of gold illuminates the early Middle Ages! It makes us understand the mysterious and formidable powers of the saint.

The statue of St. Foy is unique in its richness, but two simpler and less ancient images of saints still exist in this region. One is preserved in the church of Le Monastier, an ancient abbey deep in the solitude of Le Velay. This is a half-length statue of silver plate set with cabochons, representing a saint with bulging eyes and the fearsome name of St. Chaffre (fig. 166).[36] Chaffre is the popular form of Theofredos. St. Chaffre is a martyr from the time of the Saracen invasion.[37] As abbot of Le Monastier, he ordered his monks to flee, and he remained alone to confront the Arabs. He was beaten with rods and left dying in his church; the next day, scarcely able to stand, he appeared before the imams during a festival, to prove to them that they did not worship the true God; executioners finished him off. Like the statue of St. Foy, St. Chaffre's statue contained relics which made it even more worthy of veneration.

The statue of St. Chaffre probably dates from the eleventh century. The statue of St. Baudimus, more skilful, must date from the twelfth.[38] It is preserved in the church of St.-Nectaire and perpetuates the memory of one of the first missionaries of the faith in Auvergne (fig. 167). It is half-length, like that of St. Chaffre; it is not of silver but of repoussé copper, chased and gilded. The hair lies in parallel curls, like the hair of an archaic Greek head; eyes of ivory, with pupils of horn, give the apostle a look that is stern and intimidating. These still unrealistic works lend a distant majesty to the saints and surround them with a mystery that responded perfectly to the feelings that sainthood then evoked.

These reliquary statues, once numerous in the mountainous provinces of central France, seem to have been the work of monastic artists. There had been an atelier of goldsmiths at Conques, and the statue of St. Foy was probably made in the abbey itself in the tenth century.[39]

But toward the middle of the twelfth century, the workshops of Limoges began to take precedence. It was to be Limoges which took over the duty of celebrating the saints of Aquitaine, and later, of part of the Christian world. At Limoges, there began the long litany in honor of the saints which was to last for many centuries and is expressed in copper and enamel.

Monuments of the twelfth-century Limoges goldsmiths are rare today. Before the Revolution, one of the masterpieces of the school was in the

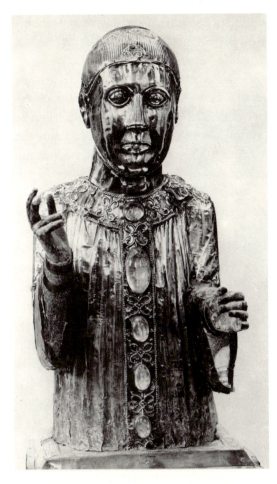 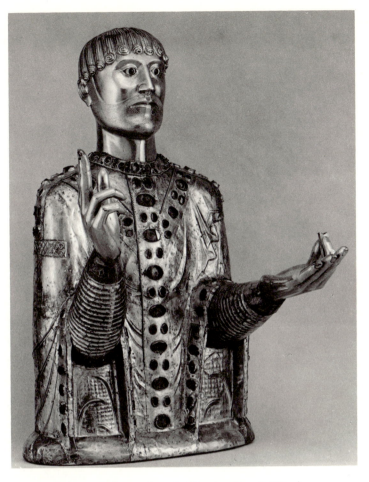

166. St. Chaffre. Reliquary bust. Le Monastier (Haute-Loire), Abbey Church.

167. St. Baudimus. Reliquary bust. St.-Nectaire (Puy-de-Dôme), Priory of St.-Nectaire.

famous abbey of Grandmont. This was an enameled reliquary which contained the relics of St. Stephen of Muret, the founder of the order. The entire life of the saint was shown there. Although St. Stephen had been born at Thiers in Auvergne, his good works linked him with Limousin, for he had lived in the forest of Muret, near Limoges.[40] It was only natural that the Limoges enamelers should honor him. A twelfth-century enamel plaque, now in the Cluny museum, is very probably a part of the reliquary from Grandmont. It shows St. Stephen of Muret, who had made a pilgrimage to Bari, at the moment when St. Nicholas, the great saint of that region, appeared to him; an inscription in the French spoken south of the Loire explains the scene.[41] A detailed life of the saint was represented on the reliquary and must have included the scene in which St. Stephen of Muret, when he decided to dedicate himself to a life of solitude, placed a ring on his finger, and on his head the act of renunciation he had just

written out. "This," he said, "will be my shield on the day of my death." This sense for symbolism was in perfect harmony with the art of the twelfth century.

We have already spoken of the reliquary shrines that celebrated St. Martial and St. Valeria. There still exists a magnificent shrine of the second half of the twelfth century dedicated by the Limoges enamelers to the glory of a saint who came from the center of France; it contains the relics of St. Calminius and is preserved in the church of Mozat, near Riom. St. Calminius, who was governor of Auvergne, Velay, and Gévaudan in the seventh century, was a descendent of Calminius, the friend of Sidonius Apollinaris.[42] On a journey to Lérins he was impressed with the beauty of monastic life. He perhaps never became a monk, but he founded monasteries, first in Velay at Calminiacum, then in Limousin at Tulle, and finally at Mozat in Auvergne. His wife, St. Namadia, shared in the work and gave him counsel. That is why one of the enamels shows the couple having Calminiacum, later called Le Monastier, built. This was the abbey which St. Chaffre was to make renowned. Next we see them having a monastery built at Tulle, and then at Mozat. Masons mix mortar and climb a ladder. The abbey is not yet finished, but the church has already been built and the chalice is on the altar; the house of God has thus been finished before the house of the monks. Their work done, Calminius and Namadia die in sanctity; their souls rise in an aureole, and the hand of God issues from heaven.

This magnificent work arouses our regret. How many similar reliquaries must have disappeared when these treasures were taken from the sanctuary and sold by weight as copper to be used in cooking kettles. The few monuments of this kind still extant date from the thirteenth or later centuries. Occasionally, in a village church surrounded by the heather and flowering black wheat of Limousin, we come upon an enamel reliquary which tells the story of St. Dulcidius[43] or St. Psalmodius,[44] or the hermit saint, Viance;[45] sometimes a reliquary bust represents the solemn St. Stephen of Muret,[46] or the slave St. Théau[47] redeemed by St. Eloi and a goldsmith like his master, or the abbot St. Yrieix,[48] or the exquisite St. Fortunata.[49] Then for an instant we breathe the perfume of the past, and there are many sumptuous masterpieces that touch us less than these humble marvels.

III

Saints of Poitou: St. Hilary. St. Triaise. St. Savinus.

Poitou occupies a place apart in St. Martial's vast domain, for in the fourth century, one of the most illustrious saints of Christendom, St. Hilary, belonged to it. This was an authentic saint that legend hardly dared to touch;

he had not lived in the obscure Merovingian times but in the fourth century, which was still illuminated by the light of antiquity. He was at first a pagan, and had been married before he became bishop, but once a Christian, he had been one of the most valiant defenders of orthodoxy against Arianism. St. Jerome said that his books had the irresistible force of the Rhone. When exiled to the East by an Arian emperor, he studied the works of Origen and made known to the Gallican Church the allegorical exegesis of the Alexandrians.

Why would such a saint have appealed to the twelfth-century pilgrims who stopped at his tomb as they passed through Poitiers on their way to Santiago de Compostela? He probably would not have, had it not been that after his death numberless miracles were known to have manifested his power and had created a legend around him. It was above the tomb of St. Hilary that the column of fire had appeared to guide Clovis before the battle of Vouillé. These were probably the miracles painted in the church of St.-Hilaire at Poitiers, one of the most famous sanctuaries in France. Forty years ago, remnants of these frescoes could still be seen in the apsidal chapels.[50] Today, a sole monument in the church recalls the memory of the great doctor: a capital representing his death. No inscription accompanies the scene, but its presence in such a place leaves little room for doubt that the saint, dead among his deacons and his soul borne to heaven by angels, is St. Hilary. An attempt was made to express emotion in this still very crude work. Leonnius, the favored disciple of the saint, leans once more over the body of his master and expresses his grief by placing his hand against his cheek, like St. John at the foot of the cross.

But at Poitiers, there is another twelfth-century church dedicated to St. Hilary—St.-Hilaire-de-la-Celle, which according to tradition is built on the site of his house. Toward the end of his life and after the death of his wife and daughter, the saint built a chapel there to which he was fond of withdrawing. It was there that he died in 368, and from there that he was carried to the church of St.-Jean-et-St.-Paul, which had been built in the center of the early Christian cemetery and which was then given his name. Until its destruction by the Protestants, a cenotaph was to be seen in the church of St.-Hilaire-de-la-Celle, depicting the life of the saint.[51] Only one fragment, representing the death of St. Hilary, remains (fig. 168).[52] The scene is majestic: St. Hilary, lying in an open sarcophagus, is a colossal figure who seems to belong to a race other than mankind. Behind him stand the clerics of his church; the two nimbed deacons at the two ends are without doubt Leonnius and Justus, St. Lienne and St. Just, as they were called, the two most cherished of his disciples. Before St. Hilary died, he asked one of them if the night were silent. In the center of the group, two angels appear with outspread wings; they have descended in that silent, religious night to gather up the soul of the dead man.

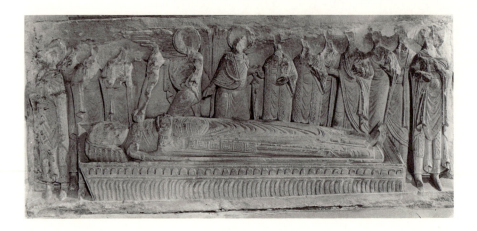

168. Tomb of St. Hilary. Poitiers
(Vienne), St.-Hilaire-le-Grand.

This lofty style of composition and feeling indicates a period in the latter part of the twelfth century.

But is only St. Hilary's death to be seen at Poitiers? Are there no traces left of his life? A relief, which now belongs to the Société des Antiquaires de l'Ouest, had for a long time decorated the now destroyed church of St.-Triaise.[53] It represents St. Hilary with crozier in hand dedicating the virgin Troecia—St. Triaise—to God. St. Hilary had been able to watch and admire the beginnings of monastic life in the East, and Troecia, his spiritual daughter, was one of the earliest nuns of Gaul. Shut in her cell, she lived among the tombs in the midst of the Christian cemetery of Poitiers, like a recluse of the Thebaid. St. Hilary's own daughter, St. Abra, followed the example of Troecia. Her father encouraged her vocation, promising her in one of his letters a pearl more beautiful than that given to virgins by their betrothed. The lid of St. Abra's sarcophagus is still displayed in the church of St.-Hilaire.

But it is in Burgundy, not in Poitou, that we find the most curious representation of the life of St. Hilary. At the church of Semur-en-Brionnais (Saône-et-Loire), dedicated to him, the most beautiful chapter of his history is told on the lintel of the portal (fig. 169). We see the saint arriving at the Council of Seleucia to combat the Arian bishops. But here, the Middle Ages have already been at work and legend has distorted the truth. In the second part of the relief, St. Hilary sits below the bishops, because the Arians would not allow him a place among them. An angel censes him from heaven and designates him as the champion of God. The false pope Leo leaves the council, pronouncing threatening words against the saint; but Leo dies an ignominious death, and devils seize his soul.[54] Although the subject of this relief is interesting, the work is not expressive; it has neither the movement nor the vitality of great Burgundian sculpture.[55]

St. Hilary, venerated in his church by so many pilgrims, was the great saint of Poitou, but many other less illustrious saints had inspired the

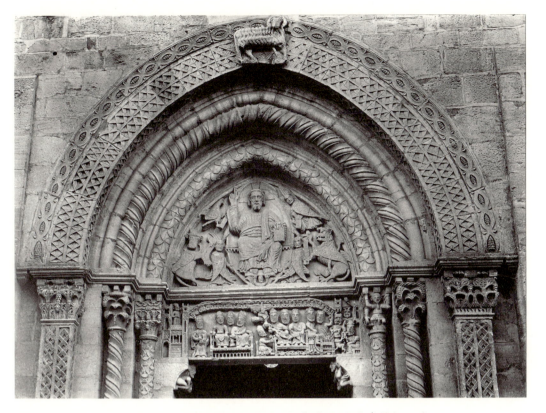

169. Christ in Majesty; Life of St. Hilary. Semur-en-Brionnais (Saône-et-Loire), Priory of St.-Hilaire. West façade, portal.

artists of this region. If the frescoes in the abbeys of Poitou had been as well preserved as those of the abbey of St.-Savin-sur-Gartempe (Vienne), we would have a veritable ecclesiastical history of the province. As a matter of fact, large figures painted not far from the scenes of the Passion in the tribune at St.-Savin represent the sainted bishops of Poitou. Inscriptions that were still visible a few years ago name St. Gelasius and St. Fortunatus, the famous bishop-poet.[56] In the crypt, a part of the frescoes devoted to St. Savinus, patron of the abbey, and his companion St. Cyprian can still be seen. Both were martyrs (fig. 170).[57] In vain were they torn by iron spikes, fastened to the wheel, and exposed to wild beasts. Each time they miraculously escaped death. Lions, which the painter made as harmless as dogs, came to lick their feet in the arena. According to tradition, the two saints were finally put to death by their persecutors not far from the abbey, on the banks of the Gartempe.

Thus, the early history of Poitou was always before the eyes of visitors to the abbey. Art revived the past, made it live in the imagination. We may be sure that in the whole region of Poitou—one of the areas in France where the greatest body of monumental painting has survived—there were sanctuaries like St.-Savin, where the history of the saints of the province

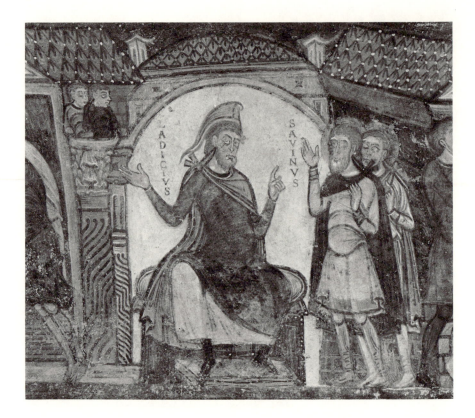

170. Legend of St. Savinus and
St. Cyprian. St.-Savin-sur-Gartempe
(Vienne), Abbey Church. Fresco
of crypt.

could be learned. The monks had long since tested the power of painting
to educate; they knew its magical power over the illiterate. But at Char-
roux, at St.-Jouin-de-Marnes, Airvault, and Maillezais, in all the illustrious
abbeys, no painting remains today.

IV

Saints of Berry: St. Outrille. St. Eusice.

Berry, with its indeterminate plains, was often thought to be the fief of
St. Martial, for according to Limousin tradition, it was he who had
founded the church of Bourges. But another legend in Berry vied with
this one, the legend of its first apostle, St. Ursin.[58] Ursin was the Nathanael
of the Gospels; it was he who was first to bring the new faith to Bourges
and he who had brought with him two priceless relics: the rope with
which Christ had been fastened to the column, and several drops of St.
Stephen's blood, for Nathanael had been present at the martyrdom of the
holy deacon. St. Ursin thus became almost equal in dignity to St. Martial.

Among the successors of St. Ursin, several bishops of Bourges had been
raised to sainthood by their virtue. Berry had also had its holy hermits—
men of God lost in solitude in this land of swamps and great forests.

Many of these saints who lived on in men's memory must have been
celebrated in the art of the twelfth century. The old churches of Berry

are not very rich in sculpture, but many of them were painted. More than one fresco is still hidden beneath whitewash, and perhaps one day the once famous saints will reappear—St. Sulpice, St. Patroclus, St. Venantius, St. Leopardinus, St. Laurianus and the shepherdess St. Solangia, as famous in Berry as St. Valeria had been in Limousin.

What, then, remains? On the exterior of the church of Châtillon-sur-Indre (Indre), there is a relief of the twelfth century which once decorated the portal and is now set into a high window of the transept. It represents Christ in Majesty seated between two seraphim; below, St. Austregisilus, whose name is inscribed, is beside St. Peter.[59] St. Austregisilus, called St. Outrille by shepherds and farm laborers, was bishop of Bourges at the beginning of the seventh century. Before he took holy orders, he had been known to go to Châlon to fight in the lists.[60] When he became bishop, he fought with all the vigor of a soldier against the Merovingian kings and their tax collectors. His sainthood was manifested by a number of miracles: at Châtillon, another relief, of which only the inscription remains, showed him curing a madwoman. It is a pity that the architect who restored the church about 1880 placed the old tympanum so badly, for we can no longer see St. Peter giving St. Austregisilus the rod of justice with which to punish a culprit.

The church of Selles-sur-Cher (Loir-et-Cher) has fortunately preserved the crude reliefs devoted to the glory of Eusitius, or St. Eusice, in their original place. There are a number of nice details in the life of St. Eusice.[61] His parents were so poor that they were obliged to sell one of their children into slavery, and it was St. Eusice who sacrificed himself for his brothers. He freed himself from slavery by his saintliness. His reputation was so great that Childebert, on the way across Berry to fight the Visigoths of Spain, wished to see him and question him about the future. He offered him fifty gold sous. "Give the money to the poor," Eusitius said to him, "as for me, all I need is to pray for my sins." Then he foretold that the king would return victorious, and his prediction came about. That is why Childebert, on his return, stopped again to see the saint. After giving him the kiss of peace, he offered him half the plunder he had brought back from Spain. In the king's retinue, there were prisoners of war "tied together two by two, like pairs of dogs," the biographer says. The only favor the saint asked of the king was that they be freed.

The odd thing is that these lively episodes do not appear in the reliefs decorating the apse of Selles-sur-Cher.[62] St. Eusice, who was great because of his charity, is treated as a thaumaturgist, almost a magician. He compels the devils to make themselves useful; at his orders, they harness themselves to a wagon and haul stones for the church. He uses wolves to guard his flocks. Nothing is beyond him: one day when his baker's peel was stolen from him, he stepped into the hot oven and calmly arranged his

loaves of bread. That is what we see in the apse of Selles-sur-Cher. These miracles charmed the people of the twelfth century, and often it was the people themselves who created these fairy tales. They turned the lives of saints into songs for the evening, into winter's tales. In his *De pignoribus sanctorum,* Guibert de Nogent says that as the women wove cloth they sang the praises of many saints with wholly legendary lives. "If anyone chides them," he adds, "they threaten him with their shuttles."[63] The reliefs at Selles-sur-Cher are further testimony to this twelfth-century passion for marvels.

<div align="center">V</div>

Saints of Auvergne: St. Austremonius. St. Nectarius. St. Priest.

Few saints are more poetic than those of Auvergne. Their charm may derive from their first historian, Gregory of Tours, who was an artist without knowing it. For instead of telling us outright about his heroes, he allows us to see them for ourselves through a mysterious half-light. Among these saints are Injuriosus and Scolastica, "the lovers of Auvergne," who were united in their graves by a rose vine; the hermits of caves and forests, St. Emilien, St. Marien, St. Lupicin, and St. Calupan, who, under frigid skies, performed the same wonders as the anchorites of Egypt; and the virgin St. George, whose funeral procession was accompanied by a flight of doves. The charm of a wild untamed countryside envelops them. The aura of the desert of La Chaise-Dieu surrounds St. Robert. The high castle of Mercoeur and the lava of the Couze valley lend their charm to St. Odilo; the vast forests of Combrailles, the *Ponticiacensis sylva,* surround the old abbots of Menat.

A traveler through Auvergne, recalling the long history of its saints, seeks them out in the splendid Romanesque churches. He finds very few; man and time have been no kinder to Auvergne than to the other provinces.

The apostle to Auvergne, St. Austremonius, was first buried in the church of Issoire. The location of his tomb had been forgotten until some men dressed in white and carrying candles, who used to appear by night in the church, rediscovered it.[64] From Issoire, the body of St. Austremonius was taken to Volvic. But soon after, his relics were taken on a last journey and placed in the abbey of Mozat. According to tradition, Pepin the Short himself carried the saint's reliquary casket on his shoulders.[65] If we look for traces of St. Austremonius at Issoire and Volvic, we will be disappointed, for there are none; but at Mozat, there is one work of art that recalls his memory. On one side of the reliquary of St. Calmin, of which we have already spoken, a bishop is shown standing with a crozier in his hand. An inscription tells us that this is Sanctus Austremonius.

But it could be that St. Austremonius was represented again elsewhere. Imbedded in a wall of the church of Mozat, there is the lintel of a former portal (fig. 171). The Virgin, seated in majesty, occupies the center and holds the Child on her knees; she resembles, and could even be taken for, one of the wooden Virgins in Auvergnat churches. St. Peter is at her right and St. John at her left. A bishop stands beside St. Peter. Who could he be if not the apostle to Auvergne, St. Austremonius, the great saint whose relics were in the church of Mozat? There is no doubt that he is among the blessed, for with his hand he points to an abbot prostrate before the Virgin. In this relief, the abbot—one of the builders of the church—is the only living person; he alone is still on earth. The very place given to the bishop at St. Peter's side is significant, for local legend, jealousy eager for St. Austremonius to be the equal of St. Martial, made him a disciple of the prince of apostles.

We come upon St. Austremonius again, at the borders of ancient Auvergne. In the church of Ebreuil, a twelfth-century fresco painted in the tribune shows the saint facing St. Valeria. Here the great saint of Poitou meets the great saint of Auvergne.

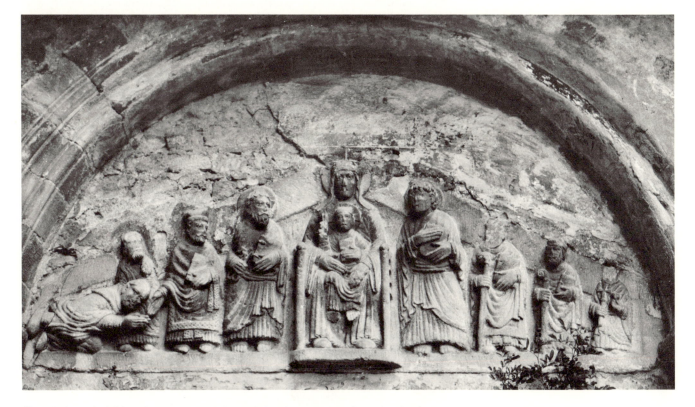

171. Virgin and Child, with St. Peter, St. John and churchmen. Mozat (Puy-de-Dôme), Abbey Church of St.-Pierre. South transept, lintel of an ancient portal.

It was related that St. Austremonius came to Gaul from Rome with two companions, Nectarius and Baudimus, and assigned them the task of evangelizing southern Limagne (Alimania) and the neighboring regions. Consequently, the church of St.-Nectaire contains both the bust of St. Baudimus, of which we have spoken, and a capital devoted to the story of its patron saint.

There are four episodes from the history of St. Nectarius carved on this capital. The artist takes us first to Rome: St. Peter ordains St. Nectarius, his godson, as priest, and the struggle between the saint and the devil begins at once. One day when he wanted to cross the Tiber to pray in a sanctuary on the other side of the river, he recognized the boatman approaching in his boat to be Satan himself. Fearlessly, he stepped into the boat, for an angel sent by God hovered above them in the sky and Satan was forced to put him safely down on the far shore—a bizarre legend that seems to transport us not to the Rome of St. Peter, but to the strange Rome of the Middle Ages.

Meanwhile, St. Peter has just sent Austremonius, Nectarius, and Baudimus to Gaul. They no sooner arrive at Sutri than Nectarius falls sick and dies; Baudimus returns to Rome to announce the news to St. Peter, who hastens to the scene. He touches the dead body with the cross, and immediately Nectarius rises from his sarcophagus.

St. Nectarius, who has passed through death, has become all-powerful over it. We see him now in Auvergne. One day while preaching the Gospel, the funeral procession of a Gallo-Roman, Bradulus, passes nearby: he is beseeched to bring Bradulus back to life. St. Nectarius takes the dead man's arm and orders him to stand up (fig. 172). Carved behind the

172. Miracle of St. Nectarius. St.-Nectaire (Puy-de-Dôme), Priory of St.-Nectaire. Choir capital.

saint is the church of St.-Nectaire as we see it today on top of its rock.[66] The artist had to be very ingenious to tell of so many things on one single capital; yet however condensed his work, it is very clear. Thus, the pilgrims who visited his church saw St. Nectarius less as an apostle than as a potent thaumaturgist.

The most famous of St. Austremonius' successors to the see of Clermont was not, as might be expected, the valiant Sidonius Apollinaris but the bishop Praejectus. In central France, Praejectus is called St. Priest; in northern France he is St. Prix. He was already famous for his virtue, almsgiving, and charitable foundations; his death made him a saint. He was murdered near Volvic by accomplices of a man whose crimes he had denounced to Childeric.[67] Some of his relics were taken to Flavigny, to St.-Quentin, and to Béthune; his cult spread. His fame at the time almost equaled that of St. Léger, his contemporary, who also had been murdered. St. Priest's body remained buried in the church at Volvic where it has been venerated for centuries; the sword of the assassin is also preserved there. Only the choir of the twelfth-century church of Volvic has been preserved; the nave is modern. A capital in the choir represents not the death of St. Priest, which was no doubt shown elsewhere in the church, but the altar of his relics; a donor stands beside the altar, which an inscription identifies as indeed that of the holy bishop.[68]

These are a few fragments of the ancient religious history of Auvergne. It is a pity that more has not been discovered. One regrets that there is nothing left in the church at Brioude to recall the martyrdom of St. Julian, once so famous. At Menat, we would expect to find some trace of the monks of the abbey who were raised to sainthood—St. Brachio, the boar-hunter, and St. Carilef, the companion of the aurochs in the forest. Unfortunately the choir of the church of Menat, where the historiated capitals were, has been destroyed. Only one capital still exists, now placed in one of the side aisles. It represents a puzzling scene which probably has to do with a monk of Menat. Perhaps it represents St. Meneleus refusing the fiancée presented to him by his father and already thinking of going to the abbot of Menat, to be seen seated at a distance on his throne, to ask to join his order.

VI

Now we will return toward the Midi, for it is in Provence that we find the most marvelous of all our legends. A tenth-century manuscript, now in the Bibliothèque Nationale,[69] tells how Mary Magdalene, her sister Martha, and her brother Lazarus, fleeing the persecution of the Jews after the resurrection of the Saviour, embarked and finally reached Marseille. It was they

Saints of Provence: the legend of Mary Magdalene, Martha, and Lazarus. The legend created in Burgundy at Vézelay. Lazarus at Autun and Avallon. St. Benignus at Dijon. St. Hugh at Anzy-le-Duc.

who brought the faith to Provence. A slightly later legend has St. Maximin, apostle to Aix, and St. Trophime, apostle to Arles, coming with them. Thus beautiful Provence, as sunlit as the Near East, became another Judaea: Lazarus arose from the tomb to bring the Gospel; Martha and Mary Magdalene came to repeat the words they had heard from the mouth of the Lord. What church could boast of a nobler origin?

Did this legend leave any trace in the twelfth-century art of Provence?

On the façade of St.-Trophime at Arles, we see St. Trophime himself among the apostles. He holds the crozier, and two angels place the miter on his head as if to indicate the divine character of his mission. In the cloister he is to be seen again, standing against a pillar; this time he is bareheaded, wears a tunic and a mantle, and were he not wearing shoes, could be taken for an apostle. There are no historiated capitals or reliefs to accompany these two images of the saint and tell the saint's story. Toward 1180, the artists of Arles had no doubt heard that St. Trophime had come to Provence with Lazarus, Mary Magdalene, and Martha, but they have nowhere alluded to the story. They seem, even, to have had another one in mind: by placing St. Trophime alongside St. Peter, they appear to have wanted to endorse the ancient tradition of the church of Arles, according to which St. Trophime was sent from Rome by the prince of apostles.[70]

Nevertheless, it would be surprising if there were not some trace in twelfth-century Provençal art of the famous legend. And in fact, we do find it at least once. On the side portal of the church of Ste.-Marthe at Tarascon, there is a well-preserved inscription giving the date of the dedication of the church (1 June 1197); it is accompanied by two small reliefs. One represents the consecration of the altar; in the other, a bishop and two deacons are grouped around a body lying on a grave slab. What is the meaning of the latter scene? It becomes clear when it is recalled that about ten years earlier the body of St. Martha was thought to have been discovered at Tarascon, and that it was to house this extraordinary relic that the church was rebuilt. Thus, what we see in the relief is either the transfer of St. Martha's relics to the sanctuary, or her funeral rites. The latter seems to me the better interpretation, for two angels are to be seen carrying the saint's soul to heaven. Furthermore, one of the figures has a nimbus. Now, the apocryphal story relates that St. Front had been miraculously transported to Tarascon to the deathbed of St. Martha.[71]

Thus, toward the end of the twelfth century, the legend of the apostleship of St. Lazarus and his sisters had been firmly established. The Tarascon relief is the earliest work of art produced in Provence by the legend —the first link in the poetic chain that ends with the last canto of Mistral's *Mireille.*

Provence had been somewhat slow to translate the legend into art;

another region, Burgundy, was quicker. It was Burgundy in fact, we now know, that created the legend. Monsignor Duchesne has convincingly explained its origin.[72] Since the middle of the eleventh century, the monks of Vézelay had boasted of possessing the relics of St. Mary Magdalene, but they were at a loss to explain to pilgrims how they had come by this precious treasure. So one of them invented a totally new account of the life of Mary Magdalene. It told, and for the first time, how the saint had landed in Provence, that she had lived there and had died there. The author added that a monk of Vézelay, traveling through Provence, had recognized a marble sarcophagus in the crypt of St.-Maximin to be the saint's tomb, and without any hesitation, he had made off with the sacred body and brought it to Burgundy. This was the story told henceforth to pilgrims by the monks of Vézelay.

As early as the end of the eleventh century, new episodes were added to the legend: Martha, Lazarus, and the bishop Maximin were said to have accompanied Mary Magdalene. Hence, this epic of sorts, which it would be tempting to think of as Provençal in origin, was created in Burgundy, and it was famous there before it was famous in Provence. Even better, Burgundy, which had just taken possession of St. Mary Magdalene's relics, soon claimed to possess also the relics of Lazarus. From the beginning of the twelfth century it was conceded that they lay in the cathedral of Autun.[73] The great crowds of pilgrims attracted by them seem to have determined the bishop, toward 1120, to undertake the building of a new church—the beautiful cathedral we see today.

Were these legends reflected in twelfth-century Burgundian art?

It would be natural to look for them first at Vézelay, the sanctuary of Mary Magdalene, but there we find nothing. The portal of the façade is a modern, clumsy and pretentious reproduction of the subjects of the old tympanum and its lintel:[74] it shows the Resurrection of Lazarus and the Gospel scenes in which Mary Magdalene figured, but nothing of the famous voyage to Provence. The capitals of the nave, so numerous and varied, contain nothing whatever about Mary Magdalene. The choir, it is true, was rebuilt in the Gothic period, and it was perhaps there, near the tomb of the saint, that her apocryphal story was told. Today, no work of art commemorates the legend in the church where the legend was born and where so many thousands of pilgrims heard it told.

Do we fare any better at the cathedral of Autun, the church of St. Lazarus? Study of the capitals and the tympanums suggests no. There, too, no work of art now represents the voyage to Provence, but this was not true in the past. Until the eighteenth century, pilgrims could see three statues standing against the trumeau of the portal of the Last Judgment: they were of Lazarus between Martha and Mary Magdalene,[75] an arrangement that takes on its full meaning when we learn that Lazarus was

dressed as a bishop. Thus, without any doubt, this was Lazarus, the apostle to Provence, that the artist was representing; and beside Lazarus were placed his two sisters, because they had been the companions of his apostolate.

In the Rolin museum at Autun, there is an historiated capital that in all likelihood came from a pilaster of the cathedral. It represents a saint with nimbus being lifted from a kind of vaulted edifice, passing through the vault; a kind of braided rug hangs from the edifice (fig. 173). I have

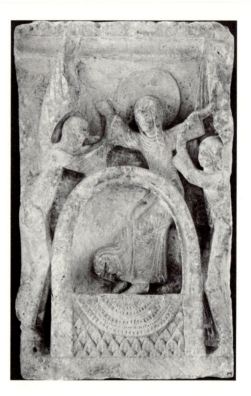

173. "Mary Magdalene taken up by angels"(?)
Capital from St.-Lazare. Autun
(Saône-et-Loire), Musée Rolin.

proposed that this is the scene of St. Mary Magdalene lifted by angels from the earth while praying on her rug in the grotto of La Ste.-Baume in Provence.[76] Indeed, as early as the twelfth century, the legend of St. Mary Magdalene, copying that of St. Mary of Egypt, told of her long penance in the desert. It would have been quite natural to tell the apocryphal history of Mary Magdalene in a cathedral dedicated to Lazarus, apostle to Provence. Nevertheless, I now have reservations about this hypothesis. I see one objection: it is not certain that the penance of St. Mary Magdalene had been localized in the famous grotto as early as about 1140. The pilgrimage to La Ste.-Baume is not mentioned before the thirteenth century. Thus, it could be that the Autun capital represents angels resurrecting the body of the Virgin, even though the scene has none of the traditional particulars.

In Burgundy, there was another church dedicated to St. Lazarus: St.-Lazare at Avallon. Three magnificent twelfth-century portals gave access to the church; only two remain, and they are stripped of statues and reliefs. Mediocre drawings published by Dom Plancher in his *Histoire de Bourgogne* give us an idea of the original.[77] On the trumeau of the central portal was a statue of a bishop: this was St. Lazarus, patron saint of the church. So, at Avallon as at Autun, the trappings of a bishop designated St. Lazarus as the first head of the Provençal church.[78]

It is regrettable that these curious statues from Autun and Avallon have not been preserved; they would have shown how the earliest Burgundian sculptors imagined the figure of the mysterious Lazarus who had twice passed through the gates of death.

The statues of Autun and Vézelay had clearly been inspired by the legend: they are the only examples we have been able to find. One relief in Provence and two statues in Burgundy—this is all that the apocryphal history of Mary Magdalene, Martha, and Lazarus produced in the art of the twelfth century. Not very much, but it is only the beginning; in the twelfth century the story created by the monks of Vézelay had only just begun to take hold of the popular imagination. It was only in succeeding centuries that it was accepted by all and became one of the springs of Christian art. However, it was through Provence, not Burgundy, that the glory of the penitent Mary Magdalene spread throughout the world. In fact, it was in 1279 that the announcement was made to the Christian world of the discovery, at St.-Maximin, of the Magdalene's body, which until that time the monks of Vézelay, misled by the error of one of their own members, had thought they possessed. The discovery was established as authentic, and henceforth the Burgundian sanctuary was abandoned in favor of the holy places of Provence: the tomb of St.-Maximin and the grotto of La Ste.-Baume. The pilgrims, who always loved to climb toward summits as they sang, abandoned the mountain of Vézelay for the high rock of La Ste.-Baume. It was then that the counts of Provence, who were also kings of Naples, made the legend known in Italy. Mary Magdalene in the Provençal desert receiving communion from the hand of St. Maximin was painted by Giotto for the Bargello in Florence and for one of the chapels of Assisi.

Lazarus, the apostle to Provence, was celebrated in Burgundy, where the legend of his apostleship had been created. But Burgundy's own apostle, the martyr St. Benignus was not neglected. Few saints had been given a more magnificent tomb in France; his tomb was at Dijon, and the monks of St.-Bénigne were its guardians. It stood at the center of a great rotunda, of which only the crypt survived the Revolution. In the twelfth century, this rotunda formed one end of a Romanesque church, later rebuilt. Access was through a beautiful portal decorated with reliefs and

statements; it has been destroyed, but we know it through the drawing by Dom Plancher (fig. 174).[79] On the trumeau there was a statue of a bishop carrying an archaic crozier in the form of the *tau* and wearing a miter resembling a bonnet: it is St. Benignus. His costume marks him as the head of one of the first Christian communities of Burgundy. The mutilated head of the apostle has been preserved in the archeological museum at Dijon. Thus, on this portal, where statues of prophets and apostles were to be seen on either side, St. Benignus was given the place of honor, and

174. Christ in Majesty. Dijon (Côte-d'Or), Abbey Church of St.-Bénigne. Entrance portal of the rotunda (destroyed) (after a drawing published by Plancher).

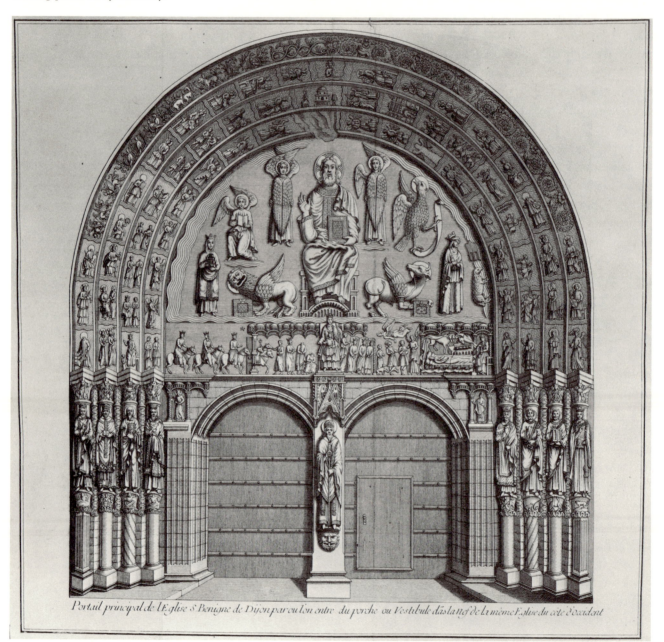

Portail principal de l'Eglise S Benigne de Dijon par ou l'on entre du porche ou Vestibule dans la nef de la même Eglise du côté d'occident

was the first to be seen by those who approached. The Burgundian artists were the first to use this means of directing the respect of the visitors to the patron saint of the church, for the St. Lazarus of Autun and the St. John the Baptist of Vézelay are the oldest trumeau statues in France. Inventive as the southern artists were, they had never imagined anything like this.

This homage rendered to St. Benignus did not seem enough to the monks of the abbey, for in addition they devoted an entire tympanum to him. At one time set into the wall of the vestibule, it has now disappeared. However, it was carefully reproduced by Dom Plancher (fig. 175). It represents the martyrdom of the saint.

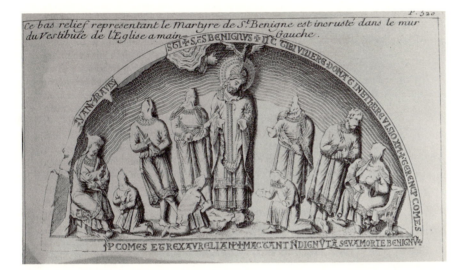

175. Martyrdom of St. Benignus. Dijon (Côte-d'Or), Abbey Church of St.-Benigne. Tympanum (destroyed) (after a drawing published by Plancher).

Benignus, sent according to tradition into Gaul by the Greek Polycarp, a disciple of St. John the Evangelist, had refused to sacrifice to the gods. Consequently, he was brought before the governor of the Castrum of Dijon, Aurelianus, and his lieutenant, Terentius, and condemned to the most subtle tortures.[80] The tympanum represents these tortures: the saint stands while two torturers fix his feet in the stone with molten lead. The martyr's hands are now broken off, but no doubt the awls driven under each fingernail could once be seen. Two other torturers have just received the order to finish off the invincible athlete; placed symmetrically at his right and left, like the centurion and the sponge bearer on Calvary, they plunge their spears in his breast. Like his master, the saint dies with his head bent on his shoulder. The legend says that at this moment the Christians saw a white dove rise above his head—a detail the artist was careful to include; a hand issuing from heaven manifests the presence of God. The beautiful character of the work and its noble symmetry assign it a date in the late twelfth century. Dijon had thus worthily celebrated its apostle.

In the Middle Ages, Burgundy was the region of the great monastic orders and sainted abbots. These are the illustrious abbots we would like to find in art, but do not. That St. Bernard is not represented is not surprising, for that was his wish: in his Order, he forbade art as a useless luxury. This twelfth-century St. Francis was second to St. Francis of Assisi only because he had no feeling for beauty. One of his biographers tells that St. Bernard walked for a whole day along the shores of the Lake of Geneva, and in the evening asked where the lake was.[81] He could never have written, in a transport of ecstasy, a canticle in praise of God's creatures. But what does astonish, is to find nowhere in Burgundy, the very heart of the immense Cluniac domain, images of the first abbots of Cluny, all of whom were saints. Cluny itself has almost totally disappeared, it is true; but there is nothing to recall them at Paray-le-Monial, where they went so often, nor at La Charité-sur-Loire, one of their most magnificent priories. The abbey of Souvigny, that cherished daughter of Cluny where St. Maïolus and St. Odilo were buried, has not even preserved their tombs. Their memory would be completely effaced had their images not been painted in the late Middle Ages on the door of a reliquary chest. To come suddenly upon the names of Maïolus and Odilo, is profoundly stirring; in imagination we see the eloquent Maïolus, in soul and mind greater than the sovereigns of his time, and the gentle Odilo, who listened to the voices from the other world and created the feast of the dead.

But it is doubtless neither the fault of the twelfth-century Burgundian artists nor of the Cluniac monks who were lovers of art and deeply attached to their past, that there is nothing in churches to recall to visitors the great names of the abbots of Cluny—St. Odo, St. Maïolus, St. Odilo, St. Hugh; it is the fault of the generations which with lack of respect and lack of love destroyed everything.

In Burgundy, a single monastic church has preserved some paintings commemorating its past: the church of Anzy-le-Duc (Saône-et-Loire). Anzy-le-Duc was not a dependency of Cluny, but of the abbey of St.-Martin of Autun, founded by Brunehaut, whose tomb was there.[82] Frescoes painted toward the end of the twelfth century in the apse of the church at Anzy tell the story of the little priory, which was proud of its origins. Below the Ascension of Christ, we see Lethbald and his wife offering to God their villa of Anzy, which then, toward 876, became a monastery. One of their descendents was Lethbald, the famous pilgrim, whose story was often repeated in the Middle Ages: as he contemplated Jerusalem from the summit of the Mount of Olives, he felt such a transport of joy that he asked God that he might die the same day; his prayer was granted.

The priory of Anzy-le-Duc was founded by Lethbald, or St. Liébaud, and was governed by a saint, St. Hugh of Autun. Hugh, a friend of Berno, the founder of Cluny, was venerated throughout Burgundy.[83] This old

man, "whose head was as white as swan's down," was consulted as an oracle. He was consulted about everything—sickness and sowing time as well as matters of conscience. The miracles that he wrought during his lifetime continued to be performed by his shrine after his death, and for a long time this attracted pilgrims to Anzy-le-Duc. The frescoes at Anzy give several details of his history. All of these paintings had been plastered over, but were accidentally discovered in 1856, and unfortunately very much restored. But they bring back from oblivion something of the past.

This is an example of what the Burgundian monks did to perpetuate their traditions and honor their saints. If St. Liébaud and St. Hugh, now forgotten, were celebrated in art, we may well believe that St. Odilo and St. Maïolus were not neglected either.

VII

Burgundy leads us toward the region around Paris. In the twelfth century, the most illustrious saint of the Ile-de-France was St. Denis. His glory had grown with the French monarchy. It was not enough that St. Denis had been the first apostle to Paris; as protector of the kings of France and guardian of their tombs, he had to have a legend worthy of him. So, it was said that St. Denis of Paris was the same St. Denis as Dionysius the Areopagite, converted by St. Paul. At Athens, he had observed the eclipse of the sun when Jesus died on Calvary, and later had written the famous book, *The Celestial Hierarchy*, which describes heaven, with God in his glory at the center of concentric circles of angels. It was this learned and profound thinker who had been thought worthy of evangelizing the city of learning.[84]

Parisians cherished his memory. He was venerated in the church St.-Denis-du-Pas, which stood on the spot behind Notre-Dame of Paris where his martyrdom had begun; at St.-Denis-de-la-Chartre in the Cité, the prison where he had been incarcerated and where his chains still hung; and on Montmartre, the place he had soaked with his blood. The abbey of St.-Denis was the end of the pilgrimage; there the martyr had been buried beside his two companions, Rusticus and Eleutherius.

We do not know how St. Denis had been honored in the art of Paris, but we can reconstruct something at the abbey of St.-Denis. The portal at the right of the spectator in the façade of the basilica has a relief filling the entire tympanum with St. Denis as the central figure. Granted that this relief is recent and that archeologists pass it by without a glance; but such disdain is only partly justified. To be sure, the heads are all modern and the draperies obviously retouched; and even some figures seem to be completely restored. The work appears to have been done yesterday, but all the same, the general composition is ancient. It does not date from

Saints of the Ile-de-France and neighboring regions: St. Denis. St. Loup at St.-Loup-de-Naud.

1839 and is not the work of the restorer, Debret. It is assuredly from approximately 1135 and belongs to Suger's artists. We can take the word of the Baron de Guilhermy, who followed closely all that was done at St.-Denis in the early nineteenth century, and who testifies that there is only one entirely modern thing on the portal: the second archivolt band with its figures. The rest is a restoration of the original composition.[85]

The scene that Suger's artists represented in the tympanum was taken from the legend of St. Denis, but its subject was neither his conversion by St. Paul, his preaching, nor his martyrdom; it showed Jesus descending with a flight of angels into the prison where the saint was awaiting death to give him communion with his own hands. We do not know when this episode was added to the legend of St. Denis; we can only say that it is represented in a miniature of a twelfth-century manuscript that came from the abbey of St.-Denis (fig. 176). It is one of those wonderful legends

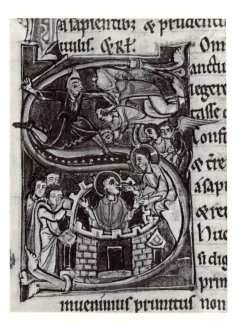

176. Christ giving communion to St. Denis in prison. Collection of homilies. Paris, Bibl. Nat., ms. lat. 11700, fol. 105r.

that completely express the spirit of the Middle Ages and its endless desire to unite with God. This is the image that pilgrims contemplated before they entered the basilica, and it gave them a more exalted idea of St. Denis than his martyrdom itself could have done. Suger, an innovator in all things, was the first to devote a portal to the glory of a saint. No one had done so before him, and there was a fairly long lapse of time before others followed his example.

In fact, it was only rather late in the twelfth century, in a region bordering the Ile-de-France, that another portal was devoted to the legend of a saint. Not far from Provins is the priory of St.-Loup-de-Naud, whose beautiful church dates from the twelfth century. St.-Loup-de-Naud was

a dependency of the abbey of St.-Pierre-le-Vif at Sens; consequently, a bishop of Sens was the patron saint of the church. St. Loup, called St. Leu in the region, was one of the seventh-century bishops who had stood up against the Merovingian kings and courageously endured exile. His goodness, charity, and zeal in visiting ancient tombs had given him the reputation of a saint, even in his lifetime. But his history was not long in being transformed entirely into accounts of his miracles;[86] these ancient stories charmed Jacobus de Voragine who later reproduced them in his *Golden Legend*.[87] Episodes from the story of the holy bishop are not carved on the tympanum of the portal at St.-Loup-de-Naud as at St.-Denis, but on the archivolts. It was on the portal at Le Mans that the scenes on the archivolts were first seen to make up a continuous story—there they tell the story of the life of Christ. The example was followed at St.-Loup-de-Naud, the legend of the saint replacing the life of Christ. Here, already, is a presage of thirteenth-century portals.[88]

The holy bishop, represented on the trumeau, welcomes the faithful (fig. 177). The carved capital above his head identified him to those who

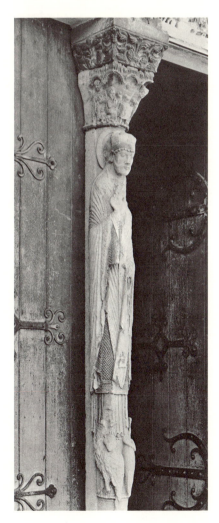

177. St. Loup. St.-Loup-de-Naud (Seine-et-Marne), Priory of St.-Loup. West façade, trumeau.

knew his legend: it shows a precious stone dropping into the chalice while St. Loup celebrates the Mass. It was said that this precious stone fallen from heaven was preserved in the royal treasure. The saint's legend is continued in the archivolt bands surrounding the Christ in Majesty on the tympanum, and there we see the bell of St.-Etienne of Sens. This bell had so beautiful a tone that King Clotaire had it removed from the cathedral and taken to Paris, but St. Loup willed that the bell be mute. It had to be sent back to Sens, where the saint restored its harmonious voice. Other miracles are told in the archivolts: prisoners are miraculously freed of their chains, and the devil is imprisoned in a great urn by the power of the saint's word. These fairy tales are given as much importance as another completely human and moving episode in which we see King Clotaire humbled by the moral grandeur of the saint he had sent into exile; the king kneels before him and asks pardon. This mixture of childishness and nobility was not shocking to the people of the time. For them, nothing was great and nothing was small, for the presence of God was revealed in all things.

VIII

St. Julian of Le Mans. St. Martin.

In the north and the west of France—in Picardy, Normandy, and Brittany—the Romanesque churches now contain nothing to recall the saints of those provinces. Monumental sculpture, in the twelfth century, was an art almost foreign to those regions. Their great bishops and sainted abbots were honored by frescoes and windows, but these have disappeared.

In Maine, however, a magnificent twelfth-century window devoted to the apostle to that province, St. Julian, has been preserved. At Le Mans, no saint was more deeply revered than St. Julian. In 1117, when Fulk, Count of Anjou and of Maine, attended the consecration of the cathedral of Le Mans with his wife and son, at the conclusion of the ceremony he took his son, still a baby, in his arms and placed him on the altar of St. Julian. By this act, he wished to convey that he was placing his son under the protection of the great saint of Le Mans, who was all-powerful with God.[89] So it is not at all surprising to find in the cathedral of Le Mans a large window devoted entirely to the life of St. Julian (fig. 178). St. Julian had come to Le Mans and had performed many miracles.[90] With his staff he caused a spring to gush forth—a miracle of symbolic significance, no doubt. He converted and baptized the governor of the Roman city, and then sent him to evangelize Angers. Each time, St. Julian is represented with a bishop's crozier and miter. Once his work was finished, the apostle died peacefully, and angels carried his soul to heaven.

Thus, while the saints were honored by sculpture and goldwork in the Midi, in the north they were honored with windows.

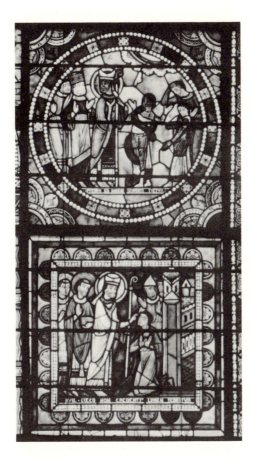

178. Scenes from the Life of
St. Julian. Le Mans (Sarthe),
Cathedral of St.-Julien.
Detail of nave window.

Nothing has been said yet about Touraine and its illustrious St. Martin. And that is because St. Martin was not the saint of one province only, but of all France. Tours was, it is true, the center of his cult, and it was at Tours that the story of his life was first told by artists. A little poem by St. Paulinus of Périgueux proves that his miracles had been painted in the famous fifth-century basilica that contained his tomb.[91] In the sixth century, another church at Tours, the cathedral, was decorated with frescoes devoted to his history. Fortunatus explained these paintings in verses that have been preserved;[92] already St. Martin was to be seen giving half his cloak to the poor man. The cathedral of Tours has been rebuilt; as for the basilica of St.-Martin, many times restored, it was finally demolished during the French Revolution. It may be that the paintings and the windows to be seen in it perpetuated the memory of the ancient frescoes. Today, in Tours, there is no work of art devoted to the life of St. Martin that is earlier than the thirteenth century.[93]

But what we do not find at Tours we find elsewhere. There were hundreds of churches in France dedicated to St. Martin; hence, it is not surprising to find him in all parts of the country. One of the earliest works representing him was discovered in the Pyrenees, but on the Spanish side.

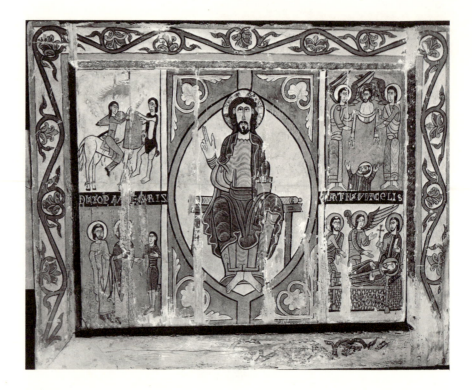

179. Scenes from the Life of
St. Martin. Retable. Vich
(Catalonia), Museo Arqueológico
Artistico Episcopal.

This is a painted panel that belonged to the church of Montgrony in Catalonia, and is now in the episcopal museum at Vich (fig. 179). The archaic character of the work indicates that it may date from the eleventh century. Only one work is earlier—a miniature in a manuscript of Fulda, illuminated about 975; but there, the saint is represented on foot.[94] In the painting at Vich, however, the saint on horseback cuts his cloak in two and shares it with the poor man, a gesture that was to be repeated century after century, and one that the Catalan artist had received from the past. St. Martin holds the long shield and lance with gonfalon carried by the barons of the *Chanson de Roland*. Another section shows the saint on his deathbed. He lies on his back because he did not wish to ease his sufferings by turning on his side, saying, "Let me contemplate heaven." Above, angels carry away his soul. This story of St. Martin had undoubtedly been inspired by a French original, and it proves that the saint's glory had penetrated to the depths of the remotest valleys.

It was natural to find St. Martin in the great abbeys, for it was he who had created the first monasteries in Gaul, and it was he who was the true ancestor of all Western monks. Hence, a capital in the cloister at Moissac is devoted to him. We see the gate of Amiens between two towers, and nearby, the young horseman cutting his cloak in two to give half to the poor man. Then Christ appears between two angels; with arms outspread he widely displays the cloak, seeming to offer it to heaven for admiration. It was then that St. Martin, in a dream, heard the words spoken by Christ:

"Behold Martin; he is yet only a catechumen, and he has covered me with his cloak." On another face of the capital, St. Martin is seen, in his role of thaumaturgist, resurrecting a young man who died before he had been baptized.

We find St. Martin in another abbey, St.-Benoît-sur-Loire. A capital of the porch represents the episode of the cloak; on another face of the capital we see the soul of the saint carried to heaven by two angels. The monks of St.-Benoît had not forgotten that in the time of the Norman invasions, the body of St. Martin had been brought from Tours to their church.

But it is in the regions evangelized by St. Martin, Nivernais and Burgundy in particular, that we most expect to find his image. There, more than elsewhere, his memory is still living. Morvan is full of miraculous springs that he caused to flow, and the peasants still show the prints left on the stone by the hooves of his mule. That is why several capitals in the church of Garchizy (Nièvre) were devoted to St. Martin. These capitals are now in the archeological museum of Nevers; one represents the episode of the mantle followed by the appearance of Christ.

The abbey of Vézelay, which rises on the Morvan border, had also preserved the memory of the great missionary to the land of the Edui. A capital in the nave represents an episode from his legend, which had already been painted in the sixth century in the cathedral of Tours. St. Martin wished to cut down a sacred pine worshiped by the pagans. The pagans consented, but on the condition that he stand in the path of the falling tree. St. Martin did not hesitate, but when the tree was on the point of falling, he raised his hand and the tree fell in the opposite direction. The pine of Vézelay, naïvely stylized, resembles a tropical plant (fig. 180).

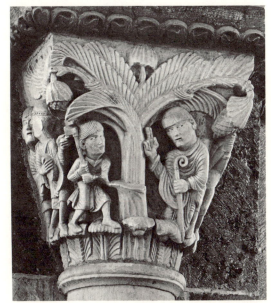

180. Scene from the Life of St. Martin. Vézelay (Yonne), Abbey Church of Ste.-Marie-Madeleine. Nave capital.

These are some of the works devoted to the saints that time has spared throughout our provinces. They are no more than a reflection, a last ray of evening that glimmers on the façade of a church or lights up a window.

Thus, the Church of France venerated its past and very early celebrated it in art. It was proud of its saints, who formed an uninterrupted procession, a long frieze of heroes. Even the most sterile centuries—those which had had neither writers, poets, nor artists—had had their saints. These centuries were poor only in appearance, for to the men of the time, the saints were the masterpieces of humanity. Like Pascal, the medieval Church placed the order of charity far above the order of intelligence. That is why the most obscure hermits, who in solitude had conquered themselves, were thought worthy of being eternalized in art. The athlete had been the ideal of Greek antiquity, the ascetic became the ideal of the new era. In the Middle Ages, the great men of the West were always ascetics; always they scorned the voluptuous East with its harems, its perfumes, its enchanting arabesques. The long struggle of the West against the East was the eternal struggle of the spirit against the senses. The soldier who sacrificed himself, the praying monk, the saint who crushed nature beneath his feet—these were the noblest expression of the Middle Ages. The saint was the true hero of this age; through the rapture he inspired he elevated mankind, pulled it out of its own mire. Even today, the people sense instinctively what surpasses the ordinary in sanctity, and they preserve the memory of the saints. The peasants of Bourbonnais have forgotten the names of the kings of France, but they still know St. Patroclus and St. Marianus, who lived at the time of Gregory of Tours. As for us, the name of an unknown saint arouses our interest; the place where he lived still moves us. Something religious clings to the hermitage, the cell, the monastery where the saint lived, just as in ancient times it invested the sacred places touched by the fire from heaven.

IX

Illuminated manuscripts devoted to the lives of the saints: Life of St. Omer. Life of St. Radegund. Life of St. Aubin.

Some other works are to be added, however, to those already passed in review: these are the illuminated manuscripts. In the abbeys and cathedrals that possessed the relics of a famous saint, there was often a collection of miniatures, a kind of picture book that told visually the story of the life of the saint. These were shown to distinguished visitors, and sometimes artists were inspired by them.

One of these manuscripts, illuminated in the twelfth century, is in the library at St.-Omer.[95] It once belonged to the collegiate church, and it made known to the pilgrims the life of the saint whose tomb they had come to venerate. St. Omer, once a monk of Luxeuil, was the apostle to the Morins in the seventh century and had brought Christianity to a vast

region that until then had been hostile to the Gospels.[96] The artist has shown him preaching the new faith to the pagans and converting one of their leaders, Adroaldus. Once baptized, Adroaldus offers to St. Omer his domain of Sithiu, where the monastery of St.-Bertin is soon to be built (fig. 181). We see him bowing before the saint, and making the symbolic legal gesture of presenting St. Omer with a flowering branch, symbol of the land he offers. But the saint's miracles were of greater interest to the artist, and we will pause for a moment before one of them. We see St. Omer stretched on his bed, probably ill, and he orders a young servant not to leave him. Instead of obeying his master, the young man goes off to Boulogne and treats himself to a boat ride on the sea. A violent tempest rages and carries him as far as the Saxon coast. In his distress, the imprudent servant invokes his master; the tempest calms at once, and a favorable wind blows him to port. He hastens to throw himself at the feet

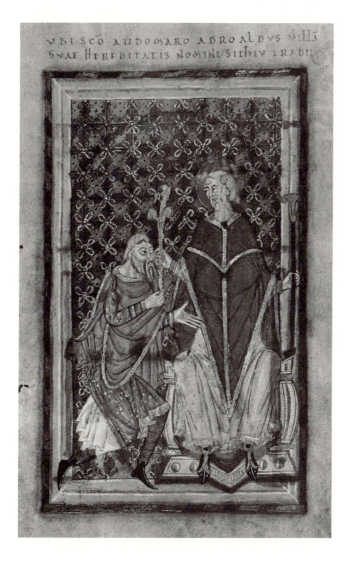

181. Adroaldus offers his domain to St. Omer. Life of St. Omer. St.-Omer (Pas-de-Calais), Bibl. Mun., ms. lat. 698, fol. 15v.

of the saint, who pardons him. The interesting thing about this miracle is that it was represented twice in the thirteenth century. Toward 1250, it was carved on the tomb of the saint, and a few years later, on the lower part of the south portal of the church. Study of these two series of reliefs easily convinces us that they were both inspired by the twelfth-century miniatures.[97] In both reliefs, as in the manuscript, the servant's cloak is lifted up at both sides of his head by the wind of the tempest and resembles a pair of wings. The number and disposition of the scenes are the same. This is one more example of the profound influence that miniatures exerted on sculpture. The accomplished sculptors of the thirteenth century assuredly had nothing to learn from the old miniaturist, but they had come under the spell of his imagination and afterwards dared no inventions themselves.

The Life of St. Radegund, now in the library of Poitiers, had a similar influence. Eleventh-century miniatures, which perhaps reproduce an earlier original, tell the story of the sainted queen as it had been told by Fortunatus.[98] She first lived in the palace of Clotaire, not as queen but as a nun, and the heavy polygonal crown decorated with stones that she wears on her head seems to weigh her down. We next see her throwing herself at St. Medard's knees and asking him to allow her to take the veil. She then takes her fill of prayers and almsgiving, but soon she covets silence and shuts herself up in a cell whose door she has walled up. Like a hermit of the Thebaid, she communicates with the world only through a narrow window, leaning out only to restore sight to a blind woman (fig. 182), or to heal a madwoman. Dead people were put through the window of her cell so that she might restore them to life.

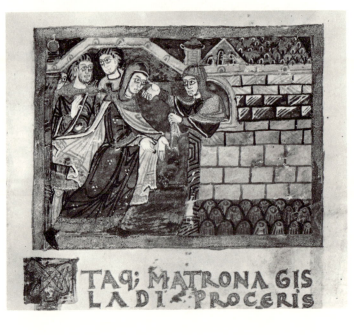

182. St. Radegund curing a blind woman. Life of St. Radegund. Poitiers (Vienne), Bibl. Mun., ms. 250, fol. 34r (detail).

This manuscript of the Life of St. Radegund was used as a model by artists. It probably inspired frescoes in the twelfth century, but it certainly inspired windows in the thirteenth. Two windows dating from 1269 in the church of Ste.-Radegonde at Poitiers tell the story of the saint as it was told in the ancient miniatures.[99] St. Radegund's gesture of taking a dead woman's hand to bring her back to life is sufficient proof of the imitation.

These old illuminated manuscripts of the lives of the saints are thus interesting to us as actual originals.

One of these collections of miniatures was added to the Bibliothèque Nationale collection several years ago.[100] It came unquestionably from St.-Aubin at Angers, for it is devoted to the sainted bishop whose relics were in that abbey. The artist represented only the miracles—miracles performed by the saint in his lifetime, and miracles performed by the saint after his death. One of them is like an episode from an epic. The Normans arrive near Guérande; the pirates, crowded into their bark, wear the helmet with nosepiece of the Bayeux tapestry (fig. 183). They besiege the town, which is about to surrender, but an unknown warrior appears among the defenders, revives their courage, and leads them to victory. This is St. Aubin, who is shown with the hand of God above his head.

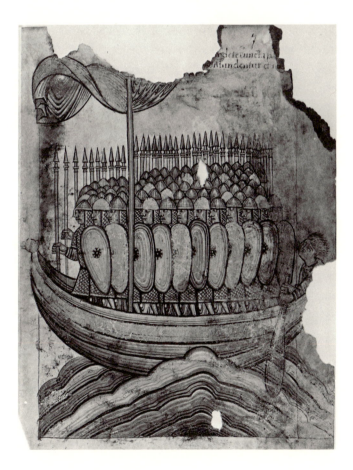

183. Norman ship heading for Guerande. Life of St. Aubin. Paris, Bibl. Nat., ms. nouv. acq. lat. 1390, fol. 7r.

These miniatures date from the late eleventh century. Enlarged, they may have become frescoes, which, though less noble in style, must have resembled those of St.-Savin.

Several such collections of miniatures still exist in France or abroad. The collegiate church of St.-Quentin has preserved a history of its patron saint decorated with twelfth-century miniatures.[101] In England at the abbey of Bury Saint Edmunds, there is an illustrated manuscript from the twelfth century devoted to the life and miracles of St. Edmund, the martyr-king.[102]

The tradition of these books of images was perpetuated for a long time. There probably was not one famous sanctuary that did not have its own collection of miniatures; these enlightened the pilgrims and inspired the stories told by the guardians of the tomb. In the thirteenth century, the monks of St.-Denis were still telling the history of their patron saint through miniatures.[103] And the same kind of book, but already enlivened with a thousand details from secular life, was presented in 1317 to King Philip the Tall.[104]

<center>X</center>

Canonized monks. Capitals devoted to the life of St. Benedict at St.-Benoît-sur-Loire, Moissac, and Vézelay. The desert saints: St. Anthony and St. Paul-the-Hermit at Vézelay and at St.-Paul-de-Varax. St. Mary of Egypt at Toulouse. St. Eugenia at Vézelay.

Thus far, I have spoken only of the local saints, but others also appeared in our art. The monks did not forget the great monks of the past, and especially they did not forget the greatest of all, St. Benedict. Moreover, St. Benedict seemed to have become a saint of Gaul since his body had been brought to the abbey of Fleury in the diocese of Orléans.

St. Benedict died in 543 in the famous monastery of Monte Cassino that he had built on the top of a mountain, on the threshold of Campania, and he was buried there beside his sister, St. Scholastica. Thirty-seven years later, in 580, the Lombards invaded southern Italy and destroyed the monastery. Monte Cassino was an abandoned ruin and for seventy-five years the saint's tomb was forgotten. In 655, Aigulf, a monk of Fleury, traveling in Italy with several monks from the diocese of Le Mans, decided to find the tomb. An old man told him that each night a light shone at the spot where the two saints had been buried. And in fact, Aigulf and his companions discovered two bodies at the place that the mysterious light indicated and took them back to Gaul. The abbot of Fleury, Mommole, went out to receive these precious relics, and with the help of Aigulf, carried them on his shoulders to his monastery. The body of St. Scholastica was given to the Bishop of Le Mans; the body of St. Benedict became the richest treasure of the abbey of Fleury, which afterwards changed its name to St.-Benoît-sur-Loire.[105] Aigulf himself was sainted after his death. He is the St. Ayoul, whose curious name surprises visitors to Provins.

At a time when the relics of saints were so passionately sought after,

it was an unparalleled glory for a monastery to possess the body of the founder of monastic life in the West, for no saint was more esteemed than St. Benedict. St. Odo of Cluny, in a sermon preached at Fleury, compared St. Benedict to Moses: "Like him, St. Benedict brought forth a living spring in the desert."[106] The fame of the monastery of Fleury can easily be explained, and it is understandable that many sick people went to seek healing at the famous shrine. The book of the Miracles of Saint Benedict recreates for us the religious fervor of those throngs of people. The first Capetian kings were as attached to Fleury as they were to St.-Denis. On his deathbed, Hugh Capet advised his son Robert "never to displease that good staunch friend, the great St. Benedict";[107] and that is why Robert the Pious enriched the abbey of Fleury with gifts. Philip I wished to be buried at Fleury beside the tomb of St. Benedict instead of at St.-Denis. The beautiful church with its magnificent porch that we admire today testifies to the ancient grandeur of Fleury.

Inevitably, St. Benedict was celebrated in the art of the monastery that kept his relics. We know that his tomb was formerly sheathed with metal on which his miracles were represented;[108] but in the present church only a few capitals devoted to his legend have been preserved. They are worth a moment's attention.

Some of the subjects are certainly not those one of our contemporaries would choose to illustrate the life of the father of Western monks. What we admire in St. Benedict is the melancholy man who was satisfied with nothing in his somber world; when the old order was dissolving, he dreamed of building a new one. He wrote down its laws, and his Rule reveals the practical genius of the old Roman lawmakers, combined with the profound knowledge of human nature provided by the Christian faith. He founded a society that was to last longer than the Rome of the kings and the Rome of the emperors. Assuredly, the Middle Ages felt his greatness; the Rule of St. Benedict seemed to bear the imprint of so divine a wisdom that it was attributed to the Holy Spirit.[109] Yet, twelfth-century art rarely saw St. Benedict as anything other than a thaumaturgist, and the capitals of his church depict almost exclusively his miracles. This is not surprising for it was miracles that the long processions of the sick and crippled came to ask for at his tomb; the works of art, no doubt explained by a monk, filled their hearts with confidence and gave promise of miracles to come. We must be able to see the art of the past with the eyes of the men of the time.

The little poem in sculpture to the glory of St. Benedict opens with a naïve tale.[110] Benedict was little more than a child when God granted him the gift of performing miracles. His power was first manifested when, one day, his nurse dropped and broke a terracotta sieve, which grieved her very much. Moved by her tears, Benedict put the pieces back together

and after a fervent prayer gave her the sieve whole. Such a miracle could not fail to delight the Middle Ages: at St. Benedict's prayer, God had thus changed the laws of the universe to dry the tears of a poor woman. This is why the artist carved the hand of God above St. Benedict in prayer.

But here, on subsequent capitals, are the first struggles of St. Benedict with the devil. The saint left his father's house and went deep into the valley of Subiaco. At the time it was a wilderness. The delightful villa built by Nero on the shore of the lake had long since been only a ruin invaded by the forest. Benedict took refuge in a cave in a rock, and lived there in meditation. Only the monk Romanus knew the saint's retreat; each day, from the top of the mountain, he let food down by a rope to which a bell was fastened as a signal to the saint. But one day, to drive St. Benedict from his solitude, the devil cut the rope and smashed the bell. Such is the episode that, with a Life of St. Benedict in hand, can be deciphered on one of the capitals.

The devil resorted to other tricks. St. Benedict saw him fly close to his face in the form of a black bird, but put him to rout with the sign of the cross. Once, however, the devil almost won: "He put in Benedict's mind the thought of a woman he had seen in the past, and his heart was so touched at the memory of her beauty that he believed himself vanquished, and he wished to leave the desert." Then his heroic spirit asserted itself; he tore off all his clothes and threw himself into thorn bushes. He came out all bloody, "but the scratches on his body cured the wounds of his soul." The artist depicted this spiritual victory in all its detail. First we see the black bird circling the head of the saint; next, his vision takes form and the devil himself holds the woman by the hand and presents her to him; lastly, the naked saint throws himself into the thorn bush, and again the hand of God appears in the sky. The work is still quite crude, to be sure, but the events related were themselves sufficiently moving.

A capital in the transept crossing represents the construction of the abbey of Monte Cassino. There was a temple of Apollo there which was inhabited by a dangerous demon. Dispossessed by the saint, he did his utmost to hinder the work of building. One day the monks were trying vainly to lift a stone into place: they did not see the devil sitting on the stone. St. Benedict appeared on the scene and had only to raise his hand to put Satan to flight. Another day, the devil pushed over a wall that was under construction; in falling, it crushed a young monk. St. Benedict, immediately notified, had the corpse brought to him, and after praying, brought the young monk back to life.

Another capital commemorates a miracle that St. Benedict had performed through the intermediary of his disciple, St. Maur. St. Benedict was meditating in his cell when he was miraculously notified that the monk Placidus had just fallen into the river where he had gone to draw

water. At once he sent St. Maur to his aid, after giving him his blessing. St. Maur, possessed of supernatural powers, walked on the water, seized Placidus by the hair, and pulled him out safe and sound. St. Benedict in his modesty did not wish to take credit for a miracle that he attributed to the obedience of St. Maur. Thus, the capital glorifies both St. Benedict and St. Maur. The memory of St. Maur was especially dear to French monks, because according to Benedictine tradition, he had brought the Rule of St. Benedict into Gaul. This is recalled by another capital in the same series, where St. Benedict, seated, confers the abbatial crozier on St. Maur just before he sets out for Gaul.[111]

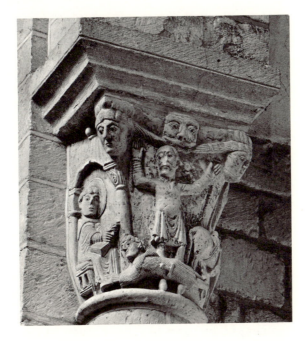

184. Galla and his captive before St. Benedict. St.-Benoît-sur-Loire (Loiret), Abbey Church. North transept capital.

Another capital tells of a miracle that again demonstrates the power of St. Benedict (fig. 184). An Arian Goth named Galla was persecuting the Catholics. One day he tortured a peasant and was about to take everything the poor man possessed. The peasant asked mercy: "I own nothing myself," he said, "for I have given my person and my possessions to the abbot Benedict." Galla at once tied his hands together and, pushing him along before him, took him to the famous abbot Benedict, whom he wished to meet. The saint was alone, reading before the door of his cell. Galla, thinking to frighten him, cried out in a terrible voice: "Get up and give back to this man what you have taken from him." The man of God paused in his reading, raised his eyes, and when they rested on the shackles binding the peasant's hands, the shackles fell away of themselves. In stupefaction, Galla saw that the peasant was freed. He then respectfully dismounted from his horse and fell at the feet of St. Benedict. This scene, as the artist has conceived it, is perfectly clear: St. Benedict is seated with

a book in his hand; Galla, dismounted, is prostrated at his feet while the prisoner raises his arms to show the broken chains hanging from his hands.

The Galla episode leads to the even finer story of St. Benedict's meeting with Totila (fig. 185). The artist carved this scene in a place of honor on

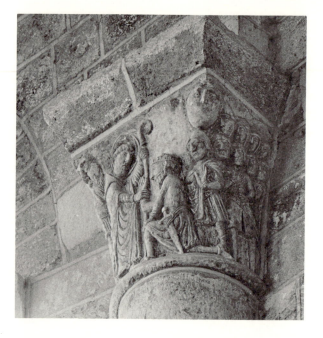

185. Totila, King of the Goths, before St. Benedict. St.-Benoît-sur-Loire (Loiret), Abbey Church. Choir capital.

a capital of the sanctuary. The king of the Goths, Totila, having conquered the generals who succeeded Belisarius, rode on toward Naples and Campania. As he was passing Monte Cassino, he wished to see the famous man who, it was said, could see into the heart and read the future. To test the saint, he first sent his sword bearer, dressed in the royal mantle and wearing shoes of purple. But when St. Benedict saw him, he said: "Take those things off, my son, take them off; what you are wearing does not belong to you." Totila then presented himself, and overwhelmed by the moral grandeur radiating like light from the saint, knelt down before him. Three times St. Benedict asked him to rise before he was able to do so. This meeting of the barbarian king and the man of God is one of the great episodes of history; all the idealism of the new era is expressed there. The Romanesque artist sensed its beauty as we do and treated his subject with delicacy. St. Benedict stands and holds out his hand to Totila kneeling before him, in an effort to raise him up.

A last capital tells the most famous of St. Benedict's miracles: the resurrection of a child. The story as told by St. Gregory the Great, St. Benedict's biographer, has a beauty reminiscent of the Gospels. A peasant came one day to put down the body of his dead child before the door of the monastery; it was the hour when St. Benedict and his monks were returning

from the fields. The peasant ran to meet the saint and said: "Give me back my child." The man of God said, "Have I taken your child?" "He is dead," the peasant replied. "Come and bring him back to life." Then the servant of God was filled with sadness: "That was the apostles' work, not mine." The peasant said: "I will not go away until you have given back my child, alive." St. Benedict knelt down and stretched himself at full length over the child's body; when he arose, he raised his arms toward heaven and said: "Lord, see not my sins, but the faith of this man." At these words, the corpse began to quiver and the soul came back into the body.[112] The artist chose the moment just before the resurrection: St. Benedict kneels before the body, and the motionless spectators await the miracle.

These are the only episodes from the life of St. Benedict that still exist in the great church that contained his tomb.[113] It was not until the early thirteenth century that the scenes of the discovery of St. Benedict's relics and their triumphal entry into the monastery of Fleury were carved on the lintel of the north portal. This still archaic work has that aura of youthfulness typical of French sculpture around 1200. Aigulf, surrounded by his companions, opens the tomb where the two saints lie and places their bones in a basket. This basket must have been copied exactly by the artist, for it was preserved for a long time in the abbey treasury.[114] Next we see a burst of miracles occurring as the relics pass by: a blind man throws himself on the reliquary, takes hold of it, and recovers his sight; a cripple rises up healed.[115] Lastly, the reliquary, carried by two monks with sweet pure faces, approaches the monastery, and the monks of Fleury, carrying censers, go out to meet it. This is the final scene of the artistic cycle of the saint at St.-Benoît-sur-Loire.

It was only natural that the legend of St. Benedict should be represented in the church that contained his relics, but there was not a single monastery where he did not have a place. For was St. Benedict not the father of all monks?

On capitals in the cloister of Moissac, there are two episodes from his legend. One is the scene of the monk crushed by the fallen wall. His body has been brought to St. Benedict, and the saint with a book in his hand goes toward him to bring him back to life. The other face of the capital would probably be incomprehensible to us were it not for the inscription accompanying it.[116] The subject is a monk at prayer seized by the devil and taken from the monastery; St. Benedict led him back and "healed" him, as the inscription says, by striking him with his stick. This was a kind of apology for corporal punishment and was placed there for the benefit of the monks of Moissac. As the legend of St. Benedict says, when the monks were whipped, it was the devil who was struck.

We find St. Benedict again at Vézelay. On several capitals in Burgundian churches, we find painful episodes in man's struggle against the

flesh. At Vézelay in particular, woman appears as the temptress and becomes a sort of musical instrument in the hands of the devil. These images might perhaps disturb the monks were not the heroic example of St. Benedict there nearby. The saint is seated, he holds a book on his lap, and contemplates the woman presented to him by the devil.[117] This is the famous episode of the temptation (fig. 186). The artist did not represent the saint among the thorns, but all the monks knew how he had triumphed in the test. Another capital is devoted to the miracle of the resurrected child. St. Benedict extends his hand over the body; the father waits, his hand against his cheek and his elbow resting on the handle of his mattock.

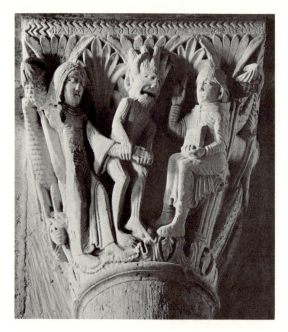

186. Temptation of St. Benedict. Vézelay (Yonne), Abbey Church of Ste.-Marie-Madeleine. Capital.

St. Benedict had created a well-ordered community; the detailed specifications of his Rule liberated the spirit by disciplining nature. Sustained by this sound practical rule, the Benedictine monk could arrive at self-mastery; nevertheless, he always remained a man, his feet firmly planted on the earth.

It was quite another matter with the hermits of Egypt, the desert anchorites. They were greater than the monks, for they had conquered nature and annihilated the body. Those such as Paul, Anthony, and Macarius seemed to have led an angelic life, and for them heaven had begun on earth. Never had man made so heroic an effort to rise above human nature, to escape as from a prison. To lift up the leaden vault that weighs us down, as great artists like Dante, Michelangelo, and Beethoven had tried to do by other means—this was what those heroes of solitude had

done. They tore away the veil of the senses that hid God from them. For two days and nights, Macarius had experienced mystical union with God. St. Nilus speaks of a joy that is above all joy.

The monks of the twelfth century lived much more than we think in this miraculous world of the Egyptian ascetics. At Cluny, after supper, there was a reading called the "collation," because ordinarily at this time one of the twenty-four chapters of the *Collationes patrum* of John Cassian was read.[118] Cassian's book transports the reader to the Egypt of the great anchorites. Cassian and his companions went across the sand or to the islands of the salt lakes to question the ancients of the desert, Cheremon, Nesteros, and Joseph of Thmuis—grave old men who knew all the secrets of the inner life and all the workings of the soul, even to the phantoms created by the imagination at night. The example of the famous hermits was so constantly cited in the monks' conversations that the Cluniac monks seemed to live with the desert fathers.

Other books told the life of the anchorites in detail. Among the only too few manuscripts that have been preserved from the abbey of Cluny, there is a Life of the Egyptian Fathers.[119]

This land to the east had infinite charm for the French monks. Many of them who had traveled in Syria saw again the desert with its starlit nights and pervasive sadness; others imagined these unknown lands, from the books they read, as a wilderness where saints talked with fauns and centaurs.

These readings left a deep mark on the souls of the monks, as we realize in studying the sculpture at Vézelay, for many of the capitals are devoted to the two greatest anchorites of the desert, St. Paul the Hermit and St. Anthony.

The first capital represents the meeting of St. Paul the Hermit and St. Anthony. Anthony had gone to the wilderness thinking that he was the first hermit to withdraw into solitude, but it was revealed to him that an anchorite even holier than he had preceded him.[120] He went to look for this man but would never have discovered his retreat had he not first been guided by a centaur, then by a faun, and finally by a wolf.

St. Paul would not open his door to this stranger who had come to disturb his contemplation until St. Anthony beseeched him so fervently that he could no longer refuse. St. Anthony said to him, "I will not go away; I would rather die on your doorstep." Then St. Paul opened the door, and the two saints embraced. When the time came for eating, a crow who miraculously brought nourishment to St. Paul, this time brought a loaf of bread twice as large as usual. Then a touching argument began between the two saints over which would cut the bread. St. Paul deferred to St. Anthony because he was the guest; St. Anthony deferred to St. Paul because he was the elder. Finally they both took the bread in their

hands and divided it into two equal parts. Such is the scene represented on the capital; nothing could be clearer, and it is hard to see how any doubts could have been raised concerning it (fig. 187). The symmetry of the scene is charmingly naïve: the two saints face each other and divide the bread;[121] the only furnishings of the poor cell are two vases, which no doubt contained only water, and two earthen bowls in a small cupboard. The beautiful leaves of the capital seem to cast the shade of palm trees over the two saints.

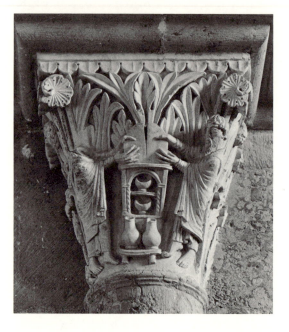

187. St. Paul the Hermit and St. Anthony sharing bread. Vézelay (Yonne), Abbey Church of Ste.-Marie-Madeleine. Nave capital.

St. Anthony returned to his solitude. He was wandering in the desert when he saw two angels bearing the soul of St. Paul; he turned back at once and found the holy hermit on his knees in the attitude of prayer, as if he were alive. "Ah! blessed soul," St. Anthony said, "your death shows what your life has been." When he set about to bury him, he found nothing with which to dig a grave; "but two lions appeared, dug a pit, and then vanished." The artist of Vézelay did not omit this famous episode of St. Paul's burial, in which saintliness radiates as a force commanding all of nature. The capital has something fiercely strange about it. While St. Anthony prays over St. Paul's body, wrapped like a mummy, two lions with devil faces dig the grave. Beasts were often given a satanic aspect by the visionary artists of Vézelay.

The devil is ever present on the capitals of Vézelay. We see him pitting himself against St. Anthony. This was at the time when St. Anthony had newly come to the desert and had withdrawn into one of the thousand-year-old tombs cut into the resplendent rock bordering the Nile. These ancient tombs, covered with mysterious paintings and magical writing,

were thought to be Satan's hide-outs. St. Anthony went there to defy him, and he fought fierce battles. His legend tells that the demons constantly tormented him; they left him unconscious and covered with wounds, but Jesus appeared in dazzling splendor to console and heal him. The Vézelay capital has the earliest known example of what was later to be called the "Temptation of St. Anthony." Demons seize him by the beard, raise their fists, and threaten him with a mallet; the face of the saint remains calm as his enemies grimace and bare their teeth. These demons are hideous, but they do not have the aspect of the malevolent specters of nocturnal visions that Burgundian art sometimes gave them.

The poetic story of St. Anthony has always charmed artists and contemplatives because it took place at the borders of two worlds. We find it in Burgundy: on the small south portal of the church St.-Paul-de-Varax, in the Dombes, St. Anthony can still be seen. The two figures filling the tympanum have been mutilated, but the holy hermit is recognizable questioning the faun in the desert. St. Anthony wears the medieval monk's habit and leans on his staff. The faun, with the goats' feet of a demigod of antiquity, raises his arm and points out the path that will lead St. Anthony to St. Paul's cell. An inscription in well-carved characters forms a crown around the tympanum and explains the scene.[122] The choice of such an episode might seem peculiar, but one of the charms of St. Anthony's story was that it directed the imagination to an unknown world. The faun reminded the spectator that St. Anthony had seen what was no longer visible to man.

The saints of the desert completed the splendid poem of the saints of the Thebaid. The most illustrious of all was St. Mary of Egypt.[123]

A capital from the cloister of St.-Etienne of Toulouse, now in the museum, represents the story of the famous penitent. Since the six episodes carved there have been misinterpreted, it would be well to explain their meaning in some detail.[124]

Mary the Egyptian, a courtesan of Alexandria, took a notion to sail to the Holy Land.[125] For her, it was merely a pleasure voyage; she could find as many admirers in Judaea as in Egypt. When she arrived at Jerusalem, she visited the Holy Sepulcher, passing under the porticoes and onto the imposing esplanade where the Rotunda of the Anastasis stood at one side and the Martyrium at the other. On that day, the cross of the Saviour was exposed in the Martyrium for the veneration of the faithful. When she tried to enter with the crowd, an unknown force stopped her at the door. This is where the story told by the sculptor begins. He has made the mystery visible by showing an angel with sword in hand driving the courtesan from the church (fig. 188).[126]

Mary, overwhelmed by this miracle, understood that of all the crowd only she was unworthy to enter the sanctuary, and she wept. There was an

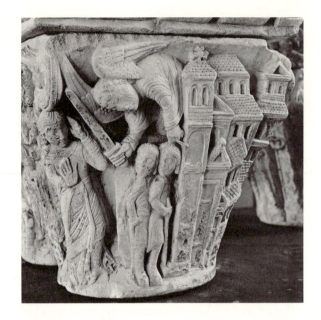

188. St. Mary of Egypt turned away from the church. Cloister capital from La Daurade. Toulouse (Haute-Garonne), Musée des Augustins.

image of the Virgin there; she called upon it to witness her repentance, and after she had prayed before it, she was able to enter the church. When she came out, she knelt again before the image, and while she was giving thanks, she heard a voice saying to her: "Cross the Jordan, and you will find peace." This is the last episode represented by the artist. While Mary prays before the Virgin, an angel seems to speak to her from heaven (fig. 189).[127] At the side, Mary appears again, and an unknown person puts three coins in her hand (fig. 190).[128] With these three coins she bought three loaves of bread, which the artist carved in the angle of the capital. The three loaves of bread, which the saint took with her to the desert, later became her usual attribute.

Toward evening, after walking all day, Mary came to the banks of the Jordan, the same place where the Saviour had been baptized. A basilica

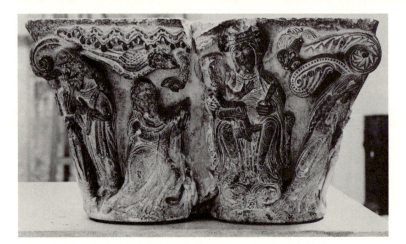

189. St. Mary of Egypt before the image of the Virgin. Cloister capital from St.-Etienne. Toulouse (Haute-Garonne), Musée des Augustins.

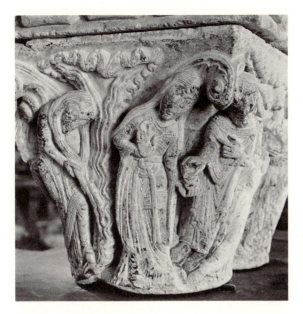

190. St. Mary of Egypt receiving the three deniers; St. Mary of Egypt washing her hair in the Jordan. Cloister capital from St.-Etienne. Toulouse (Haute-Garonne), Musée des Augustins.

dedicated to St. John the Baptist stood on the bank. She went in to pray, then went to the river, took down her beautiful hair and dipped it in the water to purify it (fig. 190). This is the scene represented by the artist. The Jordan seems to flow down from heaven, but the clouds from which it appears to come are the mountains where its source is. And the source is double, for the sculptor had heard that the Jordan was formed by the conjunction of two rivers, one called the Jor, and the other, the Dan. This was the belief of the time. The sinner is shown for this last time in the costume of the great ladies of the twelfth century; her hair, like the hair of the beautiful queens on the portal of Chartres, is divided into two long tresses which she lets fall into the water.

The next day, the saint crossed the river and plunged into the desert of Peraea, where St. John the Baptist had lived, and there she remained for forty-seven years. One day a monk named Zosimus, who left his monastery each year to search a higher perfection in the desert, thought he saw near him a human form, a strange being completely nude and burned by the sun. He wished to come nearer, but he heard a voice saying: "I am a woman, and I am naked; throw me your cloak that I may hide my nakedness." He obeyed at once. When the saint had put on his cloak, she came to him and consented to tell her story. She told only of her sins and the terrible temptations that had almost caused her to leave the desert. Zosimus remained silent in admiration, and when the saint left him he kissed the traces left by her feet. The artist conveyed Zosimus' respectful astonishment by a gesture of the hand. The saint is only half veiled, and the artist imagined her as hairy, like a beast of the forest (fig. 191).[129]

At Eastertime the following year, Zosimus carried the Eucharist to the saint, and promised to return with it each year. But when Zosimus came

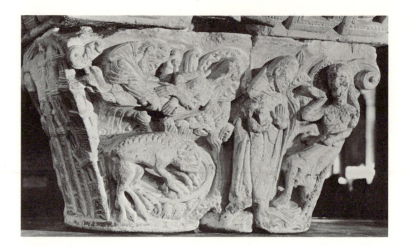

191. Zosimus meets St. Mary of Egypt;
Funeral rites for St. Mary of Egypt.
Cloister capital from St.-Etienne.
Toulouse (Haute-Garonne), Musée des
Augustins.

to the desert for the third time, he found the saint dead and lying in the sand. He did not know how to bury her, but a lion came, dug the grave, "and went away as peaceful as a lamb." The sculptor represented this miraculous burial; Zosimus holds in one hand an ancient abbatial staff in the form of a *tau*, and with the other he raises up the weightless, immaterial body of St. Mary of Egypt. The lion digs the grave. This formidable gravedigger for the desert saints lacks nobility, but he at least has the strangeness of a dream monster (fig. 191).

Thus, the Toulouse capital tells almost the complete story of St. Mary of Egypt. Such a work could be contemplated for a long time; it was as efficacious as an eloquent sermon. Sculpture had scarcely been reborn, and already it had become the most powerful ally of the faith.

There was another Egyptian saint whose romantic story was almost as famous as that of St. Mary of Egypt. This was St. Eugenia.[130] A capital at Vézelay tells her story. Eugenia was the daughter of Philip, duke of Alexandria and governor of Egypt. She was Christian, but her father remained a pagan. Despairing of attaining in her father's house the perfection she desired, she disguised herself as a man and fled to the desert.

She appeared at the door of a monastery and the abbot, thinking she was a man, admitted her as a monk. Years passed and no one suspected the truth. One day, a woman accused the monk, who had meanwhile become the abbot, of violating her and getting her with child. The case was taken before Philip, Eugenia's own father, who did not recognize his daughter. She tried in vain to prove her innocence; finally she opened her monk's frock and revealed her breasts. Her accuser remained silent, but Philip was so moved by his daughter's story that he was converted. The Vézelay artist carved the episode with such clarity that no inscription whatever is necessary for us to recognize it at a glance: St. Eugenia, tonsured like a monk, opens her robe and reveals her breasts; Philip gestures

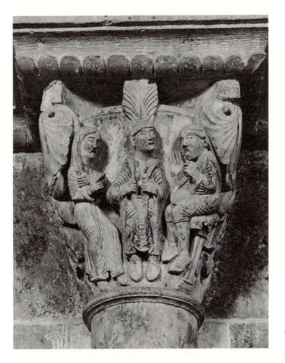

192. St. Eugenia recognized by her father. Vézelay (Yonne), Abbey Church of Ste.-Marie-Madeleine. Capital.

in astonishment, and the disconcerted accuser pulls her own hair (fig. 192).

These are the principal examples of the historiated capitals that filled the monastic churches and cloisters with lofty spirituality, for in these legends the soul reigns supreme; the soul has power over nature and seems to be the only reality of this world.

Such are the saints still found today in Romanesque churches. With the exception of St. Benedict, the desert fathers, and a few universal saints such as St. Stephen,[131] they are all French saints. There were no models to follow in depicting their lives; our artists had to create. In this way the representation of saints played a role in freeing our art of Eastern influences.

VII

Enrichment of the Iconography: The
Pilgrimage Roads in Italy

Along with the cult of the saints, pilgrimages—themselves a form of this cult—contributed to the enrichment of iconography and art.[1] There were, in fact, famous images in the sanctuaries visited by the pilgrims which the artists imitated and multiplied. And also, in the Middle Ages the pilgrim routes were the principal highways; it was along these roads that new creations in literature and art spread through the world. As we shall see, we can follow their traces and find them at every stage of the journey.[2]

The medieval pilgrim was sometimes a sinner going to ask forgiveness for his sins, sometimes a condemned man atoning for his crimes; but for the most part, the pilgrim was a simple Christian who wanted to contemplate the holy places and touch his forehead to the grills of sacred tombs. These long, tiring, and dangerous journeys were so many claims to God's mercy; God would not forget the poor pilgrim on the final day. In the Last Judgment at Autun, among the dead rising, naked as Adam, from their tombs, two pilgrims are to be seen. They still have their pilgrim's scrip slung over their shoulders. One scrip is marked with the cross of Jerusalem, the other with the cockleshell of Santiago de Compostela. With these protective emblems, they present themselves fearlessly before the judgment of God.

The people of the twelfth century passionately loved these long journeys. To them it seemed that the pilgrim's life was the true life of the Christian. For what is a Christian but a traveler who is at home nowhere, a transient on his way to an eternal Jerusalem?

I

Rome. The statue of Marcus Aurelius mistaken for the statue of Constantine. It is imitated on the façades of churches in western France.

For centuries, Rome and the tombs of the apostles had attracted great crowds. In summer, when the long days returned and rivers were easy to ford, the pilgrims crossed the Alps into Italy either by the Great St. Bernard pass and the Aosta route, or by Mont-Cenis and the Susa route. The two roads came together at Vercelli. A short distance away was the start

of the Via Emilia, the ancient road traveled by the Roman legions. It passed through Piacenza, Parma, Modena, Bologna, and straight on to Forlì. Near Reggio Emilia, the traveler could see in the distance the mountains where the castle of Canossa stood. At Forlì, the road turned sharply to the south and climbed into the Apennines. It crossed the summit—from which both the Adriatic and the Tyrrhenian seas could be seen—not far from the famous Camaldolese monastery of S. Romualdo. Then it passed through the Casentino with its forests as dense as those of the north, and descended to Arezzo. From there the traveler skirted Lake Trasimeno and the Lake of Bolsena to Viterbo, and finally came to Rome.

Sometimes the pilgrims took another route. Between Borgo San Donnino and Parma, a road branched off the Via Emilia and crossed the Apennines through the pass of La Cisa. Our old epics called this the route of Monte Bardone. The road went toward the Tuscan sea to Luni, at the foot of the mountains of Carrara marble, and then by Lucca and Siena; after visiting some holy places there, the pilgrim rejoined the main road, not far from Viterbo.

It was indeed a solemn moment when the pilgrim, after so long a journey, looked at last, from the heights of Monte Mario, upon the long anticipated Rome. Monte Mario, the promontory above the Promised Land, was called Mons Gaudii, Mountain of Joy—the "Montjoie" (Mont de la Joie) of our old battle cry. From there, all the city could be seen, "Golden Rome," the eternal city. The pilgrims could encompass with their eyes the vast honey-colored city with its square bell towers and its imposing ruins. Then they sang the verses of the famous canticle: *O Roma nobilis orbis et domina . . .* "Hail, O Rome, mistress of the world, red with the blood of martyrs, white as the lily of virgins, be glorified throughout eternity."

The city was magnificently melancholy. Great monuments, temples still sheathed in marble, rose among the ruins. Legends clung to them as ivy clings to old walls. In the twelfth century, almost all sense of history had been lost; the pilgrims wandered in a city of dreams. They were shown the Mirror Castle, a palace where Virgil had once placed a magical mirror which reflected the movements of even the remotest of the Empire's enemies. They were told that in the time of Augustus, the Capitol contained as many statues as there were Roman provinces. Each statue had a bell hung from its neck; if a province revolted, the bell of its statue tinkled. Near the Temple of Vesta in the Forum, they were terrified when they walked over the place where the dragon exorcized by the pope St. Sylvester slept under the ground. The statues still standing here and there seemed full of mystery. One pointed to the spot where Gerbert—Pope Sylvester II— had dug and found a buried treasure. A statue of a faun had spoken to the emperor Julian and advised his apostasy.[3]

The pilgrim's first visit was, for certain, to St. Peter's. There he venerated both the tomb of the apostle, and an extraordinary relic, the face of the Saviour imprinted on Veronica's veil.[4] But perhaps the great memories evoked by St. John Lateran appealed just as much to his imagination. This was the oldest church in Christendom, the mother of all churches, *omnium ecclesiarum mater et caput.* There, in a palace as large as an entire city, lived the vicar of Christ who could pardon all sins. It was Constantine who had given this palace and church to the popes. The memory of Constantine, the first Christian emperor, was more alive here than anywhere else in the world. It was told that Constantine had been baptized in the very basin the pilgrims saw in the baptistery. The emperor had leprosy, but on emerging from the holy water he found himself miraculously cured; a few white scales still clung to the marble of the basin.[5] The pilgrims were reminded again of Constantine in the imposing solitude extending before the Lateran where the Roman countryside joined its majesty with that of Rome. There stood a bronze equestrian statue which for centuries had been taken for a statue of Constantine.[6] It was respectfully contemplated. This statue still exists, but not in the same place. In 1538, at Michelangelo's suggestion, Pope Paul III had it moved to the Capitol. As we know, it is a statue of Marcus Aurelius, not of Constantine. Thus, through a curious error, the people of the Middle Ages believed they were honoring the first Christian emperor when in reality they were venerating a persecutor of the Christians.

We may well believe that this magnificent statue made a profound impression on the pilgrims, for we find imitations of it in our French churches. These strange and naïve copies deserve a moment's attention, for they are some of the earliest examples of the works of art born of the pilgrimages.

Traveling through our western provinces, we encounter on the façades of several of the charming churches of the region, the image of a horseman under a large arch (fig. 193).[7] These are the earliest equestrian statues of modern Europe. What has not been written about this mysterious horseman! Some have thought he is Pepin the Short or Henry II of England, others that he is St. George or St. Martin.[8] However, a text published long ago leaves no doubt about his true identity. Toward the middle of the twelfth century, a baron named Guillaume David, benefactor of the Abbaye-aux-Dames at Saintes, requested in a still extant document that he be buried before the right door of the church, "beneath the Constantine of Rome," *sub Constantino de Roma, qui locus est ad dexteram partem ecclesiae.*[9] There was, then, on the façade of the church of the Abbaye aux Dames at Saintes, a statue of Constantine; and it was an equestrian statue, for traces of it could still be seen on the façade fifty years ago.

To this decisive proof others have gradually been added. In the interior

193. Equestrian statue of Constantine.
Châteauneuf (Charente), St.-Pierre.
West façade.

of the baptistery of St.-Jean at Poitiers, a twelfth-century painting representing a horseman bears the inscription: *Constantinus.* In the sixteenth century, the horseman to be seen at the south door of Notre-Dame-la-Grande at Poitiers, which was destroyed by the Protestants, was commonly called Constantine.[10] In the early nineteenth century, the horsemen decorating the façades of the churches of St.-Hilaire of Melle and of Parthenay-le-Vieux were still referred to by some old people by the name of Constantine.[11] At Limoges, an equestrian group, now destroyed, had given to an ancient fountain the name of the Fountain of Constantine.[12]

Thus, it has become impossible to doubt that the enigmatic figure was Constantine.

But was this Constantine of French churches really an imitation of the Lateran figure? The document from Saintes seems to suggest so. There, Constantine is called "the Constantine of Rome," which doubtless means

not the Constantine who reigned at Rome, but the statue of Constantine that was to be seen at Rome and that perhaps the pious knight himself had seen there. This interpretation is strengthened by another document. The mosaic pavement of the church of Riez (Basses-Alpes) was once decorated with the figure of a knight designated by an inscription as *Constantinus leprosus*.[13] This was the Constantine of the Roman legend, the Constantine cured of leprosy in the baptistery of the Lateran. It is difficult not to see in this a souvenir of the pilgrimages.

Nevertheless, an objection comes to mind. The best preserved horsemen of our churches trample under their horses' hooves a small prostrate figure.[14] Before some of these groups were mutilated beyond recognition, this detail was probably found in all of them. No such thing is to be seen at Rome: there is no vanquished enemy under the hooves of Marcus Aurelius' horse.

There is no such figure today, it is true, but this was not always the case. We know from several twelfth- and thirteenth-century witnesses, who are in perfect agreement, that a chained figure, a kind of dwarf, was to be seen beneath the hooves of "the horse of Constantine."[15] This was undoubtedly a personification of the barbarians conquered by Marcus Aurelius. This figure, unnaturally small, has disappeared; the fact must be regretted for the significance of the statue is thereby altered. Today there is a less vivid sense of the high moral nobility of the philosopher-emperor who triumphs over his enemies with stoic calm.

It would now seem beyond doubt that the horsemen of our western French churches reproduced, or tried to reproduce, the Roman statue. The imitation is quite free, for probably none of our sculptors had seen the original: they were following the somewhat vague descriptions of the pilgrims. Consequently, they imagined Constantine as a twelfth-century sovereign. Sometimes they placed a falcon on his wrist, and they did not forget to clothe him in a mantle, for no great personage of the time would have dared appear in public without one. Wace tells a curious story about this very subject.[16] When Robert, Duke of Normandy, went to Rome and like everyone else went to see the famous statue of Constantine, he was so shocked that the emperor wore no mantle that he had one brought from his own wardrobe and thrown about the statue's shoulders.

In twelfth-century France, the clerics had not forgotten that Constantine was the first Christian emperor, and it is probable that they took the small figure lying under the horse's hooves to be a symbol of vanquished paganism. This might explain why there is at Châteauneuf, as there was once at Ste.-Croix of Bordeaux, a woman standing in front of the emperor's horse.[17] This woman is none other than the Christian Church welcoming her champion, as the noble lady of popular epics welcomed her knight who disarmed the enemy and avenged her honor.

The presence of the horsemen on the façades of so many churches in western France does not mean that the Christians of these regions had made more pilgrimages to Rome than other people. Some pilgrim had remembered the statue of Constantine, the conqueror of paganism, that stood before the Lateran palace, and it soon became a traditional workshop theme. We do not know where it originated, but it is apparent that it was adopted by the sculpture workshops of Saintonge and Poitou, and was spread by them in these provinces.

Furthermore, it must not be thought that the theme of the horseman was used only in this region of France. We have just mentioned an example at Riez, in the Basses-Alpes. It is also found on a capital of the cathedral of Autun, and again, set into the exterior wall of the church of St.-Etienne-le-Vieux at Caen. In these three examples, the figure of the vanquished enemy can be seen, or could once be seen, under the horse's hooves. There is no proof that these three figures were inspired by those in the west. The idea must have occurred to more than one pilgrim to have the famous statue of the Lateran reproduced. The artists, probably unknown to each other but having similar sensibilities, treated the subject in almost the same manner.[18]

II

The pilgrim who stayed on in Rome for a time visited and prayed in many churches. He encountered frequently the image of St. Peter, the true hero of Christian Rome. The saint was represented repeatedly in the mosaics decorating the apses and arches of triumph in the basilicas. Certain details of these images must have made a strong impression on observant travelers.

Rome. Images of St. Peter.

In the earliest mosaics, St. Peter was shown with the thick head of hair attributed to him by tradition, but at S. Agata dei Goti, SS. Cosma e Damiano, and the oratory of S. Venanzio,[19] his hair was cut far back on his forehead in the form of a crown. In the triclinium of the Lateran, in a slightly later mosaic contemporary with Charlemagne, St. Peter had a circle shaved in his thick hair. Thus, in Roman mosaics, St. Peter wore the cleric's tonsure. The Roman artists had marked him with this symbolic sign so that he appeared not only as the foremost of the apostles but also as the first among priests.

Other details would have struck the pilgrim. While the other apostles carried only a scroll or a book, St. Peter almost always had two keys in his hand. He was seen with the keys on the arch of triumph of S. Paolo fuori le Mura,[20] at S. Agata dei Goti, S. Venanzio, S. Teodoro, and S. Marco. These two keys were two symbols of the power given by Christ to the apostle to "bind and to loose." St. Peter carrying the keys was the pope, or rather the papacy itself. St. Peter's successors reminded the world that

this superhuman right to condemn and to absolve was given to them by God himself.

As time went on, the image of St. Peter resembled more and more the image of the popes. In the triclinium of St. John Lateran, St. Peter, tonsured like a cleric, wore the pallium—the very emblem of the sovereign pontiff—over his robe, and the keys lay in his lap. This St. Peter, a kind of allegory of the papacy, presented the standard to Charlemagne.

The pilgrim could encounter even more audacious images, for on papal coins, St. Peter was transformed into a pope and sometimes wore the cone-shaped tiara, which was its earliest form.[21]

Thus, on Roman monuments, St. Peter was always given the same aspect. He was represented as the pope, the head of the ecclesiastical hierarchy. Such an image could have originated only in Rome.

The pilgrims took this image home with them, and it appeared in France as early as the beginning of the twelfth century. The pillars of the Moissac cloister were decorated before 1100 with large figures of the apostles, which mark the beginnings of monumental sculpture (fig. 194).

194. St. Peter. Moissac (Tarn-et-Garonne), Abbey Church of St.-Pierre. Cloister pier.

St. Peter is represented there as he was at Rome. He holds the two keys in his hand and his head is tonsured. This image reminded those who had made the pilgrimage to Italy of the eternal city and its holy churches.

In French art from this time onward, St. Peter was almost always shown with this attribute given him by the art of Rome. In studying the art of the twelfth century, it is often surprising to find that even in scenes from the Gospels St. Peter is distinguished from the other apostles by a tonsure. In the great twelfth-century window of Chartres, St. Peter seated at the Last Supper is immediately recognizable by his tonsure. At Chartres, as in certain Roman mosaics, his hair is not shaved but has been shaped with scissors into layered crowns (fig. 106). At Vézelay, when the sculptors carved the history or the legend of St. Peter on capitals, they gave him the tonsure. St. Peter freed from prison by the angel resembles a Benedictine monk with his crown of hair, and to make the resemblance even more striking, the artist represented him as beardless.[22]

And we even find representations of St. Peter transformed into a pope. A capital of the cloister of Montmajour represents him, as on the papal coins, wearing the tiara.

Thus, the twelfth-century St. Peter with his attributes was originally a creation of the papacy. The abbots and bishops who directed the artists' work brought him to France from Rome.

III

The pilgrim going to Rome by the Monte Bardone route would certainly have stopped at Lucca. He arrived there not without hardship. In the spring, torrents from the Apennines carried away bridges and inundated long stretches of the ancient Roman roads. The road was so dangerous that an order of religious hospitalers was created at Altopascio under the patronage of St. James. They repaired the roads, rebuilt the bridges, and maintained ferries. Sometimes they forded the rivers, carrying the travelers on their backs as St. Christopher of the legend had done. As night fell, they rang the bells of their mountain churches to guide lost pilgrims. So it was a joyous experience for the pilgrim to see the mountains behind him recede and turn blue in the distance as he moved on through the olive groves and the cypresses of the beautiful plain of Lucca.[23]

The visitor to Lucca today is astonished at the number and the beauty of its churches. The façades of almost all of them received their charming adornment of marble colonnettes in the late twelfth or early thirteenth centuries—the era of the great pilgrimages. And in fact, Lucca was one of the principal stopping places on the road to Rome. People rested there from their journey, and each church of the town and its suburbs had its hospice where pilgrims were received.

Lucca. The miraculous crucifix of Lucca and its influence. St. Wilgefortis.

Why did pious pilgrims choose to stop at Lucca? Not to honor the ancient saints of the town, S. Frediano and S. Regolo, but to pray before an image of Christ on the cross, an image famous above all, called the "Volto Santo." In French it was called the "Saint Vou" ("Holy Face"), and it had a legendary history.[24]

It was related that in 742 a boat with neither passengers nor pilot put in at the Tuscan coast near Luni. In it was found a large Christ carved in wood which was taken at once to Lucca. This miraculous Christ was the work of Nicodemus, the disciple of the Saviour, who was a sculptor as St. Luke had been a painter.[25] Nicodemus had seen Christ dead on the cross and had tried through his art to eternalize his sorrowful image. But the task was above human capacity, and he despaired of finishing it. One day when he had fallen asleep from exhaustion near his unfinished Christ, an angel came down from heaven and completed the work—a beautiful legend, bestowing on great art a celestial origin.

The Christ of Lucca, called since the Middle Ages the "Volto Santo," the "Saint Vou" or "Holy Face," is still preserved in the cathedral of S. Martino. It is enclosed within a small Renaissance temple, the graceful work of Matteo Cividale, and is exhibited only on great feast days. The faithful who contemplate it are no doubt a bit disappointed, for this miraculous Christ is almost hidden under rich ornaments. He now wears a necklace and jewels, but this was not true in the Middle Ages. Then, the Christian saw the Christ as Nicodemus had carved him (fig. 195);[26] only a crown was placed on his head. However, on certain days, silver shoes were placed on his feet to protect them from the kisses of the pilgrims. What was original about the Lucca Christ was that he was not nude; the artist represented him on the cross wearing a long robe tied in at the waist. In all likelihood, such a work is of Eastern origin; we recognize the robed Christ dying on the cross of the Syrian Gospel-book of Florence and of other early Eastern monuments.[27]

In the twelfth century, there was already something strange about this Christ crucified in a robe; it struck the imagination all the more. Miracles were attributed to it, one of which was celebrated by poets. It was told that one evening a jongleur, after singing all day in the streets of Lucca without receiving a penny, went into the church of S. Martino, kneeled before the Volto Santo, and as a prayer played on his viol the most beautiful song he knew. The Christ at the time had on his silver shoes; he threw one to the jongleur. The poor musician was joyous and ran to show this miraculous gift to the bishop. But the bishop, incredulous, made the jongleur return it. At once, the miracle was performed again, and the church of Lucca had to pay a pretty penny to buy back Christ's shoe from the jongleur. In this way, the jongleurs of the Italian pilgrim roads cheered themselves with their own Golden Legend.

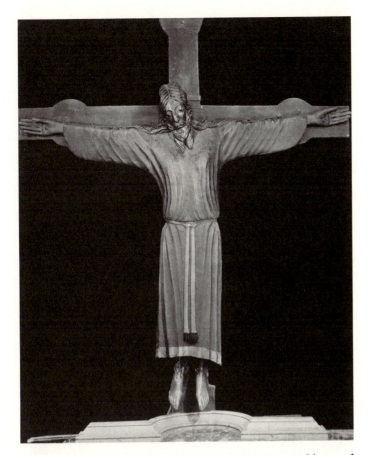

195. The Volto Santo. Wooden crucifix.
Lucca, Cathedral of S. Martino.

Thanks to the pilgrims, the renown of the Christ of Lucca spread beyond
the Alps. As early as the eleventh century, William Rufus, duke of Nor-
mandy and king of England, swore by the Volto Santo. In the twelfth
century, epic poets told that Charlemagne, in pursuit of Ogier the Dane
along the Monte Bardone road, stopped at Lucca to venerate the holy
image.[28]

Pilgrims returning to France sometimes wore a lead figurine represent-
ing the Christ of Lucca fastened to their tunics. In 1908, one of these pil-
grimage souvenirs was found at the bottom of the port of Wissant,[29] the
old port mentioned in the *Chanson de Roland*. It was there that the Eng-
lish pilgrims returning from Rome embarked. They did not forget the
holy crucifix; a twelfth-century relief on the exterior of the church of
Langford, near Oxford, is nothing more than a copy of the Christ of
Lucca.[30]

Such copies must not have been rare in our French churches, but only
a few have been preserved. One can be seen today in a chapel of the cathe-
dral of Amiens. It is a beautiful wooden Christ, clothed in a long robe,
crowned, and exactly like the Volto Santo. The still archaic delicacy of the
folds and the noble character of the head assign it to the late twelfth cen-
tury. This ex-voto of the pilgrimage to Italy would probably not have been

preserved until the present day had it not been the focal point of a legend well known to the people of Amiens. It was said that one day this Christ bowed when the relics of St. Honoré passed by. This miraculous episode is represented on the south portal of the cathedral of Amiens.[31]

These images of Christ, so little in conformity with tradition, must have deeply shocked the rational-minded clergy of the seventeenth century. Many of these old souvenirs probably disappeared at that time. It is only in remote provinces, in somewhat backward regions which long remained faithful to old customs and old images that copies of the Volto Santo were preserved. Little known churches in the mountains of Roussillon—Bellpuig (fig. 196),[32] Agoustrine, and Llagonne, on the Mont-Louis road—faithfully preserved the old wooden Christ figures from the twelfth century. All three reproduce the original of Lucca, but the Bellpuig Christ is the most faithful to its model, for the artist copied even the belt that gathers in the robe at the waist and falls in front in two long streamers.[33]

In the rest of France, these images soon came to seem very strange to those who had not seen the Volto Santo, and they set imaginations to work. The extraordinary thing is that they were soon taken to be figures of

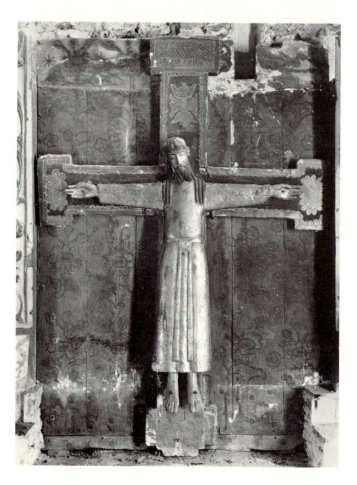

196. Wooden crucifix. Bellpuig (Pyrénées-Orientales), La Trinité.

women, and it was thought that they represented a fully clothed saint attached to the cross. That is how the legend of St. Wilgefortis originated and spread.

The story was told that a young Portuguese princess, the daughter of a pagan king but herself secretly a Christian, was about to marry an infidel prince at the order of her father. In vain she beseeched the king to give up his plan, but he remained obdurate. In despair, she fervently prayed to God to make her so ugly that she would be repellent to her fiancé. Her prayer was granted; she suddenly grew a long beard that transformed her into a man. The wrathful king had her nailed to a cross. Here, we see clearly how the misunderstanding of a work of art created a legend and a new saint.[34] There is even less reason to doubt the connection when we see the famous miracle of the Volto Santo being attributed to St. Wilgefortis. It was, in fact, related that the saint had thrown her silver shoe to a viol player, and works of art (of a fairly late period, it is true) strove to give sanction to this story.[35]

Representations of this crucified saint, still encountered here and there, are not very early; they date from a time when the Christ of Lucca had been forsaken by pilgrims and forgotten. It is possible that certain images of the Volto Santo, half destroyed by time, had been replaced in more than one church by images of St. Wilgefortis.

IV

Not all the pilgrims to the Holy Land passed through Rome. Instead of leaving the Via Emilia at Forlì and climbing the Apennines, many went directly through Rimini, Pesaro, and Ancona. From there to Brindisi, they followed the ancient Roman road along the sea. But there were very few pilgrims who did not make a short detour to visit the famous sanctuary of San Michele on Monte S. Angelo, on the promontory of the Gargano. At Sipontum, later called Manfredonia, they followed a rough path through the moaning forest celebrated in Horace's verses,[36] and climbed to the summit of the mountain. There, the mysterious grotto of the archangel opened in the earth before them and on its threshold they read this inscription: *Terribilis est iste locus*. Steps led down into the darkness to the depths of the sacred grotto, to the holy of holies, where by the light of candles they could see the imprint of the archangel's feet on the stone.

It was said, in fact, that St. Michael had appeared on this summit in 492.[37] By a prodigy, he had first terrified cowherds who were looking for a strayed bull; then he revealed to the bishop of Sipontum that he wished to be venerated in this place. In the grotto an altar was found that the archangel himself had dedicated.

What could have been more poetic than this somber grotto on the

Monte S. Angelo and the cult of St. Michael. Diffusion of the Italian type of St. Michael. The Norman Mont-St.-Michel.

summit of a mountain covered with forests extending to the sea? Medieval pilgrims as well as monks sought out awe-inspiring landscapes, for the spirit of God seemed to them to hover over mountain peaks and to fill vast spaces.

By the seventh century, the grotto of Monte S. Angelo had become one of the most celebrated pilgrimage spots of Italy. The grotto was within the duchy of Benevento and belonged to the Lombard kings who had a special cult for St. Michael. They stamped his image on their coins[38] and their banners,[39] and they built the churches at Pavia and Lucca in his honor. In St. Michael, they were honoring the angel of battle, the soldier of God.

The Holy Roman Emperors inherited this cult. When they went down to Italy, they always visited Monte S. Angelo. Otto III went there to atone for the death of Crescentius.[40] Henry II had a vision there. It seemed to him that the walls of the grotto evaporated, and he saw St. Michael appear at the head of an army of angels;[41] one of the angels came to him and touched his thigh, as the angel had once touched Jacob. Then the vision vanished but the emperor saw that he had not been dreaming, for all his life he carried the mark of the angel's finger.

Famous travelers from France also went to Monte S. Angelo: St. Odo, abbot of Cluny, St. Gerard, abbot of La Sauve-Majeure, and the illustrious Suger.

Had there been an image of some sort in the sacred cave that travelers always remembered? There is no doubt that there was, for the testimony of the monk Bernard, a French pilgrim of the ninth century, is explicit; he says: "In the interior, on the east side, there is an image of the angel."[42] This, no doubt, was a large painted icon. This ancient image of St. Michael has disappeared, but others have been preserved in the grotto. The archangel is carved on a marble throne; he is shown frontally, his two wings fall in parallel lines at his sides, and with both hands he plunges his lance in the mouth of the dragon writhing under his feet (fig. 197).[43] The work seems to date from the early twelfth century. A statuette, also preserved in the sanctuary,[44] seems to date from the end of the same century and represents the archangel in the same attitude, with the same monster under his feet. Such, in all likelihood, was the image of St. Michael that for centuries had been presented to the pilgrims for veneration on the east wall of the grotto. There is no doubt that the two images of St. Michael still preserved in the sanctuary reproduce a consecrated type. The St. Michael standing on the dragon, unknown to Byzantine art, is the St. Michael of Monte Gargano. He must have originated there in Carolingian times, and from there spread throughout Europe. This hieratic group is not without beauty and it is still meaningful to us; the angel standing on the beast seems to be the image of the soul's victory over instinct.

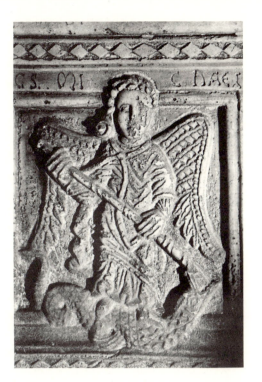

197. St. Michael on the dragon.
Marble bishop's throne (detail).
Monte S. Angelo (Gargano), Grotto of
the Archangel.

It is only natural that we should come upon the Gargano St. Michael fairly often in Italy. In the regions of the south, dominated by the sacred mount, it is to be seen carved on the façade of the cathedral of Ruvo, and on a capital in the cathedral of Molfetta. Farther north, in the Abruzzi, it appears above a portal of the abbey of S. Clemente in Casauria. As the pilgrim went north toward the Alps along the Via Emilia, he encountered it—a figure with lance in hand and dragon underfoot, just as he had seen it at Monte S. Angelo—at Borgo S. Donnino, in the baptistery of Parma, and on the façade of S. Michele at Pavia. The figure appears similarly at Pistoia, Groppoli, and Todi.

Not only was the St. Michael of the Gargano often imitated in Italy; even the archangel's grotto was imitated. As early as the seventh century, Pope Boniface[45] built a chapel dedicated to St. Michael on the top of Hadrian's mausoleum, the place where St. Gregory the Great had seen the archangel sheathing his sword. This aerial church, popularly called "St. Michael in the Clouds," was built in the form of a crypt (*cryptatim*); it was meant to remind pilgrims of the holy cave they had seen on the summit of the Apulian mountain.

In Campania, on Monte Gauro, above Sorrento, a church was erected at an early period in honor of St. Michael. Monte Gauro rises above the Tyrrhenian sea, just as Monte S. Angelo rises above the Adriatic. The two mountains correspond, and the two sanctuaries resemble each other. The church on Monte Gauro, according to the monk Bernard who visited it in the ninth century, was peculiar in having been built in the form of a crypt.

But it is on the other side of the Alps, in France, that we find the most astonishing imitation of the sanctuary of San Michele. This copy, which became as famous as the original, is our Norman Mont-St.-Michel. Here, the story is the same. St. Michael told St. Aubert, bishop of Avranches, in a dream, just as he had told the bishop of Sipontum, that he wanted a sanctuary on the mountain; both stories tell that a bull indicated the place where the archangel wished to be honored; both sanctuaries have the same form. As there was not a natural cave on the top of Mont-St.-Michel, St. Aubert hewed out a crypt "which reproduced the form of the crypt of Monte S. Angelo on the Gargano," says the text.[46] The relationship is clear. According to tradition, the dedication of the crypt of Mont-St.-Michel took place on 7 October 709.

It would be interesting to know if there had been an early image of St. Michael in the churches that succeeded each other on the summit of the Norman rock. Texts say nothing about it, but how could it have been otherwise? In the absence of relics, pilgrims needed an image: they wanted to see the archangel they had come so far to venerate. There are good reasons to believe that at Mont-St.-Michel there had been an icon similar to that of the Gargano. A seal of the abbot Robert de Torigni, dating from the twelfth century, shows St. Michael standing on the dragon (fig. 198). The cast is now half broken off, but we can guess that the archangel raised his arm to plunge his lance into the mouth of the monster beneath his feet.[47] This figure on the seal was a kind of escutcheon for the abbey, and it was used on the abbots' seals until the fourteenth century.[48] It no doubt reproduced a famous image known to all the pilgrims.

Thus, in Normandy we find not only the famous Apulian grotto, but also the Italian St. Michael.

Mont-St.-Michel-by-the-perilous-sea was soon to become immensely famous. The rock pounded by waves, the church shaken by tempests, the threatening sea and sky—all this gripped the imagination more forcefully than the luminous Italian mountain.

Our Mont-St.-Michel was imitated in turn, for there is no doubt that the dean of the cathedral of Le Puy had it in mind as a model when in 962 he built a chapel to the archangel on the summit of a basaltic rock as sheer and steep as the Norman mountain. The frescoes which decorated this little aerial church, itself a poetic fantasy, are no longer visible. The master of the place, St. Michael, is no longer to be seen, but he can be found in the cathedral of Le Puy. A large fresco shows him solemn and immobile, the lance plunged into the body of the vanquished dragon, which he tramples underfoot without deigning even to glance at it.[49] The ancient icons venerated by the pilgrims to Monte S. Angelo and Mont-St.-Michel must have resembled the fresco of Le Puy.

No doubt there were many paintings of this kind in France at one time.

Some will perhaps be found under the plaster or even in the bell towers of our Romanesque churches, for from Carolingian times onward it had been the tradition to honor the archangel in the upper parts of the church. The Cluniac monasteries were particularly faithful to this tradition. At Cluny, Payerne, Romainmotier, and Tournus, St. Michael had a chapel at the top of the towers.[50] A medieval liturgist tells us that this was a way of commemorating the appearance of the archangel on Monte S. Angelo.[51]

Although paintings are lacking in France, we do have a few relief sculptures here and there which reproduce more or less faithfully the hieratic St. Michael of the pilgrims. At Selles-sur-Cher (Loir-et-Cher), among the sculptures set into the exterior wall of the church, there is a St. Michael standing on the dragon; he is immobile, and with his left hand instead of his right, he plunges his lance into the monster's mouth. On the façade of Vermenton (Yonne), a half-destroyed St. Michael seems to conform in all ways to the accepted type. At St.-Gilles, a beautiful relief shows the group of the archangel and monster composed in the traditional way, but already the old devotional image has been invested with life, and the angel triumphs in combat.

It is interesting to watch our artists gradually throwing off the yoke of tradition. Very early they placed a shield on the left arm of the archangel. This detail, not found in Italian art, is noted frequently in France in the twelfth century. A manuscript illuminated at Mont-St.-Michel in the late twelfth century shows a St. Michael who conforms completely to the consecrated type, but he carries a shield on his arm (fig. 199).[52] Thus, innovations were introduced even into the sanctuary of the archangel. Our

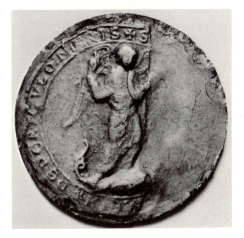

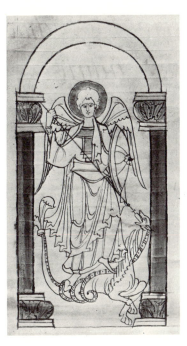

198. St. Michael on the dragon. Seal of Robert de Torigni. Formerly, Archives départementales de la Manche, collection Mont-Saint-Michel.

199. St. Michael on the dragon. St. Augustine, *Enarrationes in Psalmos.* Avranches (Manche), Bibl. Mun., ms. 76, fol. Av (detail).

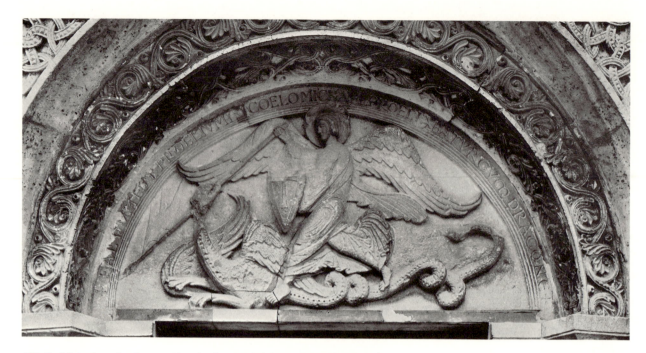

200. St. Michael on the dragon. Church of St.-Michel-d'Entraigues (Charente).
West apsidiole, tympanum.

sculptors above all were bursting with energy and creativity; they could not keep on reproducing indefinitely the ancient image. They preferred movement to the impressive immobility of the past; under their chisels, St. Michael became a knight giving battle. The most lively St. Michael created in the twelfth century is on the portal of St.-Michel-d'Entraigues, in Charente (fig. 200). Never had an artist filled a tympanum with a bolder arabesque. The winds of heaven ruffle the angel's wings and lift the hem of his robe; the dragon's long body contracts and knots. As before, St. Michael stands on the monster and plunges his lance in its mouth, but new life animates the ancient group of angel and beast. Many variants could be cited.[53] This is what French artists, by the twelfth century, were able to create from the old icon before which the pilgrims prayed.

V

The French epic along the Italian roads. The *Chanson de Roland*, and the mosaic at Brindisi. Roland and Oliver in the cathedral of Verona. The Knights of the Round Table in the cathedral of Modena. The *Roman de Troie* at Pesaro. The *Roman d'Alexandre* at Otranto, at Borgo S. Donnino.

Italy, as we see, gave to France the types of St. Peter and St. Michael, the image of the Volto Santo, and the horseman of our western churches. But Italy received even more from France, for it was by the pilgrim route, the "Via Francigena" as it was called in the Middle Ages, that French poetry and art made their way across the Alps in the twelfth century. Thousands of French pilgrims passed along these roads; some were rich, others were powerful, and some had only their souls to save. But no matter who else

might be in the throng, there were always jongleurs. At stopping places along the way, the French as well as the Italians gathered around the jongleurs on the square near the church as they recited our *chansons de geste*. In the thirteenth century, the jurisconsult Odofredo speaks of the jongleurs who sang of Roland and Oliver in the public squares of Bologna. Bologna is on the Via Emilia; that is, on the great pilgrimage road. It was through French jongleurs that Charlemagne and his barons and Arthur and his knights of the Round Table were known in Italy only a short while after they were known in France. An inscription dated 1131 from Nepi, a small town located only a short way from the pilgrim road, threatens oath breakers with the fate of Ganelon.[54]

But the jongleurs did more than repeat the *chansons de geste* they brought from France; they invented new ones. The episodes of these popular epics, composed for pilgrims on their way to visit the tomb of the apostles, had taken place along the main roads to Rome;[55] so the travelers enjoyed constant reminders of the epic heroes as they went along. Passing through Mortara, they recalled that Amis and Amile, the two saints whose friendship was celebrated by the poets, were buried there, side by side. They were respectful as they passed through the forest of Imola, for the jongleurs told them that Bertha and Milo had lived there after Charlemagne drove them into exile, and that Roland had been born there. At Sutri, they remembered Roland again, for according to the poets he had spent his childhood there, and there Charlemagne had seen him for the first time—a proud child, "like unto a lion."

The Monte Bardone route was the route of Ogier the Dane. The pilgrims recalled that this rebel in flight before Charlemagne had stopped at Luni and the castle of Montecelio, and that he too had crossed the bridge over the Serchio, thus crossing the white and the black Arno.

The great men of antiquity who had trod the stones of the Roman roads were forgotten by medieval men, but the venerable routes were not void of memories, even so. French poets restored their majesty, embellishing them with a new history. They peopled them with a world of heroes as young as the heroes of Homer.

All these stories made a profound impression on the Italian imagination. In the twelfth and even more so in the thirteenth century, the knowledge of French was widespread in Italy. St. Francis of Assisi, if we can believe Thomas of Celano, sang the praises of the Lord in the French language. Several of our great epics, copied by Italian hands, are still preserved in Italian libraries.[56]

But Italians were not content merely to listen, read, and eventually imitate the stories of our minstrels; they eternalized them in art. The remarkable thing is that the works they devoted to these stories are all found along the roads traveled by pilgrims and minstrels.

Until the mid-nineteenth century, the cathedral of Brindisi was decorated with a mosaic pavement of scenes from the Old Testament. And most interesting of all, in one section of the mosaic, Roland, Oliver, and the archbishop Turpin were represented with their names written beside them in French (fig. 201). This work was destroyed by an earthquake in 1858, and only poor drawings of it preserve any record of it.[57]

201. Archbishop Turpin and Roland. Pavement mosaic (destroyed) from the Cathedral of Brindisi (early nineteenth-century drawing by Millin). Paris, Bibl. Nat., Cab. des Est. Gb. 63.

Despite the mediocrity of the drawings, we can easily recognize several episodes from the *Chanson de Roland*.

First, there is the archbishop Turpin on horseback. His arm is raised, and he seems to be speaking to Roland who blows a horn. There is no doubt that this is an illustration of the following passage from the *Chanson*: "The archbishop pricked his horse with his spurs of pure gold. . . . 'Sir Roland,' he said, 'look, our Franks are condemned to die. Your horn cannot save us. Charles is far away and will be too long in coming. But however that may be, it is best to blow it. . . . The king will come and will somehow avenge us. The Franks of Charlemagne will dismount from their horses. They will find us dead and cut in pieces; they will gather up our heads and our bodies; they will carry our biers on the backs of their horses; they will bury us in the cloisters of monasteries. Wolves, swine, and dogs will not eat us.' 'Well said,' Roland replied. Roland put his oliphant to his lips; he trumpeted well, blowing with powerful breath. The mountains were high, and the sound carried far; the echo could be heard thirty leagues away."[58]

The mosaic then showed the last battle, but the drawing gives only a fragment. The Saracens carry round shields; their arms are not those of knights, they are bows and battle-axes. It was in this last battle that Oliver was mortally wounded.

The Saracens take flight, and Roland wanders alone over the battlefield. He finds the bodies of his comrades: "Ivo and Ivoir, Gerier and Gerin, the Gascon Engelier, Berenger, Otho, Samson, Anséis and the aged Gerard

of Roussillon. One after another, he brings in the bodies of the ten barons."[59] And the naïve mosaic showed the dead warriors carefully laid side by side, and Roland carrying a dead body on his shoulders. The archbishop Turpin is not shown blessing them, but an angel comes down from heaven with arms outstretched to receive the souls of the barons. In this way, the artist translated the words spoken by the archbishop: "May God the Glorious have all your souls, and put them in a paradise of holy flowers."[60]

Then comes the last episode:[61] Roland, leaning on his sword and almost fainting, contemplates Oliver's body. The head of the hero rests on his shield; his soul, in the form of a small child, has just left his body through his mouth, and an angel stretches out his arms to receive it. Here we recognize the exact translation of a passage from the *Chanson*: "Roland turns back to search the plain; near a wild rose, under a pine, he finds the body of his comrade-in-arms, Oliver. He puts down his friend upon a shield, near the other peers. . . . When Count Roland sees all the dead peers, and Oliver whom he had such good reason to love, his soul melted and he began to weep; his face was very pale, his grief was so great that he could not stand."[62]

Thus, the *Chanson de Roland* was sung at Brindisi, not far from the milestone marking the end of the Appian Way, beside the port where French pilgrims embarked for the Holy Land. But was this exactly the same *chanson* that we have today? One episode, not yet mentioned, surprises us. After the battle scene, we see, or barely make out, two half-effaced horsemen withdrawing from battle. The second, as his name indicates, is Oliver; the first can only be Roland. Roland leads the dying Oliver's horse by the bridle. The *Chanson de Roland*, as it has come down to us, contains nothing like this. But the same episode occurs in several foreign adaptations; for instance, in the *Rolandslied* of the German Conrad, and in two Italian imitations.[63] However, the Brindisi mosaic was not inspired by a foreign poem, for the names of the heroes are written in French. We can only conclude that the jongleurs of the Italian pilgrimage roads sang a *Chanson de Roland* that was slightly different from ours. Some additions might have crept in as time went on, for that part of the Brindisi mosaic concerned with Roland cannot be earlier than the first quarter of the thirteenth century. The date of 1178, which, it is said, could once be seen in the paving, was no doubt correct for a part but not for the whole mosaic. The long trappings on the horses, and the narrow shields decorated with armorial bearings carried by Turpin and Roland indicate a date near 1215 or 1220.[64] Consequently, it is pointless to recall that the bishop William, who is supposed to have had the whole mosaic done in 1178, was of French origin, for the episode from the *Chanson de Roland* is not of his period. The choice of such a subject proves that the

French minstrels accompanied the pilgrims to the Holy Land as far as the very southernmost end of Italy.

Let us now go back to Vercelli, at the other end of the pilgrim route. Vercelli, where the route over the Great St. Bernard pass met the Mont Cenis road, must have been a place where the jongleurs assembled, for they were sure of finding throngs of French pilgrims there. A reminder of their songs would still seem to be inscribed on the paving of the half-destroyed church of S. Maria Maggiore (fig. 202). We see a warrior blowing his horn while barons appear to be deliberating under a tree. Farther

202. Combat of Fola and Fel. Mosaic from the Church of Sta. Maria Maggiore. Vercelli, Museo Camillo Leone.

on, a knight, protected by the great shield used in the twelfth century, attacks a negro with white teeth who hurls his round buckler against the triangular shield. Illegible names are written on the blades of the two swords, which were no doubt famous. This mutilated mosaic clearly illustrates a *chanson de geste*, but was it the *Chanson de Roland*? Incomplete names are inscribed behind the two warriors: for the knight, FOLA;[65] for the negro, FEL. According to Kingsley Porter, the most recent commentator on the mosaic, the letter F of FOLA is the result of a faulty restoration. He thought it probable that, in the beginning, the letter F was an R, and that the now incomprehensible name was ROLA[ND].[66] This may seem a somewhat bold hypothesis. But one can scarcely doubt that the Vercelli mosaic was inspired by one of our *chansons*, for elsewhere in the same pavement, we see another of our heroes: Renart buried by the hens.

It may not have been proven that Roland was represented in the mosaic pavement at Vercelli, but it is, on the contrary, quite certain that he was carved on the portal of the cathedral of Verona (fig. 203).[67] *Durindarda,* for Durandal, is written on the hero's sword. Against one of the jambs of

203. Roland with his sword
("Durindarda"). Verona, Cathedral.
West façade, portal relief.

the doorway, Roland is covered with his large shield and carries his naked
sword in his hand. On the opposite jamb, another warrior is shown; he
also is almost hidden by his shield, and instead of a sword he carries a
mace. Roland's comrade can be none other than Oliver. The archaic
character of the two statues assigns them to the mid-twelfth century. The
theory has been advanced that the inscription on Roland's sword could
have been added later, but I am able to affirm from a recent on-the-spot
study of the letters that they do not differ from those decorating the bande-
roles of the other figures on the portal. Verona is not on the road to Rome,
it is true, but Verona is on the road to Venice. Now oftentimes pilgrims
to Jerusalem embarked at Venice instead of Brindisi. And Venice, more-
over, after Rome and Monte S. Angelo, was the object of the most cele-
brated pilgrimage in Italy, for it possessed the body of the evangelist St.
Mark. Thus, it is not surprising to find our epic heroes on the road to
Venice.

In this way, the Church accepted our epic poem and let Charlemagne's
comrades be represented on the portals of its cathedrals. Yet the Church

had no love for the jongleurs and often had harsh things to say of them; but it did not condemn indiscriminately, and esteemed those of them who sang of the heroes.[68] It was a mark of the medieval Church's greatness that it sensed what there was of moral beauty in our epics. Faith, courage, loyalty, devotion—these were the virtues that radiated from the valiant knights, just as from the saints. The Church understood that the poets were performing the same work as she, and like her, taught sacrifice.

If Roland and Oliver could join the company of confessors and martyrs, it is more surprising to see King Arthur and the romantic knights of the Round Table there. But we meet them, too, in the Italian churches.

In the paving of the cathedral of Otranto, laid, according to the inscription, between 1163 and 1166, King Arthur appears mounted on a fabulous animal next to scenes from Genesis and the Last Judgment (fig. 204). His name is inscribed beside him: *Rex Arturus*.[69] Along with Brindisi, Otranto was a port from which pilgrims sailed to the Holy Land.

204. King Arthur. Otranto, Cathedral. Pavement mosaic (Bertaux after Millin).

But it is at Modena,[70] one of the stages along the Via Francigena, that King Arthur and his knights were celebrated most magnificently. It is most extraordinary that an entire portal of the cathedral is devoted to them (fig. 205). They form a cavalcade around the archivolt and are designated by name: Artus of Brittany, Idier, Gawain, Keu, the famous seneschal, among others. That sculptors dared to carve secular heroes on the portal of a church means that the *chansons* of the jongleurs had long since exerted a powerful charm over the Italian mind. Even the clergy could not resist them. We can understand why, even today. The world of these poems was a new and enchanted one where the poet ruled with the wand of a magician. He could suddenly change the most splendid knights into hideous dwarfs, then restore them to their original forms; he could make the old stag of the forest talk, and he could build a palace for the fairies under the waters of a lake. His fictions resembled the luminous landscapes made by clouds in a summer sky. The imagination was freed to

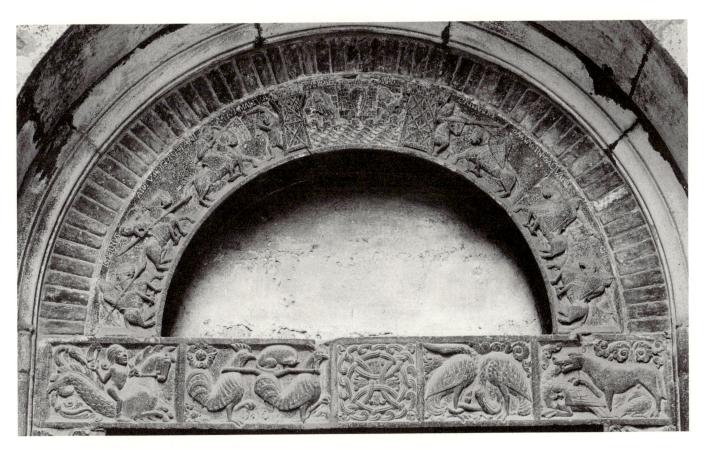

205. Arthur and the Knights of the Breton cycle. Modena, Cathedral. North façade, portal.

wander in the ether. But in this world of marvels, the most beautiful enchantment of all was the beauty of woman. For the first time, a voluptuous tenderness crept into verse. A gentle image seemed always to ride beside the knight in the forest. Love appeared to be the supreme object of life. Merlin, the wisest of men, renounced learning and enclosed himself in a magic circle with Vivian.

The medieval Church must have been singularly receptive to all elevated forms of thought for it to allow the romances of the Round Table to be carved on the doors of the sanctuary. It no doubt felt the moral refinement and delicate nuances in this new type of knight. It understood what medieval society, until recently so uncultivated, already owed to these graceful fictions in the way of courtesy, good manners, and gentleness. We owe as much perhaps to these romances as to our serious epics, for century after century, they shaped the spirit of the West. The poor madman, Don Quixote, so noble in his madness, proves that the chivalric romances never ceased to be the school of noble feeling.

The Modena portal, then, is a monument of the greatest interest. What does it represent? A square stronghold rises within a fortified enclosure;

a great buckler is suspended from its crenelations. Two figures, apparently women, appear above the walls. Arthur and his knights approach from both sides; they wear battle armor and carry lances with attached banners. However, Arthur does not carry the famous sword Marmiadoise, which came to him from Hercules. A dwarf armed with a battle-ax issues from one of the castle gates and goes to meet the knights; from the other gate a knight, named Caradoc by an inscription, comes out with his lance at the ready.

It would seem that the scene represents the last defense of the felon Caradoc, as the story is told in the *Roman de Lancelot*. King Arthur's knights have arrived at Dolourous Tower, Caradoc's castle; in it there is an old woman, the mother of Caradoc, who is even more wicked than her son, and a young captive girl who detests her captor. At the approach of the knights, a dwarf goes out of the enclosure to defy them; then Caradoc on horseback engages Lancelot in combat on the bridge of the castle. Lancelot, victorious, pursues him into the enclosure and cuts off his head.

The correspondence between the romance and the relief would be complete if Lancelot figured among the knights of the Round Table at Modena. But instead of Lancelot's name, we read the name of Gawain (Galvagin). Now in the romance, Gawain at this moment is still the prisoner of Caradoc. We must conclude either that the artist did not accurately reproduce an episode which was perhaps vague in his mind, or what is more likely, that he knew a story of the death of Caradoc different from ours.[71]

Thus, at Modena the sculptors inscribed in stone the souvenir of stories sung by French jongleurs to pilgrims in front of cathedral portals. They even added an episode from the story of Renart. On the lintel, we see Renart being buried by two cocks; they think him quite dead, but suddenly he comes to life and carries off one of the cocks in his jaws. To judge by the degree of delicate refinement in the sculptural style, the Modena portal was carved fairly late in the twelfth century. As we see, it is completely secular. It is the most extraordinary monument still in existence on the Via Francigena; it evokes for us the pilgrims from France who were greeted by poetry at every stage of their journey.

The example at Modena is not unique. In southern Italy, on the pilgrimage route to Jerusalem, the portal of the church of S. Nicola at Bari also shows knights riding toward a fortified castle. The work lacks the quality of that of Modena but is conceived in the same manner. Does it also represent King Arthur and his knights? This is a likely supposition but cannot be proved, as no names are inscribed on the stones.

Our two great epic cycles of Charlemagne and of King Arthur thus left their trace in Italy along the pilgrimage roads; the cycle of the heroes of antiquity also left theirs.

Pesaro was one of the stations on the road to Brindisi, that is, on the route to Monte S. Angelo and to Jerusalem. In the mosaic paving of the cathedral is a representation of Helen carried off in a ship toward Troy.[72] Italian scholarship has seen here a reflection of one of our French epics, the *Roman de Troie*, composed by Benoît de Sainte-Maure about 1160. The hypothesis seems a bit rash at first, for twelfth-century Italy knew the Latin poets and did not need to hear Benoît de Sainte-Maure's poem recited by jongleurs to know that Paris carried off Helen. But when we read the inscription accompanying the scene, we see that Paris is called *Rex Trojae*, and here we are at a great remove from true antiquity. This Paris, the "King of Troy," is not the shepherd of Mt. Ida of godlike beauty; he is the king-knight of our poets. The choice of such a subject, then, is probably not to be laid to precocious humanism, but to the recollection of the recitations by jongleurs.[73]

Among the heroes of antiquity, Alexander is the one who most charmed the imaginations of our medieval poets. But the Alexander they knew was not the Alexander of Arrian and of Plutarch; their hero was taken from the Pseudo-Callisthenes.

In the third century A.D., an Egyptian Greek, who took the name of Callisthenes, gathered together all of the legends that had grown up in the East around the great name of Alexander. A conqueror could not advance as far as India without suffering the consequences; he returned enveloped in legends such as to put his very existence in doubt. The Oriental imagination, which distorts everything, transformed the young Greek hero and pupil of Aristotle into a kind of Arab magician. The story of the Pseudo-Callisthenes is not unlike a story from *The Thousand and One Nights*.

Medieval poets knew the book of the Pseudo-Callisthenes through the Latin translation of Julius Valerius, a fourth-century writer. They filled out this romance with others—the *Historia de proeliis*, and the fabulous *Lettre d'Alexandre à Aristote*.[74]

As a consequence, the twelfth-century jongleurs, interpreters of Albéric de Besançon and Alexandre de Bernai, told in the public squares how Alexander had discovered the Fountain of Youth, how he had explored the depths of the sea, and had tried to rise to the highest heavens, how he had entered the enchanted forest and found a young girl of a marvelous beauty beneath each tree, and how he had heard the trees speak to him and foretell his approaching death.

The souvenir of these French poems is to be found in Italian art. On the paving of the cathedral of Otranto, Alexander is shown rising to heaven (fig. 206). The poets related that the king captured two monstrous griffins and starved them for three days. On the third day, he fastened them together with a yoke to which a seat was suspended. The king sat in this

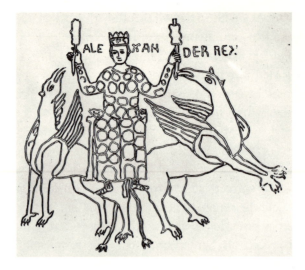

ALE XAN DER REX:

206. Alexander's ascent. Otranto,
Cathedral. Pavement mosaic (Bertaux
after Millin).

seat and raised over the animals' heads a long pole with an animal liver
fastened to the end. The famished griffins sprang into the air to seize the
food and carried the king into the sky. Although they could never reach
the food, they kept trying. In this way, Alexander mounted into the sky
for seven days, and would have gone farther had he not met a genie who
ordered him to return to earth among men. "Why wish to know the
things of the heavens," he said, "when you know nothing of the things
of the earth!"[75]

Such is the strange story illustrated by the Otranto mosaic. We recog-
nize Alexander in the seat between the two griffins, raising a double bait
at the end of two lances. Near the head of the king is an inscription:
Alexander rex. The composition has the perfect symmetry of Eastern com-
positions. A beautiful Islamic enamel, now in the museum of Innsbruck,
shows the same scene in the same way,[76] for the ascension of Alexander
had been represented in the East very early. Thus, the mosaicist of Otranto
had a model, but why had he copied it? Why had he revived this legend?
Probably because the French poems had recently made it known in Italy.
Proof is inscribed on the very pavement at Otranto, for not far from Alex-
ander rising in the sky, King Arthur is to be seen: thus the cycle of an-
tiquity is brought together with the Breton cycle—and this constitutes
the very subject matter of the tales of our jongleurs.[77]

We again find the ascension of Alexander on the façade of the cathedral
of Borgo S. Donnino (Fidenza) (fig. 207). It is odd that anyone could
mistake the meaning of this relief. The last historian of the cathedral,
accepting a probably fairly recent tradition, interpreted it as Queen Bertha
spinning.[78] However, we have only to compare the relief of Borgo S.
Donnino with the Otranto mosaic to recognize the likeness of the two
works. Both have the same symmetrical griffins and the same poles held
by Alexander in each hand.

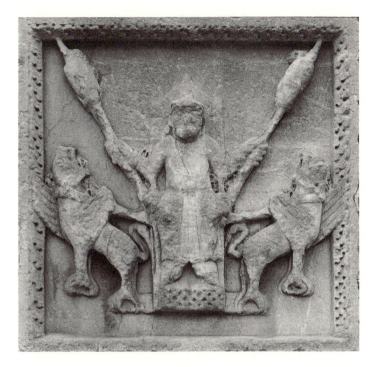

207. Alexander's ascent. Borgo
S. Donnino (Fidenza), Cathedral.
West façade.

The Church adopted this legend,[79] no doubt because it was seen as a symbol. Alexander represents human pride, man's attempt to wrest God's secrets from him by learning. Man rises and daringly penetrates the region of mysteries, but the region is limitless and he must finally stop before ever new mysteries.

Borgo S. Donnino, situated on the Via Francigena between Piacenza and Parma, was one of the stopping places on the road to Rome. French jongleurs who sang in front of the cathedral had come to know S. Donnino, the patron saint of the town. Our epic poems name him several times, and in *Aliscans*, the wounded child Vivien invokes S. Donnino along with St. Michael.[80] But in turn, Italian sculptors learned French *chansons* from our jongleurs. The image of Alexander carved on the cathedral undoubtedly commemorates the long stories listened to by the pilgrims after they had made their devotions. The pilgrims themselves were represented not far from Alexander on the façade of the cathedral of Borgo S. Donnino: the father, mother, and child walk along with staffs in hand and bundles on heads or shoulders. In spite of the countless dangers of the road, they walk without fear, for an angel, invisible to their eyes, precedes them. Farther on, we see them walking in the opposite direction; no doubt they are returning from Rome, cleansed of their sins and still accompanied by the angel.

Is it again a procession of pilgrims that is to be seen carved on a side of the south tower at Borgo S. Donnino? It is quite likely, for several of the figures have staffs in their hands and hoods pulled over their heads;

others are on horseback. One of the riders has dismounted and puts his dog on the horse's back. Such was the aspect of the long files of travelers constantly passing in front of the cathedral.

On the other face of the tower, there may possibly be a fragment of an epic poem. A knight clasps in his arms a young woman holding a flower; two champions come to grips; a man carrying an ax on his shoulder walks along followed by a child. Could this be Roland walking in the forest with Milo, his father, who has become a woodcutter? Would this be the story of Milo and Bertha, sister to Charlemagne? We are tempted to think so. But who is the horseman who draws his bow against a lion? The truth we thought we had found escapes us, and we give up trying to explain the inexplicable.

No doubt there were, and perhaps still are, other souvenirs of French epics inscribed on Italian churches, and perhaps some will one day be discovered. But those we have cited are sufficient to prove how profound the influence of the French jongleurs had been as they sang in the town squares, surrounded by crowds of pilgrims. The Church itself listened to these stories and was not above adopting some of them.

VI

French art makes its way into Italy along the pilgrimage roads. Historiated tympanums. Sculptured archivolts. Portal statues. Antelami imitates French art at Parma and at Borgo S. Donnino.

Not only did French poetry make its way into Italy along the pilgrimage roads; French art did so as well.

In the course of the twelfth century, Lombard churches were embellished with new decorations that came from France.

Pure Italian church architecture did not permit sculptured tympanums on portals. The principal doorway of S. Ambrogio at Milan (one of the oldest in existence) is rectangular, like a door from antiquity, but there is an arch above the lintel to protect it against the weight of the walls. This arch has no tympanum; it is a semicircular window opening into the church. And this is the type of portal found in a fairly large number of Lombard churches. This round arch is often filled in with a tympanum, but there is no carving on it. Such are the portals of Tuscan churches and of many in Lombardy.

The difference, then, between Italian and French churches is an important one. In most of our French provinces, even simple village churches have a carved tympanum, a poem in stone to stop the passerby and make him meditate on the things of heaven. The sculptured tympanum as it appears in all its grandeur at Moissac is a French creation, and it was from France that Italy borrowed it.

Sculptured tympanums were never very numerous in Italy, but it is interesting to note that almost all of them are either on the pilgrim routes or nearby. When the pilgrim had crossed the Alps by Mont-Cenis, he

was welcomed by the Christ carved between St. Peter and St. Paul on the tympanum of the church of La Novalesa, the ancient abbey with its many memories of Charlemagne.[81] At Vercelli, the church of S. Andrea has in its tympanum the martyrdom of the apostle, who was nailed to the cross. At Pavia, the tympanums of the church of S. Michele contain three representations of the archangel. Farther along the road, at the cathedral of Borgo S. Donnino where French art had so profound an influence, the central portal with its open round arch is completely Lombard, but the neighboring portals have carved tympanums. One shows the Virgin surrounded by the faithful, the other shows St. Michael striking down the dragon. At Parma, each of the two portals of the baptistery has its sculptured tympanum, and both are very closely related to French art. The artist was so imbued with the lessons he had learned from France that he carved other tympanums in the interior of the building. There is no carved tympanum at the cathedral of Modena, but at the abbey of Nonantola, at the gates of the town, the tympanum with its Christ in Majesty was inspired by a French original. At Forlì, the tympanum of the church of S. Mercuriale is decorated with an Adoration of the Magi. Farther south, at Arezzo, on the road to Rome, the Pieve di S. Maria has a tympanum with a Baptism of Christ, this in a region where carved tympanums are unknown. In fact, such picturesque decoration of portals was never taken up in Tuscany where the sober traditions of antiquity still prevailed. We have only to recall San Miniato at Florence, Empoli, and the churches of Pisa and Pistoia, where there is simply an arch above the lintel. The churches of Lucca have the same purely geometric portals, but Lucca was a principal stopping place for pilgrims on the Monte Bardone route, and consequently, the historiated tympanum appeared there in the thirteenth century. At the cathedral, one tympanum is devoted to the martyrdom of S. Regolo, and another to a moving Descent from the Cross, probably the work of Nicola Pisano.

In the south of Italy, it was in the vicinity of the sanctuaries of Monte S. Angelo and S. Nicola of Bari, both greatly frequented by the French, that churches with tympanums reappeared. The church of Monte S. Angelo, on the summit of the sacred mountain, near the grotto of the archangel, has a tympanum. Another tympanum is to be seen at the base of the mountain, on the portal of a church of Siponto dedicated to a French saint, St. Leonard. This one is decorated with a Christ seated in an aureole supported by angels, entirely like the French Christ in Majesty. Along the pilgrim route to the south, or near it, the churches of Barletta, Bitonto, and Terlizzi all have historiated tympanums. They were carved by Italian artists, it is true, but the idea came from France. This is not at all surprising, for in the churches of these regions, French architectural style frequently mingles with the Italian.

As we make our way back to northern Italy along the road leading to Venice, we again find the sculpted tympanums: there is one at S. Zeno of Verona and another at S. Giustina of Padua.[82]

There is another great pilgrim route that we have not yet discussed: the road along the sea from Ventimiglia to Genoa and over the Apennines to Tortona and the Via Emilia. Pilgrims from the south of France followed this road—and the portal of the cathedral of Genoa turns out to be almost entirely French: the Martyrdom of St. Lawrence is represented below a Christ in Majesty like ours.

We have reviewed above most of the Italian tympanums. Except along the great pilgrimage roads, there are very few, and a number even of these are on churches where French influence is obvious. The abbey of S. Clemente a Cesauria, in the Abruzzi, has a carved tympanum above its portal, but this portal opens at the far end of a porch copied after those of Burgundy. The abbey church of S. Fede at Cavagnolo di Brusasco, near Turin, also has a carved tympanum, but S. Fede at Cavagnolo was a dependency of our abbey of Conques in Rouergue. There is another carved tympanum at the abbey of Vezzolano in Monferrato, but here the decoration of the church is completely French, and on the rood screen there is an imitation of the Coronation of the Virgin at Senlis (fig. 208).

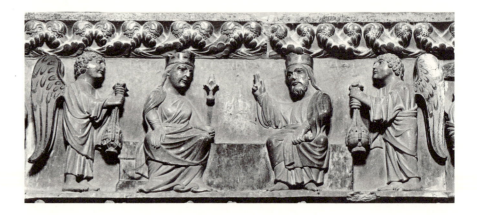

208. Coronation of the Virgin. Detail of choir screen. Vezzolano di Albugnano, Badia.

The Italian tympanums we have cited were carved fairly late in the twelfth century, or even in the thirteenth, and are thus later than ours. Carved tympanums became known in Italy through the wandering sculptors who followed the pilgrim routes and stopped in the towns where churches were being built. These sculptors were not French; they were Lombards returning from France, for the masons and stonecutters of northern Italy were always great travelers. Many of them had been trained in the workyards of our churches, and it was usually they who made known to their own country the creations of France. Their work has an unmistakable Italian accent.

Today, we still find along the pilgrim routes not only historiated tympanums but some other novelties brought from France. Even before 1135, French sculptors of the southwest had conceived the idea of animating the portal archivolts with superposed figurines, and Suger's sculptors followed their example. At St.-Denis, the half-circles of the great portal were peopled with angels and demons—a kind of sketch for the concentric circles of Dante's vision of Paradise and Hell. A few years later, on the old portal of Chartres, the figures of the Liberal Arts and the Labors of the Months appeared on the archivolts. Thus, on French portals, every stone comes to life.

The Italian portal, only moderate in size and shallow in depth, lent itself poorly to these innovations. Unlike our portals, it could not offer an entire heaven to fill. Nevertheless, the innovation seemed so beautiful to the Lombard masters that they tried to imitate it. Sometimes they suspended a row of figurines from the archivolts of their portals. At the cathedral of Parma, as at Chartres, the Labors of the Months decorate the main portal. It is a picturesque garland, but in its isolation seems somewhat meager. At Borgo S. Donnino, a band of figurines is also attached to the archivolt of the porch.

The French fashion reached as far as southern Italy. Archivolts decorated with statues are to be found on the cathedral of Ruvo near Bari, and at Cerrate, near Lecce, on the road to Otranto.

But for the most part, Italian artists were content merely to suggest the idea of the figurines of our archivolts. They carved in very low relief, arranging the prophets and apostles in a half-circle around the wide archivolt, as at Parma, or a file of knights, as at Modena and Bari. But the most beautiful imitation of French portals is on the great arches of the façade of S. Marco, at Venice. A series of charming reliefs represents the Labors of the Months; the figures, in somewhat more pronounced relief, resemble even more the figures of our archivolts.

In the first part of the twelfth century, French portals were being decorated even further. About 1132 at St.-Denis, tall statues placed against colonnettes were ranged at each side of the doorway.[83] A few years later, they were imitated at Chartres. Never has anything more poetic been imagined in art. The assembly of patriarchs and prophets form a solemn avenue; each one of them is an epoch of history; they succeed each other like the centuries, and from age to age repeat the same word of hope. It is quite likely that Suger had something to do with this beautiful, most thoughtfully conceived, creation.

In Italy, attempts were made to imitate the St.-Denis portal. At the cathedral of Verona, statues engaged in pilasters are lined up at each side of the portal: these are the prophets, unfolding long banderoles of stone (fig. 209). The Verona sculptor, here, is recalling France, but how puny

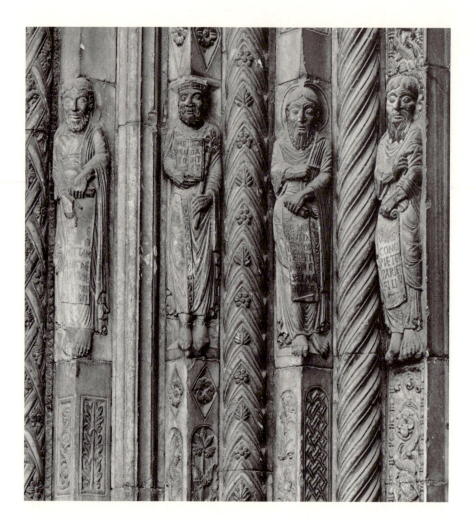

209. Prophets. Verona, Cathedral.
West façade, portal jambs.

his imitation seems. His statues are too small and lack majesty; the portal
was not made for them and they no longer give the sense that they are
the columns of the temple. The cathedral of Verona was begun in 1139;
thus the sculptor could, a few years earlier, have seen the masters of St.-
Denis at work. He probably returned to Italy with one of those long
caravans of pilgrims with which the jongleurs mingled. It was he who
carved Roland and Oliver alongside the prophets. He was summoned
to Ferrara where he again imitated the statues of St.-Denis on the portal
of the cathedral. On the banderoles of the Ferrara prophets are carved
the verses of the Play of the Prophets, a liturgical play performed in the
churches of France. Another inscription gives the name of the artist: he
was called Master Nicola.[84]

Italian churches, then, owe something of their ornamentation to France:
sculptured tympanums, historiated archivolts, statues lining the portals.
These innovations, as we have seen, are dotted along the pilgrim routes.

But to go even further, the very style of our schools of sculpture is sometimes recognizable in the decoration of Italian churches.

This is not the place to study the origins of Lombard sculpture and the singular resemblance of the earliest reliefs of northern Italy to those of southwestern France and of Provence.[85] It will suffice to cite a few examples that establish these influences beyond doubt.

In the second half of the twelfth century, a colony of artists trained in Provence arrived at the cathedral of Modena. They carved reliefs on a kind of rood screen in front of the crypt, called a *pontile* by the Italians. The style of this work is Provençal, but we can be even more precise. One of the Modena reliefs, that of the Last Supper, is identical with a relief in the church at Beaucaire. What is more, a capital in the Modena museum, depicting the holy women buying spices, exactly reproduces reliefs of the same subject at Beaucaire and at St.-Gilles. Certain capitals in the cathedral of Modena, composed of decorative heads with mustaches forming tendrils of vines, are like the capitals of the church of St.-Martin d'Ainay at Lyons and of the old bell tower of Valence. So, at Modena we meet again all the art of the Rhone Valley.

Provençal art reappeared at Parma and at Borgo S. Donnino toward the end of the twelfth century. The sculptures in the baptistery of Parma are signed. They are the work of an Italian sculptor named Benedetto Antelami, who began to work there in 1196. He had been trained in Provence; to Provence he owes his compact, almost metallic figures, which are so different from the fluid creations of Languedoc. The art of Provence sometimes seems to have been cast in bronze; the art of Languedoc undulates like a flame in the wind. Antelami's work bears the indelible imprint of his first masters; the art of the Ile-de-France, which he knew later, did not change his style. He not only borrowed his style from Provençal artists, but also their subjects. On one of the tympanums of the baptistery at Parma, he copied the Adoration of the Magi from the tympanum at St.-Gilles. The imitation is literal: the disposition of the figures is the same, the gestures are the same. In an interior relief, he imitated with almost equal exactitude the Christ seated among the four beasts of the St.-Trophime portal at Arles; his Christ, like the Christ at Arles, wears a crown. The ornamentation of the baptistery of Parma is copied from Provençal churches. There is an example of the beautiful capital that is found throughout Provence—at Arles, Aix, Avignon, and even Le Puy: it is composed of a curled branch which forms a graceful volute. The baptismal font at Parma, with its magnificent foliated scrolls, reproduces the even more beautiful font in the museum of Carcassonne.

At Borgo S. Donnino, the imitation of Provençal models is just as evident. In all likelihood, the sculptures of the façade are again the work of Benedetto Antelami. A frieze of reliefs decorates the wall between the

columns, and below, statues stand in niches. We are reminded of the façade of St.-Gilles; the composition is familiar, again with the beautiful columns brought forward as if they were an element of decoration, and the long frieze above the statues: an idea that is completely Provençal, since it appears again at St. Trophime in Arles. However, the façade of St.-Gilles is far more beautiful than that of Borgo S. Donnino. It has that delicate fragrance of classical antiquity that we breathe throughout Provence. In lovely Provence with its legacy from Greece and Rome, temples of tawny stone and arches of triumph still inspired artists and lent a festive air to their churches. The cathedral of Borgo S. Donnino has a trace of this beauty. Some of its reliefs are framed, as at St.-Gilles, with a Greek key or an egg and dart border. Antelami took these classical decorative patterns not from the Roman monuments of southern Italy, but from Provençal churches.

Trained in Provence, Antelami lived later in northern France. He admired the old portal of Chartres and imitated one detail that he chose with unerring taste. Almost nothing at Chartres is more beautiful than the figures of the elders of the Apocalypse lining the archivolts around the Christ in Majesty. One of these figurines has been enlarged into a statue of David and placed in a niche on the façade of Borgo S. Donnino (fig. 210). In the copy, we recognize the long strands of the beard and the small

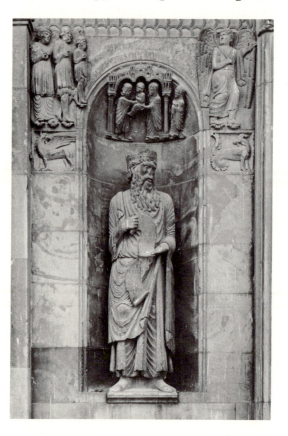

210. King David. Borgo San Donnino (Fidenza), Cathedral. West façade, niche statue.

curls of the hair showing from beneath the crown. Only the head has been imitated; the body is draped in a different fashion, but it has the bronzelike finish of the works of the Provençal school.

In his old age, Benedetto Antelami must have traveled again in France, for in the baptistery of Parma we recognize not an imitation of the west portal of Chartres, but of its north and south portals which were finished toward 1225. There can be no doubt that the Last Judgment scene of the Parma baptistery was inspired by the Last Judgment at Chartres. Christ displays his wounds, the angels support the cross in heaven, the apostle St. John is seated beside the judge. But the figures at Chartres with their poetic youthful quality seem, at Parma, to have been struck with premature old age. Farther on, the Queen of Sheba standing beside Solomon is an exact but graceless reproduction of the elegant Queen of Sheba of the north portal at Chartres. Unlike her model, she does not toy with the ends of her belt or with aristocratic grace hold back the free end of her mantle. Even the figures of angels in the niches, with their close-pleated tunics, recall the manner of the Chartres sculptors. A Tree of Jesse carved on one of the portals is further clear evidence of the influence of French thought on Italian art.

Benedetto Antelami (if it is true that he worked alone) worked for at least twenty-five years on the baptistery of Parma. In his work he blended the art of the Midi and the art of northern France.

The cathedrals of Borgo S. Donnino, Parma, Modena—all the churches where the influence of French art and poetry are so evident—stand along the pilgrimage roads from France.

What a splendid history these great roads of humanity have had! Rome used them to conquer the world; France, in turn, used them to spread her genius abroad, and as early as the twelfth century, through her pilgrims, her knights, her poets, and her artists, began her eternal mission.

VIII

Enrichment of the Iconography: The Pilgrimage
Roads in France and Spain

I

Sanctuaries of the Virgin. Chartres. The Virgin of the Chartres tympanum imitated at Paris and Bourges. Clermont-Ferrand. The Virgin of Clermont-Ferrand and its influence in Auvergne. Le Puy.

In France, few sanctuaries were more often visited by pilgrims than those of the Virgin. They were already numerous in the twelfth century. Legends, suffused with the aroma of unspoiled nature, surround their origin: woodcutters discover an image of the Virgin hidden in a forest under the bark of an oak tree; shepherds find her statues beside a fountain, or near a dolmen, or in a thorny bush. The charming names given to the churches of the Virgin sometimes recall these ancient stories. But perhaps not everything in these legends belongs to fable, for oftentimes a peasant must have mistaken a Gallo-Roman figurine for a statue of the Virgin. In fact, certain of these figurines in our collections closely resemble statues of the Virgin and Child. One of these mother-goddesses in the museum of Orléans is almost indistinguishable from a statue of Notre-Dame.[1]

Chartres is the oldest and the most illustrious of our sanctuaries of the Virgin. By the eleventh century, the Virgin of Chartres had already become the Virgin par excellence for the French of the north. She seemed quite distinct from other Virgins. The mother of Guibert de Nogent saw her in a dream, radiant with beauty and great nobility.[2]

Two miracles attracted pilgrims to Chartres: a mysterious grotto beneath the church, and a reliquary containing the priceless treasure of the sacred tunic worn by the Virgin on the day of the Annunciation, at the very moment when the Word had been conceived. In the Middle Ages, there was perhaps no more poetic relic than this. In 1793, the Jacobins opened the reliquary chest, believing it to be empty. To their surprise they found a piece of cloth that appeared to be very ancient. When the learned abbot Barthélemy was consulted, he replied that the cloth was of Eastern origin and might date from the Early Christian era. The sacred tunic had its own history; it had been preserved at Constantinople and was sent to Charlemagne by an Eastern emperor; in 861, Charles the Bald presented

it to the cathedral of Chartres.³ From then on the faithful began flocking to Chartres, and the reliquary was enriched, in the course of centuries, with the precious stones, ancient cameos, and gold ornaments that they attached to it.

The grotto opened below the cathedral. There, by the light of candles, the pilgrims could see a wooden statue of the Virgin, seated and holding the Child on her knees. Profound veneration surrounded this statue of the Virgin. Yet contemporary documents say nothing about it; it was first mentioned in 1389 in the *Vieille chronique* of Chartres. Some old men, says the author, had told him that the statue had been carved before the birth of Christ at the order of a pagan prince in honor of a Virgin who would give birth. In the sixteenth century, the continuator of the chronicle, a humanist who had read Caesar, ascribed the statue to the Druids who used to assemble in that place.

As we see, the famous legend of the Druidic statue of Chartres does not go far back in time.⁴ This celebrated statue was burned in 1793; we know it only through a copy preserved at Bergen-op-Zoom in Holland, and by an old engraving. Both the copy and the engraving show it to be a hybrid work that seems to have been restored in the seventeenth century. The original we glimpse behind the copy cannot be older than the twelfth century; the pose of the majestically seated Virgin and the hieratic attitude of the Child belong to that period. Moreover, such a work could not have appeared in northern France before the twelfth century. The statue of the Virgin of Chartres certainly did not exist in the eleventh century, and for the following reason. About 1013, Bernard, a former pupil of the school of Chartres and a disciple of Fulbert, the schoolman of Angers, went with a companion on a journey through the Midi. He was greatly astonished to see the seated statue of St. Foy at Conques and the statue of St. Gerald at Aurillac, for it seemed to him that the faithful who knelt before these statues were worshiping idols. He said ironically to his companion, "Would such statues not be well suited to Jupiter and Mars?" Nothing could have been more shocking to him than the honor paid to such images in wood or bronze; he thought that only the image of Christ on the cross should be venerated by Christians.⁵ That a former student at Chartres could have written these words means that in the eleventh century there was as yet no statue of the Virgin in the grotto of the church, for had he seen such a statue there, he would not have been so surprised at what he saw at Conques.

Thus, I believe that the Virgin of Chartres cannot be earlier than the twelfth century. It has been said that this wooden statue venerated by pilgrims had also inspired artists, and that the sculptor who carved the Virgin in Majesty of the west portal of Chartres in about 1150 had copied it. This hypothesis is tempting, but it cannot be verified. There is nothing

to prove that the wooden statue was already in existence in the crypt in about 1150; and if it had been there, there is nothing to prove that the work, recent at that time, was already surrounded by so profound a veneration. The stone relief resembles the wooden statue, it is true; the Virgin, seated on her throne, holds the seated Child exactly against the center of her breast. But these similarities can be explained by the imitation of a common model. Here we recognize the Eastern Virgin in Majesty, that image of the Virgin, as imposing as a theological idea, which appeared in art after the Council of Ephesus.

Thus, it is doubtful that the Virgin in the crypt of Chartres was imitated, but it is certain that the Virgin of the Chartres tympanum was. This was the first Virgin to appear on the façade of a church (fig. 211). The pilgrim respectfully contemplated her before entering the cathedral; she seemed to him to be queen there, Our Lady of Chartres herself. It took all the prestige of the sanctuary of Chartres to bring artists to represent the Virgin in a tympanum, the place formerly reserved for her Son. This audacity shocked no one, and moreover it was soon imitated. A few years later, the Virgin of Chartres reappeared on the tympanum of the St. Anne Portal at Notre-Dame of Paris (fig. 212). If we compare these two works

211. Virgin in Majesty. Chartres (Eure-et-Loir), Cathedral of Notre-Dame. West façade, Royal Portal, south tympanum.

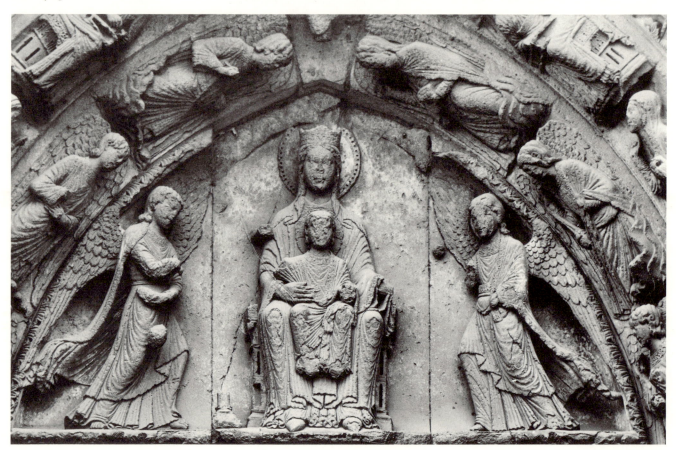

closely, we see that if they are not by the same artist, they are at least from the same workshop, for almost all the details of the original are found again in the copy.[6]

Why did the archbishop of Paris, Maurice de Sully, have the Virgin of Chartres reproduced so faithfully? He was no doubt charmed by her beauty, for there is nothing more magnificent than this majestic Virgin who holds her Son with the sacerdotal gravity of a priest carrying the chalice. But Maurice de Sully had not forgotten that this beautiful Virgin was the Virgin of Chartres, the most illustrious in the kingdom and the one greeted on the threshold of her own church by throngs of pilgrims; he wished to give them the joy of finding her image again at Paris.

At the same time, a similar Virgin was carved for another church, probably a church in the Ile-de-France. This new Virgin of Chartres, once in the Martin Le Roy collection and now in the Louvre, closely resembles the other two, but is less perfect.

In the twelfth century, a similar Virgin appeared on the north portal of Bourges Cathedral; above her head is the ciborium that lends such majesty to the Virgin of Paris (fig. 58). Bourges imitated Paris, but no doubt it had not been forgotten that this majestic Virgin was the same

212. Virgin in Majesty. Paris, Cathedral of Notre-Dame. West façade, St. Anne Portal, south tympanum.

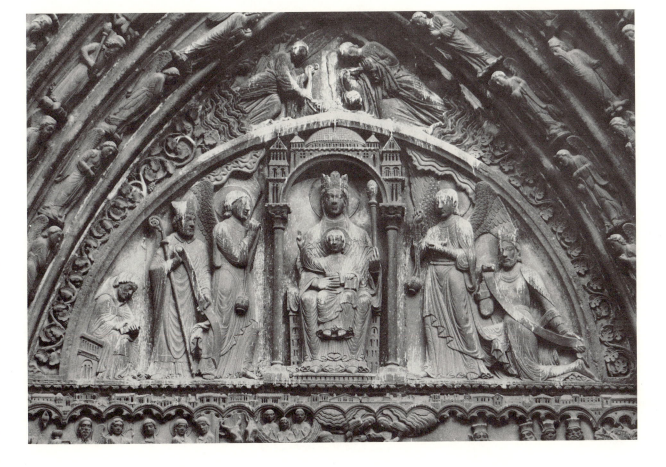

one venerated by the pilgrims to Chartres. Even at Toulouse itself, in the south of France where the sculptors of the north had learned their first lessons, the Virgin of Chartres was imitated in the cloister of La Daurade. The figure once decorated the entrance to the chapter hall; it is now in the Toulouse museum. This work, which is of the end of the twelfth century, is already less hieratic; movement is introduced but the model remains recognizable.[7]

Thus, the pilgrimage to Chartres was not without influence on art; in the twelfth century it propagated a magnificent type of Virgin.

Far from Chartres, at Clermont-Ferrand in central France, we glimpse indistinctly an ancient tradition of devotion to the Virgin. In the twelfth century, the two principal churches of the town, the cathedral and Notre-Dame-du-Port, were dedicated to her. At Notre-Dame-du-Port, the carved capitals surrounding the altar are like the verses of a poem in honor of the Virgin. The cathedral of Clermont-Ferrand, dedicated from the beginning to the martyrs Agricol and Vital, was placed under the protection of St. Mary in the tenth century.[8] From the tenth century onward, a seated statue of the Virgin holding the Child—the earliest such statue mentioned in French art—attracted pilgrims to the cathedral. The Virgin of Clermont-Ferrand also had her legend: it was said that she had brought a pallium woven by her own hands to the old bishop, St. Bonnet.[9]

The ancient statue of the Virgin of Clermont-Ferrand has long since disappeared, and we know it today only through tenth-century documents (fig. 213). An inventory of the treasury, drawn up about 970, calls it the

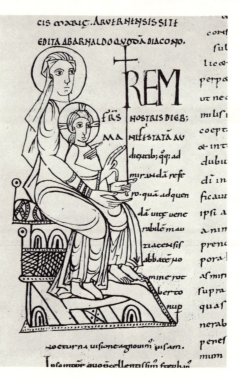

213. The "Golden Majesty" of Clermont-Ferrand. Drawing in tenth-century manuscript. Clermont-Ferrand (Puy-de-Dôme), Bibl. Mun., ms. 145, fol. 130v (detail).

"Majesty of St. Mary," *Majestatem sanctae Mariae.*[10] This was the name given at the time in the Midi to these seated statues, unknown in the north, which were placed on altars for the veneration of pilgrims. The Virgin of Clermont-Ferrand held the Child on her knees and was seated beneath a ciborium decorated with a crystal cabochon. The two figures, Mother and Son, had been transformed into reliquaries to enclose several hairs of the Virgin, shreds of her clothes and of the famous pallium she had woven. Thus, these first statues were kinds of reliquaries and were venerated primarily for the relics they held.

Regrettable as the loss of the Virgin of Clermont-Ferrand is, it is not irreparable, for copies of it exist. The churches of Auvergne and the neighboring regions have preserved a fair number of them, one of which is now in the Louvre. The Auvergnat type of Virgin is a wooden statue (fig. 214); she wears no crown; the veil closely covering her hair invests her with the air of chaste solemnity of Eastern Virgins. She sits on a throne pierced with arcades. Her costume and solemn pose, and the seriousness of the Child seated on her knees awaken the memory of Eastern models.

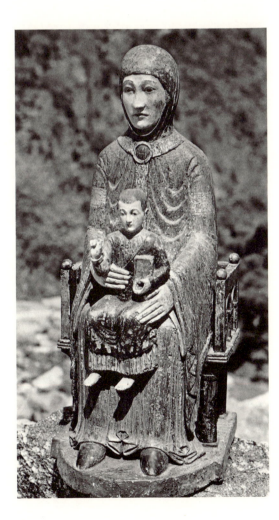

214. Virgin and Child. Wooden statue. Monistrol d'Allier (Haute-Loire), Notre-Dame-d'Estours.

But here the grandeur of the Byzantine Virgin has become somewhat rustic and simple. These Virgins, carved for peasants and placed in remote chapels in the mountains and the forests, resemble grave peasant women: they have all the virtues; they lack only beauty.

All these statues resemble each other, and the similarities are such that they presuppose the imitation of the same original. This original must have been especially venerated to have been copied so faithfully; it could scarcely have been any other than the Virgin of the cathedral of Clermont-Ferrand. This ancient "Majesty of St. Mary" established the type of the Virgin in Auvergne. The copies, moreover, are not so ancient as one might think; none seems to have been carved before the twelfth century, for that is when sculpture was revived in all of France. Monumental art itself took inspiration from the ancient model: at Mozat, near Riom, the Virgin carved on the portal reproduces it (fig. 171), with the difference, however, that she wears a crown.

Venerated as the Virgin of Clermont-Ferrand must have been, her fame did not spread far beyond Auvergne. Even the most distant peasants who venerated her—those of Bourbonnais to the north and Velay to the south—were scarcely more than two or three days' walk from her sanctuary. It is within these geographical limits that her statues are to be found. Pilgrims carried her image only that far; beyond, there are no traces of her.[11]

It is odd that the pilgrimage to Clermont-Ferrand provided art with a model, and that to Le Puy inspired almost nothing. Yet the Virgin of Clermont-Ferrand had only local fame, while the Virgin of Le Puy was known throughout France. She was almost as celebrated as the Virgin of Chartres. During the week of the Assumption, pilgrims flocked to her sanctuary. Even the rugged mountains of Velay and the difficult and unsure roads did not stop them. Among the crowds were famous troubadours and illustrious knights of the Midi. The poets sang the praises of the Virgin, the knights engaged in tourneys, and the king of the occasion carried a falcon on his wrist. *Porter le faucon au Puy* (Carry the falcon to Le Puy) was a famous proverb in the Midi.

The old cathedral is still there—an ancient witness of these forgotten festivals. Dominated by a formidable mass of rock, but itself dominating the town at the summit of its immense stairway, it is one of the most imposing monuments of the Christian world. More than any other, it acts upon the imagination through its mystery, the strangeness of its partly Arabic decoration, its Eastern domes.[12] It seems to have been brought to these mountains from a faraway land. The charm of strangeness we feel was felt also by the men of the past. They dared not imitate it, except for one timid attempt at Champagne in Ardèche. The cathedral of Le Puy has remained unique and is all the more beautiful for it.

Had there been an image of the Virgin on the altar before the twelfth

century? Probably. We know that in 1096, Raymond de St.-Gilles provided an endowment so that a lamp might burn continually before the image of the Virgin in the cathedral of Le Puy. And we also know that as early as Charlemagne's reign, the Marian sanctuary of Notre-Dame of Le Puy was famous in all of Christendom, was designated as one of the three centers for the collection of Peter's pence, and celebrated its first jubilee in 992. A chapter seal from 1206 represents this Virgin.

The statue was of cedar. Its dark color, the absence of any emblem—scepter, globe, or flower—in the hands of the Mother and Child, the absence of the veil covering the Virgin's head and the strange letters carved on her sleeve, might be proof of its Eastern or even its pagan origin. We might imagine it to be a statue of Isis brought from Egypt by legionaries, which was later transformed into a Christian Mother of God, as were many mother-goddesses at the end of the pagan era. These strange characteristics caused the old chroniclers to think that St. Louis had received the statue in the Sudan and had given it to the cathedral on his return from Egypt. Ancient historians, imaginative men, claimed that it went back to Jeremiah.[13]

Such a statue could scarcely have inspired so refined an art as that of St. Louis' time. However, it is not impossible that certain of our Black Virgins were copied from it. This must be the origin of the Black Virgins of Moulins, Beaune, and many others.[14] The Virgin of Le Puy was too famous not to have been copied, but these images of pure devotion scarcely belong to the history of art.

II

There were many other famous churches in France to which pilgrims thronged to venerate saints' relics: St.-Martin of Tours, St.-Hilaire of Poitiers, St.-Eutrope of Saintes, St.-Léonard, Ste.-Foy of Conques, St.-Pierre of Moissac, St.-Gilles, St.-Sernin of Toulouse. The curious thing is that these were not isolated sanctuaries but were united by main roads. Pilgrims went from one to the other. But they went even farther. In Gascony, these highroads came together to cross the Pyrenees. Once the mountains were crossed, they became one road at Puente la Reina—the road to Santiago de Compostela. Thus, in France, all the pilgrimage roads were directed toward Galicia, and like the Milky Way, pointed toward Compostela.

If we open the *Guide du pèlerin de Saint-Jacques* written in the twelfth century,[15] we shall see that our most famous sanctuaries were spotted along four routes.

The first route began in Provence. Arles was the pilgrim's first stop. There, near the Rhone, he venerated a tall marble column that the martyr

The pilgrimage roads to Santiago de Compostela. The sanctuaries visited by pilgrims. Origins of the legend of St. James. The pilgrimage organized by Cluny.

St. Genès had stained with his blood. Then he visited the seven churches of the Alyscamps, built among ancient tombs; whoever had a Mass said at one of these churches would have all the just buried in the cemetery for defenders on Judgment Day. After Arles came St.-Gilles, where one of the most illustrious thaumaturgists of the Christian world was buried. The relics of St. Gilles, the hermit who had come from Athens to Gaul, were contained in a magnificent golden sarcophagus. "It is here that the beautiful star of Greece set," the *Guide* says; and on the reliquary shone the twelve signs of the zodiac. Going on from St.-Gilles by way of Montpellier, the pilgrim came to the famous abbey of St.-Guilhem-le-Désert where Guillaume, Charlemagne's standard bearer, went to end his days in penance; and on to Toulouse, where he visited the beautiful basilica erected over the tomb of the martyred apostle, St. Sernin. From Toulouse, the road went by Auch and Lescar, crossing the Pyrenees at Le Somport and descending into Spain by way of Jaca and Puente la Reina.[16]

The second road was used by pilgrims from Burgundy and eastern France. It was a dangerous route through the Cévennes; the bell of the monastery of Aubrac guided the pilgrims lost in the night. It passed by Notre-Dame of Le Puy and by Ste.-Foy of Conques, which the powers of St. Foy made a place of miracles; before proceeding, the pilgrim stopped to drink from the spring that flowed before the entrance of the church. The road finally reached the plain at St.-Pierre of Moissac. From Moissac it went toward Lectoure and Condom, passing through the old towns of Eauze and Aire, both rich in memories, and coming finally to Ostabat, at the foot of the mountains.

The third route, also used by pilgrims from the east, is only broadly indicated. It begins at the beautiful church of the Madeleine at Vézelay, where Mary Magdalene, once a sinner herself, obtained pardon for sinners. Much farther along, toward the west, it reaches St.-Léonard in Limousin. St. Leonard was the supreme hope of prisoners in the blackness of their dungeons. He had delivered so many that his church was festooned with chains, manacles, and shackles, hung both inside and out, like garlands. The church of St.-Front of Périgueux was on this route. No French saint had so beautiful a tomb as St. Front; it was circular, like the tomb of Christ. The road crossed the Garonne at La Réole, passing by Bazas, Mont-de-Marsan, St.-Sever, and Orthez, and joined the road from Moissac at Ostabat.

The fourth route began at Orléans. There, in the cathedral of Sainte-Croix, the pilgrim could see the miraculous chalice of St. Euverte, the chalice that the hand of Christ, appearing above the altar, had once consecrated. Following the Loire, the traveler came to the sanctuary of St.-Martin of Tours, the most ancient and most famous place of pilgrimage in all of France. There were venerated churches along this road that trav-

ersed Poitou and Saintonge: St.-Hilaire of Poitiers with its tomb of the great Doctor; St.-Jean-d'Angély where the head of St. John the Baptist was preserved and where a choir of a hundred monks sang day and night the praises of the Precursor; St.-Eutrope of Saintes, a great basilica filled with the sick; St.-Romain of Blaye, where the paladin Roland, "martyr of Christ," was buried; St.-Seurin of Bordeaux, where the horn of the hero could be seen, the horn that had burst at Roland's powerful blast.

After Bordeaux came the great desert of Les Landes, a wild country where the traveler who strayed a step from the path sank to his knees in sand. The pilgrims stopped to rest at Belin, where a great tomb contained the bodies of the holy martyrs Oliver, Gondebaud, Ogier the Dane, Arastain de Bretagne, Garin le Lorrain, and many others of Charlemagne's soldiers who had been killed in Spain for the faith of Christ. Next came Labouheyre, Dax, Sorde, and finally the Pyrenees at Ostabat, not far from the pass at Cize. It was there that the three routes to Santiago came together. On the mountains stood an ancient cross, erected by Charlemagne, it was said; the great emperor had prayed with his face turned toward Santiago de Compostela. The pilgrims did the same, and each of them planted a small wooden cross near the stone one. The Cize pass led to Roncevaux, through which all the pilgrims passed who did not cross the Pyrenees at Le Somport. In the church of Roncevaux they admired the stone that Roland had split with his sword. After crossing the famous battlefield, they descended into Navarre. This was the most dangerous part of the journey. They met mountaineers with bare legs, fierce men who wore short, black, fringed coats and sandals made of hairy hides; they carried two spears in their hands, and a horn hung from their belts. Sometimes these wild men made cries imitating the howling of wolves or the screeching of owls, and instantly their companions were at their sides. These were the Basques, the least hospitable of people and the most feared by the travelers. They spoke an incomprehensible language: they called wine *ardum*, bread *orgui*, water *uric*. The *Guide* sets down several words of their language.

The two routes over the mountains, by Le Somport and the Cize pass, came together at Puente la Reina, and from there, only one road continued to Santiago de Compostela, by Estella, Burgos, Frómista, Carrión de los Condes, Sahagún, León, and Astorga. It was at Monte San Marcos that the pilgrims first glimpsed the bell towers of the basilica of Santiago rising in the distance. The one who saw them first was proclaimed *roi*, king of the pilgrims, and this epithet was handed down from father to son, as if it were a title of nobility. At last, after months of travel, the pilgrim arrived to kneel at the tomb of the apostle.

By what miracle could St. James the Greater, the apostle to Palestine, who was beheaded in Jerusalem according to all the ancient ecclesiastical

writers, have come to be buried at the far end of Galicia? This singular tradition, as Monsignor Duchesne has shown, is not very old.[17] A seventh-century apocryphal document of Eastern origin maintained for the first time that St. James the Greater had evangelized Spain. But none of the early Spanish writers—Paulus Orosius, Idaeus, St. Martin of Braga, all of whom were so well informed about the ancient religious history of their country—knew about it.

Two centuries passed, and the legend seemed destined to remain dormant, but in 830 the rumor spread that the bishop of Iria, Theodomir, had discovered the tomb of St. James in Galicia. Thirty years later, in 860, the Martyrology of Ado, compiled in France, states as an established fact that the apostle James was buried at the western end of Spain, not far from the sea. "His sacred bones," adds the author, "were brought there from Jerusalem."

Thus, it was only in the mid-ninth century that Christian Europe began to hear about the famous tomb of Compostela. During the following centuries these somewhat sparse stories were embellished. An explanation was given for St. James' body being brought from Jerusalem to Galicia. Seven of his disciples who had helped him to evangelize Spain wished his relics to rest in the country he had sanctified by his apostolate.

In the tenth century, the tomb of St. James began to attract foreigners. The first French pilgrim of whom there is mention was Gotescalc, bishop of Le Puy, who made the journey in 951. In the eleventh century, pilgrims to Santiago were already numerous; but by the beginning of the twelfth century, their long processions interfered with travel on the pilgrimage roads.[18] It was at this time that the *Liber Sancti Jacobi* was written for their use.[19] The famous book tells of the translation of the apostle's relics from Jerusalem to Galicia, the discovery of his tomb, and the many miracles he performed for his followers. Furthermore, the *Chronique de Turpin* is one chapter of the book, and it tells that Charlemagne and his knights, conquerors of the infidels, were the first pilgrims to Santiago. The book ends with the guide for travelers, which we described above.[20]

The *Liber Sancti Jacobi* was written in France. Bédier has shown that in all probability it was the work of Cluniac monks.[21] To the arguments he gives, another can be added that seems to me conclusive proof. Along the four great roads of France over which the pilgrims to Santiago traveled toward the Pyrenees, there were Cluniac monasteries at all the principal stopping places: St.-Gilles, St.-Pierre of Moissac, the Madeleine of Vézelay, St.-Jean-d'Angély, St.-Eutrope at Saintes. The travelers could very well have taken other roads; it was the deliberate intention of the author of the *Guide* to direct them toward the great abbeys affiliated with Cluny. Also, in Spain, priories of the Order of Cluny were dotted along the route to Compostela: San Juan de la Peña near the Somport pass,

Santa Colomba at Burgos, San Zoiló at Carrión, and Sahagún. These had not been put there by chance. We begin to perceive that as early as the eleventh century the great abbots of Cluny had organized the pilgrimage to Santiago.[22] In it they saw the most effective way of aiding the Spanish Christians in their endless crusade against the Moors, for it was no trouble for the pilgrim to turn soldier. French knights who had crossed the Pyrenees to pray at the tomb of the apostle stayed on to fight alongside the Cid. These French barons came from all parts of France, but more from Burgundy than from any other province. That is because they were enlisted by Cluny.[23]

The crusade had always been one of Cluny's great preoccupations. This became apparent when Urban II, a former Cluniac monk, called all of France to the holy war; on that day, the century-old dream of Cluny was realized. But the abbots of Cluny had not waited for the Council of Clermont to preach the crusade; very early they had been aroused by the great struggle that the Christians of Spain had been waging for centuries against the infidel. Cluny gave them all the help in its power; it enlisted our hardiest barons in their service; it even enlisted our ancient heroes by transforming Charlemagne and his worthies into examples for contemporary knights. To further the holy war, Cluny even adopted the *chansons de geste* sung by the jongleurs. The *Chanson de Roland* was born of the pilgrimage to Santiago and the war in Spain.

III

It is a great pleasure for the modern traveler in France to follow these poetic pilgrim routes to Compostela. Ancient place names point the way. He finds a Cross of St. James, a Way of St. James, a Gate of St. James, a Chapel of St. James; or he comes upon a hospice, usually dedicated to St. James but sometimes to St. Christopher or St. Julian, patron saints of travelers. Unhappily, almost all the decor of the old roads has disappeared. The inn where a sign with "the image of the great St. James" swung in the wind is no longer to be seen; nor is the little oratory dedicated to St. James by the roadside. There is no longer the cross where the traveler stopped to pray and to watch a moment, anxiously, the clouds forming in the western sky. Yet remains of the past do exist here and there. Near Notre-Dame of Le Puy, there is still a pilgrims' hospice: the two Romanesque capitals on the portal invite the traveler to enter; on one, a pilgrim receives bread from the hands of Charity, *Karitas*; on the other, he is put to bed and cared for solicitously (fig. 215). At Pons, the road to Santiago passes beneath a beautiful twelfth-century vault, a kind of arch of triumph leading to the hospice; the horseshoes engraved on the stones are the ex-votos of travelers.

Art and the roads to Santiago. A new iconography of the apostle St. James created by the pilgrimage.

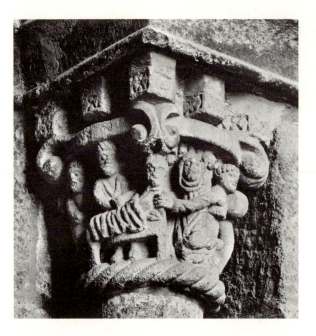

215. Pilgrim tended at hospital.
Le Puy (Haute-Loire), Hôtel-Dieu.
Portal capital.

But it is Spain that has preserved the most beautiful hospice for pilgrims along the road to Santiago. The Hospitál del Rey, founded in the twelfth century to welcome travelers at the entrance to Burgos, was rebuilt in the sixteenth century, and decorated with all the grace of the Renaissance.

Countless monuments have disappeared, but enough remain to confirm that medieval art, also, traveled the roads to Compostela. It was by these roads that some of the creations of artists were disseminated.

First of all, we find a new type of St. James. Arriving before the south portal of St.-Sernin at Toulouse, we observe in the upper part a large relief representing St. James (fig. 42). He carries the book of the Gospels and stands between two limbless tree trunks. The apostle's name is inscribed around his nimbus. We recall at once that St.-Sernin was one of the stops on the route to Compostela, and it occurs to us that this St. James of Toulouse was a preview for the pilgrim of the distant St. James of Galicia. Such an hypothesis becomes a certainty when we examine the Platerías Portal, the Portal of the Goldsmiths, of Santiago de Compostela. There, in the upper part among many other reliefs applied to the wall, we see a figure of St. James like the one at Toulouse: the apostle carries the book and stands between two limbless tree trunks, called cypresses by the twelfth-century *Guide* (fig. 216). The similarities extend even to details: at Compostela as at Toulouse, St. James' name is carved on his nimbus. Even a first glance at the Platerías Portal awakens memories of the monuments of southern France; a closer examination shows that it could have been decorated only by sculptors from Toulouse.[24]

We have here the first image of St. James created by the pilgrimage in

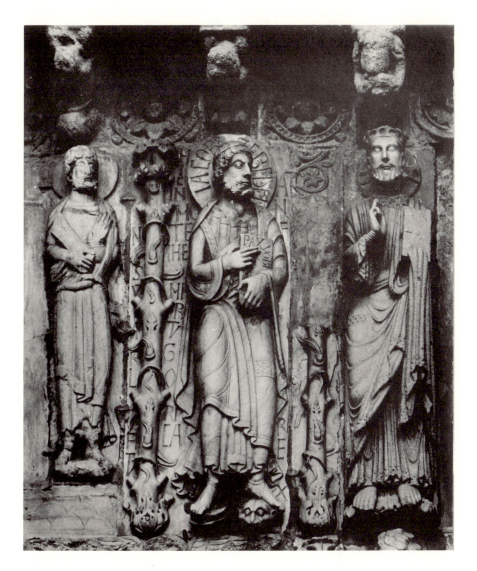

216. St. James flanked by tree trunks. Santiago de Compostela (La Coruña), Cathedral. South transept, Platerías Portal (detail).

the early twelfth century. It is not yet well defined, but the two mysterious cypress trees give it a specific character.

However, the pilgrims were soon to give shape to their saint. When they had prayed at the tomb of the apostle, they left the basilica by the north door, called the Francigena Portal, and came out onto a vast square. There, near the fountain that was said to be the most beautiful in the Christian world, merchants spread out their belts, scrips, kegs of wine, and medicinal plants.[25] But what the travelers bought most eagerly were the beautiful shells as regularly wrought as works of art that were collected on the beaches of Galicia. From the twelfth century onward, they were the distinctive badge of the pilgrim to Santiago. For his return, he proudly fastened them to his scrip, and this holy emblem made him inviolable. Who would dare to lay a hand on a Santiago pilgrim? Terrifying tales were told of the punishments meted out by the apostle to the guilty.

In the early thirteenth century, the cockleshell fastened to a scrip had become the blazon of the pilgrimage to Santiago. It was then that St. James himself was provided with it, and it is significant to note that it is on one of the roads to Compostela that we first meet him with this attribute. Travelers coming from northern France and arriving at Blaye often embarked for Bordeaux; but sometimes, instead of going back up the Gironde, they went down it to Soulac. They were drawn there by the legendary tomb of St. Veronica. From Soulac, the route turned right toward the south, parallel with the ocean; it skirted the wild marshes of Les Landes, then it penetrated solitudes where only the cries of sea birds could be heard. At intervals there were villages which served as shelters among the sands: Biscarosse, Mimizan, Bias, and St.-Julien; this was the way to Bayonne. The old church of Notre-Dame of Mimizan has almost completely disappeared, but the remains of its two portals have been brought together beneath a bell tower: near a Christ in Majesty, a row of apostles. Crude as it is, the work has certain characteristics of thirteenth-century art. However, there are surprising archaic features: one of the apostles has crossed legs, like the apostles of the old school of Toulouse. From this we conclude that the Mimizan apostles date from the early thirteenth century.[26] If this is so, we have at Mimizan one of the earliest statues of St. James the Greater represented with scrip and cockleshell. It is interesting to come upon this St. James along the pilgrim route, and to see that he has been given the same emblem as the pilgrims themselves. From this time onward, the cockleshell was never omitted from the apostle's scrip and tunic; it became his customary attribute.

But this is not all. The St. James of Mimizan carries a staff in his hand, and this detail again identifies him with the pilgrims who passed along the road. It was at Compostela that the apostle was first represented with a staff in his hand. He is shown with the staff on the trumeau of the Glory Portal, a magnificent work finished in 1183 by Maestre Mateo (fig. 217). The staff seems to be both a missionary's staff and a bishop's staff. The cathedral of Compostela still preserves the staff of St. James, enclosed in a metal case; in the past, pilgrims touched its point. Legend made it even more venerable: a window at Chartres, now destroyed, represented Christ himself bestowing the staff upon St. James. It is not surprising, therefore, to see the famous staff appearing very early in the hand of the apostle. But curiously enough, it is again along the pilgrim routes that we encounter it. He does not carry it on the south portal of Chartres, nor on the north portal of Reims, nor on the great portal of Amiens, but he already has it at Mimizan. And he carries it at Burgos, on the Portal of the Sacrament, a beautiful work of the early thirteenth century: here St. James, enveloped in a voluminous mantle and resting his two hands on his tall staff, resembles a pilgrim who pauses for a moment before continuing his

journey. At Bayonne, the end of the route through Les Landes, we again find St. James with a staff in hand. We also find him at St.-Seurin of Bordeaux, a famous stopping place for the pilgrims from the north,[27] and again at La Sauve-Majeure. For a long time, the monastery of La Sauve-Majeure in Guyenne was the starting point for the pilgrims from this region; there they received absolution for their sins and had their pilgrim staffs blessed before they set off for Compostela. By cross-country roads they joined the route from Bordeaux to Mont-de-Marsan, or if they preferred, they joined the route from Mimizan to Bayonne.[28] The principal church of La Sauve-Majeure is now partly destroyed, but the small church of St.-Pierre still exists. Its chevet is decorated with several thirteenth-century statues, among which there is a St. James with a staff in his hand and, slung over his shoulder, a scrip decorated with cockleshells.[29]

Thus, the pilgrim staff of Compostela little by little became one of the attributes of St. James. Certain images that the pilgrim saw in the basilica

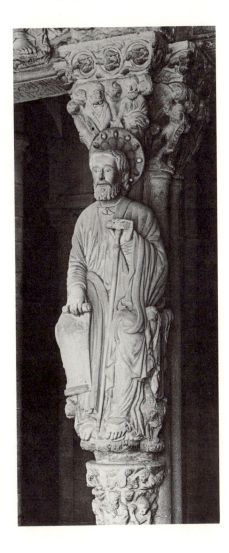

217. St. James seated. Santiago de Compostela (La Coruña), Cathedral. West porch (Glory Portal), central portal trumeau.

also had an influence on art as time went on. At Compostela, the ancient representations of St. James are strangely solemn: he is seated like a sovereign on the trumeau of the Glory Portal. He was also seated on the ciborium that in the twelfth century rose over his tomb.[30] Today, the statue of the apostle placed on the main altar for the veneration of pilgrims is a seated figure. This statue, painted and covered with a silver cloak, is very difficult to date; certain Spanish scholars think it is from the time of St. Ferdinand; that is, the thirteenth century.[31] If it is more recent, there is no doubt that it is a copy of an earlier model, for its hieratic attitude reflects the twelfth century.

Now, at the beginning of the fourteenth century, there was to be seen in Paris, on the altar of St.-Jacques-des-Pèlerins, a seated statue of the apostle. It was the work of Guillaume de Heudicourt who, strangely enough, had carved the statue on a boat in the Seine. From the boat, the statue was carried in procession to the church.[32] In this, we detect the desire to reproduce symbolically the arrival of St. James' body in Spain and the transfer of his relics to the shore at Compostela. Thus, it was not one of the twelve apostles but the great saint of Spain who was carved by Guillaume de Heudicourt; and the saint was represented as seated on the altar, just as the pilgrims saw him in the basilica of Compostela. Unfortunately, this interesting work has disappeared, but in the museum of Beauvais there is another statue of St. James from the same period which can give us an idea of it. The St. James of Beauvais is seated, like the St. James of Paris, and no doubt was once placed on an altar. It had obviously been inspired by the statue of Compostela, but the hieratic solemnity of the original was here transformed into nobility.

Images of the seated St. James are to be found up to the sixteenth century, perpetuating the memory of a venerated statue.[33]

It is again at Compostela that we see appearing, as early as the twelfth century, an episode in the legend of St. James that was to have a long history. The tympanum of one of the basilica's doors shows the apostle on horseback, holding a sword in one hand and a banner in the other. Indeed, the story was that in 834, during the battle of Clavijo, Don Ramiro saw St. James in the thick of the battle, mounted on a white horse. He saw him, sword in hand and brandishing his banner, put the infidels to rout. Such an apparition was repeated in other encounters, so that the apostle, transformed into a knight, became the champion of Spain and was henceforth called the *Matamoro*, the slayer of Moors.

It seemed natural to represent St. James as a soldier in a church where pilgrims often became crusaders. Nevertheless, for a long time the legend was confined to Spain: it would be interesting to follow its history there. France preferred another: St. James appearing to Charlemagne and pointing out to the great emperor the way to Galicia. It was only at the end of

the Middle Ages that our windows show St. James charging the infidels in the battle of Clavijo.[34] The ancient sanctuary, by then already less frequented, was still having an effect on art.

IV

Thus, the iconography of St. James was gradually enriched. But the pilgrimage to Compostela had another kind of influence on art that must be briefly indicated here. It led to the spread of a remarkable type of church.

There are several great basilicas along the pilgrimage roads; they all resemble each other. Take, for example, St.-Sernin of Toulouse on the route through Languedoc, one of the most magnificent Romanesque churches in France. A long history is contained in the beautiful church of St.-Sernin: the choir is older than the first crusade, older than the *Chanson de Roland*. When the columns of the sanctuary were erected, the Cid was still alive.[35]

What is original about St.-Sernin? First of all, the choir surrounded by a splendid ambulatory from which chapels radiate; then the transept which, like a nave, is wide enough to allow side aisles surmounted by tribunes; and lastly, the nave itself with double side aisles, illuminated by diffused light from vast tribunes. This light and shadow make the barrel vault, which has no windows, seem lighter. On the exterior, the crescendo of radiating chapels, choir, and tall square bell tower rising from the transept crossing gives the chevet admirable thrust.

Let us now follow the route from Le Puy to Moissac. At Ste.-Foy of Conques we find St.-Sernin again. Instead of being built of the rose-colored brick of the Toulouse basilica—an enchanting color under the luminous skies of that region—the church at Conques is built of stone. This daughter of a harsh countryside seems cruder, but we must not be put off by appearances, for at Conques we find again all the features contributing to the originality of St.-Sernin: the ambulatory with radiating chapels, the wide transept with its side aisles, the nave with its tribunes.[36] It has the same plan, the same elevation, the same exterior silhouette.

Beyond Conques, the route led the pilgrim to Figeac, where he would be welcomed at the Cluniac monastery of St.-Sauveur. Before alterations changed its character, the church of St.-Sauveur resembled the church of Conques.[37]

Or let us take the route from Vézelay to St.-Léonard and Périgueux. Limoges was one of the stops along this route, and in the museum of Limoges we may still see the tomb of the married couple who died in Limoges on their way to Compostela. Pilgrims never failed to stop and pray at the tomb of St. Martial, the apostle to Aquitaine. The church of

The great churches along the road to Santiago. They derive from St.-Martin of Tours. Romanesque sculpture along the roads to Santiago. Gothic sculpture makes its way into southern France and Spain along the pilgrimage roads to Santiago.

St.-Martial at Limoges, destroyed during the Revolution, is known to us only through old plans and drawings.[38] They are complete enough to show us that, feature by feature, St.-Martial resembled Ste.-Foy of Conques and St.-Sernin of Toulouse.[39]

Now let us go to the very end of the road. What is the famous basilica of Santiago de Compostela itself? A church built on almost exactly the same plan as St.-Sernin of Toulouse. The elevation is the same, the very dimensions of the two churches are almost identical; if, like St.-Sernin, Santiago had double side aisles, the two plans could be superimposed.[40]

All of these basilicas were begun in the eleventh century, only a few years apart. The church of Ste.-Foy of Conques was begun under the abbot Odolric about 1050; St.-Martial of Limoges under the abbot Adémar about 1053; Santiago de Compostela between 1075 and 1078; St.-Sernin of Toulouse about the same time, for in 1096 Pope Urban II consecrated the choir.

Where did this type of church come from—the most imposing conceived by the Romanesque era? Where is the mother church? In the *Guide du pèlerin* of the twelfth century, a sentence sheds some light on the problem. There we read: "Over the tomb of St. Martin of Tours, rises a vast basilica, built with admirable art: *it resembles the church of St. James.*" Thus, the author of the *Guide* had noticed that St.-Martin of Tours resembled Santiago de Compostela. His observation may be trusted, for many passages of his book show that he knew how to observe. He seems to imply that Santiago was the model and St.-Martin the copy; but in this he was wrong, for just the contrary is true.

When St.-Martin of Tours was destroyed during the French Revolution, one of those monument-types which explain a whole architecture disappeared. From the fifth century on, the basilica of St.-Martin had been the religious center of Gaul; so it remained for France during the entire Middle Ages. The sanctuary of Tours was for our ancestors what Delphi was for the Greeks; St. Martin was asked not only for cures but for oracles. Through the centuries his church, rebuilt several times, remained the most beautiful of all.

A plan drawn at the time of its destruction, a sketch of the nave ruins made in 1798—that, with the two towers that are still standing, is all that remains today of St.-Martin.[41] The briefest study of the plan shows us that the author of the *Guide du pèlerin* was right. Here, as at Santiago, is a choir with an ambulatory and five radiating chapels; here, as at Santiago, is a transept like a nave with side aisles. The nave itself is the same as at St.-Sernin of Toulouse, for it has double side aisles. An examination of the mediocre sketch representing the ruins brings to light other certainties. The nave with its round arches and its high Romanesque tribune recalls in all its details the naves of St.-Sernin and of Santiago. The half-

destroyed transept allows us to see, as in an architectural section, the side aisles and the tribunes above them. It becomes clear that St.-Martin of Tours resembled all the other great churches along the roads to Santiago.

But what was the date of the church of St.-Martin? Certain archeologists have thought that it had been rebuilt after the fire of 1202. Our drawing proves the contrary: the entire body of the building was preserved, and only the vaults were rebuilt. The Romanesque nave was then given a Gothic vault, a ribbed, ogival vault supported by flying buttresses. It was at this time that windows were cut in the nave, and also that the ambulatory with its radiating chapels was enlarged. The excavations of 1886 uncovered the former plan.[42] It was smaller and had the form and dimensions of the ambulatory of St.-Sernin of Toulouse and of Santiago de Compostela.

The church of St.-Martin of the plan and the drawing is, I am convinced, the church that the treasurer Hervé had constructed from 997 to 1014. It might have been somewhat restored in the course of the eleventh century after a series of fires had destroyed parts of it, but its principal lines were not changed. It is even likely that Hervé's basilica reproduced the form of an earlier basilica, for beneath Hervé's ambulatory with radiating chapels, another and much older one has been found. In the same way, the transept with side aisles and tribunes, which dates from the time of Hervé,[43] probably reproduced a similar but much older transept, since the beautiful plan of the transept with side aisles surmounted by tribunes goes back to the Early Christian era. The basilica of St.-Menas, recently discovered in Lower Egypt, provides an example of it dating from the time of the emperor Arcadius.[44]

It is not surprising to see such grand concepts embodied in the church of St.-Martin of Tours, the oldest and most beautiful of all the French pilgrimage churches. They are appropriate to a basilica that was visited by thousands of pilgrims. The double side aisles of the nave and those of the transept divided the crowds and imposed order, while the ambulatory made it possible for them to walk around the tomb. So, it was the sanctuary of St.-Martin that had been the model for all the churches along the way to Compostela; it was thought impossible to create anything more perfect.[45]

There were more churches modeled after St.-Martin of Tours than we might think. Excavations uncovered several years ago the plan of the nave and transepts of the Romanesque cathedral of Orléans. The nave had double side aisles and the transept single side aisles, just like the nave and transept of Hervé's St.-Martin. The two buildings were almost contemporary. New excavations will perhaps someday reveal the plan of the choir of the cathedral of Orléans, but I think we can predict that it will have an ambulatory with radiating chapels.[46]

Even now, we can guess that the cathedral of Orléans, a station along the Way of St. James, belonged to the family of the great pilgrimage churches.

This is not the place to discuss all that Romanesque architecture owes to St.-Martin of Tours. It is enough to say that in all probability the beautiful Romanesque churches of Auvergne derived from it,[47] and that the magnificent church of Cluny borrowed from it many details. But here we are speaking only of pilgrimage churches. These splendid basilicas, raising their identical silhouettes from St.-Martin of Tours to Santiago in Galicia, make it abundantly clear that the roads to Compostela were the great highways over which art traveled.

This is vividly clear in Spain, for there at the principal stopping places along the road to Compostela we encounter the Romanesque sculpture of France.[48]

Descending into Spain from the Somport pass, we find capitals in the style of Toulouse at San Juan de la Peña and Jaca; going by Roncevaux, we find them at Pamplona. The two roads come together at Puente la Reina, where we see again the influence of French art. It is there at almost every stop: in the beautiful reliefs of the church of Estella, in the capitals of Frómista, on the façade of Carrión de los Condes, in the reliefs of the Cluniac church of Sahagún (fig. 218),[49] and on the portal of San Isidoro at León where we recognize the art of Toulouse and of St.-Bertrand-de-Comminges. And it is there, finally, at the end of the road, at Santiago de Compostela (fig. 219). The artists who covered the side portals of the basilica with reliefs were French, and most of them had served their apprenticeship in the workshops of Toulouse and Moissac. Civilization came into Spain along the Way of St. James. The most accomplished creations of France—poetry, art, gold and silver work, Limoges enamels[50]—came into Spain along this road. Moreover, it was also by this road that Spain introduced into France the works of her own genius: the superb Apocalypse of St.-Sever, for example, which we have discussed at length, reproduces the Spanish Apocalypses. The abbey of St.-Sever, where it was illuminated, was one of the stations in France along the road to Santiago.

But there is one fact which has never been pointed out, and which is even more curious. The great sculpture of the thirteenth century, the magnificent art whose progress can be followed from Chartres to Paris, from Paris to Amiens, from Amiens to Reims, was unknown in the Midi of France for many years. When it finally arrived there, it was by way of the roads to Compostela.

South of the Loire, it is at Poitiers that we first find thirteenth-century sculpture. The three portals of the Cathedral lack the perfection of the great ensembles of the Ile-de-France and Champagne, but they imitate them. The Virgin, St. John, and angels are arranged around the Christ-Judge, just as at Notre-Dame of Paris. But in the neighboring tympanum,

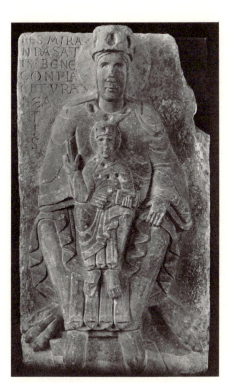

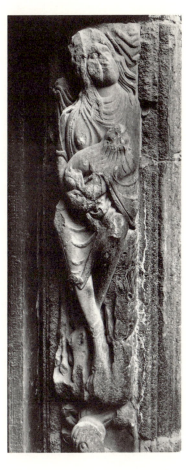

218. Virgin and Child from S. Benito
of Sahagún (León). Madrid, Museo
Arqueológico Nacional.

219. Woman holding a lion. Santiago
de Compostela (La Coruña), Cathedral.
South transept, Platerías Portal
(detail).

the story of St. Thomas has been told by an artist who knew Reims. The
svelte figures have about them something of the elegance of Champagne.[51]

The art of the north appears again at Bordeaux. Both the cathedral and
the church of St.-Seurin have a Last Judgment. The tympanum of the
cathedral is admirable in its nobility; it is the work of an artist who was
faithful to the great traditions of Chartres, Paris, and Amiens; his angels
remind us of figures from fifth-century Athens. The sculptor of St.-Seurin
went beyond this point of perfection. He knew Paris and imitated its Last
Judgment scene, but he had been even more charmed by the richness of
the art of Champagne. Beneath the tympanum, he reproduced the dec-
orative foliage of the cathedral of Reims.

Beyond Bordeaux, the route to Compostela takes us to Dax, where we
again find northern sculpture. The portal of the ancient cathedral is also
devoted to the Last Judgment—a hymn to eternal life and eternal justice
which peals forth along the entire pilgrimage route. The Dax portal has
astonishing amplitude: it has six bands of archivolts, like the great portals
of Notre-Dame of Paris, Amiens, and Bourges. The sculptor knew these
noble models, but he did not copy them slavishly. Even though he had

been inspired by the Paris composition (the most felicitous arrangement of all), he arranged his figures around the Christ-Judge with a heretofore unheard of freedom;[52] but in the details of his work there is nothing that cannot be found elsewhere.

The route through the dunes and marshes paralleled, as we have seen, the route from Bordeaux to Dax; this road along the sea ended at Bayonne. Now the cathedral of Bayonne also has two beautiful thirteenth-century portals which today open into a sacristy. There we see the Virgin and the Christ-Judge; the figures of the apostles stand in the embrasures. These elegant figures with gently inclined heads reveal the artist's sources: he had seen Reims and had been initiated into that charming art which transformed traditional solemnity into freedom and grace. His was not the supreme elegance of his masters, but he retained something of what they had taught him.

Two other roads crossed Gascony and joined at Ostabat: the road from La Réole to Bazas and Mont-de-Marsan, and the road from Moissac to Lectoure, Bauze, and Aire. Sculptors from the north had passed—and stopped—along these roads.

There are three thirteenth-century portals in the façade of the cathedral of Bazas. It is like finding a northern French church in this distant Midi. The principal themes are those created by the artists of the Royal Domain: the Last Judgment, and the Coronation of the Virgin.[53] In the scene of the Last Judgment, the Virgin, St. John, and the angels are placed on each side of the Judge in the same order as on the tympanum of Amiens, but at Bazas there is some awkwardness in the imitation.

At Aire-sur-l'Adour, we again find the Last Judgment. The church of Le Mas-d'Aire, at Aire-sur-l'Adour, is on a hill at some distance from the former cathedral. Pilgrims always went there to pray before the ancient sarcophagus containing the remains of the martyr St. Quitterie; that is why the portal of the church of Le Mas, instead of the cathedral portal, was decorated in the thirteenth century. As at Bordeaux and Bazas, the scene of the Last Judgment at Le Mas follows the traditions of northern art.[54]

Our sculptors did not stop at the Pyrenees; they crossed them along with the pilgrims. In Spain, there are two churches where we find the French sculpture of the thirteenth century in all its purity: the cathedrals of Burgos and León. Both are on the road to Santiago.

At Burgos, the Portal of the Sacrament dates from the early part of the thirteenth century. The severe style of the Christ in Majesty and the apostles seated at his feet recall the solemn art of Notre-Dame of Paris. But the charming interior portal, carved about 1260, is related to the art of Reims. The angel with great wings who is present at the baptism of Christ and the lithe figures accompanying him have a grace that was quite

new—the grace of the art of Champagne which, toward 1250, had made a conquest of French art.

The art of the cathedral of León is extremely complex; it recalls Chartres, Paris, and Reims. The tympanum devoted to the Death and the Coronation of the Virgin is a free imitation of the superb tympanum of Notre-Dame of Paris, although the copy is far inferior to the original. The principal group of the Last Judgment again recalls that of Notre-Dame of Paris, but the lintel representing the bliss of the elect is a marvel of poetry. It is the work of a creative artist schooled at Reims; the slenderness of the figures and the slight smile lighting the faces clearly reveal the artist's model. Beautiful decorative foliage covers the stone, as on the interior portal of Reims Cathedral. The more austere art of Chartres is also found at León: a statue of a saint with her hand raised reproduces the St. Modeste of the north porch of Chartres.

After this brief analysis, which we shall not prolong here, it will seem clear that south of the Loire, thirteenth-century sculpture spread along the Santiago pilgrimage roads. From Poitiers to Burgos and León, it is always along one of these roads that the great sculpted portals are to be found.[55]

Thus, after the twelfth century, artists constantly accompanied the pilgrims. Perhaps they were themselves pilgrims like others on their way to Compostela to ask forgiveness of their sins; on their way home, they offered their services to the construction workshops of the cathedrals.

V

Jongleurs, too, traveled the roads with the pilgrims. They were to be seen not only on the pilgrim roads to Santiago but at all of the sanctuaries and abbeys that attracted crowds. It was before the portals of churches that they sang the praises of heroes—Charlemagne, Roland, Oliver, Ogier the Dane, and Renaud de Montauban. Is it possible that these legends, so closely related to the devotional practices of the people, left no trace in religious art? And did not France, like Italy, receive the epic into the sanctuary?

What can be said, first of all, is that certain legendary stories preserved in abbeys inspired both artists and poets. Few places in the world have housed more poetry than the old abbeys of France. Everything in these ancient churches spoke to the imagination—ancient legends, the memory of kings and heroes, Waifer's bracelets given by Pepin the Short to one church, the shield of William the Short-Nose hanging beside the altar in another, tombs rising out of the pavement, windows that told moving stories, treasures richer than those of emperors, relics that worked miracles. The abbey, with its Rule, its monks as disciplined as soldiers, its antiphonal plainsong, was itself living poetry. It is understandable that such a place

The pilgrimages and epic romances. The legend of Pepin the Short on the portal of Ferrières in Gâtinais. The pilgrimage of Charlemagne to Jerusalem and the window at St.-Denis. The tomb of Ogier at St.-Faron at Meaux. Roland in the cloister of Roncevaux and perhaps at Notre-Dame-de-la-Règle at Limoges. Conjectures about the capitals of Conques, Brioude, and Agen. The *Roman de Renart* at Amboise. Jongleurs represented in churches.

should have given our poets the sudden emotional shock that engenders great work.

The abbey of Ferrières, in Gâtinais, was one of the oldest abbeys of France.[56] An ancient legend was responsible for a pilgrimage there. The story was told that when the three apostles of Sens, St. Savinien, St. Potentien, and St. Altin, were at that place, which was then a wilderness, they all had the same vision. The Virgin carrying the newborn Child, as in the stable at Bethlehem, had appeared to them. A chapel erected on the spot to Notre-Dame of Bethlehem and enclosed within the monastery walls had attracted pilgrims throughout the centuries. Kings came to Ferrières. Two stories, one by a monk of St.-Gall and the other by a chronicler called the "Astronome Limousin," related that when Pepin the Short was at Ferrières, he had pitted a lion against a bull.[57] The struggle was long. He said to his vassals, "Who among you is brave enough to put an end to the fight?" Since no one came forward, he himself plunged into the arena and cut off the heads of the lion and the bull.[58] This legend, worthy of epic poetry and soon to be included there, as we shall see, was doubtless known to the pilgrims to Ferrières. And it was not overlooked by artists.

The church has two doors. One is walled up; this is the papal door, which is opened only for the sovereign pontiff. It has been closed for many a year, for no pope has been to Ferrières since the time of St. Louis. Two historiated capitals decorate this portal of honor: one shows a king with a sword in his hand battling a lion; the other shows spectators who seem to be watching the struggle. If such a scene were on another church, we might take it to be a simple fantasy of the artist, but here, it has a specific meaning. We have before us the legend of Pepin, carved toward the end of the twelfth century. Art was ahead of poetry, for the story of the combat between Pepin and the lion was not written down until the thirteenth century, when it appeared in an episode of *Berte*. Thus, the monks, who were guardians of the past, carved on the portal of their church what they thought was history.

Of all the abbeys of France, St.-Denis was richest in great mementoes of the past. At the beginning of the twelfth century, its monks added still other marvels. Under the title *Descriptio*, they wrote down the story of certain of their relics. They told the pilgrims that the wood of the cross, the nail of the Passion, and the crown of thorns displayed there for their veneration had all been brought from Constantinople by Charlemagne himself. According to the *Descriptio*, the emperor Constantine, warned by a dream, had sent a letter to Charlemagne by his messengers, begging him to come to the aid of the Christians driven from Jerusalem by the infidels. Charlemagne at once gathered an army and rescued the Holy Land. On his return from Jerusalem he stopped at Constantinople. It was

then that the Eastern emperor, as testimony of his gratitude, had given him what was most precious to him: the relics of the Passion. These remarkable relics brought by Charlemagne had been kept in the church of Aix-la-Chapelle until Charles the Bald presented them to the abbey of St.-Denis.

It is scarcely necessary to say that this story is pure fiction; but legend is often more fruitful than history. As we know, this little story was responsible for the popular epic, *Le Pèlerinage de Charlemagne à Jerusalem*.[59] Minstrels recited it at St.-Denis itself, during the fifteen days when the relics were displayed and the Lendit Fair was held. The *Descriptio* was also responsible for a work of art. The abbot Suger adopted the story that did such honor to his abbey and had Charlemagne's journey represented in a window of his church. The window no longer exists, but Montfaucon reproduced two of its panels in his *Monumens de la monarchie françoise*,[60] with accompanying descriptions. One represents Constantine's envoys received by Charlemagne seated on a throne in his palace at Paris. The other shows the meeting of the two emperors at the gates of Constantinople: Constantine goes forward to meet the victorious Charlemagne and takes his hand (fig. 220). Doubtless this was followed by Constantine's giving the relics to Charlemagne, and Charlemagne's placing them on the altar of Aix-la-Chapelle, for we still have at Chartres what has disappeared from St.-Denis. In fact, the entire lower part of the famous Roland window tells the story of Charlemagne's journey to the East, and in the same way that it was told in the St.-Denis window. The similarities are too great to be attributed to chance. Thus, Suger's window, which is earlier than 1145, was still being imitated seventy years later.

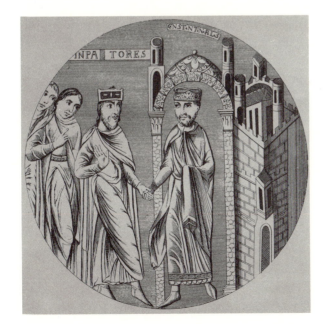

220. Meeting of Charlemagne and Constantine. St.-Denis (Seine), Abbey Church. Stained glass medallion (destroyed) (engraving after Montfaucon).

The prestige of the legend created at St.-Denis was such that it inspired both artists and poets.

The works of art we have just studied derived from Latin originals to which epic poets also went for inspiration. We shall now see the artists translating literally the work of the poets.

Meaux was one of the pilgrimage places where Parisians best liked to go. At Breuil, in the neighborhood of the town, they visited the little house where the hermit, St. Fiacre, had lived; at Meaux, they prayed at the tomb of St. Faron. The old bishop of Merovingian times was buried in the church of the abbey he had founded and which came to bear his name. In the church of St.-Faron, another tomb attracted the pilgrims' attention: the tomb of the monk Ogier and his companion Benedict.

Who was this Ogier? If the visitor asked the monks, they would tell him something like this: Ogier was one of the most illustrious figures of Charlemagne's court, and no warrior of his time was more famous. At the height of his glory, he decided to withdraw from the world and dedicate himself to God. He put on pilgrim garb, and accompanied by a faithful friend, named Benedict, wandered from monastery to monastery. When he entered the church of an abbey, he let his staff hung with bells fall on the paving; when the monks heard the sound, they always paused in their prayers and turned around. This was a decisive test for Ogier; he left the monastery at once, persuaded that he could not take his vows in a monastery where there was so little real piety. He finally came to St.-Faron of Meaux. Once more he tried out his test and let his staff fall, but no monk turned his head; all were lost in inner contemplation. That is why Ogier and his friend Benedict asked the abbot of St.-Faron to admit them to the monastery.

This story might have amply satisfied the pilgrims, but in the course of the twelfth century a new marvel was added to it. At St.-Faron, it was said that the monk Ogier was the famous Ogier the Dane celebrated by the poets. It was he who had rebelled against Charlemagne and alone had defended himself in the Chateau of Castelfort against an entire army; it was he who had been imprisoned at Reims in the Porte de Mars, and had come out to save France which had been invaded. Who could fail to be moved by such great memories? The pilgrims knew that story of Ogier the Dane and his squire Benedict, for the minstrels had sung it to them at the door of the abbey.[61]

Thus, poets and monks together had exalted this unknown Ogier who had been buried for three hundred years in the church of St.-Faron. In the late twelfth century, an extraordinary monument was erected in the choir of St.-Faron,[62] the tomb of Ogier and Benedict (fig. 221). The two friends, clothed in their monk's robes, were shown lying side by side on the same sarcophagus. A relief represented their arrival at the abbey. Ogier carried

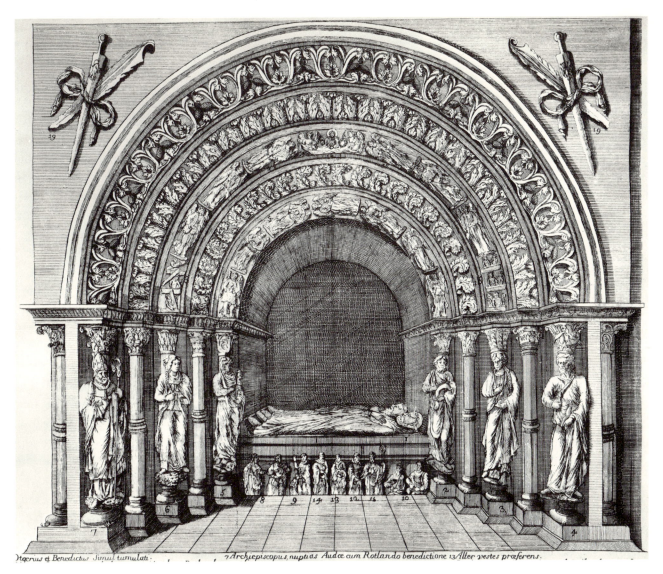

Ogerius et Benedictus simul tumulati. 7 Archiepiscopus, nuptias Audæ cum Rotlando benedictione 13 Alter vestes præferens.

221. Tomb of Ogier (destroyed). Meaux (Seine-et-Marne), St.-Faron (engraving after Mabillon).

his staff hung with bells; farther along, they were shown taking their vows in the presence of the abbot. One monk, holding scissors, made ready to cut their hair; another, to clothe them in the monastic habit; and a third held out a pen for them to sign their profession.

So far, there was nothing surprising about this tomb. What would have surprised us, however, was the magnificent setting. Before the sarcophagus was an imposing Romanesque portal; at each side, three large statues stood against columns. The first, at the right, carried a banderole on which was written:

> *Audae conjugium tibi do, Rolande, sororis,*
> *Perpetuumque mei socialis foedus amoris.*

"Roland, I give you my sister, Aude, in marriage, a perpetual pledge of the friendship uniting us." Thus, this figure was Oliver. Beside him stood a young woman with long tresses, and beside her, another hero. There was no inscription, but they can only have been the lovely Aude and Roland, for in fact, Oliver turned toward Roland as he presented his sister to him. The three statues at the left were not so easy to identify; they represented a king with a scepter and a bishop with a crozier, and between them was the figure of a woman. The bishop, or rather the archbishop, was certainly Turpin, for it was he who had saved Ogier's life by secretly feeding him in the prison of the Porte de Mars, where Charlemagne intended to let him starve. The king was no doubt Charlemagne himself, first the faithful friend and then the implacable enemy of Ogier, but who later pardoned him nevertheless. Did the statue of the woman represent Hildegarde, the wife of Charlemagne, as the Benedictines claimed? We do not know. The sculptor had placed around Ogier, as a guard of honor, the most celebrated heroes of our *chansons de geste*. The monks of St.-Faron not only displayed Ogier's tomb; they displayed his sword. Its damascened blade was decorated with an eagle and a golden lion.[63]

Ogier's tomb disappeared along with the church of St.-Faron during the Revolution, and we know it only through Mabillon's drawings.[64] The sad ignorance of those vandals who destroyed without knowing what they were doing! There was scarcely a more priceless monument in France. In it, the Middle Ages had expressed its deepest thoughts by glorifying what it most admired in this world: the hero's courage combined with the monk's self-denial.

Thus, France had represented the figures from her epic poetry not only at the door to the sanctuary but in the sanctuary itself, a few paces from the altar.

Roland was to be seen at St.-Faron of Meaux, but was he not also to be found on the road to Santiago, where his legend had taken form?

To begin with, he was represented at Roncevaux. Until at least the early eighteenth century, a cloister which has since disappeared was still attached to the St.-Esprit Chapel at Roncevaux.[65] In this cloister there were thirty grim tombs—thirty large stones without inscriptions. A fresco painted on the wall told the story of the battle of Roncevaux; other frescoes represented illustrious warriors, some of whom were named: Thierry d'Ardennes, Riol du Mans, Gui de Bourgogne, Oliver, Roland. In this way, the monks of the priory of Roncevaux reminded the pilgrims of the great battle celebrated by the poets, and they forgot neither Oliver nor Roland. As for the other heroes, we find all of them mentioned only in the *Chanson des Fierabras*, as Bédier has remarked.[66] This was a poem that also told of the Christians' struggle against the Saracens of Spain. *Fierabras* was composed about 1170; consequently, the frescoes were

painted after that date. The pilgrim who had contemplated the tomb of
Roland at Blaye, and had admired his ivory horn at St.-Seurin, found
his image again at Roncevaux, near the uninscribed tombstones of the
warriors who had died at his side.

In the past, this image of Roland was perhaps to be found in many
churches along the Way of St. James. The small reliefs which once deco-
rated the façade of Notre-Dame-de-la-Règle have been preserved in the
museum of Limoges (fig. 222). One represents a knight wearing a conical
helmet and a coat of mail made of plates fastened to his leather tunic;
he is on foot and advances with his shield on his arm and his sword in
his hand. A second relief shows a horse which is no doubt wounded, for
it has fallen. A third and smaller plaque represents the figure of a man
blowing a horn. It is tempting to see in this group, which dates from the
early twelfth century, two episodes from the *Chanson de Roland*. We see
the hero sounding his horn, abandoning his horse Veillantif which is
mortally wounded, and then fighting on foot. The *Chanson* says: "Veil-
lantif has thirty wounds; he falls dead upon the count; the pagans flee;
Count Roland is still on his feet."[67] If the figure sounding a horn also
wore a knight's coat of mail, we could be certain, but this strange, almost
naked figure is surprising. Could this be Roland? We remain in doubt.[68]

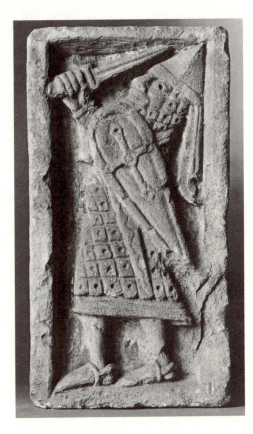

222. Roland brandishing his sword.
Archivolt from portal of Notre-Dame-
de-la-Règle. Limoges (Haute-Vienne),
Musée National Adrien-Dubouché.

Doubt follows us wherever we go. I am certain that a number of scenes from epic poetry are to be found in our Romanesque churches, but it is never possible to say with certainty which poems they are taken from. The trouble is, the inscriptions are always missing. Who are the knights in combat carved on the capitals of Conques? Who are the horn blowers? We cannot help thinking of Roland once more: a very likely conjecture for the priory of Roncevaux situated in a pass of the Pyrenees belonged to the abbey of Conques, itself a stage on the pilgrimage to Santiago. Who are the two knights in coats of mail attacking one another with lances on a capital of Brioude (fig. 223)?[69] Could one not be the famous Guillaume de Gellone, the hero of *Le Charroi de Nîmes* and of *La Prise d'Orange*? According to legend, Guillaume went to Brioude and placed his shield on the altar of St.-Julien before he became a monk in the monastery of Gellone. This was known to the pilgrims from the Midi who followed the ancient Régordane road toward Brioude.

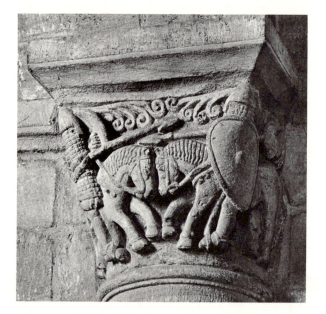

223. Guillaume de Gellone (?) in combat. Brioude (Haute-Loire), St.-Julien. Nave capital.

If we cannot grasp the truth at Conques and Brioude, we can at least glimpse a probability. But on the portal of the Abbaye-aux-Dames at Saintes, what is the meaning of the scene[70] in which two knights charge toward each other, while women lament and try to restrain them? What poem inspired the artist, what song sung by the minstrels for the pilgrims to Santiago who had stopped at Saintes? We may never know. At the cathedral of Angoulême, who are the knights attacking a castle, and reminding us of the Knights of the Round Table at Modena? Who is the Saracen playing chess with a Christian king in a fresco of Notre-Dame at Le Puy? We sense that all of these subjects were taken from popular epics, but we can identify none of them with certainty.[71]

Occasionally, we think we have come upon the truth. Near the church of St.-Caprais at Agen, there is a beautiful twelfth-century doorway opening into a chapter hall. The capitals of this portal seem completely mysterious.[72] One of them shows four warriors advancing with lowered heads and their shields hung from their necks; a curse seems to weigh upon them. We immediately think of the four famous outcasts of the epic—the four sons of Aymon. Why should these heroes have been represented at Agen? Until the seventeenth century, the tomb of the duke Renowaldus, the adversary of the king Chilperic, had stood in the cloister onto which the chapter hall opened. Renowaldus is Renaud. From the twelfth century onward, it was thought that this Renaud was the most famous of the four sons of Aymon. In its earliest form, the *Chanson de Renaud de Montauban* does not seem to go back beyond 1160;[73] the capitals of the portal could have been carved a few years after that date. Agen, a station on the pilgrim route to Santiago[74] and with a Hospital of St. James, could have heard minstrels sing the *Chanson de Renaud de Montauban* when it was still new. And we might ask ourselves, then, if the capital which is paired with that of the four warriors does not also represent an episode from the poem? Around a now half-destroyed female figure are grouped four figures without armor or arms. Could they be the four sons of Aymon returning to see their mother who wept for them for seven years but then did not at first recognize them? Unfortunately, we will probably never be sure. The sculptor has kept his secret.

It is not only the souvenir of our serious epics that we find on these capitals, but that of our comic-heroic poems also, for the minstrels sang to the pilgrims about Renart as willingly as about Roland.

Amboise was one of the stations on the great road to Compostela by way of Orléans, Tours, and Poitiers. Now, an episode from the *Roman de Renart* is to be observed on a curious capital at St.-Denis of Amboise, not far from the capital of the Massacre of the Innocents. What is this episode? Two animals, wolves or foxes, with little sacks slung over their shoulders, walk on their hind legs, leaning on staffs. According to Father Cahier, this is Renart setting off on a pilgrimage,[75] a tempting explanation at first, but one which study of the poem renders doubtful; for Renart set off on his pilgrimage not with another fox but with a sheep and a donkey.[76] Duchalais seems to me to have found the correct explanation.[77] The two travelers are the wolf Ysengrin and Dame Hersent, his wife, leaving their castle to seek justice at the court of the lion.[78]

Thus, there can be no doubt that folk poetry, scarcely allowed in the thirteenth-century cathedral, was willingly admitted into the twelfth-century church. The twelfth century was the great century of the epic; in the thirteenth, the spring had begun to run dry. It is not surprising that in the twelfth century the clergy welcomed the fine stories they

heard sung before the doors of their churches. As Bédier has so clearly demonstrated, the clergy themselves collaborated in some measure with the poets by telling them the traditional stories of their abbeys and by translating for them the inscriptions on ancient tombs.

Our great epics, born along the pilgrimage roads and sung at the principal stopping places on the journey, charmed pilgrims for more than a century. Minstrels went along on the journey; and nothing could be more picturesque than to find the minstrels themselves carved on the capitals of our Romanesque churches. They appear on the great portal of the church at Ferrières, not far from the scene of the fight between Pepin and the lion; accompanying themselves on their viols, they seem to sing of the heroic episode carved on the nearby portal. We encounter them again at the church of Souvigny in Bourbonnais, where the pilgrims came in throngs to pray at the tombs of St. Maïolus and St. Odilo. There, a strange capital in a somewhat barbaric style shows two figures playing a viol and a harp, while a third, with hand raised, seems to recite.

At the church of Bourbon l'Archambault we see minstrels again. A capital represents them playing the viol, the fife, and the Panpipes. They perpetuate the memory of the splendid festivals given by the Lords of Bourbon in the castle above the town. The charming *Roman de Flamenca* tells of one of these festivals, and no work gives us a clearer picture of jongleurs. "Then," says the poet, "the jongleurs come forward. . . . One plays the harp, another the viol, one plays the flute, others play the fife, the gigue, and the rote; one speaks the words, another accompanies him. . . . Some juggle knives; one crawls on the ground, another turns somersaults, and another dances and cuts capers. . . . People who want to hear the stories of kings, marquesses, and counts can satisfy their wish, for one minstrel tells of Priam, and another of Pyramis. . . . One tells of the Round Table where valor was always held in honor . . . , another tells how Charlemagne governed France until the time when he divided it."[79] As we see, the troupes of minstrels traveling the pilgrim roads included musicians, singers, rhapsodists, and perhaps even poets, but there were also dancers and acrobats. That is why a capital at St.-Georges of Boscherville represents a woman balancing herself on her head among minstrels who play different kinds of instruments.

These musicians, reciters of poems, and even acrobats played such a great part in the lives of the people of the time that it is not surprising to find them in our Romanesque churches. At Amboise, in the church of St.-Denis, we see the *jongleresse* who walks on her hands. On the north portal of St.-Martin of Tours there was formerly an acrobat with his head between his legs.[80] Thus, an acrobat had been carved at the door of one of the most hallowed churches of France. The pilgrims, who were constantly encountering jongleurs in the square before the church, no

doubt found it quite natural to see them carved on the wall of the sanctuary itself.

So we see that the pilgrimages were not without influence on art. Great churches of a uniform type, beautiful portals carved after models from the south and later the north of France, certain curious figures of the Virgin and of St. James, a few reminders of our popular epics and of those who sang them—these are the last souvenirs of a vanished past, the traces left by thousands upon thousands of pilgrims, like the tracks left by the carts of antiquity on the Roman roads.

IX

Encyclopedic Trends in Art: The World and Nature

I

The concept of the universe in the twelfth century. The mosaic at St.-Remi of Reims. David as musician among the elements. The capitals of Cluny. The world explained by music.

Twelfth-century art not only recounted the work of redemption and celebrated the virtues of the saints; it sometimes tried with naïve boldness to explain the entire universe, to make comprehensible the world system as it was taught in the cathedral schools and great abbeys.

Medieval science, it must be added, was nothing more than the science of antiquity, but it was a science abridged by compilers and reduced to its simplest expression. Barren as it was, it retained something of its once august character and that aspect of divine revelation bestowed upon it by the Neo-Pythagoreans.

Let us summarize in a few words the science of the universe which for centuries had been the science of the School.[1]

The earth stands motionless at the center of the world. The seven planets, the Moon, Venus, Mercury, the Sun, Mars, Jupiter, and Saturn are spaced above the earth and move around it at different speeds. The firmament, in which the fixed stars are placed, marks the limit of the world. The orbit of the stars and the planets is circular. The Greeks, who always saw a revelation of the essence of things in arithmetic and geometry, had maintained that only the perfect form of the circle could express the perfection of the divine work. The Middle Ages docilely adopted this doctrine, and it took the genius of Kepler to replace the circle with an ellipse.

On analysis, this universe is found to have only four elements: earth and fire, water and air. Plato had taught that intermediary elements were required for a smooth transition between the extreme elements of earth and fire: water that solidifies approaches earth; air that heats approaches fire.

Thus constituted, the universe is a harmony. A music issues from the world. Through Cicero's *Somnium Scipionis*, through Pliny the Elder, Macrobius, and Boethius, the Middle Ages heard a last echo of the majestic poetry of Plato's *Republic*.[2] The philosopher-become-poet tells us that

Necessity holds on her knees the spindle around which the circles of the world turn; a siren is seated on each of these circles; each sings a note and these notes form the most perfect of harmonies. This is the music of the world heard by souls before they descend into bodies; this accounts for the divine character and nostalgic charm of music, which evokes the memory of a lost home. The Neo-Pythagorean schools had been under the spell of these beautiful reveries. They related the distance of each planet from the earth to the seven strings of the lyre; the revolution of the planets produces a song that sages could sometimes hear. When a baby smiles in its cradle, it also is hearing the harmony of the spheres from which its soul has recently descended to join its body. The earth and the circle of stars added to the seven planets make the number nine, which is the number of the muses. A silent muse, Thalia, represents the earth; the other eight symbolize the music of heaven.

Boethius, at the beginning of his treatise *De musica*, speaks of this harmony which he calls *mundana musica*, the music of the world:[3] this is the harmony of the spheres, the harmony of the seasons, the harmony of the elements in which opposites are reconciled. Man, who is a world in miniature, is also a harmony—the harmony composed of the union of the four elements in his body and the concord of virtues in his soul.[4] This is *humana musica*, human music. The music made by instruments and voices, *musica instrumentalis*, holds third place, for it is only a distant echo of the sublime music of creation.

The Middle Ages remain faithful to these grandiose ideas. We find them in the twelfth-century *De imagine mundi* by Honorius of Autun, a classic treatise that was adopted by the School.[5] But the Middle Ages, intoxicated by mystic arithmetic and thoroughly Pythagorean, added other harmonies to these. To the four elements they added the four cardinal points symbolized by the four rivers of Paradise, the four winds, the four seasons, the four ages of man, the four humors of the human body, the four cardinal virtues of the soul.[6] The four disciplines of the quadrivium added to the three of the trivium give the number seven, which is the number of the planets and also of the seven tones of Gregorian music, the symbol of universal harmony.

As early as the twelfth century, art tried to express some of these ideas. The encyclopedia of divine and human knowledge, which the abbess Herrade of Landsberg illuminated at the end of the twelfth century for the Alsatian nuns of St. Odilia, was called the *Hortus deliciarum*, the "Garden of Delights." We know it today only through a copy.[7] It contains two strange miniatures. First, we see the universe. At the center is the round and motionless earth with the seven planets describing concentric circles around it. The firmament, in which the fixed stars and signs of the zodiac are fastened, is the final circle and the limit of the

world.[8] We smile at such an image today, but it summarizes thousands of years of observation and thought, the astronomy of Chaldea and of Egypt, the science of Pythagoras and of Alexandria.

After the universe, there is an image of man, its epitome (fig. 224). A miniature represents man in his nakedness as he was created by the hands of God.[9] Around him are representations of the four elements: fire and air, water and earth. Man is formed of their harmonious union: his flesh is of the nature of earth, his blood of the nature of water, his breath of the nature of air, his bodily warmth of the nature of fire. We learn this from an inscription taken from the *Elucidarium* by Honorius of Autun.[10] But the inscription tells us something else. Man is not only a summary of the world; he is also its image. The round shape of his head recalls the world's sphere; its seven openings, which are seven ways open to the senses, recall the seven planets which adorn the sky. And in fact, the artist wrote the names of the seven planets in the rays descending from above onto man's head.[11]

When the nuns of St. Odilia looked through Abbess Herrade's manuscript, they could see what the doctors were teaching in the schools. These images gave them a sense of the harmony of things.

The Church was fond of making the beautiful arrangement of the

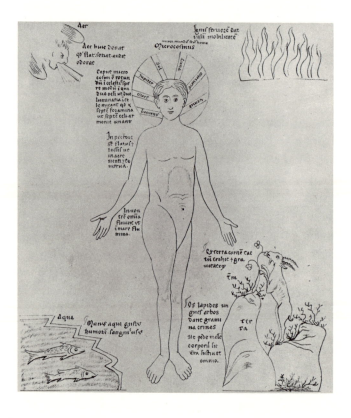

224. Man as a microcosm of the world. Herrade of Landsberg *Hortus deliciarum* (destroyed), fol. 16v. Formerly, Strasbourg, Bibl. de la Ville (after Straub).

world visible to the eye. Before the altar of St.-Remi of Reims, an extensive twelfth-century mosaic showed the imprint of divine wisdom on the universe. On this mosaic stood a large candelabrum with seven branches, itself a symbol and an affirmation of the mystery of numbers. The remarkable base of this candelabrum is the only part that has been preserved.[12]

The mosaic has long since disappeared, and we know it only through a sixteenth-century description that is vague and incomplete.[13] The man who described it did not bother even to find out what was represented on the part of the pavement covered by the monks' stalls. We can surmise that the work was very learned, arranged according to the symbolism of numbers. One section represented the Earth, and in the four corners, the Seasons; another section represented the Earth again, this time accompanied by the four rivers of paradise flowing toward the four cardinal points. The four Virtues filled another section, and the four Liberal Arts filled still another. Enclosed in a circle, which is the firmament, were the Great Bear, the Little Bear, and the signs of the zodiac. The unknown panels probably completed the display of the world system and pointed out the harmonies determined by Providence. A personification of wisdom was given a place of honor. Symbols abounded. On the steps leading to the altar was a representation of Jacob's ladder; the mystic ladder rose toward heaven just as the steps of the altar lead toward God. At the very base of the altar was the Sacrifice of Abraham, the image of the sacrifice of the Mass.

In the Reims mosaic, the world was shown to be constructed on harmonious numbers. Perhaps there were figures that conveyed the idea that the world is a music, for we shall find that idea expressed elsewhere.

In a twelfth-century Psalter, now in the library at Metz, there is a somewhat faded miniature that represents King David between personifications of spring and summer; at the four corners are images of the four elements—air, water, earth, and fire (fig. 225).[14] The artist indicated another harmony: between Water and Air there is a figure called *sanguis*—blood. It is clear that the artist intended to relate the four elements of which the world is composed to the four "humors" regulating man's body: the sanguine, the phlegmatic, the choleric, the melancholic.[15] The parallel, only indicated here, is complete in other manuscripts.[16] But what is worth our attention in the Metz Psalter is the presence of David among allegorical figures. In his hand he holds a lyre and touches its strings. The poet-king, who celebrated Divine Wisdom and the wonders of its work, is in the midst of the elements as the interpreter of universal harmony. In the Middle Ages, David was often used as the image of music. It is clear that the hymn he plays here on his lyre is, as it were, an echo of the great hymn emanating from the world.[17]

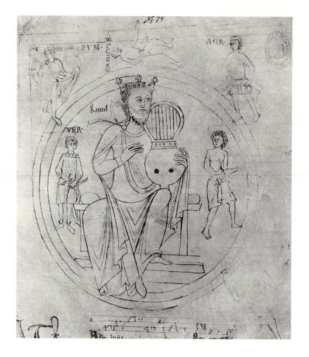

225. David. Psalter-Hymnal from
St.-Symphorien. Metz (Moselle),
Bibl. Mun., ms. 14 (destroyed),
fol. 1r (detail).

But the same thought had been expressed at Cluny in an even more striking way. In the great church erected by St. Hugh, there were beautiful marble columns decorated with historiated capitals in the ambulatory, some of which still exist.[18] They are carved on all four sides. One represents four female figures enclosed in large aureoles; they are at the same time both archaic and finely executed. Inscriptions give the names of three of the figures: one is Spring (fig. 226), the second is Summer, and the third is Prudence dressed in the coat of mail worn by twelfth-century warriors. The fourth is not Justice, as people have been saying for the past fifty years; she represents Grammar (fig. 227). There is no inscription for this figure, it is true, but she holds a strap in her hand and there was once a figure of a child beside her, for a small bare foot is still visible. She can only be Grammar, who was always represented in this way.

Here we glimpse an idea that is very close to the one controlling the composition of the pavement at Reims. The Seasons of the year are placed in correspondence with the Virtues and the Branches of Learning which ornament the soul of man. A neighboring capital, also decorated with four female figures enclosed in aureoles but with no inscriptions giving their names, no doubt developed the parallel between the Seasons, the Virtues, and the Branches of Learning.[19] Another capital represents the four rivers of paradise. These four rivers, which flow toward the four points of the horizon, symbolize the four great regions of the earth or, if you will, the four points of the compass. The number four appears again here, with its mystical meaning. Adam, who inhabited paradise

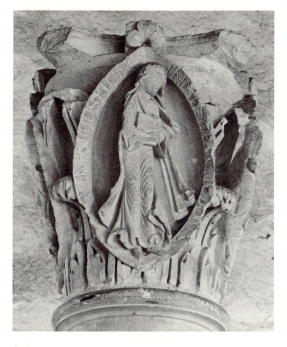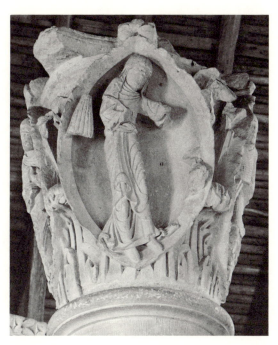

226. Spring. Ambulatory capital from the Abbey
Church. Cluny (Saône-et-Loire), Musée du Farinier.

227. Grammar. Ambulatory capital from the Abbey
Church. Cluny (Saône-et-Loire), Musée du Farinier.

where the four rivers had their source, bears this same mystery in his
name. Each letter, said Honorius of Autun, is the beginning of a Greek
word designating one of the four cardinal points: *anatole, dysis, arktos,
mesembria;*[20] and just as the four rivers brought fertility to the world,
Adam's posterity was destined to fill the four parts of the earth.

Two other mutilated capitals, no longer comprehensible, probably
showed other concordances. Did they represent the four elements, the four
temperaments, the four ages of life? It is more than likely.[21]

But fortunately two other capitals remain with inscriptions on each of
their four sides, that provide us with a key to the whole symbolic en-
semble. They represent the eight tones of Gregorian music. Each tone
is personified by a man or a woman carrying a musical instrument (fig.
228). These eight tones, in which we find twice the number four—the
number of the elements, cardinal points, seasons, cardinal virtues, and
subjects of the quadrivium—express the harmonies of the earth and of
man; but since they also give the number of the planets, they express the
harmony of the universe also. If we had the complete series of the Cluny
capitals, we would have an explanation of the world system through
music. This was certainly no small concept. It was a concept developed
by the Neo-Pythagorean schools of antiquity, which never separated sci-
ence from poetry, and held that no truth could be discovered without the

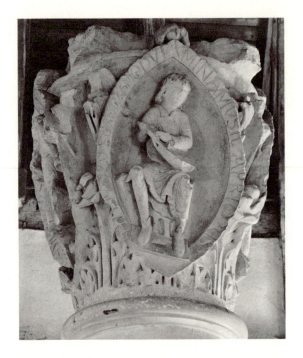

228. First Tone of Music. Ambulatory capital from the Abbey Church. Cluny (Saône-et-Loire), Musée du Farinier.

help of the muses. It was not by chance that the serious-minded Cluniac monks had this philosophy of the world carved around the sanctuary; the virile harmony of their plainsong filling the immense church seemed to them the final explanation of all things.[22]

II

Geography of the twelfth century. The tradition of antiquity. Fables about monsters by Ctesias, Megasthenes, Pliny, and Solinus. The column of Souvigny, a picture of the wonders of the world. The tympanum of Vézelay and the various peoples of the world evangelized by the apostles.

The idea that the people of the twelfth century had of the various parts of the earth was not very different from the one transmitted to them from antiquity. Geography, like astronomy, was the same as it had been in ancient times. The old Roman world had always been in full light, but at the edges of this world were great zones of shadow. It was these mysterious regions, peopled with strange beings, that aroused the most avid curiosity of the monk in his cell, and there he liked to travel in imagination. When monastic artists set about to draw a picture of the earth, it was these singular people and fabulous animals they preferred to represent. When we encounter these sculpted fables in our Romanesque churches, we are tempted to charge the Middle Ages with childishness—an unjust accusation, for there is not a detail here that does not come from antiquity. In the Middle Ages, veneration for the ancients was so profound that not a single one of their words was questioned. Their errors were respectfully transcribed and consecrated in art. The monstrous beings that we shall discuss were not born of the fantasy of twelfth-century men, as we might think, but of the imaginations or the credulity of the ancients.

When we see, on the capitals of our churches, the skiapod sheltering himself against the sun beneath his only foot, who would believe that this fable, which seems to bear the stamp of the Middle Ages, was introduced into the western world by a Greek? And in fact most of the legends about the marvels of India handed down through the centuries go back to Ctesias. He was a Cnidian who was physician to the king of Persia, Artaxerxes, in about 400 B.C. He did not go to India himself, but he heard a great deal of talk about it at Susa and Ecbatana. He had even seen Indians, for sometimes the ambassadors sent by the sovereigns of India brought presents to the Great King. He collected all of the stories that were told in Persia and circulated them throughout the Greek world. He described skiapods who had only one foot, cynocephali who were dog-headed men, pygmies who were only two cubits in height, the manticore who was a monster with the head of a man, the griffin, guardian of the treasures of India, and the unicorn, that uncapturable quadruped with a single horn in the middle of his forehead.[23]

Ctesias had not seen India, but a century later, Megasthenes, ambassador of Seleucus Nicator to the king Chandragupta—the Sandrocottos of the Greeks—went beyond Benares as far as Patna, which he called Palibothra.[24] He brought back an account of his travels which, it would appear, is full of precise facts, but in which the fabulous also figures. In fact, fables appear there that are very like those collected by Ctesias.

These marvels passed from one book to another. Pliny the Elder included some of them in his *Naturalis historia*; Solinus did likewise in his *Polyhistor*.[25] St. Augustine knew these fables. During his lifetime, a square in Carthage opening on the sea was decorated with a mosaic representing the races of monsters who lived at the ends of the earth: skiapods, pygmies, cynocephali, and still others.[26] He wondered whether such monsters really existed; he thought that if they did exist, no one should be shocked, for they were certain to have their own laws and to be a part of the great harmony.

These traditions, some of which were already ten centuries old, were condensed by Isidore of Seville into one chapter of his *Etymologiae*.[27] The Middle Ages took them from there, although they knew Pliny and Solinus. Hrabanus Maurus, in his *De universo*, copies Isidore of Seville;[28] Honorius of Autun abridged them in his *De imagine mundi*.[29]

It was in the monasteries of the Order of Cluny, under the influence of the great Burgundian abbey where learning was always held in honor, that the strange marvels of the earth were first represented. The abbey of Souvigny, in Bourbonnais, was one of the most famous of the Cluniac priories. In the church, there is still an octagonal column covered with reliefs on four of its sides. These reliefs have greatly suffered in these last years, but a drawing made about 1830 shows them almost intact.[30] The

first side of the column represents the Labors of the Months, the second, the signs of the zodiac, the third and fourth, the most singular of the peoples and monsters of Asia and Africa. The last two are the ones that interest us at present, and they can be explained almost entirely by Isidore of Seville, Honorius of Autun, and Solinus, for these were the authors who served as the artist's guides.

First we see the most curious of the earth's peoples, each represented by one figure. Three of these fantastic figures are placed on the column in the order that they are mentioned by Isidore of Seville:[31] the satyr, the skiapod, and the hippopod.[32]

The skiapod[33] has only one leg, but with this leg it can run with miraculous speed; sometimes it lies down on its back and uses its foot as a parasol. At Souvigny, the skiapod is standing.

According to Isidore, the satyr has two horns on his forehead, and his feet are goat's feet. "It was just such a satyr," Isidore said, "who appeared to St. Anthony in the desert."

The hippopod, found in the deserts of Scythia, is a man with a horse's hooves.

Above the hippopod on the column, there is a very unusual being that has no accompanying inscription. It is a kind of dog with human feet. In all probability, it is a cynocephalus, which, according to Isidore of Seville, more closely resembles a beast than a man.

Next comes an Ethiopian, who is peculiar in having four eyes. Isidore of Seville has nothing to say about this, nor has Honorius of Autun, but if we consult the *Polyhistor* of Solinus—a book of marvels exactly to the taste of the people of the Middle Ages—we find a text that explains this odd figure. "The Ethiopians, who live along the sea," says Solinus, "are supposed to have four eyes."[34]

After these pictures of strange peoples, of which we have only a part, since the Souvigny column is broken in half,[35] we find on another side the monsters who live at the ends of the earth (fig. 229). Here, the artist was inspired by the chapters which Honorius of Autun devoted to the marvels of India, for all the monsters whose names are inscribed on the column are found there.[36] Here is Ctesias' manticore, the monster with the human face who runs faster than a bird can fly and hisses like a serpent. Here is the griffin, who is both eagle and lion, and guards treasures. Here is the unicorn with a horn growing out of its forehead; the artist followed an ancient tradition of Eastern art and represented the horn pointing backward.[37] Here is the most famous of Indian animals, the elephant; and lastly, here is the siren who is half woman and half fish.[38]

Thus, the Souvigny column was both a calendar and a picture of the wonders of the world. It now stands in the church, but it is obvious that this was not its original place. Formerly, it no doubt stood in the center

at the cloister, and perhaps had at its summit the gnomon of a sundial. The meditative monk saw in it an image of time and space.

This double picture, both zoological and ethnographic, became a theme of Cluniac artists. It was used again at St.-Sauveur of Nevers, a priory of Cluny. The church has been destroyed, but several of its capitals have been preserved in the archeological museum of the town. On them we recognize some of the fabulous beings of the Souvigny column: the Ethiopian (ETHIOP) mounted on a dragon (fig. 230), the manticore with a human head, and the unicorn. A faun has been substituted for the satyr, but the faun was also mentioned by Isidore of Seville. The inscription calls it FINOS PHICA . . . , which at first glance seems very mysterious, but is nothing more than a faulty transcription of the words *faunos ficarios*, used by Isidore of Seville.[39] It was St. Jerome, in his version of Jeremiah,

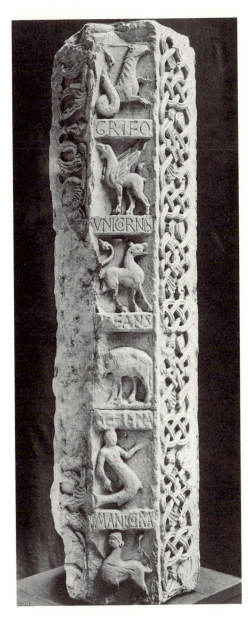

230. Ethiopian on a dragon. Capital from St.-Sauveur. Nevers (Nièvre), Musée Archéologique du Nivernais.

229. Monsters. Column from Abbey Church of St.-Pierre (cast). Souvigny (Allier), Musée Lapidaire.

who first applied the strange adjective ficarius to a faun.[40] The *fauni ficarii* were thought to be fauns who lived on figs.[41] Along with these monsters, the Nevers artist represented the chimera, who also has a place in Isidore of Seville's chapter. He is shown more or less as the ancients represented him, with his three heads spaced to correspond with his three joined bodies. At Nevers, real animals accompany these fabulous creatures: on other capitals there are a dromedary, a lion, a bear, and a monkey. Thus, in the church of St.-Sauveur, the monk had before him the chapters of a history of nature such as it was then imagined to be; through it he glimpsed the richness of the divine work, and his curiosity quite naturally turned into adoration.

It was this same curiosity, united with respect, that so often made of medieval churches veritable museums of natural history. At St.-Bertrand-de-Comminges, a crocodile is suspended at the entrance to the church; a unicorn's horn—in reality the tusk of a narwhal—is preserved in the sacristy. A griffin's paw fastened to a chain once hung in the center of the Ste.-Chapelle in Paris. It was said that a soldier who had vanquished the monster had brought it there.[42] Ostrich eggs were preserved in the cathedral of Angers—for the church was still the sole haven of science and art.

Artists trained in the school of Cluny spread these "images of the world" through Burgundy and the neighboring regions. At St.-Parize-le-Châtel (Nièvre), we find the skiapod who this time takes shelter beneath his foot. In Allier, one of the capitals in the beautiful Burgundian church of St.-Menoux shows a figure attacking a griffin. This is one of the Macrobians of India who, according to Honorius of Autun, waged a constant battle against the griffins, their enemies. On a mutilated capital of St.-Lazare at Autun, the Indian has leapt on the griffin's back and hits it with a club.[43] In the choir of the great, half-destroyed church of La Charité-sur-Loire, one of the most magnificent priories of Cluny, a dromedary, an elephant, a griffin, and a dragon are carved in a place of honor beside the lamb carrying the cross.[44]

The real animals and fabulous monsters which decorate the lower sections of the west portal of the cathedral of Sens are in the pure Burgundian tradition.

But of all the epitomes of the world imagined by twelfth-century Burgundian artists, none is more magnificent than that to be seen on the great portal of Vézelay (fig. 231). No work has seemed more mysterious to art historians, and none has been interpreted in such a variety of ways. Turn about, it has been seen as a memento of the crusade preached by St. Bernard,[45] a representation of the seven churches of the Apocalypse, and an image of the Christian Church prefigured by characters from the Old Testament.[46]

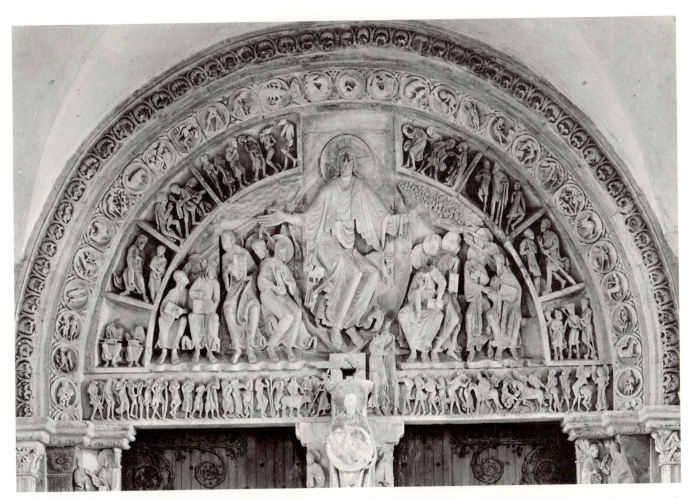

There are most certainly many strange details in this vast composition,
but as we shall see, there is no doubt about its general meaning.

In the half-circle of the tympanum there is a gigantic figure of Christ.
Long rays project from his outstretched hands and reach the apostles
seated at his sides. This is the Descent of the Holy Spirit on the day of
Pentecost. It has seemed strange to see these tongues of fire emanating
from Christ himself and not from the symbolic dove as in the later tradi-
tion, and the question has been raised whether this is indeed the Descent
of the Holy Spirit. There is no possible doubt of it, since the scene was
represented in this way several times in the twelfth century. A fresco in
the chapel of St.-Gilles at Montoire, in the Loir valley, shows a representa-
tion of the Pentecost like that of the Vézelay portal.[47] Christ is seated in
a great aureole and torrents of fire flow from his hands and fall on the
heads of the apostles. But there is an even more significant example. In
the early twelfth century at the abbey of Cluny, the mother abbey of
Vézelay, there was a lectionary decorated with miniatures in which Pente-
cost is represented. This manuscript is now in the Bibliothèque Nationale

(fig. 232).[48] Now the Descent of the Holy Spirit is conceived in the same way as at Vézelay; the Christ in an aureole, with arms outspread, sends rays of fire from his two hands onto the heads of the apostles, and he says, *Ecce ego mitto promissum patris mei in vos*— "And, behold, I send the promise of my Father upon you."[49] Thus, in the twelfth century, Christ himself was represented bestowing his Holy Spirit upon the apostles.

Thus, there can be no argument about the central part of the Vézelay tympanum; its meaning is certain. But what is the meaning of the singular scenes that unfold around the tympanum? A series of compartments enclose two, three, or even four figures who seem, with passionate gestures, to be communicating to each other an astonishing piece of news. It is clear that all these figures are closely related to the principal scene, which is the Descent of the Holy Spirit.

A look at Byzantine representations of Pentecost will put us on the track of the correct explanation. At St. Luke of Stiris in Greece, and at S. Marco of Venice in Italy, eleventh-century mosaics closely resembling each other represent the Descent of the Holy Spirit. The "tongues of fire" do not emanate from Christ alone but from the entire Trinity symbolized by a throne, a book, and a dove: the throne is the majesty of the Father, the book is the word of the Son, and the dove is the image of the Holy Spirit. The tongues of fire descend upon the apostles, but beneath their feet there are still other figures which inscriptions call ψυλαί, the tribes, and γλῶσσαι, the languages. These are the people to whom the apostles are to carry the Gospels and whose languages they will speak without having learned them.

In Eastern art, the pagan nations had long been associated with the scene of Pentecost. We find them in one of the miniatures of the famous St. Gregory of Nazianzus in the Bibliothèque Nationale, a manuscript dating from the ninth century.[50] But this miniature is probably only an abridged copy of one of the sixth-century mosaics which decorated the Church of the Holy Apostles at Constantinople. This magnificent church, built in the time of Justinian and having five cupolas, has been described in poetry by Constantine the Rhodian, and in prose by Mesarites.[51] In each cupola there was a mosaic that Mesarites described in detail. Consequently, we know that below the Pentecost scene, each of the twelve apostles was shown preaching the Gospel to a different nation. Thus, the idea of associating all the peoples of the earth with the Descent of the Holy Spirit goes back to the time of Justinian.

Manuscripts with miniatures spread the theme of the apostles' ministries. Several Greek manuscripts, among them an eleventh-century Psalter in the British Museum,[52] contain the same scene as the Constantinople mosaic: each apostle is shown preaching to a group of men representing a nation (fig. 233). The costumes of these groups differ: some wear short

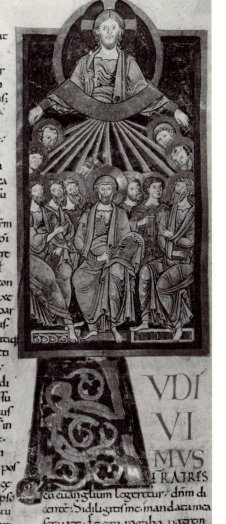

232. Pentecost. Lectionary from Cluny.
Paris, Bibl. Nat., ms. nouv. acq. lat. 2246,
fol. 79v (detail).

233. Apostles evangelizing the peoples of the world. Psalter
from the Monastery of St. John of Studion, Istanbul.
London, Brit. Mus., Add. ms. 19352, fol. 20.

tunics, others wear long robes falling to the feet; some are bareheaded,
others wear caps.

There can be no doubt that the figures placed around the scene of
Pentecost in the tympanum at Vézelay represent the different peoples of
the earth. Nor is there any doubt that the idea for the composition was
taken from the miniatures of a Byzantine manuscript. The proof is re-
corded in the relief itself. In the British Museum manuscript, in fact, the
men evangelized by St. Bartholomew and who, according to tradition,
are Armenians, wear shoes of a very strange kind—clogs in the shape of

miniature benches.[53] The figures in one of the compartments of the Vézelay tympanum wear the same kind of shoes. This similarity cannot be attributed to chance.

But if the idea for these small scenes was taken from Byzantine art, their sense of life and movement belongs entirely to the sculptor of Vézelay. Nothing could be more monotonous than the miniatures of the London Psalter; the figures are crowded together and make only a vague gesture of the hand as they listen to the words of the apostle. At Vézelay, they discuss with animation what they have just heard, or transcribe onto parchment the message that was so new to them. Nevertheless, certain gestures and attitudes are so unusual that they are disconcerting at first glance. We see two figures displaying their bare legs, while a third contemplates his foot in the attitude of the Thorn Puller of antiquity.[54] At one side, another figure shows his arm to a companion, who expresses astonishment by placing his open hand on his breast. However, the puzzle can be explained. Honorius of Autun, in a sermon for the day of Pentecost, says: "In great numbers they were converted to the faith by signs and by prodigies. . . . For, by virtue of the Holy Spirit, the apostles gave back sight to the blind, opened the ears of the deaf, loosened the tongues of the mute, made the lame to walk, healed the lepers, chased away the demons, brought the dead back to life."[55] The Vézelay sculptor represented some of these miracles that had converted the peoples; the scenes we could not explain show the lame, the lepers, and the cured paralytics. The woman carefully led by the hand is perhaps one of the blind who is about to recover her sight.

But in one of the compartments above, we find a new puzzle—two men with dog heads. What are these monsters doing among the peoples who received the Gospels? In the mind of the artist, these strange beings also were the sons of Adam; they were summoned like all the peoples and they too must listen to the word of God. Without doubt, they are the cynocephali of India. Were the cynocephali considered to be human beings? Did they participate in redemption? This was a question earnestly discussed in the Middle Ages. Ratramnus, a monk of Corbie in the time of Louis the Pious, wrote a long letter on the subject.[56] It was in reply to questions posed by St. Rimbert, a missionary about to leave for the northern countries and who no doubt expected to encounter such creatures, half human and half beast, in the Cimmerian darkness to which he was going. According to Ratramnus, the cynocephali were rational beings; the ancients reported that they kept flocks, knew how to weave their clothes, and were a true nation. He added a curious argument borrowed from an Eastern legend: St. Christopher, the valiant martyr for Christ, was said to be a cynocephalus.[57] Thus, like the rest of mankind, these poor degenerate people were descended from Adam, and a twelfth-century poet writing

in Latin explained their degradation as a consequence of the Fall.[58] We can now understand why the Vézelay sculptor placed the cynocephali among the peoples who awaited the Gospel; they belonged to the mission of St. Thomas, apostle to India.

But that is not all. The assembly of the nations of the earth is continued on the lintel, and there again we find the fabulous ethnography, dear to the Cluniac artists. We first recognize the Scythian peoples with huge ears, called Panotii by Isidore of Seville.[59] We see them enfolded in their ears, as by the valves of a shell (fig. 234). Farther on, the small figure placing

234. The large-eared people. Vézelay (Yonne), Abbey Church of Ste.-Marie-Madeleine. Lintel (detail), central portal of narthex.

a ladder against the side of a horse in order to climb into the saddle is no doubt a pygmy. Knowledge of the pygmies' existence was transmitted to the Middle Ages by Isidore of Seville and Honorius of Autun. All these peoples, and others we cannot identify, are in movement toward two tall figures standing almost at the center of the lintel. We recognize one as St. Peter, with his keys and bare feet. The other is not St. Mary Magdalene, as has often been said, but another apostle, for he also has bare feet. The apostle associated with St. Peter can be none other than St. Paul. In this connection, St. Peter and St. Paul have profound meaning: they are not only the most famous of the missionaries of the Gospels; they are the symbol of Rome itself and the unity of the faith. Represented here is the Roman Church receiving all peoples.

The other half of the lintel is more difficult to explain. It shows a procession of figures carrying bows and arrows; one figure is half naked. Again, these are savage peoples who live at the ends of the earth. In front of them are men carrying offerings—bread, a fish, a pail, a large cup, and

at the head of the procession are sacrificers armed with axes and leading a bull. A high priest seems to await them; like St. Peter and St. Paul, he is placed against the trumeau, but is smaller in stature than they. Here we would seem to have an image of the pagan world that has not yet received the great revelation, but upon whom the divine word will soon descend.[60]

The large statue standing in the center of the trumeau completes the meaning of this vast ensemble. It represents St. John the Baptist bearing the lamb, now destroyed, in an aureole. Here, St. John stands for the baptism, without which no one can enter the church. Consequently, all of these peoples coming to Christ must undergo baptism. Odilo, abbot of Cluny, recalled in a sermon on Pentecost that St. John the Baptist had said: "I baptize you with water, but he who will come after me shall baptize you with the Holy Ghost, and with fire."[61] This justifies the presence of St. John the Baptist in a scene devoted to Pentecost.[62]

The portal of Vézelay, reputedly so puzzling, can now be quite easily understood in its main lines if not in all its details. Around the Descent of the Holy Spirit, it groups all the people of the earth and even the peoples of fable. Some have already heard the Word and have witnessed the miracles that testify to the virtue of the Gospels; others still wait and persist in their ancient error, but the Word will reach them in due course, for the Church has all the centuries to come to perform its work. That is why a great zodiac, the symbol of the duration of time, surrounds this representation of the Gospel's conquest of the world.

The original idea of this great composition was Byzantine, but the Vézelay artist gave it a liveliness it never had in the mosaics of cupolas, and even less so in the miniatures of manuscripts. In this tympanum dominated by the formidable figure of Christ, all is passion, wind, and flame. The tunics of the apostles are swirled by the mighty wind that was said in the Acts of the Apostles to have swept through the Cenacle when the tongues of fire came down. But there is above all a flame of charity. These peoples with heads of beasts provoke no smile among those who have grasped the profound thought of the artist; he is trying to say that the divine word reaches even to the limits of animality, and that a fallen being will be transformed by the Gospels into a son of God. The scene emanates the rapture of the Christian missionary who was ready to give his own life to save even the most degraded savage.

At Vézelay, thanks to the genius of the Cluniacs, the fabulous ethnography of the ancients takes on a profound meaning.

III

Were animals and monsters represented in Romanesque churches only to make known the marvels of the earth and to give an idea of the vastness of the divine work? Is there an idea concealed behind them? Do they not teach us something?

Very early, the ancient Greek *Physiologus* had demonstrated that animal behavior is a reflection of the moral world, a veiled image of the drama of the Fall and Redemption.[63] Nothing could have conformed more closely to the philosophy of the Church Fathers. St. Basil, explaining the work of the six days to his listeners, showed that God had left the imprint of the truth of the faith even on the animals.[64] A single thought ruled over the creation of all beings; the Word had inscribed in each being the main outlines of the world's history. God's revelation is implanted in stones, plants, and animals.

Various applications of this method were given in the Greek *Physiologus*. For example, the lion who sleeps with open eyes is a symbol of Christ who watched in the darkness of the tomb while awaiting the resurrection.[65] Translated early into Latin, and then in the twelfth century into the languages of Europe, the *Physiologus*, as the Bestiary, continued to be widely read.[66] On occasion it inspired artists.

On a beautiful twelfth-century capital in the nave of the cathedral of Le Mans, there is an owl surrounded by small birds who seem to be attacking him (fig. 235). A capital of less skillful workmanship but similarly conceived is to be seen in the Cathedral of Poitiers. The same owl and the same birds reappear on a capital in the church of Avesnières, in a suburb of Laval. What is this unusual subject? We have only to open

The animals of the Bestiary. Their symbolism. The influence of Bestiary miniatures. Fable. The musical donkey.

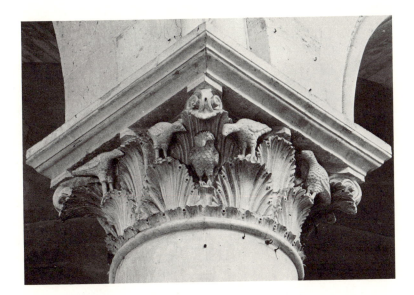

235. Owl and birds. Le Mans (Sarthe), Cathedral of St.-Julien. Capital.

the Bestiary[67] to learn that the owl (*nycticorax*), which flies only at night, is a symbol of the Jewish people who prefer darkness to light; consequently, just as the Jews are objects of derision for all peoples, the owl is an object of derision for all birds. The symbolic meaning here is clear.

A capital at Vézelay has an even stranger subject (fig. 236). A figure holding a kind of bell in front of his face seems to walk toward a composite animal, which is a cock in its forepart and a serpent behind. To take this for a simple artist's fantasy is impossible in the light of the passage in the Bestiary about the basilisk.[68] The basilisk, who shares the nature of both bird and serpent, is born from a cock's egg hatched by a toad, "for it so happens that certain cocks, in their seventh year, lay an egg." The basilisk is harmful to man only if he looks it in the eye, but whoever meets the eye of the basilisk dies on the spot. However, the dangerous fluid cannot pass through glass; if a glass bell is held in front of the face, one can look at the basilisk without harm. Thanks to this expedient, Alexander's soldiers were able to destroy the basilisks of India.[69] What is this basilisk, the Bestiary goes on to say, if not the symbol of the devil? Christ triumphed over the devil by enclosing himself in the womb of a Virgin purer than crystal. There is no doubt that the Vézelay capital represents the story of the basilisk, in spite of the presence of another monster, a locust with a human face, in the foreground. This locust looks very much like those to be seen coming out of the bottomless pit in the vision of the Apocalypse. It completes the demoniac significance of the basilisk. The Vézelay capital would seem to present the struggle of man against Satan.

To go outside France for a moment, in the cloister of Tarragona there is a capital that represents a fox lying on the ground, seemingly dead, with birds swooping down on it. A look at the illustrations in the Bestiaries, and a subject already included in the Greek *Physiologus* of Smyrna,[70] and appearing again in the thirteenth-century Bestiary now in the Arsenal library, is easily recognized.[71] The text tells us that the fox is not dead; he only feigns death to attract the birds. When they come within his reach, he jumps up and seizes them. This represents the ruses Satan uses to tempt us through the lures of the flesh and become our master. That the scene is taken from the Bestiaries is undeniable.

It was again the Bestiary that inspired a curious capital in the church of Le Mas-d'Agenais (fig. 237). We see an overturned boat, a man falling into the sea, and an enormous fish that a swimmer tries to stab with a dagger. Whale fishing and the Basque sailors come to mind. The latter were no doubt already sailing to the north seas in quest of adventure—stories of their exploits could have reached Gascony. But this is not a simple story about sailors; it has to do with a page from the Bestiary which says that the whale sometimes deceives navigators who, imagining

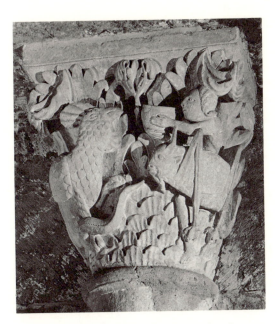

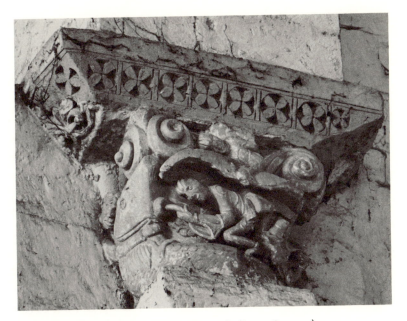

236. Basilisk. Vézelay (Yonne), Abbey Church of Ste.-Marie-Madeleine. Capital.

237. Whale upsetting a boat. Le Mas-d'Agenais (Lot-et-Garonne), Church of St.-Vincent. Capital.

that they are seeing an island, tie up their boats to the whale and build a fire on its back. Suddenly the monster plunges, taking the boat and all its crew to the bottom of the sea. The Bestiary adds that this is an example of the ruses of the devil, who is always ready to deceive those who place their hopes in him.[72]

However, artists were not always preoccupied with the moral contained in the Bestiaries. For them these illustrated manuscripts must often have been simple collections of forms. For example, I am convinced that the miniatures of the Bestiaries contributed to the circulation of images of the centaur and the siren, both of which appear so frequently in twelfth-century art. Proof of this would seem to be that in certain works the two appear together. Now, already the author of the Greek *Physiologus* brought the centaur and the siren together in the same chapter; the miniaturist who illustrated his text also placed them on the same page.[73] Following the example of the Greek *Physiologus*, the Latin and the French Bestiaries do not separate them. Thus, whenever we find twelfth-century representations of a centaur alongside a siren, we may be sure that the artist had an illustrated Bestiary before him. There was once an example on the façade of St.-Sernin of Toulouse.[74] The centaur and the siren appear side by side on a double capital now in the museum of Toulouse, and on a capital in the chapter hall at Agen.[75] In these three examples, one detail in particular would seem to transform our hypothesis into certainty. The siren is represented not as a woman-fish but as a

woman-bird, and this was the tradition long followed by the Bestiaries. The Greek *Physiologus* spoke only of the bird-siren. The old Latin Bestiary in the Brussels library, which probably dates from the tenth century, also represents sirens as half woman and half bird.[76]

This is in the pure tradition of antiquity, for the Greeks never represented sirens in any other way. They had borrowed this strange bird-headed woman from Egypt; it is nothing other than an image of the soul separated from the body, and in Greece, consequently, the siren was for a long time to be seen on tombs.[77]

It is only in French Bestiaries of the twelfth and thirteenth centuries that the siren is represented as a woman-fish.[78] However, this new type of siren was not an invention of the Middle Ages. It appeared in literature if not in art in late antiquity. In *De monstris*, a treatise on monsters probably written in the sixth century, it is stated for perhaps the first time that sirens are women with fish tails.[79] So sirens could no longer be distinguished from the beautiful figures of tritons, whose lower bodies were seahorses. Horace was speaking of tritons, not of sirens, when he said:

> *ut turpiter atrum*
> *Desinat in piscem mulier formosa superne.*[80]

The fish-tailed siren appears in art rarely before the twelfth century. The Bestiary of the Arsenal library, reconciling the two traditions, distinguishes two kinds of sirens—the bird-siren and the fish-siren;[81] one miniature represents the two types. Consequently, it is not surprising to find a woman-bird alongside a woman-fish on our twelfth-century capitals. A capital in the cloister of Elne shows them both. In these examples, it seems clear that the artist had been guided by the miniatures of a Bestiary whose text they perhaps had not read.

Once the siren-fish had been imagined, Romanesque artists were so charmed by it that they adopted it and often used it to decorate their capitals. We find it all along the Loire and in the neighboring country, in the chapel of St.-Maur-sur-Loire (Maine-et-Loire), in the cloister St.-Auban at Angers, at Cunault, and at St.-Denis of Amboise. The siren had become a kind of undine of the river. At Cunault, she comes up from the depths to offer a fish to a fisherman standing in his boat; the fisherman holds out his hand to receive it.[82] We could take this to be a representation of some ancient legend of the banks of the Loire, since forgotten. For the imagination of the people seized on these odd creations, and the siren-bird, whose original significance was beginning to be forgotten, was transformed into a kind of nocturnal vampire. In Italy, a mosaic at Pesaro, apparently twelfth century, represents women with birds' heads; they are called *lamiae* by an inscription.[83] Thus, the siren-birds were sometimes identified with the lamias of antiquity—formidable apparitions who lived

on in the tales of the Middle Ages. Gervase of Tilbury says that lamias are women who fly about at night and enter the dwellings of men to bring them bad dreams. They rest their whole weight on the chests of the sleepers, and often snatch babies from their cradles. In his infancy, Humbert, the archbishop of Arles, had been the plaything of lamias who had taken him from his bed one night and thrown him into a pond.[84] So perhaps people thought of the siren-birds on our Romanesque capitals as lamias, and the beautiful birds with heads of women that we admire today at St.-Benoît-sur-Loire (fig. 238) and at St.-Aignan (Loir-et-Cher)[85] are likely to have been viewed with a certain amount of fear.[86] The bird with a human head became again, as in the Greece of antiquity, an object of terror. The invaluable inscription at Pesaro proves that popular interpretation often prevailed over the cold commentary of the *Physiologus*; the Bestiary, in any case, is unquestionably the source of this double representation of the siren.

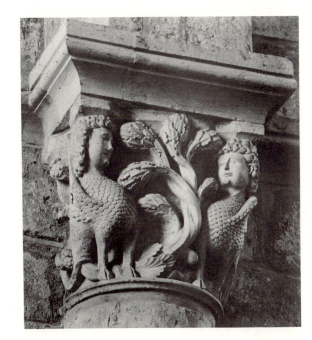

238. Sirens. St.-Benoît-sur-Loire (Loiret), Abbey Church. Nave capital.

No doubt only the clerics understood the subtle meanings of the works inspired by the Bestiary; on the other hand, the practical wisdom of the fables could be grasped by everyone. That is why the heroes of Phaedrus and of Aesop were often painted or sculpted in churches. Although both Phaedrus and Aesop were known in the Middle Ages, Phaedrus was often less popular than a subsequent writer who called himself Romulus and with naïve impudence set himself up as a Roman emperor. The so-called Romulus, moreover, did little more than make a prose version of Phaedrus' verses.[87] Aesop was known to the Middle Ages through the

Latin translation of Avianus. New stories were added to this old store, for the Middle Ages themselves were creative and in the *Roman de Renart* gave to the fable the scale of an epic.

The fable, that curious genre in which everything is alive, everything thinks, and animals seem wiser than men, takes us far back in antiquity. With its naïveté and its mystery, the fable seemed made for the Middle Ages, a time of renewed youth for humanity. No one was much astonished that beasts should speak, for the peasant knew very well that his cows talked together in the stable on Christmas night at the hour of the elevation of the Host. Medieval man lived at the edge of the forest, close to the animal world. At night he could hear the yelping of the fox, the cry of the owl, and in the morning he could see the tracks of the wolf in the snow. That was the era when fables were still invested with all their ingenuous charm. Later, it took La Fontaine's marvelously understanding genius to restore to fable its freshness.

The fable appeared very early in medieval art. Beside the canon tables in the Carolingian Gospels of Morienval, preserved in the cathedral of Noyon, we see the crow with the cheese and the fox who keeps watch— a light touch provided by the miniaturist (fig. 239).[88] Fables form the border of the Bayeux tapestry: the crow and the fox, the wolf and the lamb, the rat and the frog, the wolf and the stork frame the epic of the conquest of England by the Normans.[89] In the eleventh century at St.-Benoît-sur-Loire, the abbot Arnaldus had the fables of Aesop painted in the monks' refectory; Latin verses, which have been preserved, accompanied each episode and gave its moral.[90] The monks could easily find a higher moral in their books, but before rising to the angelic life, it was

239. The fox and the crow. Canon table. Gospel-book of Morienval, fol. 8r (detail). Noyon (Aisne), Ancient Cathedral of Notre-Dame.

prudent to acquire knowledge of the earth; no prop was to be scorned, and in the past, the desert Fathers had carried with them into the wilderness the books of the Greek sages.

All the more reason for presenting these ingenious summaries of human experience to the people. This is why preachers included fables in their sermons and sculptors represented them in churches. A capital of the portal of St.-Lazare at Autun shows the stork retrieving the bone from the wolf's throat; this is the fable that Phaedrus, and after him Romulus, called "The Wolf and the Crane."[91] The same fable reappears on the tympanum of St.-Ursin at Bourges (fig. 240). The St.-Ursin tympanum, moreover, is one of the most singular works imaginable, for it has to do only with the things of the earth. We see the Labors of the Months, a deer hunt and a boar hunt in the forest, the fable of the wolf and the crane, and the burial of Renart who, resuscitated, makes ready to leap on the cocks who are putting him in the ground.[92] Thus, in the twelfth century, art was often considered to be simple decoration; it was not always required to provide profound lessons.

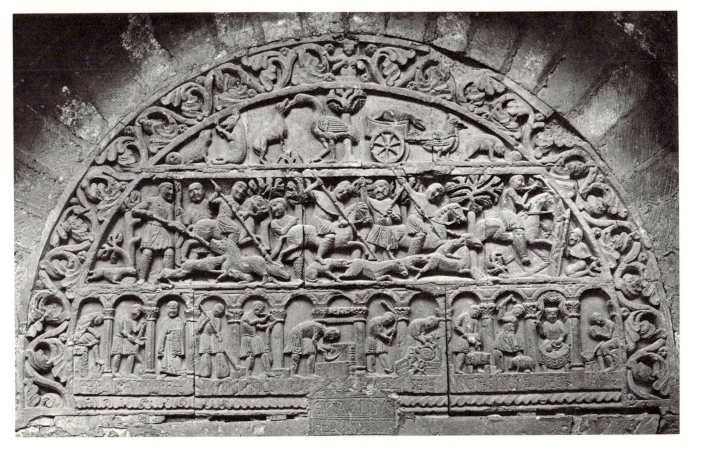

240. Tympanum from the Church of St.-Ursin. Bourges (Cher), Jardin de la Préfecture.

Among the fables conceived by the Middle Ages, there is one that artists represented several times: the education of the wolf. A clerk had undertaken to teach a wolf to read, and began by teaching him the first letters of the alphabet, A B C. "Repeat these three letters," said the clerk. "Lamb," said the wolf, who was thinking of other things. "Thus the mouth betrays the secrets of the heart" (*Quod in corde, hoc in ore*).[93] This little fable, with its fairly subtle sense of the comic, must have been well known to the clerics, for they had their artists represent it. The sculptors usually represented the wolf dressed in a monk's habit, applying himself diligently under the ferule of the master. There are now no examples of this subject in France, but we find them at Parma, Verona, Basel, and Freibourg-im-Breisgau. At Freibourg, the artist, fearing that he might not be understood, carved a second relief as a conclusion to the reading lesson which shows the wolf capturing a lamb; he had little confidence in his public, but his presentation of the fable is somewhat heavy-handed.

No fable was reproduced more often than Phaedrus' tale of the donkey and the lyre, even though it is not one of his best. A donkey found a lyre abandoned in a meadow and tried to draw notes from it. "I do not know music," he said, "but if someone else had found this lyre, he would charm the ear with divine harmonies."[94] That, added the fabulist, shows how the circumstances of one's lot keep native genius from flowering.

However, the Middle Ages probably did not take the fable from Phaedrus directly, but from a sentence in Boethius' famous *De consolatione philosophae*,[95] which every cleric had to have read. Philosophy, personified, speaks to her listener, who seems not to have understood her, saying severely, "Do you hear my words, or are you like the donkey with the lyre?" (Εσνε ὄνος λύρας?) At the beginning of the thirteenth century, an anonymous author wrote a diatribe against the animal figures decorating churches; among these animals he names "Boethius' donkey and lyre" (*Onos lyras Boetii*).[96] It was probably, then, this Greek proverb, this abbreviated fable, that inspired twelfth-century artists to carve a donkey with a lyre on capitals. We encounter it frequently in the region of the Burgundian school: at St.-Sauveur of Nevers,[97] St.-Parize-le-Châtel (Nièvre), on the portal of St.-Aignan of Cosne, on the portal of Fleury-la-Montagne (Saône-et-Loire), the portal of Meillers (Allier). But we find it in other regions also, on capitals at Brioude, St.-Benoît-sur-Loire, and Nantes (fig. 241).[98] On the south face of the old bell tower at Chartres, the statue of the donkey playing the lyre is still to be seen. It was a reminder to the young clerics, who came in droves to follow the lessons of the famous masters of Chartres, that they should apply themselves. Nearby, an angel with a sundial measured time for them.[99]

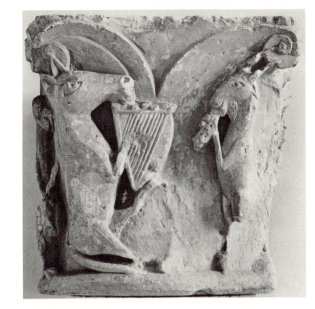

241. The musical ass. Capital from the Cathedral of St.-Pierre. Nantes (Loire-Atlantique), Musée Archéologique Thomas Dobrée.

IV

The animals discussed thus far have a meaning, and their presence in the church can be explained. But we come now to the strange fauna of capitals and portals; lions confronting each other at each side of a tree, eagles with two heads, birds placed symmetrically with necks entwined, monsters with double bodies and one head. What are we to think of them? Are they symbolic, and is there a lesson to be learned from them? Many nineteenth-century archeologists thought so, and persisted in trying to find the key to these hieroglyphs which were thought to express profound ideas. It was useless to point out to them that their research had been undermined from the beginning by St. Bernard, who stated in a famous passage that these hybrid monsters on capitals had no meaning. They replied that the great mystic was too much a stranger to the world of art for his testimony to carry any weight.[100]

It has become quite evident today that the efforts of this entire generation of scholars were unproductive. They worked in a vacuum, and St. Bernard was right. Our more profound knowledge of the decorative art of the East bears this out. It has become clear that, almost always, these strange animals of our Romanesque churches reproduce more or less freely the magnificent animals of Eastern textiles.[101] Our sculptors were not always concerned with teaching; most of the time they thought only to decorate. This is the point it is important to establish.

In Gaul, from Merovingian times, Eastern tapestries were the most magnificent ornaments of Christian basilicas. They were hung before the

Animals on capitals. They have no symbolic significance. They are borrowed from Eastern fabrics. Eastern textiles in the West. What our art owes to them. Confronting animals. Two-headed eagles. Traces of Chaldean and Assyrian art in our capitals. The hero Gilgamesh strangling two lions. The Assyrian sphinx and the human-headed bull. Birds with entwined necks. Animals with double bodies and one head. Two animals fighting.

doors and between the columns; they enclosed the sanctuary making it inaccessible like the holy of holies. They were used to decorate sarcophagi where lay the confessors and martyrs; precious cloths of silk and gold covered the tombs of St. Denis, St. Martin, and St. Remi.[102] A little of the virtue residing in the relics seems to have passed into these cloths, for people sought miracles of them. They were thought to become heavier once they were permeated with this beneficent fluid. Gregory of Tours tells us that Spanish Arians weighed the tapestry they had left on St. Martin's tomb and found it heavier than before.[103]

It has been a long time since the Church has placed rare fabrics on tombs, but Moslems have continued the practice that they borrowed from the Christians. Those who have been in the Near East know what poetry these faded fabrics lend to the old tombs of Islam.

Gregory of Tours, Fortunatus, and our early historians give us a glimpse of this beautiful church ornamentation. Dagobert had beautiful fabrics, woven of gold and decorated with pearls, hung from the walls and arcades of the basilica of St.-Denis.[104] These splendid tapestries, with flowers made of pearls, recalled those decorating the palace of the kings of Persia at Ctesiphon.

Not all these marvels have disappeared. Very early, it was the practice of the Church to wrap the relics of the saints in the richest of fabrics, for nothing was too magnificent for these holy remains. In this way, some extremely ancient fabrics have come down to us, enclosed in reliquaries. They have been removed and are now preserved in church treasuries.

The most priceless collection of textiles in France is that of the cathedral of Sens. There are wonderful silks, some of which may date from the fifth century;[105] they are only remnants, but they tell, in brief, the history of the art of textile weaving as it was practiced for seven or eight centuries. All these fabrics are Eastern. Some come from Christian Egypt, from Alexandria, or from the famous workshops of Panopolis. They are a last reflection of the art of antiquity. Others are Byzantine, but there are some that came from farther east, from the Persia of the Sassanids.[106] And here we come to the source of this marvelous art. As the genius of antiquity waned, it was Persia that was to radiate a new light and impose its taste on the ancient world. The textiles of Constantinople were inspired by Persian fabrics, and often copied them. But the extraordinary thing is that Sassanid Persia was not only heir to the ancient civilizations of the Tigris valley and the plains of Iran; it actually revived their genius. In the sixth century A.D., forms were reborn that were three thousand years old. No doubt they had never died, but during the reign of the Sassanids, which for Persia was an age of renascence, they were given new life. Chaldea, and later Assyria, had created the most powerful of all decorative arts. It was there that the composite monsters were invested with a terri-

fying realism, and symmetrical affronted animals were given religious grandeur. Heraldic art was created in Chaldea many centuries before our Middle Ages. This heritage fell to Persia, and along with it, the secret of color. As its share, Greece inherited the genius of line but seems never to have known the delights of color. Nothing could be purer than its painted vases, but could anything be more austere? Greece speaks to the higher reaches of the soul; Persia charms the eye. Sassanid tapestries and their Byzantine imitations are the color of gold and of fire; sometimes they are the color of ash, but ash of an exquisite rose or blue tone, marvels of subtlety. These are the colors we see in the sky as the sunset fades. We have only to compare this enchanting Eastern cloth with the Greek fabrics woven in Egypt and decorated with pale figures against dark backgrounds, severe as painted vases, to see what Persia contributed of light and joy to the world that was beginning. The symmetrical figures, the heraldic animals are usually enclosed in circles, but sometimes, too, lions following each other in dignified procession form a continuous frieze that recalls the relief sculptures of Susa.

The prestige of Sassanid textiles was such that even China, the country of silk, imitated them. A piece of cloth now in the museum at Tokyo shows the Persian theme par excellence—a lion hunt, interpreted by a Chinese artist.

When Persia was conquered by the Arabs, Baghdad replaced Ctesiphon, and the caliphs continued the Sassanid kings' tradition of magnificence. The colors of the cloth were as harmonious as before, and the old Asiatic decoration was faithfully perpetuated. We could not distinguish the old fabrics from the new if some Arabic characters did not sometimes identify their origin. The confronting cheetahs of the beautiful textile at Chinon, thought to be Sassanid, are Arabic, as the long-unnoticed inscription proves.[107] Thus the art of Persia did not die out with Persia; it was never more alive than in the Christian workshops of Constantinople and the Moslem workshops of Mesopotamia, Syria, Egypt, and Sicily. The ancient dreams of Chaldea and Assyria seemed to have won a share in eternity.

For centuries, our churches imported their most precious fabrics from the East. Gifts, such as those presented by the caliph Harun-el-Rachid to Charlemagne, brought us the marvels of the East.[108] But Eastern textiles were never more abundant in France than at the time of the crusades. After Antioch was taken in 1098, silk fabrics were separated from the booty shared by the barons and sent to churches.[109] When Bohemund returned from the East and traveled from sanctuary to sanctuary in France, relating his adventures to the people from the steps of the altar, he gave relics and coats of silk to the churches in memory of his visit.[110] A hero sent the banner he had taken from Arabs to a church in France. Robert

Curt-hose made a present of a flag he had won in the East to the monastery of La Trinité at Caen, which had been founded by his mother, Queen Matilda, who was buried there.[111] This glorious trophy has disappeared from the Abbaye aux Dames, but the Arab banner of Las Navas de Tolosa still hangs from the vaulting of the monastery of Las Huelgas, near Burgos. Our revolutions, indifferent to art and to glory alike, swept away our past. By singular chance and the result of an error, a beautiful piece of Moslem fabric, which was probably a flag, has been preserved in the treasury of the church at Apt, in Provence.[112] It has been known for centuries under the name of the Veil of St. Anne, and has been watched over as a precious relic. It is a large piece of cloth, almost three meters long, completely white with bands of a light color decorated with animals. On it can be deciphered the name of Al-Mustaeli, prince of believers. This name leaves the ordinary visitor unmoved, but to the historian it flashes like a bolt of lightning, for it was from the caliph Al-Mustaeli that the crusaders took Jerusalem in 1099. We have, then, at Apt a trophy probably taken in the holy city by one of Godefrey of Bouillon's comrades who had come from Provence—from Simiane or Sabran—and had made a present of it to his church. It is the oldest souvenir of a French victory preserved in France, and it is almost unknown.

Throughout the twelfth century, Eastern textiles poured into France. They came from Sicily, where the Norman princes had established workshops to reproduce Arab models, and they came also from Moslem Spain. But however plentiful these rich hangings, their beauty never ceased to astonish. The poets who described them said that they had been woven by the fairies. These fairies inhabited distant islands and clad themselves in white silk robes to work on their masterpieces, which they sometimes endowed with magical properties.[113] Such was the admiration excited by the brilliant colors and the fabulous animals of Eastern textiles.

These magnificent fabrics, to be seen everywhere in churches and even on the shoulders of priests at the altar, could scarcely have failed to stir artists' imaginations. The artist knows better how to admire than other men. The twelfth-century artist could not have held these beautiful pieces of cloth in his hands without becoming infatuated with their fairyland and its bold hieroglyphs; he would have sensed vaguely something both ancient and religious about them. Since these hangings, covered with monsters and animals, had been thought worthy to decorate the house of God, why should they not be copied on the capitals of the sanctuary? Then, what had happened in the beginnings of Greek art happened again. The earliest painted vases of Ionia, Rhodes, the Cyclades, and Corinth constantly betray the imitation of Babylonian textiles.[114] It is astonishing to find on the ancient oenochoae the affronted animals, grif-

fins, and sphinxes with women's heads of our Romanesque capitals. These similarities can easily be explained by the fact that the models used were the same, for the designs of Eastern textiles remained almost unchanged throughout thousands of years. In the West, civilizations succeeded civilizations; arts succeeded arts. The East, indifferent to events, offered its unchanging genius to these new peoples, all of whom learned in the school of the East. Our medieval art owes much to the East, infinitely more than has been acknowledged.

For example, I am persuaded that the origins of the stained glass window must be sought in the imitation of Eastern textiles. During the Middle Ages and until the fourteenth century, window openings were habitually closed by means of cloth. Imagine a piece of beautiful Eastern fabric held up to the window of a Romanesque church—it produces an illusion of stained glass: the same background of brilliant purple or blue, the same circles enclosing the subjects, the same border of ornament or points around the circles, the same palmettes placed between the circles to fill the empty spaces of the background. Moreover, one of the oldest windows in France still carries the mark of its origin; at St.-Denis, there is a window contemporary with Suger which actually represents a series of griffins inscribed in circles. Now these St.-Denis griffins are like the griffins also enclosed in circles which decorate a fabric in Sens, the sudarium of St. Siviard (fig. 242).[115] In Charlemagne's time, such fabrics, hung at the windows of basilicas, had inspired our first stained-glass artists. Soon after, the beautiful Byzantine fabrics with scenes from the Gospels enclosed in circles inspired them to represent scenes from sacred history in their windows.[116]

An Oriental carpet thrown on the floor served also as a model for the mosaics that formed the paving of the sanctuary. Nothing could have been more natural than these imitations, for the mosaic was itself a carpet, but longer lasting than one made of wool. This origin of Romanesque pavements is often quite easy to detect. At Ganagobie (Basses-Alpes), the mosaic discovered forty years ago has elephants, griffins, and all the fauna of Oriental tapestries scattered freely over the background or enclosed in circles.[117] At Lescar (Basses-Pyrénées), the lioness bringing down the ibex among birds dispersed over the background recalls a favorite motif of Sassanid and Byzantine artists, which they had imitated from Persia.[118] But the pavement that most clearly shows its origin is in Italy, at S. Benedetto di Polirone, beside the former tomb of the countess Matilda. There are the griffin, the unicorn, and the duck with dragon's head inscribed in circles with crenelated Arab borders: we could be looking at an Oriental carpet.[119]

The Eastern monsters of the mosaics sometimes struck the imagination

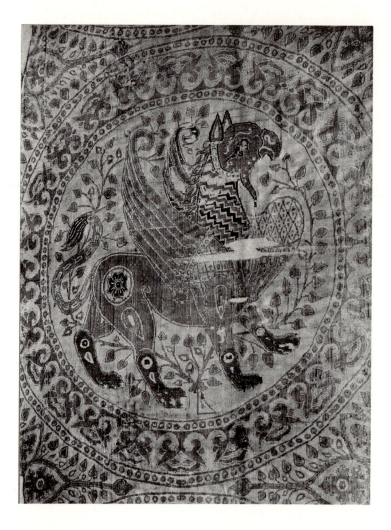

242. The shroud of St. Siviard (detail). Byzantine silk. Sens (Yonne), Treasury of the Cathedral of St.-Etienne.

so vividly that legends were created around them. At Moissac, it was related that the griffins in the pavement (now destroyed) had indicated to Clovis the place where he should lay the foundations of the monastery.[120]

If Eastern textiles inspired glass painters and mosaicists, it is not surprising that they inspired sculptors also. These are the imitations that I shall now review briefly, and we shall see the most ancient fauna of the East reappearing on our capitals.

On capitals, or even on twelfth-century tympanums, we frequently encounter two affronted animals separated by a stylized plant. The abacus of a capital at Moissac, for example, shows two symmetrical lions at each side of a palmette (fig. 243). Such a motif takes us back to the most ancient civilizations of Asia. Chaldean religious texts speak several times of the two celestial trees that grow at the entrance to the dwelling of the gods: one is the tree of life, the other, the tree of truth, and both have guardians who chase away evil spirits. The two trees planted at the entrance to the temple of Lagash were an image on earth of the two heavenly trees.[121]

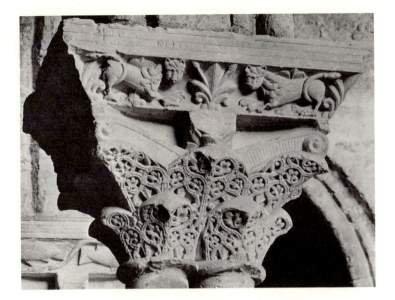

243. Affronted lions. Moissac
(Tarn-et-Garonne), Abbey Church of
St.-Pierre. Cloister capital.

Therefore, it is not surprising to find in the Tigris and Euphrates valleys
so many examples in art of a tree guarded by two spirits or sometimes by
two animals.[122] On one of the carved cylinders used as seals by the Chal-
deans, we see the tree guarded by two lions.[123] Persia borrowed the theme
from Chaldea and Assyria, and this was all the more appropriate since
Persia itself had its sacred trees. These trees are mentioned in the Avesta:
they grow near a spring, and they also have their guardians. One is called
the *haaoma* or *hom*, and its sap cures all afflictions of body and soul.[124]
Persian cylinder seals sometimes represent the *hom* guarded by two
lions.[125] Sassanid textiles transmitted the motif of the sacred tree and its
two guardians to the Arabs. Did the Moslems see in it the tree of their
paradise, the *touba*, which shades the spring out of which flow the celestial
rivers?[126] This could be, but perhaps they saw in it only a graceful decora-
tive motif. In the hands of their weavers, the tree became a simple orna-
ment, a stalk surmounted by a palm frond that separates two animals. It
was thus that this ancient Chaldean symbol, the mysterious image of life,
came down to us. It is strange, almost frightening, to encounter in our
Romanesque churches this Eastern image created so many thousands of
years ago. We walk through a rustic hamlet with its thatched roofs and
we enter the little church. The first thing we see is the tree guarded by
two lions that stood before a Chaldean temple forty centuries ago.

In our sculptors' copies, we find all the variants contained in the textiles
that served as their models. On a capital in the cloister of Moissac, as in
a relief now in the museum of Toulouse, there are two lions separated by
a palm; they seem to advance to meet each other. Such are the lions of
a Syrian fabric venerated at Chartres as the tunic of the Virgin (fig. 244).[127]

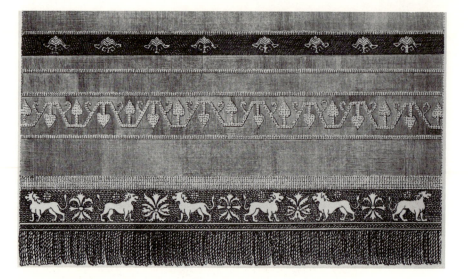

244. Tunic of the Virgin with frieze
of lions. Chartres (Eure-et-Loir),
Cathedral of Notre-Dame
(after Willemin).

But sometimes the lions rear at each side of the tree like heraldic lions; they are back to back, but they turn their heads to look at each other. Conceived in this way, the animals describe a most masterly arabesque. Lions of this type appear on a capital at La Charité-sur-Loire; they appear again on a capital at Lescar; they are to be found again and again throughout France. These tastefully stylized lions were created by Eastern artists, and Moslem textiles introduced them into France.[128]

The animals accompanying the tree are not always lions; sometimes they are birds, sometimes gazelles. Eastern artists, having forgotten the meaning of the ancient symbols, placed any kind of animal beside the tree trunk; they remained faithful to the spirit if not to the letter of the ancient models. Many Eastern fabrics are decorated with splendid birds arranged symmetrically at each side of a trunk that culminates in a fleuron (fig. 245).[129] Sometimes the two birds are back to back, but with an elegant curve of the neck, turn to confront each other.[130] Quite similar birds are to be found in France: they decorate the archivolts of a tomb at St.-Paul of Narbonne,[131] a capital in the nave at Paray-le-Monial,[132] a capital of St.-Aignan (Loir-et-Cher),[133] a frieze in the church of Marcillac (Gironde) (fig. 246)—to cite only a few examples among hundreds. In certain capitals, the imitation of textiles is betrayed by small details faithfully reproduced. In the church of Bommes (Gironde), a rosette is carved on the wings of the confronting birds, following the practice often used by Eastern weavers.[134] One of the most striking examples of this kind is on a capital in the church of Vignory (Haute-Marne).[135] This time, two gazelles are represented instead of birds. They balance each other at each side of a flowering tree; a scalloped half-circle rises above their heads and envelops them in a kind of elegant aureole. A fabric of Sassanid inspiration found several years ago at Antinoë in Egypt shows the same kind

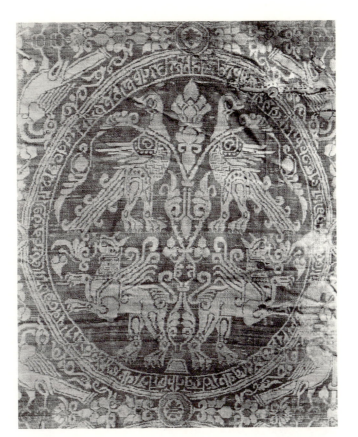

245. *Symmetrical birds. Woven textile* (detail). Sens (Yonne), Treasury of the Cathedral of St.-Etienne.

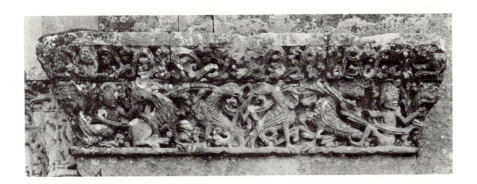

246. *Symmetrical birds.* Marcillac (Gironde), Church. Portal frieze.

of aureole above the heads of two affronted gazelles.[136] Here we see imitation in the very act. What could be more interesting than to find on the borders of Champagne the reappearance of a motif created on the plains of Iran and copied in the Nile valley. No art gives a better sense than Romanesque of the close ties between East and West, the brotherhood of the two halves of the world.

At every turn we are stirred by the symbols, so strange and so ancient, to be seen on Romanesque monuments. An abacus in the cloister of Moissac is decorated with a series of two-headed eagles (fig. 247); the same

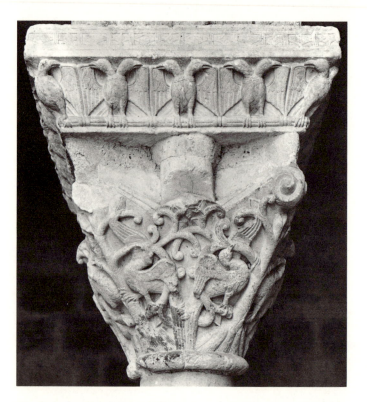

247. Two-headed eagles. Moissac (Tarn-et-Garonne), Abbey Church of St.-Pierre. Cloister capital.

two-headed eagles are carved on a door jamb of the church at Civray (Vienne), and on a capital in the church of St.-Maurice at Vienne. We are carried back in imagination to ancient Chaldea, the cradle of the civilized world. It is indeed on a very early Chaldean cylinder seal that, for the first time, a two-headed eagle appears,[137] and it has been thought to be the blazon of one of the most ancient of Chaldean towns, Sirpoula. It is a large eagle, a kind of roc from *The Thousand and One Nights*, which perches each of its talons on the back of a lion. In the art of the ancient East, the eagle is the noble bird which accompanies kings, overcomes lions, and comes to the aid of the Chaldean Hercules in his struggle against the monsters. For the peoples of Asia, this image had both

religious meaning and virtue, for it appears again among the Hittites many centuries later. The great Hittite peoples who are mentioned in the Bible, and who provided several of Solomon's wives, occupied Syria and the tableland of Asia Minor for a long time. Their art came from the valley of the Tigris and Euphrates, and the crude monuments they left in Cappadocia constantly recall Chaldea. In the rock sculpture of Petra, in Cappadocia, there is an example of the two-headed eagle with a prey in each of its talons.[138] The two-headed eagle did not disappear from these regions, for it can still be seen on the Moslem towers of Dyarbekir, the ancient Amida.[139] The Seljuk Turks had it carved on the gate of Konya, their capital, and seem to have used it from a very early time on their banners. How did this ancient Eastern symbol come down to us? Through textiles, as usual. A fabric at Sens (fig. 248), which is only a

248. Two-headed eagle. Woven textile (detail). Sens (Yonne), Treasury of the Cathedral of St.-Etienne.

remnant, is decorated with two-headed eagles outlined in yellow on a purple violet background; it is a Byzantine textile from the ninth or tenth century which was unquestionably copied from an ancient Sassanid model.[140] A famous sudarium of Périgueux is similarly decorated. Mesopotamia had faithfully preserved the ancient image, for in the thirteenth century, the eagle with two heads reappears in a textile from Baghdad.[141] This two-headed eagle is enclosed in a shield, and could be taken for the blazon of the German emperors. Indeed, their blazon undoubtedly came

from the East, copied from Eastern textiles and perhaps from Moslem banners. Surprisingly enough, the Turks could see at Lepanto, on the warships of Don Juan of Austria, the two-headed eagle that had once decorated their flags; but the old eagle of Chaldea, which had once helped them to conquer, this time turned against them. It can be seen what part ancient Chaldea played not only in the creation of decorative art, but in the creation of the heraldic art of the Middle Ages.

It is this marvelous past, vaguely glimpsed, that contributes so much charm to our twelfth-century decorative art; we come constantly upon legends that are thousands of years old. Sometimes in our travels through France we encounter capitals decorated with a figure standing between two lions which he seizes by the throat. This hero is to be seen at St.-Victor of Marseilles, and in the chapter hall of St.-Georges-de-Boscherville, near Rouen (fig. 249). It has been thought to represent Daniel in the lions'

249. Man between two lions. St.-Martin-de-Boscherville (Seine-Inférieure), Abbey Church of St.-Georges. Capital.

den, but Daniel was not a subduer of monsters. Romanesque artists were well aware of this, for they represented Daniel praying with arms raised between the two lions, who eye him but dare not approach. Daniel is represented in this way on a capital in the Moissac cloister and on a capital now in the museum of Toulouse; at St.-Eutrope of Saintes, Daniel assumes the Christian orant's posture as the lions lick his feet.[142] The figure strangling two lions cannot, therefore, be Daniel; and in fact, as Dieulafoy so ably demonstrated, he is none other than Gilgamesh, a demigod of Chaldean legend.[143] Gilgamesh is a hero of the first era of the world; his ancestors saw the Flood and handed down its story to him. Gilgamesh knew the mysteries. Accompanied by his friend Eabani, who still shared in animal nature, he wandered over Chaldea as a destroyer of monsters. When Eabani died, Gilgamesh went to the land of the dead to see him again.[144] Gilgamesh was a first version of Hercules, and there can be little doubt that his legend was known in Greece. It is he who,

in the great Assyrian relief now in the Louvre, strangles the lion in his arms just as Hercules was later to strangle the Nemean Lion. On Chaldean cylinder seals and Assyrian reliefs, there are several representations of Gilgamesh between two lions he strangles.[145] From Chaldea, Persia borrowed the hero who triumphed over monsters. A Persian cylinder seal shows him standing between the two lions he has seized by the throat.[146] Perhaps the Persian imagination interpreted this scene as an episode from Ormuzd's struggle against the forces of evil. Sassanid textiles transmitted the ancient image of the lion killer to the Byzantines and the Arabs. The treasury of the cathedral of Sens possesses a beautiful blue and gold textile that from the eighth century had been wrapped around the relics of St. Victor, one of the martyrs of the Theban legion;[147] it is the work of a Byzantine artist working from a Sassanid model (fig. 250). The figure with long hair, seizing by the throat the two lions rearing at his sides, would seem to be both a copy of a Persian cylinder seal and the model of a Romanesque capital. Here we have one of the works that were links between East and West. And there were many

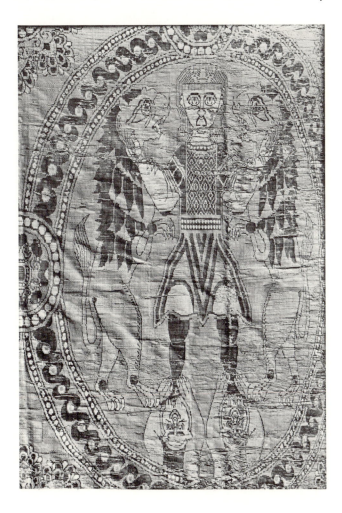

250. Shroud of St. Victor (detail). Woven silk. Sens (Yonne), Treasury of the Cathedral of St.-Etienne.

others. An almost identical textile was preserved for a long time in the treasury of the abbey of Saint Walburge at Eichstätt, in Bavaria.[148] But the masterpiece is in the museum of Vich, in Catalonia;[149] here, the hero strangling the lions has the fierce countenance, the beard, and the thick hair of the Gilgamesh of the epic; we are taken back in time to his Chaldean origins. However, this magnificent red and green cloth could not have been woven before the twelfth century, and an inscription in Kufic lettering permits us to attribute it to a Moslem workshop. We now understand how a myth more than forty centuries old could reappear on our Romanesque capital—a truly remarkable transmission, but an explainable one.[150]

Not only Gilgamesh, but Chaldean and Assyrian genii also appeared in Romanesque art. In the museum of Arles, there is a twelfth-century capital that represents a quadruped with eagle wings and the head of a woman (fig. 251);[151] the same monster reappears on the portal of St.-Loup-de-

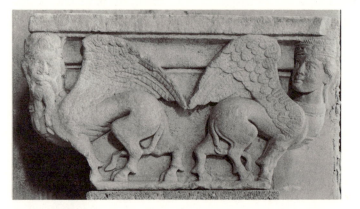

251. Winged quadruped with human head. Arles (Bouches-du-Rhône), Musée Lapidaire. Capital.

Naud, near Provins.[152] We remember seeing figures like this on the archaic vases of Greece and Ionia.[153] But the Greeks were not its inventors; they took it from Assyria and Chaldea, to which we must always return in looking for the origins of monsters, for that was their birthplace. It was not fantasy that created them but religious thought. These beings, summarizing all living nature, are at the same time quadrupeds, birds, and women; they have strength, swiftness, and intelligence; they are not gods but genii, intermediaries between man and the superior powers.[154] The Assyrians carved them on their seals,[155] embroidered them on their tunics,[156] and rested the columns of their palaces on their backs.[157] These winged sphinxes with heads of women never ceased to live in the Eastern imagination; the Persians received them from the Assyrians and transmitted them to the Arabs. For Moslems, the quadruped with a woman's head was the mare Borak, which carried Mohammed to heaven. Arab weavers, copying ancient Sassanid models, gave the Assyrian sphinx new youth. They represented it sometimes in isolation and enclosed it in a circle,[158]

and sometimes with another sphinx to form a symmetrical group.[159] This is why, in all parts of the East, sculptors themselves soon began to employ the ancient motif of the sphinx; Christendom as well as Islam adopted it. It is carved on the exterior of the Old Metropolitan Church of Athens, and on the cedar doors of the hospital in Cairo called the Muristàn Ka-läun. Thus, it is no longer a surprise to find the winged quadruped with the head of a woman in our Romanesque churches. The importation of Arab textiles explains the migration of monsters from the East to the West. In Moslem textiles, the female sphinx was sometimes given a crown, and this explains why it is crowned both at Arles and at Cairo. The remarkable thing is that in Assyrian monuments the sphinx already wore a kind of tiara. Such was the fidelity of imitation down through the centuries.

Thus far, we have described only half of the Arles capital. Paired with the female sphinx, is a masculine sphinx, a winged quadruped with a man's head and a thick beard. It is impossible not to think of the famous winged bull with human head that was the protecting genie guarding the gates of Assyrian palaces. Such a mixture of forms could not have been invented twice. On the head of the Arles monster there is a crown instead of the tiara of the bull of Khorsabad, and this again is testimony to the sacred character of the original. We can all the more easily accept this interpretation of the strange figure at Arles since it is paired with a female sphinx whose Eastern origin is beyond doubt. Moreover, at Sens there is a piece of fabric decorated with winged quadrupeds with men's heads, which proves that the Assyrian monster was known to Eastern weavers.[160] Why should this motif not have been perpetuated in the East? The Sassanid artists could admire, as we admire today, the formidable winged bulls on the high terraces of Persepolis, surrounded by desert and facing the mountains as they guard the entrance to Xerxes' palace, burned by Alexander. Many Eastern fabrics must have made the ancient genii of the gates known in France, for we come upon them several times in our churches. The baptismal font of Vermand, a work of the twelfth century, shows the figure exactly as it is at Arles; the head with a long beard also wears a crown. In the small lapidary museum of Fontenay, near Montbard, the Assyrian monster reappears on a Romanesque capital; it has no wings, it is true, but we recall that Chaldea had created a type of bull with human head but no wings. No work could remind us more forcefully of ancient Assyria than the monster of Fontenay.[161]

Thus, we must go to the farthest reaches of the East to search out the origin of our medieval decorative art. Among the motifs found in our churches, we will not forget the graceful arabesque made by the entwined necks of two birds, forming thus a kind of caduceus. This motif first appeared on a capital in the cloister of Moissac (fig. 252); then it reappeared

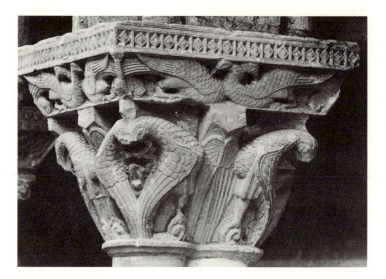

252. Birds with interlaced necks. Moissac (Tarn-et-Garonne), Abbey Church of St.-Pierre. Cloister capital.

at St.-Denis, where it was apparently brought by the artist from the Midi. Soon it was to be seen everywhere,[162] but particularly in central France—in the Cher at La Celle-Bruère, Villecelin, Neuilly-en-Dun; at Preuilly in Indre-et-Loire. Sometimes, the necks of two dragons instead of two birds are entwined.[163] At first, we are tempted to attribute this motif to the fantasy of our artists, and the conjecture seems all the more plausible since the theme was used in our manuscripts. But we change our minds upon examining various monuments of Eastern art, notably the charming ivory boxes carved in Arab Spain in the tenth and eleventh centuries to contain the jewels and perfumes of the sultans' wives. One of these, now in the Victoria and Albert Museum in London, is decorated with two birds with large wings, entwining their necks.[164] The Spanish Moslems did not borrow this motif from the Christians; it came to them from the East. In fact, animals with entwined necks are to be found everywhere in the art of the East. They are carved on the wooden door of St. Nicholas of Ochrida, on the border of ancient Macedonia. They are painted on the frontispiece of an Armenian manuscript, and here the birds with entwined necks are two magnificent peacocks.[165] We find them in Abyssinia, as far as Axum. What are we to conclude from this, if not that the theme was born in the East? And as a matter of fact, we encounter it at the very beginning of the Chaldean civilization. One of the earliest known carved cylinder seals is decorated with two strange quadrupeds whose very long necks are entwined (fig. 253).[166] They could be antediluvian monsters that these early peoples had retained some memory of. Strangely enough, these same animals reappear in Egyptian art: a carved stone—a pallet contemporary with the first Pharaohs—is decorated with two monsters with entwined necks just like those in Chaldea. The similarity is such that scholars now wonder whether Egypt (where the legend of Gilgamesh is

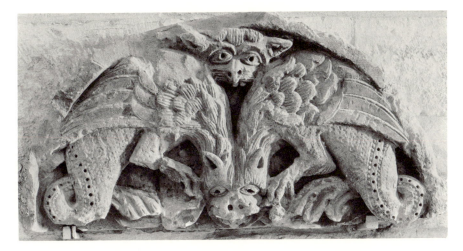

253. Animals with interlaced necks. Ancient Near Eastern cylinder seal (impression). Paris, Louvre.

also found) received some elements of its civilization from the valley of the Tigris and Euphrates. For our purpose, it is enough to have found in Chaldea the motif whose origins we are seeking. There is reason to believe that its transmission from the East to the West was performed, as usual, by Sassanid and Arab textiles. But here proof is still lacking; a discovery may one day furnish it.

We have been looking at two animals entwined; sometimes our Romanesque capitals show two animals so closely joined that they have only one head for two bodies. On the porch of Moissac, two lions are merged into a single head, with an enormous mouth and savage grin.[167] Such a motif seemed expressly made for the decoration of capitals: the head occupies the angle and the body the bell of the capital. That is why it was so often used on Romanesque capitals. There are examples at Paray-le-Monial, Notre-Dame-du-Pré of Le Mans, St.-Benoît-sur-Loire, Rieux-Minervois in Aude, and Charlieu in the Loire.[168] The monster with one head and two bodies sometimes filled an entire tympanum, as at St.-Gilles of Beauvais, a powerful work (now in the museum), which is both savage and harmonious (fig. 254).[169] Such a conception seems to take us back to an ancient stage of humanity, and in fact, we find it in the East at a very early period. Pottier, who was the first to study the history of the monster with a double body and one head, discovered it first on the intaglios of Mycenae and Vaphio, then on an Ionian vase in the Louvre.[170] Early Greek intaglios

254. Double-bodied monster. Tympanum from St.-Gilles. Beauvais (Oise), Musée Départemental de l'Oise.

often imitated Assyrian stone carvings; on the other hand, the decoration of Greek Ionian vases seems oftentimes to have been borrowed from Babylonian textiles. Thus, we infer a Chaldean original as yet undiscovered. But in this case, the Eastern textiles that transmitted the motif to our Middle Ages have been preserved. One of the most beautiful Moslem fabrics in the museum of Vich is decorated with a series of confronting birds whose upper parts fuse and for two bodies have only one head—an enormous lion's head, the eyes of which seem to emit flames.[171] A textile from Asia Minor, woven earlier than the eleventh century and now in the castle of Ofen (Buda) in Hungary, is decorated not with two but four animals with a single head.[172]

We often see on our capitals or Romanesque portals a bird of prey lighting on a quadruped and attacking it with its beak. There are excellent examples of this motif at St.-Eutrope of Saintes (fig. 255),[173] St.-Benoît-sur-Loire, Ste.-Croix of Bordeaux, and Soulac (Gironde). Sometimes the bird of prey is mounted on another bird, as on the curious capital in the nave of Fontevrault and on the portal of Espira-de-l'Agly in Roussillon. Sometimes there is a quadruped that has leaped upon another quadruped and holds it in its claws, as can still be seen at Fontevrault. The identical themes, so beautifully adapted to decoration, are to be found in the Arab art of the Middle Ages. The brass vases of Mosul, the ivory boxes of Moslem Spain, the wooden panels of Cairo, the basin of the famous fountain of the Alhambra are all decorated with eagles mounted on rabbits, falcons mounted on partridges, lions and leopards and griffins mounted on gazelles, bulls, and fabulous animals. The Christian East was as fond of this

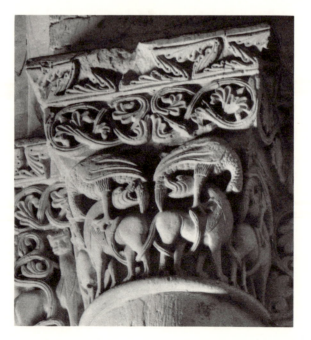

255. Birds standing on quadrupeds. Saintes (Charente-Inférieure), Abbey Church of St.-Eutrope. Transept, northeast pier capital.

motif as the Arab East, and in the monasteries of Mt. Athos it was used to decorate the balustrades of fountains. The fact is that the East and the West then had the same models: historiated textiles. Many of these models still exist today. An Arab textile from the eleventh century preserved in the treasury of Pébrac (Haute-Loire) is decorated with a series of wild beasts bringing down antelopes, and an Eastern textile that came from Clairvaux is decorated with a bird of prey mounted on another bird.[174] This beautiful fragment from Clairvaux once enfolded the relics of St. Bernard. Thus, this meaningless decor of animals and monsters, which the great Church Doctor had so eloquently condemned, accompanied him even to the grave. To honor him in this way was to proclaim the defeat of his ideas, and art was revenged.

Eastern textiles, then, transmitted to our artists the theme of the struggle between two animals, an extremely ancient motif in the East since it is found almost at the beginning of Chaldean civilization. In fact, on an ancient Chaldean cylinder seal in the Louvre, there is an eagle pouncing on a bull and devouring it.[175] Assyria took this group from Chaldea. An Assyrian intaglio represents an eagle lighting on an ibex.[176] In an Assyrian relief, there is a griffin overcoming an antelope.[177] In the beginning, the victory of the eagle and the griffin could have been a sort of sacred hieroglyph, but at the time when the weavers of Persia—so much admired by Marco Polo—were reproducing the ancient motif, they no doubt saw only its beautiful lines.

It is a no less ancient motif that reappears with fierce beauty on the trumeau of Moissac. Crossed lionesses, whose terrible muzzles seem to transform them into dragons, are superposed; three of these pairs standing one on the other form a strange pillar.[178] We think of the East in spite of ourselves, and not without reason. In fact, it is on Assyrian cylinder seals and on intaglios that we first see two standing lions intercrossed.[179] Many centuries later, they were used again on the silver ewer now in the Cabinet des Médailles, the work of Sassanid silversmiths. The motif probably came down to us in the usual way, through Persian or Arab textiles, but it is also possible that it came to be known through Eastern manuscripts. In a Bible of St.-Martial of Limoges, now in the Bibliothèque Nationale, there is a colonnade whose capitals are composed of two crossed lions,[180] and this colonnade is a clear imitation of the Gospel canon tables that decorated Syriac manuscripts. There can be no doubt that the theme had long been perpetuated in the East. The Moissac sculptor gave it a power and a strangeness that it never had before; he was more Eastern than the Assyrians themselves. The same motif is found at Souillac (Lot), and was certainly brought there by Moissac artists. It reappears again, but in weakened form, on a capital of the church of Monsempron (Lot-et-Garonne).

V

Classical decoration has little place in twelfth-century art. Confronting griffins on two sides of a cup. Eastern decoration predominates until the thirteenth century.

We have reviewed the real or imaginary animals most often encountered in Romanesque churches: all of them, as we have seen, came to us from the East. Must we conclude from this that our artists were simple copyists? Certainly not, for they often transformed the originals and created new monsters; they produced fantasies for which textiles offered no models. Nevertheless, it is clear that the East imposed the symmetry of its art upon them, like a law, and that even when they created they could not escape the influence of the heraldic art of ancient Chaldea. The East marked the art of the twelfth century with an indelible imprint.

It is strange to think that Greece and Rome played so small a part in the art of our capitals or in the decor of our portals. True, in Provence, a delicate aura of antiquity surrounds the art. Classical foliated scrolls, Greek borders, and heartleaf ornament gracefully accentuate the main lines of Romanesque architecture; nevertheless, there as elsewhere, the monsters carved on capitals were borrowed from the ancient East. In the rest of France, the lessons of classical antiquity seem to have been forgotten, and only rarely, here and there, do we come upon a motif that has retained something of the Greek genius. One might think that the eagles so often used to decorate our Romanesque capitals were taken from classical capitals, but nothing is more uncertain. The eagles stylized so majestically in Eastern textiles must much more often have inspired our artists. We would be mistaken to think that the pairs of winged horses confronting each other on the portal of the cathedral of Angoulême were imitated from the art of antiquity. They have nothing to do with Pegasus and the graceful Greek myth; they come out of Assyrian legend. In fact, the winged horse, which appeared for the first time in the sculptured reliefs of Nineveh,[181] is an Assyrian creation. Persia borrowed it from Assyria, as a Sassanid ewer, now in Japan, proves. Persian textiles made the motif known in the Far East as well as in the West. Among the textiles given to Roman churches in the eleventh century by the popes, the *Liber pontificalis* mentions one "that was decorated with a white winged horse."[182] Some of these Eastern fabrics showing winged horses still exist.[183] There is even less reason to doubt that the winged horses of Angoulême were imitated from textiles when we find the same horses in a relief of the church of S. Giovanni Maggiore at Naples.[184] But here, the stylized wings which exactly reproduce the design of the textiles identify their source.

However, our Romanesque capitals furnish one motif of undisputed Greco-Roman origin: the two griffins arranged symmetrically on each side of a vase.[185] In Roman Gaul, these two griffins were frequently orna-

ments on monuments and tombs. We can scarcely imagine anything more magnificently decorative than these two winged lions with eagle heads and one claw resting on an amphora. The beauty of this group appealed strongly to the Middle Ages. On the north portal of the cathedral of Vienne in Dauphiné, the lintel—a charming relief taken from a classical temple—is decorated with two griffins separated by a vase. We would expect to find these griffins in Provençal churches, which were built among Roman monuments, but there are none.[186] On the other hand, there are several examples in the churches of Auvergne. Although Auvergne valiantly resisted Caesar's armies, it allowed itself to be permeated by the Latin spirit. Michelet called it "the last of the Roman provinces." The Romans had built a temple on the summit of the Puy-de-Dôme which was one of the religious centers of Gaul. The Allier river valley has from time to time yielded statues, reliefs, and vases from antiquity. In the twelfth century, there must still have been Gallo-Roman tombs decorated with griffins at Clermont-Ferrand, for they are used to crown a column in the apse of Notre-Dame-du-Port. They reappear on a beautiful capital at Mozat, near Riom,[187] and again on a capital at Brioude. The Auvergnat sculptors adopted the griffins as a kind of workshop theme, which spread to neighboring regions. It is reproduced more or less faithfully on capitals in the churches of Trizac and Roffiac in Cantal, and in the church of St.-Vidal in Haute-Loire. Singularly enough, the Middle Ages seem to have taken the motif of the two griffins from the art of classical antiquity because they saw in it the same symmetry used in Eastern art, and indeed there is no doubt that these two confronting griffins again come from the Assyrian East. Long before the classical era, the lintel of a palace of Sennacherib had been decorated with two griffins placed at each side of a vase.[188] Only the Assyrians could have said what this mysterious vessel contained, and what treasure the griffins were guarding; the Greeks no longer knew. The Ionians borrowed the motif of confronting griffins from Assyria to decorate the temple of Athena at Priene. Greek artists introduced the griffins into the Mediterranean world. It is interesting to note that by a kind of instinct the Middle Ages chose from the treasury of antique ornament not what the Greeks had created but what the Greeks had received from the East.

The part played by classical antiquity in the repertoire of animals and monsters that twelfth-century artists were so fond of using amounts to very little. Almost all the motifs were borrowed from the East.

The history of decorative art is a very strange one. Throughout the centuries, the graceful fantasies of the Greek genius had charmed the Mediterranean peoples. Rome had carried the creations of Greece to the ends of the barbarian world. In the countries that were Roman, we still

come upon this enchanting decoration, the most beautiful ever created by man: dolphins, tritons, sea horses, nereids—all the poetry of the sea; Dionysiac panthers, lion muzzles, bucrania decorated with wreaths, swans wearing garlands, eagles enclosed in crowns—all the grandeur and all the grace of the animal kingdom. No poet or philosopher has given us as clear a sense of the beauty of living forms as the Greek artist revealed, and Plato could not have expressed it better when he said that beauty was the law of the world.

But the reign of the Greek genius came to an end. For the historian of art, the end of the world of antiquity is marked by the triumph of the East. The decorative art of Chaldea, Assyria, Phoenicia, and Persia was revived. The world has never been without guides, even in the most barbaric centuries. From Merovingian times on, it was from the East that Europe sought instruction. The decorative art of the Greeks, where all is light, order, and beauty, was succeeded by an art where all is dream, half-light, and religious mystery—an art ruled by the imagination, which re-fashioned the living world in its own way. This creation, parallel to nature, is certainly not lacking in grandeur. The monster, in which all the elements of animals are combined, was a creation of the East. Even real beings were conceived in the East as beautiful arabesques that could be curled or uncurled at one's pleasure. This is the art that replaced Greek art and was received by the Middle Ages; it gave to medieval decoration its strange character. It links our twelfth-century capitals to Arab and even sometimes to Chinese and Hindu decoration—a miracle easily explained, since Mesopotamia was its birthplace. The East formed our twelfth-century artist-decorators, imposed its habits of mind upon them, bent them to its own sense of symmetry, and awoke in them the spirit of heraldic art. Eastern art was in perfect harmony with the spirit of the early Middle Ages, in which dream was still all-powerful and man had not yet renewed his contact with nature. The Romanesque artist had no trouble in making this art his own, and becoming a creator in turn.

The reign of Eastern art lasted longer than that of the art of Greece. It ended abruptly in the thirteenth century. Then France, by a stroke of genius, created an entirely new decorative art. The moment when our artists first carved on their capitals the leaves of arum, plantain, and fern that they themselves had lovingly gathered was as decisive a one as that when the troubadours for the first time sang of what was in man's heart. France restored to the world its youth.

There have been only three great decorative arts: the art of Greece, the art of the East, and the art of France. The art of France lasted until the day that Italy of the Renaissance revived the decorative art of Greece.

This chapter has pointed out what the decorative art of the twelfth century owed to the East. There is no point any longer in looking for the symbolic meaning of confronting lions, birds with entwined necks, eagles with two heads—a subject that so preoccupied our predecessors. St. Bernard was a hundred times right. It has become quite clear that, with a few exceptions, the monsters carved on our capitals have no symbolic meaning. They were not meant to teach; they were meant to please. St. Bernard thought these fantasies were childish and ridiculous. But what would he have thought, had he known, as we know today, that these monsters were the legacy of the ancient pagan religions of Asia, and that they set genii, demons, and idols before Christian eyes? No doubt he would have thundered like a prophet against false gods.

With our broader knowledge of history, these monsters on capitals do not seem ludicrous to us as they did to the great Church Doctor. On the contrary, to us they are poetic marvels, the vessels of dreams transmitted from one to the other by four or five nations of people throughout thousands of years. Into Romanesque churches they brought Chaldea and Assyria, the Persia of the Achaemenids and the Persia of the Sassanids, the Greek East and the Arab East. All of Asia brought gifts to Christendom, as the magi once did to the Child.

X

The Monastic Imprint

I

The supernatural in the life of monks. The role of angels and devils. The type of Satan. The devil in the art of Moissac. The devil in Burgundian art. Art and the nocturnal visions of monks.

The monastic spirit left a deep imprint on twelfth-century art. The desire to express in visible terms the harmonies of the world, the love of the past, the exaltation of ancient saints, monks and even heroes—all these ideas that gave so great and noble a character to art originated in the cloister.

But the monks revealed other preoccupations as well. Twelfth-century art sometimes appears to be an art of visionaries. We are astonished by the part played in it by the supernatural, but the fact is that the supernatural was just as much a part of the life of the monk.

To understand the monks who built the great abbeys of the eleventh and twelfth centuries, it is not enough to read the theologians, writers of sermons, and encyclopedists; we must turn to those revealing books in which the monk depicts himself in full: the *Chronique* of Raoul Glaber, the *Historia ecclesiastica* by Ordericus Vitalis, the *Liber miraculorum* of Peter the Venerable, and the *De vita sua* of Guibert de Nogent, a book in which a medieval man, in imitation of St. Augustine, makes his confession.

Reading these extraordinary books, it sometimes seems that monks lived half in dream. For them there were no frontiers between the visible and the invisible worlds; it seemed no more extraordinary to talk with the dead than with the living. The Cluniac monk climbing the dormitory steps at night, alone, sometimes meets a dead monk who asks him to pray for his soul.[1] The lay brother going home to his farm across the forest sees a phantom rise up before him. This is the baron who had once made the countryside quake and had died long ago on his way back from Rome. He wears a fox skin on his shoulders. "Why are you wearing that fox skin?" the monk asks him. "Because I once gave it to a poor man," replies the ghost, "and now it protects me against the fires of Purgatory and keeps me wonderfully cool."[2] In the evening when the monks gathered in the heated public room and were permitted to talk, strange stories were told. In the monastery of St.-Evroul in Normandy, they talked of the

army of phantoms that Gauchelin had seen passing through the country-side. There were foot soldiers marching in double-quick time, coffin bear-ers, amazons whose saddles bristled with red hot nails, priests in mourning copes, monks with faces hidden by their hoods, barons carrying black banners and mounted on huge black horses. This somber army passed with terrible noise, in the clutches of a nameless terror. As a horseman passed by, he touched Gauchelin and the mark left on his face by the phantom's fiery fingers could be seen.[3]

Peter the Venerable himself, the grave abbot of Cluny, liked to listen to these tales: "It is a consolation," he said, "to us who lament in this sad world to hear tell of that land we sigh for, and of the things that enlarge our faith and our hope."[4] And he himself tells the story of an army of phantoms that at night passed by Estella, on the road to Santiago. One of them entered the house of his former master and revealed to him that King Alfonso had been saved from the fires of Purgatory by the prayers of the monks of Cluny.[5]

He also tells of a young novice who went by night to the cemetery of the priory of Charlieu. A lantern was lit at the top of the hollow column called the lantern of the dead. In its pale light, he saw something that froze him with horror: all the former monks had come out of their tombs to sit around the cemetery in solemn assembly.[6]

Miraculous visitors came to the great Benedictine monasteries where everything was minutely regulated and life appeared to be so monotonous. Angels manifested themselves, but only to pure souls. At Cluny, a monk saw an angel enter the infirmary and bless the stone covered with ashes on which dying monks were laid.[7] The dying, if they had lived a holy life, saw angels surrounding their beds. The monk Bernard, who for many years had prayed and meditated at the top of a tower in the chapel of St. Michael of the church of Cluny, said as he was dying that he saw an army of angels clothed in white enter the monastery.[8] And if a holy brother who had lived an angelic life could not see the angels, he heard them. Gerard, a true saint whose virtues were celebrated by Peter the Venerable, listened in ecstasy to the celestial melodies filling the empty church at night.[9]

But the devil was a more frequent visitor than the angels. He was the monk's most formidable enemy. From the moment a Christian decided to enter the cloister, he had everything to fear from this tempter. Guibert de Nogent tells the story of a novice who had his robe snatched off by devils at the very moment he first put it on, and he kept it only by hanging on with his teeth.[10] St. Hugh and Peter the Venerable compare the monas-tery to an entrenched camp besieged by the enemy. The more saintly the abbey, the more it was threatened, and it would take a whole book, Peter the Venerable said, to tell of the assaults the devil had made on Cluny.

He constantly tried to extinguish the flame in the monk's heart. Ordinarily, the devil was invisible, but sometimes he manifested himself.[11] It was mostly at night that he prowled through the sleeping abbey, before the hour of matins. A monk meditating on the Psalms as he lay in his bed saw a procession of devils cross the dormitory; they advanced slowly, their heads covered by hoods; their number, their gravity, and their silence were terrifying.[12] Sometimes Satan wore the monastic robe to deceive the monks more easily. He was bold enough to present himself at Cluny as the abbot of Grottaferrata, and he urged a young monk to leave the monastery, promising him an easier life than the one he led in the abbey.[13] Sometimes the devil assumed animal forms. In a dream, a novice at Cluny saw a monstrous bear sitting on his chest. He awoke, thinking he had dreamed this, but when he opened his eyes he saw before him the bear who growled and stared at him. The novice's terrified cries awakened the other novices and put the monster to flight.[14] A friar carpenter who slept alone in a cell lit by a lamp saw an enormous vulture with heavy wings light on the foot of his bed. Two devils appeared, and the vulture questioned them about the crimes they had caused men to commit during the day. Suddenly one of the devils said to the vulture, "Take this ax and cut off the foot of this monk who is getting out of bed." The vulture raised the ax, but the frightened monk quickly drew back his foot, and the vision vanished.[15]

Most often, the devil assumed a human face, but his hideously deformed features were all the more frightening.

The supernatural, which assumed so large a place in the lives of monks, could scarcely have been omitted from monastic art, and in fact we find many examples of it. The capitals at Vézelay give somewhat the same impression as the books written in the cloister; angels and devils constantly appear in them. Many of these capitals have no meaning for us because they have to do with legendary stories once famous in the abbeys but now forgotten. For example, an eagle[16] carries a dog in its claws and a child in its beak as a man despairs; a devil, its mouth stretched from ear to ear, bursts out laughing. Another capital shows an angel seizing a devil with both hands; the devil tries to pull away, but the angel holds fast (fig. 256). The most mysterious of these capitals, and the most strangely poetic, shows an angel of justice, with raised sword, about to behead a crowned figure kneeling before him (fig. 257). To what drama is this the conclusion? Is it the archangel of the *Légende des siècles*, who will "wipe his sword on the clouds"?

There is nothing more original at Vézelay than some of the capitals devoted to the devil. The image of him there seems to have been born of a nightmare, and we actually have before our eyes the monks' dreams.

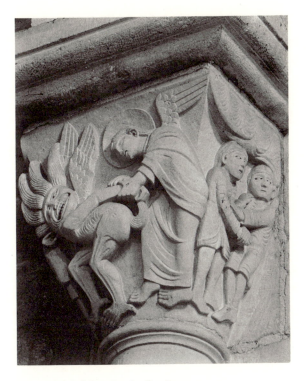

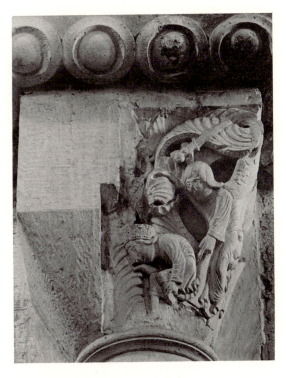

256. Angel holding the devil prisoner.
Vézelay (Yonne), Abbey Church of Ste.-Marie-
Madeleine. Capital.

257. Angel beheading a king. Vézelay
(Yonne), Abbey Church of Ste.-Marie-
Madeleine. Capital.

But to fully understand the novelty of this figure of Satan, we must
sketch briefly the artistic history of the devil.[17]

Satan appears nowhere in the art of the catacombs. What place would
he have in these gentle idyls, among the images that speak only of hope?
Even after the triumph of the Church, he does not appear in the mosaics
of apses or on the sides of carved sarcophagi. Serenity and peace emanate
from this great art of the Early Christian era. All is light, and nothing
presages the darkened centuries to come.

One of the earliest images of the devil that has come down to us is in
a famous Greek manuscript in the Bibliothèque Nationale: the St. Gregory
of Nazianzus (fig. 258).[18] This beautiful book was illuminated in the
ninth century, but its miniatures seem to be copies of sixth-century origi-
nals; hence, the Satan in the St. Gregory manuscript goes back to the
time of Justinian. He is shown before Christ in the scene of the Tempta-
tion. This devil does not in the least resemble the monster created by our
twelfth-century artists; he is a fallen angel, a son of God who has turned
away from his Creator but who has not been able to efface entirely the
divine imprint. He has wings and would be almost identical with other

258. The Temptations of Christ.
Homilies of St. Gregory of Nazianzus.
Paris, Bibl. Nat., ms. gr. 510,
fol. 165r (detail).

angels were he not half naked and his face and body the color of night.
He is not black; he is a somber purple, the color of the Eastern night. The
Greek imagination remained noble throughout the centuries; it made
nothing ugly, not even Satan. The image of the devil, fairly rare in Byzan-
tine art,[19] is never hideous. At Daphni, the Christ descending into hell
tramples beneath his feet a kind of conquered hero resembling the captive
barbarians of the reliefs of antiquity.[20] This is Satan who, even in defeat,
retains the pride of a rebel. In the Greek Gospel-books of the eleventh
century, Satan is a small winged figure of a somber color, resembling the
εἴδωλον of Greek funerary urns, the soul freed from the body floating
above the dead.[21] Nowhere do we see the terrifying images of Western
art.

Moreover, if we read the Lives of the Desert Fathers, in which the devil
played so great a role, we will be surprised to find that he is never rep-
resented as he is in the legends of our Middle Ages.[22] On the contrary, he
appeared to the anchorites in the most seductive of guises. St. Anthony
and St. Pachomius saw him in the form of a young woman whose beauty
was skillfully enhanced by ornaments.[23] The hermit Abraham, convers-
ing with an elegant young man, perceived that he was talking with the
devil.[24] St. Simeon Stylites was visited by a beautiful angel with flaming
hair, whom he quickly recognized as Satan.[25] Sometimes Satan had the
audacity to pass for Christ himself, and in this way he once deceived St.

Pachomius, but the hermit discovered the enemy's trick by the uneasiness he felt in his heart.[26] St. Anthony, who waged so many bitter battles with Satan, never saw him as our artists later pictured him; his "temptations" in no way resemble those of Callot. The demons who came to terrify him were not nameless monsters; they took on the appearance of the beasts of the desert: lions, wolves, bears, serpents, scorpions.[27] Sometimes the devil was a passerby who transformed himself into a giant and terrified the saint when his head rose as high as the roof of the house;[28] sometimes the devil was an Ethiopian with a black face.

It is thus not to the Eastern imagination that the Middle Ages owes this terrible Satan of twelfth-century capitals. He was not yet known to Carolingian art. Carolingian miniaturists seem more and more to have been the submissive pupils of Eastern artists; it was from them they borrowed their type of devil. In the Drogo Sacramentary, Satan comes to tempt Christ in the form of a nude satyr wearing an animal skin as a kind of girdle;[29] in the Utrecht Psalter, the demons are winged men who fight with the angels—figures that are not frightening in the least.[30] Toward the year one thousand, a Gospel-book illuminated at Reichenau for the Emperor Otto III, the pupil of Gerbert, reproduces faithfully the antique image of the devil.[31] In the scene of the Temptation, Satan is a fallen angel with a somber face, carrying a scepter.

It was in the eleventh century, it would seem, that the artist-monks formulated the monstrous Satan of the following century. We see his beginnings in the Apocalypse of St.-Sever—his thin body, upstanding hair, and wings armed with darts (fig. 259).[32] As for great monumental art, it is at Moissac, Beaulieu, and Souillac at the beginning of the twelfth century that he first appeared in all his novelty.

At Moissac, the demons accompanying the Parable of Dives have been worn away by time, but we can still make out their tall, emaciated silhouettes and their bestial faces (fig. 17). At Souillac, on the other hand, the demons of the Legend of Theophilus are perfectly preserved (fig. 306).[33] They still wear the slashed peplum with pointed scallops of antique satyrs around their hips, but this is a final reflection of the past. These strange figures are completely new. Satan resembles a desiccated corpse whose bones and tendons show beneath the parchment of his skin. One senses that he comes from the land of the dead. His face has nothing human left in it; membranes joining the chin to the neck give him the aspect of a toad; his nose is flattened into a muzzle; terrible eyes are set in deep sockets; the small wings fastened to his back recall that the monster, fallen lower than the beasts, was once an angel. The devil of Souillac reappears in almost identical form at Beaulieu, in the scene of the Temptation.[34] Such was the Satan created by the school of Languedoc, the first really

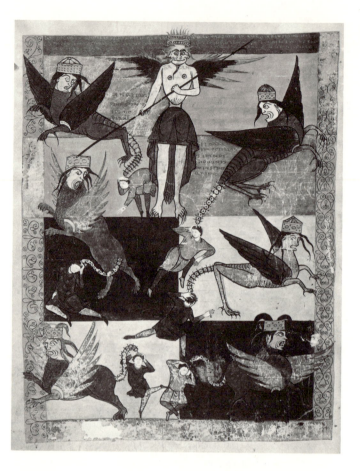

259. Satan and the locusts. Beatus
Apocalypse of St.-Sever. Paris, Bibl.
Nat., ms. lat. 8878, fol. 145v.

formidable image of the devil to appear in medieval art. We sense imaginations at work; Satan had become the terror of monks, and this strange figure was born of the legend of the cloister.

To dispel any doubts, it is enough to look at the images of Satan created by Burgundian art. They reproduce exactly the visions of Cluniac monks. The most beautiful capitals at Vézelay show the devil as a sort of dwarf with an enormous head and projecting chest; he has a human face, but his low forehead and powerful jaw revealed by a wide grin are animal-like. His hair standing up in isolated tufts resembles flames. It is impossible not to think of a nocturnal vision. And in fact, it was thus that Satan appeared three times in Burgundy to the monk Raoul Glaber. In his precise description, Satan has all the traits of the Vézelay devil. Glaber says, "He was small in stature, he had a bulging chest, a low forehead; his large mouth revealed a jaw like that of a dog; his hair stood upright, his movements were convulsive."[35] This is the very same devil which at Vézelay seems to issue from the golden calf when Moses breaks the Tablets of the Law (fig. 260). Such similarities cannot be attributed to chance.

But Satan did not always take this form in monastic visions. Peter the

Venerable relates that a Cluniac monk saw the devil appear beside his bed: he had the appearance of a man, but he had a monster's head with an inordinately long snout. Such is the demon who comes to tempt Christ on a beautiful capital in the Burgundian church of Saulieu; the scene could be an illustration of Peter the Venerable's text (fig. 261).[36]

Satan, who confronts Raoul Glaber in the guise of a dwarf, sometimes appears as a giant. Guibert de Nogent[37] and Peter the Venerable[38] describe him as a monstrous being of great height with a very small head. We cannot but recall at once the frightening demons of the Last Judgment at Autun, with their small heads and giant stature. The artists who carved these various types of Satan had shuddered on hearing the accounts of his appearances; perhaps they were even frightened by their own work, uneasy that they might thus have provoked the Evil One. For them, art was not what it is for us—an object of disinterested contemplation. It partook much more of meditation, prayer, and the life of the soul. Into each of his works, the artist put, along with his talent, his fears and his hopes.

Never has the image of the devil been so powerful as in the monastic

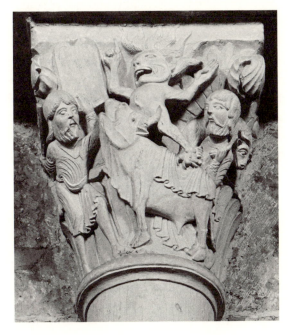

260. Demon emerging from the Golden Calf. Vézelay (Yonne), Abbey Church of Ste.-Marie-Madeleine. Capital.

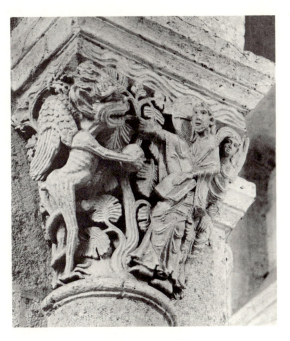

261. The devil tempting Christ. Saulieu (Côte-d'Or), Abbey Church of St.-Andoche. Capital.

art of the twelfth century. He was certainly much less terrifying to the thirteenth-century lay artists who carved the tympanums of our cathedrals. The thirteenth-century devil is not a monster but only a man degraded by vice, whose ugliness is more laughable than frightening. In the fourteenth century, he resembles the devil of our religious theater and becomes almost comic. We sometimes think we can recognize in our relief sculptures the actor of some mystery play, tricked out in a mask and sewed into an animal skin. Only the visionary monk of the twelfth century knew how to represent the devil.

II

Monks and woman. Temptation. Capitals in the cathedral of Autun and the abbey church at Vézelay. The Woman Devoured by Serpents.

For the monk, woman was almost as redoubtable as Satan himself. She is his instrument and is used by him for the perdition of the godly. Such were the sentiments of the great abbots and reformers of monastic life. All were in fear of woman: they had no wish to see the monk expose himself to temptation, only too sure that he would succumb. "To live with a woman free of danger," said St. Bernard, "is more difficult than to raise the dead."[39]

And what precautions were taken! The rule of Cluny did not permit a woman to enter the monastery enclosure under any circumstances. The rule of Cîteaux was even more severe, for a woman was not allowed to appear even at the monastery gate; the brother porter had orders to deny her alms.[40] Thus, in self-defense, the Cistercian went so far as to fail in charity. If a woman entered the church, the service was suspended, the abbot deposed, and the monks condemned to fast on bread and water.[41] Under no pretext might a woman be employed on Cistercian farms or granges.[42] On Cistercian properties, as on Mount Athos, only silent monks, bowing gravely to the visitor, were to be seen about the mills and farm buildings.

One can understand that the terrible disorders of the eleventh century, when the ancient discipline of the Church had almost foundered, were still present in the minds of the reformers. It took the heroic will of Gregory VII to save the priest from woman. Rigorous ascetics such as Pietro Damiano and Hildebrand did not indeed condemn marriage, instituted as it was by God, but man united with woman seemed to them diminished; he could no longer aspire to purity of spirit. It was only in austere seclusion, far from womankind, that a man raised himself to the divine life and heard the voice of heaven.

This struggle against woman left its mark on the capitals of Romanesque churches. A capital in the cathedral of Autun, where we find the imprint of the Vézelay artists, shows a young man contemplating a naked woman (fig. 262).[43] The artist was unable to endow his heroine with beauty, but

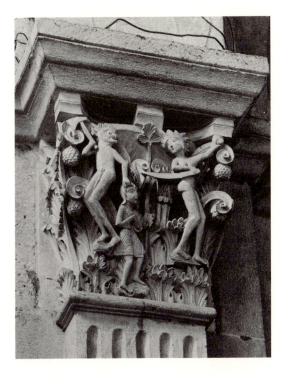

262. The woman and the devil. Autun
(Saône-et-Loire), Cathedral of
St.-Lazare. Choir capital.

he has given her a kind of sinuous grace. She turns her head to glance at her victim, letting a streamer float behind her. But at that moment the devil appears and seizes the young man by the hair; henceforth, he is the other's master, and we can see that the woman is his accomplice, for her hair, bristling like Satan's, betrays the daughter of hell.

At Vézelay, a strange capital, the work of an hallucinated artist, seems to translate an Oriental metaphor that called woman "Satan's lyre." Satan in fact plays upon a naked woman as if she were a musical instrument, while a jongleur, the devil's accomplice, adds his tune to the song of hell.[44]

These capitals were carved less to disturb than to sustain the monks' courage. We have seen, at Vézelay and at St.-Benoît-sur-Loire, the eternal battle epitomized in one heroic episode, the Temptation of St. Benedict.

All these scenes have a poetic beauty, but there is one hideous image of sinful flesh.[45] On the portal of Moissac there is an image of the fallen woman: she is naked and emaciated; two serpents hang from her breasts, a toad devours her sex (fig. 17). Never was the temptress more brutally punished. This is the punishment in hell of lust, for a devil presides over the woman's torture.

This figure of the Woman Devoured by Serpents appeared at the beginning of the twelfth century, and would seem to have come from the monastic imagination. However, there is an aura of the past surrounding it. Carolingian ivories and manuscripts from southern Italy[46] quite frequently contain an image of Earth that goes back to antiquity. Earth is

represented in the form of a woman who gives suck to all creatures; sometimes these are babies hanging at her breasts, sometimes they are animals; but again it may be the serpent, child of the Earth, who comes to drink at her breast (fig. 263).[47] Some of these miniatures seem to be precursors of the Woman Devoured by Serpents at Moissac.[48] The sculptor was no doubt familiar with them, but he used the forms he remembered to express quite another thought. The idea of associating the serpent with the punishment of lust is an old one, for as early as the fourth century, the famous Vision of Saint Paul, a book much read in the Middle Ages, represents unmarried mothers as the prey of serpents.[49]

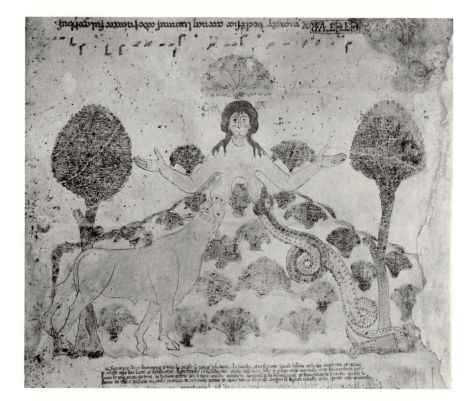

263. "Terra." Exultet roll. Vatican, Biblioteca Apostolica, cod. Barb. lat. 592, sec. 5.

In all likelihood, the Woman Devoured by Serpents is a creation of the art of Languedoc. The porch of Moissac and the south portal of St.-Sernin provide the earliest examples.[50] From this school as a center, the theme spread throughout the Midi: it is represented on capitals or reliefs at St.-Pons (Hérault), St.-Sever of Rustan (Hautes-Pyrénées), and the Pyrenees church at Oo (Haute-Garonne).[51] It appears twice on the portal of the church of Ste.-Croix at Bordeaux.[52] There are several examples in the small churches of the Gironde.[53] The motif appeared soon after in the art of western and central France. The Woman Devoured by Serpents has a place in the great Last Judgment scene decorating the façade of St.-Jouin at Marnes; it appears again at Parthenay-le-Vieux and in the

Octagon of Montmorillon, where Montfaucon took her to be a Gallic goddess. The theme was also known in Berry, for it is carved on a capital in the church of Ardentes (Indre).

Burgundy in turn picked it up. A capital at Vézelay preserves probably the earliest example; it is one of the most beautiful capitals in the church (fig. 264). Near the woman being devoured by the serpent, one of the damned, with hair on end and an enormous open mouth, plunges a dagger in his chest. This is Despair, inseparable companion of Vice. An infernal air seems to envelop this pair of sinners and raises their hair. The old sculptor, who knew the human soul as well as moralists and poets, united Debauchery and Death in his conception of hell. The Woman Devoured by Serpents appears several times in Burgundy: on the portal of the cathedral of Autun, at St.-Pierre of Semelay, at Gourdon (Lot),[54] and at Charlieu. On the Charlieu portal, the sinful woman retains in her despair a kind of grace that brings to mind the art of antiquity (fig. 265).

None of these Burgundian works seems to be earlier than the capital of St.-Sernin at Toulouse and the relief at Moissac.

It is curious to see this somber figure of sinful woman in the art of the Midi, where poets had begun to deify woman and took more pleasure in

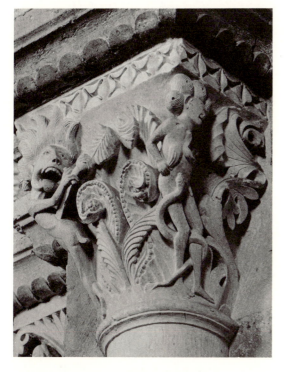

264. Despair and Lust. Vézelay (Yonne), Abbey Church of Ste.-Marie-Madeleine. Nave capital.

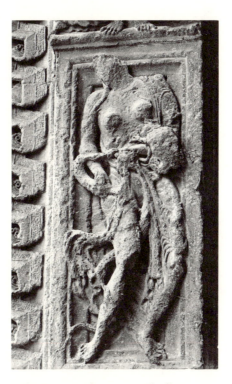

265. Woman with serpents. Charlieu (Loire), Priory of St.-Fortunat. North face of narthex.

celebrating her weaknesses than her virtues. While the monks were carving on the portals of their churches the image of her degradation, William of Aquitaine was writing ironic verses to tell of his amorous triumphs, with a pleasure untroubled by remorse. Bernart de Ventadour saw in love the sole aim of life, and wrote of it with voluptuous tenderness. In exile far from his lady, he lovingly welcomes on his face a breeze coming from the country of his loved one. Worldly morality had begun to counter the morality of the cloister, and this the monks knew very well. Consequently, they never tired of reviling the flesh. And it turned out that the monks had the last word, for the troubadour repented in his old age and entered the cloister. Bertran de Born and Bernart de Ventadour both sought refuge in the monastery of Dalon.

Such is the imprint left on stone by the monastic spirit. It is not only the monks' thoughts that we find there, but something more intimate—his deepest feelings, his struggles, and his dreams.

XI

Twelfth-Century Historiated Portals:

Their Iconography

One after the other, we have analyzed the factors that contributed to the character of twelfth-century religious iconography. The thought that ordered the great carved tympanums of our Romanesque church portals remains to be studied. These magnificent tympanums, created in France, are one of the beauties of our churches.[1] It is on them that the eye first falls; they invite meditation; they lift the faithful out of his sorry mundane thoughts and prepare him to enter the sanctuary. Even before he has crossed the threshold, he breathes the air of the other world. On a portal decorated with a Virgin in Majesty surrounded by saints, we read: "You who enter here, lift yourselves toward the things of heaven."[2] Consequently, Romanesque sculptors did their utmost to enclose lofty ideas in the arch of stone.

The Midi artists who created these sculpted tympanums had a difficult problem to solve. How could figures be artfully disposed in a half-circle? The essential, it seems, is a tall, centered, figure dominating all the others. Thus, the tympanum had to contain a triumphal scene; it was predestined to express something majestic.

This was well understood by the Midi sculptors. They created three types of portals, all three of which have this majestic character. The first is that of Moissac, which represents the Christ of the Apocalypse; the second is that of St.-Sernin of Toulouse, which represents Christ ascending to heaven; the third is that of Beaulieu, which represents Christ's appearance to judge mankind. These three portals inspired many others; they had derivatives that are worth study.

The three types of portals in the French southwest. The Apocalyptic Vision of the Moissac tympanum. The motif spreads as far as the Pyrenees. It spreads to western and central France. Imitations of the Moissac and Carennac tympanums at Chartres, Le Mans, Angers, and St.-Loup-de-Naud, Provins, and Bourges. The great tympanum at Cluny probably imitated the Moissac tympanum. Imitations of the Cluny tympanum at Bourg-Argental and Charlieu. Imitations in Burgundy of tympanums of the Ile-de-France. Colonnette figures of St.-Denis, Chartres, and Le Mans. They represent figures of the Old Law. The goose-footed Queen.

The Christ of the Apocalyptic Vision fills the tympanum of Moissac (fig. 1).[3] To look at it recalls the verse from St. John: "Behold, a door was opened in heaven."[4] God appears seated on his throne. He is of superhuman stature, of a formidable majesty; the four beasts, the two angels, the four-and-twenty elders surrounding him render him even more inaccessible and distant. All the heads are turned toward him; the eyes of the angels, men, and beasts are fixed on his face which seems to be the source of light. We imagine we can hear the words of the elders: "Thou has created all things, and it is by Thy will that they exist."[5]

I discussed, in the first chapter of this book, all that the artist owed to the manuscript of the Beatus Apocalypse: his genius is no less remarkable. At the very outset, sculpture fashioned a work of unsurpassed grandeur. Newly born, with marvelous audacity, it penetrates the heart of eternity. Medieval art begins with the sublime.

The influence of this masterpiece—the true point of departure for monumental sculpture—has been profound. It gave to the art of southwestern France its apocalyptic character. On the portals of churches from the Pyrenees to Berry, we encounter frequently the figure of Christ enthroned among the four beasts, or at least among the elders of the Apocalypse seated in a circle around the tympanum. On these Midi churches, there is a reflection of the Vision of St. John.

Moving on toward the Pyrenees, whether from the east by Maguelonne, or from the west by Nogaro, Sévignac, and Sauveterre-de-Béarn, we encounter the figure of Christ enthroned among the four beasts. It appears in the mountain valleys; it is on the portal of Luz and renders even more formidable that somber fortress-church. It appears again at Valcabrère (fig. 162) and at St.-Aventin;[6] nothing could be more harmonious with that majestic landscape than this sublime image of God.

The Pyrenees artists sometimes varied the original theme. The eagle, the lion, and the ox were placed in the hands of three angels so that only their heads are visible; they appear thus in the tympanums of St.-Aventin and Valcabrère. Our Midi artists, who crossed back and forth and worked on both sides of the Pyrenees, carried this innovation into Spain. We find it at Santo Tomé at Soria,[7] in Old Castile, and it was soon to shine with unequaled magnificence from the Glory Portal of Santiago de Compostela.[8]

Many of the portals decorated with the Vision of St. John have disappeared from the Pyrenean Midi. There had been one at the abbey of St.-Pé-de-Generez (Hautes-Pyrénées), but it was destroyed in the Wars of Religion. At Oloron and Morlaas, there is no Christ in Majesty, but there are archivolts decorated with the images of the elders of the Apocalypse;

and they were once to be seen on a church at the other end of the mountain chain, at St.-Guilhem-le-Desert.[9]

To the south, the impact of Moissac, the great model, was thus widespread. All of the Midi, moreover, with its Beatus manuscripts, seemed predestined toward these representations of the Apocalypse.

To the north, the influence of Moissac was no less far-reaching.

The first imitation of the Moissac tympanum appeared at Carennac (Lot) (fig. 266).[10] The kinship of the Carennac portal to the portal of Moissac is striking at first glance. The arrangement is the same: the tall figure of Christ accompanied by the four beasts fills the entire center of the tympanum. As at Moissac, the figures surrounding Christ are placed one above the other to fill the entire semicircular field; as at Moissac, the tympanum is not sculpted of a single block, but is composed of assembled sections. Even the twisted-ribbon ornamentation of Moissac is found here. But the imitation is far inferior to the original; the majestic vision is boxed within hard geometric lines, and the mysterious elders are supplanted by apostles.[11] Farther north, there was a Christ in Majesty on the tympanum at Déols (Indre).[12]

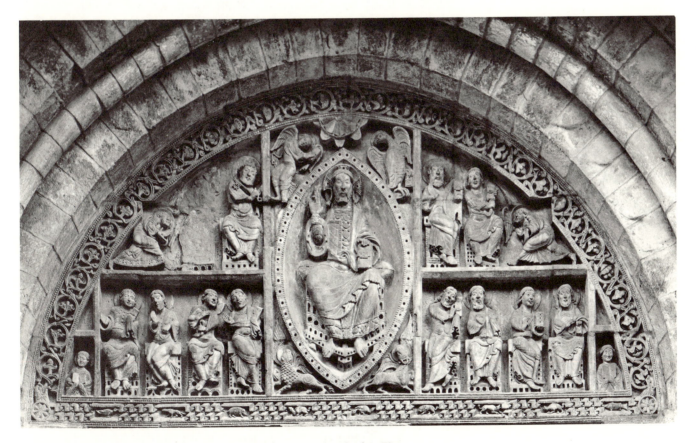

266. Christ in Majesty and the apostles. Carennac (Lot), Abbey Church of St.-Pierre. West façade, tympanum.

It was above all the theme of the elders of the Apocalypse, originating at Moissac, that spread throughout the central and western provinces. In Limousin, the elders with their chalices and viols were used to decorate the stone reliquary of St.-Junien; they decorated the portal of the half-Arab church of St.-Michel at Le Puy, in Velay; in Berry, they appeared on capitals in the church of Gargilesse (Indre).

They appear several times on our churches of Poitou and Saintonge. As we know, the churches of these regions have no tympanums, and consequently there was no place for a Christ in Majesty. But sometimes one of the archivolt bands was decorated with the elders of the Apocalypse. This is the case at Notre-Dame-de-la-Coudre at Parthenay, and at Civray, at Aulnay of Saintonge, and at Saintes. But at Saintes, they have lost all meaning and dignity; they are merely a decorative motif, indefinitely repeated.[13]

The apocalyptic theme did not reach northern France by gradual stages; it appeared suddenly on the portal in the north in the first half of the twelfth century. This abrupt appearance of the art of the Midi in the Royal Domain is easily explained. About 1135, Suger brought to St.-Denis the Midi artists who had carved the portal of Beaulieu in Corrèze, and some of whom had surely worked on the portals of Carennac and even of Moissac. It was the Beaulieu Last Judgment that these artists imitated on the central portal of St.-Denis;[14] but they also had the Apocalyptic Vision of Moissac in mind, for they represented the elders of the Apocalypse with their chalices and viols on a band of the archivolts.[15]

Once the work at St.-Denis was finished in about 1145, the workshop gathered together by Suger was moved on to Chartres.[16] It was then that the magnificent Chartres façade was begun. Here, reminiscences of Moissac and Carennac efface those of Beaulieu. The great master who organized the ensemble turned again to the Vision of the Apocalypse. From Carennac he took the idea of the great Christ figure enclosed in an aureole and accompanied by twelve seated apostles (fig. 267). Some of these Chartres apostles have strangely crossed legs, the constrained attitude they have at Carennac; some of them, despite differences in style, are almost identical. But it was from Moissac that the master took the four-and-twenty elders he placed on the archivolts. At Chartres, there is no longer the formidable grandeur of the art of Moissac; the four beasts have lost their dreamlike aspect. But if the Christ of Chartres is less a ruler, his beauty and gentle gravity bring him closer to us; he does not awe us, he attracts us to him. The Chartres elders are related to the elders of Moissac through details of their costumes and the masterly arrangement of their hair and beards, but their lines have more repose, their adoration is more meditative. The terrifying vision has been humanized.[17]

The tympanum of Chartres was imitated at Le Mans (fig. 268). The

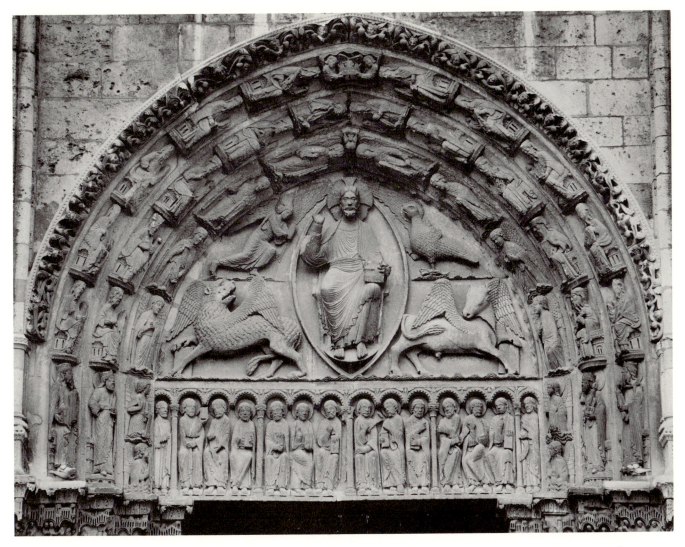

267. Christ in Majesty; apostles. Chartres (Eure-et-Loir), Cathedral of Notre-Dame. West façade, Royal Portal, central tympanum.

four beasts are exactly reproduced, but the lovely ray of light illuminating the face of Christ has vanished. The elders of the Apocalypse are missing at Le Mans. We find them on the archivolt of the portal at Angers, where they form a half-circle around Christ seated among the four beasts. The Christ figure, like that of Le Mans, derives from the Christ of Chartres, but is less beautiful.[18]

It was again the Chartres Christ that inspired the Christ of St.-Loup-de-Naud, near Provins, and the four animals surrounding him (fig. 269). At St.-Loup-de-Naud, the apostles are seated on the lintel in much the same contorted positions we saw at Chartres. At Provins, the mutilated portal of St.-Ayoul was designed like that of St.-Loup-de-Naud, and it, too, reproduced the portal of Chartres.[19]

This great school of art sent its artists as far west as Angers, and into

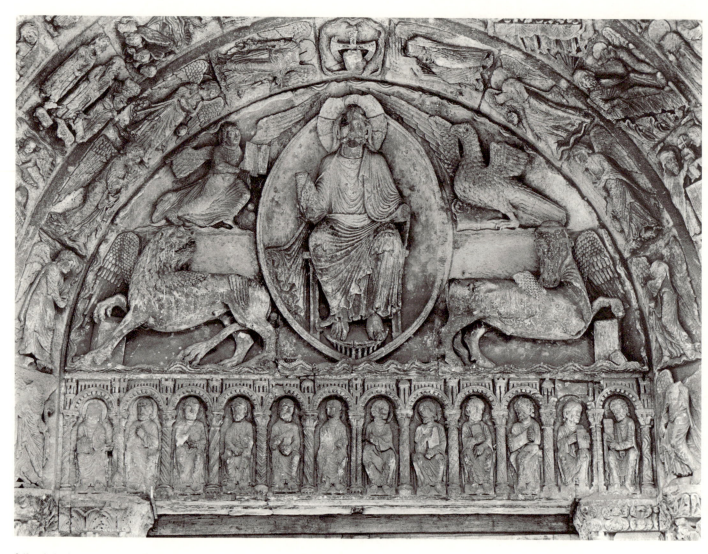

268. Christ in Majesty; apostles. Le Mans (Sarthe), Cathedral of St.-Julien.
South portal, tympanum.

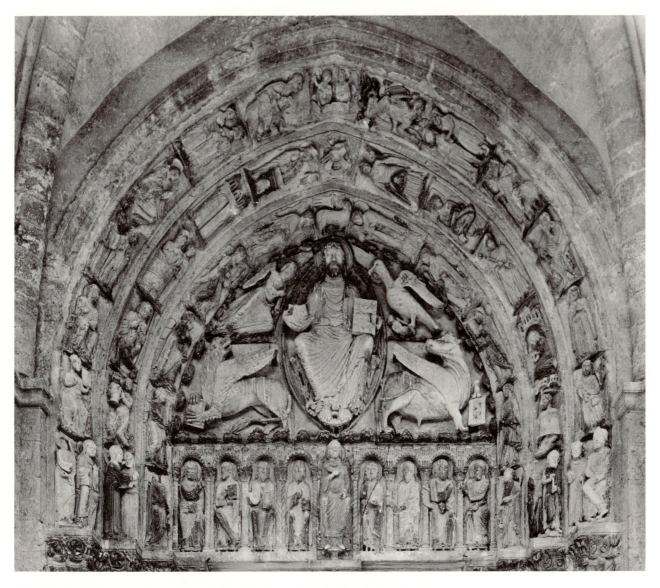

269. Christ in Majesty; apostles. St.-Loup-de-Naud (Seine-et-Marne), Church of St.-Loup. West façade, tympanum.

central France as far as Bourges (fig. 270). At the cathedral of Bourges, the portals of both the north and south sides are splendid Romanesque work dating from the second half of the twelfth century. Once again, the Christ of the Apocalypse appears on the tympanum of the south portal; the four beasts are arranged at his sides; the twelve apostles are seated below his feet. Without much difficulty we recognize here an almost literal imitation of the tympanum and lintel of the cathedral of Le Mans. At Bourges the apostles, to cite only one detail, are seated under arches surmounted by small decorative monuments: identical arches and monuments are to be found at Le Mans. A greater richness of ornamentation

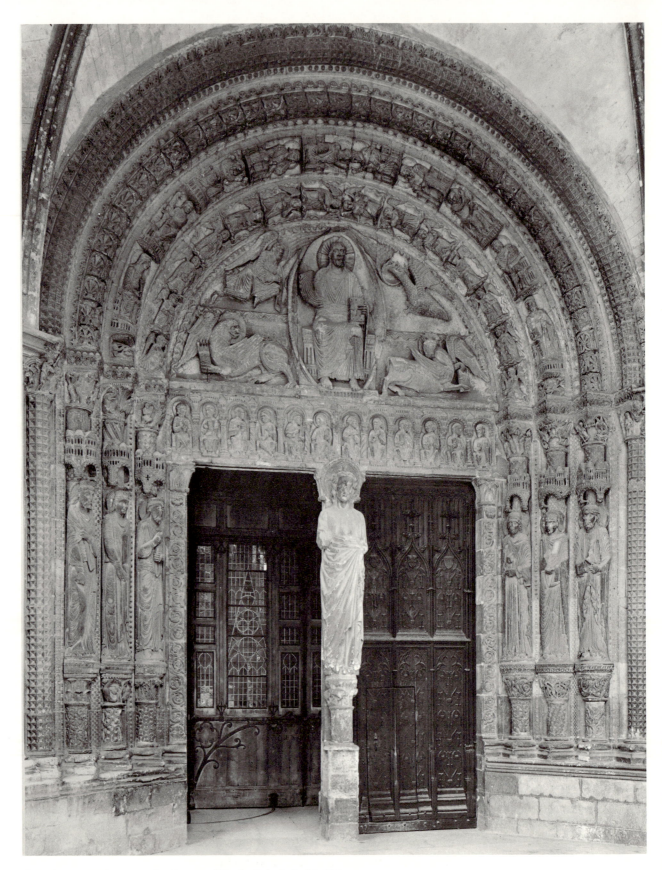

270. Christ in Majesty; apostles. Bourges (Cher), Cathedral of St.-Etienne.
South façade, portal.

and some details, to which we shall return, assign the portal of Bourges to a later date than the portal of Le Mans.[20]

The astonishing thing is that the Midi itself received from Chartres the Christ in Majesty it had created. Resemblances between the statues of the façades of Arles (fig. 271) and of Chartres were pointed out long ago. These similarities are perceptible only to the archeologists who study them, for the passerby notes only the differences. In fact, nothing could be more different than the styles of Chartres and Arles; all that is youthful, fluid, and alive at Chartres seems to have grown old, hard, and rigid at Arles. The idea that such dissimilar artists had known each other's work is not one that would occur of itself. Only minute comparisons convince us that there are likenesses between the statues of Arles and those of Chartres in attitude, costume design, and sometimes in the arrangement

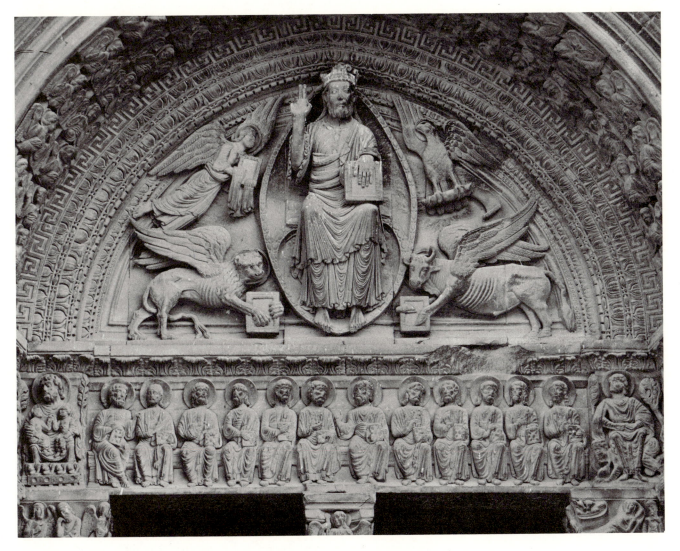

271. Christ in Majesty; apostles. Arles (Bouches-du-Rhône), St.-Trophime. West façade, central portal, tympanum.

of hair.[21] Once this fact is established, we easily recognize that the tympanum and lintel of Arles are imitations of the tympanum and lintel of Chartres. At Arles, although the sculpture has a metallic aspect, we find again the beautiful Christ of Chartres surrounded by the four beasts, with the twelves apostles seated below his feet; the likenesses outweigh the differences. Thus, toward the end of the twelfth century, Provence still sought to learn from that famous portal of Chartres, which had served as a model for all of northern France.

We see what power and influence these creations of the Moissac artists exerted; they inspired both the artists of the Midi and those of northern France.

Did they influence Burgundian sculptors? This is a delicate question, for it has to do with the very origins of sculpture in Burgundy.

The abbey church of Cluny, the largest sanctuary of the Christian faith in the twelfth century, had at its entrance a narthex as large as a church. The portal opening into the church was at the back of this narthex, and since it had been as sheltered as a masterpiece in a museum, it was still perfectly preserved when it was destroyed along with the greater part of the church in the early nineteenth century (fig. 272).[22] No loss is more regretted by art historians today, for this portal would have solved the problem of the origins of Burgundian sculpture.

In all likelihood, the tympanum of Cluny was the first work of monumental sculpture to be carved in Burgundy. The exact date is not known; we know only that the church of Cluny, whose choir was consecrated by Urban II in 1095, was not finished until 1130, when Innocent II definitively consecrated it.[23] It would not be too far wrong, I think, to suppose the portal to have been carved shortly before 1130.[24] At that time, the Moissac portal was already several years old. According to the testimony of an abbot of the monastery, who was writing, it is true, in the fifteenth century but who knew the traditions of the abbey, the portal was carved at the order of the abbot Ansquitil, who died in 1115.[25]

Like the Moissac portal, the portal of Cluny represented the Vision of the Apocalypse. A few poor drawings in the Cabinet des Estampes[26] and a confused description from the late eighteenth century[27] give us an idea of its composition. The Christ was seated in majesty among the four beasts; and on the lintel, the description says, there were "twenty-three figures of saints, almost heaped on top of each other, they were so close."[28] No doubt these were the elders of the Apocalypse, all of whom could not be represented for lack of space. Thus, as at Moissac, the artist had placed the elders on the lintel, but it had not occurred to him to space out some of the figures of elders into the tympanum, as at Moissac. Nevertheless, since there was a large unused space left in the tympanum, the Cluny sculptor, instead of placing there two large angels beside the animals, as

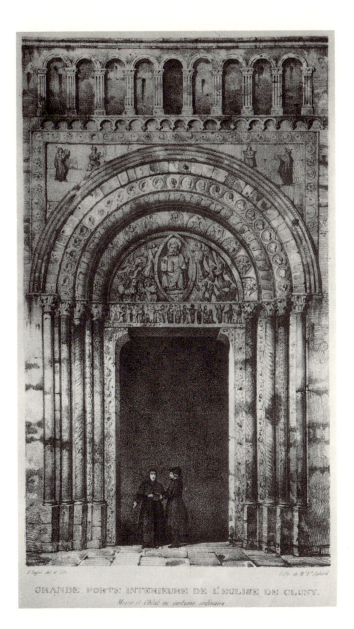

GRANDE PORTE INTERIEURE DE L'EGLISE DE CLUNY.
Moine et l'Oblat en costume ordinaire.

272. Christ in Majesty. Cluny
(Saône-et-Loire), Abbey Church
(destroyed). West façade, central
portal (after Sagot in P. Lorain,
Cluny, 1839).

at Moissac, carved four angels, two above and two below. Thus, the Cluny
tympanum was better composed than that of Moissac, in which we still
sense the imitation of a round miniature. The greater perfection of the
composition at Cluny alone would suffice to assign it a somewhat later
date.

But now we come to the most important question. Did the Cluny
sculptor imitate the Moissac sculptor?[29] Could the idea, so new at the
time, of decorating a tympanum with the Vision of the Apocalypse have
occurred spontaneously to two artists at the same time? It would be hard
to believe. What we know of the relations between Cluny and Moissac
does not support the hypothesis of spontaneous generation; quite the

contrary. Moissac was a priory of Cluny, and a priory that had been particularly dear to the abbot St. Hugh; relations between the two monasteries were constant. Thus, it is not possible that the great work at Moissac remained unknown in Burgundy. To the abbots of Cluny, the magnificent Moissac portal must have seemed the noblest entrance imaginable for a monastery church. Those elders pouring forth songs and prayers at the feet of God, the perfumes in their cups being the prayers of the just, those grave contemplators with eyes raised to heaven, seemed the very image of the perfect monk who sings and prays. No subject could have been more appropriate to decorate the portal of the holiest abbey of the Christian world.

If a single figure had been preserved from the portal of Cluny, it might immediately change our hypothesis into certainty.[30] Unfortunately, the portal was totally demolished and no comparison between the work at Moissac and Cluny is possible. However, in the museum of the little town of Cluny are preserved several capitals from the church that escaped the great destruction. As we have seen,[31] they represent the tones of Gregorian music, then the Virtues, the Sciences, and the Seasons. Studying these figures, it is a surprise to observe that there is nothing particularly Burgundian about them, and that their style relates them much less to the art of Autun and Vézelay than to that of Moissac. For example, the charming figures of Grammar and Spring from Cluny wear clinging robes that outline their bodies. The pleats, superimposed like a series of wide bands, envelop their legs (figs. 226 and 227). These resemble the Moissac figures of angels standing at Christ's sides and the figures of elders. The wide pleats are quite different from the innumerable, narrow, and concentric pleats—the kind of detailed calligraphy characterizing the tympanums of Vézelay and Autun. These capitals would not surprise us in Languedoc, but they do surprise us in Burgundy. Thus, the earliest monuments of Burgundian sculpture bear the mark of an art which seems to have come from Moissac. It is thus likely that the genius for the plastic arts was awakened in Burgundy, as in the Ile-de-France, by the magicians from the Midi. If such were the case, northern France would have received at the same time two remarkable gifts from southern France: sculpture and lyric poetry.

If these conclusions are correct, we can readily acknowledge that the idea of representing the Christ of the Apocalypse in a tympanum had come to Cluny from Moissac.

It was only natural that the portal of Cluny should in turn inspire Burgundian sculptors. In the twelfth century, the scene of the Christ in Majesty spread throughout Burgundy. In the archeological museum at Dijon, there is a tympanum from the church of St.-Bénigne which was certainly inspired by that of Cluny (fig. 273):[32] Christ is seated among

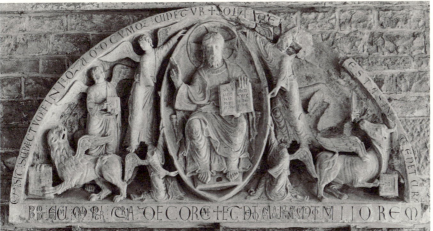

273. Christ in Majesty. Tympanum from Church of St.-Bénigne. Dijon (Côte-d'Or), Musée Départemental des Antiquités de la Côte-d'Or.

the four beasts, and as at Cluny, four angels support his aureole. This work, which dates from a much later period than the Cluny tympanum, does not reproduce its style but only the disposition of the figures. The small, badly mutilated portal of Thil-Châtel (Côte-d'Or) is probably an imitation of the same original,[33] for the field of the tympanum is not filled only with the figures of Christ and the four beasts, but in addition with four angels supporting the aureole.

Sometimes, even the ornamentation of the Cluny portal was imitated. The portal of Bourg-Argental (Loire) (fig. 274), usually thought to be a Provençal creation, must be reassigned to the Burgundian school. It is of great interest to us, for we recognize in its archivolts the very decoration of the Cluny archivolts. One of those at Bourg-Argental is decorated with a series of round medallions framing heads; another has a series of half-circles enclosing the figures: that the archivolts of the Cluny portal were similarly decorated is proven by the drawing in the Cabinet des Estampes. The portal of Bourg-Argental, deriving from that of Cluny, would necessarily have been decorated with a Christ among the four beasts, and so it is, except that lack of space compelled the artists to place only two angels beside the aureole instead of four.[34] The portal of Bourg-Argental has special significance, even though it is a mediocre work, because it provides a pale shadow of a great model.[35]

A much more magnificent imitation of the Cluny portal, but much freer and carved in a very different style, is the portal of Charlieu (Loire) (fig. 32). It has the great decorative frame that enclosed the entire portal of Cluny; there are the series of circles decorating one of the archivolt bands, and there is the Christ in Majesty of the tympanum itself. But at Charlieu, as at Bourg-Argental, the aureole is supported by only two angels.[36]

The Burgundian school is usually treated as if it had been a world apart,

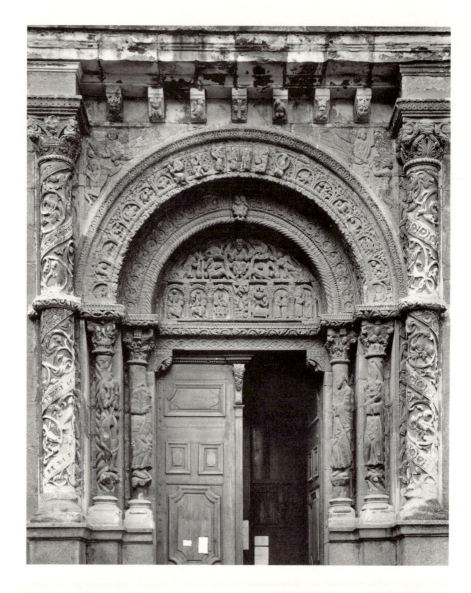

274. Christ in Majesty; Infancy cycle.
Bourg-Argental (Loire), Church of
St.-Laurent. West façade, portal.

a world closed to foreign influences. Nothing could be further from the truth. As early as the second half of the twelfth century, Burgundy was permeated with influences that came from the Ile-de-France. Had the Christ of the Apocalypse not already been known in Burgundy, it would have become known then. The tympanum of the portal of Vermenton is now empty, but it was once decorated with a Christ in Majesty, as we know from the poor drawing of it in Dom Plancher's *Histoire de Bourgogne*.[37] The Vermenton portal belongs to the art created at St.-Denis and Chartres, which, as we have seen, spread as far as Angers and Provins. The statues against the columns of the two sides of the portal, a form unknown to Burgundian art, appear at Vermenton; their style relates them to the statues at St.-Loup-de-Naud. The Christ in Majesty of the

tympanum derived, therefore, not from the Cluny tympanum, but from that of Chartres.

Although the Nivernais was a part of the Burgundian school, the portal of St.-Pierre at Nevers was only barely Burgundian in style.[38] The church of St.-Pierre was destroyed, along with several others which once lent to the town a beauty that the town itself undertook to destroy. It is only in the old *Album* of Nivernais, published in the Romantic era, that we can see today what the façade of St.-Pierre had been.[39] The tympanum of the portal represented the Christ figure seated among the four beasts, but this apocalyptic Christ owed nothing to Cluny: its model was at Chartres. Everything proves this to have been the case: the apostles seated on the lintel, the elders of the Apocalypse placed in the archivolts, the large statues set against columns. It was recognizable, at first glance, as the beautiful type of portal created by the artists of the Ile-de-France.

Thus, in Burgundy, the image of the Christ of the Apocalypse decorating tympanums came either directly from Moissac or through the intermediary of Chartres. Moissac remains the place of origin and to it we must always return, for it was there that was born the grandiose idea of carving the verses of St. John on the face of the church, of dazzling the faithful who entered the sanctuary with a vision of heaven.

Several of the portals we have just been talking about were decorated with large statues aligned at each side of the entrance. These statues have remained enigmas and have discouraged modern archeologists, who seem to have given up the search for their meaning. They certainly are not easy to explain, but perhaps the mystery has been exaggerated. They do not entirely disclose their secret, but we may at least glimpse it.[40]

The magnificent idea of placing a statue against each of the columns of a portal was born at St.-Denis about 1135. It may have been inspired by the apostles to be seen at Toulouse carved in low relief at each side of the portal of the St.-Etienne cloister. Suger, who directed all the work at St.-Denis, perhaps had some connection with this innovation, for the idea behind the transformation of persons into columns is as much a mystical as a plastic one. In any case, there can be no doubt that Suger himself chose the twenty personages who decorated the three portals of St.-Denis. Who were they? They certainly were not Merovingian kings, as the Benedictines of the eighteenth century thought. The drawings published by Montfaucon in his *Monumens de la monarchie françoise* (fig. 275)[41] contain a revealing detail. A fair number of these solemn heroes clothed in long robes wear melon hats that hug their heads. Now, a hat exactly like these appeared very early in the art of Toulouse, where it was the emblem of Jews.[42] It is found later on the west portal of Chartres, where St. Joseph wears one in the scene of the Presentation in the Temple.[43] It was a legacy from the schools of the Midi to the schools of the north. There is no doubt

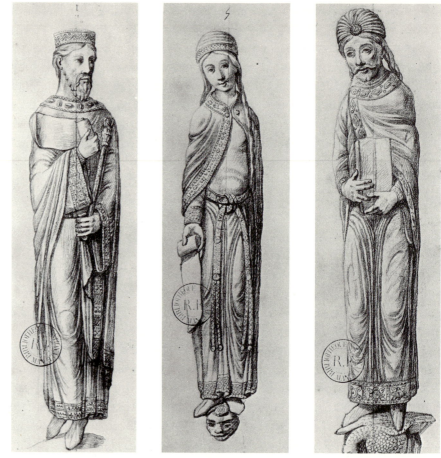

275. Old Testament figures. Abbey Church of St.-Denis, west portal (drawings by Montfaucon). Paris, Bibl. Nat., ms. fr. 15634.

that the figures at St.-Denis who wear the melon hats are the men of the Old Law. We can only conclude that the figures of kings and queens accompanying them are the kings and queens of the Bible, not of France.

Here we recognize Suger's meditative genius. He had wished to show that the Old Testament gave access to the New. Before arriving at Christ, the congregation passed before those who had awaited him throughout the centuries. If the names formerly inscribed on the banderoles held by the figures had been preserved, Suger's thought would take on a clarity that would add even more to its beauty. Which patriarchs and which kings had he chosen? This we can never know. But it is something to have understood that he conceived the heroes of the Old Law as columns of the portico leading into the temple.[44]

Suger's idea was repeated on the west portal of Chartres, where we find again the figures wearing melon hats, the kings and the queens. Even more than at St.-Denis, these tall statues, some so finely wrought, resemble columns—delicate fluted columns. As at St.-Denis, they are anonymous, for the names once inscribed on their banderoles have disappeared. Nevertheless, attempts have been made to identify the statues of the central

portal. One scholar has supposed that they exactly reproduce the characters named by St. Matthew in his genealogy of Christ, from Salmon, father of Booz, to Solomon, the son of David.[45] On one side (fig. 276) would be Jesse, father of David; David and Bathsheba, father and mother of Solomon; and lastly, Solomon. On the other side would be Obed, father of Jesse; Booz and Ruth, father and mother of Obed; Salmon and Rahab, father and mother of Booz.[46] It is a curious coincidence, but I think a fortuitous one, for St. Matthew's genealogical list cannot be found on any other portals. In fact, what we see are several statues of women, and these women are not mentioned in the Gospel text.[47]

Only one of the statues of Chartres can be named with any certainty. There is a statue on the central portal of a king holding a banderole; this king, as we shall see, can be none other than Solomon.

The portal of Le Mans is a very exact imitation of the central portal of Chartres (fig. 277). Not only did the artist copy the Christ in Majesty of

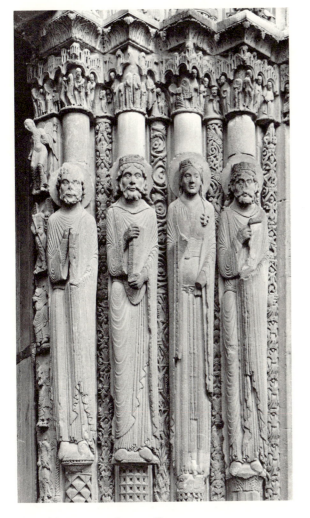

276. Old Testament figures. Chartres (Eure-et-Loir), Cathedral of Notre-Dame. West façade, Royal Portal, jambs of central door.

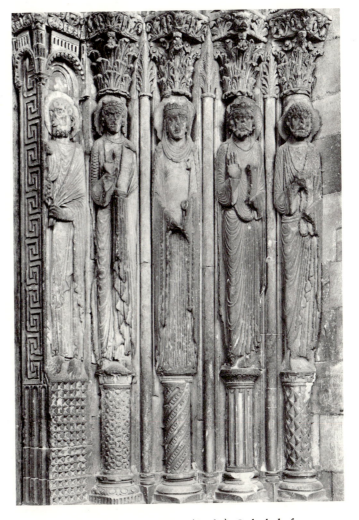

277. Old Testament figures. Le Mans (Sarthe), Cathedral of St.-Julien. South portal, jambs.

the tympanum and the apostles of the lintel, but he also copied the eight tall columnar statues. We recognize all the Chartres figures and especially the queen between two kings.[48] This is the work of a pupil who lacked his master's talent, but his imitation contains one valuable detail no longer to be seen in the original. On the scroll carried by one of the kings, the word *Salomo* could still be read in 1841.[49] From this we must conclude that the Chartres statue which served as the model for the one at Le Mans also represented Solomon. And then it seems likely that the other king is David. Does the queen separating the two represent Bathsheba? Or rather does she represent that Queen of Sheba whom we shall see appearing on other portals. We cannot say with any certainty.

Suger's thought was thus transmitted from St.-Denis to Chartres, and from Chartres to Le Mans.[50] But at Le Mans, a new idea appears. On each side of the portal, two tall figures in low relief have joined the Old Testament figures; they are obviously St. Peter and St. Paul. What are they doing here in this assemblage of biblical figures? They are there as the culmination of Suger's thought, to round out its meaning. The Saints of the Old Law were awaiting a higher Law, and it is precisely this New Law that St. Peter and St. Paul, images of the Church, represent. They are not columns of the portico; they are the very walls of the temple.

The idea so felicitously expressed by the Le Mans artist was taken up by others. It appeared a few years later on the St. Anne Portal at Notre-Dame of Paris. The large statues to be seen today are modern, but Montfaucon left drawings of the old ones.[51] They represented four kings and two queens from the Old Testament, and were accompanied by St. Peter and St. Paul. The king holding the viol was David, the poet-king who had hailed the Saviour he was never to see, the Saviour whom St. Peter and St. Paul were to announce to the world. St. Peter and St. Paul appear again on the portal of St.-Loup-de-Naud; they are accompanied by figures from the Old Law, one of whom wears the melon hat of the Chartres and St.-Denis figures.

But on the portal of St.-Bénigne at Dijon, this idea had been expressed even more clearly. This magnificent portal no longer exists, but Dom Plancher has fortunately preserved a sketch of it (fig. 174).[52] Although by its round arch it recalled the great creations of Autun and Vézelay, it was much more closely related to the art of the Ile-de-France than to the art of Burgundy. The Christ in Majesty of the tympanum, the elders of the Apocalypse one above the other in the archivolts, and the statues placed against columns connect the work with the school born of Chartres. However, some originality is mixed with imitation. Beside St. Peter and St. Paul, there are two very meaningful statues: one represents Moses with the horns of light and the Tables of the Law; the other, the high priest Aaron wearing priestly garb. Aaron resembles a bishop and this

is what he was imagined to be by the Middle Ages.[53] Thus, Moses and Aaron, symbols of the Synagogue, were placed in correspondence with St. Peter and St. Paul, symbols of the Church—a perfect expression of the continuity of the two Laws. The decoration of the portal is completed by statues of three Old Testament kings and one queen. This time the mysterious queen reveals her identity. Studying the sketch of this figure, one detail is observed that would seem incredible were there not ancient testimony to confirm it: the queen of the St.-Bénigne portal was goose-footed (fig. 278): the Dijon artist had represented the famous *Reine Pédauque*, who was none other than the Queen of Sheba.

The imaginations of the Jews and the Arabs had long dwelt on the Queen of Sheba. The East created a romantic legend around her in which djinn played a role. At Solomon's orders, they carried the queen's golden throne to Jerusalem, and to her surprise she found it in the king's palace.

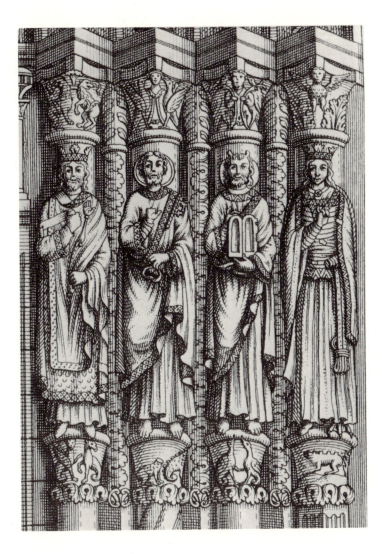

278. Queen of Sheba (at right). Dijon (Côte-d'Or), Abbey Church of St.-Bénigne. Entrance portal of the Rotunda (destroyed) (after engraving by Plancher, detail).

Solomon received her in a hall paved with crystal; the beautiful queen, thinking that she was on the banks of a stream, gathered up her skirt and revealed her hideous feet. The Eastern legend speaks of donkey feet; the Western legend of goose feet. The text of a twelfth-century German manuscript represents the Queen of Sheba as goose-footed.[54] There is no text in France as old as this one, but the Dijon statue proves that the tradition was well known in the twelfth century. It is possible that the goose-footed queen had first been represented in the workshops of Toulouse, for in the time of Rabelais there was still an image of the *Reine Pédauque* there. Her palace and its baths were shown, and for a long time her legend was associated with the young princess, Austris, who had been baptized by St. Sernin.[55]

There can be no doubt that the goose-footed queen of the Dijon portal represented the Queen of Sheba. It becomes no less certain that the facing statue of a king was Solomon; and no doubt it was David who accompanied them. Why had the Queen of Sheba been placed in the company of the heroes of the Old Law and the apostles of the New? Because, according to medieval doctrine, she symbolized the pagan world's coming to Christ, and prefigured the magi who also were searching for the true God.[56] The Journey and Adoration of the Magi were also represented on the lintel of St.-Bénigne.

Thus, the meaning of the Dijon statues is more precise than those at Chartres, or even those at Le Mans. At Dijon, we see the Jewish world and the pagan world both stirred by the desire for the Saviour whom St. Peter and St. Paul, symbols of the Church, had come to announce to them. The Church was represented in the tympanum at Christ's right by the figure of a queen; at his left, the Synagogue was shown, eyes covered by a veil and crown askew on the head—an image of medieval Jews who had understood neither the words spoken to them by their ancestors nor the example given to them by the pagans.

In this way, the generalized idea expressed by Suger at St.-Denis gradually took on a symbolic character that gave it profounder meaning.

The idea translated by the Dijon sculptors appeared on other portals, which were no doubt inspired by it.

On the portal of St.-Pierre at Nevers, already mentioned, there were four large statues. Two of them were difficult to identify, but the Queen of Sheba could be recognized by her goose's foot, and the facing statue of a king could only have been Solomon. As at St.-Bénigne, the symbols of the Church and the Synagogue were carved in the archivolts; consequently, at St.-Pierre of Nevers, influences from the Ile-de-France combined with influences from Dijon.

An ancient description of the portal of St.-Pourçain in the Bourbonnais, the statues of which have been destroyed, mentions St. Peter; a priest,

probably Aaron; a king, who was certainly Solomon; and lastly, a goose-footed queen, who was the Queen of Sheba.[57]

In Champagne, a region open to the influences of both the Ile-de-France and Burgundy, an ancient and long-famous abbey stood in a narrow valley. It was called Nesle-la-Reposte, *Nigella reposita* or Nesle-the-Hidden. It was said that Ganelon had been buried there after being tortured to death.[58] The abbey no longer exists, but Montfaucon has preserved for us a sketch of its portal.[59] It was decorated with six tall statues that can be named almost with certainty. Aaron faces St. Peter; the Queen of Sheba, recognizable by her goose's foot, faces Solomon; facing David, Moses holds the Tables of the Law. Fewer in number, they are the same personages carved on the portal of St.-Bénigne.

We found these same figures again on the south portal of Bourges, which, as we have said, imitates the Le Mans portal, reproducing very faithfully certain parts of it. But the six great statues at Bourges were inspired by another model. The artist who carved them most certainly knew the statues of St.-Bénigne at Dijon. As at St.-Bénigne, we see Moses, Aaron, two kings, who are Solomon and David, a third we cannot identify, and finally a queen who is the Queen of Sheba. It is true that here she is not goose-footed, but the resemblance between the two series is very clear. At Bourges, there was not room to represent St. Peter and St. Paul—a grave omission that deprives the portal of a part of its meaning.[60]

So these large portal statues, which in the beginning represented simply the heroes of the Old Law leading to the New, with time took on a more precise meaning. There was an attempt to organize their arrangement; the two Laws were placed in correspondence; there was a suggestion in the Old Testament of figures from the New. The symbolic idea that was soon to give so original a character to the great biblical figures of the portal of Senlis and the north portal of Chartres[61] was beginning to take shape.

II

The artists of the Midi created a second type of portal: this time the Ascension decorates the tympanum.[62] Such a subject, if less sublime than the apocalyptic vision of St. John and less expressive of God's eternity, has nevertheless a triumphal character. Christ, after passing through life and death, appears in his pure divine essence. In this, artists saw a subject that could be adapted to the form of the tympanum: across the entire length of the lintel, the apostles were aligned with their arms raised toward their master, while Christ and the angels filled perfectly the half-circle above their heads. This is the form of the earliest Ascension decorating a portal: the Ascension at St.-Sernin of Toulouse (fig. 42). The tympanum is filled entirely with Christ and the angels; and perhaps even too

The Ascension. Tympanum of Cahors. The Cahors tympanum imitated at Mauriac and Angoulême. The double meaning of the Angoulême Ascension. The Ascension at Chartres imitates that of Cahors. The Ascension in Burgundy.

much so, for there is little effect of Christ rising to heaven. This first attempt was imitated only in Spain on the portal of San Isidoro at León, where the style is very heavy.[63]

What was not perfectly successful at Toulouse was improved at Cahors (fig. 86).[64] There, the standing Christ enclosed in a mandorla rises majestically; the miracle is made visible to the eye. At each side of the mandorla, two angels lean backward, curved into two harmonious arcs, and speak to the disciples who are watching their master disappear. Studied in detail, this work appears full of beauty; already the noble face of Christ has the character of divinity. Nevertheless, the composition is not yet perfect and the artist was hard put to fill all the parts of this vast tympanum. First of all, in the upper section he placed four half-length angels who plunge headforemost from the sky to greet their God. Then, since the two sides remained empty, he filled them with little panels in which he depicted the martyrdom of St. Stephen, patron saint of the cathedral. We are aware here of imitation of the Moissac tympanum, where the elders of the Apocalypse fill the empty spaces of the background. Moreover, the entire tympanum, composed of separate plaques, is related in technique to the art of Moissac. Thus, the Cahors tympanum is not far removed from the age of the beginnings of sculpture in France.

This beautiful work was imitated on the portal of Mauriac (Cantal) in a style that is less supple, more accentuated (fig. 279).[65] At Mauriac, we easily recognize the Christ of Cahors standing in his mandorla (although the imitation does not have the beauty of the original), and especially the two angels leaning backward at each side to speak to the apostles. The tympanum is smaller and this time is perfectly filled. A small hillock, rising in the midst of the group composed of the Virgin and the apostles, recalls the Mount of Olives where the Acts place the scene of the Ascension and where pilgrims venerated the traces left by Christ's feet.

The Cahors tympanum was imitated once more in the Midi at the cathedral of Angoulême. But here, the scene of the Ascension is not enclosed in a half-circle; it spreads across the entire façade (fig. 280).[66] The Christ standing in his mandorla, with an end of his mantle tucked under a belt and his tunic flared at the feet, is draped in exactly the same way as the Christ of Cahors. The two heads cannot be compared, because the head of the Angoulême Christ has been restored. In the upper part of the composition the same half-length angels seem to fall out of the sky. Much lower down, the two large angels bend to speak to the apostles who are ranged beneath arcatures and are recognizable by their bare feet. As at Cahors, the Virgin has a place of honor. All of the elements of the beautiful Cahors model are found again at Angoulême. The scene is completed in the false doors that decorate the façade at each side of the portal: in each tympanum are three apostles who seem to be walking

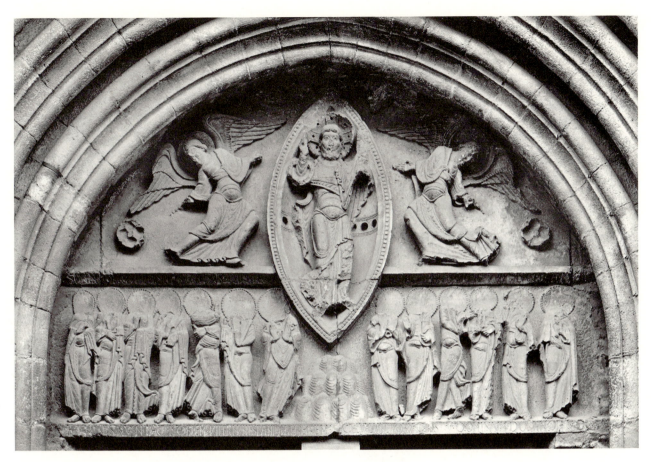

279. Ascension. Mauriac (Cantal), Notre-Dame-des-Miracles. West façade, tympanum.

with rapid step, each carrying a book, and among whom we recognize
St. Peter with his keys (fig. 281). Now that their master is gone, they are
on their way to carry his word to the ends of the earth. This is the spread-
ing of the Gospel over the world. Since twelve apostles had to be spaced
in four tympanums, the artist was obliged to group them by threes. The
same apostles, grouped in the same way, are found again at St.-Amand-
de-Boixe, in Charente; they are the work of the same workshop.[67]

 The Angoulême portal seems perfectly clear, but yet there is something
puzzling about it. Four reliefs representing the evangelical beasts are set
into the wall around Christ's mandorla; lower down, at the right and
left, sinners seem to expiate their sins in the tortures of hell. Figures who
apparently represent the blessed are enclosed in circular medallions and
placed nearer Christ. In the twelfth century, the elect were sometimes
represented in this way. A fresco at Poncé (Loir-et-Cher) in the Loir
valley represents paradise with the just framed in round medallions, as
if they were precious stones.[68] Observing these details, it is hard not to

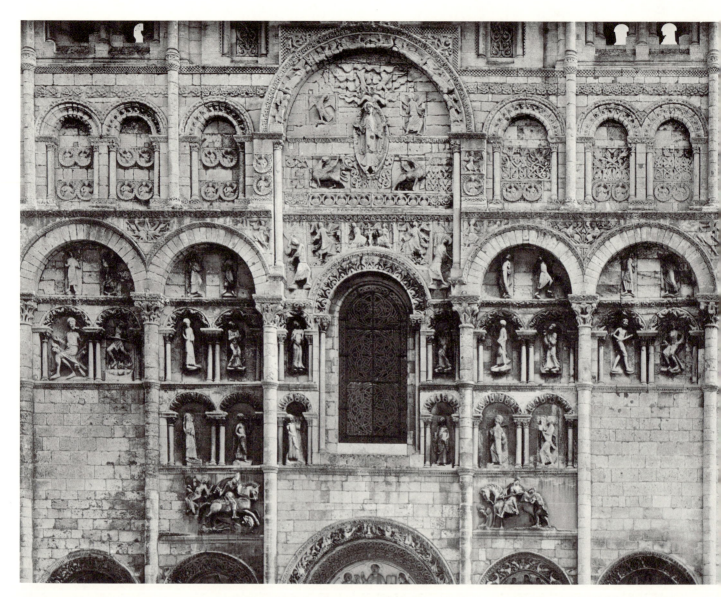

280. Ascension and Last Judgment. Angoulême (Charente), Cathedral of St.-Pierre.
Detail of west façade.

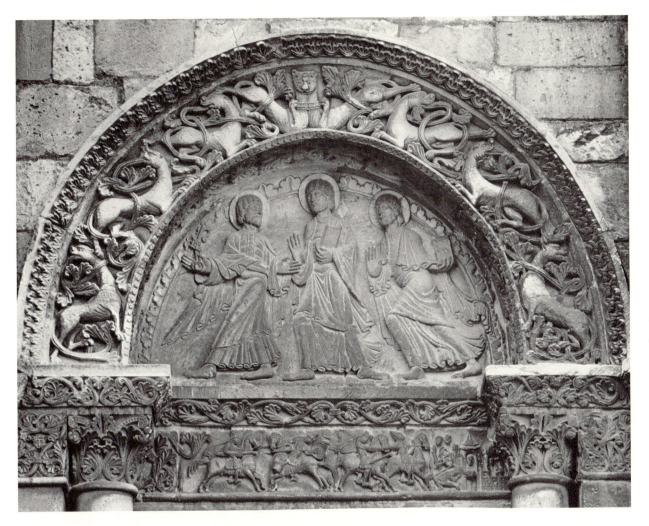

281. Apostles preaching the Gospel. Angoulême (Charente), Cathedral of St.-Pierre.
West façade, south portal, tympanum.

think of the Last Judgment. The Christ, who before seemed to be ascend-
ing to heaven, now seems to be descending, surrounded by the attributes
of the Christ of the Apocalypse, to judge mankind. Which of these inter-
pretations is the right one? Both. We have only to reread the Acts to un-
derstand the double meaning of the Angoulême façade. The angels said
to the apostles, "Ye men of Galilee, why stand ye gazing up into heaven?
This same Jesus, which is taken up from you into heaven, *shall return
in like manner as ye have seen him go into heaven.*"[69] Thus, Jesus, who
will come to judge the world, will reappear as he was on the day of the
Ascension. This was the medieval doctrine, which Honorius of Autun
formulated in the clearest terms in his *Elucidarium*: "Jesus will come to
judge mankind *in the same aspect as when he ascended to heaven.*"[70]
That is why the Angoulême Ascension scene becomes a Last Judgment.

We can accept this interpretation all the more readily because the Angoulême example is not unique. At St.-Paul-de-Varax (Ain), the Ascension scene is also a Last Judgment.[71] We also understand why the Byzantines represented the Christ of the Ascension majestically seated in an aureole like the Christ of the Last Judgment: he ascends to heaven in the same attitude he will have on the Last Day.

It is possible that the Angoulême artist completed the scene of the Ascension with the Last Judgment because of the vast amount of space at his disposal on the façade. At Ruffec,[72] where the surface to decorate was smaller, we see only the Ascension, although the imitation of Angoulême is obvious.

Such was the influence of the Cahors tympanum in the Midi. Now we shall see its influence in the north.

The left portal of the west façade at Chartres represents the Ascension (fig. 282).[73] Does it reproduce the main lines of the Cahors Ascension scene? Even before we examine it, the hypothesis seems likely, for have we not already seen on a nearby portal an imitation of the apocalyptic Christ of Moissac and the apostles of Carennac? As I have said, the Chartres workshop, which came from St.-Denis, included many southern sculptors who had worked for Suger. And why would these artists not have

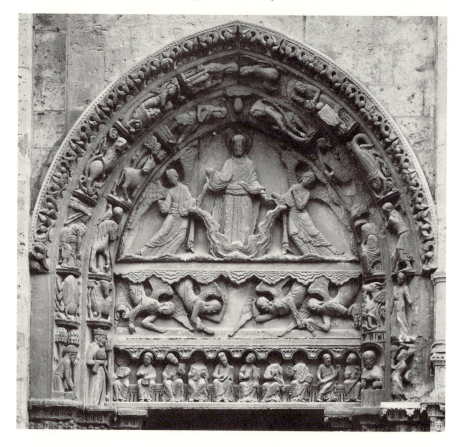

282. Ascension. Chartres (Eure-et-Loir), Cathedral of Notre-Dame. West façade, Royal Portal, north tympanum.

remembered the masterpiece of Cahors? They did, and we find its influence on the Chartres portal.

One difference strikes us at once: at Chartres, the Christ is not represented full-length; the lower part of his body is concealed in a cloud. But we can easily understand the reason for this arrangement. The artist, with his highly developed sense of proportion, wanted the standing Christ of the left portal to have exactly the same dimensions as the Virgin seated in the tympanum of the right portal, so that the two scenes would be in harmony. Thus, since the Christ figure could not be represented in entirety, we can scarcely imagine a more ingenious solution than the one found by the sculptor. Once this difference is explained, we have no trouble recognizing in the beautiful carving at Chartres some of the characteristics of the original. Christ, whose face has been worn away by weather, has the same nobility of attitude, the drapery has the same lines and, as at Cahors, one end of his mantle is tucked under his belt. The two great angels of Chartres curve backward, forming the same lines as those at Cahors. At Chartres, the slight affectation in their archaic arabesque that we find at Cahors, and which is charming nonetheless, has been corrected with exquisite artistry. The Chartres angels, with their fuller draperies and their more natural attitudes, are almost perfection itself. But the imitation of Cahors is flagrant in the four figures of half-length angels who appear out of the clouds. At Cahors, they hover above Christ's head and seem to have come from the depths of heaven to greet him. At Chartres, for reasons of symmetry and of harmony with the divisions of the tympanum at the right, the artist arranged them below Christ's feet, and it is they who speak to the apostles seated on the lintel. Such an arrangement is harmonious, but it represents an error. The text of the Acts is explicit: two angels, not four, speak to the apostles. Thus, the liberties that the Chartres artist took with the Cahors tympanum are not all equally felicitous; the original is closer to the text. Because of these changes, no one had thought of associating the portal of Chartres with the portal of Cahors, but close study leaves no doubt as to their relationship.[74] We must conclude that the tympanum of Cahors, thought to be a work of the late twelfth century, was carved before 1145, the year when the sculptors of St.-Denis were sent to Chartres.[75] We might go even further, I believe, and assert that all the great tympanums carved by the school of Moissac and Toulouse had been finished by 1135 when the sculptors from the Midi were assembled at St.-Denis by Suger. The admirable Christ of the Cahors tympanum contributes to the understanding of the precocious beauty of the Chartres figures.

The Ascension of Chartres was imitated in turn at Notre-Dame of Etampes.[76] The entire portal, with its statues, historiated capitals, and reliefs, was carved by artists from Chartres. But they were not the greatest

among them, and consequently, the Etampes tympanum seems more archaic than the tympanum of Chartres. However, it has been half destroyed, and we make out little more than the silhouettes.[77] In it, Christ is full-length, and the apostles stand, as in the Cahors tympanum. The elders of the Apocalypse in the archivolts are distantly related to the art of Moissac.

These are works that were inspired in the Midi and the north by the Cahors tympanum. We see that one historiated portal brought forth another, and workshop practices overruled even the theologians who, in cooperation with the artists, determined the decoration of church façades. A beautiful model created a tradition.

In Burgundy, also, there were several Ascension scenes carved on portals.[78] Had the idea come to Burgundy from the Midi, or even from the Ile-de-France? We may think so even if we cannot prove it, for in Burgundy the subject is handled differently; neither the Toulouse tympanum nor that of Cahors was imitated by Burgundian sculptors. But traveling abbots—and there were many at the time—who had been to Toulouse, Cahors, Mauriac, and Chartres could very well have given the sculptors the idea that the Ascension offered them the noblest and most appropriate subject they could find to frame in a tympanum. It is surely not by simple chance that the Ascension, which disappeared from the monumental art of the thirteenth century, is encountered in the twelfth century on portals both in the Midi and in Burgundy. This can hardly be accidental.

If the Burgundian sculptors accepted an idea from the Midi, as is probable, nevertheless they had for models not a carved tympanum such as that at Cahors, but manuscripts with miniatures. This is particularly evident at Montceaux-l'Etoile (fig. 84), where the figures stand out from the stone in silhouette. The manuscript that inspired the artist of Montceaux-l'Etoile, as we have explained elsewhere, had been copied from an Eastern model in which Syrian and Coptic influences were apparent.[79] Christ stands in a mandorla, like the Christ of the Syriac manuscript of Florence, and he carries the cross with a long staff that the Christian artists of Egypt so frequently placed in his hand.

On the portal of Anzy-le-Duc (fig. 83),[80] the scene is a simplified version of a Byzantine miniature: Christ ascends to heaven seated on a throne, not standing, and two angels support his aureole. The historiated archivolts of the portal at Anzy-le-Duc, such as are not found on pure Burgundian portals, seem to testify to the influence of the Ile-de-France. The presence of the elders of the Apocalypse in these archivolts reinforces the likelihood of this influence. Although representations of the Ascension differ in the two schools, here we seem to find evidence of contact.

The Ascension at St.-Paul-de-Varax[81] is conceived like that of Anzy-le-Duc. The Christ ascending to heaven in the attitude he will assume on the

Last Day, and the apostles assembled on the lintel who will then become the Judge's assessors, gave the artists an excuse to represent scenes from the Last Judgment. In the arcatures of the façade, devils lead the damned by a chain toward the yawning mouth of Leviathan, and an angel armed like a knight protects the souls of the saved with his sword. As at Angoulême, the Ascension and the Last Judgment are merged.

At Anzy-le-Duc and at St.-Paul-de-Varax, the attitude of the apostles, who raise their hands toward Christ ascending to heaven, leaves no doubt about the meaning of the scene. But was it the Ascension scene that the sculptor of Charlieu intended to represent on the interior portal of the church (fig. 283)?⁸² Here, as at Anzy-le-Duc and St.-Paul-de-Varax, Christ

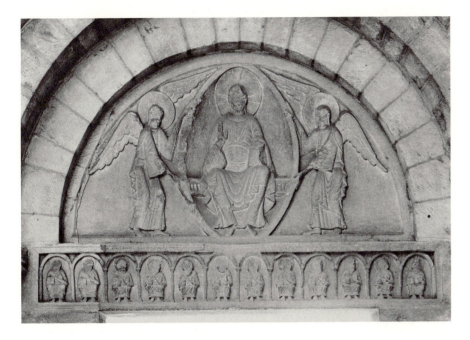

283. Christ in Majesty; apostles. Charlieu (Loire), Priory of St.-Fortunat. Inner portal of narthex, tympanum.

is seated in an aureole supported by two angels.⁸³ But below Christ's feet, the apostles are also seated. Enclosed within an arcature, they make no gestures, do not raise their heads toward heaven; the overall impression is one of solemn immobility. The general arrangement is that of the Ascension as it was usually represented in Burgundy, but the thought behind it is different. Here, the eternal aspect of Christ is paramount. The seated Christ of the Byzantine Ascension is transformed into a Christ in Majesty, comparable to the Christ of the Vision of St. John. Burgundian art often expressed this idea. The inscription accompanying the Christ in Majesty on the tympanum at Condeyssiat (Ain) provides proof:

Sic residens coelo (Beatus) Christus benedicis.

"It is thus that you are enthroned in heaven, O Christ, and that you bless us from heaven."

This is the meaning of the solemn figures of Christ that sometimes fill the upper parts of tympanums in Burgundy. At Vandeins (Ain), where Christ is seated in an aureole supported by two angels and dominates the scene of the Last Supper, there is the following inscription:

Benedicate Dominum. Majestas Domini.

"Bless the Lord. This is the Majesty of God." And lower down:

*Omnipotens Bonitas exaudiat ingredientes
Angelus Dei custodiat egredientes.*

"May the omnipotent Goodness hear the prayers of those who enter, and the angel of God watch over those who go out."[84]

These solemn words gave to the figure of the Christ in Majesty its true meaning: it is the image of God who, from the bosom of eternity, watches over his creatures.

Thus, in the Midi, as in the Ile-de-France and Burgundy, the tympanum was always composed with a tall figure of Christ dominating all others. That is why the artist of Vézelay, in the scene of Pentecost, placed a colossal Christ at the center of the apostles. At La Charité-sur-Loire, it is the figure of the Christ of the Transfiguration, standing in his aureole, that first catches our eye. Everywhere, the tympanum retained its triumphal character.

III

The Last Judgment. Tympanum of Beaulieu. The Beaulieu tympanum imitated at St.-Denis. Last Judgment scenes at Corbeil and Laon. The Last Judgment at Conques. Its Auvergnat origin. St. Michael and the scales. The Last Judgment in Burgundy. Last Judgments at Autun and Mâcon.

The artists of the Midi created a third type of portal, and one destined to have a long career, when they carved on a tympanum—that of Beaulieu—the scene of the Last Judgment. They had arrived at the subject quite naturally. At Moissac, the Christ of the Vision of St. John, seated majestically on his throne, evoked the idea of the supreme judge; the punishment of Dives, carved at Christ's right, strengthened it. There can be no doubt that twelfth-century artists sometimes thought of the Christ surrounded by the four evangelical beasts as a Christ-Judge. We find proof of this on the façade of St.-Trophime at Arles and on the Glory Portal at Santiago de Compostela, where the apocalyptic Christ is accompanied by representations of paradise and hell. Even the Christ of the Ascension does not always seem to rise to heaven, but, as we have seen at Angoulême and at St.-Paul-de-Varax, he descends again to judge mankind. The idea of the Judgment appeared to be contained in all the great works created by the artists of that time.

It is at Beaulieu (Corrèze) that we find the earliest true representation of the Last Judgment in monumental art (fig. 153).[85] This time, the angels blow their trumpets, the dead raise the lids of their coffins, and Christ,

accompanied by the apostles and surrounded by the instruments of the Passion, appears in heaven. Hell is carved on the two lintels. Monsters devouring the damned are carved against a background of rosettes imitated from those at Moissac. Beside a griffin in the haughtiest style and a dragon with three bodies, we see the seven-headed beast of the Apocalypse, the winged lion and the bear seen by Daniel in a vision. Here we sense that the Beatus Commentary was again exerting its influence.

One of the characteristic features of this Beaulieu Last Judgment is the tall cross supported by two angels, which appears in the sky behind Christ's head. This detail connects the Beaulieu tympanum with the traditions of the workshops of Toulouse. In the Last Judgment scene on a capital from the cloister of La Daurade (fig. 284),[86] there is a tall jeweled cross with its top lost in the clouds near the figure of Christ with outstretched arms, and here, also, the cross is carried by two angels. This cross was a legacy of Carolingian art. A fresco representing the Last Judgment, painted in the eighth century at the abbey of St. Gall, showed "the cross shining in the heavens"[87] beside the Christ-Judge. The ancient painting has disappeared, but not far from St. Gall, on an island in the Lake of Constance, there is a church decorated with a fresco of the Last Judgment that could date from the early eleventh century.[88] Near the Christ seated in an aureole among the apostles, there is a tall cross carried by an angel. In the Last Judgment at Burgfelden (Westphalia), which seems to have been painted somewhat later, the tall cross supported by two angels is placed in front of Christ.[89] This detail is all the more interesting because it does not appear in Eastern art; it, as well as other details, differentiates the

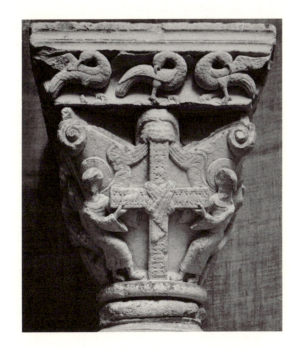

284. Triumph of the Cross. Cloister capital from La Daurade. Toulouse (Haute-Garonne), Musée des Augustins.

Western Last Judgment sharply from the Eastern. This was the way that the West, at a very early date, interpreted the passage from St. Matthew: "And then shall appear the sign of the Son of man in heaven."[90] Thus, the portal of Beaulieu perpetuates an ancient tradition.

On the other hand, there is one detail in the Beaulieu tympanum that seems entirely new. The Christ, with bare breast, extends his two arms horizontally as if he were still nailed to the cross. It is difficult not to see in this an influence of a famous book that had just been written, the *Elucidarium* of Honorius of Autun. This theological summary, presented in the form of a dialogue, is one of the most valuable sources for the twelfth century, because all the thought of the time is reflected in it. Several chapters are devoted to the Last Judgment. These pages, very well known at the time, put in men's minds the ideas that appeared in the creations of artists. The disciple asks of the master, "How will Christ appear on the day of Judgment?" The master replies, "He will appear to the elect as he showed himself on the mountain, to the damned, *just as he was on the Cross*."[91] This explains the strange attitude of the Beaulieu Christ: it is both majestic and sorrowful; majestic as on Mt. Tabor, sorrowful as on Calvary. There is no doubt that Christ's bare breast and his extended arms were intended, as the theologian said, to recall the martyrdom on the cross. The tradition of his outspread arms was long preserved in the Midi. In a manuscript illuminated at Limoges in the late twelfth century, the Christ of the Last Judgment extends his arms with bleeding hands, and a cross appears in front of him (fig. 285).[92] On the portal of Martel (Lot) (fig. 286), a vestige remains of the original idea: the arms of the Christ-Judge are no longer extended horizontally, but are still outstretched. On the façade of St.-Jouin-de-Marnes in Poitou, where a representation of the Last Judgment had been sketched out, the Christ no longer holds out his arms, but a tall cross is placed so exactly behind him that he seems to have just been unnailed from it.[93] Again it is the thought of Honorius of Autun that has been imposed on the artists.

The Last Judgment as developed in the Midi appeared in the north of France toward 1135 on the façade of St.-Denis (fig. 152). Since I have demonstrated that the tympanum of the central portal is an imitation of the tympanum at Beaulieu,[94] I shall not retrace that ground. It should be remarked, however, that the thought had gained in clarity at St.-Denis. The cross is placed behind Christ in such a way that his arms seem to be nailed to it. Never yet had the doctrine of Honorius of Autun been so perfectly translated.

The St.-Denis Last Judgment in turn inspired the Last Judgment at Notre-Dame of Corbeil, or so it would seem. An archeologist, who saw it shortly before it was destroyed in 1820, thought that it derived from that of St.-Denis,[95] and he was right. However, the imitation was not literal,

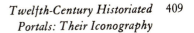

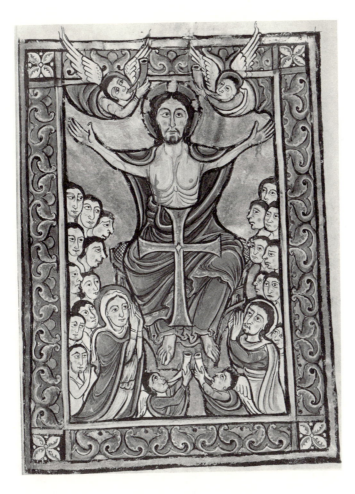

285. Last Judgment. Miniature cycle
of the Life of Christ from St.-Martial
of Limoges. New York, The Pierpont
Morgan Library, ms. 44, fol. 15r.

as the sketches that have come down to us prove; Christ does not extend
his arms, but the cross is placed behind him. Few works are to be more
regretted than the portal of Corbeil. Judging by the two admirable statues
in the collection of the Louvre, it was one of the masterpieces of twelfth-
century sculpture.[96]

At Laon (fig. 287), we find a last reflection of the Beaulieu type, or if
you will, the tympanum of St.-Denis. The tympanum of Laon devoted to
the Last Judgment is the oldest piece of carving in the cathedral; it must
go back to 1160, the date when the building of the church was apparently
begun.[97] Sometimes, as at Notre-Dame of Paris,[98] while the apse was still
under construction artists in the workshop began to carve the sculpture
for a façade that did not yet exist. More than thirty years of effort and
progress separate this archaic tympanum of Laon from the neighboring
tympanums devoted to the Virgin.[99] The Last Judgment at Laon is com-
posed of the same elements as those at Beaulieu and St.-Denis. The dead
rise from their tombs, Christ is seated in the midst of the apostles, angels
soar in the sky bearing the cross, the crown of thorns, and the nails. But

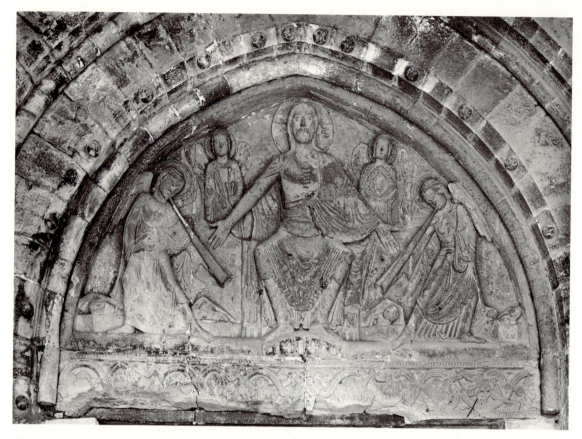

286. Last Judgment. Martel (Lot), St.-Maur. West façade, tympanum.

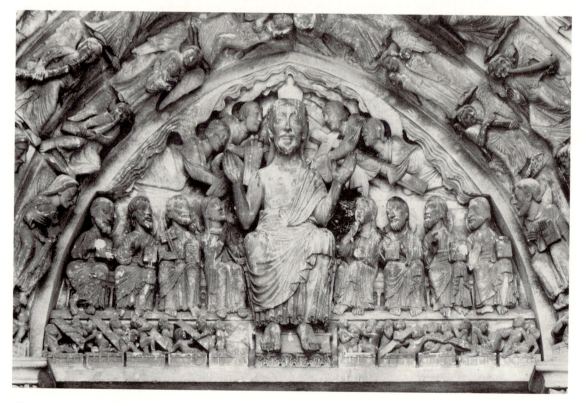

287. Last Judgment. Laon (Aisne), Cathedral of Notre-Dame. West façade, south portal, tympanum (heads modern).

already the open gesture of Christ's arms had been replaced by another. At Laon we see for the first time what we will often see in thirteenth-century sculpture: Christ raises his hands to display his wounds. The composition is still almost the same as the original, but the thought has already been transformed.

We see that the influence of the Beaulieu portal spread throughout the north through the intermediary of the St.-Denis portal.

At Beaulieu, the Last Judgment is reduced to its essential elements. The Midi was not content with so simple a representation, and created at Conques (Aveyron) an infinitely richer scene (fig. 288).[100]

One striking detail of the great portal of Conques relates it to the art of Auvergne: the top of the lintel, instead of being horizontal, slopes and recalls somewhat classical pediments. This same form was used at Notre-Dame-du-Port (fig. 23), at Chambon, and at Mozat (fig. 171). But there are still other similarities. Several small details connect the Conques relief with the Auvergne school. An angel carries a banner cut with two notches, which is identical with the banner in the hands of an angel on a capital of Notre-Dame-du-Port at Clermont-Ferrand (fig. 289). At Conques as at Clermont-Ferrand, an angel holds a large open book against his breast. At Conques and at Clermont-Ferrand, paradise is conceived as an arcade with round arches; a lamp hangs from an arch, and the area is closed off by doors. The door mounts are identical and are carved with equal care. At Conques, as at Notre-Dame-du-Port and at St.-Nectaire, angels hold long banderoles decorated with inscriptions. At Conques, St. Foy prostrates herself with hands clasped before her in the same attitude as the monk carved on the lintel of Mozat (fig. 171).[101] The Conques sculptor surely knew the churches of Auvergne, and it is even possible that he had worked on them. He does not have the somewhat heavy accent of the sculptors of Notre-Dame-du-Port and the church of St.-Nectaire, but his restrained and sober style is strikingly like that of the capitals which once decorated the ambulatory at Mozat. The capital of the Holy Women at the Tomb, which escaped destruction and is now placed at the entrance to the church (fig. 116), has more than one feature that relates it to the art of Conques: the angel with his wings outlined by a border and his hair parted in the middle appears at Conques; and at the same time, the first of the holy women reminds us of the Virgin standing beside the Judge. Only the most skillful of the Auvergne sculptors was called to Conques. We must not try to link the tympanum of Conques with the art of Languedoc, as has sometimes been done; nothing in it recalls the tense curves and the beautiful clinging drapery flaring at the hemline of the southern sculptors.

The iconography of the Conques Last Judgment is no less new; it differs profoundly from the iconography of the Beaulieu tympanum. Christ does not extend his arms in the attitude of a cross; he displays his wounds,

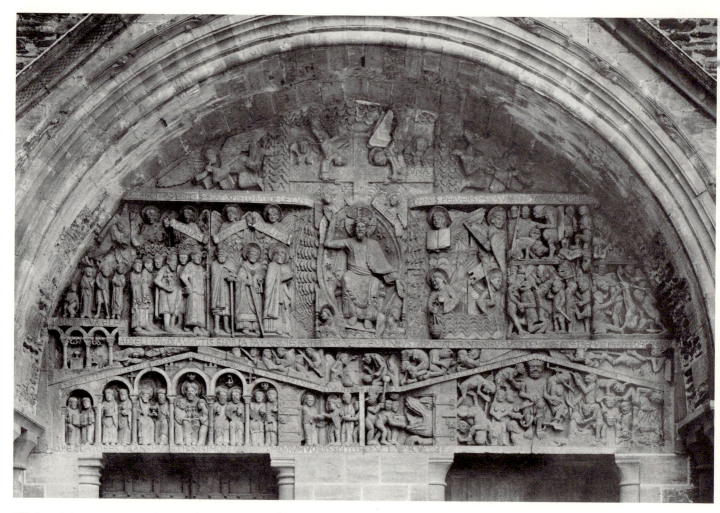

288. Last Judgment. Conques (Aveyron), Abbey Church of Ste.-Foy. West façade, central portal, tympanum.

289. Angel carrying a standard.
Clermont-Ferrand (Puy-de-Dôme), Notre-
Dame-du-Port. Choir capital.

but his right hand, on the side of the saved, is raised, while the left hand, on the side of the damned, is lowered. The apostles are not seated around him. The tympanum, thus disencumbered, is a vast field, ample enough for the representation of rewards and punishments. The Resurrection of the Dead is given only a small space. For the first time, the sun and the moon are shown in the sky above the scene of the Last Judgment beside the angels who display the lance, the nails, and the cross. In the following century, the angels would be shown carrying away the sun and the moon, as if they were useless lamps, for as Honorius of Autun said, "The cross will shine with a light more brilliant than the sun's."[102]

For the first time, the elect at Christ's right are represented as a long procession led by the Virgin and accompanied by St. Peter carrying the keys. Behind St. Peter, the solemn figure in contemplation, leaning on a staff in the form of the letter *tau,* is perhaps St. Anthony, father of hermits. The abbot behind him is no doubt St. Benedict, father of monks; he leads an emperor by the hand. The emperor, who advances timidly, is probably Charlemagne, the legendary benefactor of the abbey of Conques. He will attain heaven not by his scepter and crown, but because of the prayers of the monks he loved.

At Beaulieu, and on the portals derived from it, the Judgment is not shown in process. But at Conques, St. Michael holds the scales, weighing good and evil, while the devil, with a cynical grin, puts his thumb on the scales to tip them in his favor. The weighing of souls introduces drama into the Last Judgment scene. The scene had already been represented in southern art, for a strange capital in the museum of Toulouse dating from

the eleventh century[103] represents St. Michael weighing the souls in the presence of Satan. This moving scene spread throughout the Midi; it appears on a capital at the abbey of St.-Pons, for example, and on one side of the portal of St.-Trophime at Arles. In the west of France, it was carved on a capital of St.-Eutrope at Saintes (fig. 290). It was also known in Auvergne, as a St.-Nectaire capital proves. It had been transmitted to southern sculptors from the East through the intermediary of illuminated manuscripts, for it has become evident that this splendid episode was introduced into the Last Judgment scene in the East. An early fresco, recently discovered in the church of Peristrema, in Cappadocia,[104] shows an angel holding the scales not far from the Judge. This may have been an innovation taken from Christian Egypt. Throughout the centuries in Pharaonic Egypt, the Judgment of the Souls had been painted on the scroll of the Book of the Dead and on the walls of rock tombs. Anubis watched over the scales in the presence of Osiris seated on his throne, and his forty-two assessors. The dead man trembles with terror when he sees that his heart is no longer in his breast; it rests on one pan of the scales; the other pan holds the symbol of justice. The dead man defends himself, pronouncing the beautiful negative confession which reveals the goodness of ancient Egypt: "I have caused no tears to flow, I have not brought suffering on any person . . . , I have not taken milk from the mouths of children, I have not driven cattle from their pasture . . . , I am pure, I am pure, I am pure." If the two pans of the scales balance and the pointer stands still, the justified dead man may then cross the threshold of Amenti.

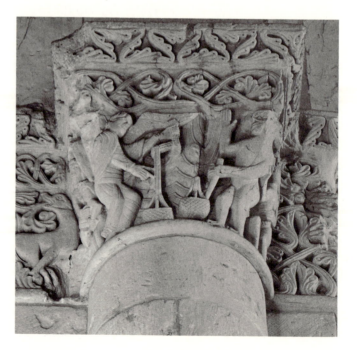

290. St. Michael holding the scales. Saintes (Charente-Inférieure), Abbey Church of St.-Eutrope. Transept, northeast pier capital.

When Egypt was Christianized, this terrible image of the scales was not forgotten; it was transferred to the hands of St. Michael, the archangel of justice.

At Conques, some of the details in the representation of hell are completely new. Hell's doorway is the mouth of a monster in which the damned are swallowed up. This is the Leviathan of the Book of Job. Medieval thought was so faithfully interpreted here that even the door is shown, behind which, according to the commentators, the monster hides his face.[105] We also see the caldron into which the sinners are thrown; Satan, taller than those around him, plants his feet on a sinner as if he were a footstool, and reigns over the torture. Pride falls from his horse; Avarice, his purse tied around his neck, is hanged as Judas was hanged; a couple, chained together throughout eternity, symbolize Lust.

Paradise is a portico under which the blessed are seated. Abraham, whose image first appeared on the porch of Moissac, reappears here and gathers two saved souls to his bosom. Martyrs, virgins, and holy women have emperors' crowns on their heads; the martyrs also bear the palm of martyrdom and carry a chalice that recalls the virtue of the blood they had shed. St. Foy, the great saint of Conques, has a place apart: she kneels beneath the hand of God.

Here we have almost all of the elements that were to be developed in the great Last Judgment scenes of the thirteenth century. At Notre-Dame of Paris, we see the archangel weighing the souls and the blessed who advance in procession; in the archivolts, there are virgins, martyrs, and Abraham who gathers the souls of the elect in his bosom; also there is the mouth of Leviathan that swallows the damned, the boiling caldron, and Satan presiding with his feet resting on the damned. To judge by a description, several of these details had already appeared before 1180 on the portal of Notre-Dame of Corbeil.[106] Are we to believe that the portal of Conques also had a role in the development of northern French art? We are tempted to think so, for this church at Conques, which now seems hidden away in the mountains, was once a much frequented station on the road to Compostela. Thousands upon thousands of pilgrims had earnestly gazed at this portal, pointing out each detail.[107]

Unfortunately, since the date of the Conques portal is not known, we have no fixed point to refer to. It was long thought to be earlier than it actually is; it was dated at the beginning of the twelfth century, because it was imagined to be an imitation of the Last Judgment at Perse, near Espalion (Aveyron), which because of its archaic character was attributed to the late eleventh century. But this is an obvious error. The Perse tympanum is not the original, but a copy of the Conques tympanum by a rustic artist who imitated several of its features with a clumsiness that was mistaken for archaism.[108] The portal of Conques can scarcely be

earlier than the second quarter of the twelfth century, but neither can it be, as has been said, of the late twelfth century. I see in it no influence of the art of northern France. On the contrary, I am inclined to think that this Last Judgment, so pictorial in character, inspired the artists of the Ile-de-France and enriched their imaginations.

It is also possible that the portal of St.-Trophime at Arles, which owes so much to the art of northern France, may have given northern France something in return. At Arles, we see for the first time the damned bound together by a rope, one end of which is held by a demon (fig. 291). This long procession, something like a frieze, appears later at Notre-Dame of Paris and at Reims.

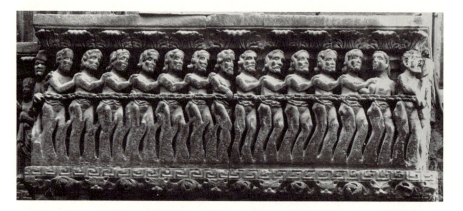

291. The Damned. Arles (Bouches-du-Rhône), St.-Trophime. West façade, detail of frieze.

The scene of the Last Judgment appeared in Burgundy also. It is curious to see all the great subjects created by the sculptors of the Midi reappear in Burgundy: the Christ of the Apocalypse, the Ascension, the Last Judgment, themes that are common to both schools. These similarities presuppose connections that today escape us. However, the Last Judgment as it was conceived by Burgundian artists differs profoundly from the Last Judgment created by the southern artists.

At one time, there were several representations of it in Burgundy,[109] but the only one preserved in its original state is that of the cathedral of Autun, signed by Gislebertus (fig. 292). The savage distortion of the work is at first disconcerting. It so horrified the eighteenth century canons that they had it covered with plaster, for which we owe them a certain amount of gratitude. They could have destroyed it.

A giant Christ dominates the inordinately tall figures; we seem to be looking into a distorting mirror. In truth, the artist divided the space so badly that to fill the middle section he had to elongate his figures beyond plausibility. This Last Judgment, which doubtless was carved a little later than that of Beaulieu, differs from it in several details. Christ does not hold out his arms in the form of a cross, nor does he display his wounds.

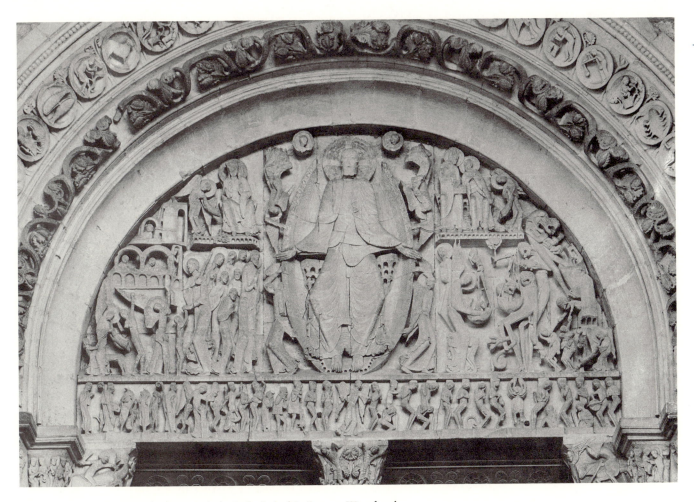

292. Last Judgment. Autun (Saône-et-Loire), Cathedral of St. Lazare. West façade, tympanum of main portal.

His hands are open, both on the side of the saved and the side of the damned, and he seems to say: "The hour is come; let justice be done."[110] He is seated between the sun and the moon, but the instruments of the Passion carried by angels are not shown above his head. He is a judge, not a redeemer who reminds men that he suffered for them and that they scorned his sacrifice. Here, any profound idea is lacking.

On the other hand, new ideas do appear. As at Beaulieu, the apostles are scattered over the tympanum, but among them is the Virgin, seated at the right of Christ, and St. John the Evangelist stands at his left. These two intercessors, who were to play so great a role in thirteenth-century Last Judgment scenes, appear here in a place of honor for the first time.

The Weighing of Souls, which was omitted at Beaulieu, is a moving drama at Autun. A demon sitting in a pan of the scales represents the weight of our sins. Other demons seem to howl as they hang on the scales to tip them on their side, and one has just thrown a toad into the pan.

But the scale, supported by a mysterious hand, sinks on the side of the naked little figure who represents what is best in our souls. The archangel takes hold of the pan which once again has obeyed justice. The soul is saved and will rise to heaven, following another soul who rises lightly like a bird. Meanwhile, two little souls, who tremble as they await the hour of judgment, press against the archangel and hide beneath his mantle. We participate in the drama that affects us so closely, and we forget the faults of the artist.

But the most original part of this Last Judgment at Autun is the Resurrection of the Dead. This episode is given almost no space at Beaulieu and Conques; here it occupies an entire lintel, and prefigures the beautiful Resurrection scenes of the thirteenth century. Never has the scene been so moving as at Autun. The artist, who seems to have believed in predestination, divided the dead into the damned and the saved at the very moment they rise from their tombs. They have not yet been judged, but the saved already stand at Christ's right and the damned at his left; an angel with sword in hand marks the boundary between good and evil. This device, which is a unique example and one that would have been condemned by a strict theologian, greatly enhances the drama of the Autun Resurrection. On one side, all is joy; on the other, all is despair. The good souls rise in ecstasy from their tombs, with their eyes and arms raised toward the light. An abbot, chin in hand, is already lost in the contemplation of God (fig. 293). A husband takes his wife by the hand and points to the heaven, but the love of earth still lives in her soul and she points to the son who slept beside them in the sepulcher and is just now throwing off his shroud; all three will be united for eternity. Two pilgrims carry both the pilgrim's staff and the scrip decorated with the cockleshell of St. James and the cross of Jerusalem; their humble faith has saved them. Children hang onto an angel's robes, as familiar with

293. Resurrection of the Elect. Autun (Saône-et-Loire), Cathedral of St.-Lazare. West façade, detail of lintel.

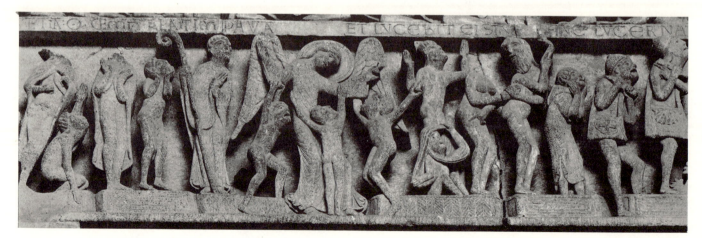

him as they would have been with their mothers;[111] with his finger, the angel points to God and seems to spell out God's mystery to them.

At the left of the Judge, the dead are bowed in terror as they come out of their tombs. They dare not raise their heads; they put their hands over their faces or clasp them in hopeless prayer. The punishment has already begun: one serpent fastens itself to a woman's breast, and another rises up against the breast of a miser, beside the purse with which he had been buried. Two monstrous and terrible hands emerge from the shadows and take hold of a sinner. Hell is not far off; above the heads of the damned we see the bottomless pit, and behind a door, the mouth of Leviathan out of which a demon is leaning to seize on a woman who is overwhelmed by despair.

Never had an artist put such fury into a Last Judgment scene. Everyone shudders, everyone trembles; even the apostles who assist the Judge make gestures of terror in the midst of this tempest of passions and cries. This astonishing artist transports us to a world of dream in which bodies defy the laws of matter and enter paradise by passing through walls. Even the elongated figures contribute to the impression of the supernatural he wishes to convey. His work obsesses us; we cannot look at it with detachment.

The Last Judgment of Autun remained an isolated work in Burgundy. What we can see of the mutilated tympanum of St.-Vincent at Mâcon is different. There, everything is more judiciously worked out. Five superimposed registers bring order to confusion and made it possible to give figures their proper proportions. The apostles are seated at each side of the Judge; the Virgin and St. John occupy the places of honor at his right and left. Twenty-four characters from the Old Law are placed below the apostles; the dead rise from their tombs below the figures from the Old Law; the good are separated from the wicked below the scene of the Resurrection of the Dead;[112] lastly, at the top, angels fly in the sky. Here, we are much nearer to the thirteenth-century Last Judgment scene than to that of Autun.

In these various attempts, the artists of Burgundy and of the Midi had expressed a host of ideas that were gathered up by the following century. Almost all of the elements of our great thirteenth-century Last Judgment scenes already existed in the twelfth century. The work of our cathedral sculptors was to coordinate them and, with the help of the theologians, to formulate a coherent system that was true to the faith and as solid as dogma.

The Last Supper and the Washing of Feet on Burgundian portals. These portals affirm the divine institution of the sacraments, as a refutation of the heretics. The reliefs representing the Miracle of the Loaves and the Crucifixion have the same significance. The role of Cluny. The imprint of Cluny. The tympanum of St.-Sauveur at Nevers.

Along with these three types of portals, all of which were created in the Midi, there is a fourth that seems to have been of Burgundian origin. In fact, it is in Burgundy, or to be more exact, in the domain of Burgundian art that it is usually found. These portals represent the Last Supper, often dominated by the figure of the Christ in Majesty. The tympanum that once decorated a door of the abbey of St.-Bénigne, at Dijon,[113] has one of the earliest representations of this subject in monumental art (fig. 294).

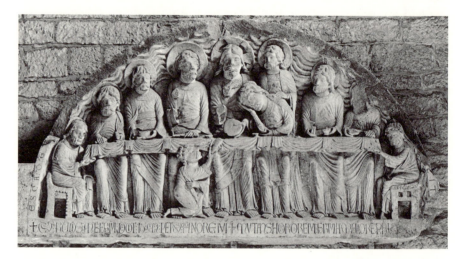

294. Last Supper. Tympanum from Church of St.-Bénigne. Dijon (Côte-d'Or), Musée Départemental des Antiquités de la Côte-d'Or.

It contains only the Last Supper; the Christ in Majesty does not appear. But at St.-Julien of Jonzy (Saône-et-Loire),[114] the formula is established: the Last Supper occupies the entire length of the lintel; the Christ in an aureole borne by two angels appears above it. This, with only slight variations, is the composition of the tympanums of Nantua and of Vandeins (Ain), the tympanum of Bellenaves (Allier) (fig. 295), the tympanum of Vizille (Isère). And there is no doubt that such was the tympanum of Savigny (Rhône), of which only the lintel devoted to the Last Supper has survived.

Since St.-Bénigne of Dijon, Savigny, Nantua, and Vizille[115] were all either abbeys or priories affiliated with Cluny, it is permissible to conclude that this type of portal had been created and propagated by the Cluniac monks. And in fact, if we travel south to the Midi, we will again see the Last Supper dominated by the Christ in Majesty on the portal of St.-Pons (Hérault), and on the central portal of the famous façade of St.-Gilles.[116] Now St.-Pons and St.-Gilles were abbeys which very early had placed themselves under the Rule of Cluny.

One interesting detail is worth pointing out: on several of these portals, the Last Supper is accompanied by the Washing of Feet. We see the two episodes brought together on the same lintel at St.-Julien of Jonzy, at

Savigny, Vandeins, Bellenaves, St.-Pons, and St.-Gilles. At Vandeins, an inscription above the lintel reveals the thought the artist intended to express:

Ad mensam Domini peccator quando propinquat
Expedit ut fraudes ex toto corde relinquat.

"When the sinner approaches the table of the Lord, he must ask with all his heart that his sins be forgiven." Thus, representations of the Last Supper and the Washing of Feet carved on twelfth-century portals have symbolic meaning: the Washing of Feet symbolizes the sacrament of Penance, as the Last Supper symbolizes the sacrament of the Eucharist.[117]

This invaluable inscription from Vandeins explains the true meaning of these portals: they were dedicated to the two principal sacraments. They represent the founding of the sacraments by the Saviour himself, and the figure of Christ looking down from the tympanum completes their supernatural character. We wonder if this was not a deliberate affirmation of dogma, and if the artist did not intend to show that confession and communion are duties imposed on all Christians.

As we travel through France and admire its beautiful Romanesque churches, themselves as solid as faith, they seem to us to have been created in a world as yet untouched by doubt. But that is an illusion that soon disappears with a bit of knowledge. The twelfth century was the century of heretics.[118] In the eleventh century, heresy had appeared briefly at

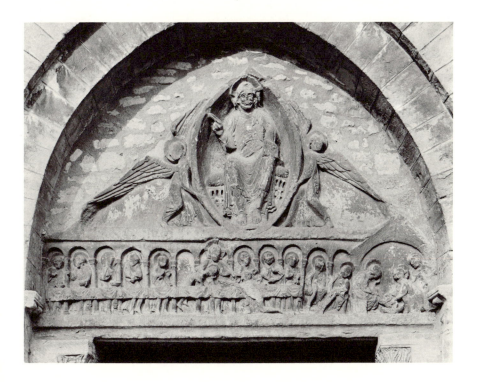

295. Christ in Majesty; Last Supper; The Washing of Feet. Bellenaves (Allier), St.-Martin. West façade, portal, tympanum.

Orléans, but it was quickly stamped out. In the twelfth century, it cropped up in twenty places at once. There were heretics at Soissons and in Champagne. There were others in Flanders who were followers of Tanchelm, a kind of prophet who dressed in purple and had a standard and sword carried before him. There were those at Cologne who called themselves the "apostolics" and who wanted to revive primitive Christianity. All of these denied the efficacy of the sacraments and the perenniality of the Church. But the most dangerous heresies were propagated in the Midi. Pierre de Bruys traveled over Provence, Languedoc, and Gascony, teaching the uselessness of the Mass, deriding the sacraments, and inciting his disciples to break crosses. He was burned by a mob at St.-Gilles in 1143, but Henry of Lausanne, a former Cluniac monk, succeeded him. Henry traveled over Switzerland and Burgundy; he preached his doctrine at Le Mans, then in Poitou, Périgord, and finally in Provence and Languedoc, where heretics appeared again and again. He was imprisoned by the Bishop of Toulouse, but his disciples were so numerous that the Church took fright. In the early twelfth century, the Church had called upon her saints to overcome heresy: St. Norbert, the founder of Prémontré, had combatted Tanchelm; St. Bernard had contended against the "apostolics" of Cologne. The Pope, to bring the disciples of Henry back to the faith, called again upon St. Bernard, who alone seemed capable of touching their hearts with his flaming words and his charismatic powers. It was a hard mission. St. Bernard himself wrote, "What evil has the heretic Henry not committed against the Church of God? The basilicas are empty of believers, and the believers are without priests . . . , the sacraments are held up to scorn, the feasts are no longer celebrated, men die in sin, infants are not given the grace of baptism."[119] St. Bernard seems to have made numerous conversions during his mission of 1145, but he could not bring the Midi back to the faith.

A new heresy had already spread throughout the south: Catharism.[120] It was less a heresy than a religion in itself which had come from the East and claimed to be a substitute for Christianity. Two ancient Asian ideas reappeared there: the good god and the evil god of Persia, and the metempsychosis of India. Their Christ was the Christ of the Alexandrian Gnostics—a pure spirit who had never assumed human form, an *aeon*. They denied the Church, and substituted new sacraments for its sacraments. In 1167, these Neo-Manicheans, who came to be called Albigensians, were numerous enough to hold their first Council at St.-Félix of Caraman. Ten years later, in 1177, Raymond V, count of Toulouse, wrote to the chapter general of Cîteaux that the heresy had spread throughout Languedoc, the people had abandoned the faith, and the churches had fallen into ruin.

In Lyons at the same time, Peter Waldo claimed to bring the Church

back to its original purity. His disciples, "the poor of Lyons" or "Vaudois,"[121] spread out through Burgundy and Franche-Comté in the north, and into the Rhone valley and Provence to the south. They clung to the Gospels but refused to recognize the hierarchy of the Church.

Thus, several of the great southern abbeys, whose beautiful carved portals we admire, were fortresses of the faith in an already hostile world. The cathedrals of the north were built in concord and peace of heart, but not the Romanesque churches of the Midi.

It is possible that contemporaries may have exaggerated the success of heresy in the twelfth century in order to make its dangers felt, but it is certain that the greatest minds of the time were surprised and uneasy. The abbot of Cluny, Peter the Venerable, who died in 1157 and saw only the beginnings of this revolt against the Church, believed that it was his duty to refute the error. He wrote a treatise against Pierre de Bruys and his disciples in defense of the Eucharist, under attack by the innovators. Cluny could not keep silent when the faith was in peril.

When we recall these struggles, which at the height of the Middle Ages foretell the religious controversies of the sixteenth century, we understand the real character of the Burgundian portals. Burgundy, apparently, was barely brushed by heresy,[122] but the Cluniac monks thought it wise to forestall it. Furthermore, in Languedoc, at St.-Gilles and St.-Pons, they were in the middle of heresy country. Therefore, in the sculptured relief of their portals, they taught that the two chief sacraments of the Church, Penance and the Eucharist, were divine institutions, and sometimes in the work of their sculptors we seem to see the very words of Peter the Venerable's doctrine. A lintel of one of the Charlieu portals represents the bloody sacrifices of the Old Law: the ram, the goat, and the calf are led to the altar to be offered up (fig. 296). In the tympanum, Christ changes the water into wine at the Wedding in Cana, and on the main portal, the lamb occupies a place of honor in the archivolt. Now in the treatise written by Peter the Venerable against Pierre de Bruys, there is this passage: "The ox, the calf, the ram, and the goat soaked the altars of the Jews with their blood; only the Lamb of God, who wipes out the sins of the world, rests on the altar of the Christians."[123] Further on, he explains that Christ's intention in changing the water into wine at the Wedding in Cana was to prefigure the Eucharist and the sacrament of the altar. When we look at the façade of Charlieu, we seem to be rereading this page from Peter the Venerable.

The example provided by Cluny seems to have been followed elsewhere in somewhat different form. On the former portal of Valence (Drôme), the scene of the Miracle of the Loaves is placed beneath the Christ seated between the angels; Christ, seated among the apostles, blesses with each

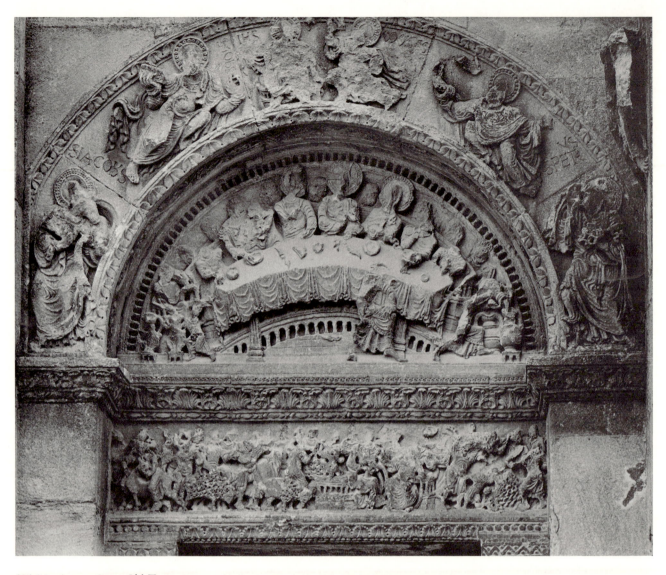

296. Marriage at Cana; Old Testament
Sacrifice. Charlieu (Loire), Priory of
St.-Fortunat. North face of narthex,
side portal.

hand the baskets presented to him (fig. 25). Now, from the time of the
catacombs, the Church had always interpreted the Miracle of the Loaves
as a symbol of the Eucharist.[124] This miracle betokens another miracle: the
body of Christ multiplying itself at the same time as the consecrated bread.

The same scene is found on a capital at St.-Pons, and in Auvergne on the
exterior of the church at Issoire. Is it not strange that in the twelfth cen-
tury, an age of conflict, this motif reappeared and then was abandoned
by the art of the thirteenth century?

And it is also curious that the first example of the crucified Christ to be
placed on the portal of a church is found in the Midi—the region where
the disciples of Pierre de Bruys broke crucifixes. Christ on the Cross
appears on one of the tympanums of St.-Pons, while the Last Supper

and the Washing of Feet appear on the other.[125] These two reliefs exalted what the heretics flouted. At St.-Gilles, where Pierre de Bruys was burned, the Last Supper appears on the lintel of the central doorway; and on the tympanum of the neighboring portal, Christ on the Cross (fig. 297). It is as if the monks wished to blot out forever all memory of the blasphemer's words. Farther north, on the portal of the church of Champagne (Ardèche), in the Rhone valley which at that time was one of the principal channels of heresy, Christ on the Cross (fig. 75) is carved above the Last Supper (fig. 298). These are the first images of Calvary to appear in monumental art; a century was to pass before Christ on the Cross would again be carved on the portals of churches.[126] Was it only by chance that these images were used in the regions where Pierre de Bruys had recruited most of his disciples?

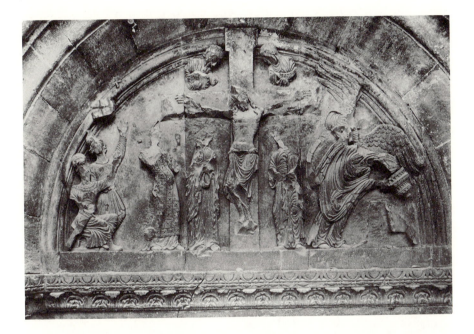

297. Crucifixion. St.-Gilles-du-Gard (Gard), Abbey Church. West façade, south portal, tympanum.

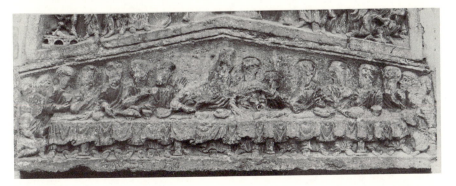

298. Last Supper. Champagne (Ardèche), Priory. West façade, central portal, lintel.

Thus, there is an entire category of portals—portals of Cluniac churches, for the most part—that reflect the religious conflicts of the twelfth century. The monks of Cluny were then what they had always been, the true defenders of the Church.

The Cluniac spirit also explains such a tympanum as that of St.-Sauveur of Nevers (fig. 299). The church of St.-Sauveur, destroyed long ago, was a Cluniac priory. One of its portals was decorated with a relief sculpture, now preserved in the archeological museum of the Porte de Croux, which represented Christ seated in profile and handing the keys to St. Peter surrounded by several apostles.[127] The scene is accompanied by the following inscription:

Visibus humanis monstratur mistica clavis.

"Here, the eyes of mankind may contemplate the mystical key." As we know, the key is the power to bind and to loose; the symbolic gift of the keys made of St. Peter the head of the Church and the first of the popes. The tympanum of St.-Sauveur, consequently, is a sort of exaltation of the papacy; the figure of St. Peter carried the implication of Rome and the succession of Roman pontiffs. No subject could have been more in harmony with the spirit of Cluny and its history. In the great abbey's deed of foundation written in 909, William of Aquitaine said, "I bequeath and surrender to the apostles Peter and Paul the village of Cluny, situated on the Grosne river . . . on the condition that a regular monastery be built there. . . . Every five years, the monks must pay ten gold sous to

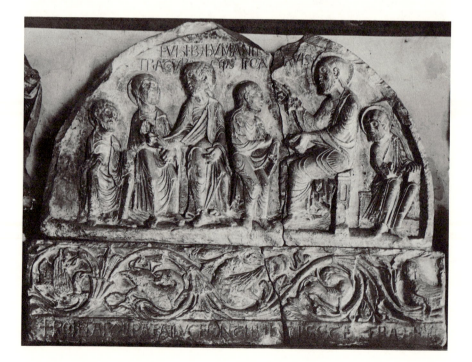

299. Christ giving the keys to St.-Peter. Tympanum from St.-Sauveur. Nevers (Nièvre), Musée Archéologique du Nivernais.

Rome for maintaining the lighting of the church of the apostles. May the apostles themselves be their protectors, and the Roman pontiff their defender."[128] A poetic symbol; in truth, throughout several centuries, Cluny kept the flame burning in St. Peter's lamp, and the greatest popes were Cluniac monks. No monastic order had ever been more completely devoted to the papacy. The abbot of Cluny, St. Hugh, was beside Gregory VII at Canossa where might came to humble itself before the spirit, and he was at Urban II's side at Clermont-Ferrand when the enthusiasm for the crusade burst forth.[129] *Roma secunda vocor*, said a monastic poet of Cluny: "I am called the second Rome." And for three hundred years, Cluny lived up to its great name.

That is why the tympanum of St.-Sauveur at Nevers expresses so well the spirit of Cluny. The work is a tribute to the papacy, an affirmation of its divine origin.

We sometimes recognize the imprint of the great abbey on the façades of Cluniac churches. An historiated capital of the small portal of Charlieu represents Christ between St. Peter and St. Paul, the two patron saints of Cluny. This is a kind of homage rendered by the priory to the mother abbey.

The Cluniac priory of Beaulieu was dedicated to St. Peter, but St. Peter is not represented alone on the portal. St. Paul is also there.[130]

This tradition was still perpetuated in the thirteenth century. The Cluniac priory of Longpont, near Montlhéry,[131] has preserved the statues of St. Peter and St. Paul on its portal.

V

All the portals we have studied thus far are dedicated to Christ, but there are others dedicated to his mother.

It was in the twelfth century that tenderness began to lighten the traditional solemnity of the cult of the Virgin. At the beginning of the century, Honorius of Autun, in his *Speculum ecclesiae*, still spoke of Mary as the ancient Church Doctors had done. To him, the Virgin was above all the instrument of redemption, the eternal thought in the mind of God. Honorius showed that she had been ever present in the Old Testament; she was symbolized by the fleece of Gideon, the furnace of the young Hebrews, the lions' den of Daniel.[132] All of this symbolism was addressed more to the mind than to the heart.

But at this same time, new orders were established which began to speak of Mary in a more emotional tone, and we see the growth of the feeling that was to flourish with poetic grace in the thirteenth century.

The ardent devotion of the Premonstratensians and the Cistercians to the Virgin was not shared to the same degree by the early Benedictines.

Portals devoted to the Virgin. The cult of the Virgin in the twelfth century. The Adoration of the Magi is the first form of homage paid to the Virgin. The Virgin in Majesty on tympanums. The standing Virgin appears in Burgundy. The Miracle of Theophilus. The Death, Burial, and Coronation of the Virgin. The portal of Senlis.

St. Norbert, the founder of the Order of the Premonstratensians, gave a white cloak to his disciples in honor of the Virgin. In the Order of Cîteaux, all of the monasteries were dedicated to her. In German-speaking countries, the Cistercian abbeys were called *Mariengarten* (Mary's Garden), *Marienburg* (Mary's Fortress), *Marienhave* (Mary's Haven), or *Marienkroon* (Mary's Crown). Each monastery might have had on its portal the inscription that was carved on the portal of Cîteaux:

> *Salve, sancta Parens, sub qua Cistercius ordo*
> *Militat. . . .*

"Hail, holy Mother, the monks of Cîteaux fight under your orders."

St. Bernard, the greatest of the Cistercians, celebrated the Virgin with a fervor that foreshadowed the emotional outpourings of the following centuries. In his *Sermones in cantica canticorum* he wrote: "It is she who might have said, 'I have been wounded with love,' for the arrow of Christ's love pierced her through and left in her virginal heart not one atom without love."[133] Elsewhere, he said, "In her, all was worthy of admiration. Her body was as beautiful as her soul, and it is her radiant beauty that drew upon her the gaze of the Eternal."[134] She is our guide, our hope. In one of his homilies on the *Missus est*, he speaks of the mysterious name, "Star of the Sea," given to her in the canticle. "Turn not your eyes from the star," he says, "if you wish not to be engulfed by the tempest. If you are buffeted by the storm of temptation, gaze on the star."[135] Henceforth, the Virgin was not only she who had wiped out the sin of Eve; she became an ideal of beauty and purity, the great mediator between God and mankind.

St. Bernard had spoken with such sweetness of the Virgin that a reward seemed due him. Legends sprang up and spread among the Cistercians. It was said that one night when he prayed alone in the church of St.-Bénigne at Dijon, angels with voices of an ineffable sweetness sang for him the *Salve regina*.[136] But on another occasion the Virgin herself appeared to him and let several drops of her milk fall on his parched mouth;[137] a subject dear to the Spanish imagination, and of which Murillo painted a masterpiece.

The enthusiasm of St. Bernard for the Virgin spread throughout his order, for his sermons were read and commentaries on them were made in the monasteries of Cîteaux.[138] In the golden legend of the order, the Virgin lavished miracles upon the Cistercians. The influence of Cîteaux was so powerful in the twelfth century that the Benedictines and the entire Church joined in her praises and gave increasing importance to the cult of the Virgin.

These new feelings were expressed in art, at first with a certain reserve, but toward the end of the century, with great fervor.

In the earliest works, the Virgin was never separated from her Son and was celebrated along with him. The first example in art of this cult of the Virgin is at Moissac. All the right side of the porch is dedicated to her: we see, in turn, the Annunciation, the Visitation, the Adoration of the Magi, the Presentation in the Temple, and the Flight into Egypt (fig. 57). The Child is honored at the same time as the Mother, but it is evident that the Virgin is the artist's heroine and that he is presenting her for our admiration. Moreover, the Annunciation and the Visitation relate only to her.

Of all the scenes sculpted on the porch at Moissac, there is one which presents the Virgin with particular majesty. This is the Adoration of the Magi: seated on a thronelike seat she receives along with her Son the homage of the kings. Henceforth, this is the scene southern artists will choose when they want to celebrate the Virgin. The Adoration of the Magi fills the tympanum of the portal of St.-Bertrand-de-Comminges (fig. 161). We come upon the same scene across the Pyrenees on the portal of Huesca,[139] the work of sculptors from Languedoc. In Catalonia, as the churches of Belloch, Agramunt, and Mura prove, this French tradition persisted for a long time. In the course of the twelfth century, several beautiful examples of the Adoration of the Magi were created in the Midi to decorate the portals of churches. In the past, on one side of the portal of Notre-Dame-des-Pommiers, at Beaucaire, the Virgin presented the Child to the magi for adoration, and on the other side, an angel told St. Joseph to flee into Egypt.[140] Only the section showing the Virgin holding the Child still exists;[141] she is seated frontally on a throne, majestic as a queen; homage is rendered to her as well as to her Son. This Adoration of the Magi at Beaucaire, carved on the portal of a church dedicated to Our Lady, is clearly intended as a glorification of the Virgin.

The work was done about 1150. Several years later, it was imitated on the portal of St.-Gilles in a style that had already changed (fig. 128).[142] At St.-Gilles, the Beaucaire tympanum is found in its entirety: on one side of the Virgin's throne, the magi offer their gifts; on the other, the angel speaks to St. Joseph.

A work of like character, now in the museum of Montpellier, once belonged to the abbey of Fontfroide (Hérault) (fig. 300).[143] Here again, the Virgin sits majestically between the magi and St. Joseph, but the angel beside St. Joseph has been omitted.

Thus it was by representing the Adoration of the Magi on tympanums that the Midi sculptors sought to honor the Virgin. Even the sculptors of St.-Trophime at Arles, who wanted to represent on their portal the Christ of the Apocalypse and the Last Judgment, made a place for the Virgin, for the Adoration of the Magi figures there.

These practices of the artists of the Midi are found again as we go

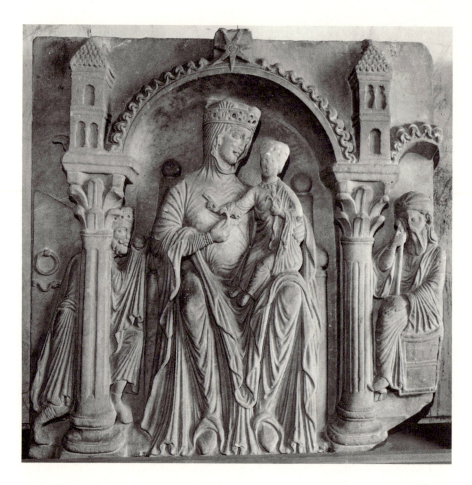

300. Virgin and Child, Adoration of the
Magi. Tympanum from the Abbey Church
of Fontfroide. Montpellier (Hérault),
Musée de la Société Archéologique.

toward the north. At Notre-Dame-du-Port, in Clermont-Ferrand, the
Adoration of the Magi and the Presentation in the Temple fill the lintel
of the portal (fig. 23). The Baptism of Christ is paired with the Adoration
of the Magi because in the Middle Ages these two events were celebrated
on the same day;[144] but the presence of two other reliefs set into the wall
of the façade, which represent the Annunciation and the Nativity, clearly
prove that the artist was above all celebrating the Virgin, to whom the
church is dedicated.[145] God in majesty, enthroned in the tympanum, seems
to contemplate his realized thought.

There is an Adoration of the Magi in the province of the Loire, on the
crude tympanum at Rozier-Côte-d'Aurec. And there is another at Bourg-
Argental. But here, as we have said, we are in the domain of Burgundian
art.

The artists of Burgundy, indeed, like the artists of the Midi, honored
the Virgin by representing the Adoration of the Magi on their portals,
and once more we must remark that the works of the two schools cor-
respond exactly.

The Adoration of the Magi fills the entire tympanum of the portal of Neuilly-en-Donjon (Allier), which is related to the art of Autun by the disproportionate height of its figures (fig. 301). The scene has a triumphal character: angels blow their horns, and personages trample beneath their feet two enormous dragons symbolizing the powers of evil. It is the victory of the Virgin that the artist celebrates in this way. In fact, on the lintel, Eve presents the forbidden fruit to Adam; farther along, the prostrate sinful woman pours perfumes on the feet of the Saviour—which means that woman, through whom sin came into the world and by whom it was perpetuated, is at last and forever rehabilitated by the Virgin. In his famous sermon, St. Bernard said, "Rejoice, Eve, rejoice in such a daughter. . . . Opprobrium has been wiped out; never again can woman be accused."[146]

301. Adoration of the Magi; Adam and Eve; Last Supper. Neuilly-en-Donjon (Allier), Ste.-Marie-Madeleine. West façade, portal, tympanum.

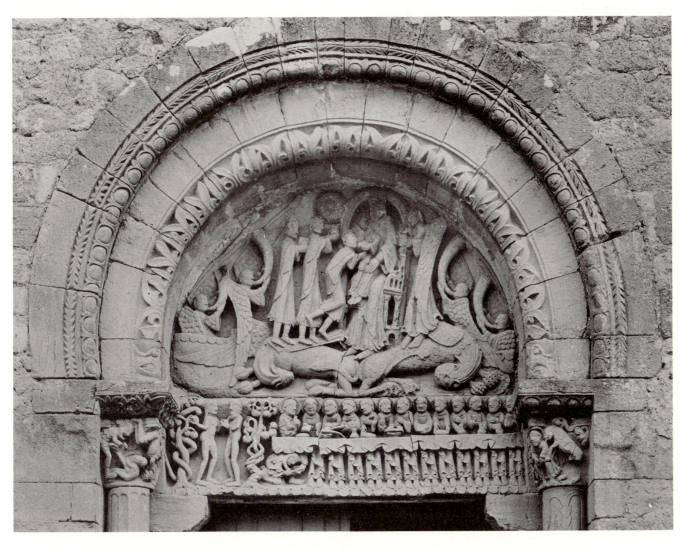

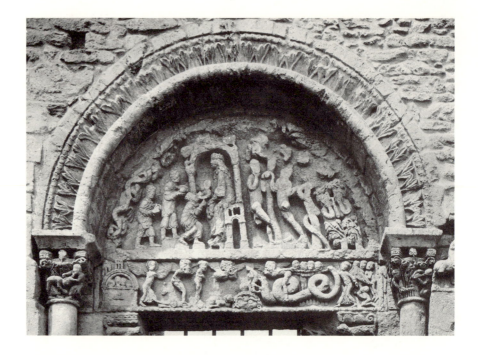

302. Adoration of the Magi; Adam and
Eve. Anzy-le-Duc (Saône-et-Loire),
Church of Ste.-Trinité-Ste.-Croix-
Notre-Dame. South portal, tympanum.

On the small portal of Anzy-le-Duc (Saône-et-Loire), the idea is expressed in almost the same way (fig. 302). The Adoration of the Magi fills only one half of the tympanum, the Sin of Eve fills the other, and below, on the lintel, hell is placed on the side of Eve, heaven on the side of the Virgin.

The Vézelay sculptors, who gave over the entire great portal to Christ and his Gospels, reserved a smaller portal for the Virgin (fig. 54). As was customary, the Adoration of the Magi decorated the tympanum: Mary, seated frontally and a little larger than the other figures, is the center of the work. On the lintel, the Annunciation, the Visitation, and the Nativity indicate clearly that the artist's intention was to celebrate the Virgin.

At St.-Lazare of Avallon,[147] the Adoration of the Magi was again used as the subject of the tympanum of one portal. The elongated figures derive from the art of Autun and Vézelay, but the work is so mutilated that we can scarcely make it out.

The scene of the Adoration of the Magi was to be found throughout twelfth-century Burgundy. It filled the entire lintel of the St.-Bénigne portal, where it was placed beneath the Christ in Majesty. At La Charité-sur-Loire, it can still be seen beneath the scene of the Transfiguration. Even when artists were celebrating Christ, they did not forget the Virgin.

I have already discussed what the side portals of Bourges owe to Burgundian art. The Virgin of the north portal is an obvious imitation of the Virgin on the St. Anne Portal of Notre-Dame at Paris, but in conformance

with Burgundian tradition, she is accompanied by the Adoration of the Magi. The Virgin of the portal of Loches, carved by artists from Bourges, is, like its model, completed by the scene of the Adoration of the Magi. As the thirteenth century approached, the artists, although they already knew a more magnificent way of celebrating the Virgin, could not bring themselves to abandon the old theme of the Adoration of the Magi. A portal of Notre-Dame of Laon is still devoted to this traditional scene.[148] And even at the height of the thirteenth century, the artists of Freiberg, in Saxony, copied the Adoration of the Magi from Laon on the tympanum of their church.

It was at Chartres that, for the first time, the artist dared omit the theme of the Adoration of the Magi and present the Virgin alone, holding the Child on her knees, for the veneration of the faithful (fig. 211). This beautiful Virgin of Chartres, accompanied by two angels, is carved on the tympanum of the right-hand portal of the west façade, and dates from about 1145.[149] As pointed out in a preceding chapter, the fame of the sanctuary of Chartres, to which thousands of pilgrims went each year to pray to the Virgin, explains this bold innovation.

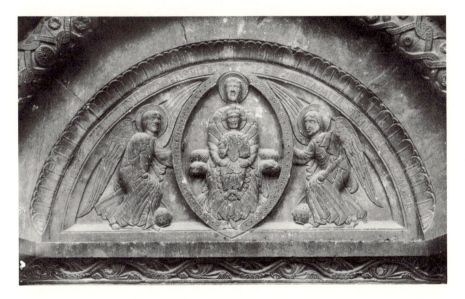

303. Virgin in Majesty. Corneilla-de-Conflent (Pyrénées-Orientales), Ste.-Marie. West façade, tympanum.

Here, I do not believe that the Midi was in advance of the north. The Virgin in Majesty appears on the tympanum of the church of Corneilla-de-Conflent (Pyrénées-Orientales); she is seated in a mandorla and holds the Child on her knees. As at Chartres, two angels holding censers accompany her (fig. 303). But in spite of its archaic aspect, the portal of Corneilla-de-Conflent is certainly later than the tympanum of Chartres. Like other Catalan portals representing the same subject, such as those at Manresa and Vallbona de las Monjas, it must date from the late twelfth or early thirteenth century.[150]

It is possible, however, that another Pyrenean Virgin, the Virgin of St.-Aventin (Haute-Garonne), was earlier than that of Chartres. But the Virgin of St.-Aventin, who also holds the Child on her lap, is not given a place of honor. The tympanum is filled with the Christ of the Apocalypse, and she is modestly recessed in one of the jambs of the portal.[151]

Thus, the Virgin of Chartres remains the earliest of the majestic Virgins to decorate a tympanum. We have seen that she was imitated many times, notably on the St. Anne Portal at Notre-Dame of Paris.[152]

Burgundy followed the example of the Ile-de-France. The Cluniac priory of Notre-Dame-du-Pré at Donzy (Nièvre), now in ruins, has preserved a beautiful portal devoted entirely to the Virgin (fig. 304). As at

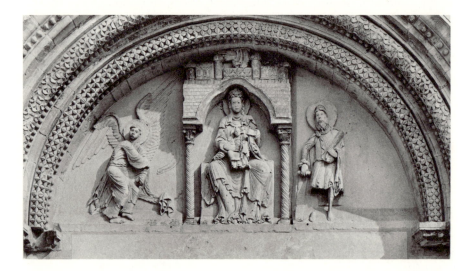

304. Virgin in Majesty. Donzy (Nièvre), Church of Notre-Dame-du-Pré. West façade, tympanum.

Chartres, she is seated in the tympanum with the Child Jesus on her knees; a ciborium, as if it were a door opening onto heaven, frames the scene and enhances its majesty.[153] She is placed between an angel with great wings who censes her, and a prophet wearing a Jewish hat who holds a banderole and a mysterious attribute. The attribute, partly destroyed, is probably the branch of a tree. If so, it is related to the prophecy of Isaiah that a branch shall grow out of the root of Jesse, and at the same time, it is a prefiguration of the Virgin and her Son. Although the style of the Donzy portal differs from the style of the portal of Chartres, they are related to each other.[154] Chartres was the prototype for all those beautiful tympanums on which the triumphant Virgin is represented.

But if Burgundy imitated at Donzy, it innovated at Moutier-St.-Jean (Côte-d'Or). Moutier-St.-Jean is an ancient abbey in the region of Montbard that has almost completely disappeared. The church once had three portals; Dom Plancher had drawings made of them (fig. 305).[155] The tympanum represented the Christ of the Apocalypse surrounded by the

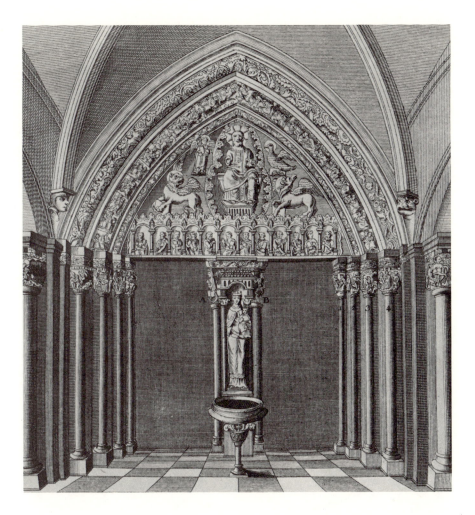

305. Christ in Majesty. Moutier-St.-Jean (Côte-d'Or), Abbey Church (destroyed). West façade, central portal (after engraving by Plancher).

four evangelical beasts,[156] but a completely new figure appeared on the trumeau. There, the crowned Virgin stood, holding the Child on her left arm, and she seemed to be greeting the congregation at the door of the church. This was perhaps the first time in monumental art that the Virgin was represented standing. The innovation was a bold one, for the seated Virgin of Chartres holding the Child on her knees seems still to be conceived of as "the throne of the Omnipotent." But at Moutier-St.-Jean, she becomes a woman; she descends from heaven to be nearer to us. Unfortunately, we do not know the date of the sculpture at Moutier-St.-Jean; however, the pointed arches of the portals—the equilateral arches that we see neither at Vézelay nor at Autun—seem to indicate the latter part of the twelfth century. One standing Virgin carrying the Child has been preserved in Burgundy on the portal of Vermenton.[157] But there, she is no longer on the trumeau, the place of honor; she is at one side of the portal, and according to the drawing published by Dom Plancher, there used to be statues of three kings facing her.[158] These were perhaps three kings of

Judah, ancestors of the Virgin, or perhaps they were simply the three magi-kings. Is the Vermenton portal earlier than the portal of Moutier-St.-Jean? We cannot say. But what seems probable is that the motif of the standing Virgin carrying the Child, which we find on our thirteenth-century cathedral portals, first appeared in Burgundy. This new type might have been suggested to Burgundian artists by the standing Virgin carved on Byzantine ivories. But it was their idea to bring her nearer to the prayers of the faithful, to place her feet within reach of their lips. It was in the Burgundy of St. Bernard that the Virgin, for the first time, seems to walk upon the earth.

Until this time, the Virgin was never shown without her Son on the portals of our churches; we shall now see her honored for herself. This time, it is the Midi that sets the example. The portal of the abbey church of Souillac (Lot) was destroyed, but the fragments have been preserved in the interior of the church (fig. 306). The tympanum was filled with a large relief whose subject was one of the most famous miracles of Notre-Dame, the miracle of Theophilus.[159] The deacon Theophilus, who had resolved to supplant his bishop, is shown in conversation with the devil. Satan hands him the parchment on which the deacon has pledged his soul to him in exchange for power and riches. Once the bargain is made, Theophilus becomes Satan's "man." He holds out his clasped hands, as a vassal would, to his new lord who takes them in his hands. This is a scene of feudal homage taken from life. Above, Theophilus has fallen

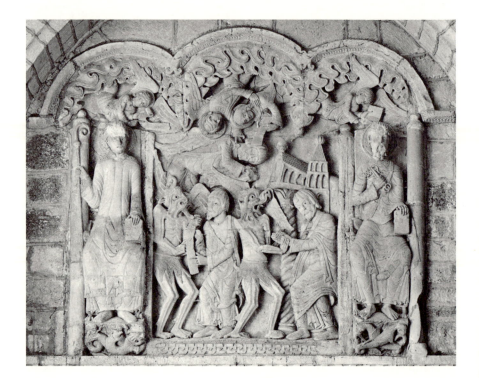

306. Miracle of Theophilus. Souillac (Lot), Abbey Church of Ste.-Marie.

asleep while praying; although he has become all-powerful, he is over-whelmed by remorse. The Virgin takes pity on his distress, descends from heaven accompanied by an angel, and is in the act of placing in the hand of Theophilus the parchment she has retrieved from Satan.[160]

This is the earliest representation of the miracle of Notre-Dame—the miracle that was to become so celebrated in the thirteenth century.[161] Its fame began in the eleventh century; Fulbert told the story in one of his sermons.[162] In the twelfth century, Honorius of Autun included it in his *Speculum ecclesiae* for the day of the feast of the Assumption,[163] and a few years earlier, Marbod, bishop of Rennes, had turned it into a poem.[164] This moving story of the Virgin's power, and above all, of her infinite gentleness, took hold of the imagination and the heart. In monumental art, the Souillac relief is the first work devoted to the Virgin alone —undoubtedly an early work, because this relief, in which we find the traditions of the art of Moissac, cannot be much later than Moissac's famous portal.

Simply to carve one of the Virgin's miracles was not honor enough to pay her. In the second part of the twelfth century, portals began to be filled with the Death, the Resurrection, and the Assumption of the Virgin.

In the museum of Bourges, there is a mutilated tympanum that comes from the destroyed church of St.-Pierre-le-Puellier (fig. 307). This work, only recently known, is of great interest, for it is probably the earliest representation in monumental art of the Death and Burial of the Virgin.[165] The artist followed the famous story told by Melito, which had been translated into Latin.[166] Inscriptions leave no doubt about the meaning of the scenes. First we see the angel telling the Virgin of her approaching death and presenting her with the branch cut from the palm tree in heaven.[167] Then the apostles, transported by a mysterious force to the

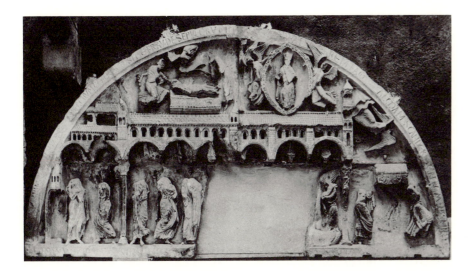

307. Death, Burial, and Assumption of the Virgin. Tympanum from St.-Pierre-le-Puellier. Bourges (Cher), Musée du Berry.

Virgin's churchlike chamber, are shown around her deathbed. Half of the relief has disappeared, and we do not know if Christ, as in Byzantine art, was present at the death of his mother.[168] Farther on, the apostles carry her body to the tomb and place it in the sepulcher. Lastly, two angels carry the Virgin, seated in an aureole, to heaven.

It seems as if the sculptor were treating this subject for the first time and that he had only miniatures as models, for the composition is very awkward. The Assumption of the Virgin, which should have filled the upper part of the tympanum above her Death and Burial, is placed in one of the angles where we scarcely notice it. This is not a triumphal song; it is straightforward prose.

The tympanum of Bourges, carved with a fairly refined technique, is difficult to date. Nevertheless, I think that it is earlier than the portal of Senlis, to which we shall now turn.[169]

The portal of Senlis must have been completed about 1185, because its reliefs were imitated in 1189 on the jubé of Vezzolano in Piedmont. As at Bourges, the entire Senlis tympanum is devoted to the Virgin, but it is a moving and poetic work in which we detect the hand and mind of a great artist. He wastes no space on secondary episodes. Two scenes on the lintel summarize the entire story: the Virgin dies surrounded by the apostles; then, three days after her burial, the angels come to take her body from the tomb. Of these two reliefs, the first is too badly damaged to speak of, but the other is marvelous (fig. 308). The resurrection of the Virgin's body by the angels was a new scene in religious iconography; the artist has made a masterpiece of it. The charming angels in their clinging tunics are freed of materiality, as weightless as birds, as light as the swallows whose pointed wings they wear. There is more of love than of respect in their haste to obey the will of God. One lifts the Virgin by the shoulders; another supports her head with loving tenderness. Still another angel, who cannot approach for lack of space, rises and steadies himself by holding to the wings of those beside him so that he may contemplate her. Another holds a crown in his hand and is running to place it on her head. The cloth clinging to the bodies, the calligraphic flourishes described by the pleats, the corkscrew curls arranged on the foreheads, all relate this relief to the old school, but its expression of life and movement, its charm and poetry, foreshadow the art that was to come. The appearance in Europe in the year 1185 of this Senlis relief is indeed extraordinary.

The lintel is dominated by a magnificent scene filling the entire tympanum; the Virgin, her crown on her head, is seated in heaven at the right of her Son (fig. 157). This is the Coronation of the Virgin in its earliest form: Mary does not bow as the crown is placed on her head, as she was shown to do later; she has already received it, and seems henceforth freed

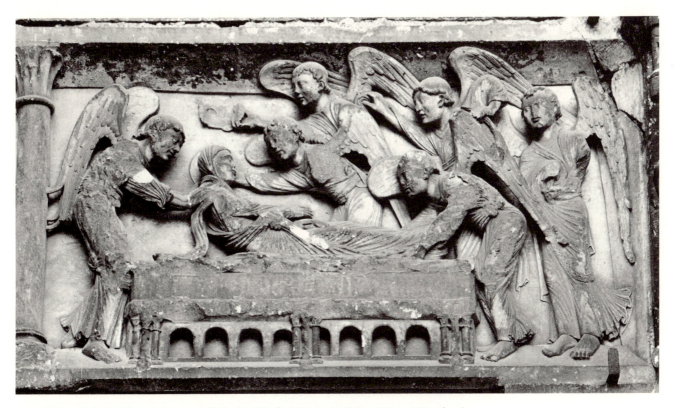

308. *Virgin raised from her tomb by angels*. Senlis (Oise), Cathedral of Notre-Dame. West façade, central portal, detail of lintel.

of the law of time. Here, the composition of the tympanum, which was tentative and unsuccessful at Bourges, found its definitive form: above the Death of the Virgin, which is no more than an episode, is her Triumph.

As we have said in an earlier chapter, Suger must probably be given the honor of having imagined the scene of the Virgin's Coronation. The window of the Triumph of the Virgin, which he gave to Notre-Dame of Paris, can scarcely have been conceived differently from the Senlis tympanum.[170] A twelfth-century window in the cathedral of Angers which represents the Death and Burial of the Virgin in the lower medallions, and in the medallions above, her Ascension and Coronation, must preserve some of the features of the Paris window. It is remarkable that at Angers, as at Senlis, the Virgin, who has just been seated at the right of Christ, already wears the crown. We infer a common model.[171]

The tympanum of Senlis must have been greatly admired, for it was imitated almost immediately at the collegiate church of Mantes. Toward 1200, it was reproduced with slight variations on the north portal of the cathedral of Chartres, and at almost the same time, on the façades of Laon and of St.-Yved of Braine.[172] In 1210, the first architect of the cathedral of Reims was also thinking of imitating it.[173]

Consequently, the portals representing the Death, Resurrection, and Coronation of the Virgin—the purest beauties of the thirteenth-century

cathedral—developed out of twelfth-century art. It was in the twelfth century that the Virgin—"Our Lady," to use the nice chivalric name given to her at this time—began to inspire great art. Her cult was at first expressed timidly; the artists dared not separate the Mother from the Son; but as the years went by, they grew bolder, daring to represent her alone, and the century ended on her "Triumph."

VI

The churches of western France and their historiated archivolts. The meaning of these archivolts.

There remains the vast region of the west—Saintonge and Poitou—yet to be spoken of. Nowhere in France is Romanesque art more beguiling.[174] In small villages, at Echillais, Rioux, Rétaud, Petit-Palais, we come upon some truly marvelous churches in which some elements of Arab decoration are combined with a mysterious something that is the product of the genius of the western provinces. These churches retain their charm only when they have not been touched by the hands of modern architects, when their stones are left to appear as if they had been carved by the rain as the columns of Pozzuoli were carved by the sea. However, richly decorated as these churches are, they have no tympanum; the round arch above the door is empty and opens onto darkness. Sometimes it is festooned, as in Moslem arches, but nowhere do we find those great reliefs enclosing the verses of a Divine Comedy.

So the artists of western France could not make their churches express all that other churches did. They tried to, nevertheless. They spread over the façade of Notre-Dame of Poitiers the characters that appeared in the Christmas liturgical play. At St.-Jouin-de-Marnes, they relegated the scenes of a Last Judgment to the gable and the area near the high window. Dispersed in such a way, these works lose some of their impact.

That is why the sculptors soon came to group their figures in the archivolts surrounding the portal. The idea of decorating the archivolts not with geometric and stylized ornamentation but with garlands of figures copied from nature appeared for the first time, I believe, on the Portal of the Ascension at the cathedral of Cahors. The archivolt of the porch is decorated with a band of figures who seem to be fighting among themselves. The idea was used again on the façade of the cathedral of Angoulême: above the Ascension (which derives from Cahors), the ample archivolt is decorated with figures of angels. About this same time, the Labors of the Months were carved on the archivolts of the portal of St.-Jouin-de-Marnes. All of these works must have been carved earlier than 1135, the date when historiated archivolts appeared in the north of France on the portal of St.-Denis. Thus, it is not surprising to see these archivolts decorated with figures on so many portals of churches in western France, since it was there that the motif seems to have been created. It is hardly

possible to believe that the idea of placing figures in the archivolts came to western France from St.-Denis and Chartres, because sculpture did not come into Saintonge, Angoumois, and Poitou from the north, but from the south. The sculpture of the west seems much closer to southern sources than does the sculpture of the Ile-de-France. We find in the western sculpture the elongated figures of Moissac and the figures with crossed legs of Toulouse; we find the concentric pleats in tunics that are a characteristic of the art of Languedoc.

Thus, in the west a fair number of churches have historiated archivolts; they are the only concession to thought on these façades which charm the eye with their graceful embroidery.

What subjects did the artists usually represent in the concentric bands? There are angels carrying the lamb in an aureole, and the elders of the Apocalypse with their chalices and their viols; in other bands, there are the Virtues wearing helmets and carrying shields and trampling the Vices underfoot; higher up, the wise virgins holding their lamps upright are paired with the foolish virgins holding their lamps upside down, while Christ opens the door before the former and closes it against the latter. A calendar in which the signs of the zodiac alternate with the Labors of the Months sometimes decorates the uppermost band of the archivolt. The most beautiful of these historiated archivolts are at Aulnay-de-Saintonge (fig. 309), Fénioux, Pont-l'Abbé, Chadenac (Charente-Maritime), and Argenton-Château (Deux-Sèvres).[175]

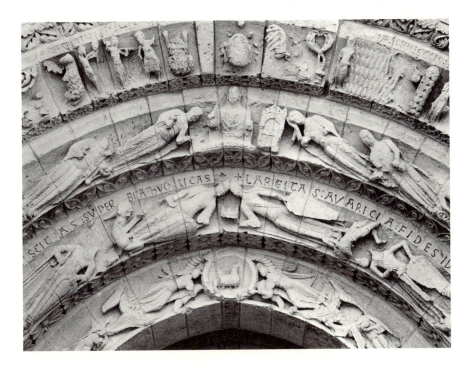

309. The wise virgins; Psychomachia. Aulnay (Charente-Inférieure), Church of St.-Pierre. West façade, archivolts of portal.

Some of the ideas expressed on these portals came from the Midi. It was at Moissac, as we have seen, that we first encountered the elders of the Apocalypse. At Oloron, they are accompanied by the Lamb of God. The wise and foolish virgins were first carved on a capital of the cloister of La Daurade at Toulouse;[176] but the battle of the Vices and the Virtues, the famous psychomachy borrowed from the poem of Prudentius,[177] appears to have been unknown to the art of Languedoc. I believe that we owe it to the artists of the west.

These subjects, seemingly so disparate, at least at first expressed a unified thought. The first artist to bring these figures together in the archivolts intended unquestionably to evoke the idea of the Last Judgment. The lamb carried in triumph in an aureole by angels is the Lamb of the Apocalypse —the lamb who unleashes the calamities foretelling the end of the world; the presence of the elders near the lamb is sufficient to prove this.[178] And again, the parable of the wise and foolish virgins is a symbol of the Judgment, the image prefiguring the separation of the good from the evil on the final day. Medieval commentators are at one on this point. Lastly, the psychomachy itself, the great battle between the Vices and the Virtues, is linked with the idea of reward and punishment. In the thirteenth century, the Vices and the Virtues were still represented on portals in scenes of the Last Judgment.

On certain of the western portals, the idea was expressed more clearly than elsewhere. On the portal of Argenton-Château (Deux-Sèvres) it is clearest of all. The lamb carried by the angels is accompanied not by the elders of the Apocalypse but by the twelve apostles; Christ is at their center. We have seen that in the twelfth century the apostles appeared in the Last Judgment as the Judge's assessors. The parable of the wise and foolish virgins and then the battle of the Vices and Virtues fill out the other archivolt bands. But above the archivolts there are reliefs sculpted on the wall that complete the thought. With some difficulty, we can make out the parable of Dives and poor Lazarus.[179] The rich man is at table with his wife, while Lazarus is stretched out at his door; only the dogs take pity on him and come to lick his sores. Facing the scene, God hands down his judgment: the soul of Lazarus is carried by angels to Abraham's bosom, and the rich man is thrown into the mouth of Leviathan by devils. Here, it is difficult not to think of Moissac, where the parable of Dives, carved on the left side of the porch, seems to give to the Vision of the Apocalypse, carved on the tympanum, all its meaning. The great Christ surrounded by the four-and-twenty elders is a Christ who rewards and punishes. In the same way, the sculptor of Argenton places before us the heaven and hell foretold both by the parable of the wise and foolish virgins and by the psychomachy.

As we see, the controlling idea is quite evident in the work at Argenton-

Château; elsewhere, it is more veiled. Although the portals of the west engendered each other and are closely related, some are incomplete and some are obscure. At Blasimon (Gironde) and Fontaine (Charente-Maritime), only the psychomachy appears near the lamb. At Corme-Royal (Charente-Maritime), both the parable of the virgins and the psychomachy are represented,[180] but not the lamb. At St.-Symphorien (Charente-Maritime), the elders of the Apocalypse decorate the portal; the psychomachy decorates the window. At Civray (Vienne), beside an archivolt band devoted to the Wise and Foolish Virgins, strangely enough there is another band representing the Assumption of the Virgin. At Notre-Dame-de-la-Coudre of Parthenay (Deux-Sèvres), alongside the psychomachy, we see the Annunciation and the angel appearing to Zachariah in the temple. It would seem that the original thought became obscured in proportion to its distance from Saintonge. In Saintonge itself, the portal type from which all the other portals derived no longer exists. Perhaps it was the façade of St.-Jean-d'Angély, one of the most magnificent abbeys of twelfth-century France;[181] or again it might have been the façade of St.-Eutrope of Saintes, one of the most beautiful churches of the west.[182]

Incomplete as these portals of Saintonge and Poitou are, they are none the less interesting. They do not open heaven to man, as the others do, but they speak to him of his duties. Oftentimes, the great exterior archivolt placed before him the image of his life, the work that awaited him each month of the year.[183] It is the struggle against nature. But there is another battle far more heroic, the battle man fights every day against the enemies within. Life is a psychomachy, a battle waged within the soul. The forces that so painfully go round and round within us, anger, pride, envy, and lust—these are the Vices trampled under foot by the Virtues carved on the western portals. Nothing is more beautiful than these triumphant figures who seem to encourage and sustain us. But we must rise even higher. There is a region where there are no more battles to be fought; where only peace reigns. This is the region where the lamp of the wise virgins burns. For the flame of this symbolic lamp, the Church Doctors say, is the flame of Charity. In this way, the portals of our western churches, in one archivolt after another, urge us to rise from work to virtue, and from virtue to love.

VII

We have seen that nearly all the ideas expressed by the magnificent façades of the thirteenth century had appeared in the twelfth. The task of thirteenth-century artists was above all to choose and to arrange. Many of the grandiose themes—the Apocalyptic Vision, the Ascensions, the Descent of the Holy Spirit—were abandoned; the Last Supper and the Washing

All of the elements of thirteenth-century portals existed in the twelfth century.

of Feet were not represented as they had been at the time when there was hope of bringing the heretics back to the faith. On the other hand, the Last Judgment, which so many different trials had brought close to its perfect form, was given a place of honor. The Resurrection and the Coronation of the Virgin, poetic subjects created in the twelfth century, became the favorite themes of the following century. The saints, who were often celebrated in the twelfth century and already occupied a tympanum at St.-Denis and the trumeau and archivolts at St.-Loup-de-Naud, henceforth had their own portal. The prophetic or symbolic statues of St.-Denis, Chartres, and Senlis—those solemn witnesses relating the history of the world and announcing Christ—reappeared on the façades or portals of cathedrals. And the subjects so often used in the west of France, the Labors of the Months, the Vices and Virtues, the Wise and Foolish Virgins, were also represented on thirteenth-century portals, but there they were arranged with more art and given their proper place. The thirteenth century ennobled and embellished; it brought form and thought to a point of perfection. But it would be unjust to forget what it owed to the twelfth century, which created so much, and which also has a claim to greatness.

NOTES

CHAPTER I

1 [On the reappearance of monumental sculpture in France, see P. Deschamps, "Etude sur la renaissance de la sculpture en France à l'époque romane," *Bulletin monumental*, 84 (1925), pp. 5-98, and H. Focillon, *The Art of the West in the Middle Ages*, London, 1963, I, pp. 47-53.]

2 See L. Bréhier, "Les Origines de la sculpture romane," *Revue des deux mondes*, 15 (1912), pp. 870-901.

3 Bréhier, *op. cit.*, pp. 886-890. [On the reliquary statue of St. Foy at Conques, see P. Deschamps, "L'Orfèvrerie à Conques vers l'an mille," *Bulletin monumental,* 102 (1943-1944), pp. 75-93; M. M. Gauthier, in *Rouergue roman* (ed. Zodiaque), Paris, 1963, pp. 135-137. In the course of restoration in 1955 it was found that the gold head of the statue dates from late antiquity (fifth century); see J. Taralon, "Le Trésor de Conques," *Bulletin de la Société Nationale des Antiquaires de France*, 1954-1955, pp. 47-54, and the exhibition catalogue, *Les Trésors des églises de France*, Musée des Arts Décoratifs, Paris, 1965, no. 534, pp. 289-294. On the other reliquary statues of southern France, see E. Mâle, "La Vierge d'or de Clermont et ses repliques," *Le Point*, 25 (June 1943), pp. 4-10; L. Bréhier, "Vierges romanes d'Auvergne," *ibid.*, pp. 12-33; E. Kovacs, "Le Chef de saint Maurice à la cathédrale de Vienne (France)," *Cahiers de civilisation médiévale*, 7 (1964), pp. 19-26.]

4 M. Lafargue discovered these dates. See M. Lafargue, *Les Chapiteaux du cloître de Notre-Dame de la Daurade*, Paris, 1939, pp. 15ff. [R. Rey, *L'Art des cloîtres romans. Etude iconographique*, Toulouse, 1955, p. 68, gives the same dates.]

5 See E. Mâle, "Les Chapiteaux romans du Musée de Toulouse et l'école toulousaine du XIIe siècle," *Revue archéologique*, 3rd ser., 20 (1892), pp. 188-189.

6 Paris, Bibl. Nat., ms. lat. 8878. The Bibliothèque Nationale has several other manuscripts of the Beatus Apocalypse, all of which are of a later date than the Apocalypse of St.-Sever. See L. Delisle, "Les Manuscrits de l'Apocalypse de Beatus conservés à la Bibliothèque Nationale et dans le cabinet de M. Didot," *Mélanges de paléographie et de bibliographie*, Paris, 1880, pp. 117-148. [W. Neuss, *Die Apokalypse des hlg. Johannes in der altspanischen und alt-christlichen Bibelillustration*, Münster and Westfalen, 1931.]

7 This manuscript is now in the Bibliothèque Nationale (ms. lat. 2855). [Only the third part (fols. 69r-160v) is from Godescalc's original manuscript. See *Bibliothèque Nationale. Catalogue général des manuscrits latins*, III, Paris, 1952, p. 167.]

8 I have discussed this at greater length in "La Mosquée de Cordoue et les églises de l'Auvergne et du Velay," *Revue de l'art ancien et moderne*, 30 (1911), pt. 2, pp. 81-89, and in "L'Espagne arabe et l'art roman," *Revue des deux mondes*, November, 1923, pp. 311-343. I have collected these studies in *Art et artistes du moyen âge*, Paris, 1927, pp. 30-88. [On this question, see A. Fikry, *Les Influences musulmanes dans l'art roman du Puy*, Paris, 1934.]

9 The Christ in Majesty surrounded by the four beasts shown in the Limoges enamels is related, as we shall see, to the Christ of the Beatus Apocalypse.

10 Mosaic in S. Prassede, Rome, and miniature of the Codex Aureus of Regensburg. [On the S. Prassede mosaic, see B. M. Apolloni Ghetti, *Santa Prassede* (*Le chiese di Roma illustrate*, 66), Rome, 1961, p. 65 and fig. 26. On the miniature of the Codex Aureus of Regensburg, Munich, Staatsbibl., Clm. 14000, fol. 6r, see G. Leidinger, *Der Codex Aureus der bayerischen Staatsbibliothek in München*, Munich, 1921-1925, pl. 11. The same theme is found in the Gospel-book of St.-Médard of Soissons (Paris, Bibl. Nat., ms. lat. 8850, fol. 15r).]

11 Mosaic on the triumphal arch of S. Paolo fuori le mura in Rome. [See J. Wilpert, *Die römischen Mosaiken und Malereien der kirchlichen Bauten vom IV. bis XIII. Jahrhundert*, 2nd ed., Freiburg-im-Breisgau, 1917, II, pp. 554-558 and figs. 185-186.]

12 These have been published by M. Prou, "Deux Dessins du XIIe siècle au trésor de l'église Saint-Etienne d'Auxerre," *Gazette*

archéologique, 12 (1887), pp. 138-144. [M. Schapiro, "Two Romanesque Drawings in Auxerre and some Iconographic Problems," *Studies in Art and Literature for Belle da Costa Greene*, Princeton, 1954, pp. 331-349.]

13 Paris, Bibl. Nat., ms. lat. 11550, fol. 6r. We observe that these apocalyptic animals are in the tradition of the Beatus Apocalypse and resemble those at Moissac. The eagle, instead of resting on a scroll, rests on the case containing the scroll. The manuscript seems to have come from St.-Martial of Limoges, because on fol. 303r St. Martial is named at the beginning of the litanies, after the evangelists. It is also said to be Catalan. [According to V. Leroquais, *Les Psautiers manuscrits latins des bibliothèques publiques de France*, Mâcon, 1940-1941, II, p. 109, the manuscript is neither from Catalonia nor from Limoges. From the liturgical evidence of its texts it comes from St.-Germain-des-Prés in Paris and dates from the middle of the eleventh century. See also J. Porcher, *Catalogue de l'exposition des manuscrits à peintures du VIIe au XIIe siècle*, Paris, 1954, p. 88, no. 246. On the eagle of St. John with the scroll, cf. Schapiro, *op. cit.*, pp. 331-334.]

14 One copy of the Beatus Apocalypse (Paris, Bibl. Nat., ms. nouv. acq. lat. 1366) shows on fol. 94r the two horsemen mounted on lions, and on fol. 116v the angel holding the sickle and standing near the throne of God. [On this infrequent theme, see Neuss, *Die Apokalypse*, p. 174.]

15 Notably in the St.-Sever manuscript (Paris, Bibl. Nat., ms. lat. 8878, fol. 302v) and in the twelfth-century Beatus (Paris, Bibl. Nat., ms. nouv. acq. lat. 1366, fol. 142r).

16 Paris, Bibl. Nat., ms. nouv. acq. lat. 2290, fol. 111r, Beatus Apocalypse, twelfth century. [The date of this manuscript is contested; Neuss, *op. cit.*, p. 60, assigns it to the thirteenth century.]

17 The St.-Sever manuscript does not have these animals with human bodies, but we find them in a Paris manuscript (Bibl. Nat., ms. nouv. acq. lat. 2290, fols. 56v and 75v) and in the Apocalypse published by A. Bachelin, "Description d'un commentaire de l'Apocalypse, manuscrit de XIIe siècle compris dans la bibliothèque d'Astorga," *Le Bibliophile français*, 4 (1869), pp. 98-108

and 129-159. [This manuscript is now in Manchester, John Rylands Library, cod. 8, fol. 89r. For its bibliography, see Neuss, *op. cit.*, p. 50. On the subject of the animal-headed evangelists, see Z. Ameisenowa, "Animal-Headed Gods, Evangelists, Saints and Righteous Men," *Journal of the Warburg and Courtauld Institutes*, 12 (1949), pp. 21-45; cf. R. Crozet, "Les quatre Evangélistes et leur symboles, assimilations et adaptions," *Cahiers techniques de l'art*, 1962, pp. 5-26.]

18 Daniel 5:21.

19 This is the manuscript studied by Bachelin, *op. cit.*, p. 153 (see above, note 17).

20 Paris, Bibl. Nat., ms. nouv. acq. lat. 1366, fols. 35r, 38r, 41v, 45r, 48r, 51r, 55v.

21 In the Apocalypse of St.-Sever (Paris, Bibl. Nat., ms. lat. 8878, fols. 108v-109r), as on the capital of St.-Benoît-sur-Loire, only the horseman holding the bow has a headdress, the other three are bareheaded. [See G. Chenesseau, *L'Abbaye de Fleury à Saint-Benoît-sur-Loire*, Paris, 1931, p. 182 and pl. 23, A-B.]

22 Nebuchadnezzar changed into a beast is seen only at Moissac, St.-Benoît-sur-Loire, and on a capital of St.-Gaudens (Haute-Garonne), but the St.-Gaudens sculpture belongs to the school of Moissac and Toulouse. [For the sculptures of St.-Gaudens, see R. Rey, *La Sculpture romane languedocienne*, Toulouse, 1936, pp. 297-300.]

23 Andrea Floriacensis, *Vita Gauzlini abbatis*, cap. LVII in J. von Schlosser, *Quellenbuch zur Kunstgeschichte des abendländischen Mittelalters*, Vienna, 1896, pp. 184ff.

24 Paris, Bibl. Nat., ms. nouv. acq. lat. 1366, fol. 12v. This is also a Beatus commentary on the Apocalypse.

25 The capital is now in the archeological museum of Poitiers. It was discovered near the church of St.-Hilaire and certainly came from the abbey. See E. Lefèvre-Pontalis, "Saint-Hilaire de Poitiers, étude archéologique," *Congrès archéologique*, 70 (1903), p. 400. [Cf. Neuss, *Die Apokalypse*, p. 238 n. 1; R. Crozet, *L'Art roman en Poitou*, Paris, 1948, p. 213.]

26 This will be demonstrated in Chapter XI.

27 Paris, Bibl. Nat., ms. lat. 254. [According to Porcher, *Manuscrits à peintures du VIIe au XIIe siècle*, p. 107, no. 314, this gospel-book comes from the region of Agen or

Moissac.] The evangelists are depicted on fols. 10r, 32r, 46v, 67v.

28 Paris, Bibl. Nat., ms. lat. 1987, fol. 43r. [On this manuscript, see J. Porcher, *Catalogue de l'exposition, L'art roman à Saint-Martial de Limoges, Les manuscrits à peintures*, Limoges, 1950, p. 68, no. 38.]

29 In the Toulouse museum, inv. no. 502. [This relief comes from St.-Sernin of Toulouse; see P. Mesplé, *Toulouse, Musée des Augustins, Les sculptures romanes* (Inventaire des collections publiques françaises), Paris, 1961, no. 206.]

30 First Bible of St.-Martial of Limoges, Paris, Bibl. Nat., ms. lat. 5 (2nd vol.), fols. 133v-134r. [See Porcher, *Manuscrits à peintures du VIIe au XIIe siècle*, no. 319.]

31 We shall return to this subject at the end of this chapter.

32 Animals quite similar to these are to be found on an Assyrian cup published by A. H. Layard, *A Second Series of the Monuments of Nineveh including Bas-reliefs from the Palace of Sennachërib and Bronzes from the Ruins of Nimroud*, London, 1953, pl. 67. [Cf. F. W. von Bissing, "Untersuchungen über die 'phoinikischen' Metallschalen," *Jahrbuch des deutschen archäologischen Instituts*, 38/39 (1923-1924), pp. 208 and 239; H. Frankfort, *The Art and Architecture of the Ancient Orient* (Pelican History of Art), Harmondsworth and Baltimore, 1954, p. 197 and pl. 172A. On columns decorated with animals in Romanesque miniature painting and sculpture, see T. Sauvel, "Les Manuscrits limousins, Essai sur les liens qui les unissent à la sculpture monumentale, aux émaux et aux vitraux," *Bulletin monumental*, 108 (1950), p. 125.]

33 Paris, Bibl. Nat., ms. lat. 9438, fol. 20v. [This manuscript is known as the Sacramentary of St.-Étienne of Limoges. Cf. Porcher, *Manuscrits à peintures du VIIe au XIIe siècle*, no. 326.]

34 Missal from Prémontré, Paris, Bibl. Nat., ms. lat. 833, fol. 135v.

35 Paris, Bibl. Nat., ms. gr. 510, fol. 149r. H. Omont, *Les Miniatures des plus anciens manuscrits grecs de la Bibliothèque Nationale du VIe au XIe siècle*, Paris, 1902, pl. XXXIV.

36 A. N. Didron, *Manuel d'iconographie chrétienne grecque et latine avec une introduction et des notes, traduit du manuscrit byzantin, Le guide de la peinture, par Dr. Paul Durand*, Paris, 1845, p. 221. The scene is conceived in almost the same way as at Moissac.

37 Admont Library, Homilies of Godfrey, abbot of Admont, cod. 73, fol. 1r. Reproduced in P. Buberl, *Die illuminierten Handschriften in Steiermark, 1. Die Stiftsbibliotheken zu Admont und zu Vorau*, Leipzig, 1911, pl. X.

38 Herrade of Landsberg, *Hortus deliciarum*, fols. 123r-123v, published by A. Straub and G. Keller, Strasbourg, 1899, pls. XXXII bis 1, XXXIII,1, XXXIII,bis 2. [For the sources of the representation of Lazarus in Abraham's bosom, see O. Gillen, *Ikonographische Studien zum Hortus Deliciarum der Herrad von Landsberg*, Berlin, 1931, pp. 48-49.]

39 L. Bréhier, "Les Chapiteaux historiés de Notre-Dame-du-Port à Clermont, Étude iconographique," *Revue de l'art chrétien*, 62 (1912), p. 261.

40 The miniatures in all of these manuscripts were photographed and published by R. Stettiner, *Die illustrierten Prudentiushandschriften*, Berlin, 1905. [Also see A. Katzenellenbogen, *Allegories of the Virtues and Vices in Mediaeval Art from Early Christian Times to the Thirteenth Century* (Studies of the Warburg Institute), London, 1939.]

41 For example, in the Berne manuscript (Stadtbibl., ms. 264), which is ninth century but which reproduces a much earlier original. [See Stettiner, *op. cit.*, pls. 141-147.]

42 Brussels, Bibl. Royale, ms. 9968-72. See Stettiner, *op. cit.*, pl. 183, no. 8.

43 Stettiner, *op. cit.*, especially pl. 78 (Valenciennes, Bibl. publ., ms. 563, fol. 5r) and pl. 183 (Brussels, Bibl. Royale, ms. 9968-72); see our fig. 20.

44 A. de Baudot and A. Perrault-Dabot, *Archives de la Commission des Monuments Historiques publiées sous le patronage de l'Administration des Beaux-Arts*, IV, Paris (n.d.), pl. 7.

45 Ezekiel 5:1-4.

46 Haimon of Auxerre, Commentary on Ezekiel, Paris, Bibl. Nat., ms. lat. 12302 fol. 1r. [See W. Neuss, *Das Buch Ezechiel in Theologie und Kunst bis zum Ende des XII. Jahrhunderts*, Münster and Westfalen, 1912, pp. 227-230 and 298-307.]

47 Paris, Bibl. Nat., ms. lat. 6 (3rd vol.), fol.

45r. The manuscript is from the monastery of Rosas in Catalonia. [It is more commonly known as the Roda Bible. See W. Neuss, *Die katalanische Bibelillustration um die Wende des erstes Jahrtausends und die altspanische Buchmalerei*, Bonn and Leipzig, 1922, pp. 10-15 and, on the miniature of fol. 45r, Neuss, *Das Buch Ezechiel*, p. 207. Cf. J. Gudiol-Cunill, *La pintura mig-eval catalana*, III, Barcelona, 1955, pp. 87-98, and P. Bohigas, *La ilustración y la decoración del libro manuscrito en Cataluña, Período románico*, Barcelona, 1960, pp. 68-77.]

48 Isaiah 6:1-4.

49 Paris, Bibl. Nat., ms. lat. 6 (3rd vol.), fol. 2v. [For the Vision of Isaiah in the Roda Bible, see Neuss, *Die katalanische Bibelillustration*, p. 84 and fig. 90.]

50 The reason the artist chose the subject of the Miracle of the Loaves will be discussed in Chapter XI, p. 424.

51 I refer, of course, only to the group of Christ and the two disciples. At Valence, the apostles were added to fill the space in the lintel.

52 Paris, Bibl. Nat., ms. gr. 510, fol. 165r, illus. Omont, *Miniatures*, pl. XXXV.

53 A capital at St.-Pons-de-Thomières (Hérault) represents the Miracle of the Loaves conceived in exactly the same way as at Valence. Christ is beardless, which indicates the imitation of an original in pure Hellenistic style. This capital is reproduced in J. Sahuc, "L'Art roman à Saint-Pons-de-Thomières," *Mémoires de la Société Archéologique de Montpellier*, 1908, 1st fasc., pl. K,5. [Mâle, in Additions and Corrections to the 6th ed., 1953, p. 443]: *Bas-relief of Valence*. I am now less certain about the Valence relief, which represents the Miracle of the Loaves. No doubt it is possible that it could have been inspired by one of the manuscripts which from century to century perpetuated this motif of Hellenistic origin, but it is also possible that it resulted from the direct imitation of Christian sarcophagi from the Arles workshop, on which we find the Miracle of the Loaves in this form. The style of the figures inclines me toward the latter hypothesis. [On the iconography of this theme, see A. Boeckler, *Ikonographische Studien zu den Wunderszenen in der ottonischen Malerei der Reichenau*, Munich, 1961, pp. 17-19.]

54 Even this Abraham came from the East. The frescoes of Cappadocia show him holding the elect to his bosom. H. Grégoire, "Rapport sur un voyage d'exploration dans le Pont et en Cappadoce," *Bulletin de correspondance hellénique*, 33 (1909), p. 104, fresco of Djanavar Kilise. [See also G. de Jerphanion, *Une nouvelle Province de l'art byzantin: les églises rupestres de Cappadoce*, II, pt. I, Paris, 1936, pp. 15 and 365, pls. 145, fig. 2 and 208, fig. 2. On this theme, see K. Moeller, "Abraham," *Reallexikon zur deutschen Kunstgeschichte*, I, Stuttgart, 1937, cols. 96-100, and H. Aurenhammer, "Abraham," *Lexikon der christlichen Ikonographie*, I, Vienna, 1959, pp. 27-28.]

55 See Ch. Diehl, *Manuel d'art byzantin*, 2nd ed., Paris, 1926, II, p. 852, fig. 424, for a reproduction of the fresco from the refectory of Lavra.

56 The Octateuch in the Seraglio Library was published by Th. Ouspensky, *The Octateuch of the Seraglio in Constantinople*, in the *Bulletin of the Russian Archeological Institute of Constantinople* (in Russian), 12 (Album), Munich, 1907. The Smyrna Octateuch [destroyed in 1923] was published by C. Hesseling, *Les Miniatures de l'Octateuque de Smyrne*, Leyden, 1909; [Cain and Abel are shown on fol. 16v, illus. pl. 24].

57 Cain and Abel offering their gifts are found again on the façade of St.-Gilles-du-Gard. When we compare the relief with the miniature on fol. 50r of the Seraglio Octateuch, Ouspensky, *op. cit.*, pl. XI,28, we see that the two works are identical. [For the reliefs of St.-Gilles-du-Gard and Nîmes, see R. Hamann, *Die Abteikirche von St. Gilles und ihre kunstlerische Nachfolge*, Berlin, 1956, pp. 94-95 and pl. 115.]

58 Now in Toulouse, Musée des Augustins, inv. no. 460. [See Mesplé, *Musée des Augustins*, cat. no. 131; Lafargue, *Notre-Dame de la Daurade*, pp. 50, 52, 67, 68 and pls. XXII,1, and XXV,3.]

59 Set in the south wall of the eighteenth-century church of Notre-Dame-des-Pommiers. [See A. K. Porter, *Romanesque Sculpture of the Pilgrimage Roads*, Boston, 1923, VIII, pls. 1292-1298, and Hamann, *Die Abteikirche von St. Gilles*, pp. 186-187.]

60 See above, p. 6.

61 [See above, note 12.]

62 The Flagellation is represented in the same manner on the east tympanum of the Platerias Portal of Santiago de Compostela. [See Porter, *Romanesque Sculpture*, VI, pl. 680.]

63 A. de Bastard-d'Estang, *Histoire de Jésus-Christ en figures. Gouaches du XIIe au XIIIe siècle conservées jadis à la collégiale de Saint-Martial de Limoges*, Paris, 1879 (not paginated). This manuscript is now M. 44 in the Pierpont Morgan Library, New York. [See J. Porcher, *Medieval French Miniatures*, New York, 1960, p. 44, and The Pierpont Morgan Library, *Exhibition of Illuminated Manuscripts Held at the New York Public Library*, New York, 1933-1934, no. 35.]

64 L. Giron, *Les Peintures murales du département de la Haute-Loire du XIe au XVIIIe siècle*, Paris, 1911, pp. 9-13, pls. II and III. [See P. Deschamps and M. Thibout, *La Peinture murale en France au début de l'époque gothique, de Philippe-Auguste à la fin du règne de Charles V (1180-1380)*, Paris, 1963, pp. 87-88 and pl. XXXVII; E. Anthony, *Romanesque Frescoes*, Princeton, 1951, pp. 138-139; and O. Demus, *Romanesque Mural Painting*, London and New York, 1970, p. 432.]

65 J. Maspero, "Rapport sur les fouilles entreprises à Baouit," *Académie des Inscriptions et Belles-Lettres, Comptes rendus des séances*, 1913, p. 290.

66 Bawit, chapel XXVIII, apse of the east wall. J. Clédat, *Le Monastère et la nécropole de Baouit*, Cairo, 1904 (Mémoires publiés par les membres de l'Institut Français d'Archéologie Orientale du Caire, 12), pl. XCVIII and p. 154.

67 The Christian ivories of Egypt offer some examples. One of these ivories is in the church of Saulieu. See P. de Truchis, "Saint-Andoche de Saulieu," *Congrès archéologique*, 74 (1907), pp. 114-115 and pl. 116. [On the diptych of Saulieu, see W. F. Volbach, *Elfenbeinarbeiten der Spätantike und des frühen Mittelalters*, 2nd ed., Mainz, 1952, p. 75, no. 145.]

68 Homilies of James the Monk, Vat., Bibl. Apost., cod. gr. 1162, fol. 5r. See C. Stornajolo, *Miniature delle omilie di Giacomo monaco (cod. vatic. gr. 1162)*, Rome, 1910, pl. 3.

69 And probably also at Charlieu, but there the hands of the Virgin are broken off. The Virgin, seated between two angels, is represented in the same way in the Psalter of Melisende (London, Brit. Mus., Egerton ms. 1139, fol. 202v), illuminated for a Latin princess by a Byzantine miniaturist. [For the Psalter of Melisende, see M. Buchthal, *Miniature Painting in the Latin Kingdom of Jerusalem*, Oxford, 1957, chap. I.]

70 A. Rhein, "Anzy-le-Duc," *Congrès archéologique*, 80 (1913), p. 290. [See also Ch. Oursel, *L'Art en Bourgogne*, Paris and Grenoble, 1953, pp. 65-66.]

71 Lectionary from Cluny, Paris, Bibl. Nat., ms. nouv. acq. lat. 2246, ca. 1100. [See F. Mercier, *Les Primitifs français. La peinture clunysienne en Bourgogne à l'époque romane, son histoire et sa technique*, Paris, 1931, pp. 128-135; cf. M. Schapiro, *The Parma Ildefonsus. A Romanesque Illuminated Manuscript from Cluny and Related Works*, New York, 1964, pp. 35-36 and 43-48.]

72 The Cluny manuscript, even though in all likelihood illuminated by a French artist, has a profoundly Byzantine character. In the scene of the Annunciation (fol. 6r), for example, the archangel wears the costume of an Eastern emperor. [See also G. Cames, "Recherches sur l'enluminure romane de Cluny. Le Lectionnaire, Paris, B.N. nouv. acq. lat. 2246," *Cahiers de civilisation médiévale*, 7 (1964), pp. 146-148.]

73 Chapter IX, p. 329.

74 Credit for this discovery belongs to J. Pijoán. See Pijoán, "Les Miniatures de l'Octateuch y les Bibles romàniques catalanes," *Anuari del Institut d'Estudis catalans*, 4 (1911-1912), pp. 479-487.

75 Paris, Bibl. Nat., ms. lat. 6. It is known as the Noailles Bible. [As noted above, n. 47, it is now more commonly known as the Roda Bible. See Neuss, *Die katalanische Bibelillustration*, pp. 10-15.]

76 Rome, Bibl. Apost., cod. vat. lat. 5729. [See Neuss, *op. cit.*, pp. 16-29, who suggests that the manuscript comes from Ripoll.]

77 In the portal of Ripoll there are jamb statues and historiated archivolts which presuppose knowledge of what had been done at St.-Denis and Chartres. The work is certainly later than the middle of the twelfth century. [According to recent studies the portal of Ripoll dates from the second quarter of the twelfth century. See J. Gudiol-Ricart and J. A. Gaya Nuño, *Arquitectura y escultura románica* (Ars Hispaniae, V), Madrid, 1948, pp. 66-68.]

78 G. Perrot and Ch. Chipiez, *Chaldée et Assyrie* (Histoire de l'art dans l'antiquité, II), Paris, 1884, pp. 224-226. China also received

this motif from Assyria. Marco Polo tells us that there were marble columns resting on lions at both sides of the great bridge spanning the Pulisanghin River.

79 Venice, Bibl. Marciana, ms. gr. 540, fol. 2v-6r. The columns rest on lions, elephants, camels, and composite creatures like the Assyrian bulls.

80 "First Bible of Charles the Bald" (Paris, Bibl. Nat., ms. lat. 1, fols. 328r-328v), Bible of St.-Aubin (Angers, Bibl. mun., ms. 4, fol. 206r), Gospel-book in Paris (Bibl. Arsenal, ms. 592, fol. 17r). See A. Boinet, *La Miniature carolingienne*, Paris, 1913, pls. LIV, LV, CLIb, CXIIa.

81 Gospel-book of Perpignan (Perpignan, Bibl. mun., ms. 1). See A. Boinet, "Notice sur un évangéliaire de la Bibliothèque de Perpignan," *Congrès archéologique*, 73 (1906), illus. p. 538. [See also M. Durliat, *Les Arts anciens du Roussillon*, Perpignan, 1954, p. 28.]

82 Paris, Bibl. Nat., ms. syr. 33, fol. 3b [for example, C. Nordenfalk, *Die spätantiken Kanontafeln*, Göteborg, 1938, pl. 116]. It is also to be seen in the Carolingian manuscript, Paris, Bibl. Nat., ms. lat. 9387 [Gospel-book of St.-Denis, fol. 9r, see Boinet, *La Miniature carolingienne*, pl. v].

83 These two motifs are brought together on the portal of Andrieu (Calvados), for example, and on the completely Norman portal of Villers-St.-Paul (Oise). The mosaic of S. Apollinare in Classe is found in R. Garrucci, *Storia dell'arte cristiana nei primi otto secoli della chiesa*, 6 vols., Prato, 1873-1881, IV, p. 76 and pl. 266, no. 5. [The portals of Andrieu and Villers-St.-Paul are reproduced in M. Anfray, *L'Architecture normande, son influence dans le nord de la France aux XIe et XIIe siècles*, Paris, 1939, pl. LIII.]

84 Armenia in its turn also interpreted in stone the zigzag and fret motifs of Syrian manuscripts, as may be seen on the portal of St. George of Ani. It is quite obvious that the resemblances between Norman and Armenian work can be explained only by their use of common models, that is, by illuminated manuscripts. [On this question, see J. Baltrušaitis, *Etudes sur l'art médiéval en Géorgie et en Arménie*, Paris, 1929, pp. 88-98 and pls. LXV and LXXIV.]

85 Rome, Bibl. Apost., cod. vat. gr. 1162, Homilies of James the Monk. [Illus. Stornajolo, *Miniature*, pl. I.]

86 Gospel-book of St.-Médard of Soissons (Paris, Bibl. Nat., ms. lat. 8850, fol. 75v), Boinet, *La Miniature carolingienne*, pl. XIXa; Gospel-book (Codex aureus) in London (Brit. Mus., ms. Harley 2788, fol. 11v), *ibid.*, pl. XVIb. [Cf. Koehler, *Die karolingischen Miniaturen*, II, pls. 70 and 52.]

87 J. Strzygowski, *Das Etschmiadzin-Evangeliar (Byzantinische Denkmäler*, I), Vienna, 1891, pp. 53ff. and pl. III. [The ms. is now in Yerevan (Matenadaran ms. 2374). In this case the frame encloses pairs of apostles on fols. 6v-7r. See also F. Macler, *L'Evangile Arménien, édition phototypique du Ms. 229 de la Bibliothèque d'Etchmiadzin*, Paris, 1920.]

88 J. Ebersolt, "Miniatures byzantines de Berlin," *Revue archéologique*, 4th ser., 6 (1905), pp. 55-70. [This solution is more clearly seen in a tenth-century Armenian manuscript in Jerusalem (Library of the Armenian Patriarchate, cod. 2555, fols. 6r-6v) illus. Nordenfalk, *Kanontafeln*, pls. 29-30.]

89 Gospel-book of St.-Médard of Soissons (Paris, Bibl. Nat., ms. lat. 8850, fols. 10v-11r), Boinet, *La Miniature carolingienne*, pl. XX. [See P. Underwood, "The Fountain of Life in Manuscripts of the Gospels," *Dumbarton Oaks Papers*, 5 (1950), pp. 41-138; Koehler, *Die karolingische Miniaturen*, II, pls. 76-77.]

90 East Berlin, Staatl. Mus. (Bode Mus.), O. Wulff, *Mittelalterliche Bildwerke*, pt. 2 of *Altchristliche und mittelalterliche byzantinische und italienische Bildwerke* (Berlin Museum, *Beschreibung der bildwerke der christlichen epochen*), 2nd ed., Berlin, 1911, p. 4, no. 2240 (inv. no. 6600). [U. Monneret de Villard, "Per la storia del portale romanico," *Medieval Studies in Memory of A. Kingsley Porter*, I, Cambridge, 1939, pp. 113-124, suggests that the idea of the tympanum may have come to Egypt from Gandhara.]

91 E. Molinier, *Histoire générale des arts appliqués à l'industrie du 5e à la fin du 18e siècle*, I. *Ivoires*, Paris, 1896, pp. 123-124. [A. Goldschmidt, *Die Elfenbeinskulpturen (aus der Zeit der karolingischen und sächsischen Kaiser)*, Berlin, 1914, I, pp. 23-24, especially the book cover of the Psalter of Charles the Bald (Paris, Bibl. Nat., ms. lat. 1152; Goldschmidt no. 40) and the plaques in the Zurich Museum (Goldschmidt no. 42). See also E. T. De Wald, *The Illustrations of the*

Utrecht Psalter, Princeton, London and Leipzig, n.d.]

92 Goldschmidt, *op. cit.*, I, e.g., nos. 1-4 and no. 74.

93 Carvers of ivories continued to imitate manuscripts in the eleventh century. The ivory casket of Brunswick reproduced with very few changes the miniatures of the Benedictional of St. Aethelwold [formerly Chatsworth, library of the Duke of Devonshire; now London, Brit. Mus., Add. ms. 49598], illuminated by a monk of Winchester in the late tenth century; O. Homburger, *Die Anfänge der Malschule von Winchester im X. Jahrhundert*, Leipzig, 1912, pp. 8-10 and pls. II and III. [Goldschmidt, *op. cit.*, I, p. 52, no. 96, dates the casket in the ninth or early tenth century; the Benedictional of St. Aethelwold may be dated between 975 and 980. Cf. A. Grabar and C. Nordenfalk, *Early Medieval Painting* (The Great Centuries of Painting), ed. Skira, 1957, p. 182.]

94 Some of these plaques are preserved in the museum of Nantes; they were also used in the churches of Africa (Bardo museum, Tunis). The twelfth-century carved plaques set into the tower of St.-Restitut (Drôme) derived from these ancient models. [On the terracottas in the Nantes museum, see D. Costa, *Nantes, Musée Th. Dobrée. Art mérovingien*, Paris, 1964, nos. 1-179; for St.-Restitut, see E. Bonnet, "Les Bas-reliefs de la tour de Saint-Restitut," *Congrès archéologique*, 76 (1909), pp. 251-274.]

CHAPTER II

1 The sculptured relief in the ambulatory of the choir must date from the late eleventh century. [Cf. Ch. Delaruelle, "Les Bas-reliefs de Saint-Sernin," *Annales du Midi*, 1929, pp. 49-60; on the iconography, see F. Gerke, *Der Tischaltar des Bernard Gilduin in Saint Sernin in Toulouse* (Akademie der Wissenschaften und der Literatur, Abhandlung der Geistes-und Sozialwissenschaftlichen Klasse, Mainz, Jahrgang 1958, Nr. 8), pp. 494-497.] The Christ of the south tympanum was probably carved not more than ten years later. [See R. Rey, *La Sculpture romane languedocienne*, Toulouse and Paris, 1936, p. 47 and p. 53. Christ is shown bearded from the beginning of the fifth century in the mosaic of S. Pudenziana in Rome, in the Baptistery of the Orthodox in

Ravenna, etc. Cf. W. F. Volbach, *Early Christian Art*, London, 1961, pl. 130 and pl. 141.]

2 Le Blant was the first to see (E. Le Blant, *Etudes sur les sarcophages chrétiens antiques de la ville d'Arles*, Paris, 1878, pp. xxiff.) that the presence of these disparate subjects is explained by the prayer recited for the dead, but he did not know its early forms. They are given by K. Michel, *Gebet und Bild in frühchristlicher Zeit* (Studien über christliche Denkmäler, I), Leipzig, 1892, pp. 3-7 and pp. 17ff.

3 W. de Bock, *Matériaux pour servir à l'archéologie de l'Egypte chrétienne*, Saint Petersburg, 1901, pp. 7-33 and pls. III-XVI, and C. M. Kaufmann, *Ein altchristliches Pompeji in der libyschen Wüste: Die Nekropolis der "grossen Oase,"* Mainz, 1902, pp. 25-27. [See also A. Fakhry, *The Necropolis of El-Bagawat in Kharga Oasis*, Cairo, Service des Antiquités de l'Egypte, 1951.]

4 [The city of Apamea in Phrygia claimed to be the place where Noah's ark rested, and pagan coins struck in the second and third centuries showed the ark: cf. F. Cabrol and H. Leclercq, "Apamée," *Dictionnaire d'archéologie chrétienne et de liturgie*, I, pt. 2, cols. 2509-2518.]

5 [See M. A. Veyries, "Les Figures criophores dans l'art grec, l'art gréco-romain et l'art chrétien," *Bibliothèque des Ecoles Françaises d'Athènes et de Rome*, 39, Paris, 1884, pp. 4ff. The connection between the Good Shepherd and these antique sources has been questioned: see, for example, J. Sauer, "Hirt," *Lexikon für Theologie und Kirche*, V, cols. 77-78, and Cabrol and Leclercq, "Pasteur (Bon)," *Dictionnaire*, XIII, pt. 2, cols. 2272ff., cf. col. 2281.]

6 [On the iconography derived from the Shepherd of Hermas and the Vision of St. Perpetua, see Cabrol and Leclercq, "Hermas," *Dictionnaire*, VI, pt. 2, cols. 2265ff., cf. col. 2286, and "Perpétue et Félicité (saintes)," *op. cit.*, XIV, pt. 1, cols. 393ff., cf. col. 411.]

7 [The origin of these ivories is not certain. Cf. W. F. Volbach, *Elfenbeinarbeiten der Spätantike und des frühen Mittelalters*, Mainz, 1952, see cat. nos. 107, 110, 111, 161, 163. On the Brescia casket, in addition to Volbach, cat. no. 107, see J. Kollwitz, *Die Lipsanothek zu Brescia*, Berlin, 1933.]

8 The miniatures of the Psalter (Paris, Bibl.

Nat., ms. gr. 139) are reproduced by H. Omont, *Les miniatures des plus anciens manuscrits grecs de la Bibliothèque Nationale du VIe au XIVe siècle*, 2nd ed., Paris, 1929. [See H. Buchthal, *The Miniatures of the Paris Psalter*, London, 1938; H. Gerstinger, *Die Wiener Genesis*, Vienna, 1931; K. Weitzmann, *The Joshua Roll*, Princeton, 1948.]

9 Mosaic in the Baptistery of the Orthodox in Ravenna. [See W. F. Volbach, *Early Christian Art*, London, 1961, pl. 141; J. Strzygowski, *Ikonographie der Taufe Christi*, Munich, 1885, pl. 1, fig. 15.]

10 Paris, Bibl. Nat., ms. gr. 139, Psalter, fol. 419v; Omont, *Les Miniatures des plus anciens manuscrits grecs*, pl. IX.

11 Paris, Bibl. Nat., ms. gr. 139, fol. IV; Omont, *op. cit.*, pl. I.

12 Paris, Bibl. Nat., ms. gr. 139, fol. 435v; Omont, *op. cit.*, pl. XIII.

13 A. Foucher, "Sculptures gréco-bouddhiques," *Monuments Piot*, 7 (1900), pp. 39-64, and cf. p. 42, fig. 1 and pl. v.

14 The written accounts of travels by pilgrims have been published by T. Tobler and A. Molinier, *Itinera hierosolymitana et descriptiones terrae sanctae* (Publications de la Société de l'Orient Latin, série géographique, I-II, *Itinera latina*), Geneva, 1879 [note especially the account of Arculf, ca. A.D. 670, pp. 141-210 (*Arculfi relatio de locis sanctis*), and that of the Venerable Bede, ca. A.D. 720, pp. 213-234], and P. Geyer, *Itinera hierosolymitana* (Corpus scriptorum ecclesiasticorum latinorum, XXXIX), Vienna, 1898, esp. pp. 223-297.

15 [Mâle, in Additions and Corrections to the 6th ed., 1953, p. 443]: *Ampullae of Monza*. The ampullae recently discovered in Italy at the monastery of Bobbio should be added to the Monza ampullae. They reflect several new mosaics of the Holy Land. See G. Celi, "Cimeli Bobbiesi," *Civiltà cattolica*, II, Rome, 1923, pp. 504ff. and III, pp. 37-45, 124-136, 335-344 and 422-439; and C. Cecchelli, "Note iconografiche su alcune ampolle Bobbiesi," *Rivista di archeologia cristiana*, 1927, pp. 115-139. [See also A. Grabar, *Ampoules de Terre Sainte (Monza-Bobbio)*, Paris, 1958, pp. 32ff. and pls. XXXII-LV.]

16 This was pointed out by D. V. Ainalov, *The Hellenistic Origins of Byzantine Art*, New Brunswick, 1961 (tr. of original Russian ed. of 1900). [See Grabar, *op. cit.*, pp.

47-49, who demonstrates the hypothetical character of Ainalov's views. Only one Palestinian mosaic illustrates a Gospel subject, namely: the Transfiguration. While absent from the ampullae, it is represented in a sixth-century mosaic in the apse of St. Catherine at Mount Sinai.]

17 They are reproduced in R. Garrucci, *Storia dell'arte cristiana*, Prato, 1880, VI, pls. 433-435.

18 Garrucci, *op. cit.*, III, pls. 128-140. [See the recent study by C. Cecchelli, G. Furlani and M. Salmi, *The Rabbula Gospels*, Olten and Lausanne, 1959, facsimile edition.]

19 J. Strzygowski, *Etschmiadzin-Evangeliar, Beiträge zur Geschichte der armenischen, ravennatischen und syro-ägyptischen Kunst* (Byzantinische Denkmäler, 1), Vienna, 1891, pl. II-VI.

20 A. Muñoz, *Il codice purpureo di Rossano e il frammento Sinopense*, Rome, 1907.

21 H. Omont, "Peintures du manuscrit grec de l'Evangile de Saint Matthieu, copié en onciale d'or sur parchemin pourpré, récemment acquis pour la Bibliothèque Nationale," *Monuments Piot*, 7 (1901), pp. 175-185 and pls. XVI-XIX. [See also A. Grabar, *Les Peintures de l'évangéliaire de Sinope (Bibl. Nat., suppl. gr. 1286)*, Paris, 1948.]

22 See G. de Jerphanion, "Les Eglises souterraines de Gueurémé et Soghanle (Cappadoce)," *Les Comptes rendus de l'Académie des Inscriptions et Belles-Lettres*, 1908, pp. 7-21; G. de Jerphanion, "Deux Chapelles souterraines en Cappadoce," *Revue archéologique*, 4th ser., 12 (1908), pp. 1-32; H. Grégoire, "Rapport sur un voyage d'exploration dans le Pont et en Cappadoce," *Bulletin de correspondance hellénique*, 33 (1909), pp. 1-170.

23 G. de Jerphanion, *Une nouvelle Province de l'art byzantin, Les églises rupestres de Cappadoce*, Paris, 3 vols., 1925-1944. [See also Jerphanion, *La Voix des monuments, Notes et études d'archéologie chrétienne*, Paris and Brussels, 2 vols., 1930-1938, and M. Restle, *Die Byzantinische Wandmalerei in Kleinasien*, Recklinghausen, 1967.]

24 [Cf. fresco in the "Coemeterium Majus" in Rome dated to the fourth century: J. Wilpert, *Le pitture delle catacombe romane*, Rome, 1903, pl. 207.]

25 [The maphorion is sometimes seen in representations of the Virgin in the Roman catacombs, e.g., in the Adoration of the Magi

in the fourth-century catacomb of Domitilla: Wilpert, *op. cit.*, pls. 116 and 141.]

26 [This "tower of the flock" is already mentioned by St. Jerome; see G. Millet, *Recherches sur l'iconographie de l'Evangile*, Paris, 1916, p. 129.]

27 [On the commemorative cross of the Jordan, see *ibid.*, p. 206; Jerphanion, *La Voix des monuments*, I, xxxv,1 (fresco at Elmali Kilise, Cappadocia: Göreme, Chapel 19).]

28 [See C. R. Morey, *Early Christian Art*, Princeton, 1942, p. 282 and fig. 209.]

29 [See C. Cecchelli, *La Cattedra di Massimiano ed altri avori romano-orientali*, Rome, 1936-1944, and cf. Volbach, *Elfenbeinarbeiten*, no. 140 and pl. 43; Christ is beardless as in the Hellenistic type; but the Trial of the Virgin by Water follows the Protoevangelium of James (16:1-2) as in the older Cappadocian frescoes. See Jerphanion, *Les Eglises rupestres*, pl. 37, fig. 4; pl. 46, fig. 1; pl. 65, fig. 1; pl. 75, fig. 1; and Restle, *Die Byzantinische Wandmalerei*, II, figs. 140, 141, 263, 65, 111.]

30 Ph. Lauer, "Le Trésor du Sancta Sanctorum," *Monuments Piot*, 15 (1906), pp. 7-140 and pl. xv. [See also W. F. Volbach, *I Tessuti del Museo Sacro Vaticano (Catalogo del Museo Sacro . . .)*, III, fasc. I, Vatican, 1932, no. T. 104.]

31 The Ravenna sarcophagus must date from the middle or end of the fifth century. [See "Annonciation" in Cabrol and Leclercq, *Dictionnaire*, I, pt. 2, col. 2256 and fig. 761.] The ivories (as, for example, that of the throne of Maximian) are sixth century. [See also Volbach, *Elfenbeinarbeiten*, pl. 41, no. 130; pl. 47, no. 145; pl. 55, no. 174, etc.] The Annunciation scene woven into the silk fabric of the Sancta Sanctorum of the Lateran must date from the same period.

32 Syrian manuscript in Florence (Rabbula Gospels); Paris, Bibl. Nat., ms. syr. 33, fol. 3b; frescoes at Tokali, Göreme and Balleq Kilise in Cappadocia [Jerphanion, *Les Eglises rupestres*, pl. 74, fig. 1; pl. 35, fig. 1; pl. 178, fig. 2, and Restle, *op. cit.*, II, figs. 110 and 125].

33 Examples in manuscripts of the seated Virgin: Gospel-book of St.-Médard of Soissons (Paris, Bibl. Nat., ms. lat. 8850, fol. 124r), ninth century [W. Koehler, *Die karolingischen Miniaturen*, II, Berlin, 1958, pl. 86]; Gradual of Prüm (Paris, Bibl. Nat., ms. lat. 9448, fol. 1v), late eleventh century; Sacra-

mentary of St.-Bertin (Paris, Bibl. Nat., ms. lat. 819, fol. 98r), late eleventh or early twelfth century; Lectionary of the abbey of Cluny (Paris, Bibl. Nat., ms. nouv. acq. lat. 2246, fol. 6r), late eleventh or early twelfth century; in this manuscript the angel wears the rich costume of the Byzantine emperors [see F. Mercier, *Les Primitifs français. La Peinture clunisienne en Bourgogne à l'époque romane*, Paris, 1931, pl. 92]. Examples of the Virgin standing: Epistles of St. Cyprian (Paris, Bibl. Nat., ms. lat. 1654, fol. 1v), twelfth century; writings of the Church Fathers (Paris, Bibl. Nat., ms. lat. 13013, fol. 29v), twelfth century.

34 J. Birot, "Les Chapiteaux des pilastres de Saint-Martin d'Ainay à Lyon," *Congrès archéologique*, 74 (1907), pp. 526-536, illus. opp. p. 532.

35 [For the capital at Lubersac, see R. Fage, "L'Eglise de Lubersac," *Bulletin monumental*, 76 (1912), pp. 38-58, illus. p. 47; for Arles, see A. K. Porter, *Romanesque Sculpture of the Pilgrimage Roads*, Boston, 1923, IX, fig. 1370, and R. Rey, *L'Art des cloîtres romans. Etude iconographique*, Toulouse, 1955, fig. 117; for the so-called Cordeliers Annunciation in Toulouse, see P. Mesplé, *Toulouse, Musée des Augustins, les sculptures romanes* (Inventaire des collections publiques françaises), Paris, 1961, nos. 248-249, with bibl.]

36 Notably at Balleq Kilise, Tchaouch In and Qeledjar Kilise (Göreme, Chapel 29). [See Jerphanion, *Les Eglises rupestres*, pl. 46, fig. 1; pl. 141, fig. 1; pl. 178, fig. 3.]

37 [Basilica of Bishop Eufrasius, apse mosaic, A.D. 539-543, see Morey, *Early Christian Art*, p. 279 and fig. 187.]

38 Paris, Bibl. Nat., ms. gr. 510, fol. 3r. This manuscript is from the ninth century, but derives from much earlier originals. [Illus. Omont, *Miniatures des plus anciens manuscrits grecs*, pl. xx.]

39 The following can be added: a capital at Ile-Bouchard (Indre-et-Loire) [illus. Porter, *Romanesque Sculpture*, VII, fig. 1101]; a capital at Gargilesse (Indre) [illus. *ibid.*, II, fig. 83]; a capital in the museum at Avignon [from St.-Ruf of Avignon, see J. Girard, *Musée Calvet de la ville d'Avignon*, Avignon, 1924, illus. p. 48 and p. 53.] This is the formula most frequently encountered. [The capital of St.-Benoît-sur-Loire is reproduced in Porter, *op. cit.*, x, fig. 1416; the

relief of the portal of St.-Gabriel, *ibid.*, IX, fig. 1291; the relief at Fécamp, F. Daoust, *L'Abbatiale de la Sainte-Trinité*, Fécamp, 1963, fig. 13.]

40 [See H. Frank, "Epiphanie," *Lexikon für Theologie und Kirche*, III, Freiburg-im-Breisgau, 1959, col. 942.]

41 Werden pyxis and Milan ivory. [See Volbach, *Elfenbeinarbeiten*, no. 119 (Milan) and no. 169 (Werden).]

42 The Menologium of Basil II in the Vatican (cod. gr. 1613, p. 271) [see S. Beissel, *Vatikanische Miniaturen*, Freiburg-im-Breisgau, 1893, pl. 16] which dates from the late tenth century, is one of the last examples.

43 This invaluable ampulla reproduces several mosaics from the Holy Land. [See Grabar, *Ampoules*, pp. 46-49.] The scene of the Nativity is placed in the center of the composition.

44 On this subject, see Millet, *Recherches*, p. 100.

45 We find it in its simplest form on the cover of a reliquary discovered in the Sancta Sanctorum of the Lateran (Lauer, "Le Trésor du Sancta Sanctorum," pl. XIV); several scenes from the Gospels are painted there; they all derive from Palestine. The monument seems to date from the tenth century.

46 Lauer, *op. cit.*, pl. VI.

47 Arculf, *De locis sanctis*, lib. II, cap. III (Tobler and Molinier, *Itinera hierosolymitana*, I, *Itinera latina*, p. 170).

48 The grotto is not shown on the Monza ampulla, but we see it on the painted cover from the Sancta Sanctorum of the Lateran. If this work really dates from the tenth century, as has been said, it is the copy of an original which must go back to at least the sixth century. [In fact, the grotto appears on an ampulla in Monza; see Grabar, *Ampoules*, pp. 52-53.]

49 Paris, Bibl. Nat., ms. gr. 74, fol. 4r. [See H. Omont, *Évangiles avec peintures byzantines du XIe siècle*, Paris, 1908, pl. 6.]

50 [Paris, Bibl. Nat., ms. lat. 9428, fol. 24r. See W. Koehler, *Die karolingischen Miniaturen*, III, Berlin, 1960, pl. 81a.]

51 [Cf. A. Humbert, "Les Fresques romanes de Brinay," *Gazette des beaux-arts*, XI (1914), pp. 217-234, illus. p. 217.]

52 [Cf. J. Vallery-Radot, "Gannat," *Congrès archéologique*, 101 (1938), pp. 304-328, illus. p. 317.]

53 [Cf. M. Aubert, "Lyon, Cathédrale," *Congrès archéologique*, 98 (1935), pp. 54-90, illus. p. 67.] The same is found at Notre-Dame-la-Grande of Poitiers, on the façade. [Cf. G. Dez, "Notre-Dame-la-Grande de Poitiers," *Congrès archéologique*, 109, (1951), pp. 9-19, illus. opp. p. 17.]

54 In Italy, on the other hand, this complicated type was frequently imitated until the fourteenth century, both in painting and sculpture.

55 Rohault de Fleury, *L'Evangile. Etudes iconographiques et archéologiques*, Tours, 1874, I, pl. XVII, fig. 2.

56 There is only one difference: on one of the Monza ampullae two of the magi have beards. The same detail is found in the Gospel-book of Etchmiadzin [cf. chap. I, n. 87; Strzygowski, *Das Etschmiadzin-Evangeliar*, pl. VI, fig. 1] which also reproduces a mosaic from the Holy Land. Thus, it was in Palestine that the magi were first differentiated by age. [On this subject, see H. Kehrer, *Die heiligen drei Könige in Literatur und Kunst*, II, Leipzig, 1909, fig. 33 and pp. 46ff.]. The Monza ampulla is the earliest example extant which shows this differentiation. [See Grabar, *Ampoules*, pp. 16-17. Kehrer believes that the model for the ampulla was a mosaic in Bethlehem, spared by the Persians in the seventh century, which the abbot Daniel was still able to see between 1113 and 1115.]

57 Strzygowski, *op. cit.*, pl. VI, fig. 1 and p. 69.

58 Ivory in the British Museum, and Crawford ivory now in Manchester. [See Volbach, *Early Christian Art*, fig. 222 and p. 355, and Volbach, *Elfenbeinarbeiten*, no. 127, pl. 41 and p. 65.]

59 At Bethlehem, there were probably three mosaics of the Adoration of the Magi: one in the apse of the church, another on the façade, and a third in the Grotto of the Nativity. This would explain the three variants that we have pointed out. See Kehrer, *op. cit.*, II, pp. 46-47. [Cf. Grabar, *Ampoules*, pp. 46-49.]

60 [Miniature in the Drogo Sacramentary (Paris, Bibl. Nat., ms. lat. 9428, fol. 34v), see Kehrer, *op. cit.*, II, fig. 101; and ivory book cover of Paris, Bibl. Nat., ms. lat. 9393, Metz school, c. 850, see Kehrer, *ibid.*, II, fig. 104.]

61 Paris, Bibl. Nat., ms. lat. 8878, fol. 12r. [See W. Neuss, *Die katalanische Bibelillus-*

tration um die Wende des ersten Jahrtausends und die altspanische Buchmalerei, Bonn and Leipzig, 1922, pl. 55, fig. 167.]

62 [The crowns already appear in an early eighth-century mosaic in the Vatican Grottoes (see Garrucci, *Storia*, IV, pl. 280, no. 5) and in the Menologium of Basil II in the Vatican (cod. gr. 1613), c. 1000 (illus. Kehrer, *Die heiligen drei Könige*, II, fig. 49).]

63 London, Brit. Mus., Add. ms. 7169, fol. 8v. [See Millet, *Recherches*, fig. 107. This manuscript dates from the twelfth century.]

64 Paris, Bibl. Nat., ms. lat. 819, fol. 21v. [See M. Schott, *Zwei lüttiche Sakramentare*, Strasbourg, 1931, pl. v, fig. 13.]

65 The Virgin of Bourges, however, is obviously imitated from the Virgin of the St. Anne Portal at Notre-Dame of Paris. The figure missing from the Virgin's right was very probably St. Joseph.
[For the analogies between the portals of Bourges and Paris, see A. Lapeyre, *Des Façades occidentales de Saint-Denis et de Chartres aux portails de Laon*, Paris, 1960, pp. 148 and 163; A. Katzenellenbogen, *The Sculptural Programs of Chartres Cathedral*, Baltimore, 1959, p. 9.]

66 [See Porter, *Romanesque Sculpture*, VII, figs. 1112-1114.] Also in the archivolts of the portal of the cathedral of Le Mans. [See Lapeyre, *op. cit.*, fig. 60.]

67 [See Grabar, *Ampoules*, pl. II.] The same at La Chaise-Giraud (Vendée) [see R. Crozet, *L'Art roman en Poitou*, Paris, 1948, p. 189] and on a capital at Chauvigny (Vienne) [*ibid.*, and Y. Labande-Mailfert, *Poitou roman* (ed. Zodiaque), La Pierre-qui-Vire, 1957, pl. 23].

68 [See Rey, *La Sculpture romane languedocienne*, p. 210, fig. 162; Mesplé, *Musée des Augustins*, no. 28 (inv. 389).]

69 [See P. Deschamps and M. Thibout, *La Peinture murale en France, Le haut Moyen Age et l'époque romane*, Paris, 1951, pl. XLI,2.] The magi on horseback are also to be seen on the façade of St.-Trophime at Arles [R. Hamann, *Die Abteikirche von St. Gilles und ihre künstlerische Nachfolge*, Berlin, 1956, fig. 237], on a capital of the Cathedral of Lyon [cf. M. Aubert, "Lyon, Cathédrale," *Congrès archéologique*, 98 (1935), pp. 54-90, illus. p. 68], on the carved doors of the cathedral of Le Puy [illus.

Forez-Velay (ed. Zodiaque), Le Puy, 1952, pl. 13], and in a Limoges enamel. [See M. M. Gauthier, *Emaux limousins champlevés des XIIe, XIIIe et XIVe siècles*, Paris, 1950, p. 39, a reliquary in the British Museum; the cavalcade of the magi is also shown on two enameled reliquaries, at Laval (Corrèze) and Beaulieu; see E. Rupin, *L'Oeuvre de Limoges*, Paris, 1890, II, figs. 418-419.]

70 [See L. Grodecki, "Les Vitraux de Saint-Denis: l'Enfance du Christ," *De Artibus Opuscula XL, Essays in Honor of Erwin Panofsky*, New York, 1961, pp. 170-186, figs. 9-11, 15-16.]

71 Cf. J. Déchelette, "Autun," *Congrès archéologique*, 74 (1907), pp. 119-157, illus. opp. p. 137.

72 [See Porter, *Romanesque Sculpture*, VII, figs. 1111 and 1114. This subject is already found in Carolingian art, e.g., an ivory in Lyon, illus. Kehrer, *Die heiligen drei Könige*, II, figs. 48 and 106.]

73 On this subject see Millet, *Recherches*, p. 140. A manuscript in Jerusalem seems to preserve something of the early type; Greek Patriarchal Library, *Hierosolymiticus*, ms. 14, Homilies of St. Gregory Nazianzus, fols. 104r-107v; cf. *ibid.*, p. 141 n. 1, and p. 741.

74 Berlin, Staatsbibl., ms. Sachau 220, fol. 8v (end of eighth or early ninth century), published by A. Baumstark, "Spätbyzantinisches und früchristlich-syrisches Weihnachtsbild," *Oriens christianus*, 9th ser., 3 (1913), p. 118, fig. 1.

75 Paris, Bibl. Nat., ms. gr. 510, fol. 137r. Reproduced by Omont, *Les Miniatures des plus anciens manuscrits grecs*, pl. XXXII.

76 Paris, Bibl. Nat., ms. gr. 115, fols. 24v-25r; Millet, *Recherches*, p. 139, figs. 82-83.

77 Florence, Bibl. Laur., ms. Plut. VI, 23, fol. 6v; Millet, *op. cit.*, fig. 86, opp. p. 140; see also p. 141.

78 Paris, Bibl. Nat., ms. lat. 9428, fol. 34v: initial "D." [See A. Boinet, *La Miniature carolingienne*, Paris, 1920, pl. XC; Kehrer, *op. cit.*, II, fig. 101, and p. 105; Koehler, *Die karolingischen Miniaturen*, III, pl. 82c.]

79 On a Frankfurt ivory [ninth-century Metz book cover in the Städtbibliothek, ms. Barth. typ. 2 (Kehrer, *op. cit.*, fig. 102)], the magi on horseback point at the star when they arrive, as they do in the eighth-century Syriac manuscript. [Berlin, Staatsbibl., ms. Sachau 220, fol. 8v. For the Lyon ivory

book cover, see Kehrer, *op. cit.*, fig. 106; cf. A. Goldschmidt, *Die Elfenbeinskulpturen (aus der Zeit der karolingischen und sächsischen Kaiser VIII.-XI. Jahrhundert)* 1, Berlin, 1914, pl. xxvii, no. 68 (Lyon) and p. 36, and pl. xxxi, no. 75 (Frankfurt-am-Main) and p. 42.]

80 Almost always, there is a dove above the Child's head [Strzygowski, *Iconographie der Taufe Christi*, pl. 1, figs. 5-8].

81 Throne of Maximian at Ravenna, sixth century (545-553) [in the Archepiscopal Palace: Strzygowski, *op. cit.*, pl. 11, fig. 8; Volbach, *Early Christian Art*, fig. 232].

82 Today the Christ has a beard, but the head has been restored. In the mosaic of the Baptistery of the Arians, which imitates the mosaic of the Baptistery of the Orthodox, the Christ is beardless [Strzygowski, *op. cit.*, pl. 1, figs. 14-15; Volbach, *op. cit.*, figs. 141 and 149].

83 In the mosaic of the Baptistery of the Arians, he carries this shepherd's crook and is dressed in the exomis.

84 Strzygowski, *Iconographie der Taufe Christi*, p. 16 n. 2.

85 Certain Greek liturgies say expressly that the angels were present at Christ's baptism. See Millet, *op. cit.*, p. 178 n. 11.

86 The fresco reproduced (fig. 64) is exceptional in that Christ does not cover his nakedness; [this is also the case at the church of Tokali and at Qaranleq Kilise: Jerphanion, *Les Eglises rupestres*, pl. 89, fig. 2, and pl. 103, fig. 3].

87 [See Lapeyre, *Des Façades occidentales*, fig. 62.]

88 [On the frescoes of Brinay, see A. Humbert, "Les Fresques romanes de Brinay," *Gazette des beaux-arts*, xi (1914), pp. 217-234, illus. p. 227; as at Chartres, Christ is flanked by St. John the Baptist and an angel. Cf. O. Demus, *Romanesque Mural Painting*, New York, 1970, figs. 151-155 and pp. 105-106, 424-425.]

89 [Metz ivory, c. 855; see Goldschmidt, *Die Elfenbeinskulpturen*, 1, pl. xxx, no. 74a.]

90 Paris, Bibl. Nat., ms. lat. 9438, fol. 24r. In the miniature two divinities are to be seen pouring water from urns. These are the rivers Jor and Dan which, it is said, flowed together and formed the Jordan.

91 [See J. Lafond, "Les Vitraux de la cathédrale Saint-Pierre de Troyes," *Congrès archéologique*, 113 (1955), pp. 29-62, esp. p. 39.]

92 Rohault de Fleury, *L'Evangile*, Tours, 1874, ii, pl. lxx, fig. 3.

93 Millet, *Recherches*, pp. 280ff.

94 *Evangelium Nicodemi, Gesta Pilati*, pt. 1, a, chap. 1. 3; ed. C. Tischendorf, *Evangelia Apocrypha*, rev. ed., Leipzig, 1876, p. 340 [repr. ed., Hildesheim, 1966: *et infantes Hebraeorum frangentes ramos de arboribus sternentes in via; et alii ramos tenebant in manibus suis; alii autem vestimenta sua sternebant in via clamantes* (and the children of the Hebrews held branches in their hands and cried out, and others spread their garments beneath him—M. R. James, *The Apocryphal New Testament*, Oxford, 1961, p. 97)].

95 The manuscript, closely related to the Sinope fragment in the Bibliothèque Nationale (ms. suppl. gr. 1286), was illuminated in Anatolia, and perhaps, as Millet thought, in Cappadocia. See Millet, *op. cit.*, p. 557.

96 [F. W. Deichmann, *Repertorium der christlich-antiken Sarkophage*, 1, Wiesbaden, 1967, no. 772, pl. 123, no. 63, pl. 20. This theme also appears in Carolingian ivories; cf. Goldschmidt, *Die Elfenbeinskulpturen*, 1, pl. xlix, no. 107 (London, Victoria and Albert Museum).]

97 [Paris, Bibl. Nat., ms. lat. 9428, fol. 43r: Koehler, *Die karolingischen Miniaturen*, iii, pl. 83b.]

98 [See Porter, *Romanesque Sculpture*, ix, fig. 1360.]

99 [For the south wall of the choir, see Deschamps and Thibout, *La Peinture murale en France*, pl. xxxviii.]

100 London Psalter (Brit. Mus., Add. ms. 19352, fol. 6r); Barberini Psalter (Rome, Vatican, Barberini gr. 372, fol. 10r); see Millet, *Recherches*, pp. 263-264 and figs. 241-242. [The capital of Saint-Benoît-sur-Loire is reproduced by G. Chenesseau, *L'Abbaye de Fleury à Saint-Benoît-sur-Loire*, Paris, 1931, pl. 62z.]

101 A. Boinet, "Notice sur un évangéliaire de la Bibliothèque de Perpignan," *Congrès archéologique*, 73 (1906), pp. 534-551; illus. opp. p. 542.

102 Paris, Bibl. Nat., ms. lat. 9438, fol. 44v. In this same miniature we again recognize the imitation of an Eastern prototype, at the top of the page, where Christ commands two

disciples to search out the ass's foal, a detail found in the Greek Gospel-book of Florence, Bibl. Laur., ms. Plut. VI, 23, fol. 84v. [Millet, *Recherches*, p. 276, fig. 246.]

103 See the Christian sarcophagi published by Garrucci, *Storia*, V, 1879, pl. 335, nos. 2, 3, and 4; Le Blant, *Sarcophages chrétiens*, pl. XXVIII. The relief we cite (fig. 67) is unfortunately so badly damaged that we can scarcely make out the true character of the scene.

104 [O. von Gebhardt and A. Harnack, *Evangeliorum codex graecus purpureus Rossanensis*, Leipzig, 1880, pl. VIII (fol. 3r); Volbach, *Early Christian Art*, pl. 238 and p. 357.]

105 See Millet, *Recherches*, p. 313, for a reproduction of a tenth-century fresco from Hemsbey Kilise; also of the miniature from the lectionary in Patmos [Monastery of St. John the Theologian, cod. 70, fol. 177v, reproduced here fig. 68; see also K. Weitzmann, *Die byzantinische Buchmalerei des IX. und X. Jahrhunderts*, Berlin, 1935, fig. 446, and pp. 67-68].

106 Gospel-book of the Emperor Otto III (Munich, Staatsbibl., Clm. 4453; G. Leidinger, *Das sogenannte Evangeliarium Kaiser Ottos III* (Miniaturen aus Handschriften der Kgl. Hof- und Staatsbibliothek in München, 1), Munich, 1912, pl. 47) and of Henry II (Munich, Staatsbibl., Clm. 4452; G. Leidinger, *Das Perikopenbuch Kaiser Heinrichs II* (*ibid.*, V), Munich, 1914, pl. 17).

107 Fresco of Hemsbey Kilise (tenth century), reproduced by Millet, *Recherches*, p. 313, no. 300.

108 [The relief of St.-Gilles is reproduced in Hamann, *Die Abteikirche von St. Gilles*, fig. 122; the portal of Vandeins, *ibid.*, fig. 430; the Bellenaves portal, *ibid.*, fig. 423.]

109 [For the reliefs of Selles-sur-Cher, see Porter, *Romanesque Sculpture*, VII, fig. 1079; for Beaucaire, *ibid.*, IX, fig. 1293.]

110 Paris, Bibl. Nat., ms. gr. 74, fol. 195v, Omont, *Evangiles*, IV, pl. 168; and the mosaic in San Marco in Venice [O. Demus, *Die Mosaiken von San Marco in Venedig, 1100-1300*, Baden, 1935, fig. 8 and p. 20].

111 O. M. Dalton, *Catalogue of Early Christian Antiquities and Objects from the Christian East in the Department of British and Mediaeval Antiquities of the British Museum*, London, 1901, pl. VI, no. 291b. [Cf. P. Thoby, *Le Crucifix, des origines au Concile de Trente, Etude iconographique*, Paris, 1959, pl. IV and p. 22.]

112 One of the ampullae (Garrucci, *Storia*, VI, pl. 434, no. 2) represents the cross standing between the two crucified thieves, but Christ is not nailed to it; his bust is seen in the sky above the cross. Another ampulla (Garrucci, *op. cit.*, pl. 434, no. 4) represents the same scene, but this time the clothed Christ is seen nailed to the cross. [See Grabar, *Ampoules*, pls. XVI and XXIV and pp. 55-58; cf. Thoby, *op. cit.*, pl. VII and pp. 26ff.]

113 Garrucci, *Storia*, III, pl. 139, no. 1. [Also see Morey, *Early Christian Art*, fig. 126.]

114 On the other hand, the Greek ivory of the British Museum represents the lance bearer piercing Christ's left side. [See W. de Grüneisen, *Sainte-Marie Antique*, Rome, 1911, p. 326 n. 1 and fig. 270.]

115 The two heavenly bodies appear already on the Monza ampullae. [Cf. Grabar, *Ampoules*, nos. 3-6, 9-13.]

116 G. Schlumberger, "Quelques monuments byzantins inédits," *Mélanges d'archéologie byzantine*, Paris, 1895, I, pp. 163-166; Cabrol and Leclercq, *Dictionnaire*, I, pt. 2, "Amulette," cols. 1784ff.; cf. col. 1821, fig. 486; and III, pt. 2, "Croix," cols. 3045ff.

117 Lauer, "Le Trésor du Sancta Sanctorum," pl. XIV,2; [cf. Morey, *Early Christian Art*, fig. 129 and pp. 122-123].

118 Chvolson, Pokrovskij and Smirnof, "Un Plat d'argent syrien trouvé dans le gouvernement de la Perm," *Materiaux pour servir à l'archéologie de la Russie*, St. Petersburg, 22 (1899), p. 7, fig. 3. [See also J. Reil, *Die frühchristlichen Darstellungen der Kreuzigung Christi*, Leipzig, 1904, pl. II and p. 65.]

119 Grüneisen, *Sainte-Marie Antique*, pp. 326ff. [See also M. Avery, "The Alexandrian Style at Santa Maria Antiqua, Rome," *Art Bulletin*, 7 (1925), pp. 131-149, cf. fig. 9.]

120 The painted Crucifixions in the underground churches of Cappadocia have this same symmetry; e.g., fresco of Qeledjar Kilise [Jerphanion, *Les Eglises rupestres*, pl. 51, fig. 1].

121 [Goldschmidt, *Die Elfenbeinskulpturen*, II, pl. XV, no. 48 and p. 27; on another ivory of the tenth century, from Cluny, Christ wears a loincloth (*ibid.*, I, pl. LI, no. 115). On an ivory of the tenth century in Bonn and an ivory of the ninth century in London, Vic-

toria and Albert Museum, Christ wears a long robe (*ibid.*, I, pl. XVII, no. 37, and pl. LVII, no. 132a).]

122 Gospel-book of Otto III (Munich, Staatsbibl., Clm. 4453, fol. 248v; Leidinger, *Das sogenannte Evangeliarium Kaiser Ottos III*, pl. 50) and the Pericopes of Henry II (Munich, Staatsbibl., Clm. 4452, fol. 107v; Leidinger, *Das Perikopenbuch Kaiser Heinrichs II*, pl. 18). It is curious that in these totally Syrian Crucifixions, the Christ is beardless.

123 E. Raulin, "Orfèvrerie et émaillerie, Mobilier liturgique d'Espagne," *Revue de l'art chrétien*, 1903, p. 25, fig. 1; Rupin, *L'Oeuvre de Limoges*, p. 256, fig. 319.

124 For example, at Belpuig and at Llagonne; see A. Brutails, "Note sur quelques crucifix des Pyrénées-Orientales," *Bulletin archéologique du Comité des Travaux historiques et scientifiques*, 1891, pp. 283-285, pls. XIX-XX. [Cf. W. W. S. Cook and J. Gudiol Ricart, *Pintura e imaginería románicas* (Ars Hispaniae, VI), Madrid, 1950, pp. 294ff., cf. figs. 288-289.]

125 See Chapter VII, pp. 254ff.

126 Carolingian ivory in the cathedral treasury of Tournai [Goldschmidt, *Die Elfenbeinskulpturen*, I, pl. LXXI, no. 160: "school of Tournai, ca. 900"]; ivory in the treasury of the cathedral of Narbonne [*ibid.*, I, pl. XV, no. 31: "Ada group, ninth or tenth century," and H. Fillitz, "Die Elfenbeinreliefs zur Zeit Kaiser Karls des Grossen," *Aachener Kunstblätter*, 32 (1966), pp. 14ff., cf. fig. 15]; miniature in the Gospels of François II (Paris, Bibl. Nat., ms. lat. 257, fol. 12v).

127 Paris, Bibl. Nat., ms. lat. 818, fol. 4r, sacramentary of the eleventh or early twelfth century. Christ is beardless and has long hair. [See V. Leroquais, *Les Sacramentaires et les missels manuscrits des bibliothèques de France*, Paris, 1924, I, pp. 151-154, from the diocese of Troyes.]

128 An example outside France is the very crude relief of the Cluniac priory of Morat, in Switzerland. Christ on the cross is beardless. See J. J. Berthier, "Un Crucifix du XIIe siècle," *Revue de l'art chrétien*, 1895, pp. 64-66, illus. p. 65.

129 At Göreme, for example. [See Jerphanion, *La Voix des monuments*, pl. L.]

130 Carolingian ivory in the Bargello in Florence. [See Goldschmidt, *Die Elfenbeinskulp-*

turen, I, pl. L, no. 114: "Metz school, ninth or tenth century."]

131 This window surely dates from the twelfth century, and not from the thirteenth, as Barbier de Montault has said ("Le Vitrail de la Crucifixion à la cathédrale de Poitiers," *Bulletin monumental*, 1885, pp. 17-45 and 365-378). I attempted to prove this in A. Michel, *Histoire de l'art*, I, pt. 2 (1905), p. 791. [See also R. Crozet, "Le Vitrail de la Crucifixion à la cathédrale de Poitiers," *Gazette des beaux-arts*, 11 (1934), pp. 218-231; R. Grinnell, "Iconography and Philosophy in the Crucifixion Window at Poitiers," *Art Bulletin*, 28 (1946), pp. 171-196; L. Grodecki, "Les Vitraux de la cathédrale de Poitiers," *Congrès archéologique*, 109 (1952), pp. 143-146 and 156-160.]

132 See Millet, *Recherches*, p. 402 n. 7.

133 [See Porter, *Romanesque Sculpture*, IV, fig. 330.]

134 Ch. Diehl, "Mosaïques byzantines de Saint-Luc en Phocide," *Monuments Piot*, 3 (1896), p. 235. [Cf. E. Diez and O. Demus, *Byzantine Mosaics in Greece: Hosios Lucas and Daphni*, Cambridge, 1931.]

135 [See Hamann, *Die Abteikirche von St. Gilles*, I, fig. 477.]

136 See also the Christ on the Cross of the late tenth-century Stroganoff enamel; he is shown with closed eyes. See G. Schlumberger, "Un Tableau reliquaire byzantin inédit du Xe siècle," *Monuments Piot*, 1 (1894), pp. 99-104, pl. XIV. [These enamels may be a century later.]

137 [The Crucifixion with three nails makes its first appearance in the Mosan region in the mid-twelfth century. See K. A. Wirth, *Die Entstehung des Dreinagel-Crucifixus*, Frankfurt-am-Main, 1953, and also "Dreinagelkruzifixus," *Reallexikon zur deutschen Kunstgeschichte*, IV (1958), cols. 524-525 (relief on baptismal font of Tirlemont, Namur, 1149).]

138 Trivulzio ivory; see Garrucci, *Storia*, VI, pl. 449, no. 2; [Volbach, *Early Christian Art*, pl. 92].

139 Garrucci, *op. cit.*, VI, pl. 434, nos. 2 and 4-7; [cf. Grabar, *Ampoules*, e.g., nos. 3, 5, and pls. IX-XI.]

140 O. Schoenewolf, *Die Darstellung der Auferstehung Christi, Ihre Entstehung und ihre ältesten Denkmäler*, Leipzig, 1909, pp. 64 and 70; A. Heisenberg, *Grabeskirche und*

Apostelkirche in Jerusalem, Leipzig, 1908, pp. 125ff., pp. 172ff., and p. 205.

141 Matthew 28:1.

142 Mark 16:1.

143 O. M. Dalton, *Byzantine Art and Archaeology*, Oxford, 1911, p. 620, fig. 393 [bronze censer in the British Museum].

144 Schoenewolf, *Die Darstellung der Auferstehung Christi*, p. 72 n. 3.

145 London, Victoria and Albert Museum; see M. Semper, "Ivoires du Xe et du XIe siècle au Musée National de Budapest," *Revue de l'art chrétien*, 1897, pp. 389-404, fig. IV.

146 Henceforth, the angel was given wings and a scepter.

147 Formerly Spitzer collection; see E. Molinier, *Histoire générale des arts appliqués à l'industrie du Ve à la fin du XVIIIe siècle*, Paris, 1896, illus. p. 140.

148 See Chapter IV, pp. 131ff.

149 [Porter, *Romanesque Sculpture*, VIII, figs. 1225-1227.]

150 [For St.-Nectaire (Puy-de-Dôme), see Porter, *op. cit.*, VIII, fig. 1190; for Brioude (Haute-Loire), E. Lefevre-Pontalis, "Les Dates de Saint-Julien de Brioude," *Congrès archéologique*, 71 (1904), pp. 542-555, illus. after p. 548].

151 *Evangelium Nicodemi, Gesta Pilati*, pt. 1, A, chap. XVI. 3; ed. C. Tischendorf, *Evangelia Apocrypha*, rev. ed., Leipzig, 1876, p. 386 (repr. ed., Hildesheim, 1966). [Cf. M. R. James, *The Apocryphal New Testament*, Oxford, 1961, p. 112].

152 Le Blant, *Sarcophages chrétiens*, pl. XXIX and pp. 46ff.

153 Garrucci, *Storia*, VI, pls. 434, nos. 2, 3, and 435, no. 1; [cf. Grabar, *op. cit.*, nos. 1, 10, 11, and pls. III, XVII, XIX, XXI].

154 J. Clédat, *Le Monastère et la nécropole de Baouît* (Mémoires publiés par les membres de l'Institut Français d'Archéologie Orientale du Caire, XII), Cairo, 1904, pl. XLI and pp. 75-76. The fresco is at the east apse of chapel XVII.

155 Lauer, "Le Trésor du Sancta Sanctorum," pl. XIV,2; [see above, n. 117].

156 Chvolson, Pokrovskij and Smirnof, in *Matériaux pour servir à l'archéologie de la Russie*, 22 (1899), p. 7, fig. 3; [cf. above n. 118].

157 Acts 1:9-12.

158 Garrucci, *Storia*, III, pl. 139, no. 2. [Cf. Cecchelli, Furlani and Salmi, *The Rabbula Gospels* (facsimile), fol. 13b and pp. 71-72.]

159 Paris, Bibl. Nat., ms. lat. 9428, fol. 71v; Boinet, *La Miniature carolingienne*, pl. LXXXVII,B. [See Koehler, *Die karolingischen Miniaturen*, III, pl. 88,b.]

160 Fol. 292v; Boinet, *op. cit.*, pl. CXXVIII,A.

161 See E. T. De Wald, "The Iconography of the Ascension," *American Journal of Archaeology*, 19 (1915), pp. 297ff.

162 Paris, Bibl. Nat., ms. lat. 13336, fol. 91v, late eleventh century.

163 [For the tympanum of the portal of the south transept of San Isidoro of León, see G. Gaillard, *La Sculpture romane espagnole*, I, Paris, 1946, pl. XXXVI and p. 39.]

164 [Cf. e.g., Paris, Bibl. Nat., ms. gr. 74, fol. 112r (Omont, *Evangiles*, pl. 90); and the mosaic of Hagia Sophia in Salonika (Dalton, *Byzantine Art and Archaeology*, fig. 222), dating to the ninth or tenth century.]

165 [See, e.g., G. Cames, "Recherches sur l'enluminure romane de Cluny," *Cahiers de civilisation médiévale*, 7 (1964), pp. 145-159.]

166 Paris, Bibl. Nat., ms. lat. 819, fol. 55v. [See Schott, *Zwei lütticher Sakramentare*, pl. II, fig. 14. This manuscript probably comes from Liège rather than St.-Omer.]

167 Paris, Bibl. Nat., ms. lat. 9438, fol. 84v.

168 [On the iconography of the Ascension in twelfth-century art, see S. H. Gutberlet, *Die Himmelfahrt Christi in der bildenden Kunst*, Strasbourg, 1934, pp. 224-243.]

169 On this subject, see Ch. Diehl, *Manuel d'art byzantin*, Paris, 2nd ed., 1926, II, pp. 513-563.

170 [See O. Demus, *Byzantine Art and the West*, New York, 1970, pp. 79-98.]

171 See the texts of the Greek commentators collected by Millet, *Recherches*, pp. 216ff.

172 Text by Mesarites, cited by Millet, *op. cit.*, p. 217.

173 Schlumberger, *L'Epopée byzantine*, I, illus. p. 465.

174 Schlumberger, *L'Epopée byzantine*, III, illus. p. 449.

175 It is possible that the picture in the Louvre is later than the panel of the Chartres window, but that is of little importance since there had been many earlier models [for example, a miniature of the Gospel-book in Florence, Bibl. Laur., ms. Plut. VI, 23, fol. 34v; illus. Millet, *Recherches*, fig. 198].

176 Paris, Bibl. Nat., ms. gr. 74, fol. 128v, see Omont, *Evangiles*, II, pl. 112; and Florence,

Bibl. Laur., ms. Plut. vi, 23, fol. 34v; Millet, *op. cit.*, figs. 198-199.

177 Reproduced by L. Giron, *Les Peintures murales du département de la Haute-Loire*, Paris, 1911, pl. viii. [On this subject, see C. P. Duprat, "Enquête sur la peinture murale en France à l'époque romane (suite et fin)," *Bulletin monumental*, 102 (1942), pp. 161-223, esp. p. 215 n. 1.]

178 He placed Christ, the two prophets, and the three apostles on the same level. At Christ's left are the two apostles: one, who bows slightly, has veiled hands and the other seems to bend his knee, but both, however, in spite of the amazement clearly expressed by their attitudes, look directly at Christ and behold his brilliance. At Christ's right, the artist placed a standing apostle, but with knees bent and hands veiled. We might think that the demands of monumental sculpture required this arrangement, but that would be an illusion. In fact, the artist had before him a model which had come from the Asiatic East, and not a Byzantine model. A tenth-century fresco has been discovered at Tchaouch In, in Cappadocia, whose arrangement bears a striking resemblance to the tympanum of La Charité-sur-Loire. (G. de Jerphanion, "La Date des peintures de Toqalé-Kilissé en Cappadoce," *Revue archéologique*, 20 (1912), p. 250 and fig. 7; and Jerphanion, *Les Eglises rupestres*, ii, pl. 138, fig. 1). At Christ's left, as at La Charité, we see two standing apostles, one with veiled hands; at Christ's right a standing apostle, also with veiled hands, turns his head. Thus, through a miniature, the artist of La Charité knew a formula different from the Byzantine and one that was earlier and less harmonious. The mosaic of the church of SS. Nereo e Achilleo at Rome derives from an original of the same family. [On the Presentation in the Temple, see D. C. Shorr, "The Iconographic Development of the Presentation in the Temple," *Art Bulletin*, 28 (1946), pp. 17-32.]

179 There is also an Hellenistic formula for the Kiss of Judas, as shown by the sarcophagi and the mosaic of S. Apollinare Nuovo at Ravenna, but this formula was not perpetuated. [Cf. Millet, *Recherches*, p. 326.]

180 [See Porter, *Romanesque Sculpture*, vii, fig. 1080.]

181 [Drogo Sacramentary (Paris, Bibl. Nat., ms.

lat. 9428, fol. 44v): illus. Koehler, *Die karolingischen Miniaturen*, iii, pl. 83d.] On the Coptic-Arabic manuscript of the Catholic Institute, ms. no. 1, see H. Hyvernat, *Album de paléographie copte pour servir à l'introduction paléographique des Actes des Martyrs de l'Egypte*, Paris, 1888, p. 17 and pl. xlix; and Millet, *Recherches*, p. 332.

182 Vatican, Bibl. Apost., ms. gr. 1156, fol. 194v (twelfth century). See Millet, *Recherches*, p. 335, fig. 344.

183 See above, pp. 32ff.

184 Gospel-book of Gelat, fol. 267v, illus. Millet, *Recherches*, p. 335, fig. 345; same detail in the Psalter of London, Brit. Mus., ms. Add. 19352, fol. 45v, and in the Gospel-book of Parma, Palatina, ms. Palat. 5, fol. 90r, illus. Millet, *op. cit.*, p. 335, fig. 341 (Parma) and fig. 343 (London).

185 Millet, *Recherches*, fig. 354 and p. 340. [Cf. R. van Marle, *The Development of the Italian School of Painting*, i, The Hague, 1923, pp. 348-350.]

186 Gospel-book of Parma, Palatina, ms. Palat. 5, fol. 90r, and the Psalter of London, Brit. Mus., Add. ms. 19352, fol. 45v, illus. Millet, *op. cit.*, p. 335 and figs. 341 and 343. [According to Millet the oriental type shows Judas approaching from the right; the Hellenistic type shows him approaching from the left.]

187 At Beaucaire (twelfth-century frieze set in the wall of the eighteenth-century church), the Malchus episode is omitted.

188 However, on a capital at St.-Nectaire, a new detail has been added to this already complex scene. Jesus, at the moment when Judas embraces him, restores Malchus' ear which St. Peter has just cut off. He responds to his betrayal with an act of goodness. Our Romanesque artists transmitted this formula to our Gothic artists, who adopted it. Did they invent it? There is good reason to doubt that they did, for the Coptic manuscript in Paris, Bibl. Nat., ms. copt. 13, fol. 67r, contains the same detail [illus. Millet, *op. cit.*, p. 333, fig. 340]. This Coptic manuscript is a copy of an Eastern original which appears to be very ancient. Thus, in the East, there was a tradition which the Byzantines did not adopt, but which was known in the West. On the St.-Nectaire capital, however, the principal figures are more harmoniously grouped than in the Coptic manuscript.

189 Gospel-book of Florence, Bibl. Laur., ms. Conv. soppr. 160, fol. 213v, illus. Millet, *op. cit.*, fig. 495.

190 This Descent from the Cross with only two figures is found in the Codex Egberti of Trier (Stadtbibl., cod. 24, fol. 85v), and in a Carolingian manuscript at Angers (Bibl. mun., ms. 24), [Millet, *op. cit.*, p. 468, fig. 492]. It presupposes a Syrian prototype that has just been discovered in a Cappadocian fresco at Tavchanlé (Millet, *op. cit.*, fig. 620).

191 *Evangelium Nicodemi, Acta Pilati*, pt. 1, B, chap. XI. 1-5; ed. C. Tischendorf, *Evangelia Apocrypha*, rev. ed., Leipzig, 1876, pp. 309-314 (repr. ed., Hildesheim, 1966). [Cf. M. R. James, *The Apocryphal New Testament*, p. 117.]

192 Paris, Bibl. Nat., ms. gr. 510, Homilies of St. Gregory Nazianzus, fol. 30v (ca. 880); Omont, *Miniatures des plus anciens manuscrits grecs*, pl. XXI.

193 George of Nicomedia, Homilies; Migne, *P. G.*, 100, col. 1488 A.

194 [Cf. H. Focillon, *Peintures romanes des églises de France*, Paris, 1938, pl. 87; E. W. Anthony, *Romanesque Frescoes*, Princeton, 1951, figs. 355 and 359; the Virgin's attitude is the same in the Le Liget fresco.]

195 [R. Fage, "L'Eglise de Lubersac (Corrèze)," *Bulletin monumental*, 76 (1912), pp. 38-58, fig. opp. p. 49.]

196 [Illus. Porter, *Romanesque Sculpture*, VII, fig. 1061.]

197 [See the Gospel-book on Mount Athos, ms. Iviron 5, fol. 129v (P. Huber, *Athos. Leben, Glaube, Kunst*, Zurich, 1969, figs. 137-152), and Berlin Gospels, Staatsbibl., ms. gr. 66, fol. 256v (Millet, *Recherches*, figs. 498 and 505).]

198 Fresco at Foti, Crete, illus. Millet, *op. cit.*, fig. 499. [Millet says (p. 474) that Mary and the disciple receive Christ's hands in their mantle and kiss them; in this fresco it is actually Nicodemus who takes the hands of Christ while St. John remains at the right, near the Virgin.]

199 A. de Bastard-d'Estang, *Histoire de Jesus-Christ en figures, Gouaches du XIIe au XIIIe siècle conservées jadis à la collégiale de Saint-Martial de Limoges*, Paris, 1879, pl. XIX. [This manuscript is now M. 44 in the Pierpont Morgan Library, New York. See The Pierpont Morgan Library, *Exhibition of Illuminated Manuscripts Held at the New York Public Library*, New York, 1933-1934, p. 20, no. 35.]

200 A. Baumstark, "Palaestiniensia," *Römische Quartalschrift*, 20 (1906), pp. 123-188, esp. p. 125. [Cf. A. Grabar, *Martyrium*, 1, Paris, 1946, pp. 257-282.]

201 [See Volbach, *Early Christian Art*, pl. 83, and O. Demus, "The Church of San Marco in Venice," *Dumbarton Oaks Papers*, 6 (1960), pp. 166-167 and p. 208 (on the contested date of the columns).]

202 [These are illustrated in a recent study of the Anastasis by R. Lange, *Die Auferstehung* (Iconographia Ecclesiae Orientalis), Recklinghausen, 1966; cf. Diez and Demus, *Byzantine Mosaics in Greece*, fig. 100 (Daphni) and pl. XIV (Hosios Lucas).]

203 See E. Mâle, *L'Art religieux du XIIIe siècle en France*, 9th ed., Paris, 1958, pp. 224ff.

204 On the right portal of St.-Lazare, at Avallon, the Descent into Limbo has almost completely disappeared. However, we can make out a kind of cave, shown in cross section, with gates destroyed and Satan overthrown [see J. Vallery-Radot, "L'Iconographie et le style des trois portails de Saint-Lazare d'Avallon," *Gazette des beaux-arts*, 52 (1958), pp. 23-34 and p. 27, fig. 3]. This detail was copied exactly from Byzantine mosaics and miniatures, and we may well believe that the entire scene was a close imitation of Eastern originals. In the Musée Massénat of Brive, there are a few fragments of a twelfth-century Descent into Limbo. Adam and Eve are dressed as in the Byzantine models. [Illus. Porter, *Romanesque Sculpture*, IV, fig. 353. For a comparison with Byzantine works of art, see the ciborium column in San Marco in Venice, the Mosaic in Daphni, or in Rome, the fresco in the basilica of San Clemente (J. Wilpert, *Die römischen Mosaiken und Malereien der kirchlichen Bauten vom IV. bis XIII. Jahrhundert*, IV, Freiburg-am-Breisgau, 1916, pl. 209, no. 3; for a discussion of the theme, *ibid.*, II, pp. 887-896).]

CHAPTER III

1 [E.g., in the church of St.-Lazare in Autun (see D. Grivot and G. Zarnecki, *Gislebertus, Sculptor of Autun*, New York, 1961, pl. 40a), and a capital in the choir of the cathe-

dral of St.-Jean of Lyon (see R. Hamann, *Die Abteikirche von St.-Gilles und ihre künstlerische Nachfolge*, Berlin, 1955, fig. 405.]

2 Mâle, *L'Art religieux du XIIIe siècle en France*, 9th ed., Paris, 1958, p. 188. [The crib on arcades is found as early as the fifth century on the Werden pyxis (see W. F. Volbach, *Elfenbeinarbeiten der Spätantike und der frühen mittelalters*, Mainz, 1952, pl. 54, no. 169), and is also seen in Carolingian ivories, e.g., A. Goldschmidt, *Die Elfenbeinskulpturen (aus der Zeit der karolingischen und sächsischen Kaiser, VIII.-XI. Jahrhundert)*, i, Berlin, 1914, nos. 14, 26, 53, 117 and 159.]

3 I have explained this in A. Michel, *Histoire de l'art*, Paris, 1905, i, pt. 2, pp. 786ff. [The Nativity scene in the Infancy window is preserved and shows the crib on arcades. See L. Grodecki, "Les Vitraux de Saint-Denis," *De Artibus Opuscula XL, Essays in Honor of Erwin Panofsky*, New York, 1961, pp. 178-179 and 184-185, and fig. 7.]

4 See Chapter v.

5 See Chapter v, pp. 157ff.

6 [On the motif of the cloth which covers the hands and its liturgical symbolism, see G. de Jerphanion, *La Voix des monuments*, i, Paris, 1930, p. 182: "It is the liturgical cloth with which the deacon, at the altar, covers his hands before touching the sacred objects."]

7 Ciborium column in S. Marco, Venice. See R. Garrucci, *Storia dell'arte cristiana*, vi, Prato, 1880, pl. 498, no. 1.

8 I have corrected Didron's incorrect translation. The text is: ἄγγελοι ἔχοντες ἀπλωμένας [τὰς χεῖρας] ὑποχάτω τῶν ἱματίων (the angels having their hands outstretched under their tunics). [See A. N. Didron, *Manuel d'iconographie chrétienne grecque et latine, traduit du manuscrit byzantin, Le guide de la peinture*, Paris, 1845, p. 163.]

9 A. de Bastard-d'Estang, *Histoire de Jésus-Christ en figures. Gouaches du XIIe au XIIIe siècle conservées jadis à la collégiale de Saint Martial de Limoges*, Paris, 1879, pl. VIII [New York, Pierpont Morgan Library, ms. 44, fol. 5r].

10 Jesus Christ, Son of God, Saviour.

11 See G. Millet, *Recherches sur l'iconographie de l'Evangile*, Paris, 1916, pp. 286ff.

12 Garrucci, *Storia*, iii, pl. 141, no. 2.

13 [W. Weidlé, *Mosaïques vénitiennes*, Milan, 1956, pl. 49.] The long trestle table is found in a fresco in the church of Qaranley Kilise, in Cappadocia [Jerphanion, *La Voix des monuments*, i, pl. XLVII,1]. Jesus is seated at one end.

14 Leningrad, Pub. Lib., cod. 21, fol. 9v; Millet, *Recherches*, fig. 275. [This manuscript is dated by Millet before the iconoclastic controversy; it is placed in the ninth or tenth century by K. Weitzmann, *Die byzantinische Buchmalerei des 9. und 10. Jahrhunderts*, Berlin, 1935, pp. 59-61 and figs. 392-398.]

15 However, the East did not take from the Gospel of St. John the attitude of St. John resting his head on Christ's bosom.

16 St. John 13:21-26.

17 [See P. Mesplé, *Toulouse, Musée des Augustins, les sculptures romanes* (Inventaire des collections publiques français), Paris, 1961, no. 125 with illus.]

18 Paris, Bibl. Nat., ms. lat. 12054, fol. 79r (illus. Ch. Rohaut de Fleury, *L'Évangile*, Tours, 1874, ii, pl. LXXIV, fig. 2) and the Gospel-book in Perpignan, Bibl. mun., ms. 1, fol. 108v, *Congrès archéologique*, 73 (1906). [J. Gudiol i Cunill, *La pintura mig-eval catalana, Els Primitius*, Barcelona, 1955, p. 125, fig. 119.] To this list might be added a capital of the Royal Portal of Chartres, and the tympanums of Bellenaves (Allier) [illus. our fig. 295], Jonzy (Saône-et-Loire) [illus. Hamann, *Die Abteikirche von St. Gilles*, fig. 432], and St.-Bénigne of Dijon (now in the archeological museum).

19 [See A. K. Porter, *Romanesque Sculpture of the Pilgrimage Roads*, Boston, 1923, vol. IX, pl. 1318, and cf. Hamann, *op. cit.*, fig. 195.]

20 [The lintel of Champagne is reproduced by Hamann, *Die Abteikirche von St. Gilles*, fig. 425; the relief of Vizille, *ibid.*, fig. 428; for Vandeins, *ibid.*, fig. 430; for Vizille, cf. Porter, *op. cit.*, VIII, pl. 1185.]

21 A capital of St.-Nectaire (Puy-de-Dôme) shows a third manner of conceiving the Last Supper, and one that remained quite rare in monumental art [R. Rey, *L'Art roman et ses origines*, Toulouse and Paris, 1945, p. 419, fig. 133]. Jesus blesses the bread and distributes it to his apostles; each loaf is round and stamped with a cross, as if it were a kind of Host. Thus, the artists wanted to represent not only the betrayal by Judas, but the institution of the Eucharist according to

St. Matthew. An ancient miniature must have suggested this composition which goes far back in time, since the Cambridge manuscript, a reproduction of an Eastern prototype, already represents this institution of the Eucharist. In the Cambridge manuscript [Gospel-book said to be by St. Augustine, Cambridge, Corpus Christi College, ms. 286, fol. 125r, probably of the sixth century; F. Wormald, *The Miniatures in the Gospels of St. Augustine*, Cambridge, 1954, pls. I, III, IV], as on the capital of St.-Nectaire, each apostle holds a piece of bread in his hand. In the Life of Christ of St.-Martial of Limoges, published by the Comte de Bastard, the Betrayal by Judas is combined with the institution of the Eucharist [now Pierpont Morgan Library, New York, ms. 44, fol. 6v; cf. Bastard, *Histoire de Jésus-Christ*, pl. XI. [The provenance of this manuscript is debated; see D. Gaborit-Chopin, *La Décoration des manuscrits à Saint-Martial de Limoges et en Limousin du IXème au XIIème siècle*, Paris and Geneva, 1969, p. 219; cf. *The Year 1200*, Exhibition Catalogue, The Metropolitan Museum of Art, New York, 1970, no. 242.]

22 Mâle, *L'Art religieux du XIIIe siècle*, 9th ed., pp. 384-385.

23 It is possible that the maw of the Leviathan had appeared in English art before it appeared in France. In an English manuscript from the beginning of the eleventh century, London, British Museum, Cotton Ms. Titus D. XXVII [containing the Offices of the Cross and of the Trinity, Winchester, c. 1012-1020], on fol. 75v, it already symbolizes hell. [The upper part of the miniature depicts the Trinity and includes the Virgin holding the Christ Child, with the Dove of the Holy Spirit perched on her head. The gaping hellmouth is depicted below the Trinity; Satan in chains appears just over the mouth which is flanked by the heretic Arius and Judas. See F. Wormald, *English Drawings of the Tenth and Eleventh Centuries*, London, 1952, pl. 16a; and in the Register and Martyrology of New Minster, at Winchester (c. 1016-1020), Brit. Mus., Stowe ms. 944 fol. 7, illus. E. Millar, *English Illuminated Manuscripts from the X*th *to the XIII*th *Century*, Paris and Brussels, 1926, pl. 25.] (Cf. *The Palaeographical Society, Facsimiles of Manuscripts and Inscriptions*, ed. E. A. Bond and E. M. Thompson, London, 1873-1878, III,

pl. 60 [and E. H. Kantorowicz, "The Quinity of Winchester," *Art Bulletin*, 29 (1947), pp. 73-85 and fig. 1]. In the twelfth century it appeared in a relief in the vestry of the canons of Bristol [F. Saxl, *English Sculpture of the Twelfth Century*, ed. H. Swarzenski, London, 1954, pl. XI] and among the exterior reliefs at Lincoln Cathedral [E. Trollope, "The Norman Sculptures of Lincoln Cathedral," *Archaeological Journal*, 25 (1868), pp. 1-20, fig. 10]. These reliefs represent the Descent into Limbo.

24 There are two shepherds on the capital at Moissac [cf. R. Rey, *La Sculpture romane languedocienne*, Toulouse and Paris, 1936, p. 143, description of the west face (one shepherd) and reproduction of the southern face (another shepherd and the angel) *ibid.*, p. 143, fig. 113], on the portal of La Charité-sur-Loire [Porter, *Romanesque Sculpture*, II, fig. 122], and on the St. Anne Portal of Notre-Dame of Paris. There are three on the portal and in the west window of Chartres [west façade, tympanum of the right bay, E. Houvet, *Monographie de la Cathédrale de Chartres, Portail occidental ou royal, XIIe siècle*, Paris, 1927, pl. 55 (we see only an arm of the third shepherd); and cf. Y. Delaporte, *Les Vitraux de la cathédrale de Chartres*, Chartres, 1926, I, pl. IV], three also in the Life of Christ published by Bastard [see our fig. 109].

25 There are two shepherds in the Greek Gospel-book, Paris, Bibl. Nat., ms. gr. 74 [Millet, *Recherches*, fig. 100]; there are three in the Vatican Library Gospels, gr. ms. 1156 [*ibid.*, figs. 76-77].

26 As Millet has established, *op. cit.*, pp. 114ff.

27 [See Millet, *op. cit.*, pp. 131 and 133-135.]

28 Florence, Bibl. Laur., ms. Plut. VI, 23, fol. 104v (Millet, *Recherches*, fig. 78).

29 Paris, Bibl. Nat., ms. gr. 74, fol. 108v; H. Omont, *Évangiles avec peintures byzantines du XIe siècle*, Paris, n.d., pl. 97.

30 There are vestiges of the staff he carried in his hand. [A. Michel, "Les Sculptures de l'ancienne façade de Notre-Dame de la Couldre à Parthenay," *Monuments Piot*, 22 (1916-1918) pp. 179-195, cf. p. 192, illus. pl. XVIII.]

31 L. Serbat, "La Charité-sur-Loire," *Congrès archéologique*, 80 (1913), pp. 374-400, illus. opposite p. 394.

32 [Mâle, in Additions and Corrections to the 6th ed., 1953, p. 441]: *The Annunciation to*

the Shepherds at Notre-Dame-de-la-Couldre of Parthenay, now in the Louvre. Do the doubts about the authenticity of the shepherd's head have any real foundation? It does not seem so. We must first note that the gesture of the shepherd who takes hold of his beard as he reflects on what he sees and hears is found more than once in medieval art. It will suffice to cite the tympanum of the right portal of the north façade of Chartres Cathedral, where one of Job's friends makes the same gesture [Houvet, *Chartres, Portail occidental*, I, pl. 75, detail pls. 76 and 78]. And again, the gesture of the shepherd who puts his hand above his eyes to shield them from the dazzling light of the angel is the same as at Sainte-Eulalie of Benet (Vendée) [illus. *Congrès archéologique*, 30 (1864), facing p. 126, and Crozet, *L'Art roman*, p. 189]. We might add that this shepherd is separated from his companion by sheep seen frontally, as in the relief of the Louvre. On the relief at Benet, see the study of E. Maillart, "La Façade romane de l'église Sainte-Eulalie de Benet en Bas-Poitou," *Bulletin archéologique du Comité des Travaux historiques et scientifiques*, 1927, pp. 379-385. [On this question, see J. J. Rorimer, "Forgeries of Medieval Stone Sculpture," *Gazette des beaux-arts*, 26 (1944), pp. 195-210, and "The Restored Twelfth-Century Parthenay Sculptures," *Technical Studies*, 10 (1941-1942), pp. 123-130.]

33 [Houvet, *Chartres, Portail occidental*, pl. 52. The book is the one containing Isaiah's prophecy (*Ecce virgo concipiet*) which according to patristic tradition the Virgin was reading when the angel appeared. See G. Cames, "Recherches sur l'enluminure romane de Cluny," *Cahiers de civilisation médiévale*, 7 (1964), pp. 145-159.]

34 [Cf. M. Lafargue, *Les Chapiteaux du cloître Notre-Dame de la Daurade*, Paris, 1939, pl. v, figs. 1-2.]

35 [Florence, Bibl. Laur. ms. Plut. vi, 23; Millet, *Recherches*, fig. 198.]

36 At St.-Nectaire [Porter, *Romanesque Sculpture*, viii, fig. 1202], as at Toulouse [Lafargue, *op. cit.*, pl. v, fig. 4], the three tabernacles that St. Peter was to make, the *tria tabernacula*, are represented by three churches. Curiously enough, the Coptic manuscript of the Bibliothèque Nationale of Paris (Copte 13, fol. 48r) has the same detail, although the Transfiguration is conceived quite differently [cf. Millet, *Recherches*, fig. 186]. The artist of St.-Nectaire consequently had before him a miniature of this type from which he seems to have taken only this detail [Lafargue, *op. cit.*, p. 28 n. 3, cites a similar representation on a Carolingian ivory in the Victoria and Albert Museum]. It is to be remembered that three churches had been erected on Mt. Tabor to commemorate the Transfiguration and the *tria tabernacula*; see Adamnanus, *De locis sanctis*, lib. ii, cap. xxvii, *De Monte Thabor*, in P. Geyer, *Itinera hierosolymitana* (Corpus script. eccl. lat., 39, 1898), p. 275.

37 [For the problem of Cappadocian and Byzantine influence on Romanesque mural painting in France see especially A. Grabar, "L'Etude des fresques romanes," *Cahiers archéologiques*, 2 (1947), pp. 163-177, who introduces the evidence of Italian intermediaries to the question; he develops this idea in *Romanesque Painting* (The Great Centuries of Painting), ed. Skira, 1958, pp. 106-108. Cluny also played a role in these transmissions (see Schapiro, *The Parma Ildefonsus*, pp. 41-53). According to Grabar the "Cappadocian" elements belong either to Early Christian tradition or to the creation of Byzantine post-iconoclastic iconography, received from Byzantium. These observations may also be applied to Romanesque sculpture (cf. W. Koehler, "Byzantine Art in the West," *Dumbarton Oaks Papers*, 1, 1941, pp. 81-87.]

CHAPTER IV

1 Lintel of the north portal of the façade of St.-Gilles [for a description of this lintel, see R. Hamann, *Die Abteikirche von St.-Gilles und ihre künstlerische Nachfolge*, Berlin, 1955, pp. 80-81]; apostles at St.-Guilhem-du-Désert [see R. Hamann, *op. cit.*, pp. 247-248 and p. 243, figs. 306-307]; lintel of the portal of Pompierre (Vosges) [see G. Durand, "Églises romanes des Vosges," *Revue de l'art chrétien*, suppl. ii, Paris, 1913, p. 270 and p. 269, fig. 203]; the illustrated Life of Christ from St.-Martial of Limoges [published by A. de Bastard-d'Estang, *Histoire de Jésus-Christ en figures. Gouaches du XIIe au XIIIe siècle conservées jadis à la collégiale de Saint-Martial de Li-*

moges, Paris, 1879 (not paginated); now Pierpont Morgan Library, M. 44: *Exhibition of Illuminated Manuscripts Held at the New York Public Library*, New York, 1933-1934, pl. 35].

2 Ivory of St.-Lupicin. The ivory is Hellenistic, and yet Christ is represented, under Syrian influence, riding sidesaddle on his mount. [On this ivory and its bibliography, see W. F. Volbach, *Elfenbeinarbeiten der Spätantike und des frühen Mittelalters*, 2nd ed., Mainz, 1952, p. 71, no. 145 and pl. 47.]

3 London, Brit. Mus., ms. Add. 49598, fol. 45v, G. F. Warner and A. Wilson, *The Benedictional of Saint Aethelwold, Reproduced in Facsimile*, Oxford, 1910. [Cf., F. Wormald, *The Benedictional of St. Ethelwold*, London, 1959.]

4 Fol. 175r, S. Beissel, *Des hlg. Bernward Evangelienbuch im Dom zu Hildesheim, mit Handschriften des X. und XI. Jahrhunderts in kunsthistorischer und liturgischer Hinsicht verglichen*, 3rd ed. published by G. Schrader and F. Koch, Hildesheim, 1894, p. 13 and pl. XXIII,19; [cf., F. J. Tschan, *Saint Bernward of Hildesheim*, Notre-Dame (Indiana), III, 1952, pl. 75].

5 [On the theme of the Entry into Jerusalem and its evolution, see W. W. S. Cook, "The Earliest Painted Panels of Catalonia," *Art Bulletin*, 10 (1927-1928), pp. 167-178.]

6 Menologium of Basil II in the Vatican; church of Qeledjlar Kilise in Cappadocia (Göreme, Chapel 29), north side of sanctuary arch [reproduction in M. Restle, *Die Byzantinische Wandmalerei in Kleinasien*, Recklinghausen, 1967, II, fig. 268]; Paris, Bibl. Nat., ms. gr. 74, fol. 109v, reproduction in H. Omont, *Évangiles avec peintures byzantines du XIe siècle*, Paris, n.d., II, pl. 94; Florence, Bibl. Laur., ms. Plut., VI, 23; London, Brit. Mus., ms. Harley 1810, fol. 146b.

7 Church of Qaterdji Djami in Cappadocia; Vienna, Öst. Nationalbibl., ms. 154, fol. 143r.

8 [On the symbolism of the participants in the Presentation in the Temple, see A. Katzenellenbogen, *The Sculptural Programs of Chartres Cathedral*, Baltimore, 1959, pp. 14-15.]

9 Honorius of Autun, *Gemma animae*, cap. XXIV, "De purificatione sanctae Mariae," Migne, *P. L.*, 172, col. 649. [On the iconography of the Presentation in the Temple, see D. C. Shorr, "The Iconographic Development of the Presentation in the Temple," *Art Bulletin*, 28 (1946), pp. 17ff. For the representation of this theme on the Infancy of Christ window at Chartres, see Y. Delaporte, *Les Vitraux de la cathédrale de Chartres, histoire et description*, Chartres, 1926, p. 151.]

10 West façade, north portal, lower register. [L. Bégule, *La Cathédrale de Sens, son architecture, son décor*, Lyon, 1929, p. 39.]

11 The heads of almost all these figures are missing. [On this portal, see W. Saulerländer, *Von Sens bis Strassburg*, Berlin, 1966, pp. 19-33.]

12 In the mosaic of the Baptistery of the Orthodox at Ravenna, a fifth-century work, St. John pours water from a dipper over Christ's head. This dipper would be a unique example, but as Strzygowski has demonstrated, it was added when the mosaic was restored—a restoration that greatly changed the character of this mosaic: J. Strzygowski, *Iconographie der Taufe Christi, ein Beitrag zur Entwicklungsgeschichte der christlichen Kunst*, Munich, 1885, p. 10 and pl. I,14. [On the formation and evolution of the iconography of the Baptism, see G. de Jerphanion, *La Voix des monuments*, Paris and Brussels, 1930, pp. 177-188.]

13 Sacramentary of St.-Étienne of Limoges, Paris, Bibl. Nat., ms. lat. 9438, fol. 24r. [See J. Porcher, *Le Sacramentaire de Saint-Étienne de Limoges*, Paris, 1953, pl. III.]

14 Lambach Ritual, Lambach, Stiftsbibl., Cod. 73, fol. 25r, reproduced in G. Swarzenski, *Die Salzburger Malerei von den ersten Anfängen bis zur Blütezeit des romanischen Stils*, I, Leipzig, 1908, pl. CXXV, fig. 424. The miniature represents the Baptism; the naked infant is dried after being taken out of the baptismal font.

15 Abbé J. Corblet, *Histoire dogmatique, liturgique et archéologique du sacrement de baptême*, I, Paris and Brussels, 1881, pp. 231-249. [On the evolution of the rite of baptism, see F. Cabrol and H. Leclercq, *Dictionnaire d'archéologie chrétienne et de liturgie*, see "Immersions," VII, 1, Paris, 1926, cols. 305-308.]

16 St. Bonaventure, *Commentaria in quatuor libros sententiarum*, dist. III, pars II, art. II,

17 St. Dunstan, *De regimine monachorum*, Migne, *P. L.*, 187, col. 493.

18 See the many examples assembled by C. Lange, *Die lateinischen Osterfeiern*, 1 (Jahresbericht über die Realschule erster Ordnung in Halberstadt), Halberstadt, 1881, pp. 7-35.

19 G. Millet, *Recherches sur l'iconographie de l'Évangile*, Paris, 1916, pp. 517-529. [Mâle, in Additions and Corrections to the 6th ed., 1953, p. 443]: *The Sarcophagus of the Resurrection.* It is strange that the earliest representation we know of the Holy Women at the Tomb, that of the third-century fresco discovered a few years ago at Dura-Europos, near the Euphrates, shows the tomb of Christ as a great sarcophagus. This is a detail that could scarcely have been perpetuated after the discovery of the Holy Sepulcher. From that time onward, we find either the tugurium of the Constantinian rotunda represented by the Syrian artists or the beautiful monument in several tiers represented by the Hellenistic artists. These are the two formulas which were transmitted to succeeding centuries, and no link can be established between the sarcophagus of Dura-Europos and the medieval sarcophagus, which was created by liturgical drama. [For the paintings at Dura-Europos, see C. H. Kraeling, *The Synagogue*, New Haven, 1956 (The Excavations at Dura-Europos . . . Final Report, VIII), and A. Grabar, *Le premier Art chrétien*, Paris, 1966, pp. 67-77. On the oldest representations of this theme and its evolution in early Christian art, see R. Louis, "La Visite des Saintes Femmes au tombeau dans le plus ancien art chrétien," *Mémoires de la Société Nationale des Antiquaires de France*, 9th ser., III (1954), pp. 109-122; on the evolution up to the Romanesque period, see also Cook, "The Earliest Painted Panels of Catalonia," pp. 332-363; J. Evans, *Cluniac Art of the Romanesque Period*, Cambridge, 1950, pp. 91-92.]

20 Gospel-book, Leningrad, Pub. Lib., cod. 21, fol. 8v, Millet, *op. cit.*, pp. 520-521, fig. 570. [On this miniature, see also C. R. Morey, "Notes on East Christian Miniatures," *Art Bulletin*, 11 (1929), pp. 84-87 and fig. 100.]

21 Ritual of Metz, Paris, Bibl. Nat., ms. lat. 990, fol. 52v: *discooperiant capsam argen-team quae est super altare* (they open the silver coffer which is upon the altar). This manuscript is a copy, made in the seventeenth century, of an older Ritual of Metz, written on parchment and of unknown date. The plural *discooperiant* is explained by the presence of two angels beside the altar instead of one. [On this manuscript, which is a notarized copy of the thirteenth century ms. 82 in the Library of Metz, see *Bibliothèque Nationale, Catalogue général des manuscrits latins*, ed. Ph. Lauer, 1, Paris, 1939, p. 353, no. 990.]

22 See the texts assembled by J. K. Bonnell, "The Easter Sepulchrum in its Relation to the Architecture of the High Altar," *Publications of the Modern Language Association of America*, 31 (1916), pp. 667-679. [On the theme of the Holy Sepulcher in art and literature, see K. Young, *The Drama of the Medieval Church*, Oxford, 1933, II, pp. 507-513.]

23 At St. Mary's in Woolnorth there was "a sepulcher chest that stood in the choir" (Bonnell, *op. cit.*, p. 685).

24 *Item angelus aperto sepulcro . . .* (an angel, having opened the tomb) (Prague, 13th cent.), or *Hic discooperiat sepulchrum . . .* (he opens the tomb) (Saint-Florian, 14th cent.); Bonnell, *op. cit.*, p. 675.

25 *. . . Et unus sedet ad caput et alius ad pedes . . .* (one sat at the head, the other at the feet) (Speyer, 15th cent.); Bonnell, *op. cit.*, p. 672.

26 The Easter plays collected by Lange, *Die lateinischen Osterfeiern*, 1, especially pp. 8-9, show that in certain churches the scene was played by two angels.

27 Chalais (Charente), west façade, tympanum of the south portal [reproduction in A. K. Porter, *Romanesque Sculpture of the Pilgrimage Roads*, Boston, 1923, VII, pl. 1089]; Chadenac (Charente-Maritime), capital [described and reproduced in H. Nodet, "Sur quelques Eglises romanes de la Charente-Inférieure," *Bulletin monumental*, 56 (1890), p. 372].

28 [The Poitiers stained-glass window is described in R. Crozet, "Le Vitrail de la Crucifixion à la cathédrale de Poitiers," *Gazette des beaux-arts*, 11 (1934), pp. 218-231, and R. Grinnell, "Iconography and Philosophy in the Crucifixion Window at Poitiers," *Art Bulletin*, 28 (1946), pp. 171-196.]

29 It should be noted that the angel on the

reliquary of Limoges, like the angel of Poitiers, holds a cross. [On this reliquary, which dates from the beginning of the thirteenth century, see M. M. Gauthier, *Emaux limousins champlevés des XIIe, XIIIe et XIVe siècles*, Paris, 1950, pp. 73 and 152-153 and pl. 11, and the exhibition catalogue, *Les Trésors des églises de France*, Paris, 1965, no. 112, and pl. 53.]

30 For example, a capital from St.-Pons (Hérault); a capital in the château of Castelnau-de-Bretenoux (Lot); in Spain, on the tympanum of the south crossing of the church of San Isidoro at León [illus. Porter, *Romanesque Sculpture*, VI, pl. 702]; on the tympanum of Chalais the angel has disappeared.

31 W. Meyer, "Wie ist die Auferstehung Christi dargestellt worden?" *Nachrichten von der königlichen Gesellschaft der Wissenschaften zu Göttingen, Philologische-historische Klasse aus dem Jahre 1903*, Göttingen, 1904, pp. 236-254. [On the theme of the Resurrection, see H. Schrade, *Die Auferstehung Christi*, Berlin and Leipzig, 1932; W. Braunfels, *Die Auferstehung*, Düsseldorf, 1951; H. Aurenhammer, "Auferstehung," *Lexikon der christlichen Ikonographie*, Vienna, 1959, I, pp. 232-249.]

32 Toulouse, Musée des Augustins, inv. no. 463; see E. Mâle, "Les Chapiteaux romans du musée de Toulouse et l'école toulousaine du XIIe siècle," *Revue archéologique*, 3rd ser., 20 (1892), pp. 182-183 and pl. XIX. [It should be noted that the theme of Christ stepping from the open sarcophagus is not a creation of Toulousian art. It appears in the second decade of the eleventh century in an Ottonian miniature; see Schrade, *Die Auferstehung Christi*, pp. 43-56; M. Lafargue, *Les Chapiteaux du cloître Notre-Dame de la Daurade*, Paris, 1939, p. 72; P. Mesplé, *Toulouse, Musée des Augustins, les sculptures romanes* (Inventaire des collections publiques françaises), Paris, 1961, no. 137.]

33 Bourges Cathedral, ambulatory, symbolic window of the Old and New Testament, upper large medallion [reproduced in E. Mâle, *L'Art religieux du XIIIe siècle en France*, 9th ed., Paris, 1958, p. 143, fig. 78].

34 Mark 16:1.

35 *Miscellanea Turonensia*, Tours, Bibl. de la Ville, ms. 927 (second half of the twelfth century). The manuscript was published by E. de Coussemaker, *Drames liturgiques du moyen âge*, Rennes, 1860, pp. 21-48 and 319-322, and by G. Milchsack, *Die Oster- und Passionsspiele*, I, *Die lateinischen Osterfeiern*, Wolfenbüttel, 1880, pp. 97-102. [The text is also published by Young, *The Drama of the Medieval Church*, I, pp. 438-447, who dates the play in the thirteenth century. On the contested date of this manuscript, see *Catalogue général des manuscrits des bibliothèques publiques de France (Départements)*, XXXVII, Paris, 1905, pp. 667-670.]

36 W. Creizenach, *Geschichte des neueren Dramas*, I, *Mittelalter und Frührenaissance*, Halle, 1893, pp. 90-91.

37 C. Martin, *L'Art roman en France, l'architecture et la décoration*, 2nd ser., Paris, 1910, pl. XLII. [See also Hamann, *Die Abteikirche von St.-Gilles*, pl. 95.]

38 Nearby is the relief representing the sepulcher surmounted by the cross already referred to. The ensemble translates the liturgical drama of Easter morning. [On the representations of the holy women buying spices at St.-Gilles, Beaucaire, and Arles, see Hamann, *op. cit.*, pp. 87-88, 187-190 and 197.]

39 The sarcophagus at Modena, with its decorative circles, is similar in every particular to that at Beaucaire, and is almost identical with that at St.-Gilles. [For a comparison between the capital at Modena and the frieze at Beaucaire, see R. Jullian, *L'Eveil de la sculpture italienne, la sculpture romane dans l'Italie du nord*, Paris, 1945, I, p. 189, and especially G. H. Crichton, *Romanesque Sculpture in Italy*, London, 1954, p. 56, who stresses the influence of liturgical drama, by way of Provence, on this capital.]

40 The presence of the guards near the tomb at St.-Gilles need not surprise us, for they had a role in the liturgical play of Tours. [On the role of the soldiers in the Play of Tours, see Young, *The Drama of the Medieval Church*, I, pp. 442-443.]

41 Coussemaker, *Drames liturgiques du moyen âge*, pp. 195-209. The earliest liturgical play of the Pilgrims to Emmaus that has been preserved is found in a manuscript from St.-Benoît-sur-Loire, now in Orléans (Bibl. mun., ms. 201). It dates from the end of the twelfth or beginning of the thirteenth century. There certainly had been earlier ones. [This manuscript was studied by Young, *op. cit.*, I, pp. 665-666, who dates it

in the thirteenth century. On the theme of the Pilgrims to Emmaus, see W. Stechow, "Emmaüs," *Reallexikon zur deutschen Kunstgeschichte*, v, Stuttgart, 1959, cols. 228-242. For the similarities between iconography and liturgical drama, see *ibid.*, cols. 232-233; Evans, *Cluniac Art of the Romanesque Period*, Cambridge, 1950, p. 93; O. Pächt, C. R. Dodwell and F. Wormald, *The St. Albans Psalter (Albani Psalter)*, London, 1960, pp. 73-77.]

42 . . . *pilleos in capitibus habentes et baculos in manibus ferentes* (with caps on their heads and bearing staffs in their hands), Coussemaker, *Drames liturgiques du moyen âge*, p. 204. [See also Young, *op. cit.*, I, p. 471.]

43 Dom E. Roulin, "Les Cloîtres de l'abbaye de Silos," *Revue de l'art chrétien*, 60 (1910), p. 1, fig. 31. [The date of the reliefs of the cloister at Silos is contested. According to some historians they date from the eleventh century. On this question, see G. Gaillard, "L'Eglise et le cloître de Silos, dates de la construction et de la décoration," *Bulletin monumental*, 91 (1932), pp. 39-80, with a reproduction of the relief of the Pilgrims to Emmaus on p. 44.]

44 . . . *peram cum longa palma gestans, bene ad modum Peregrini paratus, pilleum in capite habens* (carrying a scrip and with a long staff, well prepared in the manner of pilgrims, and wearing caps on their heads), says the Play of St.-Benoît-sur-Loire. [See Young, *The Drama of the Medieval Church*, I, p. 471. On the attributes of the Pilgrims to Emmaus, see A. Boeckler, *Die Bronzetüren des Bonanus von Pisa und des Barisanus von Trani*, Berlin, 1953, p. 25 n. 67.]

45 Hildesheim, treasury of the church of St. Godehard, *St. Albans Psalter*, fol. 35r, A. Goldschmidt, *Der Albanipsalter in Hildesheim und seine Beziehung zur symbolischen Kirchenskulptur des XII. Jahrhunderts*, Berlin, 1895, p. 144 and pl. vi. The Psalter was made during the abbacy of Gaufridus (1119-1146), *ibid.*, p. 30. [Also see Pächt, Dodwell and Wormald, *The St. Albans Psalter*, pp. 73-77, illus., p. 69.]

46 Or at least one of the two; the attribute of the other has been mutilated. [This representation is on the lower register of the tympanum of the north portal of the narthex; see F. Salet and J. Adhémar, *La Made-*

leine de Vézelay, Melun, 1948, pp. 180-181 and pl. 23.]

47 *Portantes baculos et peras . . . et sint barbati* (carrying pilgrim staffs and scrips . . . and are bearded) (Rouen, Bibl. de la Ville, ms. 384, fols. 84v-85r). A. Gasté, *Les Drames liturgiques de la cathédrale de Rouen*, Evreux, 1893, p. 65. The manuscript is from the fourteenth century but the text is certainly much earlier. [See Young, *op. cit.*, I, p. 693, who notes (p. 461) that in the thirteenth-century manuscript (Rouen, Bibl. de la Ville, ms. 222, fols. 43v-45r) of this play, it is not specified that the disciples be bearded.]

48 [It is not certain that this capital (Musée des Augustins, inv. no. 465) was influenced by liturgical drama. The idea of giving Christ the attributes of a pilgrim could come from a miniature in the Bible of Avila, Madrid, Bibl. Nac., ms. E.V. 8; see Lafargue, *Les Chapiteaux du cloître de Notre-Dame-de-la-Daurade*, pp. 59-60.]

49 A mosaic at Monreale, in Sicily, in which Christ carries the staff and scrip in the Emmaus episode, does not invalidate our findings. The Monreale mosaics, which date from the second half of the twelfth century, are not purely Byzantine works; in them we sense local collaboration. The way in which the scene of the Pilgrims to Emmaus is conceived is enough to prove that Latins had worked on this great composition. It is likely that the liturgical dramas which were performed in the churches of France were also performed in Sicilian churches under the Norman kings. [This mosaic is on the north wall of the transept (illus., O. Demus, *The Mosaics of Norman Sicily*, London, 1949, pl. 73a). It must be noted that Demus considers the mosaics of Monreale almost exclusively the work of Byzantine artists: *ibid.*, p. 148.]

50 Gaston Paris said, "It could be demonstrated that all medieval Christian liturgical drama is of French origin": "Chronique," *Romania*, 19 (1890), p. 370.

51 See H. Anz, *Die lateinischen Magierspiele, Untersuchungen und Texte zur Vorgeschichte des deutschen Weihnachtsspiels*, Leipzig, 1905. He classified (pp. 12-111) the plays devoted to the magi in the order of their growing complexity. His conclusion (p. 126) is that the Play of the Magi is of

French origin. [On the date of the Limoges Magi Play, see Young, *op. cit.*, I, p. 34 n. 2.]

52 *Office des Mages* of Limoges, published by E. du Méril, *Origines latines du théâtre moderne*, Paris, 1849, p. 155. [See also Young, *op. cit.*, II, pp. 34-35.]

53 U. Chevalier, *Ordinaires de l'église cathédrale de Laon (XIIe-XIIIe siècles) suivis de deux mystères liturgiques, publiés d'après les manuscrits originaux* (Bibliothèque liturgique, VI), Paris, 1897, p. 392. [The text of the *Officium Stellae* of the Laon manuscript (Laon, Bibl. mun., ms. 263, fols. 149r-151r) is reproduced in Young, *op. cit.*, II, pp. 103-106.]

54 On this subject, see H. Kehrer, *Die heiligen drei Könige in Literatur und Kunst*, I, Leipzig, 1908, p. 63. [The theme of the Three Magi has been the subject of numerous studies. See, e.g., G. Vezin, *L'Adoration et le cycle des Mages dans l'art chrétien primitif, étude des influences orientales et grecques sur l'art chrétien*, Paris, 1950; W. W. S. Cook, "The Earliest Painted Panels of Catalonia," *Art Bulletin*, 10 (1927-1928), pp. 309-322; S. Waetzoldt, "Dreikönige," *Reallexikon zur deutschen Kunstgeschichte*, IV, Stuttgart, 1958, cols. 476-502; H. Aurenhammer, "Anbetung der Könige," *Lexikon der christlichen Ikonographie*, I, Vienna, 1959, pp. 117-127; E. Kirschbaum, "Der Prophet Balaam und die Anbetung der Weisen," *Römische Quartalschrift für christliche Altertumskunde und Kirchengeschichte*, 49 (1954).]

55 Méril, *Origines latines du théâtre moderne*, p. 153. [See also Young, *op. cit.*, II, p. 35.]

56 Anz, *Die lateinischen Magierspiele*, p. 145.

57 Méril, *op. cit.*, p. 168. [See also Young, *op. cit.*, II, p. 88.]

58 It could be claimed that the attitude is of Eastern origin, since it is found on one of the Monza ampullae. [A. Grabar, *Ampoules de Terre-Sainte (Monza-Bobbio)*, Paris, 1958, p. 53 and pl. II.] But I think that this would be wrong. The liturgical plays indicate expressly that the first of the magi kneels, while another raises his hand to point to the star. Since these two attitudes are always found together in works of art, we are justified in inferring the influence of liturgical drama. [This view is adopted by Evans, *Cluniac Art*, p. 95 and, with some

reservation, by the following: Waetzoldt, "Dreikönige," col. 487; Aurenhammer, "Anbetung der Könige," p. 21. It has been questioned in Vezin, *L'Adoration et le cycle des Mages dans l'art chrétien primitif*, pp. 60-62.]

59 Or perhaps the day of the Circumcision (1 January); see M. Chasles, "Le Drame liturgique," *La Vie et les arts liturgiques*, 3 (1916-1917), p. 126 n. 3.

60 The Benedictines, in their great edition of St. Augustine (Antwerp, 1700-1703), placed this sermon among the apocryphal works. [On this sermon, see Young, *op. cit.*, II, p. 125; Young, "Ordo prophetarum," *Transactions of the Wisconsin Academy of Sciences, Arts and Letters*, 20 (1922), pp. 1-82.]

61 For the text of this sermon, see M. Sepet, *Les Prophètes du Christ, étude sur les origines du théâtre au moyen âge*, Paris, 1878, pp. 2-8. [This text is also published in Young, *The Drama of the Medieval Church*, II, pp. 126-131.]

62 Paris, Bibl. Nat., ms. lat. 1139. Text and music published by Coussemaker, *Drames liturgiques du moyen âge*, pp. 11-20. [For the text of the Limoges Play, and commentary, see Young, *op. cit.*, II, pp. 138-145.]

63 A new personage was introduced at Limoges: Israel. [See Young, *op. cit.*, II, p. 143.]

64 Published by Chevalier, *Ordinaires de l'église cathédrale de Laon*, p. 389. [For the text of the Laon *Ordo prophetarum* (Laon, Bibl. mun., ms. 263 dated in the thirteenth century), see Young, *op. cit.*, II, pp. 145-152.]

65 Published by Gasté, *Les Drames liturgiques de la cathédrale de Rouen*, pp. 4-20. [For the text of the Rouen *Ordo prophetarum*, see Young, *op. cit.*, II, pp. 154-165. The missing text is reconstructed from two manuscripts of the fourteenth and fifteenth centuries (Rouen, Bibl. de la Ville, ms. 384, fols. 33r-35r and ms. 382, fols. 31v-33r). For the exegesis of the text, see Young, *op. cit.*, II, pp. 165-170.]

66 [For the Play of Adam, see P. Studer, *Le Mystère d'Adam, an Anglo-Norman Drama of the Twelfth Century*, 3rd ed., Manchester, 1949.]

67 By a rather odd error, the beginning of Jeremiah's prophecy, *Et non aestima[bitur]*, was inscribed on the banderole of Moses

at the end of his prophecy. These inscriptions are given by J. Durand, "Monuments figurés du moyen âge éxécutés d'après les textes liturgiques," *Bulletin monumental*, 54 (1888), pp. 528-530. He was the first to associate these inscriptions with the text of the Pseudo-Augustine.

68 It is interesting to note that Jesse is carved on the façade of Poitiers not far from the prophets. The flowering rod, spoken of by Isaiah, rises above his head. We shall come back to Jesse and the Play of the Prophets in the following chapter. [A. Watson, *The Early Iconography of the Tree of Jesse*, London, 1934, p. 88, questions this derivation of the Poitiers sculptures; cf. Y. Labande-Mailfert, *Poitou roman* (ed. Zodiaque), La Pierre-qui-Vire, 1957, p. 66.]

69 However, at Cremona and Ferrara, Ezekiel's words are not in the sermon of the Pseudo-Augustine, but his speech is very similar to that in the Rouen Play.

70 In fact, many inscriptions correspond to the lines of the liturgical drama of Rouen and the Play of Adam. [Cf. the opinion of Crichton in *Romanesque Sculpture in Italy*, pp. 18 and 23.]

71 U. Plancher, *Histoire générale et particulière de Bourgogne, avec des notes, des dissertations et des preuves justificatives*, Dijon, 1739-1781, I, p. 503. [On the jamb statues of St.-Bénigne of Dijon, see P. Quarré, "La Sculpture des anciens portails de Saint-Bénigne de Dijon," *Gazette des beaux-arts*, 50 (1957), p. 190.]

72 London, Brit. Mus., ms. Lansdowne 383, fol. 15r. This manuscript is a Psalter from the abbey of Shaftesbury. St. Thomas of Canterbury does not figure in it, since he was canonized in 1173, but Edward the Confessor, canonized in 1161, does. [See M. A. Farley and F. Wormald, "Three Related English Romanesque Manuscripts," *Art Bulletin*, 22 (1940), pp. 157-161.]

73 Exodus 34:30-35.

74 Gasté, *Les Drames liturgiques de la cathédrale de Rouen*, p. 6 [cf. Young, *op. cit.*, II, p. 156].

75 Abraham is placed beside Moses only in the Anglo-Norman Play of Adam. [See Studer, *Le Mystère d'Adam, an Anglo-Norman Drama of the Twelfth Century*, pp. 37-38.]

76 [The theme of the horned Moses is older than liturgical drama. A horned Moses appeared as early as the Vulgate (Exodus 34:29—"Moses came down, after this, from Mount Sinai, bearing with him the two tablets on which the law was written; and his face, although he did not know it, was all radiant—here the Vulgate reads "cornuta" or "horned"—after the meeting at which he had held speech with God.") and in patristic texts. In the eleventh century the theme appears in miniature painting. See Watson, *The Early Iconography of the Tree of Jesse*, p. 26.]

77 Exodus 33:11.

78 *Tunc veniet Aaron episcopali ornatu* (Then Aaron arrives in bishop's dress): Play of Adam published by L. Palustre, Paris, 1877, p. 114. [See also Studer, *Le Mystère d'Adam, an Anglo-Norman Drama of the Twelfth Century*, p. 38.] *Aaron ornatus pontificalibus indumentis et mitra* (Aaron dressed in miter and pontifical garb): Play of Rouen, Gasté, *Les Drames liturgique de la cathédrale de Rouen*, p. 7. [Cf. Young, *op. cit.*, II, p. 157.]

79 [For Aaron in episcopal attire prior to the twelfth century, see Watson, *The Early Iconography of the Tree of Jesse*, p. 28; K. Möller, "Aaron," *Reallexikon zur deutschen Kunstgeschichte*, I, Stuttgart, 1937, cols. 6-7; H. Aurenhammer, "Aaron," *Lexikon der christlichen Ikonographie*, I, Vienna, 1959, p. 2.]

80 Paris, Bibl. Nat., ms. lat. 11564, fol. 2v: Commentary of Raoul de St.-Germer en Flaix on Leviticus.

81 The portal of Nesle-la-Reposte, now destroyed, was reproduced by B. de Montfaucon, *Les Monumens de la monarchie françoise*, Paris, 1729-1733, I, p. 192, pl. xv. [See also A. Lapeyre, *Des Façades occidentales de Saint-Denis et de Chartres aux portails de Laon*, Paris, 1960, pp. 118-121 and fig. 75.]

82 Coussemaker, *Drames liturgiques du moyen âge*, pp. 1-10. [For the text, see Young, *op. cit.*, II, pp. 362-369; cf. Evans, *Cluniac Art*, p. 97.]

83 They represent two wise virgins. One is in the Bargello museum in Florence, the other is in the Vienna museum, in Austria. See J. J. Marquet de Vasselot, "Les émaux limousins à fond vermiculé," *Revue archéologique*, 4th ser., 6 (1905), p. 420 and pl. xvii. [On the theme of the Wise and

Foolish Virgins, see W. Lehmann, *Die Parabel von den klugen und törichten Jungfrauen*, Berlin, 1916.]

84 Rossano Cathedral, *Rossano Gospels*, fol. 2v. [See O. von Gebhardt and A. Harnack, *Evangeliorum codex graecus purpureus rossanensis*, Leipzig, 1880, pl. VII; A. Grabar, *La Peinture byzantine*, Geneva, 1953, p. 163.] Milan, Bibl. Ambr., ms. Ambr. E 24, Homilies of St. Gregory of Nazianzus, fol. 778r. [Description in W. Lehmann, *op. cit.*, pp. 12-13.] Paris, Bibl. Nat., ms. gr. 74, Gospel-book. [Cf. Omont, *Évangiles avec peintures byzantines du XIe siècle*, I, pl. 39.]

85 Chadenac, Corme-Royal, Aulnay, Pont-l'Abbé, Pérignac (Charente-Maritime), Argenton-Château (Deux-Sèvres). On the influence of theater on sculpture in the west of France, see W. Cloetta, "Le Mystère de l'épouse," *Romania*, 22 (1893), pp. 177-227; G. Paris, *La Littérature française au moyen âge, XIe-XIVe siècle*, Paris, 1890, p. 237; Lehmann, *op. cit.*, p. 60; R. Crozet, *L'Art roman en Poitou*, Paris, 1948, p. 191; on the spread of the theme to the Ile-de-France, see Lehmann, *op. cit.*, pp. 60ff.]

CHAPTER V

1 [On Suger's life and work, see E. Panofsky, *Abbot Suger, On the Abbey Church of St.-Denis and its Art Treasures*, Princeton, 1946; cf. esp. O. Cartellieri, *Abt Suger von Saint-Denis*, Berlin, 1898; M. Aubert, *Suger* (Figures monastiques), Saint-Wandrille, 1950.]

2 Suger, *Liber de rebus in administratione sua gestis*; cf. *Oeuvres complètes de Suger*, ed. A. Lecoy de La Marche (Société de l'Histoire de France, 101), Paris, 1867, pp. 155-209. [Cf. E. Panofsky, "Postlogium Sugerianum," *Art Bulletin*, 29 (1947), pp. 119-121.]

3 [Tr. Panofsky, *Abbot Suger*, pp. 48-49 from *De rebus in administratione sua gestis*, XXVII.]

4 Suger's description [*De rebus in administratione sua gestis*, XXXII: *De Crucifixo aureo*; cf. Lecoy de La Marche, *Oeuvres complètes*, pp. 194-196] must be filled out by the details given by Dom Doublet in his *Histoire de la royale abbaye de Saint-Denis*, Paris, 1625, pp. 251ff., and by the *Inventaire du*

trésor de Saint-Denis, a manuscript dating from the early seventeenth century, in the Archives Nationales of Paris (LL, no. 1327). J. Labarte, in his *Histoire des arts industriels*, II, Paris, 1864, pp. 253ff., esp. pp. 255-256, has made very good use of all the information that can be gleaned from these three sources. [On Suger's cross, cf. P. Verdier, "La grande Croix de l'abbé Suger à Saint-Denis," *Cahiers de civilisation médiévale*, 13 (1970), pp. 1-31, bibl.]

5 The editor of the *Inventaire du trésor de Saint-Denis*, not knowing what these four figures represented, called them prophets. [Cf. Verdier, *op. cit.*, pp. 17-18.]

6 Dom Doublet, *Histoire de la royale abbaye de Saint-Denis*, p. 253.

7 [See Panofsky, *Abbot Suger*, p. 177, on the reading of *abyssus*, which should be translated as "the deep"; thus, only two elements are actually present.]

8 O. von Falke and H. Frauberger, *Deutsche Schmelzarbeiten des Mittelalters*, Frankfurt-am-Main, 1904. [See also H. Swarzenski, *Monuments of Romanesque Art*, London and Chicago, 1954, pp. 29ff. and figs. 359-361, 364-366; S. Collon-Gevaert, in *Art roman dans la vallée de la Meuse aux XIe et XIIe siècles*, Brussels, 1962, pl. 30, p. 204.]

9 Falke and Frauberger, *op. cit.*, p. 78.

10 [On the brazen serpent and the *Tau* sign, see Grodecki, "Les Vitraux allégoriques de Saint-Denis," *Art de France*, 1 (1961), pp. 37-38, 41.]

11 [Reliquary triptych now in the Pierpont Morgan Library, New York, attributed to Godefroid de Claire, Stavelot, c. 1160. Cf. Swarzenski, *op. cit.*, p. 68 and figs. 364-365, and Collon-Gevaert, *op. cit.*, pl. 27, p. 198.]

12 B. de Montfaucon, *Les Monumens de la monarchie françoise*, I, Paris, 1729, pl. L.

13 A further argument may be added. The shrine of St. Heribert in Deutz, a work of Godefroid de Claire, has a peculiarity which is a mark of its origin. One of the prophets has crossed legs; he seems about to dance (Falke and Frauberger, *op. cit.*, pl. 84). [See Collon-Gevaert, *Art roman*, pl. 29, p. 202.] This unusual attitude is also to be seen in some of the statues of the portal at St.-Denis which we know from the drawings of Montfaucon. [A. Katzenellenbogen, *The Sculptural Programs of Chartres Cathedral*, Baltimore, 1959, p. 120 n. 5, and figs.

34, 35 and esp. 36, after pls. XVI-XVIII of Montfaucon, I.]

14 See J. Helbig, *L'Art mosan depuis l'intro-duction du christianisme jusqu'à la fin du XVIIIe siècle*, I, Brussels, 1906, pp. 38-39. [This relationship between Godefroid de Claire and a "school of St.-Denis" was questioned by M. Laurent, "Godefroid de Claire et la croix de Suger à l'abbaye de Saint-Denis," *Revue archéologique*, 19 (1924), pp. 79-87 and 84ff.]

15 Suger's cross was consecrated by Pope Eugene III in 1147, when he came to St.-Denis, but it could have been finished several years before. It is probable that it was begun at the same time as the choir, toward 1140. [Cf. Panofsky, *Abbot Suger*, pp. 58-60, and Verdier, *op. cit.*, pp. 9-10.]

16 Along with several archeologists, I once believed that the scenes from the Old and New Testaments painted at Ingelheim in the palace of Louis the Pious and described by Ermoldus Nigellus were paired, one representing the reality and the other the symbol. A closer study of Ermoldus Nigellus' poem has convinced me that these correspondences did not exist. The scenes were narrative in intention and nothing more. [For the Nigellus text, see J. von Schlosser, *Schriftquellen zur Geschichte der karolingischen Kunst* (Quellenschriften für Kunstgeschichte und Kunsttechnik des Mittelalters und der Neuzeit, Neue Folge, IV), Vienna, 1892, pp. 321-323, no. 925. For interpretations of the text, see P. Clemen, *Die romanische Monumentalmalerei in den Rheinländern*, Düsseldorf, 1905, pp. 746-747, and K. Künstle, *Ikonographie der christlichen Kunst*, Freiburg-im-Breisgau, 1926-1928, I, pp. 55-56.]

17 And not St. John the Baptist, as is usually said (Paris, Bibl. Nat., ms. lat. 9428, fol. 15v.: W. Koehler, *Die karolingischen Miniaturen*, Berlin, 1960, III, pl. 79a). [On the subject of medieval typology, cf. W. Molsdorf, *Christliche Symbolik der mittelalterlichen Kunst*, 2nd ed., Leipzig, 1926; A. Weis, "Ekklesia und Synagoge," *Reallexikon zur deutschen Kunstgeschichte*, IV, Stuttgart, 1958, cols. 1189-1215; O. Gillen, "Bund," *ibid.*, III, Stuttgart, 1954, cols. 90-112.]

18 Published by Schlosser, *Quellenbuch*, N.F., VII (1896), pp. 34-37.

19 The Venerable Bede, *Vita quinque sanctorum abbatum*, in Migne, *P. L.*, 94, col. 720c.

20 There were seventeen enamels on each face; they were grouped two by two, but one stood alone (cf. above, n. 4).

21 [Panofsky, *Abbot Suger*, pp. 74-75.]

22 [On the symbolism of St.-Denis, the question of its diffusion, see L. Grodecki, "Les Vitraux de Saint-Denis," *De Artibus Opuscula XL, Essays in Honor of Erwin Panofsky*, New York, 1961, pp. 170-186, esp. pp. 182ff. and *idem*, "Les Vitraux allégoriques," pp. 19-41.]

23 Enamel crosses of the Victoria and Albert Museum and of the British Museum; the St.-Bertin pedestal of a cross. [For the Victoria and Albert Museum cross, see Falke and Frauberger, *Deutsche Schmelzarbeiten*, pl. 75, and cf. figs. 140, 134 above.]

24 Cross of the Victoria and Albert Museum; the St.-Bertin pedestal of a cross; cross in the British Museum.

25 Cross in the Victoria and Albert Museum; cross in the British Museum; the St.-Bertin pedestal of a cross; portable altar of Augsburg. [Falke and Frauberger, *op. cit.*, pls. 76-77.]

26 Cross of the Victoria and Albert Museum; St.-Bertin pedestal of a cross. [The two spies are found only on the British Museum cross and the St.-Bertin pedestal of a cross (see figs. 140 and 134). For the typological relationship to the crucifixion, see J. de Borchgrave d'Altena, "Crucifixions mosanes," *Revue belge d'archéologie et d'histoire de l'art*, 3 (1933), pp. 62-67, and K. H. Usener, "Kreuzigungsdarstellungen in der mosanen Miniaturmalerei und Goldschmiedekunst," *ibid.*, 4 (1934), pp. 201-210.]

27 Portable altar from Stavelot. [Cf. Collon-Gevaert, in *Art roman*, pls. 31-32, pp. 206-208.]

28 Portable altar from Stavelot.

29 For the explanation of these symbols, too long to be included here, see *L'Art religieux du XIIIe siècle en France*, 9th ed., Paris, 1958, pp. 142ff. These symbolic correspondences are listed by Molsdorf, *Christliche Symbolik, passim*.

30 *Botrum vecte ferunt qui Christum cum cruce querunt* (They who seek Christ with the Cross bear the cluster of grapes upon a staff). [See Panofsky, *Abbot Suger*, pp. 62-63, 180-182.]

31 I have attempted to prove this in A. Michel,

Histoire de l'art, I, pt. 2, Paris, 1905, pp. 784ff. [Cf. L. Grodecki, in M. Aubert and others, *Le Vitrail français*, Paris, 1958, pp. 105-107.]

32 B. de Montfaucon, *Monumens de la monarchie françoise*, I, pls. xxiv, xxv. [Cf. Mâle, *L'Art religieux du XIIIe siècle*, p. 352, fig. 163 and p. 353, fig. 164; Y. Delaporte, *Les Vitraux de la cathédrale de Chartres*, Chartres, 1926, pp. 313-319, and pls. I, cvi-cx.]

33 [On this controversial view, no longer current, cf. Laurent, "Godefroid de Claire," pp. 79-87, who follows W. R. Lethaby, "The Part of Suger in the Creation of the Medieval Iconography," *Burlington Magazine*, 1914, pp. 206, 211; Grodecki, "Les Vitraux de Saint-Denis," p. 185 n. 96.]

34 It is almost never found except on a few German portable altars of the beginning of the twelfth century which perpetuated the Carolingian tradition of the Drogo Sacramentary. They illustrate the canon of the Mass. There we see the Sacrifice of Abraham, the Offerings of Abel and Melchisedek, and sometimes the high priest Aaron, and Moses. As examples, I can cite the portable altars of Munich and of the Martin Le Roy collection, which Falke and Frauberger attribute to the Cologne goldsmith Eilbertus, and date about 1130 (*Deutsche Schmelzarbeiten*, pls. 23-24).

35 The Peterborough Psalter, a beautiful English manuscript illuminated toward the middle of the thirteenth century, reproduces, in a later style, the paintings in the church. This has been established by M. R. James in volume IX of the *Cambridge Antiquarian Society's Communications*, pp. 178-194. [For the Peterborough Psalter, c. 1300, now in Brussels (Bibl. Roy. ms. 9961-62), see C. Gaspar and F. Lyna, *Les principaux Manuscrits à peintures de la Bibliothèque Royale de Belgique* (Société Française de Reproduction des Manuscrits à Peintures), pt. I, Paris, 1937, pp. 114-121. The subjects of the miniatures mentioned by Mâle are to be found on fols. 48r, 46v, 73v of the manuscript.] The inscriptions accompanying the miniatures are the same as those that accompanied the frescoes. They are found again in a symbolic window at Canterbury. [See B. Rackham, *The Ancient Glass of Canterbury Cathedral*, London, 1949, pp. 73-80.]

36 See J. Van den Gheyn, *Le Psautier de Peter-borough* (Le Musée des enluminures), Haarlem, 1905, pp. 11ff., with reproduction of all the miniatures.

37 Reproduced in A. N. Didron, ed., *Annales archéologiques*, 8 (1848), p. 1. The altar has been linked by Falke and Frauberger with the group of works by the goldsmith Fridericus (*op. cit.*, p. 29).

38 See the reproductions given by K. Drexler and T. Strommer, *Der Verduner Altar. Ein Emailwerk des XII. Jahrhunderts im Stifte Klosterneuburg bei Wien*, Vienna, 1903. [The altar is fully illustrated in F. Röhrig, *Der Verduner Altar*, Klosterneuburg, 1955.]

39 Ancient frescoes of St.-Emmeran of Regensburg, painted probably between 1177 and 1201 (cf. J. A. Endres, "Romanische Deckenmalereien und ihre Tituli zu St Emmeran in Regensburg," *Zeitschrift für christliche Kunst*, 15 (1902), cols. 206-210, and esp. cols. 235-240, 275-282, 297-306); the choir of the church of St.-Emmeran was dedicated to St. Denis [cf. E. W. Anthony, *Romanesque Frescoes*, Princeton, 1951, pp. 131ff., and O. Demus, *Romanesque Mural Painting*, New York, 1970, pp. 36, 37, 134, 136, 610-612, with ills.]; frescoes of Gröningen (Saxony) (O. Doering, "Die romanischen wandmalereien in der Kirche von Kloster Gröningen," *Zeitschrift für christliche Kunst*, 25 (1912), cols. 298, 306, fig. 3); Missal of Hildesheim (second half of the twelfth century), in which several symbolic events of the Old Testament were grouped around a single event of the life of Christ (cf. S. Beissel, "Ein Missale aus Hildesheim und die Anfänge der Armenbibel," *Zeitschrift für christliche Kunst*, 15 (1902), cols. 266-274, 307-318). [Cf. also A. Boeckler, *Die Regensburg-Prüfeninger Buchmalerei des XII. und XIII. Jahrhunderts* (Miniaturen aus Handschriften der bayerischen Staatsbibliothek in München, VIII), Munich, 1924, e.g., figs. 19, 30, and pp. 20-28, 33-46.]

40 The window now shows only a part of the inscription, and the letters are jumbled. [See Panofsky, *Abbot Suger*, pp. 74-75, and cf. Grodecki, "Les Vitraux allégoriques," pp. 32-35.]

41 *De Civitate Dei*, Lib. xvi, cap. xxvi, in Migne, *P. L.*, 41, col. 505. [Cf. Loeb Classical Library, Saint Augustine, *The City of God*, London and Cambridge (Mass.), 1965, v, pp. 128-129.]

42 Christ between the Church and the Syna-

gogue is in the upper archivolt. [See A. Lapeyre, *Des façades occidentales de Saint-Denis et de Chartres aux portails de Laon*, Paris, 1958, pp. 33, 37-38.]

43 [*Ibid.*, p. 32, fig. 9; p. 33 n. 5; p. 36 n. 9.]

44 [See Panofsky, *Abbot Suger*, pp. 74-75:

By working the mill, thou, Paul, takest
the flour out of the bran.

Thou makest known the inmost meaning
of the Law of Moses.

From so many grains is made the true
bread without bran,

Our and the angels' perpetual food.

Cf. Grodecki, "Les Vitraux allégoriques," pp. 22-23.]

45 The date of the Vézelay capitals is not known. We know only that the nave of the church burned in 1120 and that it must have been rebuilt. We do not know how long this work took. The capitals, however, were oftentimes carved long after the monuments were finished. The symbolic capital of the mill, in which Suger's thought appears so distinctly, cannot be earlier than 1145. [Cf. F. Salet and J. Adhémar, *La Madeleine de Vézelay*, Melun, 1948, p. 114 n. 1, who date this capital c. 1130-1135 and question whether it represents St. Paul and the mystic mill; cf. also Grodecki, "Les Vitraux allégoriques," p. 24 n. 53.]

46 [What Moses veils the doctrine of Christ unveils: Panofsky, *Abbot Suger*, pp. 74-75.]

47 [See Panofsky, *op. cit.*, pp. 72-73; A. Watson, *The Early Iconography of the Tree of Jesse*, London, 1934, pp. 81, 113.]

48 This extremely skillful restoration, so skillful that the old parts cannot be distinguished, was done by Henri Gérente (1848). Baron de Guilhermy, who studied St.-Denis with scrupulous care during the extensive work done in 1839-1848, says that four figures of the Tree of Jesse were old, as well as the Christ with the Seven Doves (Bibl. Nat., nouv. acq. franç. 6121, fol. 94r). Lenoir, who had the window transferred to the Musée des Monuments Français, has left a drawing of it but it is incomplete, for he reproduced only the superposed kings of Judah. A fragment of the Tree of Jesse can still be seen at St.-Denis in another window not far from the window restored by Gérente; these are parts of the Suger window which Gérente did not use. [The displaced portions of the window have since been properly restored.

See L. Grodecki, "Fragments de vitraux provenant de Saint-Denis," *Bulletin monumental*, 110 (1952), pp. 51-62.]

49 We have only to compare the kings of Judah of St.-Denis, sketched by Lenoir before any restoration was done, with the kings of Judah in the Chartres window. By this, we can affirm that the two windows were absolutely alike, and that at St.-Denis, Gérente was right to restore Jesse asleep and the prophets at each side corresponding to the kings of Judah. [See Grodecki, "Les Vitraux de Saint-Denis," p. 182 nn. 83-84, p. 186.]

50 [This refers to the monumental form in the St.-Denis window. For earlier examples in manuscript illustration and on the origins of the Tree of Jesse, cf. Watson, *op. cit.*, passim.]

51 *Candelabrum etiam magnum in choro aereum, quod Jesse vocatur, in partibus emit transmarinis.* W. Thorn, *Chronique*, in R. Twysden, *Historiae anglicanae scriptores decem*, London, 1652, II, col. 1796. [The passage cited is taken from the period of William II (1098). See Watson, *op. cit.*, pp. 70-76.]

52 One of these first attempts exists in the Gospel-book of Prague called the "Coronation Gospels of King Bratislav," which is usually attributed to the late eleventh century (published by F. J. Lehner, *Česka skola malarska XI. věku* (*Die böhmische Malerschule des XI. Jahrhunderts*), Prague, 1902, pl. VIII, pp. 35-36) [and Watson, *op. cit.*, pl. I]. There we see Jesse seated alongside Isaiah who carries a banderole; Jesse's attribute is a bush on which seven doves have lighted. This rudimentary form of the Tree of Jesse was also used at the height of the twelfth century on the façade of Notre-Dame-la-Grande at Poitiers (see fig. 129), in the fresco at Le Liget (Indre-et-Loire) [Wilson, *op. cit.*, pl. XII], and in a Gospel-book of Salzburg (Cod. lat. S. n. 2700, Nat. Bibl. Vienna). [This is an Antiphonary made c. 1160 for the Abbey Church of St. Peter where it was catalogued as Cod. a. xii, 7; cf. Watson, *op. cit.*, pp. 92-93, pl. VIII.] A miniature in the manuscript of St. Jerome's Commentary on Isaiah (Dijon, Bibl. mun., ms. 129), shows only the Virgin with the Child and the sleeping Jesse. [C. Oursel, *La Miniature du XIIème siècle à l'abbaye de Cîteaux d'après les manuscrits de la Biblio-*

théque de Dijon, Dijon, 1926, pl. XLIX; and *Manuscrits à peintures*, Bibl. Nat., 1954, cat. no. 285.]

53 Paris, Bibl. Nat., ms. lat. 1139. [Cf. A. Gasté, *Les Drames liturgiques de la cathédrale de Rouen*, Paris and Caen, 1888, p. 106 n. 2, and J. Chailley, "Le Drame liturgique médiéval à Saint-Martial de Limoges," *Revue d'histoire du théâtre*, 1955, esp. p. 139 n. 35: the Play of the Prophets is a development of the *Versus Sybille*.]

54 See the Play of the Prophets of Rouen in Gasté, *Les Drames liturgiques*, pp. 104-121, esp. pp. 109ff.

55 Moses and Balaam are included in the liturgical play of Rouen [*ibid.*, p. 105 and p. 109 n. 2] and in the Play of the Prophets which is inserted in *Le Mystère d'Adam*. See *Adam, mystère du XIIème siècle*, published by L. Palustre, Paris, 1877, pp. 112-114, 119-121. [See *Le Mystere d'Adam and Anglo-Norman Drama of the Twelfth Century*, ed. P. Studer, Manchester University, 1918, and cf. tr. by E. N. Stone, *Adam, A Religious Play of the Twelfth Century*, University of Washington Publications in Language and Literature, 4 (1926), pp. 159-202, with bibl.]

56 In the Limoges play, the necessities of rhyme and rhythm obliged the poet to change somewhat the verse attributed to Moses. It reads: *Dabit Deus vobis vatem* (Gasté, *op. cit.*, p. 106 n. 1), but in the Play of the Prophets inserted in *Le Mystère d'Adam*, we read: *Prophetam suscitabit Deus* (Palustre, *op. cit.*, p. 112).

57 Edward the Confessor, canonized in 1161, figures among the saints invoked in the Psalter; but St. Thomas of Canterbury, who was canonized in 1173, is not named. See G. F. Warner, *Illuminated Manuscripts in the British Museum*, London, 1903, pl. XIII. [It is known as the Shaftesbury Psalter (Lansdowne ms. 383, fol. 15). Cf. E. G. Millar, *English Illuminated Manuscripts from the Xth to the XIIIth Century*, Paris and Brussels, 1926, pl. 32a, p. 28, and M. J. Rickert, *Painting in Britain, The Middle Ages*, Baltimore, 1954, pp. 83-84.]

58 Let me add that Moses is represented with horns. I have explained in the preceding chapter that this attribute was taken from liturgical drama (p. 150).

59 Wolfenbüttel, Cod. Helmst. 568 (521), fol.

6v; A. Haseloff, *Eine thüringisch-sächsische Malerschule des XIII. Jahrhunderts*, Strasburg, 1897, pl. 33, fig. 72, and pp. 87-89. [Cf. Watson, *op. cit.*, pp. 20-22.]

60 In the Wolfenbüttel miniature, Balaam is mounted on an ass, as in the Rouen play and in the *Mystère d'Adam*. [See Gasté, *op. cit.*, p. 116 n. 37.]

61 In the Rouen play, the sibyl is thus described: *Sibylla coronata et muliebri habitu induta*. [Cf. Gasté, *op. cit.*, p. 120.]

62 Léopold Delisle mistook the high priest Aaron for St. Joseph, because he holds a flowering staff in his hand (L. Delisle, *Notice sur douze livres royaux*, Paris, 1902). Aaron carrying the flowering staff appears along with the sibyl in the Rouen play. [Cf. Watson, *op. cit.*, pl. XX, and pp. 169-170, for a late twelfth-century Tree of Jesse in Douai (Bibl. mun., ms. 340, fol. 11r) which also includes a sibyl; see also M. L. Thérel, "Une Image de la sibylle sur l'arc triomphal de Sainte-Marie Majeure à Rome?" *Cahiers archéologiques*, 12 (1962), pp. 153-171.]

63 [See H. Martin and P. Lauer, *Les principaux Manuscrits à peintures de la Bibliothèque de l'Arsenal à Paris* (S.F.R.M.P.), Paris, 1929, pl. VII; and *Manuscrits à peintures*, Bibl. Nat., Paris, 1955, cat. no. 2.]

64 [For the Sainte-Chapelle, see L. Grodecki and J. Lafond, *Les Vitraux de Notre-Dame et de la Sainte-Chapelle de Paris* (Corpus Vitrearum Medii Aevi, France 1), Paris, 1959, pl. 44, pp. 172-174; on the cathedral of Le Mans, see L. Grodecki, "Les Vitraux de la cathédrale du Mans," *Congrès archéologique*, 119 (1961), p. 78; for the cathedral of Angers, see J. Hayward and L. Grodecki, "Les Vitraux de la cathédrale d'Angers," *Bulletin monumental*, 124 (1966), pp. 41-42.]

65 Toward 1300, manuscripts begin to show the Virgin replacing Christ at the top of the Tree of Jesse. There is an example in the Psalter of Richard of Canterbury. [Formerly Malvern, Coll. C. W. Dyson Perrins, no. 14, fol. 6; see G. F. Warner, *Descriptive Catalogue of Illuminated Manuscripts in the Library of C. W. Dyson Perrins*, Oxford, 1920, no. 14; cf. E. G. Millar, *Manuscripts of the XIVth and XVth Centuries*, Paris and Brussels, 1928, pl. 39, p. 55.] Earlier examples could no doubt be found. [One is already to be found in the Bible of St.-Bénigne

(Dijon, Bibl. mun., ms. 2) illus. Watson, *op. cit.*, pl. x.]

66 [A. Knowles, *Essays in the History of the York School of Glass Painting*, London, 1936, p. 7, fig. 1.]

67 Paris, Bibl. Sainte-Geneviève, ms. 10, fol. 132r. Since the miniature is conceived as a marginal decoration, and as a consequence is very narrow, there was no space for the prophets. The foliage scrolls became simple lozenges. [This Bible, in three volumes (mss. 8-10), was written by Manerius of Canterbury; it is thought to be part of a group of manuscripts illuminated in France in the late twelfth or early thirteenth century. Cf. C. R. Dodwell, *The Canterbury School of Illumination*, Cambridge, 1954, pp. 109-110, and J. Porcher, *L'Enluminure française*, Paris, 1959, p. 39.]

68 The panel on which Christ figures is a modern restoration, and has no archeological value. [Cf. H. Schrade, *Die Romanische Malerei*, Cologne, 1963, pp. 204-205, with bibl.]

69 Fr. Quaresimus, *Historica theologica et moralis Terrae Sanctae elucidatio*, Venice, 1882, II, pp. 645ff., and M. de Vogüé, *Les Eglises de la Terre Sainte*, Paris, 1860, pp. 67-69, 98-99.

70 In the Bethlehem mosaic, Micah, Amos, and Joel are the only prophets who do not speak the words found in the most complete of our liturgical plays, that of Rouen [Vogüé, *op. cit.*, p. 68; Gasté, *op. cit.*, p. 106 n. 3 (Amos), p. 112 n. 1 (Joel), p. 113 n. 1 (Micah).] But variants are numerous, and the concordance of the three plays—Limoges, *Adam*, and Rouen—is far from perfect.

71 The Tree of Jesse is found in Italy on the portal of the cathedral of Genoa, on the portal of the baptistery of Parma [cf. G. H. Crichton, *Romanesque Sculpture in Italy*, London, 1954, pp. 18-19, and R. Jullian, *L'Eveil de la sculpture italienne, La sculpture romane dans l'Italie du nord*, Paris, 1949, pl. XCVIII,5], and on the most recent of the double doors of S. Zeno at Verona [*ibid.*, pl. LXXII,1], monuments whose sculpture reveals the influence of France. In Spain, the Tree of Jesse was carved on one of the piers of the cloister of Santo Domingo de Silos and on the Glory Portal at Santiago de Compostela. At Silos, as at Compostela, French influences are obvious. All these examples are later than the window at St.-

Denis. [See Watson, *op. cit.*, pls. XIV, XXI; and cf. J. Gudiol Ricart and J. A. Gaya Nuño, *Arquitectura y escultura románicas* (Ars Hispaniae, V), Madrid, 1948, p. 255 (Silos), p. 350 (Compostela).]

72 Bibl. Nat., nouv. acq. franç. 6121, fols. 32v-34v. [Cf. Lapeyre, *Des Façades occidentales*, p. 19 n. 3.]

73 Guilhermy even adds (fol. 34v): "I have been assured that the slightest indications were followed, down to the devils' tails, etc."

74 We may also believe, although Guilhermy says nothing about it, that the draperies were retouched and freshened in 1839-1840. However, it could be that this tympanum had already been marred in 1771 when the large statues decorating the embrasures of the portals were removed. Soufflot, who carried out a similar project at Notre-Dame of Paris, used the opportunity to retouch the figures of the Vices on the central portal. [See W. S. Stoddard, *The West Portals of St.-Denis and Chartres*, Cambridge (Mass.), 1952, pp. 2-3.]

75 Suger, *De rebus in administratione sua gestis*, cap. XXVII. [See Panofsky, *Abbot Suger*, pp. 48-49 and p. 165.]

76 W. Vöge, *Die Anfänge des monumentalen Stiles im Mittelalter*, Strasbourg, 1894, pp. 8off., esp. pp. 86-89. [Cf. L. Grodecki, "La première Sculpture gothique. Wilhelm Vöge et l'état actuel des problèmes," *Bulletin monumental*, 117 (1959), pp. 271-275.]

77 Did the original Christ figure at St.-Denis hold two banderoles as it now does? I do not know. But there is not the slightest doubt that the inscriptions on the banderoles are modern. The same is true of the inscription INRI carved on the cross (Guilhermy, fol. 33).

78 [See A. Katzenellenbogen, *The Sculptural Programs of Chartres Cathedral*, Baltimore, 1959, pp. 84-85.]

79 Suger says that the work on the façade of St.-Denis was finished in 1140. It had no doubt gone on for six or seven years, according to the calculations made by A. Saint-Paul ("Suger, l'église de Saint-Denis et saint Bernard," *Bulletin archéologique du Comité des Travaux historiques et scientifiques*, 1890, p. 264). Thus, the portal might have been carved as early as 1133, and it is likely that the Beaulieu portal is earlier

than this date; therefore, the Moissac portal is earlier still.

80 The church of Notre-Dame at Corbeil was demolished after 1820, but a brief description, accompanied by mediocre drawings, has been preserved (T. Pinard, "Notre-Dame de Corbeil," *Revue archéologique*, 2 (1845), pp. 165ff.). Insofar as we can tell today, there were close similarities between the two Last Judgment scenes. True, at Corbeil Christ's arms were not extended, but he was placed with his back against the cross, as at St.-Denis. The apostles were placed in the tympanum. The elders of the Apocalypse were distributed in the archivolts; feature by feature, they recall the elders at St.-Denis. A text proves that the portal of Corbeil existed (and no doubt had existed for several years) in 1180. [Cf. F. Salet, "Notre-Dame de Corbeil," *Bulletin monumental*, 100 (1941), p. 84 n. 3 and p. 109. On the Last Judgment, *ibid.*, pp. 110ff., esp. pp. 116-117. Cf. also Lapeyre, *Des Façades occidentales*, pp. 256-263, figs. 197-202.]

81 The statues destroyed in 1771 are known only through the drawings published by Montfaucon, *Monumens de la monarchie françoise*, 1, p. 194, pls. XVI-XVIII. [The drawings are in the Bibl. Nat., ms. fr. 15634, Divers, 6228. Several heads of these statues are now in the United States: see M. C. Ross, "Monumental Sculptures from St.-Denis, an Identification of Fragments from the Portal," *The Journal of the Walters Art Gallery*, 3 (1940), pp. 90-107, and M. Aubert, "Têtes de statues-colonnes du portail occidental de Saint-Denis," *Bulletin monumental*, 103 (1945), pp. 243-248. See below, Chapter XI, pp. 391ff.

82 Several of these lamps are restorations (see Guilhermy, fol. 32v).

83 One of these capitals came from the cloister of St.-Etienne; the provenance of the other is unknown. I have studied them in the *Revue archéologique*, 3rd ser., 20 (1892), p. 33, pl. XVII,2. On the capital reproduced here, the wise virgins do not carry lamps, but the foolish virgins, on the other face of the capital, do. The other capital at Toulouse, however, shows the wise virgins with their lamps. [Cf. P. Mesplé, *Toulouse, Musée des Augustins, Les sculptures romanes*, Paris, 1961, nos. 34 and 37.]

84 All of these heads and many of the hands are restorations (1840). [See Guilhermy, fol. 32v.]

85 Two of the St.-Denis virgins have this typical attitude.

86 J. von Schlosser, *Schriftquellen zur Geschichte der karolingischen Kunst*, Vienna, 1892, p. 312, no. 900. In Alcuin's text, he refers to the wise virgins:

> *Hic pariter fulgent sapientes quinque puellae*
> *Æterna in manibus portantes luce lucernas.*
> (Here shine alike five maidens wise
> Their hands bearing lamps of eternal light.)

[Titulus of the abbey church of Gorze, consecrated by Chrodegang of Metz, July 11, 765.]

87 They are restorations. [M. Aubert, *Notre-Dame de Paris, Architecture et sculpture*, Paris, 1928, pl. 41, p. 21.]

88 For an explanation of this symbolism, see *L'Art religieux du XIIIe siècle*, 9th ed., pp. 174ff. [Cf. also Grodecki, "Les Vitraux allégoriques," pp. 27-28.]

89 Published by A. N. Didron, *Iconographie chrétienne, Histoire de Dieu*, Paris, 1843, p. 593 and fig. 145 [Engl. tr. E. J. Millington, ed. M. Stokes, New York, 1968, II, p. 70, fig. 145]. It came from the abbey of Notre-Dame-aux-Nonnains. [See L. Morel-Payen, *Les plus beaux Manuscrits et les plus belles reliures de la Bibliothèque de Troyes*, Troyes, 1935, p. 101, pl. XIV, fig. 57, who dates this manuscript in the thirteenth century.]

90 Bibl. mun., ms. 1; published by A. Boinet, *Congrès archéologique*, 73 (1906), p. 536. [Cf. Grodecki, "Les Vitraux allégoriques," pp. 28, 29 n. 110. This miniature is dated from the end of the eleventh century.]

91 The Monk Guillaume, *Vie de Suger*, bk. II [Lecoy de La Marche, *Oeuvres complètes*, p. 387].

92 P. Le Vieil, *L'Art de la peinture sur verre et de la vitrerie*, Paris, 1774, p. 23. It goes without saying that Suger's window came from the church which preceded the present cathedral, since Notre-Dame was begun in 1163 and Suger died in 1151. It is not surprising that some windows were preserved, since they were valued for the memories they recalled.

93 [On the Senlis portal, see W. Sauerländer, "Die Marienkrönungsportale von Senlis und

Mantes," *Wallraf-Richartz-Jahrbuch*, xx (1958), pp. 115-162; P. Wilhelm, *Die Marienkrönung am Westportal von Senlis*, Hamburg, 1941; Lapeyre, *Des Façades occidentales*, pp. 239-242.]

94 At Rome, as at Senlis, the Virgin seated on the throne is already crowned. [Cf. G. Zarnecki, "The Coronation of the Virgin on a Capital from Reading Abbey," *Journal of the Warburg and Courtauld Institutes*, xiii (1950), pp. 1ff.]

95 [See Panofsky, *Abbot Suger*, p. 178.]

96 [See C. Cecchelli, *I mosaici della basilica di S. Maria Maggiore*, Turin, 1956, pl. 65, pp. 246ff.]

97 It can scarcely be supposed that Suger borrowed the idea from Italy. Suger went to Italy three times, but it seems that he did not go there after 1124; see his *Life of Louis le Gros*. [Suger was in Rome in 1112, during the Second Lateran Council; he met with Calixtus II in Bironto in 1121; he spent six months in Italy during the Ecumenical Council of the Lateran in 1123. Cf. Lecoy de La Marche, *Oeuvres complètes*, pp. 39, 109, 114.]

CHAPTER VI

1 Dom T. Ruinart, *Acta primorum martyrum sincera et selecta*, Paris, 1689, pp. 109-113.

2 All these details are given by Antoine Noguier in his *Histoire Tolosaine*, Toulouse, 1559. He reproduced the inscriptions accompanying the statues; consequently there can be no doubt about the meaning of the scenes [the baptism of Austris, pp. 62-63, and King Antoninus on a throne, p. 58].

3 J. de Lahondès, *Toulouse chrétienne, L'église Saint-Etienne, cathédrale de Toulouse*, Toulouse, 1890, p. 32.

4 J. de Lahondès, "Saint-Hilaire," *Congrès archéologique*, 73 (1906), pp. 57-60, pl. facing p. 56. [See G. Mot, "L'Ossuaire de saint Saturnin à Saint-Hilaire d'Aude," *Mémoires de la Société Archéologique du Midi de la France*, 27 (1961), pp. 41-47, illus.]

5 [Capital on the east side of the cloister; see R. Rey, "Les Cloîtres historiés du Midi dans l'art roman, Etude iconographique," *Mémoires de la Société Archéologique du Midi de la France*, 23 (1955), pp. 36-37, and M. Durliat, "Les Origines de la sculpture romane à Toulouse et à Moissac," *Cahiers de*

civilisation médiévale, 12 (1969), pp. 362, 363; M. Vidal, "Le Culte des saints et des reliques dans l'abbaye de Moissac," *O Distrito de Braga*, 4 (1967).]

6 Benedictine Order, *Acta Sanctorum ordinis sancti Benedicti in Saeculorum classes distributa*, ed. J. Mabillon, Paris, 1668-1702, October, iii, pp. 263-266.

7 [See P. Mesplé, *Toulouse, Musée des Augustins, les sculptures romanes*, Paris, 1961, no. 256; the author believes that this capital of the paired columns from the cloister of Lombez (Gers) represents the martyrdom of St. Caprasius.]

8 Abbé Dubos, "Essai d'identification des lieux du martyre et des premières sépultures de saint Vincent, diacre," *Congrès archéologique*, 68 (1901), pp. 243-267. [See Marquise de Maillé, *Vincent d'Agen et saint Vincent de Saragosse, Etude de la "Passio S. Vincentii martyris,"* Melun, 1949. Maillé's conclusion that St. Vincent of Agen is another name for the same St. Vincent of Saragossa is questioned by B. de Gaiffier, "La Passion de S. Vincent d'Agen," *Analecta Bollandiana*, 70 (1952), fasc. 1-2, pp. 160-181.]

9 I do not know if the other capital, with the horseman who has just dismounted to cut off the head of a saint, really represents the death of St. Eutichius, father of St. Maurin, as Abbot Barrère thinks. However, this explanation has some likelihood. See J. Barrère, *Histoire religieuse et monumentale du diocèse d'Agen*, i, Agen, 1855, p. 131.

10 *Album des monuments et de l'art ancien du Midi de la France*, publ. under the direction of E. Cartailhac, Toulouse, 1898, i, p. 153.

11 *Acta Sanctorum*, October 16, vii, pp. 1140-1184.

12 [Capital on the east side; see Rey, "Les Cloîtres historiés du Midi dans l'art roman," pp. 36-37.]

13 B. Bernard, "Découverte des reliques dans l'autel de l'église de Valcabrère (Haute-Garonne)," *Bulletin monumental*, 52 (1886), pp. 501-508.

14 [The two Spanish saints are also represented on a pier from the cloister of the cathedral of Narbonne which is now in the Musée des Augustins; see Mesplé, *Toulouse, Musée des Augustins*, no. 261.]

15 A female figure wearing a crown accompanies the statues of St. Stephen, St. Justus, and St. Pastor. She holds a cross before her

breast. This is very probably St. Helena carrying the True Cross. [See S. Damiron, "Eglises romanes pyrénéennes, Saint-Just de Valcabrère," *L'Information culturelle artistique*, 1, no. 2 (Jan.-Feb. 1956), pp. 16-17.] No doubt there had been a piece of the wood of the cross at Valcabrère. At St.-Sernin of Toulouse, a reliquary from Limoges, which contained a fragment of the True Cross, was decorated with the history of St. Helena. [See M. M. Gauthier, *Emaux limousins champlevés des XIIe, XIIIe et XIVe siècles*, Paris, 1950, pp. 154-155 and pl. 28, and the exhibition catalogue, *Les Trésors des églises de France*, Paris, 1965, cat. no. 498, pp. 270-271, with bibl.]

16 I think this capital is a little later than the period we are studying. The cloister of Elne, which dates from the twelfth century, was partly rebuilt in the thirteenth; work was still going on in the fourteenth century. [See M. Durliat, *La Sculpture romane en Roussillon*, II, *Corneilla de Conflent et Elne*, Perpignan, n.d., pp. 31-90.] It seems that the artist may have confused St. Eulalia of Merida with St. Eulalia of Barcelona, for he has represented her after her descent from the cross.

17 For the origins of the legend of St. Martial, see Mgr. L. Duchesne, *Fastes épiscopaux de l'ancienne Gaule*, II. *L'Aquitaine et les Lyonnaises*, 2nd ed., Paris, 1900, pp. 104-117, and C. de Lasteyrie, *L'Abbaye de Saint-Martial de Limoges. Etude historique, économique et archéologique*, Paris, 1901.

18 C. Jouhanneaud, "La Crosse de saint Martial," *Bulletin de la Société Archéologique et Historique du Limousin*, 60 (1911), pp. 367-370.

19 In 1427, for the first time, St. Amadour was said to be the same person as Zacchaeus [see E. Albe, "La Vie et les miracles de S. Amator," *Analecta Bollandiana*, 28 (1909), pp. 57-90]. [Mâle, Additions and Corrections to the 6th ed., 1953, p. 443]: *Zacchaeus and St. Amadour*. The assimilation of St. Amadour with Zacchaeus must go back much earlier than the fifteenth century, because of the Romanesque capitals in two churches not far from Rocamadour, at Vigeois and Arnac-Pompadour (Corrèze). They represent a subject that was little used in the Middle Ages: Christ speaking to Zacchaeus who sits in a tree. Thus, it is probable that as early as the twelfth century it was

known in Limousin that Zacchaeus and St. Amadour were the same person. Doubtless it was known in Auvergne also, as the capital at St.-Nectaire devoted to Zacchaeus would seem to prove.

20 On this subject, see Abbé Arbellot, "Dissertation sur l'apostolat de saint Martial," *Bulletin de la Société Archéologique et Historique du Limousin*, 4 (1852), pp. 267-270.

21 E. Sackur, *Die Cluniacenser in ihrer kirchlichen und allgemeingeschichtlichen Wirksamkeit bis zur Mitte des elften Jahrhunderts*, Halle, 1894, II, p. 405.

22 (Here comrade comes to the aid of comrade)—A. Noguier, *Histoire Tolosaine*, Toulouse, 1559, p. 63. [In the cloister of La Daurade in Toulouse one of the capitals showed St. Martial serving Christ and the apostles at the Last Supper (see Rey, "Les Cloîtres historiés du Midi dans l'art roman," pp. 77-78).]

23 Abbé Damourette, "Caractères principaux des églises du Bas Berry depuis le XIème siècle jusqu'à la Renaissance," *Congrès archéologique*, 40 (1873), p. 428. [See also F. Deshoulières, "L'Eglise abbatiale de Méobec (Indre)," *Bulletin monumental*, 101 (1942), p. 287; P. Deschamps and M. Thibout, *La Peinture murale en France, Le haut Moyen Age et l'époque romane*, Paris, n.d. [1951], pp. 105-108 and pl. XLVII,2; E. W. Anthony, *Romanesque Frescoes*, Princeton, 1951, p. 153; and R. Crozet, *L'Art roman en Berry*, Paris, 1932, pp. 360ff.]

24 The other is perhaps St. Hilary. [See R. Crozet, *L'Art roman en Poitou*, Paris, 1948, p. 194.]

25 J. J. Marquet de Vasselot, *Catalogue raisonné de la collection Martin Le Roy*, fasc. 1, *Orfèvrerie et émaillerie*, Chartres, 1906, no. 22, pp. 35-36, pl. XV. The vermiculated background, the costumes, and the style indicate the twelfth century. [This reliquary is now in the Louvre; see M. M. Gauthier, "La Légende de sainte Valérie et les émaux champlevés de Limoges," *Bulletin de la Société Archéologique et Historique du Limousin*, 86 (1955), pp. 54-56.]

26 Nearby, St. Martial is led to his martyrdom.

27 Former Soltykoff collection [now in the British Museum]; see E. Rupin, *L'Oeuvre de Limoges*, II, *Les Monuments*, Paris, 1890, pp. 403-404 [and Gauthier, "La Légende de sainte Valérie," pp. 47-49, figs. 1-2].

28 There is a drawing of this fresco in L. Gobillot, "Note sur une fresque de l'ancienne église paroissiale de Saint-Pierre de la Trimouille," *Bulletin de la Société des Antiquaires de l'Ouest*, 3rd ser., 2 (1912), p. 633 [cf. Deschamps and Thibout, *La Peinture murale en France*, p. 99].

29 [See H. Focillon, *Peintures romanes des églises de France*, Paris, 1950, pp. 55ff., pl. 91; Deschamps and Thibout, *La Peinture murale en France*, pp. 113-115, pl. XLIX (1 and 2); Anthony, *Romanesque Frescoes*, pp. 154-155.]

30 It is not earlier than the thirteenth century. E. Rupin, "La Statue de la Vierge à Roc-Amadour (Lot)," *Revue de l'art chrétien*, 42 (1892), pp. 8-15.

31 *Liber miraculorum Sanctae Fidis*, published by A. Bouillet, Paris, 1897, bk. I, chap. XIII, pp. 46-47.

32 *Ibid.*, bk. I, chap. XXVIII, pp. 71-72.

33 [See the exhibition catalogue, *Les Trésors des églises de France*, cat. no. 534, pp. 289-294, pls. 34-35, with bibl.; also J. Taralon, and R. Maître-Devallon, *Treasures of the Churches of France*, New York, 1966, pp. 291-293, pls. 201-202, illus. pp. 13, 14, 20, 23.]

34 *Liber miraculorum Sanctae Fidis*, bk. II, chap. IV, pp. 100-101.

35 St. Foy was well known at Le Puy. She appeared in the frescoes that decorated St.-Michel d'Aiguilhe, which could still be seen there about 1850.

36 N. Thiollier, "Les Oeuvres des orfèvres du Puy," *Congrès archéologique* 71 (1904), p. 516. [Cf. the exhibition catalogue, *Les Trésors des églises de France*, cat. no. 428, p. 236, pl. 81, with bibl.]

37 *Acta Sanctorum*, saec. III, pars I, Paris, 1672, *Vita Theofredi*, pp. 476-485.

38 [See the exhibition catalogue, *Les Trésors des églises de France*, cat. no. 447, pp. 246-247, and pl. 79, and Taralon and Maître-Devallon, *Treasures of the Churches of France*, pp. 262-263, pl. 67, figs. 3-5.]

39 A. Bouillet and L. Servières, *Sainte Foy, vierge et martyre*, Rodez, 1900, pp. 159-160.

40 Dom E. Martène, *Veterum scriptorum et monumentorum historicorum . . . amplissima collectio*, VI, Paris, 1729, pp. 1043-1134.

41 "Nicolas ert parlan am en Eteve de Muret." [See G. Souchal, "Les Emaux de Grandmont," *Bulletin monumental*, 120 (1962), pp. 345-357; 121 (1963), pp. 41-64 and 122-150; 122 (1964), pp. 129-159; cf. the exhibition catalogue, *Les Trésors des églises de France*, cat. no. 353, pp. 191-192.]

42 *Acta Sanctorum*, August, III, pp. 756-762.

43 [Reliquary now in Chamberet (Corrèze); see the exhibition catalogue, *Les Trésors des églises de France*, cat. no. 397, pp. 215-216, with bibl.]

44 The reliquary of St. Psalmodius which was once at Eymoutiers disappeared several years ago.

45 [Reliquary, second half of the thirteenth century, now in St.-Viance (Corrèze); see the exhibition catalogue, *Les Trésors des églises de France*, cat. no. 407, pp. 223-224, with bibl., esp. Gauthier, *Emaux limousins champlevés*, pls. 48-50.]

46 [Reliquary statue, end of the twelfth century, now at Les Billanges (Haute-Vienne); see the exhibition catalogue, *Les Trésors des églises de France*, cat. no. 357, p. 194, pl. 69.]

47 [Reliquary bust (14th-15th century) now in the church treasury of Solignac; see *Les Trésors des églises de France*, cat. no. 379, p. 206.]

48 [The reliquary head that can be seen in the parish church of St.-Yrieix (Haute-Vienne), is a copy of the original now in the Metropolitan Museum of Art, New York; cf. J. J. Rorimer and W. H. Forsyth, in *Bulletin of the Metropolitan Museum of Art*, 1954, p. 123, illus. p. 142.]

49 [Reliquary head now in Ste.-Fortunade (Corrèze); see *Les Trésors des églises de France*, cat. no. 404, pp. 221-222, and S. Delbourgo, "Le Chef-reliquaire de sainte Fortunade, Etude spectrographique," *Bulletin du laboratoire du Musée du Louvre*, 1965, pp. 6-14, illus.]

50 M. de Longuemar, "Note sur les fresques récemment découvertes dans l'église de Saint-Hilaire," *Bulletin de la Société des Antiquaires de l'Ouest*, 13 (1871-1873), pp. 375-382 [Deschamps and Thibout, *La Peinture murale en France*, pp. 64-65, with bibl., pp. 69-71 and 94; Crozet, *L'Art roman en Poitou*, p. 252; Anthony, *Romanesque Frescoes*, pp. 144-145, figs. 310-311].

51 Dom F. Chamard, "Histoire ecclésiastique du Poitou," *Mémoires de la Société des Antiquaires de l'Ouest*, 37 (1873), p. 455 [and Crozet, *L'Art roman en Poitou*, pp. 177 and 205, with bibl.].

52 C. de La Croix, "Trois bas-reliefs religieux dont les originaux existent à Poitiers," *Congrès archéologique*, 70 (1903), p. 218. This fragment seems to me to have come from the cenotaph. We know that the Protestants broke off the heads of figures, and here, in fact, all the heads are broken.

53 M. de Longuemar, "Essai historique sur l'église collégiale de Saint-Hilaire-le-Grand de Poitiers," *Mémoires de la Société des Antiquaires de l'Ouest*, 23 (1856), p. 1. At the beginning of the history of the church of St.-Hilaire is a drawing of this relief.

54 He died "in the privy." This legend is told in full by Jacobus de Voragine, *Legenda aurea*, ed. Graesse, 3rd ed., Breslau, 1890, pp. 98-100 [cf. tr. by G. Ryan and H. Ripperger, *The Golden Legend*, London and New York, 1941, I, pp. 90-92].

55 [For Semur-en-Brionnais, see R. and A. M. Oursel, *Les Églises romanes de l'Autunois et du Brionnais, Cluny et sa région*, Mâcon, 1956, p. 294. Crozet, *L'Art roman en Poitou*, p. 205, mentions a similar representation on a sarcophagus fragment which disappeared in the seventeenth century. Cf. also J. Evans, *Cluniac Art of the Romanesque Period*, Cambridge, 1950, p. 108.]

56 Prosper Mérimée, *Notice sur les peintures de l'église Saint-Savin*, Paris, 1845; pl. XXXIII shows the saints before the judge. [See also Deschamps and Thibout, *La Peinture murale en France*, pp. 71-86, bibl. p. 73, and Anthony, *Romanesque Frescoes*, pp. 139ff.]

57 Mérimée, *op. cit.*, p. 47. [B. de Gaiffier, "Les Sources de la Passion des SS. Savin et Cyprien," *Analecta Bollandiana*, 73 (1955), pp. 323-341.]

58 P. Labbé, *Novae bibliothecae manuscriptorum librorum*, II, Paris, 1657, pp. 5-10.

59 There is a drawing of this tympanum in Abbé Auber, "Châtillon-sur-Indre, La ville et l'église Notre-Dame," *Bulletin monumental*, 42 (1876), pp. 127-141, pl. II, and in the interesting monograph by B. de Roffignac, "L'Eglise de Châtillon-sur-Indre," *Mémoires de la Société des Antiquaires du Centre*, 43 (1929), pp. 99-156, fig. 2.

60 Labbé, *Novae bibliothecae manuscriptorum librorum*, II, pp. 350-364; a capital at Châtillon shows Austregisillus preparing for combat.

61 Labbé, *ibid.*, pp. 372-376. *Recueil des historiens des Gaules et de la France*, III (Dom M. Bouquet, re-ed. by L. Delisle, Paris, 1869), pp. 428-429.

62 M. Aubert, "L'Eglise abbatiale de Selles-sur-Cher," *Bulletin monumental*, 77 (1913), pp. 387-401.

63 On this subject, see *Histoire littéraire de la France*, X, Paris, 1756, p. 480.

64 Gregory of Tours, *De gloria confessorum*, chap. XXX, in Migne, *P. L.*, 71, cols. 850 and 851.

65 Mabillon published the history of the transfer of St. Austremonius' relics. *Acta Sanctorum*, saec. III, pars II, Paris, 1672, pp. 191-195.

66 From the evidence of this capital, the church could be accurately restored.

67 25 January 674. *Acta Sanctorum*, January, II, pp. 628-636.

68 *Pro anima sua et co[njugis] incipit donalia sancti pre[je]cti: qve fe[c]it: gvilelmes: de beza* (For his soul and that of his wife, Guilelmes de Beza presents these votive offerings to St. Praejectus).

69 Bibl. Nat., ms. lat. 17627, *Sermo de s[an]c-[t]a Maria Magdalena*, fols. 93v-95. [This sermon has been published by B. de Gaiffier, "Hagiographie bourguignonne, A propos de la thèse de doctorat de M. René Louis sur Girart comte de Vienne," *Analecta Bollandiana*, 69 (1951), pp. 131-147 (text on pp. 145-147, and cf. pp. 134-140).]

70 The tradition appears as early as 450 in a letter of the bishops of the province of Arles to Pope Leo; Mgr. L. Duchesne, *Fastes épiscopaux de l'ancienne Gaule*, I, pp. 253-254.

71 All these legends were later summarized by Jacobus de Voragine, *Legenda aurea, De sancta Martha*, pp. 444-447 [cf. tr. Ryan and Ripperger, *The Golden Legend*, II, pp. 391-395].

72 Mgr. L. Duchesne, "La Légende de sainte Marie-Madeleine," *Annales du Midi*, 5 (1893), pp. 1-33, and *idem, Fastes épiscopaux*, I, pp. 321-340. [See also R. Louis, *De l'Histoire à la légende, Girart, comte de Vienne (819-877) et ses fondations monastiques*, Auxerre, 1946, I, pp. 154-196 and 209-210, and Gaiffier, "Hagiographie bourguignonne," pp. 131-147; cf. also V. Saxer, "L'Origine des reliques de sainte Marie-Madeleine à Vézelay dans la tradition historiographique du moyen âge," *Revue des sciences religieuses*, 29 (1955), pp. 1-19.]

73 The former cathedral of Autun was dedi-

cated to St. Nazaire; *Nazaire* could have been confused with *Lazare*.

74 The tympanum and lintel still exist, but they are so mutilated that the subjects can barely be made out.

75 J. S. Devoucoux, *Description de l'église cathédrale d'Autun dédiée à saint Lazare*, Autun, 1845, p. 38.

76 E. Mâle, "Le Ravissement de Marie-Madeleine au Musée d'Autun," *Congrès archéologique*, 74 (1907), pp. 537-539. [See D. Grivot and G. Zarnecki, *Gislebertus, Sculptor of Autun*, New York, 1961, p. 140 and cf. n. 4.]

77 Dom U. Plancher, *Histoire générale et particulière de Bourgogne*, I, Dijon, 1739, p. 515. [J. Vallery-Radot, "L'Iconographie et le style des trois portails de Saint-Lazare d'Avallon," *Gazette des beaux-arts*, 52 (1958), pp. 23-34; A. Lapeyre, *Des Façades occidentales de Saint-Denis et Chartres aux portails de Laon*, Paris, 1960, pp. 109-112; and W. Sauerländer, *Gotische Skulptur in Frankreich 1140-1270*, Munich, 1970, pp. 84, 117.]

78 A document dating from 1482, published by A. de Charmasse: "Enquête faite en 1482 touchant le chef de saint Lazare," *Bulletin de la Société d'Etudes d'Avallon*, 7 (1865), p. 72, tells us that a painted inscription gave the name of the bishop as *S. Ladre* (popular form of Lazarus). This inscription in French was certainly later than the statue, but it perpetuated a tradition.

79 Plancher, *Histoire générale et particulière de Bourgogne*, I, p. 503. [See P. Quarré, "La Sculpture des anciens portails de Saint-Bénigne de Dijon," *Gazette des beaux-arts*, 51 (1957), pp. 177-194, and Lapeyre, *Des Façades occidentales*, pp. 101-108, and 286-287; and Sauerländer, *Gotische Skulptur*, pp. 72-74, pls. 22, 23.]

80 *Acta Sanctorum*, November, I, pp. 152-173.

81 J. de Voragine, *Legenda aurea, De sancto Bernardo*, p. 533 [cf. tr. Ryan and Ripperger, *The Golden Legend*, II, pp. 465-477].

82 J. G. Bulliot, *Essai historique sur l'abbaye de Saint-Martin d'Autun de l'ordre de saint Benoît*, Autun, 1849, I, pp. 1-18 (foundation), and pp. 66-67, pl. 1 (Brunehaut's tomb).

83 *Acta Sanctorum*, saec. V, Paris, 1685, pp. 90-106.

84 *Acta Sanctorum*, October, IV, St. Dionysius the Areopagite, pp. 696-792, St. Dionysius, St. Rusticus, and St. Eleutherius, pp. 865-987. J. de Voragine, *Legenda aurea, De Dionysio*, pp. 680-686. [Cf. tr. Ryan and Ripperger, *The Golden Legend*, St. Dionysius and his companions, II, pp. 616-622. See *The Celestial Hierarchy*, tr. J. Parker, Oxford, 1897-1899; cf. C. E. Rolt, *Dionysius the Areopagite on the Divine Names and the Mystical Theology*, London and New York, 1940, introd.]

85 F. de Guilhermy, *Monographie de l'église royale de Saint-Denis*, Paris, 1848, pp. 12-13, and *idem*, Bibl. Nat., nouv. acq. franç. 6121, fol. 56.

86 *Acta Sanctorum*, September, I, pp. 255-265.

87 *Legenda aurea, De sancto Lupo*, pp. 579-580 [cf. tr. Ryan and Ripperger, *The Golden Legend*, II, pp. 515-516].

88 [Lapeyre, *Des Façades occidentales*, pp. 132-138, and pp. 288-290, and Sauerländer, *Gotische Skulptur*, pp. 78ff., pls. 24, 25.]

89 *Histoire littéraire de la France*, XI, 2nd ed., Paris, 1841, p. 269.

90 *Acta Sanctorum*, January, II, pp. 761-767. [On the St. Julian window in the cathedral of Le Mans, see Grodecki, "Les Vitraux de la cathédrale du Mans," *Congrès archéologique*, 119 (1961), pp. 70-71.]

91 Migne, *P. L.*, 61, cols. 1071-1074. [Cf. F. J. E. Raby, *A History of Christian Latin Poetry*, Oxford, 1927, p. 82.]

92 E. Le Blant, *Les Inscriptions chrétiennes de la Gaule antérieures au VIIIème siècle*, I, Paris, 1856, nos. 185-192, pp. 247-253. [V. Fortunatus, *Miscellanea*, bk. X, chap. VI, in Migne, *P. L.*, 88, cols. 328-331. Cf. also, P. Monceaux, *Saint Martin*, Paris, 1927, p. 49.]

93 [Cf. M. Vieillard-Troiekouroff, "Fresques récemment découvertes à Saint-Martin de Tours," *Les Monuments historiques de la France*, 1967, no. 2, pp. 16-33.]

94 Göttingen, University Library, cod. theol. 231, fol. 113a [cf. *Ars sacra, Kunst des frühen Mittelalters*, exhibition catalogue, Munich, 1950, cat. no. 84 (Sacramentary of Fulda) with bibl.]. The same is true in a manuscript from Ivrea (969-1002) [see L. Magnani, *Le Miniature del sacramentario d'Ivrea e di altri codici Warmondiani*, Vatican City, 1934, pl. XXIX].

95 [Ms. 698. A. Boinet, "Un Manuscrit à peintures de la Bibliothèque de Saint-Omer," *Bulletin archéologique du Comité des Tra-*

vaux historiques et scientifiques, 1904, pp. 415-430. Cf. *Manuscrits à peintures*, 1954, Paris, Bibl. Nat., cat. no. 118, with bibl., and J. Porcher, *Medieval French Miniatures*, New York, 1959, pp. 30, 32, pl. XXI.]

96 *Acta Sanctorum*, September, II, pp. 550-587. [The life of St. Omer is linked to that of St. Bertin.]

97 This has been demonstrated by Boinet, "Un Manuscrit à peintures," pp. 427-428.

98 These miniatures were published by E. Ginot, "Le Manuscrit de sainte Radegonde de Poitiers et ses peintures du XIème siècle" (S.F.R.M.P., 4, no. 1, 1914/1920), pp. 9-80, pls. I-XXVII. [Bibl. mun. of Poitiers, ms. 250. Cf. *Manuscrits à peintures*, 1954, cat. no. 222 and pl. XXII, with bibl., and Porcher, *Medieval French Miniatures*, p. 30, fig. 31.]

99 See Ginot, *op. cit.*, pp. 62-67 [and also T. Sauvel, "A Propos d'une exposition récente: les manuscrits poitevins ornés de peintures," *Bulletin de la Société des Antiquaires de l'Ouest*, 1955, no. 4, p. 268].

100 Bibl. Nat., nouv. acq. lat. 1390: Life of St. Aubin. [Cf. *Manuscrits à peintures*, 1954, cat. no. 221 and pl. XXII, with bibl., and Porcher, *Medieval French Miniatures*, p. 30, pl. XX.]

101 [Life and Miracles of St. Quentin, St.-Quentin, Basilica. Cf. *Manuscrits à peintures*, 1954, cat. no. 180 and pl. XIX, with bibl.]

102 See Burlington Fine Arts Club exhibition catalogue, London, 1908, no. 18 and pl. 23. [Now Morgan Library, M 736; see *Morgan Library, Exhibition of Illuminated Manuscripts*, New York, 1933-1934, cat. no. 30.]

103 Bibl. Nat., nouv. acq. franç. 1098. [Cf. *Manuscrits à peintures*, 1955, cat. no. 5, with bibl.]

104 [Bibl. Nat., fr. 2090-2092] published by H. Martin, *La Légende de saint Denis*, Paris, 1908. [Cf. *Manuscrits à peintures*, 1955, cat. no. 33 and pl. VII, and Porcher, *Medieval French Miniatures*, pp. 51, 90, pl. L.]

105 See the story of the discovery of St. Benedict's body, written by the monk Adalbert, in the *Acta Sanctorum*, March, III, pp. 302-305. [G. Chenesseau, *L'Abbaye de Fleury à Saint-Benoît-sur-Loire*, Paris, 1931, pp. 5-7, 12.]

106 This sermon of St. Odo on St. Benedict was read at Cluny until the twelfth century. See

E. Sackur, *Die Cluniacenser in ihrer kirchlichen und allgemeingeschichtlichen Wirksamkeit bis zur Mitte des elften Jahrhunderts*, Halle, 1894, II, pp. 334-335.

107 Helgaud, *Vie de Robert le Pieux*, in *Recueil des Historiens des Gaules et de la France*, X, Paris, 1760, p. 105.

108 Aimoin, *Vita S. Abbonis*, XV, in Migne, *P. L.*, 139, col. 406.

109 A capital in the abbey church of Le Ronceray at Angers represents a monk writing on tablets while a dove speaks into his ear (E. Lefèvre-Pontalis, "L'Eglise abbatiale du Ronceray d'Angers," *Congrès archéologique*, 77 (1910), p. 136). This must be St. Benedict writing his Rule, as dictated by the Holy Spirit. Were it St. Gregory, who was also represented with the dove, the pontifical pallium would have been represented to designate a pope.

110 To understand the capitals of St.-Benoît-sur-Loire, it is necessary to read the life of St. Benedict written by St. Gregory the Great: *Vita S. Benedicti, Acta Sanctorum*, March, III, pp. 276-288. [See E. Dubler, *Das Bild des heiligen Benedikt bis zum Ausgang des Mittelalters*, Zurich, 1966.]

111 Miniatures represent St. Maur receiving the New Law from the hand of his master; see for example, Add. ms. 16979, fol. 21v, of the British Museum, from the region of St.-Gilles, written in 1129.

112 Gregory the Great, *Vita S. Benedicti*, p. 286.

113 The capitals of St.-Benoît-sur-Loire do not form a continuous series; they are scattered throughout the church. In the sanctuary, at the top of four engaged columns above the triforium, are the following: the Legend of the Sieve; St. Placidus Saved by St. Maur; Totila; the Resurrection of the Child. Also in the sanctuary, one of the capitals of the triforium shows the departure of St. Maur for Gaul. In the north transept at the entrance to a chapel, we see the episode of Galla; at the top of one of the piers of the transept crossing, we see the devil seated on the stone and the death of the novice; at the entrance to the nave, is a representation of the broken bell and of the saint throwing himself into the thorns.

114 Adalbertus, *Acta Sanctorum*, March, III, pp. 302-303.

115 *Ibid.*, pp. 303-304.

116 *Vir Dei Benedictus virga percussit mon-*

achu[*m*] *et sanavit eu*[*m*] (Benedict, the man of God, struck the monk with his staff and cured him).

117 *Diabolus* is written twice on the abacus, as if the woman also were a devil. *Sanctus Benedictus* is written above the head of the monk.

118 John Cassian, *Collationes*, in Migne, *P. L.*, 49, cols. 477-1328 [tr. E. C. S. Gibson in *A Select Library of Nicene and Post-Nicene Christian Fathers*, New York and Oxford, ser. II, 11 (1894), pp. 161-641].

119 Bibl. Nat., ms. nouv. acq. lat. 1491, eleventh century.

120 *Vitae Patrum*, ed. by H. de Rosweyde and d'Annot, Antwerp, 1615, pp. 35-74 [cf. Migne, *P. L.*, 13, cols. 21ff.].

121 One of the heads is broken.

122 *Abbas querebat Paulu*[*m*] *faun*[*us*]*que doce*[*bat*] (The abbot was in search of Paul, and a faun showed him the way). This episode is shown here because the church, a dependency of the chapter of St.-Paul at Lyon, was dedicated to St. Paul. The story of St. Paul the Apostle is depicted on the façade; the south portal, by depicting the meeting of St. Anthony with the faun, commemorates St. Paul the Hermit.

123 The life of St. Mary of Egypt was well known to the clerics of the Middle Ages. John, a monk of St.-Evroult, had put it into verse in the early twelfth century; Hildebert, bishop of Le Mans, also composed a poem in her honor; Honorius of Autun told her story in the *Speculum ecclesiae*, in Migne, *P. L.*, 172, cols. 906-908.

124 I have explained this capital in "Les Chapiteaux romans du Musée de Toulouse et l'école toulousaine du XIIème siècle," *Revue archéologique*, 3rd ser., 20 (1892), p. 29. See Mesplé, *Toulouse, Musée des Augustins*, no. 33.

125 *Vitae Patrum*, pp. 381-392 [cf. Migne, *P. L.*, 73, cols. 673ff.].

126 Mâle, "Les Châpiteaux romans du Musée de Toulouse," pp. 28-35, 176-197, and pls. XV-XVI.

127 Mâle, *op. cit.*, pl. XVI,2.

128 Mâle, *op. cit.*, pl. XV,3.

129 Mâle, *op.cit.*, pl. XVI,4.

130 Her story is told in the *Speculum ecclesiae* of Honorius of Autun, in Migne, *P. L.*, 172, cols. 819-820; see also *Vitae Patrum*, pp. 340-350 [cf. Migne, *P. L.*, 73, cols. 605ff.].

131 Tympanum at Cahors, capital at Autun, window at Le Mans (twelfth century).

CHAPTER VII

1 This and the following chapter appeared in *La Revue de Paris*, 1919 and 1920.

2 [See A. P. Newton, ed., *Travel and Travellers of the Middle Ages*, London, 1949, and E. R. Labande, "Recherches sur les pèlerins dans l'Europe des XIème et XIIème siècles," *Cahiers de civilisation médiévale*, 1 (1958), pp. 159-169 and 339-347.]

3 Many of these legends are found in the *Mirabilia Romae*, published by G. Parthey, Berlin, 1869 [tr. F. M. Nichols, *The Marvels of Rome*, London and Rome, 1889; see also R. Valentini and G. Zucchetti, *Codice topografico della Città di Roma*, III, Rome, 1946, pp. 3-196], and in the abridged work, *Graphia aureae urbis Romae*, published by A. F. Ozanam, *Documents inédits pour servir à l'histoire littéraire de l'Italie depuis le VIIIème jusqu'au XIIIème siècle*, Paris, 1850, pp. 163-164, 167, 168-169. These served as guides for the use of pilgrims. All of the legends current in Rome during the Middle Ages have been studied by A. Graf, *Roma nella memoria e nelle immaginazioni del medio evo*, 2 vols., Turin, 1882-1883, and by D. Comparetti, *Virgilio nel medio evo*, Leghorn, 1872. [See also J. Adhémar, *Influences antiques dans l'art du moyen âge français* (Studies of the Warburg Institute, 7), London, 1939, pp. 90-98. Cf. Adamnani, "De Locis sanctis," *Corpus christianorum, Series latina*, 175, *Itineraria et alia Geographica*, Turnholt, 1965, pp. 175ff.]

4 On the subject of this relic, see P. Rajna, "Per la data della 'Vita Nuova,'" *Giornale storico della letteratura italiana*, 6 (1885), pp. 131-134. [See also A. Grabar, *La Sainte Face de Laon; le mandylion dans l'art orthodoxe*, Prague, 1931. Cf. F. Cabrol and H. Leclercq, *Dictionnaire d'archéologie chrétienne*, xv, pt. 2, Paris, 1953, cols. 2962-2966.]

5 Graf, *Roma*, II, p. 87.

6 For the twelfth century, we have the testimony of Benjamin de Tudela, C. L. Urlichs, *Codex urbis Romae topographicus*, Würzburg, 1871, pp. 178-179, and E. Charton, *Voyageurs anciens et modernes du Vème au XIXème siècle*, Paris, 1855, II, p. 164;

and also, in Robert Wace's *Roman de Rou*, ed. F. Pluquet, Rouen, 1827, I, p. 406, v. 8197-8198:

Constantin vit ki est a Rome
De quivre fet en guise d'home.

(He saw the Constantine that is in Rome
Made of bronze in form of man.)

[See Cabrol and Leclercq, *Dictionnaire*, XIV, pt. 2, 1948, col. 3000, and also Adhémar, *Influences antiques*, pp. 95-96; H. von Roques de Maumont, *Antike Reiterstandbilder*, Berlin, 1958, pp. 55ff.]

7 There are examples of this sculpted horseman at Châteauneuf-sur-Charente, Surgères, Parthenay-le-Vieux, Benet, St.-Hilaire at Melle (restored), and Civray (restored); and in the past, at Notre-Dame-la-Grande at Poitiers, Sainte-Croix at Bordeaux, the Abbaye-aux-Dames and St.-Eutrope at Saintes, at Aulnay, at Airvault, and at Déols. [See R. Crozet, *L'Art roman en Poitou*, Paris, 1948; e.g., pls. XXVII, XXX, XXXI.]

8 On this subject, see L. Audiat, "Les Cavaliers au portail des églises," *Congrès archéologique*, 38 (1871), pp. 317-343. More recently, A. Leroux has theorized that many of these horsemen might represent Henry II of England ("Les Portails commémoratifs de Bordeaux, Essai d'interprétation par l'histoire locale," *Annales du Midi*, 1915-1916, pp. 438-453). [See R. Crozet, "Nouvelles remarques sur les cavaliers sculptés ou peints dans les églises romanes," *Cahiers de civilisation médiévale*, I (1958), pp. 27-36.]

9 P. T. Grasilier, *Cartulaires inédits de la Saintonge*, Niort, 1871, II, charter no. XXXVIII, p. 44.

10 A. de La Bouralière, "Guide archéologique du Congrès de Poitiers: Notre-Dame-la-Grande," *Congrès archéologique*, 70 (1903), p. 28.

11 *Bulletin de la Société Nationale des Antiquaires de France*, 1886, pp. 92-93.

12 Abbé Arbellot, "Mémoire sur les statues équestres de Constantin placées dans les églises de l'ouest de la France," *Bulletin de la Société Archéologique et Historique du Limousin*, 32 (1885), pp. 1-34.

13 The inscription was copied by Peiresc. See E. Müntz, *Etudes iconographiques et archéologiques sur le moyen âge*, Paris, 1887, p. 53.

14 This detail is found at Parthenay-le-Vieux, Châteauneuf-sur-Charente, St.-Etienne-le-

Vieux at Caen, and on a capital in the cathedral of Autun [cf. D. Grivot and G. Zarnecki, *Gislebertus, Sculptor of Autun*, New York, 1961, p. 59 and pl. 6]. It was once to be seen at Sainte-Croix of Bordeaux, as an old drawing shows, and in the mosaic at Riez. [Cf. the interpretation of Crozet, "Nouvelles remarques sur les cavaliers," pp. 33-36.]

15 In Graf, *Roma*, II, pp. 114-115, see the passage from the *Mirabilia*. G. Paris, in *Le Journal des savants* (Oct. 1884), pp. 557-577 (review of Graf), publishes the testimony of the chronicler Enenkel (thirteenth century).

16 Wace, *Le Roman de Rou*, ed. Pluquet, I, p. 406, v. 8197-8212.

17 The group at Sainte-Croix of Bordeaux, already badly mutilated in the eighteenth century, was sketched in 1754 by Venuti. His drawing was reproduced by Leroux, "Les portails commémoratifs de Bordeaux," p. 447.

18 [Mâle, Additions and Corrections to the 6th ed., 1953, p. 444]: *Constantine on horseback*. To the examples found at a distance from the churches of the west, I should add the badly mutilated horseman near the side door of the former cathedral of Alet (Aude), and the mutilated horseman of the west façade of Sens Cathedral. M. Bloch, "Les vicissitudes d'une statue équestre: Philippe de Valois, Constantin ou Marc-Aurèle?" *Revue archéologique*, 1924, pp. 132-136, is right, I believe, in his contention that the horseman of Sens is a Constantine.

19 The mosaic in the church of S. Agata dei Goti has disappeared and the church is restored. The church was erected in 472 by the Goth Ricimer; we know its mosaic through J. Ciampini, *Vetera Monimenta*, Rome, 1690-1699, I, pt. 2, p. 272; see also Müntz, *Etudes iconographiques*, pp. 65-74. The mosaic in the church of SS. Cosma e Damiano dates from the sixth century [see J. Wilpert, *Die römischen Mosaiken und Malereien*, Freiburg-im-Breisgau, 1917, III, pls. 102 and 103bis-107, and E. W. Anthony, *A History of Mosaics*, Boston, 1935, pp. 79-81, pl. IX], that of S. Venanzio from the seventh. The chapel of S. Venanzio is in the baptistery of St. John Lateran. [See Wilpert, *op. cit.*, II, fig. 308 on pl. 737, and III, pl. 111, and Anthony, *op. cit.*, pp. 134-135, pl. XXXI. On the iconography of St. Peter, see

Cabrol and Leclercq, *Dictionnaire*, xiv, pt. 1, 1939, cols. 935-938, and A. Penna, "Pietro," *Bibliotheca Sanctorum*, x, Rome, 1968, cols. 588-612.]

20 This is the earliest example. It goes back to the time of Galla Placidia, the fifth century.

21 It appeared for the first time on the coins of Pope Sergius III (904-911).

22 The idea of identifying St. Peter with a cleric is certainly responsible for his sometimes being represented in the twelfth century as beardless; for example, on the south portal of St.-Sernin of Toulouse (our fig. 42).

23 For the monks of Altopascio, see E. Wüscher-Becchi, "Der Grosse Gott von Schaffhausen und der Volto santo von Lucca," *Anzeiger für Schweizerische Altertumskunde*, 1 (1900), pp. 123-126. In Paris, the Altopascio monks had a house as well as the church of St.-Jacques-du-Haut-Pas. *Haut-Pas* is the French translation of Altopascio. Until today, this name has preserved the memory of the ancient pilgrimage to Rome by the Monte Bardone route. See J. Lebeuf, *Histoire de la ville et de tout le diocèse de Paris*, Paris, 1883 ed., i, p. 155; and P. Helyot, *Histoire complète et costumes des ordres monastiques religieux et militaires et des congrégations des deux sexes*, Guingamp, 1839, ii, pp. 91-95. [See A. Boinet, *Les Eglises parisiennes*, Paris, 1962, ii, pp. 173ff., with bibl.]

24 [See P. Thoby, *Le Crucifix, des origines au Concile de Trente*, Nantes, 1959, p. 109; G. Schiller, *Ikonographie der christlichen Kunst*, Gütersloh, 1968, ii, pp. 156-157; and C. Black, "The Origin of the Lucchese Cross Form," *Marsyas*, 1 (1941), pp. 27-40, pls. xiii-xvii. See also S. Pedica, *Il Volto Santo nei documenti della chiesa*, Rome, 1960.]

25 C. Cahier, ed., *Caractéristiques des saints*, Paris, 1867, i, p. 290. [P. Cannata, *Luca evangelista, Bibliotheca Sanctorum*, viii, Rome, 1966, cols. 188-222.]

26 Garrucci sketched the Christ of Lucca without the modern garments (*Storia dell'arte cristiana*, vi, Prato, 1880, pl. 432, fig. 4).

27 [On the representation of Christ in the Rabbula Gospels (Florence, Bibl. Laurenziana, Plut. 1.56, fol. 13a), see Thoby, *Le Crucifix*, pp. 24-25, pl. v, no. 11. On the representation of the clothed Christ, see M.

Trens, *Les Majestats Catalanes*, Barcelona, 1966, chaps. ii-iv.]

28 J. Bédier, *Les Légendes épiques*, Paris, 1917, ii, p. 221.

29 Pas-de-Calais. E. Soyez, *La Croix et le crucifix, Etude d'archéologie*, Amiens, 1910, p. 60, pl. iii. The Wissant pilgrimage emblem is later than the twelfth century.

30 [See D. Talbot-Rice, "The Iconography of the Langford Rood," *Mélanges René Crozet*, Poitiers, 1966, i, pp. 169-172.]

31 On the Christ of Amiens, see Soyez, *La Croix*, pp. 35-45, illus. on the frontispiece [also Thoby, *Le Crucifix*, p. 110, pl. lxxii, no. 164].

32 A. Brutails, "Notes sur quelques crucifix des Pyrénées orientales," *Bulletin archéologique du Comité des Travaux historiques et scientifiques*, 1891, p. 283, pl. xx. [See also M. Durliat, "Les Christs vêtus des Pyrénées-Orientales, Etude de leur décoration peinte," *Etudes médiévales offertes à M. le Doyen Fliche*, Montpellier, 1952, pp. 55-65; and Thoby, *Le Crucifix*, p. 110, pl. lxxi, no. 163.]

33 An analogous Christ is in the museum of Vich in Catalonia; see E. Roulin, "Orfèvrerie et émaillerie. Mobilier liturgique d'Espagne," *Revue de l'art chrétien*, 53 (1903), p. 25, fig. 1. [This cross is of metal and enamel; see also P. Thoby, *Les Croix limousines de la fin du XIIème siècle au début du XIVème siècle*, Paris, 1953, p. 161, pl. xlvii; and p. 145, pl. xli, another cross of the same type now in the Walters Art Gallery in Baltimore.]

34 The name of St. Wilgefortis probably comes from *Virgo fortis*. She was also called St. Liberata, the saint saved by God; see Cahier, ed., *Caractéristiques*, i, p. 121, and ii, p. 569. [Cf. Trens, *Les Majestats Catalanes*, pp. 42-45, and R. Van Doren, *Vilgefortis, Bibliotheca Sanctorum*, xii, Rome, 1969, cols. 1094-1099, with bibl.]

35 For the most part, these are engravings; Cahier, *op. cit.*, ii, p. 569, reproduced one [so does Trens, *op. cit.*, p. 43].

36 [Horace, *Odes*, bk. ii, no. 9; see C. E. Bennett, ed., Loeb Classical Library, London and Cambridge (Mass.), 1960, pp. 128-129.]

37 The date given in the *Legenda aurea* is 390 [p. 642; see tr. Ryan and Ripperger, *The Golden Legend*, ii, p. 579]. The earliest accounts of the miracle do not seem to go back beyond the beginning of the sixth

century. Benedictine Order, *Acta Sanctorum ordinis sancti Benedicti*, ed. J. Mabillon, Paris, 1668-1702, September, VIII, 1762, pp. 54-58. [See Cabrol and Leclercq, *Dictionnaire*, XI, pt. 1, 1933, col. 905; and A. Graf von Keyserlingk, *Vergessene Kulturen in Monte Gargano*, Nuremberg, 1968, p. 19.]

38 A. Engel and R. Serrure, *Traité de numismatique du moyen âge*, Paris, 1891, I, p. 33.

39 Paul Diacre, *De gestis Longobardorum*, bk. v, chap. XLI, in Migne, *P. L.*, 95, col. 620, n.i.

40 *Monumenta Germaniae Historica, Scriptores*, IV, Hanover, 1841, pp. 617, 849. [See also E. R. Labande, "Mirabilia Mundi, Essai sur la personnalité d'Otton III," *Cahiers de civilisation médiévale*, 6 (1963), p. 461.]

41 *Monumenta Germaniae Historica, Scriptores*, IV, p. 818.

42 Migne, *P. L.*, 121, col. 568. The monk Bernard made his pilgrimage in 870.

43 E. Bertaux, *L'Art dans l'Italie méridionale*, Paris, 1903, p. 449, fig. 185, and p. 450. [Mâle, Additions and Corrections to the 6th ed., 1953, p. 444]: *St. Michael*. Reverend Father Jerphanion thought that the Gargano St. Michael, which is not of Byzantine origin, might have derived from Coptic art. He found an ancient Coptic fabric decorated with a figure standing on a dragon; the silhouette is similar to that of the archangel. But since this figure has no wings, his hypothesis remains doubtful. See G. de Jerphanion, "L'Influence de la miniature musulmane sur un évangéliaire syriaque illustré du XIIIème siècle (Vat. Syr. 559)," *Comptes rendus de l'Académie des Inscriptions et Belles-Lettres*, 1939, pp. 483-509.

44 E. W. Schulz, *Denkmäler der Kunst des Mittelalters in Unteritalien*, Dresden, 1860, I, p. 240.

45 Ado, in his *Vetus romanum martyrologium* (29 Sept.), does not further identify him; Migne, *P. L.*, 123, cols. 368-369. But it must have been Pope Boniface III (607), or Pope Boniface IV (608). Ado said that the church was erected on the top of the circus, but as C. Baronius (*Martyrologium romanum*, Antwerp, 1589, p. 433) has shown, he confused the circus with Hadrian's circular tomb. [Cf. Cabrol and Leclercq, *Dictionnaire*, VI, pt. 2, 1925, cols. 1980-1981.]

46 Avranches, Bibl. mun., ms. 211. The translation of the Avranches manuscript, which tells of the origins of the Norman sanctuary, is found in P. Gout, *Le Mont-Saint-Michel, Histoire de l'abbaye et de la ville*, Paris, 1910, I, pp. 91-100. [See also J. Hourlier, "Les Sources écrites de l'histoire montoise antérieure à 966," *Millénaire monastique du Mont-Saint-Michel* (Bibliothèque d'histoire et d'archéologie chrétiennes), Paris, 1967, II, pp. 121-132; and J. J. G. Alexander, *Norman Illustration at Mont-Saint-Michel 966-1100*, Oxford, 1970, pp. 224-226.]

47 Robert de Torigni was abbot from 1154 until 1186. The seal is reproduced in Gout, *op. cit.*, I, p. 148, fig. 68. [See A. Dufief, "La Vie monastique au Mont-Saint-Michel pendant le XIIème siècle (1085-1186)," *Millénaire monastique du Mont-Saint-Michel*, I, pp. 102-126.]

48 It was still in use in 1328; Gout, *op. cit.*, I, p. 179, fig. 106.

49 L. Giron, *Les Peintures murales du département de la Haute-Loire (du XIème au XVIIIème siècle)*, Paris, 1911, pp. 3-5, pl. 1. [Cf. P. Deschamps and M. Thibout, *La Peinture murale en France, Le haut Moyen Age et l'epoque romane*, Paris, 1951, pp. 56ff., and O. Demus, *Romanesque Mural Painting*, New York, 1970, pp. 76, 416, fig. 106.]

50 On the aerial cult of St. Michael, see A. J. Crosnier, "Culte aérien de saint Michel," *Bulletin monumental*, 28 (1862), pp. 693-700, and J. Gauthier, "Les deux Cathédrales de Besançon," *Bulletin archéologique du Comité des Travaux historiques et scientifiques*, 1897, p. 133. [See also J. Vallery-Radot, "Notes sur les chapelles hautes dédiées à saint Michel," *Bulletin monumental*, 88 (1929), pp. 453-478.]

51 Jean Beleth, *Rationale divinorum officiorum*, chap. CLIV, in Migne, *P. L.*, 202, col. 154: *Hic quoniam in Gargano monte visus sit, ac ipse locum sibi in alto elegerit, ideo ei ubique fere terrarum in edicto loco basilica constituitur* (Since he was seen on Monte Gargano, and since he himself chose for himself a place on high, so is his church, almost everywhere in the world, built on the indicated spot).

52 Avranches, Bibl. mun., ms. 76, fol. AV, *Enarrationes in Psalmos*, Gout, *Le Mont-Saint-Michel*, I, p. 147, fig. 72. [See F. Avril, "La Décoration des manuscrits au Mont-Saint-Michel (XIème-XIIème siècle)," *Millénaire monastique du Mont-Saint-Michel*, II, pp. 215-218, with bibl., and also

Alexander, *Norman Illustration*, chap. IV, pt. I, pp. 85ff., and p. 218.]

53 The beautiful twelfth-century relief in the Louvre should not be overlooked. [Cf. M. Aubert and M. Beaulieu, *Description raisonnée des sculptures*, I. *Moyen Age*, Paris, 1950, p. 41, no. 29.]

54 P. Rajna, "Un'inscrizione Nepesina del 1131," *Archivio storico Italiano*, 4th ser., 18 (1886), pp. 329ff., and 19 (1887), pp. 23ff.

55 On this subject, see J. Bédier, *Les Légendes épiques*, II, pp. 145-293. He brings out fully the role played by pilgrim routes in the formation of legends. [A. Viscardi, *Storia letteraria d'Italia, Le origini*, 2nd ed., Milan, 1950, chap. XIV, discusses Bédier's conclusions.]

56 See P. Meyer, "De l'Expansion de la langue française en Italie pendant le moyen âge," *Atti del Congresso internazionale di scienze storiche*, Rome, 1903 (1904), IV, pp. 61-104.

57 Schulz, *Denkmäler der Kunst*, Atlas, p. 305, pl. XLV, fig. 2, and Bertaux, *L'Art dans l'Italie méridionale*, pp. 493-494, fig. 216. Drawings of the mosaics of Brindisi and Otranto, reproduced by Millin, are in the Cabinet des Estampes of the Bibl. Nat., Paris, Gb. 63. [See R. Lejeune and J. Stiennon, *La Légende de Roland dans l'art du moyen âge*, Brussels, 1966, I, pp. 97-102, and II, pls. 68-74.]

58 *Chanson de Roland*, ed. L. Gautier, Paris, 1872, I, p. 140, v. 1737ff. [*The Song of Roland*, tr. C. K. Scott Moncrieff, London, 1919, and New York, 1920.]

59 *Ibid.*, I, p. 174, v. 2184-2192.

60 *Ibid.*, I, p. 174, v. 2195-2199.

61 In the drawings, the episodes are misplaced. For an approximately correct order of the events, the scenes must be read from right to left.

62 *Chanson de Roland*, I, p. 176, v. 2200-2221.

63 P. Rajna, "Contributi alla storia dell'epopea," *Romania*, 26 (1897), pp. 56-59.

64 [Lejeune and Stiennon, *La Légende de Roland*, I, pp. 97-102.]

65 The letter A is interlaced with the letter L.

66 A. K. Porter, *Lombard Architecture*, New York, repr. ed. 1967, III, pp. 464-465. [This interpretation is questioned by Lejeune and Stiennon, *op. cit.*, pp. 78-82.]

67 [See Lejeune and Stiennon, *op. cit.*, I, pp. 61-71, and II, pls. 35-44, who identify another Roland representation on the façade of S. Zeno at Verona (*op. cit.*, I, pp. 73-75, and II, pls. 45-46).]

68 E. Faral, *Les Jongleurs en France au moyen âge*, Paris, 1910, chaps. II-III, pp. 25-60.

69 Bertaux, *op. cit.*, p. 491, fig. 215 [Lejeune and Stiennon, *op. cit.*, I, p. 101].

70 [R. Jullian, *L'Eveil de la sculpture italienne, La sculpture romane dans l'Italie du Nord*, Paris, 1945, p. 116 n. 3, also identifies Oliver and Roland in the tower of the cathedral of Modena. Lejeune and Stiennon, *op. cit.*, I, p. 105, and II, pls. 75-77, distinguish two representations of Roland, one with a sword, the other with a horn, and a representation of Gawain.]

71 The *Roman de Lancelot* dates from the early thirteenth century, while the Modena relief was carved about 1160. The sculptor and the writer were both inspired by stories that are now lost. Here are the names carved by the Modena sculptor beside the heroes of his epic: the two figures who appear above the walls of the castle are Winlogee and Mardoc. In the romance, neither the young girl who is so sympathetic to Gawain in prison nor the mother of Caradoc is called by name. Winlogee is Guineloie. In the *Chevalier aux deux épées* (v. 88ff., ed. W. Förster, Halle, 1877), it is said expressly that Guineloie was the friend of Gawain:

Mademoiselle Guineloie
ki loiaus, drue et fine amie
A mon seignor Gauvain estoit.

The dwarf who comes out of the castle is called Burmaitus, according to W. Förster's reading ["Ein neues Artus-dokument," *Zeitschrift für romanische Philologie*, 22 (1898), pp. 243ff.], and Durmaltus, according to Colfi ["Di una interpretazione data alle sculture dell'arcivolta nelle porta settentrionale del duomo di Modena," *Atti e Memorie della R. Deputazione di Storia Patria per le provincie modenesi*, 4th ser., 9 (1899), pp. 133ff.]. The photograph reproduced by C. Martin, *L'Art roman en Italie*, Paris, 1912, I, pl. 47, shows that the name carved in the stone is Burmaltus. The other names are Artus de Bretania, Isdernus (Idier), Carrado, Galvagin (Gawain), Galvarium (unknown knight), and Che (the senechal Keu). [More recent scholars have identified this scene as an episode of the deliverance of Queen Guenievre (= Winlogee or Guineloie); see R. S. Loomis, *Arthurian Legends in the Medieval Art*, London and New

York, 1938, p. 34, and *idem, Arthurian Literature in the Middle Ages,* Oxford, 1959, pp. 60-61; R. Lejeune and J. Stiennon, "La Légende arthurienne dans la sculpture de la cathédrale de Modène," *Cahiers de civilisation médiévale,* 6 (1963), p. 290, and *idem, La Légende de Roland,* I, chap. II.]

72 A. Venturi, *Storia dell'arte italiana,* III, Milan, 1904, pp. 428, 436. In the Pesaro mosaic, there are very old sections that may go back to antiquity; but there are others which date only from the twelfth century. Near the abduction of Helen, we see the medieval Bestiary.

73 The romance of Benoît de Sainte-Maure was very popular in Italy. Six copies in an Italian hand exist in libraries; Meyer, *De l'Expansion de la langue française,* p. 72. [See, for the illustrated manuscripts, H. Buchthal, *Miniature Painting in the Latin Kingdom of Jerusalem,* Oxford, 1967, pp. 68-69 and ff.]

74 On the antique sources of French poems about Alexander, see P. Meyer, *Alexandre le Grand dans la littérature française du moyen âge,* Paris, 1886, I, pp. 1-132 [and also D. J. A. Ross, *Alexander Illustratus, A Guide to Medieval Illustrated Alexander Literature,* London, The Warburg Institute, 1963].

75 [On the theme of Alexander's flight, see G. de Francovich, *Benedetto Antelami, architetto e scultore e l'arte del suo tempo,* Milan and Florence, 1952, pp. 347-353, with bibl.; and also "Alexander der Grosse," *Reallexikon zur deutschen Kunst,* I, Stuttgart, 1937, cols. 334-344; H. P. L'Orange, *Studies in the Iconography of Cosmic Kingship,* Oslo and Cambridge (Mass.), 1953, pp. 118ff.]

76 G. Migeon, *Manuel d'art musulman, Arts plastiques et industriels,* 2nd ed., Paris, 1927, pp. 20-21, fig. 223. The enamel dates from 1148.

77 Italian libraries possess three copies of the French *Roman d'Alexandre* written by Italian hands; Meyer, *De l'Expansion de la langue française,* p. 72. [Cf. Ross, *Alexander Illustratus,* p. 11.]

78 Porter, *Lombard Architecture,* II, p. 191, "Berta che filava." [Cf. Jullian, *L'Eveil de la sculpture italienne,* p. 135 n. 1, who supports Mâle's interpretation, and also Lejeune and Stiennon, *La Légende de Roland,* I, p. 158.]

79 There is the scene of Alexander mounting to the sky at S. Marco of Venice.

80 Bédier, *Les Légendes épiques,* II, p. 206. [See Lejeune and Stiennon, *op. cit.,* I, pp. 153-160, esp. p. 154; and cf. pp. 156-157, where the authors identify the scene with the Roland cycle as a representation of the story of Bertha and Milo from the Childhood of Roland.]

81 The tympanum is now in the museum of Turin. [See L. Mallé, *Le Sculture del museo d'arte antica,* Turin, 1965, p. 80 and pl. 20.]

82 This tympanum is now in the sacristy of the church. [See Jullian, *L'Eveil de la sculpture italienne,* p. 285.]

83 They were destroyed in the eighteenth century. [See W. Sauerländer, *Gotische Skulptur in Frankreich 1140-1270,* Munich, 1970, pp. 63-65.]

84 Perhaps the Wheel of Fortune at S. Zeno in Verona should be attributed to him because of its close resemblance to that of St.-Etienne of Beauvais. [Porter, *Lombard Architecture,* III, p. 537, attributes this to the Master of Brioloto, rather than to Niccolo. Cf. G. H. Crichton, *Romanesque Sculpture in Italy,* London, 1954, pp. 83, 92, and pl. 47, who follows Porter's attribution.]

85 I pointed out these resemblances in "L'Architecture et la sculpture en Lombardie à l'époque romane, A propos d'un livre récent," *Gazette des beaux-arts,* 14 (1918), pp. 35-46. [On the question of priorities between Italian and French Romanesque sculpture, see, e.g., A. K. Porter, "Bari, Modena and St.-Gilles," *Burlington Magazine,* 43 (1923), pp. 58-67; T. Krautheimer-Hess, "Die figurale Plastik der Ostlombardei von 1100 bis 1178," *Marburger Jahrbuch für Kunstwissenschaft,* 4 (1928), pp. 231-307; G. de Francovich, *Benedetto Antelami, passim,* who reviews the whole question; and R. Salvini, *Wiligelmus e le origini della scultura romanica,* Milan, 1956, chap. III, pp. 41ff.]

CHAPTER VIII

1 [See M. Durand-Lefèbvre, *Art gallo-romain et sculpture romane, Recherches sur les formes,* Paris, 1937, pp. 182-183; and also F. Benoît, *L'Art primitif méditerranéen de la vallée du Rhône,* Paris, 1945, pp. 13-14, pl. I.]

2 Guibert de Nogent, *De vita sua sive mono-diarum*, bk. I, chap. XVI, in Migne, *P. L.*, 156, col. 871.

3 [On the tunic of the Virgin and its importance for the Chartres pilgrimage, see E. Mâle, *Notre-Dame de Chartres*, 2nd ed., Paris, 1963, pp. 9-10.]

4 R. Merlet, "La Cathédrale de Chartres et ses origines à propos de la découverte du puits des Saints-Forts," *Revue archéologique*, 3rd ser., 41 (1902), pp. 232-241. The ancient writers of Chartres never spoke of this statue; neither did they attribute an excessive age to the church of Chartres. It is only in a document dating from 1322 that it was said, for the first time, that the church of Chartres had been built in honor of the Virgin *in her lifetime*. See M. Jusselin, "Les Traditions de l'eglise de Chartres," *Mémoires de la Société Archéologique d'Eure-et-Loir*, 15 (1915-1922), p. 20 [and Mâle, *Notre-Dame de Chartres*, pp. 7-8].

5 *Liber miraculorum Sanctae Fidis*, ed. A. Bouillet, Paris, 1897, bk. I, chap. XIII, p. 47.

6 I have made this comparison in *Art et artistes du Moyen Age*, Paris, 1927, chap. VIII, pp. 188-208 (repr. Paris, 1968, pp. 140-152). [See also Mâle, *Notre-Dame de Chartres*, pp. 29-30, and W. Sauerländer, "Die kunstgeschichtliche Stellung des Westportale von Notre-Dame in Paris," *Marburger Jahrbuch für Kunstwissenschaft*, 17 (1959), pp. 1ff.; A. Katzenellenbogen, *The Sculptural Programs of Chartres Cathedral*, Baltimore, 1959, pp. 7-24.]

7 The head of the child is modern [as is also his right hand with the ball]. The Virgin is beneath a ciborium that is very much like that of Notre-Dame of Paris. This ciborium once existed at Chartres; the base of one of its columns can be seen beside the Virgin. [See P. Mesplé, *Toulouse, Musée des Augustins, les sculptures romanes*, Paris, 1961, no. 83; and A. K. Porter, *Romanesque Sculpture of the Pilgrimage Roads*, Boston, 1923, pp. 243-247, pl. 479, who believes that this theme derives from the Beaucaire tympanum of the Adoration of the Magi; cf. R. Hamann, *Die Abteikirche von St.-Gilles und ihre künstlerische Nachfolge*, Berlin, 1955, pp. 263 and 366.]

8 The names of Saints Agricol and Vital were preserved, but placed after that of the Virgin.

9 *Benedictine Order, Acta Sanctorum ordinis sancti Benedicti*, ed. J. Mabillon, Paris, 1668-1702, January, I, sanctus Bonitus (*Miracula casulae beatae Virginis*).

10 L. Bréhier, *Etudes archéologiques*, Clermont-Ferrand, 1910, pp. 34-42; [cf. *idem*, *L'Art chrétien, son developpement iconographique des origines à nos jours*, 2nd ed., Paris, 1928, p. 240 and fig. 126]. All the texts relating to the statue are brought together. A text more recently discovered by Bréhier proves that the statue was of gold. [See E. Mâle, "La Vierge d'or de Clermont et ses repliques," *Le Point*, 25 (June 1943), pp. 4-10; cf. I. H. Forsyth, "Magi and Majesty: a Study of Romanesque Sculpture and Liturgical Drama," *Art Bulletin*, 50 (1968), pp. 215ff.]

11 The principal Auvergnat Virgins are those of Orcival, St.-Nectaire, Mailhat, Marsat (Puy-de-Dôme), Brioude (now in the Rouen Museum), Saugues, Ste.-Marie-des-Chazes, Notre-Dame-des-Tours (Haute-Loire), Bredons, Molompize (Cantal), Chappes, Meillers (Allier). Marquis de Fayolle, "Le Trésor de l'église de Saint-Nectaire," *Congrès archéologique*, 62 (1895), pp. 292ff.; F. Fabre, A. Achard, and N. Thiollier, "Cinq Statues en bois du XIIème et du XIIIème siècle dans la Haute-Loire," *Congrès archéologique*, 71 (1904), pp. 564ff. [See also Mâle, "La Vierge d'or," pp. 4-10; L. Bréhier, "Vierges romanes d'Auvergne," *Le Point*, 25 (June 1943), pp. 10-33. These statues are illustrated in B. Craplet, *Auvergne romane* (ed. Zodiaque), La-Pierre-qui-vire, 1955, pls. 17 (Orcival), 23 (St.-Nectaire), 19 (Mozat).]

12 I have indicated what the cathedral of Le Puy owes to the imitation of the Arab art of Spain in two chapters of *Art et artistes du moyen âge*, Paris, 1927, pp. 33-35 and 60-66. [Repr. Paris, 1968, pp. 33-39 and 55-67. This question is discussed further by A. Fikry, *L'Art roman du Puy et les influences islamiques*, Paris, 1934, and also by H. Focillon, *The Art of the West in the Middle Ages*, London, 1963, I, p. 83; cf. K. J. Conant, *Carolingian and Romanesque Architecture* (The Pelican History of Art), Harmondsworth and Baltimore, 1959, pp. 104-105.]

13 Dr. Bachelier studied this question carefully. The ashes of the statue burned in 1794 were

taken to a field where a stone on which there are Isiac figures that had come from the statue was later found.

14 The Black Virgin of La Daurade at Toulouse could also very well be an imitation of the Virgin of Le Puy, for it probably is not earlier than the fourteenth century; Abbé Degert, "Origine de la Vierge Noire de la Daurade," *Bulletin de la Société Archéologique du Midi de la France*, 14 (1903), pp. 355-358.

15 P. F. Fita and J. Vinson, *Le Codex de Saint-Jacques de Compostelle*, Paris, 1882. There is an excellent edition, with translation, by J. Vielliard, *Le Guide du pèlerin de Saint-Jacques de Compostelle*, Mâcon, 1938 (3rd ed. 1963). [Cf. the complete publication of this codex by W. M. Whitehill, *Liber sancti Jacobi, Codex Callixtinus*, Santiago de Compostela, 1944, I: Text, II: Music reproduction and transcription; and also E. Mâle, "Saint Jacques le Majeur," *Centre International d'Etudes Romanes*, 1957, pp. 4-26; reprinted in Mâle, *Les Saints compagnons du Christ*, Paris, 1958, pp. 135-168; W. F. Starkie, *The Road to Santiago*, New York, 1957, pp. 13-77.]

16 We have supplemented the indications in the pilgrim guide, which are scanty after Gascony, by the work of modern scholars, notably A. Lavergne, *Les Chemins de Saint-Jacques en Gascogne*, Bordeaux, 1887; J. E. Dufourcet, "Les Voies romaines et les chemins de Saint-Jacques dans l'ancienne Novempopulanie," *Congrès archéologique*, 55 (1888), pp. 241-264; C. Daux, *Le Pèlerinage de Compostelle et la confrérie de Mgr. saint Jacques à Moissac*, Paris, 1898. [See also Porter, *Romanesque Sculpture*, I, pp. 179-184; L. Vázquez de Parga, J. M. Lacarra and J. Uría Ríu, *Las Peregrinaciones a Santiago de Compostela*, I, Madrid, 1948, pp. 171-461, and II, Madrid, 1949, *passim*; E. Lambert, *Le Pèlerinage de Compostelle, Etudes d'histoire médiévale*, Toulouse, 1959, 4, pp. 33-49 and pp. 81-115; Y. Bottineau, *Les Chemins de Saint-Jacques*, Paris and Grenoble, 1964, pp. 65-124; catalogue of the exhibition *Pèlerins et chemins de Saint-Jacques en France et en Europe*, Paris, 1965. V. and H. Hell, introd. by Sir Thomas Kendrick, *The Great Pilgrimage of the Middle Ages, The Road to St.-James of Compostela*, New York, 1966.]

17 L. Duchesne, "Saint-Jacques en Galice," *Annales du Midi*, 12 (1900), pp. 145-158. [See K. J. Conant, *The Early Architectural History of the Cathedral of Santiago de Compostela*, Cambridge (Mass.), 1926, pp. 3-10; R. Menéndez Pidal, *Historia de España*, Madrid, 1935-1940, VI, pp. 51-57; Vázquez de Parga, Lacarra, and Uría Ríu, *Las Peregrinaciones a Santiago de Compostela*, I, pp. 9-36; Bottineau, *Les Chemins de Saint-Jacques*, pp. 15-32; J. S. Stone, *The Cult of Santiago*, New York, 1927, pp. 1-182.]

18 *Vix patebat liber callis* (The way was hardly ever free); H. Florez, *España Sagrada, theatro geographico-historico de la Iglesia de España*, XX (Historia Compostelana), Madrid, 1765, bk. II, chap. XLIX, p. 349.

19 The finest example of the "Book of St. James" is now in the chapter library at Compostela. It was written after 1139 [cf. Whitehill, *Liber sancti Jacobi*].

20 For an extensive study of the "Book of St. James," see J. Bédier, *Les Légendes épiques*, III, Paris, 1912, pp. 75-114. [Cf. a fundamental analysis by P. David, "Etudes sur le Livre de saint Jacques attribué à Callixte II," *Bulletin des études portugaises*, 10 (1946), pp. 1-41; 11 (1947), pp. 113-185; 12 (1948), pp. 1-154; cf. C. Meredith-Jones, *Historia Karoli Magni et Rotholandi ou Chronique de Turpin*, Paris, 1936, pp. 5-84; M. Défourneaux, *Les Français en Espagne aux XIème et XIIème siècles*, Paris, 1949, pp. 79-102; Vielliard, *Le Guide du Pèlerin*, pp. ix-xiii; Whitehill, *Codex Calixtinus*, III, *Estudios*, pp. xiii-lxxv.]

21 [Bédier's thesis (*op. cit.*) that the "Book of St. James" was composed by Cluniac monks has been contested by Lambert, *Le Pèlerinage de Compostelle*, p. 22.]

22 [On the role of Cluny in the organization of the pilgrimage, see Porter, *Romanesque Sculpture*, pp. 174-177; Starkie, *The Road to Santiago*, esp. pp. 32-36. The part played by the other orders (e.g., the Augustinians) in this development is pointed out by Lambert, *Le Pèlerinage de Compostelle*, pp. 22-29.]

23 E. Petit, "Croisades bourguignonnes contre les Sarrazins d'Espagne au XIème siècle, Les princes de la Maison de Bourgogne fondateurs des dynasties espagnoles et portugaises," *Revue historique*, 30 (1886), pp. 259-272. [Cf. P. Boissonade, *Du Nouveau*

sur la Chanson de Roland, La genèse historique, le cadre géographique, le milieu, les personnages, la date et l'auteur du poème, Paris, 1923, pp. 1-68, and Défourneaux, *op. cit.,* pp. 125-193.]

24 [See Porter, *Romanesque Sculpture,* p. 214 nn. 1-2; R. Rey, *La Sculpture roman languedocienne,* Toulouse and Paris, 1936, pp. 50-60; G. Gaillard, *Les Débuts de la sculpture romane espagnole: Léon, Jacca, Compostelle,* Paris, 1938, pp. 209-211.]

25 *Le Codex de Saint-Jacques de Compostelle,* ed. Fita and Vinson, chap. ix, 5-6, pp. 49-50; Vielliard, *Le Guide du pèlerin,* pp. 94-97; [Whitehill, *Codex Calixtinus,* i, bk. iv, chap. ix, p. 379 (Spanish tr. pp. 557-558)].

26 Another archaic feature: with the exception of St. Peter, St. Paul, and St. James the Greater, the apostles have no attributes. [Cf. Porter, *Romanesque Sculpture,* p. 253, pls. 490-491; and F. Salet, "Mimizan," *Congrès archéologique,* 102 (1939), p. 338.]

27 He was also shown with his staff (now broken) on the portal at Dax, which was on one of the routes to Santiago. [See Mâle, *Les Saints compagnons du Christ,* pp. 167-168; L. Réau, *Iconographie de l'art chrétien,* iii,2, *Iconographie des saints,* Paris, 1958, pp. 690-702; Bottineau, *Les Chemins de Saint-Jacques,* pp. 200-204.]

28 This itinerary can be found in Abbé Cirot de La Ville, *Histoire de l'abbaye et congrégation de Notre-Dame de la Grande Sauve, ordre de saint Benoît, en Guienne,* Paris and Bordeaux, 1844, i, pp. 504-514.

29 See L. Drouyn, *Album de la Grande-Sauve,* Bordeaux, 1851. [For the chevet statues of the church of St. Peter of La Sauve-Majeure, see A. Masson, "La Sauve Majeure," *Congrès archéologique,* 102 (1939), pp. 235-236.]

30 *Beatus Jacobus residet in medio* (St. James is seated in the middle), *Codex de Saint-Jacques de Compostelle,* ed. Fita and Vinson, chap. ix, 14, p. 57; [Vielliard, *Le Guide du pèlerin,* p. 112; Whitehill, *Codex Calixtinus,* i, bk. iv, chap. ix, p. 385 (Spanish tr. p. 568)].

31 P. F. Fita and D. A. Fernandez-Guerra, *Recuerdos de un viaje a Santiago de Galicia,* Madrid, 1880, pp. 78-79. There is a reproduction of the statue.

32 The documents were published by H. Bordier, "La Confrérie de Saint-Jacques-aux-Pèlerins," *Mémoires de la Société de l'His-*

toire de Paris et de l'Ile-de-France, 2 (1876), pp. 349-351.

33 Seated statue of St. James at Notre-Dame of Verneuil [illus. Bottineau, *Les Chemins de Saint-Jacques,* p. 199]. In the sixteenth century, medals of the confraternity of St.-Jacques-de-la-Boucherie still represented St. James as seated; A. Forgeais, *Collection de plombs historiés trouvés dans la Seine,* 3rd ser., *Variétés numismatiques,* Paris, 1864, p. 104.

34 Window of Notre-Dame-en-Vaux at Châlons-sur-Marne [see J. Lafond, *Le Vitrail français,* Paris, 1958, p. 219 and p. 322 n. 36].

35 [On the chronology of the construction of St.-Sernin at Toulouse, see M. Durliat, "La Construction de Saint-Sernin de Toulouse au XIème siècle," *Bulletin monumental,* 121 (1963), pp. 151-170; cf. Conant, *Carolingian and Romanesque Architecture,* pp. 91-103.]

36 There is only one difference: the nave of Conques has single instead of double side aisles. [See Conant, *loc. cit.;* M. Deyres, "La Construction de l'abbatiale Sainte-Foy de Conques," *Bulletin monumental,* 123 (1965), pp. 7-23; G. Gaillard, "Une Abbaye de pèlerinage: Sainte-Foy de Conques et ses rapports avec Saint-Jacques," *Compostellanum,* 10 (1965).]

37 The old tribunes are clearly visible in the transept. [Cf. F. Deshoulières, "Figeac, L'église Saint-Sauveur," *Congrès archéologique,* 101 (1938), pp. 9ff.]

38 C. de Lasteyrie, *L'Abbaye Saint-Martial de Limoges,* Paris, 1901. [E. Lambert, "L'Ancienne église abbatiale de Saint-Martial de Limoges," in the exhibition catalogue, *L'Art roman à Saint-Martial de Limoges, Les manuscrits à peintures, Historique de l'abbaye, La basilique,* Limoges, 1950, pp. 27-42.]

39 As at Conques, the nave has single side aisles.

40 [See Conant, *Santiago de Compostela,* pp. 13-35; *idem, Carolingian and Romanesque Architecture,* pp. 99-103; Lambert, "Le Pèlerinage de Compostela," pp. 141-157.]

41 Along with the plan of the church, there is an engraved view of its ruins in C. de Grandmaison, *Tours archéologique, Histoire et monuments,* Paris, 1879, pp. 51, 57; [see also illus., Bottineau, *Les Chemins de Saint-Jacques,* p. 220].

42 C. de Grandmaison, "Résultats des fouilles de Saint-Martin de Tours en 1886," *Biblio-*

thèque de l'Ecole des Chartes, 54 (1893), pp. 3-13. [C. K. Hersey, "The Church of St.-Martin at Tours (903-1150)," *Art Bulletin*, 25 (1943), pp. 1-39; F. Lesueur, "Saint-Martin de Tours et les origines de l'art roman," *Bulletin monumental*, 107 (1949), pp. 7-84; M. Vieillard-Troiekouroff, "Les Sculptures et objets préromans retrouvés dans les fouilles de 1860 et de 1886 à Saint-Martin de Tours," *Cahiers archéologiques*, 13 (1962), pp. 85-118. On the origin of the ambulatory, see E. Gall, "Chorumgang," *Reallexikon zur deutschen Kunstgeschichte*, III, Stuttgart, 1954, cols. 575-589; *idem*, "Chor," *ibid.* cols. 491-493.]

43 Abbé Plat, "La Touraine, berceau des écoles romanes du Sud-Ouest," *Bulletin monumental*, 77 (1913), pp. 351-352.

44 K. M. Kaufman, *Die Menasstadt und das Nationalheiligtum der altchristlichen Aegypter in der Westalexandrinischen Wüste, Ausgrabungen der Frankfurter Expedition am Karm Abu Mina, 1905-1907*, Leipzig, 1910, I, p. 67 [cf. plan reproduced in Gall, "Chor," col. 491].

45 [This thesis was challenged by Porter, *Romanesque Sculpture*, pp. 193-194, and M. Gómez-Moreno, *El arte románico español*, Madrid, 1934. Their arguments have been thoroughly refuted by G. Gaillard, "Les Commencements de l'art roman en Espagne," *Bulletin hispanique*, 37 (1935), pp. 273-308, and *idem, Les Débuts de la sculpture romane espagnole*, pp. xxvi-xxxii. See also R. Crozet, "Remarques sur les relations artistiques entre la France du Sud-Ouest et le Nord de l'Espagne à l'époque romane," *Actes du 19ème Congrès International d'Histoire de l'Art*, Paris, 8-13 Sept. 1958 (Paris, 1959), pp. 62-71; cf. Conant, *Carolingian and Romanesque Architecture*, pp. 91-103; Bottineau, *Les Chemins de Saint-Jacques*, pp. 205-223. See also Focillon, *The Art of the West*, I, pp. 95-96, and J. Gudiol Ricart and J. A. Gaya Nuño, *Arquitectura y escultura románicas* (Ars Hispaniae, V), Madrid, 1948, pp. 209-212.]

46 The excavations of 1937 uncovered this ambulatory with radiating chapels. [See G. Chenesseau, "Les Fouilles de la cathédrale d'Orléans (sept.-déc. 1937)," *Bulletin monumental*, 90 (1957), p. 205.]

47 The cathedral of Clermont, consecrated by Bishop Etienne II in 946, had an ambulatory with radiating chapels, as the excavations in the crypt show. This ambulatory derived from the first ambulatory of St.-Martin of Tours, which was much earlier than that of Hervé [see M. Vieillard-Troiekouroff, "La Cathédrale de Clermont du Vème au XIIIème siècle," *Cahiers archéologiques*, 11 (1960), pp. 199-247].

48 [See P. Deschamps, "Notes sur la sculpture romane en Languedoc et dans le nord de l'Espagne," *Bulletin monumental*, 82 (1923), pp. 305-351; A. K. Porter, "Spain or Toulouse," *Art Bulletin*, 7 (1924), pp. 3-25; see also Focillon, *The Art of the West*, I, pp. 120-124; and Gaillard, *Les Débuts de la sculpture romane espagnole*, pp. 225-234, and *passim*.]

49 This is a Virgin, now in the archeological museum of Madrid. [See A. K. Porter, *Spanish Romanesque Sculpture* (Pantheon), Florence and Paris, 1928, I, p. 60, pl. 46; Gudiol Ricart and Gaya Nuño, *Arquitectura y escultura románicas*, p. 197, fig. 326.]

50 [See W. L. Hildburgh, *Medieval Spanish Enamels*, London, 1936, chap. II, pp. 10ff.; cf. Bottineau, *Les Chemins de Saint-Jacques*, pp. 249-259; and M. M. Gauthier, "Le Frontal limousin de San Miguel in Excelsis," *Art de France*, 3 (1963), pp. 40-61.]

51 [On the influence of the ateliers of the Ile-de-France and Champagne on the cathedral of Poitiers, see E. Maillard, "Les Sculptures de la façade occidentale de la cathédrale de Poitiers," *Gazette des beaux-arts*, 62 (1920), pp. 289-308, and A. Mussat, *Le Style gothique de l'Ouest de la France (XIIème-XIIIème siècles)*, Paris, 1963, p. 262.]

52 The figure of Christ has disappeared. [For the north transept portal of the cathedral of Dax, see F. Salet, "Dax, Cathédrale," *Congrès archéologique*, 102 (1939), pp. 386-390.]

53 The third portal is dedicated to St. Peter. [See J. Vallery-Radot, "Bazas, Cathédrale," *Congrès archéologique*, 102 (1939), pp. 292-300.]

54 [See J. Gardelles, *La Cathédrale Saint-André de Bordeaux, sa place dans l'évolution de l'architecture et de la sculpture*, Bordeaux, 1963, pp. 141-171.]

55 [See, for the influence of the Franco-champenois ateliers upon the cathedrals of Bayonne, Burgos, and León; E. Lambert, *L'Art gothique en Espagne aux XIIe et XIIIe siècles*, Paris, 1931, pp. 232-257; F. B. Decknatel, "The Thirteenth-Century Gothic

Sculpture of the Cathedrals of Burgos and Léon," *Art Bulletin*, 17 (1935), pp. 243-389; Focillon, *The Art of the West*, II, pp. 58-60; A. Duran Sanpere and J. Ainaud de Lasarte, *Escultura gotica* (Ars Hispaniae, VIII), Madrid, 1953, pp. 15-63. Cf. H. Mahn, *Kathedralplastik in Spanien, Die monumentale Figuralskulptur in (Alt-) Kastilien, Leon und Navarra zwischen 1230 und 1380* (Tübingen Forschungen zur Archäologie und Kunstgeschichte, XV), Reutlingen, 1931.]

56 E. Jarossay, *Histoire d'une abbaye à travers les siècles, Ferrières-en-Gâtinais ordre de saint Benoît (508-1790), son influence religieuse, sociale et littéraire d'après les documents inédits tirés des archives publiques et privées*, Orléans, 1901, pp. 11-40.

57 *Monumenta Germaniae Historica, Scriptores*, II, Hanover, 1829, pp. 758, 616 n. i.

58 The monk of St.-Gall relates the episode, but does not say where it took place. It was the Astronome Limousin who placed the scene at Ferrières. On this subject, see G. Paris, "La Légende de Pépin 'le Bref,'" *Mélanges Julien Havet*, Paris, 1895, pp. 608-609.

59 Bédier, *Les Légendes épiques*, IV, pp. 121-156. [Bédier's theories are discussed by M. de Riquer, *Les Chansons de geste françaises*, 2nd ed., Paris, 1957, pp. 194-207. For the *chanson, Le Pèlerinage de Charlemagne*, a text from the middle of the twelfth century, see J. Horrent, *Le Pèlerinage de Charlemagne* (Bibliothèque de la Faculté de Philosophie et Lettres de l'Université de Liège, fasc. CLVIII), Paris, 1961, with bibl.]

60 B. de Montfaucon, *Les Monumens de la monarchie françoise*, I, Paris, 1729, p. 277, pl. XXII. [See R. Lejeune and J. Stiennon, *La Légende de Roland*, Brussels, 1966, I, p. 46; and Y. Delaporte and E. Houvet, *Les Vitraux de la cathédrale de Chartres*, Chartres, 1926, pp. 313-319 and pls. CVI-CX.]

61 Bédier, *Les Légendes épiques*, II, pp. 299-334. Benoît, Ogier's companion, became his page in the epic poem. [Cf. R. Lejeune, *Recherches sur le thème: les chansons de geste et l'histoire* (Bibliothèque de la Faculté de Philosophie et Lettres de l'Université de Liège, fasc. CVIII), Liège, 1948, pp. 45-195.]

62 Insofar as we can judge from the drawing in J. Mabillon, ed., *Acta Sanctorum ordinis sancti Benedicti*, IV,1, Paris, 1677, p. 664, the work must date from about 1180. The iconography, certain details of the costumes, and the style (which we glimpse) seem to indicate this date. [See also a drawing of 1742, in Paris, Bibl. Nat., coll. Champagne, XIX, fol. 127, illus. A. Lapeyre, *Des Façades occidentales de Saint-Denis et de Chartres aux portails de Laon*, Paris, 1960, pp. 232 and 298, and pp. 231, 233. See also Lejeune and Stiennon, *La Légende de Roland*, I, pp. 161-168; II, pls. 140-142.]

63 Dom Toussaint Du Plessis, *Histoire de l'église de Meaux*, Paris, 1731, I, p. 77.

64 At Meaux, there is a fine twelfth-century head of a monk which, according to M. Gassies, came from the tomb of Ogier ("Note sur une tête de statue trouvée à Meaux," *Bulletin archéologique du Comité des Travaux historiques et scientifiques*, 1905, pp. 40-42, pl. VI). The style of this head seems to me too archaic for it to have belonged to a figure on this tomb. Moreover, its eyes are open, while Ogier and Benedict (to go back to Mabillon's drawing) were represented with eyes closed. [Cf. J. Hubert, in *Bulletin de la Société Nationale des Antiquaires de France*, 1945-1947, pp. 253, 307 n. 2.]

65 G. Daniel, *Histoire de France depuis l'établissement de la monarchie françoise dans les Gaules*, new ed., I, Paris, 1722, pp. 417-418. [On the monuments of Roncevaux, see Lambert, *Le Pèlerinage de Compostelle*, pp. 176-198.]

66 Bédier, *Les Légendes épiques*, III, p. 169. [For the Roncevaux frescoes, now destroyed, see Lambert, *op. cit.*, pp. 187-188, and Lejeune and Stiennon, *La Légende de Roland*, I, pp. 365-366.]

67 *La chanson de Roland*, ed. Gautier, v. 2160-2163, pp. 204-205 [cf. Scott Moncrieff, English tr., London, 1919].

68 In a brochure entitled *Roland ou les sculptures de Notre-Dame-de-la-Règle* (reprint from *Bulletin de la Société Archéologique et Historique du Limousin*, 37, 1890, pp. 137-141), Abbé Arbellot stated without reservation that this figure represented Roland. [This interpretation is supported by Lejeune and Stiennon, *La Légende de Roland*, I, pp. 87-88; II, pls. 56, 58.]

69 [See J. C. Fau, *Les Chapiteaux de Conques*, Toulouse, 1956, pp. 57-62, and Lejeune and

Stiennon, *op. cit.*, I, pp. 19-24; II, pls. 1-6. For Brioude, see *ibid.*, I, pp. 94-95, and II, pl. 65.]

70 On a capital of the left portal.

71 [For the interpretation of the Angoulême lintel, see Lejeune and Stiennon, *op. cit.*, I, pp. 29-42; II, pls. 12-19. For the frescoes of Le Puy, see *ibid.*, I, pp. 121-122 and 366, and F. Enaud, "Peintures murales découvertes dans une dépendance de la cathédrale du Puy-en-Velay (Haute-Loire), Problèmes d'interprétation," *Les Monuments historiques de la France*, 1968, no. 4, pp. 43-47.]

72 Abbé Barrère, *Histoire religieuse et monumentale du diocèse d'Agen*, Agen, 1855, I, pp. 141-143, thought that these capitals represented the story of Duc Renowald and his wife. Such an explanation must be rejected. [See Rey, *La Sculpture romane languedocienne*, pp. 360-361, who shows that the capital represents soldiers from the Massacre of the Innocents.]

73 Bédier, *Les Légendes épiques*, IV, p. 218.

74 See Daux, *Le Pèlerinage de Compostelle et la confrérie de Mgr. saint Jacques à Moissac*, pp. 162-163. The pilgrims from Moissac sometimes went by way of Agen to Sauve-Majeur or Bordeaux.

75 C. Cahier, *Nouveaux mélanges d'archéologie, d'histoire et de littérature sur le moyen âge*, Paris, 1874, p. 214. [Cf. V. H. Debidour, *Le Bestiaire sculpté en France*, Paris and Grenoble, 1961, p. 266, fig. 378.]

76 Moreover, the *Pèlerinage de Renart*, which forms part VIII of the *Roman*, did not appear before 1190; see L. Foulet, *Le Roman de Renart*, Paris, 1914, pp. 118, 434-438. The capitals at Amboise seem to be earlier than this date.

77 A. Duchalais, "Le Rat employé comme symbole dans la sculpture du moyen âge," *Bibliothèque de l'Ecole des Chartes*, 2nd ser., 4 (1847-1848), p. 230 [Debidour, *op. cit.*, pp. 88, 96, 246, with illus.].

78 *Roman de Renart*, v. 6088-6104 [M. Roques, *Le Roman de Renart, branches VII-IX*, Paris, 1955, pp. 17-18].

79 P. Meyer, *Le Roman de Flamenca*, Paris, 1865, pp. 277-286.

80 Grandmaison, *Tours archéologique*, p. 54. [See H. Focillon, "Apôtres et jongleurs, Etudes de mouvement," *Revue de l'art ancien et moderne*, 1921, no. 1, pp. 13-28.]

CHAPTER IX

1 The best guide to this subject is the great work by P. Duhem, *Le Système du monde, Histoire des doctrines cosmologiques de Platon à Copernic*, Paris, 1913-1959, 10 vols. [See R. Taton, ed., *Ancient and Medieval Science*, London, 1963, cf. pt. III; see also A. C. Crombie, *Augustine to Galileo*, London, 1952.]

2 [See Macrobius, *Commentary on the Dream of Scipio*, ed. and tr. W. H. Stahl, New York, 1922. See also R. Klibansky, *The Continuity of the Platonic Tradition during the Middle Ages*, London, 1950; and H. R. Patch, *The Tradition of Boethius*, New York, 1935.]

3 Boethius, *De musica*, bk. I, chap. 2, in Migne, *P. L.*, 63, cols. 1171-1172 [cf. Stahl, *op. cit.*, pp. 185ff.].

4 [F. Saxl, "Macrocosm and Microcosm in Mediaeval Pictures," in *Lectures*, Warburg Institute, London, 1957, pp. 58-72.]

5 Honorius of Autun, *De imagine mundi*, bk. I, chaps. LXXX-LXXXII, in Migne, *P. L.*, 172, col. 140.

6 Raoul Glaber, *Historiarum sui temporis*, bk. I, chap. I, in Migne, *P. L.*, 142, cols. 613-615. [Cf. Prou, ed., Paris, 1886, and French tr., E. Pognon, *L'An Mille*, Paris, 1947, pp. 41-144. See also Saxl, *op. cit.*, *passim*; cf. J. Evans, *Cluniac Art of the Romanesque Period*, Cambridge, 1950, pp. 110ff.]

7 Herrad of Landsberg, *Hortus deliciarum* (outline reproductions published by the Société pour la Conservation des Monuments Historiques d'Alsace, with explanatory text by Canons Straub and Keller), Strasbourg, 1879-1899. The original, which was in the library of Strasbourg, was destroyed by the Germans in 1870. [See also a new edition by J. Walter, Strasbourg and Paris, 1962. Cf. O. Gillen, *Ikonographische Studien zum Hortus Deliciarum der Herrad von Landsberg* (Kuntswissenschaftliche Studien, 9), Berlin, 1931.]

8 Straub and Keller, *op. cit.*, pl. V.

9 *Ibid.*, pl. VI [and Walter, *op. cit.*, pp. 63-64 with fig., and pl. VI].

10 Honorius of Autun, *Elucidarium*, bk. I, chap. XI, in Migne, *P. L.*, 172, col. 1117. [Cf. Gillen, *op. cit.*, pp. 66-69. For the ancient background of this tradition see R. Reitzenstein and H. H. Schaeder, *Studien*

zum antiken Synkretismus aus Iran und Griechenland (Studien der Bibliothek Warburg), Leipzig, 1926; and cf. Saxl, *op. cit.*, pp. 58-59.]

11 [The correlation of the seven planets with man's head may also be seen in the twelfth-century manuscript from Prüfening (Munich, Staatsbibl., ms. Clm. 13002, fol. 7v), and in a fourteenth-century German manuscript in Vienna (Öst. Nationalbibl., cod. 2357, fol. 65r), illus. Saxl, *op. cit.*, pl. 37.]

12 [See P. Bloch, "Siebenarmige Leuchter in christlichen Kirchen," *Wallraf-Richartz Jahrbuch*, 23 (1961), pp. 55-190.]

13 This description was written in the sixteenth century by Nicolas Bergier. It is found in his *Histoire des grands chemins de l'Empire*, ed. 1728, p. 200. It was reproduced by G. Marlot in his *Histoire de la ville, cité et université de Reims*, Reims, 1845, II, pp. 542-544. [Some fragments of the mosaic seem to have survived until the nineteenth century; cf. A. Blanchet and G. Lafaye, *Inventaire des mosaïques de la Gaule*, Paris, 1909, II, no. 1090, pp. 90-91, and H. Stern, *Recueil général des mosaïques de la Gaule*, fasc. I,1, Paris, 1957, no. 5, figs. 91-92, with bibl.]

14 Comte A. de Bastard-d'Estang, *Documents archéologiques*, Paris, Bibl. Nat., Cab. des Estampes, Ad. 150g, 8, fol. 13r, under the word "David," the word "Terra" is no longer visible. [Glossed Psalter and Hymnal of St.-Symphorien at Metz, now in the Bibl. Mun., ms. 14, fol. 1r; cf. V. Leroquais, *Les Psautiers manuscrits latins des Bibliothèques Publiques de France*, Mâcon, 1940-1941, I, pp. 251-254, pl. XXII. See also C. de Tolnay, "The Music of the Universe—Notes on a Painting by Bicci di Lorenzo," *Journal of the Walters Art Gallery*, 6 (1943), pp. 83-104.]

15 Honorius of Autun, *De imagine mundi*, bk. II, chap. LIX, in Migne, *P. L.*, 172, col. 154. [Cf. E. Panofsky, *Albrecht Dürer*, 3rd ed., Princeton, 1943, I, pp. 157-158, and H. Bober, "The Zodiacal Miniature of the 'Très Riches Heures' of the Duke of Berry," *Journal of the Warburg and Courtauld Institutes*, 11 (1948), pp. 8-9, with bibl.]

16 Notably in a manuscript of Denys the Little, from Fleury-sur-Loire. See Bastard-d'Estang, *Documents archéologiques*, Paris, Bibl.

Nat., Cab. des Estampes, Ad. 150r, 19, fol. 4r, under the words "Points cardinaux." [The manuscript is now Paris, Bibl. Nat., ms. lat. 5543 (fol. 136r). Cf. H. Bober, "An Illustrated Medieval School Book of Bede's *De natura rerum*," *Journal of the Walters Art Gallery*, 19/20 (1956-1957), p. 96, and on the four humors, E. Wickersheimer, "Figures médico-astrologiques des IXème, Xème et XIème siècles," *Janus*, 19 (1914), pp. 164ff.]

17 David was also represented in the mosaic of St.-Remi at Reims, probably with the same meaning. [Cf. de Tolnay, "The Music of the Universe," pp. 85-89; and also H. Steger, *David rex et propheta*, Nuremberg, 1961, pp. 118ff.]

18 In the Farinier museum of Cluny. [See K. J. Conant, *Cluny, Les églises et la maison du chef d'ordre*, Mâcon, 1968, pp. 84-92, pls. LXIV-LXXVI.]

19 One figure carries a scepter, another a coffer, the third had an object in her hands which has disappeared. The fourth figure has been destroyed. [See K. J. Conant, "The Iconography and Sequence of the Ambulatory Capitals of Cluny," *Speculum*, 6 (1930), pp. 283-285; *idem, Cluny, chef d'ordre*, pp. 86-92; cf. Evans, *Cluniac Art*, pp. 119ff.]

20 Honorius of Autun, *Elucidarium*, bk. I, chap. XI, in Migne, *P. L.*, 172, col. 1117.

21 [See K. J. Conant, "The Apse of Cluny," *Speculum*, 8 (1932), pp. 23-35, and *idem, Cluny, chef d'ordre*, pp. 86-92.]

22 [See Conant, *Cluny, chef d'ordre*, pp. 90-92; cf. Evans, *Cluniac Art*, pp. 110-119.]

23 The account by Ctesias in *Indica*, which Photius transmitted to us, must be supplemented by passages from Pliny the Elder on the book of Ctesias. It is from a passage in Pliny the Elder, *Historia naturalis*, bk. VIII, chap. XXX, 11. 75ff. [see Loeb Classical Library, T. R. Rackham, ed., Harvard and London, 1956, pp. 55ff.], that we know that Ctesias described the skiapods. [For Photius on the *Indica* of Ctesias, see text and French tr., R. Henry (ed. La Bibliothèque), Paris, 1959, I, v. 45a-49b. For Ctesias, see G. Sarton, *Introduction to the History of Science*, Baltimore, 1927 (repr. 1950), I, p. 107, with bibl.]

24 [*Indica* in F. Jacoby, *Die Fragmente der griechischen Historiker*, Leiden, 1958, part III, c, no. 715, pp. 603-639.]

25 [C. Julius Solinus, *Collectanes rerum memorabilium*, ed. R. Mommsen, Berlin, 1895. See Sarton, *op. cit.*, for bibl. and tr.]

26 Augustine. *De civitate Dei*, bk. xvi, chap. 8,i. [The mosaic has long since disappeared; see A. Audollent, *Carthage romaine, 146 av. J-C—698 ap. J-C*, Paris, 1904, p. 227 n. 1, and p. 661.]

27 Isidore of Seville, *Etymologiae*, bk. xi, chap. iii, *De portentis* [see W. M. Lindsay, ed., *Isidori Hispalensis episcopi etymologiarum sive originum*, Oxford, 1911].

28 Hrabanus Maurus, *De universo*, bk. xxii, chap. vii, in Migne, *P. L.*, 111, cols. 195-199.

29 Honorius of Autun, *De imagine mundi*, bk. i, chap. xi-xiii, in Migne, *P. L.*, 172, cols. 123-125.

30 It is found in the album of *L'Ancien Bourbonnais* of A. Allier, Moulins, 1833. It was reproduced in the *Bulletin monumental* for 1855, pp. 384-385 and pp. 390-391. [See L. Bréhier, "Le Pilier de Souvigny et l'histoire naturelle fantastique au moyen âge," *Bulletin régional des Amis de Montluçon*, 8 (1923), pp. 29-48, and Evans, *Cluniac Art*, p. 28.]

31 Isidore of Seville, *loc. cit.*

32 The remarkable thing is that the inscriptions on the column are usually in the plural. The same is true in Isidore of Seville, who in this way intended to characterize the entire species. For example, "Satyri, Hippopodes, Ethiopes."

33 The inscription, which is incomplete and incorrect, seems to read *Cidipes*. [C. Picard, "Le Mythe de Circé au tympan du grand portail de Vézelay," *Bulletin monumental*, 104 (1945), p. 226 n. 3, departs from Isidore's interpretation and proposes the reading *Oedipes* instead of *Cidipes*; for him this is a representation of a man whose feet are bound and swollen, and not a skiapod.]

34 Solinus, *Polyhistor*, chap. xxx, in Mommsen edition.

35 Proved by the fact that there are only five months out of twelve.

36 Honorius of Autun, *De imagine mundi*, chaps. xi-xiii, in Migne, *P. L.*, 172, cols. 123-125. [See R. Wittkower, "The Marvels of the East," *Journal of the Warburg Institute*, 5 (1942), pp. 159-197.]

37 The unicorn with its horn pointing backward is found in the Greek Physiologus, fol. 74r (see J. Strzygowski, *Der Bilderkreis des griechischen Physiologus des Kosmas Indikopleustes und Oktateuch, nach Handschriften der Bibliothek zu Smyrna* (Byzantinisches Archiv, 2), Leipzig, 1899, pl. xii), and in the Chludov Psalter, fol. 93v [see J. Ebersolt, *La Miniature byzantine*, Paris and Brussels, 1926, pl. xiii, fig. 2]. The same is found in the West in the Utrecht Psalter (see J. J. Tikkanen, *Die Psalterillustrationen im Mittalter*, Helsingfors, 1895, p. 43 (Chludov Psalter), p. 190 (Utrecht Psalter).

38 The siren is the only one of these monsters that does not appear in Honorius of Autun. There is another animal figure with a serpent's tail on the Souvigny column that has no inscription and cannot be identified. [Bréhier, "Le Pilier de Souvigny," pp. 29-48, identifies this monster as a dragon.] [Mâle, Additions and Corrections to the 6th ed., 1953, p. 444]: *Column of Souvigny*. The Souvigny column was formerly inside the church, but is now in a repository nearby.

39 Isidore of Seville, *Etymologiae*, bk. xi, chap. iii, 22, in Migne, *P. L.*, 182, col. 422. [Cf. ed. Lindsay, Oxford, 1911, ii.]: *Dicuntur quidam et silvestres homines quos nonnulli Faunos ficarios vocant* (and there are reports of certain forest folk whom some call "fig fauns").

40 Jeremiah 50:39.

41 This may not be the correct interpretation. Perhaps it refers to the fig-shaped growths that hang from the necks of fauns.

42 *Propriétés des bêtes*, publ. by J. Berger de Xivrey, *Traditions tératologiques*, Paris, 1836, p. 384. [J. von Schlosser, *Die Kunst- und Wunderkammern der Spätrenaissance*, Leipzig, 1908, pp. 12-15.]

43 Honorius of Autun, *De imagine mundi*, bk. i, chap. xi, in Migne, *P. L.*, 172, col. 124. [See V. Debidour, *Le Bestiaire sculpté au Moyen Age en France*, Paris and Grenoble, 1961, p. 391, "Griffon"; and D. Grivot and G. Zarnecki, *Gislebertus, Sculptor of Autun*, New York, 1961, p. 71 and pl. 48.]

44 [R. Raeber, *La Charité-sur-Loire*, Bern, 1964, pp. 66-68. Cf. Debidour, *op. cit.*, under "chameau," "éléphant," and "dragons," pp. 388-389.]

45 G. Sanoner, "Le Portail de l'abbaye de Vézelay," *Revue de l'art chrétien*, 54 (1904), pp. 448-459.

46 L.-Eug. Lefèvre, "Le Symbolisme du tympan de Vézelay," *Revue de l'art chrétien*, 56

(1906), pp. 253-257; P. Mayeur, "Le Tympan de l'église abbatiale de Vézelay," *ibid.*, 58 (1908), pp. 103-108, and 59 (1909), pp. 326-332. [See also A. Fabre, "L'Iconographie de la Pentecôte," *Gazette des beaux-arts*, 65 (1923), pp. 33-42; A. Katzenellenbogen, "The Central Tympanum at Vézelay, its Encyclopedic Meaning and its Relations to the First Crusade," *Art Bulletin*, 26 (1944), pp. 141-151; F. Salet and J. Adhémar, *La Madeleine de Vézelay*, Melun, 1948, pp. 174-177; Evans, *Cluniac Art*, pp. 69-70, and C. Beutler, "Das Tympanon zu Vezelay, Programm, Planwechsel und Datierung," *Wallraf-Richartz Jahrbuch*, 19 (1967), pp. 7-30.]

47 [Mâle, Additions and Corrections to the 6th ed., 1953, p. 444]: This tympanum represents the Pentecost. It cannot possibly represent the Appearance of Christ in the Cenacle after his resurrection, as has been contended, because this very subject was used at Vézelay, alongside the great portal in the small portal at the left. In spite of what may have been said, the fresco at St.-Gilles of Montoire also represents the Pentecost. The fairly recently discovered watercolor painted in 1841 gives the original state of the fresco and shows red rays issuing from Christ's hands; this gave rise to the hypothesis that these rays were the Saviour's blood which he caused to flow over the heads of the apostles (J. de La Martinière, "Les Fresques de Saint-Gilles de Montoire d'après les aquarelles de Jorand en 1881," *Gazette des beaux-arts*, 75, 1933, pp. 193-204). That would be an extraordinary subject indeed. It will suffice to recall that the beautiful enamelled thirteenth-century triptych of Chartres representing the Pentecost has red rays issuing from Christ's hands. In the Middle Ages, red was the color used for fire as well as for blood. In a window at Bourges, the fiery sword of the archangel who drove Adam and Eve from the Earthly Paradise is red in color. [Cf. G. Plat, "La Chapelle de Saint-Gilles de Montoire," *Bulletin de la Société Archéologique, Scientifique et Littéraire du Vendômois*, 67 (1928), pp. 89-105. See R. Gérard, *Saint-Gilles de Montoire, XIème siècle*, Paris, 1935, pp. 58ff., who confirms that the restoration in 1934 revealed the wounds in the hands.]

48 Paris, Bibl. Nat., ms. nouv. acq. lat. 2246, fol. 79v. [See exhibition catalogue, *Les Manuscrits à peintures en France du VIIe au XIIe siècle*, Paris, Bibl. Nat., 1954, cat. no. 295, and F. Mercier, *Les Primitifs français, La peinture clunysienne en Bourgogne à l'époque romane*, Paris, 1931, pp. 128ff., pls. 92ff. Cf. M. Schapiro, *The Parma Ildefonsus, A Romanesque Illuminated Manuscript from Cluny and Related Works*, New York, 1964, pp. 43-44.]

49 Acts 2:17. The miniature does not show the full figure of Christ, but only the bust surrounded by an aureole. On this subject, see F. Lesueur, "Les Fresques de Saint-Gilles de Montoire et l'iconographie de la Pentecôte," *Gazette des beaux-arts*, 66 (1924), pp. 19-29.

50 Paris, Bibl. Nat., ms. gr. 510, fol. 301r; H. Omont, *Miniatures des plus anciens manuscrits grecs de la Bibliothèque Nationale du VIe au XIVe siècle*, Paris, 1929, pl. XLIV.

51 These texts are given in A. Heisenberg, *Grabeskirche und Apostelkirche*, Leipzig, 1908, II, pp. 9-96. [On Constantine the Rhodian (c. 940), cf. R. Krautheimer, *Early Christian and Byzantine Architecture* (The Pelican History of Art), Harmondsworth and Baltimore, 1965, p. 355 n. 78; and Nicholas Mesarites (1163/4-1215?), cf. G. Downey, in *Transactions of the American Philosophical Society*, N.S. 47 (1957), pp. 859ff.]

52 London, British Museum, Add. ms. 19352, fols. 19v-20r [S. Der Nersessian, *L'Illustration des Psautiers grecs du moyen âge*, II, *Londres, Add. 19.352*, Paris, 1970, p. 22, pl. 13, figs. 34-35].

53 This detail can barely be seen in our reproduction; at the bottom on the right. [Cf. for this detail, Der Nersessian, *op. cit.*, e.g., pl. 15, fig. 43.]

54 [See J. Adhémar, *Influences antiques dans l'art du moyen âge français*, London, 1939, pp. 189-192, pl. XVII; cf. W. S. Heckscher, "Dornauszieher," *Reallexikon zur deutschen Kunstgeschichte*, IV, Stuttgart, 1958, cols. 289-299.]

55 Honorius of Autun, *Speculum ecclesiae*, in Migne, *P. L.* 172, col. 963. See also, Paris, Bibl. Nat., ms. lat. 11700, fol. 33v. [Cf. Katzenellenbogen, "The Central Tympanum at Vézelay," pp. 142-144.]

56 Ratramnus, *Epistola de cynocephalis*, in Migne, *P. L.*, 121, cols. 1153-1156. [Cf. the

critical edition by E. Dümmler, *Monumenta Germaniae Historica*, Epistola vi, 1925, pp. 149-158. See Katzenellenbogen, *op. cit.*, p. 144.]

57 This is why St. Christopher was sometimes represented with a dog's head in Eastern art. [See Z. Ameisenowa, "Animal-headed Gods, Evangelists, Saints and Righteous Men," *Journal of the Warburg and Courtauld Institutes*, 12 (1949), pp. 42-45. Cf. W. Loeschke, "Beiträge zur Ikonographie des Kynokephalen hl. Christophorus," *Actes du Xème Congrès International d'Etudes Byzantines* (*1955*), Istanbul, 1957, pp. 145-148.]

58 Poem attributed to Payen Balotin, Canon of Chartres, *Histoire littéraire de la France*, xi, Paris, 1759, p. 8.

59 "Those who are all ears," Isidore of Seville, *Etymologiae*, bk. xi, chap. iii, 19, Migne, *P. L.*, 182, cols. 421-422; [in ed. Lindsay, ii; cf. Katzenellenbogen, "The Central Tympanum at Vézelay," p. 143].

60 Katzenellenbogen, *op. cit.*, p. 146.

61 Odilo of Cluny, *Sermones*, Sermo ix, in Migne, *P. L.*, 142, col. 1016.

62 As for the apostles grouped two by two beneath the tympanum, they seem to be the apostles meeting together for the last time before separating to go forth and evangelize the world. [See Salet and Adhémar, *La Madeleine de Vézelay*, p. 174; cf. Katzenellenbogen, *op. cit.*, p. 147, and *idem*, "The Separation of the Apostles," *Gazette des beaux-arts*, 91 (1949), pp. 81-98.]

63 [Cf. F. Lauchert, *Geschichte des Physiologus*, Strasbourg, 1889; see M. R. James, *The Bestiary*, Oxford, 1928, cf. pp. 4ff.; cf. also L. Thorndike, *A History of Magic and Experimental Science*, New York, 1947, i, pp. 497-503.]

64 [St. Basil, *Hexameron*, in Migne, *P. G.*, 29, cols. 4ff. See also ed. and French tr. by S. Giet (*Sources chrétiennes*), Paris, 1949.]

65 [Cf. James, *op. cit.*, pp. 35-36, and facs. 2r-3v.]

66 [F. McCulloch, *Mediaeval Latin and French Bestiaries*, Chapel Hill, 1960; T. H. White, *The Bestiary, A Book of Beasts*, New York, 1960 (with tr. of the twelfth-century Latin Bestiary, Cambridge, University Library, ms. ii.4.26), see esp. appendix pp. 230ff.]

67 C. Cahier and A. Martin, "Le Physiologus ou Bestiaire," *Mélanges d'archéologie*, ii, pp. 169-172. [See White, *op. cit.*, pp. 133-134.]

68 On this subject, see Cahier and Martin, "Deux Chapiteaux historiés du XIIème siècle," *Mélanges d'archéologie*, i, pp. 153-156, and "Le Physiologus," *ibid.*, ii, pp. 213-214. [See Salet and Adhémar, *La Madeleine de Vézelay*; White, *The Bestiary*, pp. 168ff.; cf. McCulloch, *op. cit.*, p. 93, and also Debidour, *Le Bestiaire sculpté*, p. 386.]

69 This detail is found in Brunetto Latini, *Li Livres dou Tresor* [ed. F. J. Carmody, Berkeley and Los Angeles, 1948, i, p. 140].

70 This manuscript (Cod. b. viii) has been destroyed. For a description, see Strzygowski, *Der Bilderkreis des griechischen Physiologus*, pl. vi.

71 Cahier and Martin, "Le Physiologus," *Mélanges d'archéologie*, ii, pl. xx. The fox lying on the ground represented in the Arsenal manuscript (ms. 283) is again an imitation of a Byzantine original.

72 Cahier and Martin, "Bestiaires," *Mélanges d'archéologie*, iii, p. 251. [See White, *op. cit.*, pp. 197-198; cf. Debidour, *op. cit.*, pp. 224 and 386 (under "Baleine").]

73 Strzygowski, *op. cit.*, pl. ii.

74 The Siren of St.-Sernin is now in the museum [see P. Mesplé, *Toulouse, Musée des Augustins, les sculptures romanes*, Paris, 1961, no. 208]. Inscriptions explain how these monsters were composed. Beneath the centaur, the inscription reads: *Juncta simul faciunt unum corpus corpora duo* (Joined together the two bodies make one), and *Pars prior est hominis altera constat equo* (The upper part is of a man, the other consists of a horse). Beneath the siren—the siren-bird which I shall discuss—is written: *Corpus avis, facies hominis volucri manet isti* (The body of a bird, the face of a human abide in this winged creature). See A. Noguier, *Histoire Tolosaine*, Toulouse, 1559, pp. 64-66. [See White, *op. cit.*, pp. 134-135. For other examples, see Debidour, *op. cit.*, p. 397; and also D. Jalabert, "De l'Art oriental antique à l'art roman, Recherches sur la faune et la flore romanes, ii, Les sirènes," *Bulletin monumental*, 95 (1936), pp. 433-471.]

75 The siren is again placed beside the centaur on a capital at Souvigny and in the Canterbury Bible in the Ste.-Geneviève library [Bible Manerius, ms. 10, fol. 127v; see A.

Boinet, *Les Manuscrits à peintures de la Bibliothèque Sainte-Geneviève de Paris*, Paris, 1921, pp. 26-27, pl. VIII]. The centaur is often represented as Sagittarius shooting an arrow.

76 Cahier and Martin, "Le Physiologus," *Mélanges d'archéologie*, II, pl. XXIV, fig. cc. [Brussels, Bibl. Royale, ms. 10074, fol. 146v; see C. Gaspar and F. Lyna, *Les Principaux manuscrits à peintures de la Bibliothèque Royale de Belgique* (S.F.R.M.P.), Paris, 1937, I, pp. 21, 24-25; and cf. the twelfth-century Bestiary in Oxford, Bodl. Libr., ms. 602, fol. 102r (F. Saxl and H. Meier, ed. H. Bober, *Verzeichnis astrologischer und mythologischer illustrierter Handschriften*, III, *Handschriften in englischen Bibliotheken*, London, 1953, p. 312, pl. II).]

77 M. Collignon, *Les Statues funéraires dans l'art grec*, Paris, 1911, pp. 11ff. [Cf. "Siren" in A. F. von Pauly and G. Wissowa, *Real-Encyclopädie der classischen Altertumswissenschaft*, 2nd ser., III, Stuttgart, 1929, cols. 290ff.]

78 In the Bestiary of Philippe de Thaon, which dates from the early twelfth century, and in the Bestiary of the Arsenal, which dates from the thirteenth. [See *Le Bestiaire de Philippe de Thaün*, ed. E. Walberg, Paris and Lund, 1900; and Engl. tr., T. Wright, ed., "Philippe de Taon, 'Li Livre des créatures,'" *Popular Treatises on Science Written During the Middle Ages in Anglo-Saxon, Anglo-Norman, and English*, London, 1841, pp. 20-73. Cf. McCulloch, *op. cit.*, pp. 47-54, and 166-169.]

79 The *De monstris* has been published by J. Berger de Xivrey in his *Traditions tératologiques*. Sirens are described in chap. VIII, p. 25. [See E. Faral, "La Queue de poisson des sirènes," *Romania*, 74 (1953), pp. 433-506. Cf. White, *op. cit.*, p. 135, illustrates the woman-bird-fish type after the twelfth-century English Bestiary in Cambridge, University Library, ms. II.4.26, cf. facs. ed. James, *The Bestiary*, fol. 39r.]

80 ["So that it ends repulsively in a dark fish tail, though a lovely woman above": Horace, *Ars poetica*, v. 3-4; cf. Loeb Classical Library, ed., H. Rushton Fairclough, London and Cambridge (Mass.), 1966, pp. 450-451.]

81 Cahier and Martin, "Le Physiologus," *Mélanges d'archéologie*, II, p. 172, and pl. XX, fig. 2.

82 [See Baroness Brincard, *Cunault, ses chapiteaux du XIIème siècle*, Paris, 1937, p. 96, pl. XV,1. Cf. Debidour, *Le Bestiaire sculpté*, figs. 331-332.]

83 A. Venturi, *Storia dell'arte italiana*, III, Milan, 1903, p. 436 n. 2. [Mâle, Additions and Corrections to the 6th ed., 1954, p. 444]: *The capitals of Cunault*. The capitals of Cunault have been studied by Baroness Brincard in the *Bulletin monumental*, 1930, pp. 113ff.

84 Gervase of Tilbury, *Otia imperialia*, ed. F. Liebrecht, Hanover, 1856, pp. 38-41, *Tertia decisio*, chaps. 85-86. Gervase of Tilbury's book was written at the beginning of the thirteenth century.

85 These are works from the same workshop.

86 Other siren-birds are at St.-Germain-des-Prés, Pons (Hérault), St.-Loup-de-Naud, St.-Ferme (Gironde), and on the portal of Savonnières (Indre-et-Loire), etc. [See Jalabert, "De L'Art oriental antique à l'art roman, Recherches sur la faune et la flore romanes, II. Les sirènes," pp. 433-471.]

87 On this subject, see L. Hervieux, *Les Fabulistes latins depuis le siècle d'Auguste jusqu'à la fin du moyen âge*, Paris, 1884, II. [See Phaedrus, *Fables*, ed. A. Brenot, Paris, 1961. Cf. Adhémar, *Les Influences antiques*, pp. 223-230.]

88 A. Boinet, "L'Evangéliaire de Morienval à la cathédrale de Noyon," *Congrès archéologique*, 72 (1905), p. 642. [Cf. exhibition catalogue, *Manuscrits à peintures*, 1954, cat. no. 49.]

89 [See F. Stenton, ed., *The Bayeux Tapestry*, London, 1957, e.g., pl. 20 (the raven and the fox), pl. 30 (the crane and the wolf), pl. 31 (the raven and the fox), cf. pp. 27-28. See also L. Herrmann, *Les Fables antiques de la broderie de Bayeux* (Coll. Latomus, 69), Brussels and Berchem, 1964.]

90 Text in J. von Schlosser, *Quellenbuch zur Kunstgeschichte des abendländischen Mittelalters*, Vienna, 1896, pp. 187ff.

91 *Phaedrus*, bk. I, fab. 8 (Hervieux, *op. cit.*, II, p. 7); Romulus Nilantius, bk. I, fab. 8 (Hervieux, *op. cit.*, II, p. 334); *Romulus* by Marie de France, fab. IX (Hervieux, *op. cit.*, II, p. 504). Fables were very popular in the Middle Ages. Vincent of Beauvais, in the *Speculum historiale*, bk. IV, chaps. 2-8, gives this as one that might serve as an *exemplum* for preachers [ed. Douai, 1629, repr. Graz, 1964]. It was carved in

Italy, as well as in France, and appears in the cloister of Aosta (twelfth century). [See Adhémar, *Influences antiques*, pp. 223-230.]

92 [See Debidour, *Le Bestiaire sculpté*, pp. 259, 261, figs. 349 and 373.]

93 Hervieux, *op. cit.*, II, p. 576; *Romulus* by Marie de France, fab. CXXIV, and Marie de France, fab. LXXXII. [Mâle, Additions and Corrections to the 6th ed., 1953, p. 444]: *The education of the wolf.* On a capital of the south portal of the church of St.-Ursanne (canton of Bern, Switzerland), the wolf pounces on the lamb after the reading lesson, as at Freiburg-im-Breisgau. [An early twelfth-century example is to be found in an English manuscript illustration in Cambridge (Trinity College, ms. 0.4.7, fol. 75r); see T. S. R. Boase, *English Art, 1100-1216* (Oxford History of Art, III), Oxford, 1953, p. 45, and pl. 7c.]

94 *Phaedrus*, Appendix, XIV (Hervieux, *op. cit.*, II, p. 66). [Cf. Debidour, *op. cit.*, pp. 258, 385.]

95 Boethius, *De consolatione philosophae*, bk. I, chap. IV, 42, in Migne, *P. L.*, 63, col. 614. [See Patch, *The Tradition of Boethius*, with bibl. Cf. J. Baltrušaitis, *Art sumérien, Art roman*, Paris, 1934, pp. 51-52, fig. 32; and H. Frankfort, *Cylinder Seals*, London, 1939, p. 318, fig. 28, and pl. XLVIIA, and *idem, The Art and Architecture of the Ancient Orient* (The Pelican History of Art), Harmondsworth and Baltimore, 1954, pl. 38 and p. 35 for the musical ass from early Dynastic Ur.]

96 L. Delisle, *Mélanges de paléographie et de bibliographie*, Paris, 1880, p. 206. [See A. K. Porter, *Romanesque Sculpture of the Pilgrimage Roads*, Boston, 1923, fig. 126.]

97 The capital is now in the archeological museum of Nevers. [See Porter, *Romanesque Sculpture*, fig. 1253 (Meillers), and Debidour, *Le Bestiare sculpté*, fig. 363 (St.-Parize).]

98 The Nantes capital, discovered several years ago (1906), came from the former cathedral; it is now in the museum; see L. Maître, "Les Substructions du chevet de la cathédrale de Nantes," *Bulletin archéologique du Comité des Travaux historiques et scientifiques*, 1906, p. 272, and pl. LXIII. [See also Debidour, *op. cit.*, fig. 356 (Brioude).]

99 Sometimes a pig replaces the donkey playing the lyre, as on the cornice of the church of Bruyères (Aisne). It is sometimes accompanied by a monkey playing a violin (St.-Parize-le-Chatel, Nièvre), or by a musical goat (Fleury-la-Montagne, Saône-et-Loire). [Cf. Debidour, *op. cit.*, fig. 362, for a pig with a monkey playing the violin on a capital in the museum of Chalon-sur-Saône. For the pig-harpist, see F. C. Sillar and R. M. Meyler, *The Symbolic Pig*, Edinburgh and London, 1961, pp. 25, 27, and pls. 11-13, 29.]

100 [The famous passage of St. Bernard in his letter to William Abbot of St.-Thierry, is published in Migne, *P. L.*, 182, cols. 914-916. For English tr., see G. G. Coulton, *Life in the Middle Ages*, 3rd ed., New York, 1936, IV, pp. 174ff. Cf. M. Schapiro, "On the Aesthetic Attitude in Romanesque Art," *Art and Thought, Issued in Honour of Dr. Ananda K. Coomaraswamy*, London, 1947, pp. 130-150.]

101 [See Evans, *Cluniac Art*, pp. 46ff., H. Swarzenski, *Monuments of Romanesque Art*, Chicago, 1954, pp. 27, 35.]

102 Gregory of Tours, *De gloria martyrum*, chap. LXXII (Migne, *P. L.*, 71, col. 769), and *De gloria beatorum confessorum*, chap. LV (Migne, *P. L.*, 71, col. 808).

103 *De miraculis sancti Martini*, bk. I, chap. XI, in Migne, *P. L.*, 71, col. 924.

104 [See *Gesta Dagoberti*, ed. B. Krush, *Monumenta Germaniae Historica, Scriptores rerum merovingicarum*, II, Hanover, 1956, p. 407.]

105 On the Sens textiles, see the articles (accompanied by reproductions) by E. Chartraire, "Les Tissus anciens du trésor de la cathédrale de Sens," *Revue de l'art chrétien*, 61 (1911), pp. 261-280, 371-386, and 452-468. [Cf. also the exhibition catalogue, *Les Trésors des églises de France*, Paris, 1965, cat. no. 812, p. 431, and no. 819, p. 435.]

106 [Cf. A. U. Pope and P. Ackerman, eds., *A Survey of Persian Art*, III, pt. 1, London and New York, 1939, pp. 1995ff.]

107 See E. Migeon, *Manuel d'art musulman*, 2nd ed., Paris, 1927, II, p. 307, fig. 416.

108 [Einhard describes the gifts from the Persian caliph, Harun el Rachid, as including textiles, spices, and even an elephant. Cf. Eginhard, *Vie de Charlemagne*, ed. and French tr. L. Halphen, Paris, 1938, pp. 44ff.]

109 Alb. Aquensis, *Historia hierosolymitana*, bk. V, chap. I [*Recueil des historiens des*

croisades, *Historiens occidentaux*, IV, Paris, 1879, p. 433], and Guillaume de Tyr, *Historia rerum*, bk. VI, chap. 23 [*ibid.*, I, Paris, 1844, p. 274].

110 Ordericus Vitalis, *Historia ecclesiastica*, pt. III, bk. XI, in Migne, *P. L.*, 188, col. 808.

111 Robert Wace, *Le Roman de Rou*, v. 14.814-14.823, ed. F. Pluquet, Rouen, 1827, II, pp. 322-323.

112 G. Arnaud d'Agnel, "Le Trésor de l'église d'Apt (Vaucluse)," *Bulletin archéologique du Comité des Travaux historiques et scientifiques*, 1904, pp. 333-334, and pl. XXVII.

113 F. Michel, *Recherches sur le commerce, la fabrication et l'usage des étoffes de soie, d'or et d'argent et autres tissus précieux en Occident, principalement en France, pendant le moyen âge*, Paris, 1854, II, pp. 64-93. Texts taken from our poets are included. [See also R. S. Lopez, "Silk Industry in the Byzantine Empire," *Speculum*, 20 (1945), pp. 1-42.]

114 G. Perrot and C. Chipiez, *Histoire de l'art dans l'antiquité*, Paris, 1911, IX, pp. 454ff., and x, pp. 62ff.

115 Illus. Chartraire, "Les Tissus anciens du trésor de la cathédrale de Sens," pp. 372-373, no. 18.

116 Here I refer only to the original idea, and to the arrangement of stained-glass windows. The technique, as E. Socard has shown in "Le Vitrail carolingien de la châsse de Séry-les-Mézières," *Bulletin monumental*, 74 (1910), pp. 5-23, is related to the technique of Merovingian goldsmiths who enclosed small pieces of colored glass in bands of metal. [On the origins of stained glass, see J. Lafond, *Le Vitrail*, Paris, 1966, chaps. I-II, with bibl.]

117 Published by G. Arnaud d'Agnel, "Notice archéologique sur le prieuré de Ganagobie (Basses-Alpes), église et cloître du XIIème siècle," *Bulletin archéologique du Comité des Travaux historiques et scientifiques*, Paris, 1910, pp. 314-327, pls. LII-LIX. The inscription refers to the prior Bertram, who was in office in 1122. [See also H. Stern, "Mosaïques de pavement préromanes et romanes en France," *Cahiers de civilisation médiévale*, 5 (1962), p. 27.]

118 P. Raymond, "Notice sur une mosaïque placée dans la grande abside de la cathédrale de Lescar (Basses-Pyrénées)," *Revue archéologique*, new ser., 13 (1866), pp. 305-313. The work dates from the time of Bishop Guy (1115-1141). See also M. Lanore, "La Cathédrale de Lescar," *Bulletin monumental*, 68 (1904), pp. 190-259 [and Stern, "Mosaïques de pavement," pp. 22-24].

119 A. Venturi, *Storia dell'arte*, III, Milan, 1904, p. 434, and figs. 410-411. I am not referring to the central section which represents the Virtues.

120 See J. Bédier, *Les Légendes épiques*, Paris, 1913, IV, p. 366.

121 P. Dhorme, "L'Arbre de vérité et l'arbre de vie," *Revue biblique*, 1907, pp. 271-274; [and E. O. James, *The Tree of Life, an Archaeological Study*, Leiden, 1966, chap. 5, "The Cosmic Tree," pp. 129ff.].

122 Perrot and Chipiez, *Histoire de l'art dans l'antiquité*, II, p. 685, fig. 343, p. 689, fig. 348, and p. 771, fig. 443. [See also Frankfort, *The Art and Architecture of the Ancient East*, pp. 67-68.]

123 L. de Clercq and J. Menant, *Collection de Clercq, Catalogue*, I, *Cylindres orientaux*, Paris, 1888, pl. II, fig. 15. [See also Frankfort, *Cylinder Seals*, e.g., pl. XLII, a,g, and pp. 261ff.]

124 *Avesta, Livre sacré des sectateurs de Zoroastre*, tr. C. de Harlez, Liège, Paris, and Louvain, 1876, II, chaps. 9-10, pp. 72-82.

125 Examples are given in the study by Goblet d'Alviella on "Les Arbres paradisiaques des Sémites et des Aryens," *Bulletin de l'Académie Royale des Sciences, des Lettres et des Beaux-Arts*, 3rd ser., 19 (1890), pp. 633-679. [Cf. Pope and Ackerman, *A Survey of Persian Art*, IV, pt. 1, e.g., pl. 123b.]

126 Tabari, *Commentaire sur le Coran*, chap. 13, pp. 86-87.

127 Reproduced in N. X. Willemin and A. Pottier, *Monuments français inédits*, Paris, 1839, I, pp. 9-10.

128 Lyons, Musée Historique des Tissus; cf. Migeon, *Manuel d'art musulman*, p. 298 and fig. 413. The fabric was woven in the thirteenth century, but it reproduces an ancient design.

129 [Cf. O. von Falke, *Kunstgeschichte der Seidenweberei*, Berlin, 1921, fig. 163.]

130 Migeon, *op. cit.*, p. 323, fig. 422. Arab textile preserved in Spain.

131 E. Lefèvre-Pontalis, "Saint-Paul de Narbonne, Etude archéologique," *Congrès archéologique*, 73 (1906), illus. facing p. 366.

132 E. Lefèvre-Pontalis, "Paray-le-Monial, l'Eglise," *Congrès archéologique*, 80 (1913), illus. p. 56.

133 R. de Lasteyrie, *L'Architecture religieuse en France à l'époque romane*, Paris, 1929, p. 623, fig. 627.

134 J. A. Brutails, *Etude archéologique sur les églises de la Gironde*, Bordeaux, 1912, p. 229, fig. 268.

135 G. Dehio and G. von Bezold, *Die kirchliche Baukunst des Abendlandes*, Stuttgart, 1884, pl. 343, fig. 3.

136 Falke, *op. cit.*, fig. 19, p. 4. [*Idem*, p. 34, identifies these as zebras; cf. R. Bernheimer, *Romanische Tierplastik und die Ursprünge ihrer Motive*, Munich, 1931, p. 75, figs. 47 and 49.]

137 L. Heuzey, "Les Armoiries chaldéennes de Sirpoula," *Monuments Piot*, 1 (1894), pp. 7-20, pl. 11; and *idem*, "Le Vase d'argent," *ibid.*, 2 (1895), pp. 5-28, pl. 1. [For the earlier iconography of the eagle and its interpretation, see H. P. L'Orange, *Studies on the Iconography of Cosmic Kingship in the Ancient World*, Oslo, 1953, pp. 69ff., with illus.]

138 Perrot and Chipiez, *Histoire de l'art dans l'antiquité*, IV, p. 682, fig. 343.

139 M. Van Berchem and J. Strzygowski, *Amida*, Heidelberg and Paris, 1910, pp. 93ff. [See Falke, *op. cit.*, figs. 116-119, for the double-headed eagles from Iraq, Amida, and Konia.]

140 Chartraire, "Les Tissus anciens du trésor de la cathédrale de Sens," pp. 378-379, no. 24.

141 J. Lessing, *Gewebesammlung des königlichen Kunstgewerbemuseums zu Berlin*, Berlin, 1900-1907, II, pl. 38. [See also Falke, *op. cit.*, fig. 122.]

142 See A. Rhein, "Sainte-Eutrope de Saintes," *Congrès archéologique*, 79 (1912), p. 337. [See also R. Hamann, "Das Tier in der romanischen Plastik Frankreichs," *Medieval Studies in Memory of A. Kingsley Porter*, Cambridge (Mass.), 1939, figs. 4-5, p. 420.]

143 E. Wrangel and M. Dieulafoy, "La Cathédrale de Lund," *Comptes rendus de l'Académie des Inscriptions et Belles-Lettres*, 1913, pp. 322-326 on Daniel-Gilgamesh.

144 [Cf. *The Epic of Gilgamesh*, tr. R. C. Thompson, London, 1928.]

145 A. H. Layard, *The Monuments of Nineveh*, 2nd ser., London, 1853, pl. 64, bronze plate from Nimrud. [Historians of art still speak of the ancient Near Eastern hero who overcomes the two beasts as "Gilgamesh." This identification is generally rejected by scholars of Near Eastern archeology who, further, deny that any scenes from the Epic of Gilgamesh can be found on the ancient seals (cf. Frankfort, *Cylinder Seals*, pp. 62-63). The misnamed "Gilgamesh" must by now remain as a convention, just as in the instance of the Bayeux "tapestry."]

146 Falke, *op. cit.*, I, p. 17, fig. 97. Gilgamesh between two lions was also known in Phoenicia; cf. Perrot and Chipiez, *Histoire de l'art dans l'antiquité*, III, p. 635, fig. 426. [Cf. Frankfort, *Cylinder Seals*, pl. XLVII,f.]

147 Chartraire, "Les Tissus anciens du trésor de la cathédrale de Sens," p. 371, no. 17. [See also Falke, *op. cit.*, fig. 96.]

148 Cahier and Martin, *Mélanges d'archéologie*, II, pl. XVIII. [See Falke, *op. cit.*, fig. 98.]

149 Lessing, *op. cit.*, V, pl. 32. [The shroud of San Bernardo Calvo, Bishop of Vich, is in the Episcopal museum of Vich (see *Cataleg de les Fotografies del Museu de Vich*, Arxiu d'Arqueologia Catalana, II, n.d., pl. 126, nos. 3126-3128). Falke, *op. cit.*, fig. 144, cites a fragment in the museum of Berlin. Another fragment is in the collection of the Cleveland museum (see D. G. Shepherd, "A Dated Hispano-Islamic Silk," *Ars orientalis*, 2 (1957), pp. 373ff., cf. pl. 8a and p. 378 on the Cleveland fragment.]

150 [Baltrušaitis, *Art sumérien, art roman*, esp. chap. 5, pp. 59ff.; J. Ebersolt, *Orient et Occident*, 2nd ed., Paris, 1954.]

151 [See Hamann, "Das Tier," pp. 441-442, and figs. 30-31; cf. Frankfort, *Cylinder Seals*, pl. XLVII,g.]

152 [The monster at St.-Loup-de-Naud, however, is not a quadruped; see Debidour, *op. cit.*, fig. 326, and cf. fig. 328.]

153 Perrot and Chipiez, *Histoire de l'art dans l'antiquité*, IX, p. 439, fig. 223, and X, 1914, p. 79, fig. 69. [See A. Rumpf, ed., *Chalkidische Vasen*, Berlin and Leipzig, 1927, pls. 20-21, 59-60, 65, etc.]

154 L. Heuzey, *Les Origines orientales de l'art*, Paris, 1891-1915, pp. 254-255.

155 De Clercq and Menant, *Collection de Clercq, Catalogue*, I, pl. XXXIX, no. 337bis. [Cf., e.g., Frankfort, *Cylinder Seals*, p. 256, and pl. XLI,o.]

156 Layard, *The Monuments of Nineveh*, 2nd ser., I, pl. VI.

157 Perrot and Chipiez, *Histoire de l'art dans l'antiquité*, II, p. 224, figs. 83-84. [Cf. L'Orange, *Iconography of Cosmic Kingship*, pp. 62-63; and A. Parrot, *The Arts of Assyria* (in *The Arts of Mankind*, ed. A. Malraux and G. Salles), New York, 1961, figs. 95-96, pp. 86-87.]

158 G. Schlumberger, *L'Epopée byzantine à la fin du dixième siècle*, Paris, 1900, II, p. 337; Cahier and Martin, *Mélanges d'archéologie*, II, pl. XXXVIII.

159 Lessing, *op. cit.*, II, pl. 5; [e.g., textile in Vich, illus. Falke, *op. cit.*, fig. 145].

160 Chartraire, "Les Tissus anciens du trésor de la cathédrale de Sens," p. 386, no. 39.

161 [See D. Jalabert, "De L'Art oriental antique à l'art roman, Recherches sur la faune et la flore romanes, I, Le sphinx," *Bulletin monumental*, 94 (1935), pp. 70-104.]

162 [E.g., at Soulac, and at Plaimpied, illus. in Debidour, *op. cit.*, figs. 231-232.]

163 For example, on the tomb in the church of La Magdalena, at Zamora in Spain. [See J. Gudiol Ricart and J. A. Gaya Nuño, *Arquitectura y escultura románicas* (Ars Hispaniae, V), Madrid, 1948, fig. 432, p. 280, and in France, on a capital in the chevet of the church at Blesle, Debidour, *op. cit.*, fig. 233.]

164 [M. H. Longhurst, *Catalogue of Carvings in Ivory*, pt. I, London, 1927, no. 10-1866, pl. XXXII, and p. 54; see also J. Ferrandis, *Marfiles y Azabaches Españoles*, Barcelona and Buenos Aires, 1928, pl. XVIII.]

165 Van Berchem and Strzygowski, *Amida*, p. 362, fig. 312; in a Gospel-book, dated 1198, from the Armenian cathedral of Lvov (fol. 2v).

166 [L. Delaporte, *Catalogue des cylindres orientaux, cachets et pierres gravées de style oriental*, Musée du Louvre, Paris, 1920, I, pl. 64.9, and II, p. 99; cf. Frankfort, *Cylinder Seals*, pl. v,h, and pp. 27, 30, 31, 34.]

167 [M. Schapiro, "The Romanesque Sculpture of Moissac," *Art Bulletin*, 13 (1931), fig. 127, p. 514; and cf. Debidour, *op. cit.*, figs. 240-241.]

168 [Cf., e.g., Debidour, *op. cit.*, figs. 238-241.]

169 *Congrès archéologique*, 72 (1905), p. 23, illus. [Cf. Hamann, "Das Tier," p. 450, and fig. 45; V. Sloman, *Bicorporates, Studies in Revivals and Migrations of Art Motifs*, Copenhagen, 1967.]

170 E. Pottier, "Histoire d'une bête," *Revue de l'art ancien et moderne*, 2 (1910), pp. 419-436, esp. fig. 5. [See also A. Roes, "Histoire d'une bête," *Bulletin de correspondance hellénique*, 59 (1935), pp. 313-328.]

171 [Migeon, *Manuel d'art musulman*, II, p. 317, fig. 424, and p. 325, and cf. Falke, *op. cit.*, fig. 161.]

172 Migeon, *op. cit.*, II, p. 394. [It is on the coronation robe of the kings of Hungary. See B. Czobor and E. de Radisics, *Les Insignes royaux de Hongrie*, Budapest, 1896, with illus.]

173 [Cf. E. L. Mendell, *Romanesque Sculpture in Saintonge*, New Haven, 1940, pl. 119, and p. 94; see also Debidour, *op. cit.*, figs. 191-192.]

174 A. Gaussen, *Portefeuille archéologique de la Champagne*, Bar-sur-Aube, 1861, pl. XIII.

175 L. Heuzey, *Musée National du Louvre, Catalogue des antiquités chaldéennes*, Paris, 1902, no. 233.

176 De Clercq and Menant, *Collection de Clercq, Catalogue*, II, pl. v, no. 95. [Cf. Sassanid intaglio illus. M. L. Vollenweider, *Catalogue raisonné des sceaux, cylindres et intailles*, Geneva, 1967, I, no. 102, pl. 110,39.]

177 Perrot and Chipiez, *Histoire de l'art dans l'antiquité*, II, p. 774, fig. 447. [Cf. E. Porada, *Mesopotamian Art in Cylinder Seals of the John Pierpont Morgan Library*, New York, 1947, fig. 66.]

178 [Cf. Schapiro, "The Romanesque Sculpture of Moissac," pp. 525ff. and fig. 130.]

179 De Clercq and Menant, *Collection de Clercq, Catalogue*, I, pl. XXXVII, no. 45bis, and II, pl. v, no. 114. [Cf. early Mesopotamian examples illus. D. J. Wiseman, *Catalogue of the Western Asiatic Seals in the British Museum*, I. *Cylinder Seals, Uruk-Early Dynastic Period*, London, 1962, nos. 10246, 103318, pls. 21d, 24c; Sloman, *Bicorporates*, figs. 495, 498-500 and, on a Late Minoan seal, fig. 493.]

180 Paris, Bibl. Nat., ms. lat. 8, the "Second Bible of St.-Martial." [Illus. Sloman, *op. cit.*, fig. 484; cf. Schapiro, "The Sculptures of Souillac," p. 376 n. 1.]

181 Layard, *The Monuments of Nineveh*, 2nd ser., I, pl. 44, fig. 1, and pl. 50, fig. 6; II, p. 462.

182 *Liber pontificalis*, ed. L. Duchesne and C. Vogel, Paris, 1957, II, p. 69.

183 Lessing, *op. cit.*, 9-10, pl. 41, thirteenth-century Byzantine textile. [Cf. W. F. Volbach,

I tessuti del Museo Sacro Vaticano, Vatican City, 1942, no. T.117, p. 44, and pls. XXVI, XXXIX, for a splendid eighth-century Byzantine example.]

184 E. Bertaux, *L'Art dans l'Italie méridionale*, Paris, 1903, p. 79, fig. 18.

185 [Cf. K. Lehmann and E. Olsen, *Dionysiac Sarcophagi in Baltimore*, Baltimore, 1942, pp. 63-64, and figs. 16-18, on the funerary symbolism of the griffins and vase.]

186 [The motif does appear in Provence, e.g., in the cathedral of Aix-en-Provence, on an impost block of the south aisle; cf. Debidour, *op. cit.*, fig. 218.]

187 [See B. Craplet, *Auvergne romane* (ed. Zodiaque), La-Pierre-qui-Vire, 1955, pl. 15, following p. 208.]

188 Perrot and Chipiez, *Histoire de l'art dans l'antiquité*, II, p. 248, fig. 95. [Mâle, Additions and Corrections to the 6th ed., 1953, p. 444]: *Auvergne and the art of antiquity.* In Auvergne there are a few more motifs taken from the art of antiquity than I mentioned in the first editions of the book. I should cite the Mozat capital which represents Victory writing on a shield, and in several churches, notably at St.-Nectaire, the figures of centaurs, triton, and nereids. The figure of the Good Shepherd carrying the lamb on his shoulders found so frequently on Auvergnat capitals (Mozat, Issoire, Brioude, Volvic, etc.), derives from the art of Christian sarcophagi. [See Adhémar, *Influences antiques*, pp. 159ff. It is to be noted that griffins are often confused with dragons, as Perrot has pointed out in this case. For confronting griffins in Assyrian art, cf. Layard, *op. cit.*, 2nd ser., I, pl. 43, fig. 7; pl. 46, fig. 2; etc.]

CHAPTER X

1 Peter the Venerable, *De miraculis*, bk. I, chap. X, in Migne, *P. L.*, 189, cols. 873-874.

2 Peter the Venerable, *De miraculis*, bk. I, chap. XI, *ibid.*, cols. 874-875.

3 Ordericus Vitalis, *Historia ecclesiastica*, pt. II, bk. VIII, in Migne, *P. L.*, 188, cols. 607-612. Nothing in Orderic Vital's books is more magnificently strange than this story.

4 *De miraculis*, bk. I, chap. IX, in Migne, *P. L.*, 189, col. 871.

5 *Idem*, bk. I, chap. XXVIII, *ibid.*, cols. 903-906.

6 *Idem*, bk. II, chap. XXVII, *ibid.*, cols. 941-942.

7 *Idem*, bk. I, chap. XIX, *ibid.*, cols. 884-885.

8 *Idem*, bk. I, chap. XX, *ibid.*, cols. 885-887.

9 *Idem*, bk. I, chap. VIII, *ibid.*, col. 869.

10 *De vita sua*, bk. II, chap. VI, in Migne, *P. L.*, vol. 156, cols. 907-908.

11 *De miraculis*, bk. I, chap. XII, in Migne, *P. L.*, vol. 189, col. 876.

12 *Idem*, bk. I, chap. XVI, *ibid.*, cols. 881-882.

13 *Idem*, bk. I, chap. XIII, *ibid.*, cols. 876-877.

14 *Idem*, bk. I, chap. XVIII, *ibid.*, col. 883.

15 *Idem*, bk. I, chap. XIV, *ibid.*, cols. 877-878.

16 [Mâle, Additions and Corrections to the 6th ed., 1953, p. 444]: J. Adhémar has supposed that this capital represents Ganymede carried off by the eagle of Jupiter (*Bulletin monumental*, 91 [1932], p. 291). This explanation is ingenious and it could be correct, for there were humanists among twelfth-century monks. However, if this is the case, the presence of the devil in the scene is surprising. [See J. Adhémar, *Influences antiques dans l'art du moyen âge français*, London, 1939, pp. 222-223, fig. 73.]

17 [See E. Reisner, *Le Démon et son image*, Paris, 1961, chap. VIII, and also H. Schade, *Dämonen und Monstren, Gestaltungen des Bösen in der Kunst des frühen Mittelalters*, Regensburg, 1962.]

18 Paris, Bibl. Nat., ms. gr. 510, fol. 165r. [See the exhibition catalogue, *Byzance et la France médiévale*, Paris, Bibl. Nat., 1958, cat. no. 9, with extensive bibl. Cf. the devil in a Psalter on Mt. Athos (Monastery of the Pantocrator, ms. 61, second half of the ninth century); see S. Dufrenne, *L'Illustration des Psautiers grecs du moyen âge, I, Pantocrator 61, Paris Grec 20, British Museum 40731* (Bibliothèque des cahiers archéologiques, I), Paris, 1966; the devil is to be seen on fol. 130v, repr. pl. 20, cf. p. 32.]

19 [There are so-called "demons," indistinguishable from the devils, in Byzantine Psalters of the tenth century, e.g., Paris, Bibl. Nat., ms. gr. 20, fol. 18r (Dufrenne, *op. cit.*, pl. 42, cf. p. 45); and the Bristol Psalter, London, Brit. Mus., ms. Add. 40731 (end of tenth century or beginning of eleventh), fol. 104r (demon), fol. 154r (devil) (*ibid.*, pls. 53, 56, and pp. 60, 63).]

20 See E. Diez and O. Demus, *Byzantine Mosaics in Greece: Daphni and Hosios Lucas*, Cambridge (Mass.), 1931, fig. 100.]

21 Eleventh-century Gospel-books (Paris, Bibl. Nat., ms. gr. 74) published by H. Omont, *Evangiles avec peintures byzantines du XIème siècle*, Paris, 1908, pls. 16, 101, 115.

[See the exhibition catalogue, *Byzance et la France médiévale*, cat. no. 21. Also the Psalter of 1066 from the monastery of St. John of the Studion in Constantinople, now London, Brit. Mus., ms. Add. 19352, fol. 78r (demon), and fol. 123v (devil): S. Der Nersessian, *L'Illustration des Psautiers grecs du moyen âge*, II, *Londres Add. 19352* (Bibliothèque des cahiers archéologiques), Paris, 1970, figs. 125, 201, and pp. 35, 46. The devil appeared in this form in the sixth-century Gospel-book of Rabbula (Florence, Biblioteca Laurenziana, Syriac ms. Plut. 1, 56), fol. 8b; see R. Garrucci, *Storia dell'arte cristiana*, III, Prato, 1876, pl. 134, fig. 2; and the facs. ed. by C. Cecchelli, G. Furlani, M. Salmi, Olten and Lausanne, 1959.]

22 See the *Vitae Patrum* in the beautiful edition made by H. Rosweyde at Antwerp in 1615, Plantin. [Rosweyde's collection of the Lives of the Fathers has been published (from the 1628 Antwerp edition) in Migne, *P. L.*, 73 (1879). For the Desert Fathers, cf. J. Brémond, *Les Pères du Désert*, Paris, 1927.]

23 *Vitae Patrum*, ed. Rosweyde, pp. 116 and 371; cf. Migne, *P. L.*, 73, cols. 129 and 240-241. [The Life of St. Anthony written by Athanasius (fourth century) is available in an English translation in *A Select Library of Nicene and Post-Nicene Fathers*, 2nd ser., ed. P. Schaffer and H. Wace, IV, pp. 195ff., repr. Grand Rapids, Michigan, 1957, from the 1891 ed., cf. pt. 5, p. 197.]

24 Rosweyde, pp. 148-149 [and Migne, *P. L.*, 73, col. 290].

25 Rosweyde, pp. 171-172 [and Migne, *P. L.*, 73, col. 328].

26 Rosweyde, p. 135 [and Migne, *P. L.*, 73, cols. 266-267].

27 Rosweyde, p. 39 [and Migne, *P. L.*, 73, col. 132; cf. *Life of St. Anthony*, pt. 9, p. 198].

28 Rosweyde, p. 42 [and Migne, *P. L.*, 73, col. 138].

29 [Paris, Bibl. Nat., ms. lat. 9428, fol. 41r. See W. Koehler, *Die karolingischen Miniaturen*, III, Berlin, 1960, pl. 83a; and also H. Weigart, "Dämonen," *Reallexikon zur deutschen Kunstgeschichte*, III, Stuttgart, 1954, cols. 1020-1021.]

30 [E. T. De Wald, *The Illustrations of the Utrecht Psalter*, Princeton, n.d., pls. IV, V, etc.]

31 G. Leidinger, *Miniaturen aus Handschriften des kgl. Hof- und Staatsbibliothek in München*, Fasc. 1, *Das sogenannte Evangeliarium Kaiser Ottos III*, Munich, n.d., pl. XX; [also repr. in Schade, *Dämonen und Monstren*, fig. 39].

32 [Paris, Bibl. Nat., ms. lat. 8878, fol. 145v; see the exhibition catalogue, *Manuscrits à peintures*, 1954, cat. no. 304, with bibl.] It is also found in the Hrabanus Maurus of Monte Cassino, which dates from 1023: see *Miniature sacre e profane dell'anno 1023 illustranti l'Enciclopedia medioevale di Rabano Mauro*, Monte Cassino, 1896, pl. XXXIV. [Cf. D. Grivot, *Le Diable*, 1960, with bibl.]

33 [M. Schapiro, "The Sculptures of Souillac," *Medieval Studies in Memory of A. Kingsley Porter*, Cambridge (Mass.), 1939, p. 361, fig. 2.]

34 [A. K. Porter, *Romanesque Sculpture of the Pilgrimage Roads*, Boston, 1923, IV, fig. 420.]

35 Raoul Glaber, *Chronique*, bk. v, chap. I, in Migne, *P. L.*, 142, col. 686 [cf. ed. M. Prou, Paris, 1886, p. 115, and French tr., *L'An Mille*, ed. E. Pognon, 8th ed., Paris, 1947, p. 130].

36 P. de Truchis, "Saulieu," *Congrès archéologique*, 74 (1907), p. 108. Peter the Venerable, *De miraculis*, bk. I, chap. VII, in Migne, *P. L.*, 189, col. 862. [See also Reisner, *Le Démon et son image*, pp. 212-214.]

37 Guibert de Nogent, *De vita sua*, bk. I, chap. XV, in Migne, *P. L.*, 156, col. 868. [Cf. English tr. C. C. Swinton Bland, London and New York (1925?).]

38 *De miraculis*, bk. II, chap. XXIX, in Migne, *P. L.*, 189, col. 946.

39 *Sermones in cantica canticorum*, sermo LXV, in Migne, *P. L.*, 183, col. 1091. [See H. Kraus, *The Living Theatre of Medieval Art*, Bloomington and London, 1967, pp. 41ff.]

40 *Usus antiquiores ordinis Cisterciensis*, pt. v, chap. CXXI, in Migne, *P. L.*, 166, col. 1499.

41 *Statuta capitulorum generalium ordinis Cisterciensis*, 1190 A.D., no. 55, and 1192 A.D., no. 50 [published by Dom J. M. Canivez, I, Louvain, 1933, pp. 129 and 156].

42 *Statuta capitulorum*, 1180 A.D., no. 13 [*ibid.*, I, p. 88; see also p. 14, chap. vii for 1134 A.D.].

43 [D. Grivot and G. Zarnecki, *Gislebertus, sculptor of Autun*, New York, 1961, p. 74, fig. 4, and pl. 4.]

44 [See F. Salet and J. Adhémar, *La Madeleine*

de Vézelay, Melun, 1948, capital of the nave no. 6, pl. 29, and pp. 181-182.]

45 [A. Katzenellenbogen, *Allegories of the Virtues and Vices in Mediaeval Art*, London, 1939, pp. 58-59.]

46 Particularly the Exultet which contains the Benediction of the Paschal Candle. E. Bertaux, *L'Art dans l'Italie méridionale*, Paris, 1904, p. 231.

47 [Rome, Bibl. Vat., Vat. Barb. lat. 592, Exultet Roll, sec. 5, in M. Avery, *The Exultet Rolls of South Italy*, Princeton, London and The Hague, 1936, pl. 148.]

48 Notably in the Hrabanus Maurus of Monte Cassino, *Miniature sacre e profane*, pls. LXXI-LXXII.

49 P. Meyer, "La Descente de saint Paul en enfer, poème français composé en Angleterre," *Romania*, 24 (1895), pp. 368-369.

50 The Woman Devoured by Serpents is on a capital of the portal. [See M. Durliat, "Les Origines de la sculpture romane à Toulouse et à Moissac," *Cahiers de civilisation médiévale*, 12 (1969), p. 352.]

51 The relief formerly in the church of Oo has been moved to the museum of Toulouse. [See P. Mesplé, *Toulouse, Musée des Augustins, les sculptures romanes*, Paris, 1961, no. 254.]

52 One of the women has serpents hanging from her breasts, another has toads; each is accompanied by a devil. [See Katzenellenbogen, *Virtues and Vices*, p. 58, and pl. XXXIV, fig. 56.]

53 Targon, Saint-Genès de Lombaud, Saint-Palais.

54 And at Perrecy-les-Forges, which like Semelay, is in Nièvre.

CHAPTER XI

1 [On the origin of tympanum, see H. Focillon, *L'Art des sculpteurs romans*, new ed., Paris, 1964, pp. 150-159, and U. Monneret de Villard, "Per la storia del portale romanico," *Medieval Studies in Memory of A. Kingsley Porter*, Cambridge (Mass.), 1939, I, pp. 113-124. On the meaning of the tympanum, see Y. Christe, *Les Grands portails romans, Etudes sur l'iconographie des théophanies romanes*, Geneva, 1969, pp. 9-23.]

2 *Ingrediens templum refer ad sublimia vultum.* Portal of the church at Mozat, near Riom (Puy-de-Dôme). [See B. Craplet, *Auvergne romane* (ed. Zodiaque), La-Pierre-qui-Vire, 1955, pp. 227ff.]

3 [See G. Bandmann, "Ein Fassadenprogramm des 12. Jahrhunderts," *Das Münster*, 5 (1952), pp. 1-21, and Christe, *op. cit.*, pp. 135-153; F. Van der Meer, *Maiestas Domini, Theophanies de l'Apocalypse dans l'art chrétien*, Rome and Paris, 1938. See also L. Grodecki, "Le Problème des sources iconographiques du tympan de Moissac," *Moissac et l'occident au XIème siècle, Actes du Colloque international de Moissac, 1963*, Toulouse, 1964, pp. 59-68.]

4 Revelation 4:1.

5 Revelation 4:11.

6 [A. K. Porter, *Romanesque Sculpture of the Pilgrimage Roads*, Boston, 1923, pl. 508.]

7 [*Ibid.*, pls. 795-796, Santo Domingo at Soria.]

8 [*Ibid.*, pls. 822-823.]

9 Now in the archeological museum of Montpellier. [See R. Hamann, *Die Abteikirche von St.-Gilles und ihre künstlerische Nachfolge*, Berlin, 1955, pp. 240-254, and figs. 318-319.]

10 [See J. Evans, *Cluniac Art of the Romanesque Period*, Cambridge, 1950, pp. 55-56, fig. 108, and also M. Vidal, *Quercy roman* (ed. Zodiaque), La-Pierre-qui-Vire, 1959, pp. 235ff.]

11 Commentators of the Apocalypse authorized this substitution because, for them, the twenty-four elders were the prefigurations of the twelve prophets and the twelve apostles. On this subject, see *L'Art religieux du XIIIe siècle*, 9th ed., Paris, 1958, p. 369.

12 The beautiful but mutilated tympanum of Déols is now in the Châteauroux museum. [See W. Sauerländer, *Gotische Skulptur in Frankreich 1140-1270*, Munich, 1970, pp. 83-84, fig. 18.]

13 [See E. L. Mendell, *Romanesque Sculpture in Saintonge*, New Haven, 1940, pp. 63ff., fig. 124, and also Christe, *op. cit.*, pp. 139-143.]

14 See above Chapter V. [Cf. Christe, *op. cit.*, esp. pp. 150-152.]

15 For the most part, these figures have been restored. [See W. S. Stoddard, *The West Portals of St.-Denis and Chartres*, Cambridge (Mass.), 1952, pp. 32ff.]

16 [Various hypotheses have been put forth concerning the origin of the style of the sculptures of the Chartres portal. See Hamann, *Die Abteikirche von St.-Gilles*, p.

280; A. Lapeyre, *Des Façades occidentales de Saint-Denis et de Chartres aux portails de Laon*, 1960, pp. 24ff.; Sauerländer, *Gotische Skulptur*, pp. 66-70.]

17 [See A. Katzenellenbogen, *The Sculptural Programs of Chartres Cathedral*, Baltimore, 1959, pp. 24-25; Christe, *op. cit.*, pp. 142-144.]

18 [Christe, *op. cit.*, p. 18. See also Stoddard, *op. cit.*, pp. 32ff., and Sauerländer, *Gotische Skulptur*, p. 70.]

19 As the style of the statues proves, the portal of St.-Ayoul is certainly earlier than that of St.-Loup-de-Naud. [See Lapeyre, *Des Façades occidentales*, pp. 187-193 and 132-138, and Sauerländer, *Gotische Skulptur*, p. 86, fig. 22.]

20 [For Bourges, see Lapeyre, *op. cit.*, pp. 153-160, and Sauerländer, *op. cit.*, p. 83, with bibl., pls. 34-39.]

21 W. Vöge, *Die Anfänge des monumentalen Stiles im Mittelalter*, Strasbourg, 1894, pt. 1, chap. 11, pp. 8ff. Vöge pointed out the resemblances between Arles and Chartres, but he made a fundamental mistake in supposing that the Arles portal was the model for that of Chartres. The contrary is true. See R. de Lasteyrie, "Etudes sur la sculpture française au moyen âge," *Monuments Piot*, 8 (1902). [Vöge returned to this question in "Zur provençalischen und nordfranzösichen Bildnerei des 12. Jahrhunderts," *Repertorium für Kunstwissenschaft*, 1903, pp. 512-520. See L. Grodecki, "La Première sculpture gothique, Wilhelm Vöge et l'état actuel des questions," *Bulletin monumental*, 117 (1959), pp. 271-275. See also Christe, *op. cit.*, pp. 130 and 176.]

22 [Our fig. 272 reproduces a lithograph by Emile Sagot from the *Essai historique sur l'abbaye de Cluny*, published in 1839.]

23 The narthex dated from the thirteenth century.

24 [See K. J. Conant, *Cluny, Les églises et la maison du chef d'ordre*, Mâcon, 1968, pp. 100-104, and pls. 83-92. Conant's chronology is questioned by F. Salet, "Cluny III," *Bulletin monumental*, 126 (1968), pp. 288-291.]

25 The text of Aymeric de Peyrac is published in E. Rupin, *L'Abbaye et les cloîtres de Moissac*, Paris, 1897, p. 66 n. 2: *Dictus Asquilinus fecit fieri portale pulcherrimum et sublissimo opere constructum ecclesiae dicti monasterii* (The said Asquilinus saw to the making of a portal that was most beautiful and constructed with the most sublime workmanship for the church of the said monastery). [See M. Schapiro, "The Romanesque Sculpture of Moissac," *Art Bulletin*, 13 (1931), pp. 253-254 and 511ff.]

26 These drawings are in the *Grande Topographie de la France*, under "Cluny" (Paris, Bibl. Nat., Cabinet des Estampes, Va 193). [See Conant, *Cluny, chef d'ordre*, pp. 23-40, and A. Erlande-Brandenburg, "Iconographie de Cluny III," *Bulletin monumental*, 126 (1968), pp. 293-294, 308, 321.]

27 An unpublished manuscript in the Bibliothèque Nationale, ms. nouv. acq. fr. 4336: *Description historique et chronologique de la ville abbaye et banlieue de Cluny, par le citoyen Bouché* [*de la Bertillière.*]

28 Paris, Bibl. Nat., ms. nouv. acq. fr. 4336, fol. 108r.

29 [This question is still controversial. The Moissac tympanum has been dated ca. 1115 (cf. M. Schapiro, "The Sculptures of Souillac," *Medieval Studies in Memory of A. Kingsley Porter*, Cambridge, 1939, 11, p. 383 n. 1), but the date of the Cluny sculpture is debated. K. J. Conant dates the choir capitals between 1088 and 1095 (*Cluny, chef d'ordre*, pp. 86ff.); he dates the sculptures of the great portal between 1106 and 1112 (*ibid.*, p. 104). This dating is accepted by M. Aubert, (*La Sculpture française au moyen âge*, Paris, 1946, pp. 91-92). Others have dated the Cluny sculpture twenty years later: see P. Deschamps, *French Sculpture of the Romanesque Period* (Pantheon ed.), Florence and New York, n.d., pp. 35-37, and Salet, "Cluny III," pp. 238ff.]

30 [See Conant, *Cluny, chef d'ordre*, p. 104.]

31 Chapter IX, pp. 320-322. [See Conant, *Cluny, chef d'ordre*, pp. 86ff. The date of the capitals proposed by Conant has been questioned by F. Salet, "Chronologie de l'ancienne église abbatiale de Cluny," *Académie des Inscriptions et Belles-Lettres, Comptes rendus de l'année 1968*, pp. 30-39. P. Deschamps, in *ibid.*, pp. 39-41 summarizes the question.]

32 [See Lapeyre, *Des Façades occidentales*, p. 103 n. 3. Cf. P. Quarré, "La Sculpture des anciens portails de Saint-Bénigne de Dijon," *Gazette des beaux-arts*, 49 (1957), pp. 177-194, and Sauerländer, *Gotische Skulptur*, pp. 73-75, pls. 22, 23, fig. 8; B. Kerber, *Burgund und die Entwicklung der französischen*

Kathedralskulptur in 12. Jahrhundert, Recklinghausen, 1966, pp. 41ff.]

33 I am not referring to the great portal where the same subject occurs, for this portal has been much restored.

34 The rest of the portal is filled with scenes from the Infancy of Christ. [Cf. Lapeyre, *Des Façades occidentales*, p. 107 n. 2.]

35 The statues placed against the columns prove that the influences from the Ile-de-France operated also at Bourg-Argental. The two columns decorated with rinceaux which frame the portal are a modern addition.

36 I have shown in Chapter I, p. 36, that the Charlieu lintel, like the Lavaudieu fresco, derives from an illustrated manuscript. [Cf. Evans, *Cluniac Art*, p. 71.]

37 *Histoire générale et particulière de Bourgogne*, I, Dijon, 1739, illus. p. 514. [See Lapeyre, *Des Façades occidentales*, pp. 138-146 (and illus. p. 139), and Sauerländer, *Gotische Skulptur*, p. 84, pls. 19-20 and fig. 19.]

38 I shall comment later on the extent to which it was.

39 J. N. Morellet, S. B. F. Barat, E. Bussière, *Le Nivernois, Album historique et pittoresque*, Nevers, 1838-1840, II, pl. 7. [See Lapeyre, *Des Façades occidentales*, pp. 121-123, illus. p. 122.]

40 [Since it was first taken up by Vöge, *Anfänge des monumentalen Stiles*, the problem of the jamb statues has been extensively discussed, most recently by Sauerländer, *Gotische Skulptur*, pp. 10-14, and 41-46.]

41 I, Paris, 1729, pp. 193-194, pls. XVI-XVIII. [The original drawings by A. Benoît are in Paris, Bibl. Nat., Manuscrits, ms. fr. 15634, fols. 33ff.]

42 The Jews arresting Christ in the Garden of Olives on a capital from La Daurade, now in the museum of Toulouse, wear this cap; [see Mesplé, *Toulouse, Musée des Augustins*, no. 131].

43 On the portal at the right dedicated to the Virgin.

44 [See Katzenellenbogen, *Chartres*, chap. III, pp. 27ff.]

45 Vöge, *Anfänge des monumentalen Stiles*, pp. 170-175.

46 The statue designated by the name of Salmon has been destroyed, but there is little doubt that between these two statues of women there was once a statue of a man.

47 In the first editions of *L'Art religieux du XIIIe siècle*, I accepted Vöge's interpretation, but closer study has caused me to reject it. Thus, I think that there is a statue of Moses at Chartres on the right side of the left portal. This is a figure wearing a melon hat (like the Moses of Bourges). In his hand he holds the open Tables of the Law, now almost unrecognizable because only a fragment remains. This Moses figure was at St.-Denis, and also at Etampes where the imitation of Chartres is obvious. If this is indeed Moses, it is clear that this cannot be the genealogy of Christ. [See Lapeyre, *Des Façades occidentales*, pp. 23-24, and Katzenellenbogen, *Chartres, loc. cit.*]

48 It must be noted that the statues at Le Mans, which are the same as those at Chartres, are placed in reverse order. The first king, instead of being near the door, is at the opposite side. [See Lapeyre, *Des Façades occidentales*, pp. 90-92.]

49 E. Hucher, *Etudes sur l'histoire et les monuments du département de la Sarthe*, Le Mans and Paris, 1856, pp. 41-46. The inscription was very old, for it was found under a coat of paint that had completely covered it.

50 And also on the portal of St.-Germain-des-Prés, now destroyed, but which Montfaucon (*Monumens de la monarchie françoise*, I, Paris, 1729, pl. VII) and Dom Bouillart (*Histoire de l'abbaye royale de Saint-Germain-des-Prés*, Paris, 1724, p. 309, pl. IV) reproduced. On this one portal, the artist carved the biblical kings and queens. One king, if we can credit the drawing of Montfaucon, carried a scepter surmounted by a bird on its nest. This was David with the symbolic pelican spoken of in the Psalms and which was placed beside him in thirteenth-century stained-glass windows (*L'Art religieux du XIIIe siècle*, 9th ed., p. 145, fig. 79). A bishop was at the head of the series of kings. This bishop, whom we find elsewhere, was the high priest Aaron. [See Lapeyre, *Des Façades occidentales*, pp. 165-166 (illus. p. 164).]

51 Montfaucon, *Monumens de la monarchie françoise*, I, p. 56, pl. VIII. [See Sauerländer, *Gotische Skulptur*, pp. 87-89, fig. 25.]

52 *Histoire générale et particulière de Bourgogne*, I, p. 503. Only the skeleton of the portal exists today. [See Lapeyre, *Des Façades occidentales*, p. 101. See above, note 25.]

53 See Chapter IV, p. 150.

54 W. Meyer, "Die Geschichte des Kreuzholzes von Christus," *Abhandlungen der philosophisch-philologischen Klasse der königlich-bayerischen Akademie der Wissenschaften*, 16-2 (1882), pp. 103-166. In the fifteenth century, the Germans were still representing the Queen of Sheba with a goose-foot. See J. Lucien-Herr, "La Reine de Saba et le bois de la croix," *Revue archéologique*, 23 (1914), pp. 1-31; [and A. Chastel, "La Légende de la reine de Saba," *Revue de l'histoire des religions*, 119 (1939), pp. 204-225; 120 (1939), pp. 27-44 and 121 (1939), pp. 160-174].

55 Abbé Lebeuf, "Conjectures sur la reine Pedauque," *Histoire de L'Académie Royale des Inscriptions et Belles-Lettres*, 23 (1756), pp. 227-235.

56 Hrabanus Maurus, in Migne, *P. L.*, 109, cols. 472-473.

57 Abbé Lebeuf, *op. cit.*, p. 228. Lebeuf points out two apostles with books. Perhaps they were St. Paul and Moses. [Cf. Lapeyre, *Des Façades occidentales*, pp. 123-126.]

58 Aubri des Trois-Fontaines, *Monumenta Germaniae Historica, Scriptores*, 23, Hanover, 1874, p. 725.

59 *Monumens de la monarchie françoise*, 1, p. 192. [See Lapeyre, *Des Façades occidentales*, pp. 118-121.]

60 [See above, n. 20, and cf. R. Branner, "Les Portails latéraux de la cathédrale de Bourges," *Bulletin monumental*, 115 (1957), pp. 263-270.] The portal of Angers has a very similar series, but restorations, some dating from the seventeenth and others from the nineteenth centuries, have deprived this portal of most of its interest. We recognize Moses, Aaron (with a miter), David (with a harp), Solomon, the Queen of Sheba (without goose-foot). The heads of two other statues have been restored and cannot be identified. F. de Guilhermy said, "The heads have just been restored in a completely unintelligent manner." [See Lapeyre, *Des Façades occidentales*, p. 88.] The two admirable statues from Notre-Dame of Corbeil, now in the Louvre, come from a portal whose large statues connected it with the series of buildings we have just studied. The king and queen from Corbeil perhaps represent Solomon and the Queen of Sheba [cf. Lapeyre, *op. cit.*, p. 262].

61 *L'Art religieux du XIIIe siècle*, 9th ed., p. 178.

62 [See Christe, *op. cit.*, pp. 66ff., with bibl. esp. H. Schrade, "Zur Ikonographie der Himmelfahrt Christi," *Vorträge der Bibliothek Warburg*, 1928/1929, and also, L. Bréhier, *L'Art chrétien, son développement iconographique*, Paris, 1928, pp. 264ff.]

63 [Porter, *Romanesque Sculpture*, pl. 702.]

64 [The portal on the north side of the church was shifted from its original location, probably at the end of the thirteenth century. On the iconography and restorations of the tympanum, cf. R. Rey, "Cathédrale Saint-Etienne de Cahors," *Congrès archéologique*, 100 (1938), pp. 247ff., and see also Vidal, *Quercy roman*, pp. 193ff.]

65 There are two other imitations of the Cahors tympanum at Collonges and at St.-Chamant (Corrèze). [See Christe, *op. cit.*, pp. 84-85.]

66 [See Christe, *op. cit.*, pp. 85-86; and for further illustrations and details, see Porter, *Romanesque Sculpture*, pls. 929-940.]

67 [*Ibid.*, pls. 944-945.]

68 [See P. Deschamps and M. Thibout, *La Peinture murale en France, Le haut Moyen Age et l'époque romane*, Paris, 1951, pp. 122ff. and pl. LVIII,2.]

69 *Viri Galilei, qui statis respicientes in coelum? Hic Jesus, qui assumptus est a vobis in coelum, sic veniet quemadmodum vidistis eum euntem in coelum* (Which also said, Ye men of Galilee, why stand ye gazing up into heaven? this same Jesus, which is taken up from you into heaven, shall so come in like manner as ye have seen him go into heaven) Acts 1:11.

70 *Christus in ea forma, qua ascendit, in judicium veniet*: Honorius of Autun, in Migne, *P. L.*, 172, col. 1165.

71 See below, p. 405.

72 [See Porter, *Romanesque Sculpture*, pls. 1025-1027.]

73 [See Katzenellenbogen, *Chartres*, pp. 24-25; and Christe, *op. cit.*, pp. 66-67.]

74 [Cf. L. Lefrançois-Pillion, *Les Sculpteurs français du XIIème siècle*, Paris, 1931, pp. 122-123.]

75 [R. Rey suggests a date of c. 1135 for the sculpture of Cahors, *Congrès archéologique*, 100 (1938), pp. 251-252; so does Vidal in *Quercy roman*, pp. 193ff., with illus. Cf. Aubert's date of c. 1150, *La Sculpture française au moyen âge*, p. 73.] [Mâle, Additions and Corrections to the 6th ed., 1953, p. 445]: The reconstitution of the tympa-

num of the church at Collonges (Corrèze), whose fragments had been embedded in the wall and had remained almost unknown, supplies further proof of the southern origin of the Chartres Ascension scene. At Collonges as at Chartres, two angels hold the clouds, as if they were drapery, above which Christ rises. This ingenious theme, found nowhere else, could not have been imagined at two different times. The Collonges portal, related to that of Cahors, is later, but both are earlier than the Royal Portal of Chartres, which was begun in 1145.

76 [See Lapeyre, *Des Façades occidentales*, pp. 62-64; and Sauerländer, *Gotische Skulptur*, pp. 81-82, pl. 31, and fig. 17.]

77 [See Stoddard, *op. cit.*, pls. 23-24.]

78 [Christe, *op. cit.*, p. 90.]

79 Chapter II, p. 96. [See Christie, *op. cit.*, esp. p. 83 n. 1, and p. 91.]

80 [See Christe, *op. cit.*, esp. pp. 86-88.]

81 [Porter, *Romanesque Sculpture*, pl. 88.]

82 This should not be confused with the beautiful exterior portal I have just mentioned. [See Christe, *op. cit.*, pp. 86-88.]

83 [See Christe, *op. cit.*, pp. 88-90.]

84 J. Guédel, *L'Architecture romane en Dombes*, Bourg-en-Bresse, 1911, p. 56.

85 [See Christe, *op. cit.*, pp. 105-133, and on Beaulieu esp. pp. 122-129, 173-179.]

86 In the Museum of Toulouse. [See Mesplé, *Toulouse, Musée des Augustins*, no. 119; and Christe, *op. cit.*, p. 125.]

87 *Crux micat in coelis*, in the *Carmina Sangallensia* (J. von Schlosser, *Schriftquellen zur Geschichte der karolingischen Kunst*, Vienna, 1892, p. 328, no. 93,3). [See Christe, *op. cit.*, pp. 112-116.]

88 This is the church of St.-George at Oberzell, on the island of Reichenau; F. X. Kraus, *Geschichte der christlichen Kunst*, II(1), Freiburg-im-Breisgau, 1897, p. 378, fig. 249. [See Christe, *op. cit.*, pp. 116-117, and O. Demus, *Romanesque Mural Painting*, New York, 1970, pp. 133, 600-601, and pl. 241.]

89 Kraus, *op. cit.*, II(1), p. 57, fig. 36. [See Christe, *op. cit.*, p. 118, and Demus, *loc. cit.*]

90 Matthew, 24:30.

91 Honorius of Autun, in Migne, *P. L.*, 172, col. 1166. [In the ninth century Rabanus Maurus already spoke of the Apparition of the Cross before Judgment (*De Fide Catholica Rythmus*); cf. Christe, *op. cit.*, p. 116.]

92 A. de Bastard-d'Estang, *Histoire de Jésus-Christ en figures*, Paris, 1879, pl. XXVIII. [Now in the Pierpont Morgan Library, New York, ms. 44. fol. 15r. See above, p. 464 n. 1.]

93 [R. Crozet, *L'Art roman en Poitou*, Paris, 1948, p. 197 and pl. XXVIII.]

94 Chapter V, p. 179.

95 T. Pinard, "Monographie de l'église Notre-Dame de Corbeil," *Revue archéologique*, 2 (1845), pp. 167-168. [See Lapeyre, *Des Façades occidentales*, pp. 256-259, and Sauerländer, *Gotische Skulptur*, pp. 81ff.]

96 [See Louvre Catalogue, M. Aubert and M. Beaulieu, *Description raisonnée des sculptures*, 1. *Moyen Age*, Paris, 1950, nos. 79-80, with illus.]

97 [On the Last Judgment tympanum, and its date, see Sauerländer, *Gotische Skulptur*, p. 110, pl. 69; cf. Aubert, *La Sculpture française au moyen âge*, pp. 214-215.]

98 The St. Anne Portal, which must have been begun shortly after 1163, the date when work was started at Notre-Dame. [See Sauerländer, *Gotische Skulptur*, pp. 87-89, pls. 40-41.]

99 Modern restorations have spoiled this Last Judgment tympanum. All of the heads were redone with no sense of proportion. The beautiful lintel which accompanies this tympanum at Laon is later, and contemporary with the two other portals.

100 [See Christe, *op. cit.*, esp. pp. 124-128, and G. Gaillard, *Rouergue roman* (ed. Zodiaque), La-Pierre-qui-Vire, 1963, pp. 49-50.]

101 This chapter was already written when Bréhier presented a study of the style of the Conques portal to the *Congrès d'Histoire de L'Art*, held at the Sorbonne in September 1921. He too associates it with Auvergne, and some of his arguments are the same as mine. That the conclusions reached are the same prove them to be the only ones that attentive study of the Conques portal will produce. [C. Bernouilli considers Conques the source of the Auvergnat sculpture rather than a derivative, *Die Skulpturen der Abtei Conques-en-Rouergue*, Basel, 1956, pp. 62-71; and cf. Gaillard, *Rouergue roman*, pp. 49-50.]

102 Migne, *P. L.*, 172, col. 1166.

103 It came from the cloister of La Daurade. [See Mesplé, *Toulouse, Musée des Augustins*, no. 116, and Christe, *op. cit.*, pp. 128-129.]

104 H. Rott, *Kleinasiatische Denkmäler* (Studien über christliche Denkmäler, v-vi), Leipzig, 1908, p. 270. [M. and N. Thierry, *Nouvelles églises rupestres de Cappadoce, Région de Hasan Dagi*, Paris, 1963, pp. 93ff. (Yilanli Kilise, in the Peristrema Valley).]

105 Bruno d'Asti, *In Job*, in Migne, *P. L.*, 164, cols. 688-689. See *L'Art religieux en France au XIIIe siècle*, 9th ed., pp. 384-386.

106 Pinard, "Monographie de l'église Notre-Dame de Corbeil," p. 170. There were the maw of Leviathan, the cauldron, the patriarchs holding the souls of the elect to their bosoms. [See above, note 95.]

107 [Mâle, Additions and Corrections to the 6th ed., 1953, p. 445]: A capital in the ambulatory of Santiago de Compostela, near the Santa Fe chapel, represents a miser, with his purse suspended from his neck, fastened to a gibbet by Satan. This miser is exactly like the miser about to be killed by a demon represented on the tympanum of Conques. This is proof of the influence of Conques. See P. Deschamps, "Etude sur les sculptures de Sainte-Foy de Conques et de Saint-Sernin de Toulouse," *Bulletin monumental*, 100 (1941), pp. 239ff.

108 Weighing of Souls, Maw of Leviathan, Lucifer Enthroned. [Cf. above, note 101.]

109 On the exterior portal of Vézelay reconstructed by Viollet-le-Duc, and at St.-Vincent of Mâcon (mutilated). [See D. Grivot and G. Zarnecki, *Gislebertus, Sculptor of Autun*, New York, 1961, and Christe, *op. cit.*, pp. 127-130.]

110 [Revelation 14:7, "For the hour of his Judgment has come."]

111 Children do not appear in thirteenth-century Last Judgment scenes which, in conformance with theological doctrine, included only adults.

112 A large area of the lower registers have been destroyed by a huge opening cut out of the tympanum. [See Christe, *op. cit.*, pp. 122ff., and Porter, *Romanesque Sculpture*, pl. 92.]

113 Now in the archeological museum of Dijon. [See Quarré, "La Sculpture des anciens portails de Saint-Bénigne de Dijon," pp. 171-194; Lapeyre, *Des Façades occidentales*, pp. 104-105; and Sauerländer, *Gotische Skulptur*, pp. 73-74, pl. 22.]

114 [Christe, *op. cit.*, esp. p. 87.]

115 [See Porter, *Romanesque Sculpture*, pls. 1185, 1214, 1318, 1292-1293, and cf. Bréhier, *L'Art chrétien*, pp. 253ff.]

116 [See Hamann, *Die Abteikirche von St.-Gilles*, pp. 333-357.]

117 This symbolic interpretation of the Washing of Feet was traditional. *Glossa ordinaria*, John 13:8, in Migne, *P. L.*, 114, col. 405.

118 [See J. B. Russell, *Dissent and Reform in the Early Middle Ages*, Berkeley and Los Angeles, 1965, pp. 5ff., and H. Kraus, *The Living Theatre of Medieval Art*, Bloomington and London, 1967, pp. 119ff.]

119 *Epistolae*, no. 241, Migne, *P. L.*, 182, col. 434 [cf. ed. and French tr. Abbé Charpentier, Paris, 1865, 1].

120 [See C. Thouzellier, *Catharéisme et valdéisme en Languedoc à la fin du XIIème siècle et au début du XIIIème siècle*, Paris, 1966; and *Cathares en Languedoc, Session d'histoire religieuse du Midi de la France aux 12ème et 13ème siècles* (Cahiers de Fangeaux, no. 3), Toulouse, 1968. Cf. D. Walther, "Survey of Recent Research on the Albigensian Cathari," *Church History*, 34 (1935), pp. 146ff.]

121 [See Thouzellier, *op. cit.*, esp. pp. 60-67, with bibl.]

122 In 1167, nine heretics were discovered at Vézelay.

123 Peter the Venerable, in Migne, *P. L.*, 189, col. 796. [See Evans, *Cluniac Art*, p. 35.]

124 [See Bréhier, *L'Art chrétien*, pp. 45-46.]

125 This almost barbarian work is not as old as it has been thought; it probably is no earlier than the mid-twelfth century. It was certainly not this poor artist who created the motif of the Last Supper surmounted by a Christ in Majesty. He imitated a model that he was incapable of copying. [See Hamann, *Die Abteikirche von St.-Gilles*, pp. 346-347, and pp. 375ff.; and Porter, *Romanesque Sculpture*, pls. 1147-1148.]

126 Portal of the west façade of Reims, devoted to the Passion: Christ on the Cross is placed in the gable. [Evans, *Cluniac Art*, p. 87; Hamann, *Die Abteikirche von St.-Gilles*, pp. 372-376.]

127 [See Evans, *Cluniac Art*, p. 100; Porter, *Romanesque Sculpture*, pl. 133.]

128 [See J. F. Lemarignier, "L'Exemption monastique et les origines de la réforme grégorienne," *A Cluny, Congrès scientifique, 9-11 juillet 1949, Travaux*, Dijon, 1950, pp. 288-334. Cf. N. Hunt, *Cluny under Saint Hugh 1049-1109*, London, 1967, pp. 39ff.]

129 [Hunt, *op. cit.*]

130 These are the two side figures of the portal.

131 Seine-et-Oise. [See Evans, *Cluniac Art*, pp. 99-101.]

132 Honorius of Autun, in Migne, *P. L.*, 172, cols. 904-905. [See F. Unterkircher and G. Schmidt, *Die Wiener Biblia Pauperum*, Graz, Vienna and Cologne, 1962, I, pp. 20ff. (on typological imagery, with bibl.). Cf. Christe, *op. cit.*, p. 22.]

133 St. Bernard, in Migne, *P. L.*, 183, col. 953. [Cf. ed. and French tr. Charpentier, II. See Dom J. Leclercq, "Etudes sur saint Bernard et le texte de ses écrits," *Analecta sacri ordinis Cisterciensis*, 9 (1953), pp. 92-113.]

134 *Super missus est homeliae*, Migne, *P. L.*, 183, col. 62 [cf. ed. Charpentier, III].

135 Migne, *P. L.*, 183, col. 70.

136 Aubri des Trois-Fontaines, *Chronique, Monumenta Germaniae Historica, Scriptores*, XXIII, Hanover, 1874, p. 828.

137 *Acta Sanctorum*, 20 August, IV, pp. 206-208.

138 [See the Sermons of St. Bernard, ed. Charpentier, III.]

139 [For Agramunt, see J. Gudiol Ricart and J. A. Gaya Nuño, *Arquitectura y escultura románicas* (Ars Hispaniae, V), Madrid, 1948, p. 95, and pl. 161, and Porter, *Romanesque Sculpture*, pl. 532.]

140 A. L. Millin, *Voyage dans les départements du Midi de la France*, III, Paris, 1808, pp. 434-435. [Cf. Hamann, *Die Abteikirche von St.-Gilles*, p. 358. For other monumental representations of the Adoration of the Magi, see G. Schiller, *Ikonographie der christlichen Kunst*, I, Gütersloh, 1966, pp. 116-119.]

141 The heads of the Virgin and Child are modern. The work is at Beaucaire, privately owned. [See above, note 140.]

142 [Hamann, *Die Abteikirche von St.-Gilles*, pp. 156ff.]

143 [*Ibid.*, pp. 359ff.]

144 See *L'Art religieux du XIIIe siècle*, 9th ed., pp. 183-184.

145 Isaiah, who had foretold the Immaculate Conception, is at one side of the door; at the other, St. John the Baptist who presided at the Baptism.

146 St. Bernard, *Super missus est homeliae*, in Migne, *P. L.*, 183, col. 62. [Cf. ed. Charpentier, III. For Neuilly-en-Donjon, see M. Génermont and P. Pradel, *Les Eglises de France, Allier*, Paris, 1938, pp. 187-188, and W. Cahn, "Le Tympan de Neuilly-en-Donjon," *Cahiers de civilisation médiévale*, 8 (1965), pp. 351-364.]

147 [See above, note 146.]

148 At Laon, the sculptor seemed to remember the tympanum of St.-Gilles; the arrangement is the same. The beautiful portal of Germigny-l'Exempt (Cher), related to the Laon portal, should also be mentioned. [See Hamann, *Die Abteikirche von St.-Gilles*, pp. 362-363, and Sauerländer, *Gotische Skulptur*, pp. 108-111, pl. 69.]

149 Curiously enough, on one of the portals of the north façade of Chartres, dating from about 1200, we again find the Adoration of the Magi—so strong was the tradition. [Cf. Katzenellenbogen, *Chartres*, pp. 7-12, 66.]

150 J. Puig y Cadafalch, A. de Falguera y Sivilla, and J. Goday y Casals, *L'Arquitectura romànica a Catalunya*, III, Barcelona, 1918, pp. 808-809. [See M. Durliat, *L'Art catalan*, Paris and Grenoble, 1963, p. 107 and fig. 74 (Corneilla); for Vallbona-de-las-Monjas, see Gudiol Ricart and Gaya Nuño, *op. cit.*, fig. 179.]

151 The Virgin of the portal of the chapter house of La Daurade in the museum of Toulouse [see Mesplé, *Toulouse, Musée des Augustins*, no. 83] is, as the attitude of the Child proves, from the latter part of the twelfth century. We sense the imitation of the Virgins of Chartres and of the St. Anne Portal of Notre-Dame at Paris.

152 Chapter VIII, p. 284.

153 The ciborium once existed at Chartres; we see it on the St. Anne Portal of Notre-Dame at Paris.

154 Donzy was a dependency of La Charité-sur-Loire, where the influence of Chartres is evident. [Cf. Evans, *Cluniac Art*, p. 95, and F. Salet, "L'Eglise de Donzy-le-Pré," *Congrès archéologique*, 125 (1967), pp. 142-152.]

155 *Histoire générale et particulière de Bourgogne*, I, p. 516. [See Lapeyre, *Des Façades occidentales*, p. 144.]

156 This portal, which also had the seated apostles carved on the lintel, was very similar to the south portal of Bourges.

157 The figures of the Virgin and Child are badly damaged. [Cf. Lapeyre, *Des Façades occidentales*, pp. 144-145.]

158 *Histoire générale et particulière de Bourgogne*, I, p. 514.

159 The relief, which is rectangular, does not at present have the form of a tympanum, but it is composed of assembled pieces like the tympanums of Moissac, Beaulieu, and Cahors, and some of these pieces must be missing. [See Schapiro, "The Sculptures of Souillac," pp. 359n., 368-372.]

160 The Souillac relief, which long remained an enigma, was explained for the first time by A. Ramé, "Explication du bas-relief de Souillac, La légende de Théophile," *Gazette archéologique*, 10 (1885), pp. 225-232. [See K. Plenzat, *Die Theophiluslegende in den Dichtungen des Mittelalters* (Germanische Studien, 43), Berlin, 1926, and G. Frank, ed., *Rutebeuf, Le miracle de Théophile*, Paris, 1925. Cf. Schapiro, *loc. cit.*, and Vidal, *Quercy roman*, pp. 284-285.]

161 *L'Art religieux du XIIIe siècle*, 9th ed., pp. 261-263.

162 Fulbert of Chartres, in Migne, *P. L.*, 141, col. 323.

163 Migne, *P. L.*, 172, col. 993.

164 Migne, *P. L.*, 171, col. 1593.

165 M. Deshoulières, "Le Tympan de l'église Saint-Pierre-le-Puellier," *Mémoires de la Société des Antiquaires du Centre*, 38 (1917-1918), pp. 38-46. [Cf. Evans, *Cluniac Art*, p. 96.]

166 *L'Art religieux du XIIIe siècle*, 9th ed., pp. 249-250. [See K. Künstle, *Ikonographie der christlichen Kunst*, I, Freiburg-im-Breisgau, 1928, pp. 563ff.]

167 This group is mutilated and the palm no longer exists, but the inscription refers to it: *Palmam vi[c]trici fert angelus* (The angel bears the palm to the victor). [Cf. Deshoulières, *op. cit.*, p. 44.]

168 The presence of an angel, who is about to receive her soul, makes this hypothesis likely.

169 [See P. Wilhelm, *Die Marienkrönung am Westportal der Kathedral von Senlis*, Hamburg, 1941, and Sauerländer, *Gotische Skulptur*, pp. 90-91, pls. 42-45.]

170 Chapter v, p. 184. [See J. Lafond and L. Grodecki, *Les Vitraux de Notre-Dame et de la Sainte Chapelle de Paris* (Corpus Vitrearum Medii Aevi, France I), Paris, 1959, p. 15.]

171 I have indicated elsewhere (A. Michel, ed., *Histoire de l'art*, I(2), Paris, 1905, p. 790) that the stained-glass artists of Angers seem to have been in touch with those of St.-Denis, that is, with the art created by Suger. [See J. Hayward and L. Grodecki, "Les Vitraux de la cathédrale d'Angers," *Bulletin monumental*, 124 (1966), pp. 13-15.]

172 The fragments of this portal have been placed inside the church; A. Boinet, "L'Ancien portail de l'église Saint-Yved de Braine (Aisne)," *Congrès archéologique*, 78 (1911), pp. 259-278. [See Sauerländer, *Gotische Skulptur*, pp. 111-112, pls. 74-75.]

173 I discussed these imitations in a chapter called "Le Portail de Senlis et son influence," in *Art et artistes du moyen âge*, 1927, pp. 209ff.

174 [See Mendell, *Romanesque Sculpture in Saintonge*, and Crozet, *L'Art roman en Poitou*. Cf. R. Crozet and Y. Labande-Mailfert, in *Poitou roman* (ed. Zodiaque), La-Pierre-qui-Vire, 1957, and P. Bouffard, *Sculpteurs de la Saintonge romane*, Paris, 1962.]

175 The subjects of these archivolts have been studied by C. Dangibeaud, "L'Ecole de sculpture romane saintongeaise," *Bulletin archéologique du Comité des Travaux historiques et scientifiques*, 1910, pp. 22-49, and by P. Deschamps, "Le Combat des vertus et des vices sur les portails romans de la Saintonge et du Poitou," *Congrès archéologique*, 79 (1912), II, pp. 309-324. The domain of portals with historiated archivolts like those of Saintonge is vast. They are found as far south as Blasimon (Gironde), and as far north as the cloister of St.-Aubin at Angers. [See Mendell, *op. cit.*; and Crozet, *L'Art roman en Poitou*, pp. 181-216. Cf. Katzenellenbogen, *Virtues and Vices*, pp. 17-19.]

176 In the museum of Toulouse, there is a second capital (incomplete) of the Wise and Foolish Virgins. [Mesplé, *Toulouse, Musée des Augustins*, nos. 34 and 37, attributes them to St.-Etienne.]

177 [See ed. H. J. Thompson, Loeb Classical Library, Cambridge (Mass.) and London, 2 vols., 1959.] *L'Art religieux du XIIIe siècle*, 9th ed., pp. 100-102. [See Katzenellenbogen, *Virtues and Vices*, pp. 1ff.]

178 On the portal of Notre-Dame-de-la-Couldre at Parthenay (Deux-Sèvres) and on the portal of Varaize (Charente-Maritime). At Aulnay-de-Saintonge, the lamb decorates one of the two portals, the elders decorate the other.

179 G. Sanoner explained these reliefs in a very plausible way ("Analyse du portail de l'église Saint-Gilles à Argenton-Château

(Deux-Sèvres)," *Revue de l'art chrétien*, 53 (1903), pp. 402-405). It is also very probably the parable of the Wicked Rich Man that is placed in the false door at the left of the façade of Ruffec. [Crozet, *L'Art roman en Poitou*, p. 203, sees there an episode of the legend of St. Andrew, patron of the church.]

180 These figures decorate the archivolts of the window of the first storey and a neighboring arcature.

181 The Abbey of St.-Jean-d'Angély was destroyed by the Protestants in 1568; very little remains of the church.

182 The façade of the church of St.-Eutrope was destroyed during the Wars of Religion.

183 For the month of August, at Aulnay, Argenton-Chateau, Fenioux and Civray, we see a reaper beside a kind of wattle-fencing, which has seemed inexplicable. This kind of wattle-fencing seems to me nothing more than a field of wheat in which the heads of wheat are superposed. [See Crozet, *L'Art roman en Poitou*, pp. 211-213.]

BIBLIOGRAPHY

"Adam, A Religious Play of the Twelfth Century," tr. E. N. Stone. *University of Washington Publications in Language and Literature*, 4 (1926), pp. 159-202.

Adhémar, Jean. "L'Enlèvement de Ganymède sur un chapiteau de Vézelay," *Bulletin monumental*, 91 (1932), pp. 290-292.

——. *Influences antiques dans l'art du moyen âge français* (Studies of the Warburg Institute). London, 1939.

Agnel, G. Arnaud d'. "Notice archéologique sur le prieuré de Ganagobie (Basses-Alpes), église et cloître du XIIème siècle," *Bulletin archéologique du Comité des Travaux historiques et scientifiques*, 1910, pp. 314-327.

——. "Le Trésor de l'église d'Apt (Vaucluse)," *Bulletin archéologique du Comité des Travaux historiques et scientifiques*, 1904, pp. 333-334.

Ainalov, D. V. *The Hellenistic Origins of Byzantine Art.* New Brunswick, 1961 (tr. of original Russian ed. of 1900).

Albe, E. "La Vie et les miracles de S. Amator," *Analecta Bollandiana*, 28 (1909), pp. 57-90.

Alexander, J. J. G. *Norman Illustration at Mont-Saint-Michel: 966-1100.* Oxford, 1969.

Allier, Achille. *L'Ancien Bourbonnais.* Moulins, 1833.

Alviella, Goblet d'. "Les Arbres paradisiaques des Sémites et des Aryens," *Bulletin de l'Académie Royale des Sciences, des Lettres et des Beaux-Arts*, 3rd ser., 19 (1890), pp. 633-679.

Ameisenowa, Zofja. "Animal-headed Gods, Evangelists, Saints and Righteous Men," *Journal of the Warburg and Courtauld Institutes*, 12 (1949), pp. 21-45.

Anfray, Marcel. *L'Architecture normande, son influence dans le nord de la France aux XIe et XIIe siècles.* Paris, 1939.

Annales archéologiques, ed. A. N. Didron. 28 vols. Paris, 1844-1881.

Anthony, Edgar Waterman. *A History of Mosaics.* Boston, 1935.

Anz, H. *Die lateinischen Magierspiele, Untersuchungen und Texte zur Vorgeschichte des deutschen Weihnachtsspiels.* Leipzig, 1905.

Apolloni Ghetti, B. M. *Santa Prassede* (Le chiese di Rome illustrate, 66). Rome, 1961.

Arbellot, abbé. "Dissertation sur l'apostolat de saint Martial," *Bulletin de la Société Archéologique et Historique du Limousin*, 4 (1852), pp. 267-270.

——. "Mémoire sur les statues équestres de Constantin placées dans les églises de l'ouest de la France," *Bulletin de la Société Archéologique et Historique du Limousin*, 32 (1885), pp. 1-34.

——. "Roland ou les sculptures de Notre-Dame-de-la-Règle," *Bulletin de la Société Archéologique et Historique du Limousin*, 37 (1890), pp. 137-141.

Auber, abbé. "Châtillon-sur-Indre, la ville et l'église Notre-Dame," *Bulletin monumental*, 42 (1876), pp. 127-141.

Aubert, Marcel. "L'Eglise abbatiale de Selles-sur-Cher," *Bulletin monumental*, 77 (1913), pp. 387-402.

——. "Lyon, Cathédrale," *Congrès archéologique*, 98 (1935), pp. 54-90.

——. *Notre-Dame de Paris; architecture et sculpture.* Paris, 1928.

——. *La Sculpture française au moyen-âge.* Paris, 1946.

——. *Suger* (Figures monastiques). Saint-Wandrille, 1950.

——. "Têtes de statues-colonnes du portail occidental de Saint-Denis," *Bulletin monumental*, 103 (1945), pp. 243-248.

—— and others. *Le Vitrail français.* Paris, 1958.

——, Louis Grodecki, Jean Lafond, and Jean Verrier. *Les Vitraux de Notre-Dame et de la Sainte-Chapelle de Paris* (Corpus Vitrearum Medii Aevi, France 1). Paris, 1959.

Audiat, Louis. "Les Cavaliers au portail des églises," *Congrès archéologique*, 38 (1871), pp. 317-343.

Audollent, Auguste. *Carthage romaine; 146 avant Jésus-Christ—698 après Jésus-Christ.* Paris, 1901.

St. Augustine. *The City of God,* tr. Marcus Dods. (Modern Library ed.) New York, 1950.

Avery, Myrtilla. "The Alexandrian Style at Santa Maria Antiqua, Rome," *Art Bulletin*, 7 (1925), pp. 131-149.

——. *The Exultet Rolls of South Italy.* Princeton, London, and The Hague, 1936, II (plates).

Avesta, Livre sacré des sectateurs de Zoroastre, tr. C. de Harlez. Liège, Paris and Louvain, 1876.

Avignon, Musée Calvet. Girard, J. *Musée Calvet de la Ville d'Avignon.* Avignon, 1924.

Avril, François. "La Decoration des manuscrits au Mont-Saint-Michel (XIème-XIIème siècle)," *Millenaire monastique du Mont-Saint-Michel; Mémoires commémoratifs,* Paris, 1966, II, pp. 215-218.

Bachelin, A. "Description d'un commentaire de l'Apocalypse, manuscrit du XIIe siècle compris dans la bibliothèque d'Altamira," *Le Bibliophile français,* 4 (1869), pp. 98-108 and 129-159.

Baltrušaitis, Jurgis. *Art sumérien, art roman.* Paris, 1934.

——. *Études sur l'art médiéval en Géorgie et en Arménie.* Paris, 1929.

Bandmann, G. "Ein Fassadenprogramm des 12. Jahrhunderts," *Das Münster,* 5 (1952), pp. 1-21.

Barbier de Montault, Xavier. "Le Vitrail de la Crucifixion à la cathédrale de Poitiers," *Bulletin monumental,* 51 (1885), pp. 17-45 and 141-168.

Baronius, C. *Martyrologium romanum.* Antwerp, 1589.

Barrère, J. *Histoire religieuse et monumentale du diocèse d'Agen.* Agen, 1855.

St. Basil. *Hexaemeron,* ed. and tr. S. Giet (Sources chrétiennes). Paris, 1949.

Bastard-d'Estang, Auguste, comte de. *Documents archéologiques.* Paris, Bibliothèque Nationale, Cabinet des Estampes, Ad. 150.

——. *Histoire de Jésus-Christ en figures. Gouaches du XIIe au XIIIe siècle conservées jadis à la collégiale de Saint-Martial de Limoges.* Paris, 1879.

Baudot, A. de and A. Perrault-Dabot. *Archives de la Commission des Monuments Historiques.* 5 vols. Paris, n.d.

Baumstark, A. "Palaestiniensia," *Römische Quartalschrift,* 20 (1906), pp. 123-188.

——. "Spätbyzantinisches und frühchristlich-syrisches Weihnachtsbild," *Oriens cristianus,* 9th ser., 3 (1913), pp. 118ff.

Bédier, Joseph. *Les Légendes épiques; recherches sur la formation des chansons de geste.* 4 vols. Paris, 1908-1913.

Bégule, Lucien. *La Cathédrale de Sens, son architecture, son décor.* Lyon, 1929.

Beigbeder, Olivier. *Forez-Velay* (ed. Zodiaque). Le Puy, 1952.

Beissel, Stephan. *Des hlg. Bernward Evangelienbuch im Dome zu Hildesheim, mit Handschriften des X. und XI. Jahrhunderts in kunsthistorischer und liturgischer Hinsicht verglichen,* 3rd ed. G. Schrader and F. Koch, Hildesheim, 1894.

——. "Ein Missale aus Hildesheim und die Anfänge der Armenbibel," *Zeitschrift für christliche Kunst,* 15 (1902), cols. 266-274 and 307-318.

——. *Vatikanische Miniaturen.* Freiburg-im-Breisgau, 1893.

Benedictine Order. *Acta Sanctorum ordinis sancti Benedicti in saeculorum classes distributa,* ed. Jean Mabillon. 9 vols. Paris, 1668-1702.

Benoît, Fernand. *L'Art primitif méditerranéen de la vallée du Rhône; La sculpture* (Editions d'art et d'histoire). Paris, 1945.

Bercham, Max van and Josef Strzygowski. *Amida.* Heidelberg and Paris, 1910.

Berger de Xivrey, J. *Traditions tératologiques.* Paris, 1836.

Bergier, Nicolas. *Histoire des grands chemins de l'Empire.* Paris, ed. of 1728.

St. Bernard. *Oeuvres complètes de Saint Bernard,* ed. and tr. abbé Charpentier. Paris, 1865.

Bernard, B. "Découverte des reliques dans l'autel de l'église de Valcabrère (Haute-Garonne)," *Bulletin monumental,* 52 (1886), pp. 500-508.

Bernheimer, Richard. *Romanische Tierplastik und die Ursprünge ihrer Motive.* Munich, 1931.

Bernouilli, Christoph. *Die Skulpturen der Abtei Conques-en-Rouergue.* Basel, 1956.

Bertaux, Emile. *L'Art dans l'Italie méridionale.* Paris, 1904.

Berthier, J. J. "Un Crucifix du XIIe siècle," *Revue de l'art chrétien,* 44 (1895), pp. 64-66.

Beutler, C. "Das Tympanon zu Vézelay; Programm, Planwechsel und Datierung," *Wallraf-Richartz Jahrbuch,* 19 (1967), pp. 7-30.

Bibliotheca Sanctorum. 12 vols. Rome, 1961-1969.

Birot, J. "Les Chapiteaux des pilastres de Saint-Martin-d'Ainay à Lyon," *Congrès archéologique,* 74 (1907), pp. 526-536.

Bissing, Fr. W. von. "Untersuchungen über die 'phoinikischen' Metallschalen," *Jahrbuch des deutschen archäologischen Instituts,* 38/39 (1923-1924), pp. 180-241.

Black, Clairece. "The Origin of the Lucchese Cross Form," *Marsyas,* 1 (1941), pp. 27-40.

Blanchet, Adrien and Georges Lafaye. *Inven-*

taire des mosaïques de la Gaule. 3 vols. Paris, 1909.

Bloch, Marc. "Les Vicissitudes d'une statue équestre: Philippe de Valois, Constantin ou Marc-Aurèle?" *Revue archéologique*, 19 (1924), pp. 132-136.

Bloch, Peter. "Siebenarmige Leuchter in christlichen Kirchen," *Wallraf-Richartz Jahrbuch*, 23 (1961), pp. 55-190.

Boase, Thomas Sherrer Ross. *English Art: 1100-1216* (Oxford History of Art, III). Oxford, 1953.

Bober, Harry. "An Illustrated Medieval School Book of Bede's 'De natura rerum,' " *Journal of the Walters Art Gallery*, 19/20 (1956-1957), pp. 65-97.

———. "The Zodiacal Miniature of the 'Très Riches Heures' of the Duke of Berry," *Journal of the Warburg and Courtauld Institutes*, 11 (1948), pp. 1-34.

Bock, W. de. *Matériaux pour servir à l'archéologie de l'Egypte chrétienne*. Saint Petersburg, 1901.

Boeckler, Albert. *Die Bronzetüren des Bonanus von Pisa und des Barisanus von Trani*. Berlin, 1953.

———. *Ikonographische Studien zu den Wunderszenen in der ottonischen Malerei der Reichenau*. Munich, 1961.

———. *Die Regensburg-Prüfeninger Buchmalerei des XII. und XIII. Jahrhunderts* (Miniaturen aus Handschriften der bayerischen Staatsbibliothek in München, VIII). Munich, 1924.

Bohigas Balaguer, Pedro. *La ilustración y la decoración del libro manuscrito en Cataluña*, I. *Período románico*. Barcelona, 1960.

Boinet, Amédée. "L'Ancien Portail de l'église Saint-Yved de Braine (Aisne)," *Congrès archéologique*, 76 (1911), pp. 259-278.

———. *Les Eglises parisiennes*. 3 vols. Paris, 1958-1962.

———. "L'Evangéliaire de Morienval à la cathédrale de Noyon," *Congrès archéologique*, 72 (1905), pp. 637ff.

———. "Un Manuscrit à peintures de la Bibliothèque de Saint-Omer," *Bulletin archéologique du Comité des Travaux historiques et scientifiques*, 1904, pp. 415-430.

———. *La Miniature carolingienne; ses origines, son développement*. Paris, 1913.

———. "Notice sur un évangéliaire de la Bibliothèque de Perpignan," *Congrès archéologique*, 73 (1906), pp. 534-551.

Boissonnade, P. *Du Nouveau sur la Chanson de Roland; La genèse historique, le cadre géographique, le milieu, les personnages, la date et l'auteur du poème*. Paris, 1923.

St. Bonaventure. *Opera omnia*. 11 vols. Clara Aqua, 1882-1902.

Bonnell, J. K. "The Easter Sepulchrum in its Relation to the Architecture of the High Altar," *Publications of the Modern Language Association of America*, 31 (1916), pp. 667-679.

Bonnet, E. "Les Bas-reliefs de la tour de Saint-Restitut," *Congrès archéologique*, 76 (1909), pp. 251-274.

Borchgrave d'Altena, J. de. "Crucifixions mosanes," *Revue belge d'archéologie et d'histoire de l'art*, 3 (1933), pp. 62-67.

Bordier, H. "La Confrérie de Saint-Jacques-aux-Pelerins," *Mémoires de la Société de l'Histoire de Paris et de l'Ile-de-France*, 2 (1876), pp. 349-351.

Bottineau, Yves. *Les Chemins de Saint-Jacques*. Paris and Grenoble, 1964.

Bouffard, Pierre. *Sculpteurs de la Saintonge romane*. Paris, 1962.

Bouillart, Dom. *Histoire de l'abbaye royale de Saint-Germain-des-Prés*. Paris, 1724.

Bouillet, A. and L. Servières. *Sainte Foy, vierge et martyre*. Rodez, 1900.

Bouquet, Martin, ed. *Rerum Gallicarum et Francicarum scriptores* (Recueil des historiens des Gaules et de la France). 24 vols. Paris, 1738-1904. Re-ed. of vols. 1-19 by L. Delisle, Paris, 1868-1880; vols. 20-23, 1893-1894; vol. 24, Paris, 1904.

Branner, Robert. "Les Portails latéraux de la cathédrale de Bourges," *Bulletin monumental*, 115 (1957), pp. 263-270.

Braunfels, W. *Die Auferstehung*. Düsseldorf, 1951.

Bréhier, Louis. *L'Art chrétien, son développement iconographique des origines à nos jours*. Paris, 2nd ed., 1928.

———. "Les Chapiteaux historiés de Notre-Dame-du-Port à Clermont. Étude iconographique," *Revue de l'art chrétien*, 62 (1912), p. 261.

———. *Études archéologiques*. Clermont-Ferrand, 1910.

———. "Les Origines de la sculpture romane," *Revue des deux mondes*, 15 (1912), pp. 12-33 and 870-901.

———. "Le Pilier de Souvigny et l'histoire naturelle fantastique au moyen âge," *Bulletin régional des Amis de Montluçon*, 8 (1923), pp. 29-48.

Brémond, J. *Les Pères du désert*. 2 vols. Paris, 1927.

Brincard, Baroness. *Cunault, ses chapiteaux du XIIème siècle*. Paris, 1937.

Brussels, Bibliothèque Royale. Gaspar, Camille and Frédéric Lyna. *Les Principaux manuscrits à peintures de la Bibliothèque Royale de Belgique* (Société français de reproductions de manuscrits à peintures). Paris, 1937.

Brutails, Jean Auguste. *Étude archéologique sur les églises de la Gironde*. Bordeaux, 1912.

———. "Notes sur quelques crucifix des Pyrénées-Orientales," *Bulletin archéologique du Comité des Travaux historiques et scientifiques*, 1891, pp. 283-285.

Buberl, Paul. *Die illuminierten Handschriften in Steiermark*, I. *Die Stiftsbibliotheken zu Admont und zu Vorau*. Leipzig, 1911.

Buchthal, Hugo. *Miniature Painting in the Latin Kingdom of Jerusalem*. Oxford, 1957.

———. *The Miniatures of the Paris Psalter*. London, 1938.

Bulliot, J. G. *Essai historique sur l'abbaye de Saint-Martin d'Autun de l'ordre de saint Benoît*. Autun, 1849.

Cabrol, Fernand and Henri Leclercq. *Dictionnaire d'archéologie chrétienne et de liturgie*. 15 vols. Paris, 1907-1954.

Cahier, Charles and Arthur Martin. *Mélanges d'archéologie*. 3 vols. Paris, 1847-1853.

———. *Nouveaux mélanges d'archéologie, d'histoire et de littérature sur le moyen âge*. 4 vols. Paris, 1874-1877.

Cahn, Walter. "Le Tympan de Neuilly-en-Donjon," *Cahiers de civilisation médiévale*, 8 (1965), pp. 351-364.

Cames, Gérard. "Recherches sur l'enluminure romane de Cluny. Le Lectionnaire Paris, B. N. Nouv. acq. lat. 2246," *Cahiers de civilisation médiévale*, 7 (1964), pp. 145-159.

Cartailhac, E. *Album des monuments et de l'art ancien du Midi de la France*. Toulouse, 1898.

Cartellieri, Otto. *Abt Suger von Saint-Denis, 1081-1151*. Berlin, 1898.

Cathares en Languedoc, Session d'histoire religieuse du Midi de la France aux 12ème et 13ème siècles (Cahiers de Fangeaux, no. 3). Toulouse, 1968.

Cecchelli, Carlo. *La cattedra di Massimiano ed altri avori romani-orientali*. Rome, 1936-1944.

———. *I mosaici della basilica di S. Maria Maggiore*. Turin, 1956.

———. "Note iconografiche su alcune ampolle Bobbiesi," *Rivista di archeologia cristiana*, 1927, pp. 115-139.

———, Giuseppe Furlani and Mario Salmi. *The Rabbula Gospels* (facsimile edition). Olten-Lausanne, 1959.

Celi, G. "Cimeli Bobbiesi," *Civiltà cattolica*, 2 (1923), pp. 504ff.; 3 (1924), pp. 37-45, 124-136, 335-344 and 422-439.

Chailley, J. "Le Drame liturgique médiéval à Saint-Martial de Limoges," in *Revue d'histoire du théâtre*, 1955.

Chamard, F. "Histoire ecclésiastique du Poitou," *Mémoires de la Société des Antiquaires de l'Ouest*, 37 (1873).

Charmasse, A. de. "Enquête faite en 1482 touchant le chef de saint Lazare," *Bulletin de la Société d'Etudes d'Avallon*, 7 (1865).

Charton, E. *Voyageurs anciens et modernes du Vème au XIXème siècle*. Paris, 1855.

Chartraire, Eugène. "Les Tissus anciens du trésor de la cathédrale de Sens," *Revue de l'art chrétien*, 61 (1911), pp. 261-280, 371-386 and 452-468.

Chasles, M. "Le Drame liturgique," *La Vie et les arts liturgiques*, 3 (1916-1917), pp. 125ff.

Chastel, André. "La Légende de la reine de Saba," *Revue de l'histoire des religions*, 119 (Mar.-June 1939), pp. 204-225; 120 (July-Aug. 1939), pp. 27-44; 121 (Sept.-Dec. 1939), pp. 160-174.

Chenesseau, Georges. *L'Abbaye de Fleury à Saint-Benoît-sur-Loire*. Paris, 1931.

———. "Les Fouilles de la cathédrale d'Orléans (sept.-déc. 1937)," *Bulletin monumental*, 97 (1938), pp. 73-94.

Chevalier, Ulysse. *Ordinaires de l'église cathédrale de Laon (XIIe-XIIIe siècles) suivis de deux mystères liturgiques, publiés d'après les manuscrits originaux* (Bibliothèque liturgique, VI). Paris, 1897.

Christe, Y. *Les Grands portails romans; Etudes sur l'iconographie des théophanies romanes*. Geneva, 1969.

Chvolson, Pokrovoskij and Smirnof. "Un Plat d'argent syrien trouvé dans le gouvernement de la Perm," *Matériaux pour servir à l'archéologie de la Russie*, 22 (1899).

Ciampini, Giovanni. *Vetera Monimenta*. 2 vols. Rome, 1690-1699.

Cirot de la Ville, abbé. *Histoire de l'abbaye et congrégation de Notre-Dame de la Grand*

Sauve, ordre de saint Benoît, en Guienne. 2 vols. Paris and Bordeaux, 1845.

Cistercian Order. *Statuta capitulorum generalium ordinis Cisterciensis,* ed. J. M. Canivez. 8 vols. Louvain, 1933-1941.

Clédat, Jean. *Le Monastère et la nécropole de Baouït* (Mémoires publiés par les membres de l'Institut Français d'Archéologie Orientale du Caire, XII). Cairo, 1904.

Clemen, Paul. *Die romanische Wandmalereien der Rheinlanden* (Gesellschaft für Geschichtskunde, Publikationen, 25). Düsseldorf, 1905.

Clercq, L. de and J. Menant. *Collection de Clercq, Catalogue,* I, *Cylindres orientaux.* Paris, 1888.

Cloetta, W. "Le Mystère de l'épouse," *Romania,* 22 (1893), pp. 177-227.

Colfi, B. "Di una interpretazione data alle sculture dell'arcivolta nelle porta settentrionale del duomo di Modena," *Atti e Memorie della R. Deputazione di Storia Patria per le provincie modenesi,* 4th ser., 9 (1899), pp. 133ff.

Collignon, Maxime. *Les Statues funéraires dans l'art grec.* Paris, 1911.

Collon-Gevaert, Suzanne, Jean Lajeune and Jacques Stiennon. *Art roman dans la Vallée de la Meuse aux XIe et XII siècles.* Brussels, 1962.

Comparetti, Domenico. *Virgilio nel medio evo.* 2 vols. Leghorn, 1872.

Conant, Kenneth John. "The Apse of Cluny," *Speculum,* 8 (1932), pp. 23-35.

——. *Carolingian and Romanesque Architecture, 800-1200* (The Pelican History of Art). Harmondsworth and Baltimore, 1959.

——. *Cluny: Les églises et la maison du chef d'ordre.* Mâcon, 1968.

——. *The Early Architectural History of the Cathedral of Santiago de Compostela.* Cambridge (Mass.), 1926.

——. "The Iconography and Sequence of the Ambulatory Capitals of Cluny," *Speculum,* 6 (1930), pp. 283-285.

Cook, Walter W. S. "The Earliest Painted Panels of Catalonia," *Art Bulletin,* 5 (1923), pp. 85-101; 6 (1923), pp. 31-60; 8 (1925-1926), pp. 57-104 and 195-234; 10 (1927-1928), pp. 153-204 and 305-365.

—— and José Gudiol Ricart. *Pintura e Imaginería Románicas* (Ars Hispaniae, VI). Madrid, 1950.

Corblet, J. *Histoire dogmatique, liturgique et archéologique du sacrement du baptême.* Paris and Brussels, 1881.

Corpus Christianorum. Series Latina. 1954ff.

Corpus scriptorum ecclesiasticorum latinorum. Vienna, 1866ff.

Coulton, George Gordan. *Life in the Middle Ages.* 4 vols. 3rd ed., New York, 1936.

Coussemaker, E. de. *Drames liturgiques du moyen âge.* Rennes, 1860.

Craplet, Bernard. *Auvergne romane* (ed. Zodiaque). La-Pierre-qui-Vire, 1945.

Creizenach, W. *Geschichte des neueren Dramas,* I. *Mittelalter und Frührenaissance.* Halle, 1893.

Crichton, George Henderson. *Romanesque Sculpture in Italy.* London, 1954.

Crombie, Alistair Cameron. *Augustine to Galileo.* London, 1952.

Crosnier, A. J. "Culte aérien de saint Michel," *Bulletin monumental,* 28 (1862), pp. 693-700.

Crozet, René. *L'Art roman en Berry.* Paris, 1932.

——. *L'art roman en Poitou.* Paris, 1948.

——. "Nouvelles remarques sur les cavaliers sculptés ou peints dans les églises romanes," *Cahiers de civilisation médiévale,* 1 (1958), pp. 27-36.

——. "Les quatres Evangélistes et leurs symboles, assimilations et adaptations," *Cahiers techniques de l'art,* 1962, pp. 5-26.

——. "Remarques sur les relations artistiques entre la France du sud-ouest et le nord de l'Espagne à l'époque romane," *Actes du 19ème Congrès International d'Histoire de l'Art,* Paris, 8-13 Sept. 1958, pp. 62-71.

——. "Le Vitrail de la Crucifixion à la cathédrale de Poitiers," *Gazette des beaux-arts,* 11 (1934), pp. 218-231.

Czobor, Béla and E. de Radisics. *Les Insignes royaux de Hongrie.* Budapest, 1896.

Dalton, O. M. *Byzantine Art and Archaeology.* Oxford, 1911.

Damiron, S. "Eglises romanes pyrénéennes, Saint-Just de Valcabrère," *L'Informations culturelle artistique,* 1, no. 2 (Jan.-Feb. 1956), pp. 16-17.

Damourette, abbé. "Caractères principaux des églises du Bas Berry depuis le XIème siècle jusqu'à la Renaissance," *Congrès archéologique,* 40 (1873).

Dangibeaud, C. "L'Ecole de sculpture romane saintongeaise," *Bulletin archéologique du*

Comité des Travaux historiques et scientifiques, 1910, pp. 22-49.

Daniel, Gabriel. *Histoire de France depuis l'établissement de la monarchie françoise dans les Gaules*. 2 vols. new ed., Paris, 1722.

Daoust, F. *L'Abbatiale de la Sainte-Trinité*. Fécamp, 1963.

Daux, C. *Le Pèlerinage de Compostelle et la confrérie de Mgr. saint Jacques à Moissac*. Paris, 1898.

David, P. "Etudes sur le Livre de saint Jacques attribué à Callixte II," *Bulletin des études portugaises*, 10 (1946), pp. 1-41; 11 (1947), pp. 113-185; 12 (1948), pp. 1-154.

De Tolnay, Charles. "The Music of the Universe—Notes on a Painting by Bicci di Lorenzo," *Journal of the Walters Art Gallery*, 6 (1943), pp. 83-104.

Debidour, Victor Henri. *Le Bestiaire sculpté du Moyen Age en France*. Paris and Grenoble, 1961.

Déchelette, J. "Autun," *Congrès archéologique*, 74 (1907), pp. 119-157.

Défourneaux, M. *Les Français en Espagne aux XIème et XIIème siècles*. Paris, 1949.

Degert, abbé. "Origine de la Vierge Noire de la Daurade," *Bulletin de la Société Archéologique du Midi de la France*, 14 (1903), pp. 355-358.

Dehio, Georg and Gustav von Bezold. *Die kirchliche Baukunst des Abendlandes*. 2 vols. and atlas. Stuttgart, 1887-1901.

Deichmann, Friedrich Wilhelm. *Repertorium der christlich-antiken Sarkophage*, 2 vols. Wiesbaden, 1967.

Deknatel, Frederick B. "The Thirteenth Century Gothic Sculpture of the Cathedrals of Burgos and Leon," *Art Bulletin*, 17 (1935), pp. 243-389.

Delaporte, Yves. *Les Vitraux de la cathédrale de Chartres, histoire et description*. 4 vols. Chartres, 1926.

Delaruelle, Charles. "Les Bas-reliefs de Saint-Sernin," *Annales du Midi*, 1929, pp. 49-60.

Delbourgo, S. "Le Chef-reliquaire de sainte Fortunade, Etude spectrographique," *Bulletin du laboratoire du Musée du Louvre*, 1965, pp. 6-14.

Delisle, Léopold. "Les Manuscrits de l'Apocalypse de Beatus conservés à la Bibliothèque Nationale et dans le cabinet de M. Didot," *Mélanges de paléographie et de bibliographie*, Paris, 1880, pp. 117-148.

———. *Notice sur douze livres royaux*. Paris, 1902.

Demus, Otto. *Byzantine Art and the West*. New York, 1970.

———. *The Church of San Marco in Venice* (Dumbarton Oaks Studies, VI). Washington, D.C., 1960.

———. *The Mosaics of Norman Sicily*. London, 1949.

———. *Die Mosaïken von San Marco in Venedig, 1100-1300*. Baden, 1935.

———. *Romanesque Mural Painting*. New York, 1970.

Der Nersessian, Sirapie. *L'Illustration des Psautiers grecs du moyen âge, II. Londres Add. 19352* (Bibliothèque des Cahiers Archéologiques). Paris, 1970.

Deschamps, Paul. "Le Combat des vertus et des vices sur les portails romans de la Saintonge et du Poitou," *Congrès archéologique*, 79 (1912), II, pp. 309-324.

———. "Etude sur la renaissance de la sculpture en France à l'époque romane," *Bulletin monumental*, 84 (1925), pp. 5-98.

———. "Etude sur les sculptures de Sainte-Foy de Conques et de Saint-Sernin de Toulouse," *Bulletin monumental*, 100 (1941), pp. 239-264.

———. *French Sculpture of the Romanesque Period; Eleventh and Twelfth Centuries* (Pantheon ed.). Florence and New York, 1930.

———. "Notes sur la sculpture romane en Languedoc et dans le nord de l'Espagne," *Bulletin monumental*, 82 (1923), pp. 305-351.

———. "L'Orfèvrerie à Conques vers l'an mille," *Bulletin monumental*, 102 (1943-1944), pp. 75-93.

——— and Marc Thibout. *La Peinture murale en France; Le haut Moyen Age et l'époque romane*. Paris, 1951.

——— and Marc Thibout. *La Peinture murale en France au début de l'époque gothique: de Philippe-Auguste à la fin du règne de Charles V (1180-1380)*. Paris, 1963.

Deshoulières, F. "L'Eglise abbatiale de Méobec (Indre)," *Bulletin monumental*, 101 (1942), pp. 277-290.

———. "Figeac, l'église Saint-Sauveur," *Congrès archéologique*, 101 (1938), pp. 9-17.

———. "Le Tympan de l'église Saint-Pierre-le-Puellier," *Mémoires de la Société des Antiquaires du Centre*, 38 (1917-1918), pp. 38-46.

Devoucoux, J. S. *Description de l'église cathédrale d'Autun dédiée à saint Lazare*. Autun, 1845.

De Wald, E. T. "The Iconography of the Ascension," *American Journal of Archaeology*, 19 (1915), pp. 297ff.

——. *The Illustrations of the Utrecht Psalter*. Princeton, n.d.

Deyres, Marcel. "La Construction de l'abbatiale Sainte-Foy de Conques," *Bulletin monumental*, 123 (1965), pp. 7-23.

Dez, G. "Notre-Dame-de-la-Grande de Poitiers," *Congrès archéologique*, 109 (1951), pp. 9-19.

Dhorme, P. "L'Arbre de vérité et l'arbre de vie," *Revue biblique*, 1907, pp. 271-274.

Didron, A. N. *Iconographie chrétienne; Histoire de Dieu*. Paris, 1843. Engl. tr. (ed. Bonn, 1851) E. J. Millington. 2 vols. New York, 1968.

——. *Manuel d'iconographie chrétienne grecque et latine avec une introduction et des notes, traduit du manuscrit byzantin, Le guide de la peinture, par le Dr. Paul Durand*. Paris, 1845.

Diehl, Charles. *Manuel d'art byzantin*. 2 vols. 2nd ed., Paris, 1925-1926.

——. "Mosaïques byzantines de Saint-Luc en Phocide," *Monuments Piot*, 3 (1896).

Diez, Ernst and Otto Demus. *Byzantine Mosaics in Greece: Hosios Lucas and Daphni*. Cambridge, 1931.

St. Dionysius the Areopagite. *The Divine Hierarchy*, tr. J. Parker. Oxford, 1897-1899.

Dodwell, C. R. *The Canterbury School of Illumination, 1066-1200*. Cambridge, 1954.

Doering, O. "Die romanischen Wandmalereien in der Kirche von Kloster Gröningen," *Zeitschrift für christliche Kunst*, 25 (1912), cols. 298ff.

Doublet, Jacques. *Histoire de l'abbaye de S. Denys en France*. 2 vols. Paris, 1625.

Downey, Glanville. "Nikolas Mesarites. Description of the Church of the Holy Apostles in Constantinople," *Transactions of the American Philosophical Society*, n.s. 47 (1957), pp. 859ff.

Drexler, Karl and T. Strommer. *Der Verduner Altar: Ein Emailwerk des XII. Jahrhunderts im Stifte Klosterneuburg bei Wien*. Vienna, 1903.

Drouyn, Léo. *Album de la Grande-Sauve*. Bordeaux, 1851.

Du Méril, E. *Origines latines du théâtre moderne*. Paris, 1849.

Du Plessis, Toussaint. *Histoire de l'église de Meaux*. Paris, 1731.

Dubler, E. *Das Bild des heiligen Benedikt bis zum Ausgang des Mittelalters*. Zurich, 1966.

Dubos, abbé. "Essai d'identification des lieux du martyre et des premières sepultures de saint Vincent, diacre," *Congrès archéologique*, 68 (1901), pp. 243-267.

Duchalais, A. "Le Rat employé comme symbole dans la sculpture du moyen âge," *Bibliothèque de l'École des Chartes*, 2nd ser., 4 (1847-1848), pp. 230ff.

Duchesne, L. *Fastes épiscopaux de l'ancienne Gaule*, II, *L'Aquitaine et les Lyonnaises*. 2nd ed., Paris, 1900.

——. "La Légende de sainte Marie-Madeleine," *Annales du Midi*, 5 (1893), pp. 1-33.

——. "Saint-Jacques en Galice," *Annales du Midi*, 12 (1900), pp. 145-158.

Dufief, André. "La Vie monastique au Mont-Saint-Michel pendant le XIIème siècle (1085-1186)," *Millénaire monastique du Mont-Saint-Michel; Mémoires commémoratifs*, I, Paris, 1967, pp. 81-126.

Dufourcet, Jean-Eugène. "Les Voies romaines et les chemins de Saint-Jacques dans l'ancienne Novempopulanie," *Congrès archéologique*, 55 (1888), pp. 241-264.

Dufrenne, Suzy. *L'Illustration des Psautiers grecs du moyen âge*, I. *Pantocrator 61, Paris Grec 20, British Museum 40731* (Bibliothèque des Cahiers Archéologiques). Paris, 1966.

Duhem, Pierre. *Le Système du monde; Histoire des doctrines cosmologiques de Platon à Copernic*. 10 vols. Paris, 1913-1959.

Duprat, C. P. "Enquête sur la peinture murale en France à l'époque romane (suite et fin)," *Bulletin monumental*, 102 (1942), pp. 161-223.

Duran Sanpere, Agustín and Juan Ainaud de Lasarte. *Escultura gotica* (Ars Hispaniae, VIII). Madrid, 1956.

Durand, G. *Eglises romanes des Vosges* (*Revue de l'art chrétien*, Supplement 2), Paris, 1913.

Durand, J. "Monuments figurés du moyen âge exécutés d'après les textes liturgiques," *Bulletin monumental*, 54 (1888), pp. 528-530.

Durand-Lefèbvre, Marie. *Art gallo-romain et sculpture romane; Recherches sur les formes*. Paris, 1937.

Durliat, Marcel. *L'Art catalan*. Paris and Grenoble, 1963.

——. *Arts anciens du Roussillon*. Perpignan, 1954.

——. "Les Christs vêtus des Pyrénées-Orientales, Etude de leur decoration peinte,"

Etudes médiévales offertes à M. le Doyen Fliche, Montpellier, 1952, pp. 55-65.

———. "La Construction de Saint-Sernin de Toulouse au XIème siècle," *Bulletin monumental*, 121 (1963), pp. 151-170.

———. "Les Origines et la sculpture romane à Toulouse et à Moissac," *Cahiers de civilisation médiévale*, 12 (1969), pp. 349-364.

———. *La Sculpture romane en Roussillon.* 3 vols. Perpignan, 1948.

Ebersolt, Jean. *La Miniature byzantine.* Paris and Brussels, 1926.

———. "Miniatures byzantines de Berlin," *Revue archéologique*, 4th ser., 6 (1905), pp. 55-70.

———. *Orient et Occident.* 2nd ed., Paris, 1954.

Einhard. *Vie de Charlemagne*, ed. and tr. Louis Halphen. Paris, 1938.

Enaud, F. "Peintures murales découvertes dans une dépendance de la cathédrale du Puy-en-Velay (Haute-Loire); Problèmes d'interprétation," *Les Monuments historiques de la France*, 1968, no. 4, pp. 43-47.

Endres, J. A. "Romanische Deckenmalereien und ihre Tituli zu St. Emmeran in Regensburg," *Zeitschrift für christliche Kunst*, 15 (1902), cols. 206ff.

Engel, A. and R. Serrure. *Traité de numismatiques du moyen âge.* Paris, 1891.

Erlande-Brandenburg, Alain. "Iconographie de Cluny III," *Bulletin monumental*, 126 (1968), pp. 293-321.

Evans, Joan. *Cluniac Art of the Romanesque Period.* Cambridge, 1950.

Fabre, A. "L'Iconographie de la Pentecôte," *Gazette des beaux-arts*, 65 (1923), pp. 33-42.

Fabre, F., Auguste Achard and Noël Thiollier. "Cinq statues en bois du XIIe et du XIIIe siècle dans la Haute-Loire," *Congrès archéologique*, 71 (1904), pp. 564-569.

Fage, R. "L'Eglise de Lubersac (Corrèze)," *Bulletin monumental*, 76 (1912), pp. 38-58.

Fakhry, A. *The Necropolis of El-Bagawat in Kharga Oasis.* Cairo, 1951.

Falke, Otto von and H. Frauberger. *Deutsche Schmelzarbeiten des Mittelalters.* Frankfurt-am-Main, 1904.

———. *Kunstgeschichte der Seidenweberei.* Berlin, 1921.

Faral, Edmond. *Les Jongleurs en France au moyen âge.* Paris, 1910.

———. "La Queue de poisson des sirènes," *Romania*, 74 (1953), pp. 433-506.

Farley, Mary Ann and Francis Wormald. "Three Related English Romanesque Manuscripts," *Art Bulletin*, 22 (1940), pp. 157-161.

Fau, Jean-Claude. *Les Chapiteaux de Conques.* Toulouse, 1956.

Fayolle, Marquis de. "Le Trésor de l'église de Saint-Nectaire," *Congrès archéologique*, 62 (1895), pp. 292-306.

Ferrandis, José. *Marfiles y Azabaches Españoles.* Barcelona and Buenos Aires, 1928.

Fikry, Ahmad. *L'Art roman du Puy et les influences islamiques.* Paris, 1934.

Fillitz, H. "Die Elfenbeinreliefs zur Zeit Kaiser Karls des Grossen," *Aachener Kunstblätter*, 32 (1966), pp. 14ff.

Fita, P. F. and J. Vinson. *Le Codex de Saint-Jacques de Compostelle.* Paris, 1882.

——— and D. A. Fernandez-Guerra. *Recuerdos de un Viaje á Santiago de Galicia.* Madrid, 1880.

Florenz, Henrique and others. *España Sagrada, theatro geographico-historico de la Iglesia de España.* 51 vols. Madrid, 1747-1879.

Focillon, Henri. "Apôtres et jongleurs; Etudes de mouvement," *Revue de l'art ancien et moderne*, 1 (1921), pp. 13-28.

———. *L'Art des sculpteurs romans; Recherches sur l'histoire des formes.* New ed., Paris, 1964.

———. *The Art of the West in the Middle Ages*, ed. Jean Bony. 2 vols. London, 1963.

———. *Peintures romanes des églises de France.* 2nd ed., Paris, 1950.

Förster, W. "Ein neues Artus-dokument," *Zeitschrift für romanische Philologie*, 22 (1898), pp. 243ff.

Forgeais, Arthur. *Collections de plombs historiés trouvés dans la Seine.* 5 vols. Paris, 1862-1866.

Forsyth, Ilene Haering. "Magi and Majesty: A Study of Romanesque Sculpture and Liturgical Drama," *Art Bulletin*, 50 (1968), pp. 215-222.

Foucher, A. "Sculptures gréco-bouddhiques," *Monuments Piot*, 7 (1900), pp. 39-64.

Foulet, L. *Le Roman de Renart.* Paris, 1914.

Francovich, Géza de. *Benedetto Antelami, architetto e scultore, e l'arte del suo tempo.* 2 vols. Milan and Florence, 1952.

Frankfort, Henri. *The Art and Architecture of the Ancient Orient* (The Pelican History of Art). Harmondsworth and Baltimore, 1954.

———. *Cylinder Seals; A Documentary Essay on the Art and Religion of the Ancient Near East.* London, 1939.

Gaiffier, B. de. "Hagiographie bourguignonne, A propos de la thèse de doctorat de M. René Louis sur Girart comte de Vienne," *Analecta Bollandiana*, 69 (1951), pp. 131-147.

——. "La Passion de S. Vincent d'Agen," *Analecta Bollandiana*, 70 (1952), pp. 160-181.

——. "Les Sources de la Passion des SS. Savin et Cyprien," *Analecta Bollandiana*, 73 (1955), pp. 324-341.

Gaillard, Georges. "Une Abbaye de pèlerinage: Sainte-Foy de Conques et ses rapports avec Saint-Jacques," *Compostellanum*, 10 (1965).

——. "Les Commencements de l'art roman en Espagne," *Bulletin hispanique*. 37 (1935), pp. 273-308.

——. *Les Débuts de la sculpture romane espagnole; Leon, Jacca, Compostelle*. Paris, 1938.

——. "L'Eglise et le cloître de Silos, dates de la construction et de la décoration," *Bulletin monumental*, 91 (1932), pp. 39-80.

—— and others. *Rouergue roman* (ed. Zodiaque). La-Pierre-qui-Vire, 1963.

——. *La Sculpture romane espagnole*. 2 vols. Paris, 1946.

Gardelles, Jacques. *La Cathédrale Saint-André de Bordeaux, sa place dans l'évolution de l'architecture et de la sculpture*. Bordeaux, 1963.

Garrucci, Raffaele. *Storia dell'arte cristiana nei primi otto secoli della chiesa*. 6 vols. Prato, 1873-1881.

Gassies, M. "Note sur une tête de statue trouvée à Meaux," *Bulletin archéologique du Comité des Travaux historiques et scientifiques*, 1905, pp. 40-42.

Gasté, A. *Les Drames liturgiques de la cathédrale de Rouen*. Evreux, 1893.

Gaussen, A. *Portefeuille archéologique de la Champagne*. Bar-sur-Aube, 1861.

Gauthier, J. "Les Deux cathédrales de Besançon," *Bulletin archéologique du Comité des Travaux historiques et scientifiques*, 1897.

Gauthier, Marie-Madeleine. *Emaux limousins champlevés des XIIe, XIIIe et XIVe siècles*. Paris, 1950.

——. "Le Frontal limousin de San Miguel in Excelsis," *Art de France*, 3 (1963), pp. 40-61.

——. "La Légende de sainte Valerie et les émaux champlevés de Limoges," *Bulletin de la Société Archéologique et Historique du Limousin*, 86 (1955), pp. 54-56.

Gebhart, O. von and A. Harnack. *Evangeliorum codex graecus purpureus Rossanensis*. Leipzig, 1880.

Génermont, Marcel and Pierre Pradel. *Les Eglises de France; Allier*. Paris, 1938.

Geneva, Musée d'art et d'histoire. Vollenweider, Marie Louise. *Catalogue raisonné des sceaux, cylindres et intailles*. Geneva, 1967.

Gérard, Robert. *Sur un Prieuré bénédictin de la route des pèlerinages; Saint-Gilles de Montoire (XIème siècle)*. Paris, 1935.

Gerke, Friedrich. *Der Tischaltar des Bernard Gilduin in Saint Sernin in Toulouse* (Akademie der Wissenschaften und der Literatur, Abhandlung der Geistes- und Sozialwissenschaftlichen Klasse, Nr. 8). Mainz, 1958.

Gerstinger, Hans. *Die Wiener Genesis*. Vienna, 1931.

Gervais de Tilbury. *Otia imperialia*, ed. F. Liebrecht. Hanover, 1856.

Geyer, P. *Itinera hierosolymitana saeculi iiii-viii* (Corpus scriptorum ecclesiasticorum latinorum, xxxix). Vienna, 1898.

Gheyn, Joseph Van den. *Le Psautier de Peterborough* (Le Musée des Enluminures). Haarlem, 1905.

The Epic of Gilgamesh, tr. R. C. Thompson. London, 1928.

Gillen, O. *Ikonographische Studien zum Hortus Deliciarum der Herrad von Landsberg* (Kunstwissenschaftliche Studien, 9). Berlin, 1931.

Ginot, Emile. "Le Manuscrit de sainte Radegonde de Poitiers et ses peintures du XIème siècle," *Bulletin de la Société Française de Reproductions de Manuscrits à Peintures*, 4 (1914-1920), pp. 9-80.

Giron, Léon. *Les Peintures murales du département de la Haute-Loire (du XIème au XVIIIème siècle)*. Paris, 1911.

Glaber, Raoul. *Chronique*, ed. and tr. M. Prou. Paris, 1886.

Gobillot, L. "Note sur une fresque de l'ancienne église paroissiale de Saint-Pierre de la Trimouille," *Bulletin de la Société des Antiquaires de l'Ouest*, 3rd ser., 2 (1912).

Goldschmidt, Adolph. *Der Albanipsalter in Hildesheim und seine Beziehung zur symbolischen Kirchenskulptur des XII. Jahrhunderts*. Berlin, 1895.

——. *Die Elfenbeinskulpturen*. 4 vols. Berlin, 1914-1926.

Gómez-Moreno, Manuel. *El arte románico español*. Madrid, 1934.

Gout, Paul. *Le Mont-Saint-Michel, Histoire de l'abbaye et de la ville.* 2 vols. Paris, 1910.

Grabar, André. *Ampoules de Terre Sainte (Monza-Bobbio).* Paris, 1958.

——. "L'Etude des fresques romanes," *Cahiers archéologiques,* 2 (1947), pp. 163-177.

—— and Carl Nordenfalk. *Le Haut Moyen-Age* (Les grands siècles de la peinture). Geneva, 1957.

——. *Martyrium.* 3 vols. Paris, 1943-1946.

——. *La Peinture byzantine* (Skira ed.). Geneva, 1953.

——. *Les Peintures de l'évangéliaire de Sinope (B.N. suppl. gr. 1286).* Paris, 1948.

——. *Le premier Art chrétien (200-395)* (L'Univers des formes, 9). Paris, 1966.

—— and Carl Nordenfalk. *Romanesque Painting from the Eleventh to Thirteenth Century* (Skira ed.). New York, 1958.

——. *La Sainte Face de Laon; le Mandylion dans l'art orthodoxe.* Prague, 1931.

Graf, Arturo, *Roma nella memoria e nelle immaginazioni del Medio evo.* 2 vols. Turin, 1882-1883.

Grandmaison, Charles de. "Résultats des fouilles de Saint-Martin de Tours en 1886," *Bibliothèque de l'Ecole des Chartes,* 54 (1893), pp. 3-13.

——. *Tours archéologique; histoire et monuments.* Paris, 1879.

Grasilier, P. T. *Cartulaires inédits de la Saintonge.* Niort, 1871.

Grégoire, H. "Rapport sur un voyage d'exploration dans le Pont et en Cappadoce," *Bulletin de correspondance hellénique,* 33 (1909), pp. 1-170.

Grinnell, Robert. "Iconography and Philosophy in the Crucifixion Window at Poitiers," *Art Bulletin,* 28 (1946), pp. 171-196.

Grivot, Denis. *Le Diable.* [Privately printed], 1960.

—— and George Zarnecki. *Gislebertus, sculptor of Autun.* New York, 1961.

Grodecki, Louis. "Fragments de vitraux provenant de Saint-Denis," *Bulletin monumental,* 110 (1952), pp. 51-62.

——. "La Première sculpture gothique. Wilhelm Vöge et l'état actuel des problèmes," *Bulletin monumental,* 117 (1959), pp. 263-289.

——. "Le Problème des sources iconographiques du tympan de Moissac," *Moissac et l'Occident au XIème siècle, Actes du colloque international de Moissac, 1963,* Toulouse, 1964, pp. 59-68.

——. "Les Vitraux allégoriques de Saint-Denis," *Art de France,* 1 (1961), pp. 19-46.

——. "Les Vitraux de la cathédrale du Mans," *Congrès archéologique,* 119 (1961), pp. 59-99.

——. "Les Vitraux de la cathédrale de Poitiers," *Congrès archéologique,* 109 (1952), pp. 143-146 and 156-160.

——. "Les Vitraux de Saint-Denis: l'Enfance du Christ," *De Artibus Opuscula XL, Essays in Honor of Erwin Panofsky,* New York, 1961, pp. 170-186.

Grüneisen, W. de. *Sainte-Marie Antique.* Rome, 1911.

Gudiol i Cunill, Josep. *La pintura mig-eval catalana.* 3 vols. Barcelona, 2nd ed., 1955.

Gudiol Ricart, José and Juan Antonio Gaya Nuño. *Arquitectura y escultura románicas* (Ars Hispaniae, v). Madrid, 1948.

Guédal, J. *L'Architecture romane en Dombes.* Bourg-en-Bresse, 1911.

Guibert de Nogent. *De vita sua,* tr. C. C. Swinton Bland. London and New York, 1925.

Guilhermy, F. de. *Monographie de l'église royale de Saint-Denis.* Paris, 1848.

Gutberlet, S. Helena. *Die Himmelfahrt Christi in der bildenden Kunst.* Strasbourg, 1934.

Hamann, Richard. *Die Abteikirche von St. Gilles und ihre künstlerische Nachfolge.* Berlin, 1955.

——. "Das Tier in der romanischen Plastik Frankreichs," *Medieval Studies in Memory of A. Kingsley Porter,* Cambridge (Mass.), 1939, II, 413-452.

Haseloff, Arthur. *Eine thüringisch-sächsische Malerschule des XIII. Jahrhunderts.* Strasbourg, 1897.

Hayward, Jane and Louis Grodecki. "Les Vitraux de la cathédrale d'Angers," *Bulletin monumental,* 124 (1966), pp. 7-67.

Heisenberg, A. *Grabeskirche und Apostelkirche in Jerusalem.* 2 vols. Leipzig, 1908.

Helbig, Jules. *L'Art mosan depuis l'introduction du Christianisme jusqu'à la fin du XVIIIe siècle.* 2 vols. Brussels, 1906-1911.

Hell, Vera and Helmut. *The Great Pilgrimage of the Middle Ages; The Road to St. James of Compostela,* intro. Sir Thomas Kendrick. New York, 1966.

Helyot, Pierre. *Histoire complète et costumes des ordres monastiques religieux et militaires et des congrégations des deux sexes.* Guingamp, 1839.

Henry, R. *La Bibliothèque.* Paris, 1959.

Herrad of Landsberg. *Hortus deliciarum*, ed. A. Straub and G. Keller. Strasbourg, 1879-1899.

———. *Hortus deliciarum*, ed. Joseph Walter. Strasbourg and Paris, 1952.

Herrmann, L. *Les Fables antiques de la broderie de Bayeux* (Collection Latomus, 69). Brussels and Berchem, 1964.

Hersey, Carl Kenneth. "The Church of St. Martin at Tours (903-1150)," *Art Bulletin*, 25 (1943), pp. 1-39.

Hervieux, Léopold. *Les Fabulistes latins depuis le siècle d'Auguste jusqu'à la fin du moyen âge*. 5 vols. Paris, 1884.

Hesseling, C. *Les Miniatures de l'Octateuque de Smyrne*. Leiden, 1909.

Heuzey, Léon. "Les Armoiries chaldéennes de Sirpoula," *Monuments Piot*, 1 (1894), pp. 7-20.

———. *Les Origines orientales de l'art*. Paris, 1891-1915.

———. "Le Vase d'argent," *Monuments Piot*, 2 (1895), pp. 5-28.

Hildburgh, W. L. *Medieval Spanish Enamels*. London, 1936.

Histoire littéraire de la France, ed. Antoine Rivet de la Grange and others. 36 vols. Paris, 1733-1927.

Homburger, Otto. *Die Anfänge der Malschule von Winchester im X. Jahrhundert*. Leipzig, 1912.

Horace. *Ars poetica*, tr. and ed. H. Rushton Fairclough (Loeb Classical Library). London and Cambridge (Mass.), 1966.

———. *Odes and epodes*, tr. and ed. Charles E. Bennett (Loeb Classical Library). London and Cambridge (Mass.), 1960.

Horrent, J. *Le Pèlerinage de Charlemagne* (Bibliothèque de la Faculté de Philosophie et Lettres de l'Université de Liège, fasc. CLVIII). Paris, 1961.

Hourlier, Jacques. "Le Mont-Saint-Michel avant 966," *Millénaire monastique du Mont-Saint-Michel, Mémoires commémoratifs*, Paris, 1967, II, pp. 13-28.

Houvet, Etienne. *Cathédrale de Chartres; Portail Nord (XIIIe siècle)*. 2 vols. Chelles, 1919.

———. *Cathédrale de Chartres; Portail Occidental ou Royal (XIIe siècle)*. Chelles, 1919.

Huber, Paul. *Athos; Leben, Glaube, Kunst*. Zurich, 1969.

Hubert, Jean. "L'Eglise Notre-Dame d'Arles," *Bulletin de la Société Nationale des Antiquaires de France*, 1945-1947.

Hucher, Eugène. *Etudes sur l'histoire et les monuments du département de la Sarthe*. Le Mans and Paris, 1856.

Humbert, A. "Les Fresques romanes de Brinay," *Gazette des beaux-arts*, 11 (1914), pp. 217-234.

Hunt, Noreen. *Cluny under Saint Hugh, 1049-1109*. London, 1967.

Hyvernat, H. *Album de paléographie copte pour servir à l'introduction paléographique des Actes des Martyrs de l'Egypt*. Paris, 1888.

Isidore of Seville. *Isidori Hispalensis episcopi etymologiarum sive originum*, ed. Wallace Martin Lindsay. Oxford, 1911.

Jacobus de Voragine. *Legenda aurea*, ed. Graesse. 3rd ed., Breslau, 1890.

———. *The Golden Legend*, tr. Granger Ryan and Helmut Ripperger. 2 vols. London and New York, 1941.

Jacoby, Felix. *Die Fragmente der griechischen Historiker*. 17 vols. Berlin and Leiden, 1923-1958.

Jalabert, Denise. "De l'Art oriental antique à l'art roman, Recherches sur la faune et la flore romanes," *Bulletin monumental*, "I, Le sphinx," 94 (1935), pp. 70-104; "II, Les sirènes," 95 (1936), pp. 433-471.

James, Edwin Oliver. *The Tree of Life, an Archaeological Study*. Leiden, 1966.

James, Montague Rhodes. *The Apocryphal New Testament*. Oxford, 1953.

———. *The Bestiary*. Oxford, 1928.

———. "On the Paintings Formerly in the Choir at Peterborough," *Communications of the Cambridge Antiquarian Society*, 9 (1895-1896), pp. 178-194.

Jarossay, E. *Histoire d'une abbaye à travers les siècles, Ferrières-en-Gâtinais ordre de saint Benoît (508-1790), son influence religieuse, sociale et littéraire d'après les documents inédits tirés des archives publiques et privées*. Orleans, 1901.

Jerphanion, Guillaume de. "La Date des peintures de Toqalé-Kilissé en Cappadoce," *Revue archéologique*, 4th ser., 20 (1912), pp. 236-254.

———. "Deux Chapelles souterraines en Cappadoce," *Revue archéologique*, 4th ser., 12 (1908), pp. 1-32.

———. "Les Eglises souterraines de Gueurémé et Soghanle (Cappadoce)," *Les Comptes rendus de l'Académie des Inscriptions et Belles-Lettres*, 1908, pp. 7-21.

Jerphanion, Guillaume de. "L'Influence de la miniature musulmane sur un évangéliaire syriaque illustré du XIIIème siècle (Vat. Syr. 559)," *Les Comptes rendus de l'Académie des Inscriptions et Belles-Lettres,* 1939, pp. 483-509.

———. *Une nouvelle Province de l'art byzantin; les églises rupestres de Cappadoce.* 3 vols. Paris, 1925-1944.

———, *La Voix des monuments; Notes et études d'archéologie chrétienne.* 2 vols. Paris and Brussels, 1930-1938.

Jouhanneaud, C. "La Crosse de saint Martial," *Bulletin de la Société Archéologique et Historique du Limousin,* 60 (1911), pp. 367-370.

Jullian, René. *L'Eveil de la sculpture italienne; La sculpture romane dans l'Italie du nord.* 2 vols. Paris, 1945-1949.

Jusselin, Maurice. "Les Traditions de l'église de Chartres," *Mémoires de la Société Archéologique d'Eure-et-Loir,* 15 (1915-1922).

Kantorowicz, Ernst H. "The Quinity of Winchester," *Art Bulletin,* 29 (1947), pp. 73-85.

Katzenellenbogen, Adolf. *Allegories of the Virtues and Vices in Mediaeval Art from Early Christian Times to the Thirteenth Century* (Studies of the Warburg Institute). London, 1939.

———. "The Central Tympanum at Vézelay, its Encyclopedic Meaning and its Relations to the First Crusade," *Art Bulletin,* 26 (1944), pp. 141-151.

———. *The Sculptural Programs of Chartres Cathedral.* Baltimore, 1959.

———. "The Separation of the Apostles," *Gazette des beaux-arts,* 91 (1949), pp. 81-98.

Kaufmann, C. M. *Ein altchristliches Pompeji in der libyschen Wüste: Die Nekropolis der "grossen Oase."* Mainz, 1902.

———. *Die Menasstadt und das national Heiligtum der altchristlichen Aegypter in der Westalexendrinischen Wüste, Ausgrabungen der Frankfurter Expedition am Karm Abu Mina, 1905-1907.* Leipzig, 1910.

Kehrer, H. *Die heiligen drei Könige in Literatur und Kunst.* 2 vols. Leipzig, 1908-1909.

Kerber, Bernhard. *Burgund und die Entwicklung der französischen Kathedralskulptur in zwölften Jahrhundert.* Recklinghausen, 1966.

Keyserlingk, Adalbert Graf von. *Vergessene Kulturen im Monte Gargano.* Nuremberg, 1968.

Kirschbaum, E. "Der Prophet Balaam und die Anbetung der Weisen," *Römische Quartalschriften für christliche Altertumskunde und Kirchengeschichte,* 49 (1954).

Klibansky, Raymond. *The Continuity of the Platonic Tradition during the Middle Ages.* London, 1950.

Knowles, John A. *Essays in the History of the York School of Glass Painting.* London, 1936.

Koehler, Wilhelm. "Byzantine Art in the West," *Dumbarton Oaks Papers,* 1 (1941), pp. 63-87.

———. *Die karolingischen Miniaturen.* 3 vols. Berlin, 1933-1960.

Kollwitz, Johannes. *Die Lipsanothek zu Brescia.* Berlin, 1933.

Kovacs, E. "Le Chef de saint Maurice à la cathédrale de Vienne (France)," *Cahiers de civilisation médiévale,* 7 (1964), pp. 19-26.

Kraeling, Carl H. *The Synagogue* (The Excavations at Dura-Europos conducted by Yale University and the French Academy of Inscriptions· and Letters, Final Report, VIII). New Haven, 1956.

Kraus, Franz Xavier. *Geschichte der christlichen Kunst.* 2 vols. Freiburg-im-Breisgau, 1896-1908.

Kraus, Henry. *The Living Theatre of Medieval Art.* Bloomington and London, 1967.

Krautheimer, Richard. *Early Christian and Byzantine Architecture* (The Pelican History of Art). Harmondsworth and Baltimore, 1965.

Krautheimer-Hess, Trude. "Die figurale Plastik der Ostlombardei von 1100 bis 1171," *Marburger Jahrbuch für Kunstwissenschaft,* 4 (1928), pp. 231-307.

Künstle, Karl. *Ikonographie der christlichen Kunst.* 2 vols. Freiburg-im-Breisgau, 1926-1928.

La Bouralière, O. A. de. "Guide archéologique du Congrès de Poitiers: Notre-Dame-le-Grande," *Congrès archéologique,* 70 (1903), pp. 1-84.

La Croix, Camille de. "Trois Bas-reliefs religieux dont les originaux existent à Poitiers," *Congrès archéologique,* 70 (1903), pp. 214-222.

La Martinière, J. de. "Les Fresques de Saint-Gilles de Montoire d'après les aquarelles de Jorand en 1881," *Gazette des beaux-arts,* 75 (1933), pp. 193-204.

Labande, Edmond-René. "Mirabilia Mundi, Essai sur la personnalité d'Otton III," *Cahiers de civilisation médiévale*, 4 (1963), pp. 297-313 and 455-476.

——. "Recherches sur les pèlerins dans l'Europe des XIème et XIIème siècles," *Cahiers de civilisation médiévale*, 1 (1958), pp. 159-169 and 339-347.

Labande-Mailfert, Yvonne. *Poitou roman* (ed. Zodiaque). La Pierre-qui-Vire, 1957.

Labarte, Jules. *Histoire des arts industriels au Moyen Age à l'époque de la Renaissance*. 2 vols. Paris, 1864.

Labbé, P. *Novae bibliothecae manuscriptorum librorum*. Paris, 1657.

Lafargue, M. *Les Chapiteaux du cloître Notre-Dame de la Daurade*. Paris, 1939.

Lafond, Jean. "Les Vitraux de la cathédrale Saint-Pierre de Troyes," *Congrès archéologique*, 113 (1955), pp. 29-62.

Lahondès, Jules de. "Saint-Hilaire," *Congrès archéologique*, 73 (1906), pp. 57-60.

——. *Toulouse chrétienne, L'église Saint-Etienne, cathédrale de Toulouse*. Toulouse, 1890.

Lambert, Elie. *L'Art gothique en Espagne aux XIIème et XIIIème siècles*. Paris, 1931.

——. *Le Pèlerinage de Compostelle, Etudes d'histoire médiévales*. Toulouse, 1959.

Lange, C. *Die lateinischen Osterfeiern*, 1 (Jahresbericht über die Realschule erster Ordnung in Halberstadt). Halberstadt, 1881.

Lange, Reinhold. *Die Auferstehung* (Iconographia Ecclesiae Orientalis). Recklinghausen, 1966.

Lanore, M. "La Cathédrale de Lescar," *Bulletin monumental,* 68 (1904), pp. 190-259.

Lapeyre, André. *Des Façades occidentales de Saint-Denis et de Chartres aux portails de Laon*. Paris, 1960.

Lasteyrie, C. de. *L'Abbaye de Saint-Martial de Limoges; Étude historique, économique et archéologique*. Paris, 1901.

Lasteyrie, R. de. *L'Architecture religieuse en France à l'époque romane*. 2nd ed., Paris, 1929.

——. "Études sur la sculpture française du moyen âge," *Monuments Piot*, 8 (1902).

Latini, Brunetto. *Li Livres dou Tresor*, ed. F. J. Carmody. Berkeley and Los Angeles, 1948.

Lauchert, F. *Geschichte des Physiologus*. Strasbourg, 1889.

Lauer, Ph. "Le Trésor du Sancta Sanctorum," *Monuments Piot*, 15 (1906), pp. 7-140.

Laurent, M. "Godefroid de Claire et la croix de Suger à l'abbaye de Saint-Denis," *Revue archéologique*, 19 (1924), pp. 79-87.

Lavergne, A. *Les Chemins de Saint-Jacques en Gascogne*. Bordeaux, 1887.

Layard, Austen Henry. *A Second Series of the Monuments of Nineveh, including Bas-reliefs from the Palace of Sennachërib and Bronzes from the Ruins of Nimroud*. London, 1853.

Le Blant, Edmons. *Études sur les sarcophages chrétiens antiques de la ville d'Arles*. Paris, 1878.

——. *Les Inscriptions chrétiennes de la Gaule antérieures au VIIIème siècle*. 2 vols. Paris, 1856-1865.

Le Vieil, P. *L'Art de la peinture sur verre et de la vitrerie*. Paris, 1774.

Lebeuf, abbé. "Conjectures sur la reine Pedauque," *Histoire de l'Académie Royale des Inscriptions et Belles-Lettres*, 23 (1756), pp. 227-235.

——. *Histoire de la ville et de tout le diocèse de Paris*, ed. A. Augier. 6 vols. Paris, 1883.

Leclercq, J. "Etudes sur saint Bernard et le texte de ses écrits," *Analecta sacri ordinis Cisterciensis*, 9 (1953), pp. 92-113.

Lefèvre, L.-Eug. "Le Symbolisme du tympan de Vézelay," *Revue de l'art chrétien*, 56 (1906), pp. 253-257.

Lefèvre-Pontalis, E. "Les Dates de Saint-Julien de Brioude," *Congrès archéologique*, 71 (1904), pp. 542-555.

——. "L'eglise abbatiale du Ronceray d'Angers," *Congrès archéologique*, 77 (1910), pp. 121-145.

——. "Saint-Hilaire de Poitiers, étude archéologique," *Congrès archéologique*, 70 (1903), pp. 361-405.

Lefrançois-Pillion, Louise. *Les Sculpteurs français du XIIème siècle*. Paris, 1931.

Lehmann-Hartleben, Karl and Erling O. Olsen. *Dionysiac Sarcophagi in Baltimore*. Baltimore, 1942.

Lehmann, W. *Die Parabel von den klugen und törichten Jungfrauen*. Berlin, 1916.

Lehner, F. J. *Česka skola malarska XI. věku (Die böhmische Malerschule des XI. Jahrhunderts)*. Prague, 1902.

Leidinger, Georg. *Der Codex Aureus der bayerischen Staatsbibliothek in München*. 3 vols. Munich, 1921-1925.

——. *Das Perikopenbuch Kaiser Heinrichs II* (Miniaturen aus Handschriften der Kgl. Hof- und Staatsbibliothek in München, v). Munich, 1914.

Leidinger, Georg. *Das sogenannte Evangeliarium Kaiser Ottos III* (Miniaturen aus Handschriften der Kgl. Hof- und Staatsbibliothek in München, 1). Munich, 1912.

Lejeune, Rita and Jacques Stiennon. *La Légende de Roland dans l'art du Moyen Age.* 2 vols. Brussels, 1966.

———. *Recherches sur le thème: les chansons de geste et l'histoire* (Bibliothèque de la Faculté de Philosophie et Lettres de l'Université de Liège, fasc. cviii). Liège, 1948.

Lemarignier, J. F. "L'Exemption monastique et les origines de la réforme grégorienne," *A Cluny, Congrès scientifique, 9-11 juillet 1949, Travaux,* Dijon, 1950, pp. 288-334.

Leroquais, V. *Les Psautiers, manuscrits latins des bibliothèques publiques de France.* 2 vols. and atlas. Mâcon, 1940-1941.

———. *Les Sacramentaires et les missels manuscrits des bibliothèques de France.* 3 vols. Paris, 1924.

Leroux, Alfred. "Les Portails commémoratifs de Bordeaux, Essai d'interprétation par l'histoire locale," *Annales du Midi,* 1915-1916, pp. 428-453.

Lessing, Julius. *Gewebesammlung des königlichen Kunstgewerbemuseums zu Berlin.* Berlin, 1900-1907.

Lesueur, Frédéric. "Les Fresques de Saint-Gilles de Montoire et l'iconographie de la Pentecôte," *Gazette des beaux-arts,* 66 (1924), pp. 19-29.

———. "Saint-Martin de Tours et les origines de l'art roman," *Bulletin monumental,* 107 (1949), pp. 7-84.

Lethaby, W. R. "The Part of Suger in the Creation of the Medieval Iconography," *Burlington Magazine,* 25 (1914), pp. 206-211.

Lexikon der christlichen Ikonographie. ed. Engelbert and Kirschbaum. Rome, 1968.

Lexikon für Theologie und Kirche. 10 vols. Freiburg-im-Breisgau, 1957ff.

Liber miraculorum Sanctae Fidis, ed. A. Bouillet. Paris, 1897.

Liber pontificalis, ed. Louis Duchesne and Cyrille Vogel. 3 vols. Paris, 1955-1957.

Limoges, Musée Municipal. Catalogue of the Exhibition. *L'Art roman à Saint-Martial de Limoges; Les manuscrits à peintures, histoire de l'abbaye, la basilique.* Limoges, 1950.

Loeschke, W. "Beiträge zur Ikonographie des Kynokephalen hl. Christophorus," *Actes du Xème Congrès International d'Etudes Byzantines (1955),* Istanbul, 1957, pp. 145-148.

London, British Museum. O. M. Dalton. *Catalogue of Early Christian Antiquities and Objects from the Christian East, in the Department of British and Mediaeval Antiquities of the British Museum.* London, 1901.

———. G. F. Warner. *Illuminated Manuscripts; Miniature Borders and Initials Reproduced in Gold and Colours.* London, 1903.

———. D. J. Wiseman. *Catalogue of the Western Asiatic Seals in the British Museum,* 1. *Cylinder Seals: Uruk-Early Dynastic Periods.* London, 1962.

London, The Palaeographical Society. *Fac-Similes of Manuscripts and Inscriptions,* ed. E. A. Bond and E. M. Thompson. London, 1873ff.

London, The Victoria and Albert Museum. Margaret H. Longhurst. *Catalogue of Carvings in Ivory.* 2 vols. London, 1927-1929.

Longuemar, M. de. "Essai historique sur l'église collégiale de Saint-Hilaire-le-Grand de Poitiers," *Mémoires de la Société des Antiquaires de l'Ouest,* 23 (1856), pp. 1ff.

———. "Note sur les fresques récemment découvertes dans l'église de Saint-Hilaire," *Bulletin de la Société des Antiquaires de l'Ouest,* 13 (1871-1873), pp. 375-382.

Loomis, Roger Sherman. *Arthurian Legends in Medieval Art.* London and New York, 1938.

———. *Arthurian Literature in the Middle Ages: A Collaborative History.* Oxford, 1959.

Lopez, Robert Sabatino. "Silk Industry in the Byzantine Empire," *Speculum,* 20 (1945), pp. 1-42.

Lorain, Prosper. *Essai historique sur l'abbaye de Cluny, suivi de pièces justificatives et de divers fragments de la correspondance de Pierre-le-Vénérable avec Saint Bernard.* Dijon, 1839.

L'Orange, H. P. *Studies in the Iconography of Cosmic Kingship.* Oslo and Cambridge (Mass.), 1953.

Louis, René. *De l'Histoire à la légende, Girart, comte de Vienne (819-877) et ses fondations monastiques.* Auxerre, 1946.

———. "La Visite des Saintes Femmes au tombeau dans le plus ancien art chrétien," *Mémoires de la Société Nationale des Antiquaires de France,* 9th ser., 3 (1954).

Lucien-Herr, J. "La Reine de Saba et le bois de la croix," *Revue archéologique,* 23 (Jan.-Feb. 1914), pp. 1-31.

Macler, F. *L'Évangile Arménien, édition photo-typique du Ms. 229 de la Bibliothèque d'Etchmiadzin.* Paris, 1920.

Macrobius. *Commentary on the Dream of Scipio,* ed. and tr. William Harris Stahl. New York, 1922.

Magnani, Luigi, ed. *Le miniature del Sacramentario d'Ivrea e di altri Codici Warmondiani.* Vatican City, 1934.

Mahn, Hannshubert. *Kathedralplastik in Spanien; Die monumentale Figuralskulptur in (Alt-) Kastilien, León und Navarra zwischen 1230 und 1380* (Tübinger Forschungen zur Archäologie und Kunstgeschichte, xv). Reutlingen, 1931.

Maillard, Elisa. "Les Sculptures de la façade occidentale de la cathédrale de Poitiers," *Gazette des beaux-arts,* 62 (1920), pp. 289-308.

Maillart, E. "La Façade romane de l'église Saint-Eulalie de Benet en Bas-Poitou," *Bulletin archéologique du Comité des Travaux historiques et scientifiques,* 1927, pp. 379-385.

Maillé, Marquise de. *Vincent d'Agen et saint Vincent de Saragosse, Étude de la "Passio S. Vincentii martyris."* Melun, 1949.

Maître, L. "Les Substructions du chevet de la cathédrale de Nantes," *Bulletin archéologique du Comité des Travaux historiques et scientifiques,* 1906.

Mâle, Emile. "L'Architecture et la sculpture en Lombardie à l'époque romane, A propos d'un livre récent," *Gazette des beaux-arts,* 14 (1918), pp. 35-46.

——. *Art et artistes du moyen âge.* Paris, 1927 (re-ed. Paris, 1968).

——. *L'Art religieux du XIIIe siècle en France.* 9th ed., Paris, 1958.

——. "Les Chapiteaux romans du musée de Toulouse et l'école toulousaine du XIIe siècle," *Revue archéologique,* 3rd ser., 20 (1892), pp. 28-35 and 176-197.

——. "Les Influences arabes dans l'art roman," *Revue des deux mondes,* 15 (Nov. 1923), pp. 311-343.

——. "La Mosquée de Cordoue et les églises de l'Auvergne et du Velay," *Revue de l'art ancien et moderne,* 30 (Aug. 1911), pp. 81-89.

——. *Notre-Dame de Chartres.* Paris, 1948 (re-ed. Paris, 1963).

——. "Le Ravissement de Marie-Madeleine au musée d'Autun," *Congrès archéologique,* 74 (1907), pp. 537-539.

——. "Saint Jacques le Majeur," *Centre International d'Etudes Romanes,* 1957, pp. 4-26.

——. *Les Saints compagnons du Christ.* Paris, 1958.

——. "La Vierge d'or de Clermont et ses répliques," *Le Point,* 25 (June 1943), pp. 4-10.

Marle, Raimond van. *The Development of the Italian School of Painting.* 19 vols. The Hague, 1923-1938.

Marlot, G. *Histoire de la ville, cité et université de Reims.* Reims, 1845.

Marquet de Vasselot, J. J. *Catalogue raisonné de la collection Martin Le Roy,* Fasc. 1, *Orfèvrerie et émaillerie.* Chartres, 1906.

——. "Les Emaux limousins à fond vermiculé," *Revue archéologique,* 4th ser., 6 (1905), pp. 15-30, 231-245, 418-431.

Martène, E. and U. Durand, eds. *Veterum scriptorum et monumentorum amplissima collectio.* 2nd ed. 9 vols. Paris, 1724-1733.

Martin, Camille. *L'Art roman en France, l'architecture et la décoration.* 2nd ser., Paris, 1910.

——. *L'Art roman en Italie.* 2 vols. Paris, 1912-1914.

Martin, H. *La Légende de Saint Denis.* Paris, 1908.

Maspero, Jean. "Rapport sur les fouilles entreprises à Baouït," *Académie des Inscriptions et Belles-Lettres, Comptes rendus des séances,* 1913.

Masson, André. "La Sauve Majeure," *Congrès archéologique,* 102 (1939), pp. 216-236.

Mayeur, P. "Le Tympan de l'église abbatiale de Vézelay," *Revue de l'art chrétien,* 57 (1908), pp. 103-108 and 58 (1909), pp. 326-332.

McCulloch, Florence. *Mediaeval Latin and French Bestiaries.* Chapel Hill, 1962.

Mendell, Elizabeth Lawrence. *Romanesque Sculpture in Saintonge.* New Haven, 1940.

Menéndez Pidal, Ramón, ed. *Historia de España.* 6 vols. Madrid, 1935-1957.

Mercier, Fernand. *Les Primitifs français; La peinture clunysienne en Bourgogne à l'époque romane, son histoire et sa technique.* Paris, 1931.

Meredith-Jones, C. *Historia Karoli Magni et Rotholandi ou Chronique de Turpin.* Paris, 1936.

Mérimée, Prosper. *Notice sur les peintures de l'église de Saint-Savin.* Paris, 1845.

Merlet, René. "La Cathédrale de Chartres et ses origines à propos de la découverte du puits des Saints-Forts," *Revue archéologique,* 3rd ser., 41 (1902), pp. 232-241.

Meyer, P. *Alexandre le Grand dans la littérature française du moyen âge.* 2 vols. Paris, 1886.

————. "La Descente de saint Paul en enfer, poème français composé en Angleterre," *Romania*, 24 (1895), pp. 368-369.

————. "De l'Expansion de la langue française en Italie pendant le moyen âge," *Atti del Congresso internazionale di scienze storiche, 1903*, IV, Rome, 1904, pp. 61-104.

————. *Le Roman de Flamenca.* Paris, 1865.

Meyer, W. "Die Geschichte des Kreuzholzes vor Christus," *Abhandlungen der philosophisch-philologischen Klasse der königlich-bayerischen Akademie der Wissenschaften*, 16-2 (1882), pp. 103-166.

————. "Wie ist die Auferstehung Christi dargestellt worden?" *Nachrichten von der königlichen Gesellschaft der Wissenschaften zu Göttingen, Philologische-historische Klasse aus dem Jahre 1903*, Göttingen, 1904, pp. 236-254.

Michel, André, ed. *Histoire de l'art depuis les premiers temps chrétiens jusqu'à nos jours.* I, Paris, 1905.

————. "Les Sculptures de l'ancienne façade de Notre-Dame de la Couldre à Parthenay," *Monuments Piot*, 22 (1916-1918), pp. 179-195.

Michel, Francisque. *Recherches sur le commerce, la fabrication et l'usage des étoffes de soie, d'or et d'argent et autres tissus précieux en Occident, principalement en France, pendant le moyen âge.* 2 vols. Paris, 1852-1854.

Michel, K. *Gebet und Bild in frühchristlicher Zeit* (Studien über christliche Denkmäler, 1). Leipzig, 1892.

Migeon, Gaston. *Manuel d'art musulman, Arts plastiques et industriels.* 2 vols. 2nd ed., Paris, 1927.

Migne, J.-P., ed. *Patrologiae cursus completus, Series graeca.* 161 vols. Paris, 1857-1904.

————. *Patrologiae cursus completus, Series latina.* 217 vols. Paris, 1844-1905.

Milchsack, G. *Die Oster- und Passionsspiele*, I. *Die lateinischen Osterfeiern.* Wolfenbüttel, 1880.

Millet, Gabriel. *Recherches sur l'iconographie de l'Evangile.* Paris, 1916.

Millin, Aubin Louis. *Voyage dans les départements du Midi de la France.* Paris, 1808.

Miniature sacre e profane dell'anno 1023 illustranti l'Enciclopedia medioevale di Rabano Mauro. Monte Cassino, 1896.

Mirabilia urbis Romae. The Marvels of Rome, or a picture of the Golden City, tr. Francis Morgan Nichols. 2 vols. London and Rome, 1889.

Mirabilia Romae e codicibus Vaticanis emendata, ed. Gustav Parthey. Berlin, 1869.

Molinier, Emile, *Histoire générale des arts appliqués à l'industrie du 5e à la fin du 18e siècle*, I. *Ivoires.* Paris, 1896.

Molsdorf, Wilhelm. *Christliche Symbolik der mittelalterlichen Kunst.* 2nd ed., Leipzig, 1926.

Monceaux, P. *Saint Martin.* Paris, 1927.

Monneret de Villard, Ugo. "Per la storia del portale romanico," *Medieval Studies in Memory of A. Kingsley Porter*, I, Cambridge, 1939, pp. 113-124.

Montfaucon, Bernard de. *Les Monumens de la monarchie françoise.* 5 vols. Paris, 1729-1733.

Monumenta Germaniae Historica, Epistolae, ed. P. Ewald and L. M. Hartmann. 3 vols. Berlin, 1887 (repr. Berlin, 1957).

Monumenta Germaniae Historica, Scriptores, ed. G. H. Pertz, T. Mommsen and others. 32 vols. Hanover, 1826-1913 (repr. Stuttgart and New York, 1963-1964).

Monumenta Germanicae Historica, Scriptores rerum langobardicarum et Italicarum, ed. Societas Aperiendis Fontibus rerum Germanicarum Medii Aevi. 7 vols. Hanover, 1878 (repr. Stuttgart, 1964).

Morel-Payen, Lucien. *Les plus beaux Manuscrits et les plus belles reliures de la Bibliothèque de Troyes.* Troyes, 1935.

Morellet, J. N., S. B. F. Barat and E. Bussière. *Le Nivernois, Album historique et pittoresque*, Nevers, 1838-1840.

Morey, Charles Rufus. *Early Christian Art.* Princeton, 1942.

————. "Notes on East Christian Miniatures," *Art Bulletin*, 11 (1929), pp. 5-103.

Mot, G.-J. "L'Ossuaire de saint Saturnin à Saint-Hilaire d'Aude," *Mémoires de la Société Archéologique du Midi de la France*, 27 (1961), pp. 41-47.

Munich, Bayerische Staatsbibliothek. Exhibition Catalogue. *Ars sacra, Kunst des frühen Mittelalters.* Munich, 1950.

Muñoz, Antonio. *Il codice purpureo di Rossano e il frammento Sinopense.* Rome, 1907.

Muntz, Eugène. *Etudes iconographiques et archéologiques sur le moyen âge.* Paris, 1887.

Mussat, André. *Le style gothique de l'Ouest de la France (XIIème-XIIIème siècles).* Paris, 1963.

Nantes, Musée Th. Dobrée. Costa, D. *Art méro-vingien*. Paris, 1964.

Neuss, Wilhelm. *Die Apokalypse des hl. Johannes in der altspanischen und altchristlichen Bibel-illustration*. 2 vols. Münster-in-Westfalen, 1931.

———. *Das Buch Ezechiel in Theologie und Kunst bis zum Ende des XII. Jahrhunderts*. Münster-in-Westfalen, 1912.

———. *Die katalanische Bibelillustration um die Wende des ersten Jahrtausends und die altspanische Buchmalerei*. Bonn and Leipzig, 1922.

New York, The Pierpont Morgan Library. *Exhibition of Illuminated Manuscripts Held at the New York Public Library*. New York, 1933-1934.

———. Porada, Edith. *Mesopotamian Art in Cylinder Seals of the Pierpont Morgan Library*. New York, 1947.

Newton, Arthur Percival, ed. *Travel and Travellers of the Middle Ages*. London and New York, 1930.

Nodet, Henri. "Sur quelques Eglises romanes de la Charente-Inférieure," *Bulletin monumental*, 56 (1890), pp. 363-384.

Noguier, Antoine. *Histoire Tolosaine*. Toulouse, 1559.

Nordenfalk, Carl. *Die spätantiken Kanontafeln*. Gothenburg, 1938.

Omont, Henri. *Evangiles avec peintures byzantines du XIe siècle*. 2 vols. Paris, 1908.

———. *Les Miniatures des plus anciens manuscrits grecs de la Bibliothèque Nationale du VIe au XIVe siècle*. 2nd ed., Paris, 1929.

———. "Peintures du manuscrit grec de l'Evangile de Saint Matthieu, copié en onciale d'or sur parchemin pourpré, récemment acquis pour la Bibliothèque Nationale," *Monuments Piot*, 7 (1901), pp. 175-185.

Oursel, Charles. *L'Art en Bourgogne*. 2nd ed., Paris and Grenoble, 1953.

———. *La Miniature du XIIème siècle à l'abbaye de Cîteaux d'après les manuscrits de la Bibliothèque de Dijon*. Dijon, 1926.

Oursel, Raymond and A.-M. *Les Eglises romanes de l'Autunois et du Brionnais, Cluny et sa région*. Mâcon, 1956.

Ouspensky, Th. *The Octateuch of the Seraglio in Constantinople* (in Russian: Bulletin of the Russian Archeological Institute of Constantinople, 12). Munich, 1907.

Ozanam, A. F., ed. *Documents inédits pour servir à l'histoire littéraire de l'Italie depuis le VIIIème jusqu'au XIIIème siècle*. Paris, 1850.

Pächt, Otto, C. R. Dodwell and Francis Wormald. *The St. Albans Psalter* (*Albani Psalter*). London, 1960.

Palustre, Léon, ed. *Adam, mystère du XIIème siècle*. Paris, 1877.

Panofsky, Erwin, ed. and tr. *Abbot Suger on the Abbey Church of St.-Denis and Its Art Treasures*. Princeton, 1946.

———. *Albrecht Dürer*. 3rd ed., Princeton, 1948.

———. "Postlogium Sugerianum," *Art Bulletin*, 29 (1947), pp. 119-121.

Paris, Archives Nationales. *Inventaire du Trésor de Saint-Denis*. (LL, no. 1327).

———, Musée des Arts Décoratifs. Exhibition Catalogue. *Les Trésors des églises de France*. Paris, 1965.

———, Bibliothèque de l'Arsenal. H. Martin and Ph. Lauer. *Les Principaux manuscrits à peintures de la Bibliothèque de l'Arsenal à Paris*. (S.F.R.M.P.). Paris, 1929.

———, Bibliothèque Nationale. Exhibition Catalogue. *Byzance et la France médiévale*. Paris, 1956.

———. *Catalogue général des manuscrits latins*. I-III. Paris, 1939-1952.

———. Exhibition Catalogue. *Les Manuscrits à peintures en France du VIIe au XIIe siècle*. Paris, 1954.

———. Exhibition Catalogue. *Les Manuscrits à peintures en France du XIIIe au XVI siècle*. Paris, 1955.

———, Bibliothèque Sainte-Geneviève. Amédée Boinet. *Les Manuscrits à peintures de la Bibliothèque Sainte-Geneviève de Paris*. Paris, 1921.

———, Musée national du Louvre. Marcel Aubert and Michèle Beaulieu. *Description raisonnée des sculptures*, 1. Moyen Age. Paris, 1950.

———. Delaporte, Louis. *Catalogue des cylindres cachets et pierres gravées de style oriental*. 2 vols. Paris, 1920-1923.

———. Heuzey, Léon. *Catalogue des antiquités chaldéennes; sculpture et gravure à la pointe*. Paris, 1902.

Paris, Gaston. "Review of Graf, *Roma . . .*," *Le Journal des Savants* (Oct. 1884), pp. 557-577.

Paris, Gaston. "Chronique," *Romania*, 19 (1890), p. 370.

———. "La Légende de Pépin 'le Bref,'" *Mélanges Julien Havet*, Paris, 1895, pp. 608-609.

———. *La Littérature française au moyen âge, XIe-XIVe siècle*. Paris, 1890.

Parrot, André. *The Arts of Assyria* (The Arts of Mankind, ed. A. Malraux and G. Salles). New York, 1961.

Patch, H. R. *The Tradition of Boethius*. New York, 1935.

Pauly, August Friedrich von and Georg Wissowa, eds. *Paulys Real-Encyclopädie der classischen Altertumswissenschaft*. Stuttgart, 1914-1958.

Pedica, S. *Il Volto Santo nei documenti della chiesa*. Rome, 1960.

Perrot, Georges and Charles Chipiez. *Histoire de l'art dans l'antiquité*. 10 vols. Paris, 1882-1914.

Petit, E. "Croisades bourguignonnes contre les Sarrazins d'Espagne au XIème siècle, Les princes de la Maison de Bourgogne fondateurs des dynasties espagnoles et portugaises," *Revue historique*, 30 (1886), pp. 259-272.

Phaedrus. *Fables*, ed. A. Brenot. Paris, 1961.

Philippe de Taon. *Le Bestiaire de Philippe de Thaün*, ed. E. Walberg. Paris and Lund, 1900.

Picard, Charles. "Le Mythe de Circé au tympan du grand portail de Vézelay," *Bulletin monumental*, 104 (1945).

Pijoán, J. "Les Miniatures de l'Octateuch y les Biblies romàniques catalanes," *Anuari del Institut d'Estudis catalans*, 4 (1911-1912), pp. 479-487.

Pinard, T. "Monographie de l'église Notre-Dame de Corbeil," *Revue archéologique*, 2nd ser., 1 (1845), pp. 167-168.

Plancher, Urbain. *Histoire générale et particulière de Bourgogne, avec des notes, des dissertations et des preuves justificatives*. 4 vols. Dijon, 1739-1781.

Plat, abbé. "La Touraine, berceau des écoles romanes du Sud-Ouest," *Bulletin monumental*, 77 (1913), pp. 347-378.

Plat, G. "La Chapelle de Saint-Gilles de Montoire," *Bulletin de la Société Archéologique, Scientifique et Littéraire du Vendômois*, 67 (1928), pp. 89-105.

Plenzat, K. *Die Theophiluslegende in den Dichtungen des Mittelalters* (Germanische Studien, 43). Berlin, 1926.

Pliny the Elder. *Historia Naturalis*, ed. and tr. H. Rackham, W. H. S. Jones and D. E. Eichholz (The Loeb Classical Library). 10 vols. London and Cambridge, 1938-1963.

Pognon, Edmond, ed. *L'An Mille*. 8th ed., Paris, 1947.

Pope, Arthur Upham and Phyllis Ackerman, eds. *A Survey of Persian Art from Prehistoric Times to the Present*. 6 vols. London and New York, 1938-1939.

Porcher, Jean. *Medieval French Miniatures*, tr. Julian Brown. New York, 1960.

———. *Le Sacramentaire de Saint-Etienne de Limoges*. Paris, 1953.

Porter, Arthur Kingsley. "Bari, Modena and St.-Gilles," *Burlington Magazine*, 43 (1923), pp. 58-67.

———. *Lombard Architecture*. 4 vols. New York, 1917 (re-ed. New York, 1967).

———. *Romanesque Sculpture of the Pilgrimage Roads*. 10 vols. Boston, 1923.

———. "Spain or Toulouse? and other Questions," *Art Bulletin*, 7 (1924), pp. 3-25.

———. *Spanish Romanesque Sculpture* (Pantheon ed.). 2 vols. Florence and Paris, 1928.

Pottier, Edmond. "Histoire d'une bête," *Revue de l'art ancien et moderne*, 2 (1910), pp. 419-436.

Prou, M. "Deux Dessins du XIIe siècle au trésor de l'église Saint-Etienne d'Auxerre," *Gazette archéologique*, 12 (1887), pp. 138-144.

Prudentius. *Collected Works*, ed. H. J. Thompson (The Loeb Classical Library). 2 vols. London and Cambridge, 1949.

Puig y Cadafalch, José, Antoni de Falguera y Sivilla and J. Goday y Casals. *L'Arquitectura romànica a Catalunya*. 3 vols. Barcelona, 1909-1918.

Quaresimus, Fr. *Historica theologica et moralis Terrae Sanctae elucidatio*. 2 vols. Venice, 1880-1882.

Quarré, Pierre. "La Sculpture des anciens portails de Saint-Bénigne de Dijon," *Gazette des beaux-arts*, 49 (1957), pp. 177-194.

Raby, Frederic James Edward. *A History of Christian-Latin Poetry from the Beginnings to the Close of the Middle Ages*. Oxford, 1927.

Rackham, Bernard. *The Ancient Glass of Canterbury Cathedral*. London, 1949.

Raebber, Regula. *La Charité-sur-Loire*. Berne, 1964.

Rajna, P. "Contributi alla storia dell'epopea," *Romania*, 26 (1897), pp. 56-59.

——. "Un'inscrizione Nepesina del 1131," *Archivio storico Italiano*, 4th ser., 18 (1886), pp. 329ff. and 19 (1887), pp. 23ff.

——. "Per la data della 'Vita Nuova,'" *Giornale storico della letteratura italiana*, 6 (1885), pp. 131-134.

Ramé, A. "Explication du bas-relief de Souillac, La légende de Théophile," *Gazette archéologique*, 10 (1885), pp. 225-232.

Raymond, P. "Notice sur une mosaïque placée dans la grande abside de la cathédrale de Lescar (Basses-Pyrénées)," *Revue archéologique*, new ser., 13 (1866), pp. 305-313.

Reallexikon zur deutschen Kunstgeschichte, eds. Otto Schmitt, Ernst Gall and L. H. Heydenreich. Stuttgart, 1937ff.

Réau, Louis. *Iconographie de l'art chrétien*. 3 vols. Paris, 1955-1959.

Recueil des historiens des Croisades, ed. Académie des Inscriptions et Belles-Lettres. 16 vols. Paris, 1841-1906.

Reil, J. *Die frühchristlichen Darstellungen der Kreuzigung Christi*. Leipzig, 1904.

Reisner, E. *Le Démon et son image*. Paris, 1961.

Reitzenstein, R. and H. H. Schaeder. *Studien zum antiken Synkretismus aus Iran und Griechenland* (Studien der Bibliothek Warburg, VII). Leipzig, 1926.

Restle, Marcell. *Die byzantinische Wandmalerei in Kleinasien*. 3 vols. Recklinghausen, 1967.

Rey, Raymond. *L'Art des cloîtres romans, étude iconographique*. Toulouse, 1955.

——. "Cathédrale Saint-Etienne de Cahors," *Congrès archéologique*, 100 (1937), pp. 216-265.

——. "Les Cloîtres historiés du Midi dans l'art roman, Etude iconographique," *Mémoires de la Société Archéologique du Midi de la France*, 23 (1955), pp. 36-37.

——. *La Sculpture romane languedocienne*. Toulouse and Paris, 1936.

Rhein, André. "Anzy-le-Duc," *Congrès archéologique*, 80 (1913), pp. 269-291.

——. "Sainte-Eutrope de Saintes," *Congrès archéologique*, 79 (1912), pp. 354-371.

Rice, David Talbot. "The Iconography of the Langford Rood," *Mélanges René Crozet*, I, Poitiers, 1966, pp. 169-172.

Rickert, Margaret J. *Painting in Britain: The Middle Ages* (The Pelican History of Art). Harmondsworth and Baltimore, 1954.

Riquer, M. de. *Les Chansons de geste françaises*. 2nd ed., Paris, 1957.

Röhrig, Floridus. *Der Verduner Altar*. Vienna, 1955.

Roes, Anne. "Histoire d'une bête," *Bulletin de correspondance hellénique*, 59 (1935), pp. 313-328.

Roffignac, B. de. "L'Eglise de Châtillon-sur-Indre," *Mémoires de la Société des Antiquaires du Centre*, 43 (1929), pp. 99-156.

Rohault de Fleury, C. *L'Evangile; Etudes iconographiques et archéologiques*. Tours, 1874.

Roland, Legend of. *Chanson de Roland*, ed. Léon Gautier. Paris, 1872.

——. *The Song of Roland*, tr. Charles Scott Moncrieff. London, 1919 and New York, 1920.

Rolt, C. E. *Dionysius the Areopagite on the Divine Names and the Mystic Theology*. London and New York, 1940 ed.

Roques, Mario. *Le Roman de Renard, branches VII-IX*. Paris, 1955.

Roques de Maumont, Harald von. *Antike Reiterstandbilder*. Berlin, 1958.

Rorimer, James J. "Forgeries of medieval stone sculpture," *Gazette des beaux-arts*, 26 (1944), pp. 195-210.

—— and William H. Forsyth. "The Medieval Galleries," *Bulletin of the Metropolitan Museum of Art*, new series, 12 (1954), pp. 121-144.

——. "The Restored Twelfth-Century Parthenay Sculptures," *Technical Studies*, 10 (1941-1942), pp. 123-130.

Ross, D. J. A. *Alexander Historiatus; A Guide to Medieval Illustrated Alexander Literature*. London, 1963.

Ross, M. C. "Monumental Sculptures from St.-Denis, an Identification of Fragments from the Portal," *The Journal of the Walters Art Gallery*, 3 (1940), pp. 90-107.

Rott, Hans. *Kleinasiatische Denkmäler aus Pisidien, Pamphylien, Kappadokien und Lykien* (Studien über christliche Denkmäler, V-VI). Leipzig, 1908.

Roulin, E. "Les Cloîtres de l'abbaye de Silos," *Revue de l'art chrétien*, 60 (1910), pp. 1ff.

——. "Orfèvrerie et émaillerie. Mobilier liturgique d'Espagne," *Revue de l'art chrétien*, 53 (1903), pp. 19-31, 200-206, 292-303.

Ruinart, T. *Acta primorum martyrum sincera et selecta*. Paris, 1689.

Rumpf, Andreas, ed. *Chalkidische Vasen*. Berlin, 1927.

Rupin, Ernest. *L'Abbaye et les cloîtres de Moissac*. Paris, 1897.

Rupin, Ernest. *L'Oeuvre de Limoges.* 2 vols. Paris, 1890.

———. "La Statue de la Vierge à Roc-Amadour (Lot)," *Revue de l'art chrétien,* 42 (1892), pp. 8-15.

Russell, J. B. *Dissent and Reform in the Early Middle Ages.* Berkeley and Los Angeles, 1965.

Rutebeuf, Le miracle de Theophile, ed. G. Frank. Paris, 1925.

Sackur, E. *Die Cluniacenser in ihrer kirchlichen und allgemein-geschichtlichen Wirksamkeit bis zur Mitte des elften Jahrhunderts.* 2 vols. Halle, 1892-1894.

Sahuc, J. "L'Art roman à Saint-Pons-de-Thomières," *Mémoires de la Société Archéologique de Montpellier,* 1908.

Saint-Paul, A. "Suger, l'église de Saint-Denis et Saint Bernard," *Bulletin archéologique du Comité des Travaux historiques et scientifiques,* 1890, pp. 258-275.

Salet, Francis. "Chronologie de l'ancienne église abbatiale de Cluny," *Académie des Inscriptions et Belles-Lettres, Comptes rendus de l'année 1968,* pp. 30-39.

———. "Cluny III," *Bulletin monumental,* 126 (1968), pp. 235-292.

———. "Dax, Cathédrale," *Congrès archéologique,* 102 (1939), pp. 380-390.

———. "L'Eglise de Donzy-le-Pré," *Congrès archéologique,* 125 (1967), pp. 142-152.

——— and Jean Adhémar. *La Madeleine de Vézelay.* Melun, 1948.

———. "Mimizan," *Congrès archéologique,* 102 (1939), pp. 336-344.

———. "Notre-Dame de Corbeil," *Bulletin monumental,* 100 (1941), pp. 81-118.

Salvini, Roberto. *Wiligelmo e le origini della scultura romanica.* Milan, 1956.

Sanoner, G. "Analyse du portail de l'église Saint-Gilles à Argenton-Château (Deux-Sèvres)," *Revue de l'art chrétien,* 53 (1903), pp. 402-405.

———. "Le Portail de l'abbaye de Vézelay," *Revue de l'art chrétien,* 54 (1904), pp. 448-459.

Sarton, George. *Introduction to the History of Science.* 3 vols. 2nd ed., Baltimore, 1950.

Sauerländer, Willibald. *Gotische Skulptur in Frankreich, 1140-1270.* Munich, 1970.

———. "Die kunstgeschichtliche Stellung der Westportale von Notre-Dame in Paris," *Marburger Jahrbuch für Kunstwissenschaft,* 17 (1959), pp. 1-56.

———. "Die Marien-krönungsportale von Senlis und Mantes," *Wallraf-Richartz Jahrbuch,* 20 (1958), pp. 115-162.

———. *Von Sens bis Strassburg.* Berlin, 1966.

Sauvel, Tony. "Les Manuscrits limousins, Essai sur les liens qui les unissent à la sculpture monumentale, aux émaux et aux vitraux," *Bulletin monumental,* 108 (1950), pp. 117-144.

———. "A propos d'une Exposition récente: les manuscrits poitevins ornés de peintures," *Bulletin de la Société des Antiquaires de l'Ouest,* 1955, pp. 257-271.

Saxer, Victor. "L'Origine des reliques de sainte Marie-Madeleine à Vézelay dans la tradition historiographique du moyen âge," *Revue des sciences religieuses,* 29 (1955), pp. 1-19.

Saxl, Fritz. *English Sculptures of the Twelfth Century,* ed. Hanns Swarzenski. London, 1954.

———. *Lectures.* 2 vols. London, 1957.

——— and Hans Meier, ed. Harry Bober. *Verzeichnis astrologischer und mythologischer illustrierter Handschriften in englischen Bibliotheken.* 3 vols. London, 1915-1953.

Schade, Herbert. *Dämonen und Monstren; Gestaltungen des Bösen in der Kunst des frühen Mittelalters.* Regensburg, 1962.

Schapiro, Meyer. "On the Aesthetic Attitude in Romanesque Art," *Art and Thought, issued in honour of Dr. Ananda K. Coomaraswamy,* London, 1947, pp. 130-150.

———. *The Parma Ildefonsus: A Romanesque Illuminated Manuscript from Cluny and Related Works.* New York, 1964.

———. "The Romanesque Sculpture of Moissac," *Art Bulletin,* 13 (1931), pp. 249-350 and 464-531.

———. "The Sculptures of Souillac," *Medieval Studies in Memory of A. Kingsley Porter,* Cambridge (Mass.), 1939, II, pp. 359-387.

———. "Two Romanesque Drawings in Auxerre and some Iconographic Problems," *Studies in Art and Literature for Belle da Costa Greene,* Princeton, 1954, pp. 331-349.

Schiller, Gertrud. *Ikonographie der christlichen Kunst.* 2 vols. Gütersloh, 1966-1968.

Schlosser, Julius von. *Die Kunst- und Wunderkammern der Spätrenaissance.* Leipzig, 1908.

———. *Quellenbuch zur Kunstgeschichte des abendländischen Mittelalters* (Quellenschriften für Kunstgeschichte und Kunsttechnik des Mittelalters und der Neuzeit, Neue Folge, VII). Vienna, 1896.

——. *Schriftquellen zur Geschichte der karolingischen Kunst* (Quellenschriften für Kunstgeschichte und Kunsttechnik des Mittelalters und der Neuzeit, Neue Folge, IV). Vienna, 1892.

Schlumberger, Gustave. *L'Epopée byzantin à la fin du dixième siècle.* 3 vols. Paris, 1896-1905.

——. *Mélanges d'archéologie byzantine.* Paris, 1895.

——. "Un Tableau reliquaire byzantin inédit du Xe siècle," *Monuments Piot*, I (1894), pp. 99-104.

Schoenewolf, O. *Die Darstellung der Auferstehung Christi; Ihre Entstehung und ihre ältesten Denkmäler.* Leipzig, 1909.

Schorr, Dorothy S. "The Iconographic Development of the Presentation in the Temple," *Art Bulletin*, 28 (1946), pp. 17-32.

Schott, Max. *Zwei lüttiche Sakramentare* (Studien zur deutschen Kunstgeschichte, 284). Strasbourg, 1931.

Schrade, H. *Die Auferstehung Christi.* Berlin and Leipzig, 1932.

——. "Zur Ikonographie der Himmelfahrt Christi," *Vorträge der Bibliothek Warburg*, 8 (1928-1929), pp. 66-190.

——. *Die Romanische Malerei.* Cologne, 1963.

Schulz, E. W. *Denkmäler der Kunst des Mittelalters in Unteritalien.* Dresden, 1860.

A Select Library of Nicene and Post-Nicene Fathers of the Christian Church, ed. Philip Schaff and Henry Wace. 2nd ser., 14 vols. Oxford and New York, 1890 (repr. Grand Rapids, Michigan, 1964).

Semper, M. "Ivoires du Xe et du XIe siècle au Musée National de Budapest," *Revue de l'art chrétien*, 47 (1897), pp. 389-404.

Sepet, M. *Les Prophètes du Christ, étude sur les origines du théâtre au moyen âge.* Paris, 1878.

Serbat, Louis. "La Charité-sur-Loire," *Congrès archéologique*, 80 (1913), pp. 374-400.

Shepherd, Dorothy G. "A Dated Hispano-Islamic Silk," *Ars Orientalis*, 2 (1957), pp. 373ff.

Sillar, Frederick Cameron and Ruth Mary. *The Symbolic Pig.* Edinburgh and London, 1961.

Sloman, Vilhelm. *Bicorporates, Studies in Revivals and Migrations of Art Motifs.* 2 vols. Copenhagen, 1967.

Socard, Edmond. "Le Vitrail carolingien de la châsse de Séry-les-Mézières," *Bulletin monumental*, 74 (1910), pp. 5-23.

Solinus, C. Julius. *Collectanes rerum memorabilium*, ed. R. Mommsen. Berlin, 1895.

François-Souchal, Geneviève. "Les Emaux de Grandmont au XIIe siècle," *Bulletin monumental*, 120 (1962), pp. 339-357; 121 (1963), pp. 41-64 and 122-150; 122 (1964), pp. 129-159.

Soyez, Edmond. *La Croix et le crucifix, Etude d'archéologie.* Amiens, 1910.

Starkie, Walter Fitzwilliam. *The Road to Santiago; Pilgrims of St. James.* New York, 1957.

Steger, Hugo. *David rex et propheta.* Nuremberg, 1961.

Stenton, Frank, ed., *The Bayeux Tapestry.* London, 1957.

Stern, Henri. "Mosaïques de pavement préromanes et romanes en France," *Cahiers de civilisation médiévale*, 5 (1962), pp. 13-33.

——. *Recueil général des mosaïques de la Gaule*, Fasc. I. Paris, 1957.

Stettiner, Richard. *Die illustrierten Prudentiushandschriften.* Berlin, 1905.

Stiennon, Jacques and Rita Lajeune. "La Légende arthurienne dans la sculpture de la cathédrale de Modène," *Cahiers de civilisation médiévale*, 6 (1963), pp. 281-296.

Stoddard, Whitney S. *The West Portals of St.-Denis and Chartres; Sculpture in the Ile de France from 1140 to 1190, Theory of Origins.* Cambridge (Mass.), 1952.

Stone, James S. *The Cult of Santiago; Traditions, Myths and Pilgrimages.* London and New York, 1927.

Stornajolo, Cosimo. *Miniature delle omilie di Giacomo monaco (Cod. vatic. gr. 1162) e dell'Evangeliario greco urbinate (Cod. vatic. urbin gr. 2).* Rome, 1910.

Strzygowski, Josef. *Der Bilderkreis des griechischen Physiologus des Kosmas Indikopleustes und Oktateuch, nach Handschriften der Bibliothek zu Smyrna* (Byzantinisches Archiv, 2). Leipzig, 1899.

——. *Etschmiadzin-Evangeliar, Beiträge zur Geschichte der armenischen, ravennatischen und syro-ägyptischen Kunst* (Byzantinische Denkmäler, I). Vienna, 1891.

——. *Iconographie der Taufe Christi, ein Beitrag zur Entwicklungsgeschichte der christlichen Kunst.* Munich, 1885.

Studer, P. *Le Mystère d'Adam, an Anglo-Norman Drama of the Twelfth Century.* 3rd ed., Manchester, 1949.

Suger. *Oeuvres complètes de Suger*, ed. A. Lecoy de La Marche (Société de l'Histoire de France, 101). Paris, 1867.

Swarzenski, Georg. *Die Salzburger Malerei von den ersten Anfängen bis zur Blütezeit des romanischen Stils*. 4 vols. Leipzig, 1908-1913.

Swarzenski, Hanns. *Monuments of Romanesque Art; the Art of Church Treasures in Northwestern Europe*. London and Chicago, 1954.

Taralon, Jean and Roseline Maître-Devallon. *Treasures of the Churches of France*. New York, 1966.

———. "Le Trésor de Conques," *Bulletin de la Société Nationale des Antiquaires de France*, 1953-1954, pp. 47-54.

Taton, R., ed. *Ancient and Medieval Science*. London, 1963.

Thérel, Marie-Louise. "Une Image de la sibylle sur l'arc triomphal de Sainte-Marie Majeure à Rome?" *Cahiers archéologiques*, 12 (1962), pp. 153-171.

Thierry, Marcel and Nicole. *Nouvelles églises rupestres de Cappadoce, Région de Hasan Dagi*. Paris, 1963.

Thiollier, Noël. "Les Oeuvres des orfèvres du Puy," *Congrès archéologique*, 71 (1904), pp. 506-541.

Thoby, Paul. *Les croix limousines de la fin du XIIème siècle au début du XIVème siècle*. Paris, 1953.

———. *Le Crucifix, des origines au Concile de Trente, Etude iconographique*. Nantes and Paris, 1959.

Thorndike, Lynn. *A History of Magic and Experimental Science*. 8 vols. New York, 1923-1958.

Thouzellier, C. *Catharéisme et valdéisme en Languedoc à la fin du XIIème siècle et au début du XIIIème siècle*. Paris, 1966.

Tikkanen, J. J. *Die Psalterillustrationen im Mittelalter*. Helsingfors, 1895.

Tischendorf, C., ed. *Evangelia Apocrypha*. Rev. ed., Leipzig, 1876 (repr. Hildesheim, 1966).

Tobler, Titus and Auguste Molinier, ed. *Itinera hierosolymitana et descriptiones Terrae Sanctae* (Publications de la Société de l'Orient Latin, Série géographique, I-II, Itinera latina). Geneva, 1879-1885.

Toulouse, Musée des Augustins. Paul Mesplé. *Toulouse, Musée des Augustins, Les sculptures romanes* (Inventaire des collections publiques françaises). Paris, 1961.

Trens, Manuel. *Les Majestats Catalanes*. Barcelona, 1966.

Trollope, E. "The Norman Sculpture of Lincoln Cathedral," *Archaeological Journal*, 25 (1868), pp. 1-20.

Truchis, Pierre de. "Saint-Andoche, Saulieu," *Congrès archéologique*, 74 (1907), pp. 108-116.

Tschan, F. J. *Saint Bernward of Hildesheim*. 3 vols. Notre-Dame (Indiana), 1942-1952.

Turin, Museo Civico. Luigi Mallé. *Le sculture del Museo d'Arte Antica*. Turin, 1965.

Twysden, R., ed. *Historiae anglicanae scriptores decem*. London, 1652.

Underwood, Paul. "The Fountain of Life in Manuscripts of the Gospels," *Dumbarton Oaks Papers*, 5 (1950), pp. 41-138.

Unterkircher, Franz and Gerhard Schmidt, ed. *Die Wiener Biblia Pauperum*. 3 vols. Graz, Vienna and Cologne, 1962.

Urlichs, Karl Ludwig von. *Codex urbis Romae topographicus*. Wurzburg, 1871.

Usener, K. H. "Kreuzigungsdarstellungen in der mosanen Miniaturmalerei und Goldschmiedekunst," *Revue belge d'archéologie et d'histoire de l'art*, 4 (1934), pp. 201-210.

Valentini, Roberto and Giuseppe Zucchetti, ed. *Codice topografico della Città de Roma*. 4 vols. Rome, 1940-1953.

Vallery-Radot, Jean. "Bazas, Cathédrale," *Congrès archéologique*, 102 (1939), pp. 274-300.

———. "Gannat," *Congrès archéologique*, 101 (1938), pp. 304-328.

———. "L'Iconographie et le style des trois portails de Saint-Lazare d'Avallon," *Gazette des beaux-arts*, 52 (1958), pp. 23-34.

———. "Notes sur les chapelles hautes dédiées à saint Michel," *Bulletin monumental*, 88 (1929), pp. 453-478.

Vatican, Museo Sacro. Volbach, W. F. *I Tessuti del Museo Sacro Vaticano* (Catalogo del Museo Sacro . . .). Vatican, 1932.

Vázquez de Parga, Luis, José M. Lacarra and Juan Uría Ríu. *Las peregrinaciones a Santiago de Compostela*. 3 vols. Madrid, 1948-1949.

Venturi, A. *Storia dell'arte italiana*. 11 vols. Milan, 1901-1940.

Verdier, Phillipe. "La Grande Croix de l'abbé Suger à Saint-Denis," *Cahiers de civilisation médiévale*, 13 (1970), pp. 1-31.

Veyries, M. A. *Les Figures criophores dans l'art*

grec, *l'art gréco-romain et l'art chrétien* (Bibliothèque des Ecoles Françaises d'Athènes et de Rome, fasc. 39). Paris, 1884.

Vezin, G. *L'Adoration et le cycle des mages dans l'art chrétien primitif, étude des influences orientales et grecques sur l'art chrétien.* Paris, 1950.

Vich, Museo Arqueológico Artístico Episcopal. *Cátalogo de les Fotografies del Museu de Vich* (Arxiu d'Arqueologia Catalana). 2 vols. n.d.

Vidal, M. "Le Culte des saints et des reliques dans l'abbaye de Moissac," *O Distrito de Braga,* 4 (1967).

——, Jean Maury and Jean Porcher. *Quercy roman* (ed. Zodiaque). La Pierre-qui-Vire, 1959.

Vieillard-Troiekouroff, May. "La Cathédrale de Clermont du Vème au XIIIème siècle," *Cahiers archéologiques,* 11 (1960), pp. 199-247.

——. "Fresques récemment découvertes à Saint-Martin de Tours," *Les Monuments historiques de la France,* 1967, no. 2, pp. 16-33.

——. "Les Sculptures et objets préromans retrouvés dans les fouilles de 1860 et de 1886 à Saint-Martin de Tours," *Cahiers archéologiques,* 13 (1962), pp. 85-118.

Vielliard, Jeanne, ed. *Le Guide du pèlerin de Saint-Jacques de Compostelle.* 3rd ed., Mâcon, 1963.

Vincent de Beauvais. *Speculum historiale,* ed. Douai, 1629 (repr. Graz, 1964).

Viscardi, A. *Storia letteraria d'Italia, Le origini.* 2nd ed., Milan, 1950.

Vitae patrum, ed. H. de Rosweyde and d'Annot. Antwerp, 1615.

Vöge, Wilhelm. *Die Anfänge des monumentalen Stiles im Mittelalter.* Strasbourg, 1894.

——. "Zur provençalischen und nordfranzösischen Bildnerei des 12. Jahrhunderts," *Repertorium für Kunstwissenschaft,* 1903, pp. 512-520.

Vogüé, Melchoir, Marquis de. *Les Eglises de la Terre Sainte.* 2 vols. Paris, 1860.

Volbach, W. F. *Early Christian Art.* London, 1961.

——. *Elfenbeinarbeiten der Spätantike und des frühen Mittelalters.* 2nd ed., Mainz, 1952.

Wace, Robert. *Roman de Rou,* ed. F. Pluquet. 2 vols. Rouen, 1827.

Walther, D. "A Survey of Recent Research on the Albigensian Cathari," *Church History,* 34 (1935), pp. 146ff.

Warner, G. F. and A. Wilson. *The Benedictional of Saint Aethelwold, Reproduced in Facsimile.* Oxford, 1910.

——. *Descriptive Catalogue of Illuminated Manuscripts in the Library of C. W. Dyson Perrins.* Oxford, 1920.

Watson, A. *The Early Iconography of the Tree of Jesse.* London, 1934.

Weidlé, M. *Mosaïques vénitiennes.* Milan, 1956.

Weitzmann, Kurt. *Die byzantinische Buchmalerei des IX. und X. Jahrhunderts.* Berlin, 1935.

——. *The Joshua Roll* (Studies in Manuscript Illumination, 2). Princeton, 1948.

White, T. H., ed. and tr. *The Bestiary, A Book of Beasts* (Twelfth Century Latin Bestiary, Cambridge, University Library, ms. 11.4.26). New York, 1960.

Whitehill, Walter Muir, ed. *Liber sancti Jacobi, codex Calixtinus.* 3 vols. Santiago de Compostela, 1944.

Wickersheimer, E. "Figures médico-astrologiques des IXème, Xème et XIème siècles," *Janus,* 19 (1914), pp. 164ff.

Wilhelm, P. *Die Marienkrönung am Westportal der Kathedral von Senlis.* Hamburg, 1941.

Willemin, N. X. and André Pottier. *Monuments français inédits.* 2 vols. Paris, 1839.

Wilpert, Joseph. *Le pitture delle catacombe romane.* Rome, 1903.

——. *Die römischen Mosaiken und Malereien der kirchlichen Bauten vom IV. bis XIII. Jahrhundert.* 4 vols. Freiburg-im-Breisgau, 1916.

Wirth, Karl-August. *Die Entstehung des Dreinagel-Crucifixus.* Frankfurt-am-Main, 1953.

Wittkower, Rudolf. "The Marvels of the East," *Journal of the Warburg and Courtauld Institutes,* 5 (1942), pp. 159-197.

Wormald, Francis. *The Benedictional of St. Ethelwold.* London, 1959.

——. *The Miniatures in the Gospels of St. Augustine (Corpus Christi College Ms. 286).* Cambridge, 1954.

——. *The Utrecht Psalter.* Utrecht, 1953.

Wrangel, E. and M. Dieulafoy. "La Cathédrale de Lund," *Comptes rendus de l'Académie des Inscriptions et Belles-Lettres,* 1913, pp. 322-326.

Wright, Thomas, ed. *Popular Treatises on Sci-*

ence Written during the Middle Ages in An-glo-Saxon, Anglo-Norman and English. London, 1841.

Wüscher-Becchi, E. "Der 'Grosse Gott von Schaffhausen' und der Volto santo von Luc-ca," *Anzeiger für Schweizerische Altertums-kunde,* 1 (1900), pp. 123-126.

Wulff, Oskar. *Altchristliche und mittelalterliche byzantinische und italienische Bildwerke.* 2 vols. Berlin, 1909-1911.

Young, Karl. *The Drama of the Medieval Church.* 2 vols. Oxford, 1933.

———. "Ordo Prophetarum," *Transactions of the Wisconsin Academy of Sciences, Arts and Letters,* 20 (1922), pp. 1-82.

Zarnecki, George. "The Coronation of the Vir-gin on a Capital from Reading Abbey," *Jour-nal of the Warburg and Courtauld Insti-tutes,* 13 (1950), pp. 1-12.

LIST OF ILLUSTRATIONS

INDEX

Library of Congress Cataloging in Publication Data

Mâle, Émile, 1862-1954.
 Religious art in France, the twelfth century.

 (Bollingen series; 90:1) (His Studies in religious iconography)
 Translation of L'art religieux du XIIe siècle en France.
 Includes bibliographical references and index.
 1. Christian art and symbolism. 2. Art, Romanesque—France. 3. Art, French.
I. Title. II. Series.
N7949.A1M3413 709'.44 72-14029
ISBN 0-691-09912-X